THE PELICAN HISTORY OF ART

Founding Editor: Nikolaus Pevsner

Joint Editors: Peter Lasko and Judy Nairn

EARLY CHRISTIAN AND BYZANTINE ART

John Beckwith

John Beckwith, M.A., F.B.A., F.S.A., read Modern History at Oxford with special studies in Medieval History. In 1948 he was appointed Assistant Keeper in the Department of Textiles in the Victoria and Albert Museum, where he specialized in medieval textiles; in 1955 he moved to the Department of Architecture and Sculpture, where he became Keeper, pursing his study of medieval sculpture with particular emphasis on ivory carving. He has lectured at Dumbarton Oaks, Harvard University, the University of Missouri, Columbia, Missouri, and elsewhere. He was selected for the English Committee of several Council of Europe exhibitions. He also collaborated on the 1958 Exhibition of Masterpieces of Byzantine Art. His publications range from specialized essays and monographs on medieval ivory carvings and textiles to more general surveys which include *The Art of Constantinople*, 1961; *Coptic Sculpture*, 1963; *Early Medieval Art*, 1964; and *Ivory Carvings in Early Medieval England*, 1972, on which was based his exhibition at the Victoria and Albert Museum with the same title in 1974. As Slade Professor of the Fine Arts at Oxford in 1978–9 his lectures were entitled *Early Medieval Art and the Imperial Ideal*.

Early Christian and Byzantine Art

John Beckwith

Penguin Books

PENGUIN BOOKS

Published by the Penguin Group
27 Wrights Lane, London w8 5TZ, England
Viking Penguin, a division of Penguin Books USA Inc.,
375 Hudson Street, New York, New York 10014, USA
Penguin Books Australia Ltd, Ringwood, Victoria, Australia
Penguin Books Canada Ltd, 2801 John Street, Markham, Ontario, Canada L3R 1B4
Penguin Books (NZ) Ltd, 182–190 Wairau Road, Auckland 10, New Zealand

Penguin Books Ltd, Registered Offices: Harmondsworth, Middlesex, England

First published 1970
Second (integrated) edition 1979
Reprinted 1986, 1990

Copyright © John Beckwith, 1970, 1979
All rights reserved

Set in Monophoto Ehrhardt
Printed and bound in Great Britain by
Butler & Tanner Ltd, Frome and London

LIBRARY OF CONGRESS CATALOGING IN PUBLICATION DATA

Beckwith, John, 1918–
 Early Christian and Byzantine art.
 (The Pelican history of art)
 Bibliography: p. 376.
 Includes index.
 1. Art, Early Christian. 2. Art, Byzantine.
I. Title. II. Series.

N7832.B3 1979 709'.02 79–11228
ISBN 0 14 0560.33 5 (UK hardback)
ISBN 0 14 0561.33 1 (USA and UK paperback)

Designed by Gerald Cinamon

When a man hath done, then he beginneth.
Ecclesiasticus xviii:6

CONTENTS

FOREWORD

An attempt has been made to present Early Christian and Byzantine Art as a panoramic story which is meant to be read rather than consulted. It is emphasized that the book is neither dictionary nor encyclopedia, neither catalogue nor hand-list. It would have been impossible to include everything even if that were desirable in a work directed at a general educated public as well as students and specialists. Byzantine studies are still in their infancy and there is much that needs careful appraisal and reassessment, frequently in the light of new excavations and discoveries which have not yet reached final publication. The author is conscious that his work is only a stage in the gradual rediscovery of the facts, the influences, and the tendencies which, when placed in proper perspective, should lead to a full and profound understanding of Early Christian and Byzantine Art. At the same time he has tried to be up to date in matters of research and he hopes that the story that he has told gives a true picture in the light of our knowledge today.

It would be impossible, also, to thank individually the innumerable friends, colleagues, and institutions who have helped during the preparation of this book and the author hopes that they will accept this quite inadequate gesture of gratitude. In cases of help over details of scholarship I have made acknowledgements in the notes. There are, however, a few close friends who have watched anxiously over my work, given constant advice, and made useful suggestions on different levels: Professor Hugo Buchthal, the Rev. Gervase Mathew, O.P., Mademoiselle Sirarpie Der Nersessian, Sir Steven Runciman, and Professor Francis Wormald. Before them, here and now, in thanks for their benevolence I make *proskynesis*.

<div align="right">

JOHN BECKWITH
London, 1968

</div>

For the second edition it has proved necessary to make only one or two changes in the text, but the Notes and Bibliography have been extensively amplified.

PROLOGUE

The Eucharist, the central act of the Christian religion, was first done in an upper room of a private house before a restricted company of chosen disciples. The early Christians had no public place of worship. After the Ascension the Apostles 'were continually in the temple, praising and blessing God', and after Pentecost 'Peter and John went up together in the temple at the hour of prayer, being the ninth hour' (Acts iii). The Temple at Jerusalem was destroyed in A.D.70. The synagogue was in the first century A.D. a comparatively modern institution and had no hereditary claim on the reverence and affection of either Jews or Christians; as well as a place of worship, it was a village institute and a police court where cases were tried, prisoners sentenced, and the sentences carried out. The early Christians were soon forbidden the synagogue for teaching purposes. The 'breaking of bread' was done from 'house to house' (Acts ii:46) followed by a prayer and a sermon. The company long remained restricted. All who were not already of the 'laity' by baptism and confirmation – even those who were already convinced of the truth of the Gospel but had not yet received the sacraments – were invariably turned out before prayer of any kind was offered. The early Christians had no need for any special building for worship for at least a century and a half and were content with the 'house-churches' to which there are several references in the New Testament and in the second century.[1]

The first Christian writings were the Epistles of St Paul. The Gospel of St Mark, written at Rome in 'translation Greek' with strong Jewish overtones about A.D. 65–7, is probably the oldest of the Gospels and reflects both Petrine and Pauline traditions. The Gospel of St Matthew was written in Aramaic at Antioch or Jerusalem about A.D. 80. That of St Luke and the Acts –

St Luke was not a Jew but possibly the son of a Greek freedman of some Roman family, a physician in constant attendance on St Paul – were written well within the first century A.D. and are the most literate of the New Testament writings. The Gospel of St John, which Eusebius of Caesarea says was written after the first three, was probably dictated at Ephesus but again well within the first century A.D. It seems probable that the literary stage in the transmission of the Gospel materials belongs largely to Greek-speaking Christianity. There were no liturgical books – sacramentaries, lectionaries, psalters – before the fourth century. There is no allusion to the surrender, or to any demand for surrender, of liturgical books during the early persecutions, though the surrender, or the demand for surrender, of copies of Holy Scripture is frequently mentioned. There is no appeal to the authority of a settled liturgical text during the controversies of the first three centuries. Knowledge of the text of the Creed and of the eucharistic liturgy was withheld from the unbaptized by the *'disciplina arcani'*, and indeed such a withholding of the text would have been difficult if it had been committed to writing.[2]

The earliest account of Christian worship in any detail occurs in St Justin's *Apology*, written about 155, where the Eucharist is described twice: once it is preceded by the *synaxis* (meeting) and once it is preceded by the conferring of baptism. The next earliest witness, St Hippolytus in his *Apostolic Tradition* written about 215, also describes the Eucharist twice: once preceded by the consecration of a bishop, and once preceded by baptism and confirmation. When celebrated normally the Eucharist began with the Offertory – small loaves of bread and a little wine which the faithful brought with them. The ceremony was austerely simple and matter-of-fact. There was no appeal to the senses or to the

emotions as in the cults of Isis, Hecate, Diony-sos, or Mithras; there were no sophisticated speeches or clever philosophical discourses; there was no mumbo-jumbo. Two accessories of the Eucharist are mentioned in the New Testament: the chalice (cf. I Cor. x:16; I Cor. x:21) and the table or altar (I Cor. x:21; Heb. xiii:10). St Cyprian, Bishop of Carthage, mar-tyred in 257, speaks of an altar being placed in the church and of assisting at God's altar, and refers to the use of a pulpit from which the Gospel was read. Origen of Alexandria, the first Christian to join the intellectual élite of his age, speaks of the altar and its adornment. There is, however, no evidence of fixed altars in Rome before the fifth century, and portable altars must have been the general rule in early times. At the beginning of Diocletian's persecution in 303 the Christians in a small church, a converted private house, at Cirta (now Constantine) in Algeria were asked to surrender the scriptures, gold and silver chalices, silver dishes, a silver bowl, silver lamps, bronze candlesticks and lamps, and various articles of clothing; there was no reference to an altar. Indeed, Minucius Felix mentions it as a charge against the Chris-tians that they had no churches nor altars, and Arnobius, writing towards the end of the third and the beginning of the fourth century, states that Christians were charged with having no temples, statues, nor effigies of their divinity, no altars on which to offer sacrifices, incense, libations, and sacred meals. Cyprian, Tertul-lian, and Origen, however, all refer to churches under the name 'ecclesia' and 'domus dei'. Euse-bius and Optatus mention the existence of many churches at Rome and elsewhere at the beginning of the fourth century, but Constan-tine, in his letter to Eusebius on the building of Christian churches, refers to the small size and the ruin of previously existing buildings. To-day, after more than half a century of intensive research through the Mediterranean world, there is nothing whatever to suggest that before the reign of Constantine the Church had made any attempt to develop a monumental architec-ture of its own.[3]

The holy water of baptism is mentioned in the Canons of St Hippolytus, and later St Cyprian refers to consecrated water. For the early Christian baptism meant total immersion, although this was probably soon modified for convenience. There may, therefore, have been an early use of fonts, most likely in the form of a piscina, and certainly bowls of precious metal. At S. Giovanni in Fonte at Naples, for example, the earliest surviving baptistery in the West, dating from the early fifth century, the piscina was not deep enough for total immersion. The baptized stood up to his knees in water and the ceremony was conducted with a triple pouring of water over his head. Oil was required for the sacraments of confirmation, holy orders, and extreme unction. Anointing by consecrated oil was a Jewish custom, and again sacred vessels were required. Incense, so intimately associated with the worship of idols and homage to the Emperor, was not used by Christians during the first three centuries. The earliest authentic record of the use of incense occurs in the Pil-grimage of Eutheria (or Sylvia) about 385 when she describes the Sunday vigil service at Jeru-salem. Incense is first ordered for use in the *Apostolic Canons* and in the writings of Diony-sius the Areopagite, both post-Nicene authori-ties.

In view of the fact that the Christians at Cirta were asked to surrender various articles of clothing, it should be stressed that there is little proof of the existence of any distinctive dress of the Christian clergy during the first three centuries. The first reference to a vest-ment occurs in the Canons of St Hippolytus; the next occurs early in the fourth century when the Emperor Constantine gave to Macarius, Bishop of Jerusalem, a rich vestment embroid-ered in gold to wear when administering bap-tism. Eusebius refers to the tradition that St John the Evangelist wore the mitre (derived from that of the Jewish high priest), presum-ably in his archiepiscopal capacity. Church vestments seem, however, to be a survival of the ordinary lay dress worn in the fourth century and a little later.[4]

In connexion with the daily offering of the burnt sacrifice of a lamb in the Jewish Temple there was vocal and instrumental music. Silver trumpets were blown by the priests, and the Levites played various instruments. A special psalm was appointed for use on each day of the week, but there is no early evidence for any scheme of the regular repetitions of the Psalter corresponding to its use in the Divine Office of the Christian Church, either in the case of the Temple or the synagogue services. Jewish melodic recitation, on the other hand, may have influenced the mode of chanting the Christian service. In 347-8 at Antioch a confraternity of ascetic laymen under the direction of the orthodox monks Flavian and Diodore adopted the custom of meeting together in private houses for the recital of the Psalms. They were soon advised to confine themselves to a basilica by the Arianizing Bishop of Antioch, who wished to keep them under observation. The custom, nevertheless, spread rapidly, and Jerusalem, rather than Antioch, became the centre and example for the diffusion of the Divine Office which became one of the personal achievements of St Cyril, Bishop of Jerusalem, about 350. Pope Damasus, about 382, deliberately modelled the Roman office on that of Jerusalem. Damasus, indeed, whose pontificate (366-84) marked the period of the first definite self-expression of the Papacy, formulated in brief, incisive terms the doctrine of Rome upon the Creed, the Bible, and the Pope. At Milan the beginnings of the Office appear to go back to 386, when the troubles provoked by the Arian Empress Justina caused the orthodox to keep watch at night in the basilicas, during which time St Ambrose occupied their minds with a vigil service based on the new Eastern model. The *Psalterium romanum*, published by St Jerome in 383, was to be supplanted almost entirely by the *Psalterium gallicanum*, a second version made by St Jerome with the aid of the *Hexapla* in 392, when he was at Bethlehem. In the sixth century a copy of this new version was sent to Tours and was circulated in Gaul. St Jerome's final version, the *Hebraicum*, a fresh translation from the Hebrew, has not been used for the services of any church.[5]

Latin-speaking Christianity first emerges at Carthage towards the end of the second century, but it must be remembered that at this time the church at Lyons - St Irenaeus, Bishop of Lyons about 180-200, was a disciple of Polycarp, who had been a disciple of St John the Evangelist - was still mainly composed of Greek-speaking orientals, and the Roman Church continued to use Greek in the third century and perhaps even later. At the beginning of the third century no bishop possessed such a large, well-organized, and efficient administrative machine as the Patriarch of Alexandria. From the time of Bishop Demetrius, who died in 232, ecclesiastically Alexandria dominated the whole of Egypt and also the adjacent areas of Libya and the Pentapolis. Alexandrian Christian philosophers like Clement and Origen did much to synthesize neo-Platonist thought with the teachings of the Apostles. Language and the philosophical cults, in fact, proved something of a stumbling block. Christian teaching was expressed in a Greco-oriental 'dialect' which was apt to be rebarbative to the educated pagan. Although Christianity had made great progress during the first three centuries, it still remained a minority sect, was still largely confined to the lower and middle classes, and had made little impression on the aristocracy. Eusebius refers more than once to numbers of rich and well-born Christians in Antioch and Alexandria, some serving in the imperial administration, but Roman nobility tended to hold fast to its pagan customs. After the conversion of Constantine imperial support made Christianity the dominant religion of the Empire, but it is significant that the religious change coincided with a social change which brought to the front men of the middle and lower classes. Even in the late fourth century, when asked to become a bishop, Synesius of Cyrene found his love of studious pursuits and philosophy combined with his life as a gentleman and a landowner a serious obstacle. Culture, not paganism - Synesius was never

tempted to worship the ancient gods – kept men of letters of the old aristocracy at bay from Christianity. Nevertheless, from the second century onwards, Christianity had drawn to itself men of outstanding ability and original power. To speak only of the West, Tertullian, Minucius Felix, Cyprian, Arnobius, and Lactantius were all steeped in the rhetorical tradition of the schools and wrote for an educated public.[6]

Even in the first century A.D., moreover, there had been a few Roman nobles and wealthy Christians throughout the Empire, among them the Flavii and the Acilii, who opened their houses for the breaking of bread and their burial grounds for the dead. If in Apostolic times Christians were buried in pagan cemeteries, as were St Peter and St Paul, they acquired their own burial grounds outside the walls of Rome as early as the second century. Some pagan cemeteries were sacred to pagan divinities which were naturally abhorrent to the Christians, pagans preferred cremation to inhumation, a practice adopted by the Christians, and it was inevitable that the Christians should, like the Jews and various syncretistic sects, acquire burial grounds of their own. These were protected by Roman property and funerary laws. In the second century a rich Christian like Praetextatus placed his ground at the disposal of the faithful, and in the third century others followed suit: Maximus, Draco, and Basilla. St Agnes was buried on the Via Nomentana and St Eugenia on the Via Latina 'in their own ground'. In the early third century Pope Zephyrinus put the deacon Callixtus in charge of the cemetery which now bears his name on the Via Appia – the first to be administered in the name of the Church under the direct control of the Bishop of Rome. Zephyrinus (d. 217) was buried in a tomb above ground on the Via Appia – by the third century in addition to the catacombs there were a number of Christian cemeteries on the surface – but many third-century Popes were buried in the catacomb of Callixtus. Within the walls of Rome ground for churches was probably first acquired during the

long peace of 211–49. The earliest mention of church property in the city is when the Emperor Alexander Severus (222–35), according to Lampridius writing in the fourth century, decided a question of disputed ownership of land between the 'christiani' and the 'popinarii' in favour of the former, because of the religious use which they were going to make of it. Alexander Severus was inclined to be tolerant; he added an image of Christ, with those of Abraham and Orpheus, to his collection of household gods.[7]

In 261, under the Emperor Gallienus, Christianity became a *religio licita*, but it was still advisable to avoid publicity. For those who sought preferment in high places, for those notable in public life, Christian belief was a liability. The Christian refusal to take part in the worship of the Emperor was a seditious act, and the waters of Christian baptism were considered, indeed not without reason, to have undermined the foundations of the Empire. The Christian habit of secret meeting, of careful screening of their mysteries, and their joy and fortitude before martyrdom were inevitably a source of suspicion and alarm. Even if a local governor or judge was inclined to be tolerant, his attitude was frequently set at naught by the mob, gullible, sadistic, and insatiable for the sight of torture and violent death. The troubles of the times were often laid by the ignorant and the not so ignorant at the doors of the faithful. When the peace of the Empire was constantly threatened by outside menaces – the great invasion of the Goths which was crushed by Claudius II in 269, and the German invasion of 276, repulsed by Probus, but leaving Gaul devastated for years – it was easy to put the blame on the Christians. 'Ever since the Christians have been on the earth, the world has gone to ruin; many and various scourges have attacked the human race; and the celestial beings themselves, abandoning the care with which hitherto they have watched over our interests, are banished from the regions of the earth' – so, ironically, relates Arnobius in *Adversus Nationes*, Book I, written in 296–7.

Indeed, the worst, most thorough persecution of all was to begin under Diocletian in 303 and the Church nearly foundered.[8]

Peace came finally in 312–13 with the imperial pronouncement that everyone might follow that religion which he considered best, but it soon became clear that Constantine intended Christianity to be the official faith. One privilege after another was given to the Church, including immunity for its ecclesiastics from compulsory service and obligatory state office, freedom from taxation, and the right to inherit property. It soon also became clear that Constantine had views of his own position in the Church: the Emperor was the Vicar of God and with the help of the Logos, as Eusebius stated, he imitated God, steering and standing at the helm of all earthly things. 'How much power of faith in God was sustained in his soul, anyone might learn by reckoning how on his gold coinage his very own image was figured as a type conceived as looking up and yearning towards God in prayer.' The portrait was, in fact, based on that of Alexander, and later the Emperor Julian was to make great fun of this idea, stating that in reality Constantine was inflamed with passion, Helios lusting for Selene. The Emperor wanted unity and peace for the imperial Church he had founded, but he soon discovered that the Christians were far from being united and at peace among themselves. The condemnation of Arius and the Nicene Creed were the next steps. The Council of Nicaea, over which Constantine presided in 325 'like some heavenly messenger of God with a circumambient halo resembling rays of light', opened rather than closed the history of Arianism on the larger stage. The problems set by imperial intervention in the affairs of the Church became more acute when the Emperor himself became a heretic, particularly when the Arian Constantius II ordered that whatever he wished should be considered a canon, or when the Emperor's ideas of justice conflicted with those of the ecclesiastics. It was for Ambrose, the Bishop, not Theodosius, the Emperor, to decide whether the Christians should be compelled to rebuild the synagogue which they had destroyed at Callinicum. With more propriety from the modern view, St Ambrose excluded Maximus from the Eucharist because of the murder of Gratian, and Theodosius because of the massacre at Thessalonika. Among the Fathers of the fourth century St Ambrose pointed the way to the medieval theocracy of the Papacy and indicated that he was prepared to retain for the Church a penny or two which might properly have been rendered to Caesar.[9]

In the summer of 384 St Ambrose stated that the Roman Senate was for the most part Christian, but it should be remembered that in the same year – the year St Jerome published his correct version of the Four Gospels in Rome – both Symmachus and Praetextatus attained high office in the city and dedicated new temples to the old gods. The complexity of the situation is illustrated by the pagan Symmachus sponsoring St Augustine's application (he was then a Manichee) to be professor of rhetoric at Milan, in the teeth, as it were, of St Ambrose. Many pagans married Christians, and frequently the daughters of such a marriage were brought up as Christians, the sons as pagans. St Ambrose was the first Latin Church Father to be born and educated as a Christian and the first Roman aristocrat – he came of consular family and was governor of northern Italy before he became bishop – publicly to defend the Church. He was in close personal touch with St Basil, one of the greatest of the Greek Fathers, also an aristocrat, and he did not hesitate in his sermons to follow closely and consistently the treatises of Plotinus. St Jerome, not quite so well born but often happily ensconced in an admiring circle of grand Roman ladies, feared that his devotion to Cicero's prose would jeopardize his salvation. The writings of St Augustine, although his knowledge of Greek was limited, pay frequent homage to Plato as well as Vergil. The late fourth and early fifth century is the golden age of early Christian theology and humanism. Christianity, not paganism, was attracting the finest minds of the age, and even today St Augustine remains an intellectual power.[10]

The history of the Councils of the Church is not always edifying to the modern reader. The bishops attending these councils often appear ferocious, bigoted, unprincipled, and devoid of charity. St Cyril of Alexandria's behaviour at the Council of Ephesus in 431, which declared the Virgin Mary Mother of God and defined the true personal unity of Christ, was illegal and dishonest. Nevertheless, the process of standardization advanced under the combined efforts of Church and State, and the final condemnation of Origen by the Emperor Justinian in 553 must have seemed meet and just to a ruler determined to establish throughout the Empire one faith and one law. In practice the dogma of the Councils sometimes failed to make impact on everyday piety. The Empress Theodora (d. 547) professed strong Monophysite sympathies and Justinian himself got entangled in heresy. The problems of mysticism and the controversy about images were to perturb the faithful for many years to come. Those who rejected the decrees of the Councils – of Chalcedon in 451 and of Constantinople in 553 – like the Jacobites in Syria and the Copts in Egypt, exasperated by pressure from the imperial administration, were only too ready when the time came to fall into the hands of Islam. On the other hand, orthodox theology in the East was gradually paralysed by its own traditionalism, and eventually Latin theology, which owed everything to the Greeks, was to triumph in independent power and spiritual life.[11]

EARLY CHRISTIAN ART:

ROME AND THE LEGACY OF THE CAESARS

The earliest Christian vault and wall mosaics so far discovered are in a small mausoleum not far from the tomb of St Peter on the Vatican hill. The mausoleum was built towards the end of the second century for the Julii family, but the mosaics probably date from the middle of the third century and the subjects represented are a curious mixture of pagan and Christian symbolism. On the walls and ceiling of the tomb the luxuriant vine of Dionysos has become the True Vine of Christ. On the north wall a fish is hooked by an angler standing on rocks while a second fish swims away. Christ had called St Peter and St Andrew to leave their nets and become fishers of men (Matthew iv:19), and later Clement of Alexandria placed additional emphasis on the fisherman who recalls the deliverance of Christians by the Apostles from the Sea of the World and the new birth through baptism. Christ is the Fisher of Souls, and the soul represented as a fish is washed and reborn through the waters of baptism into a new, divine life of Grace – an idea new to the pagan world. On the east wall Jonah falling into the mouth of the whale provides an obvious parallel with the Christian belief in the resurrection of the body – a belief beyond the hope of any pagan. On the west wall Christ is represented as the Good Shepherd, again with a good New Testament tradition. In the centre of the vault a beardless charioteer [1] dressed in a tunic and a flying cloak, nimbed with rays shooting upwards and sideways like the arms of a cross, bearing in the left hand an orb, the right (which is missing) possibly raised in an act of benediction, represents the risen and ascending Christ, the new *Sol Invictus, Sol Salutis, Sol Iustitiae*. The pagan type of the sun-god in his chariot, or the apotheosis of an emperor or a hero, has been

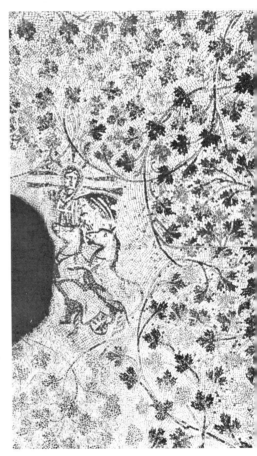

1. Christus-Sol. Mosaic on a vault in the necropolis under St Peter's. Mid third century. *Rome, Grotte Vaticane*

adapted to the Christian belief in the risen God, His triumph over death, and, through the orb in his left hand, His eternal dominion.[1]

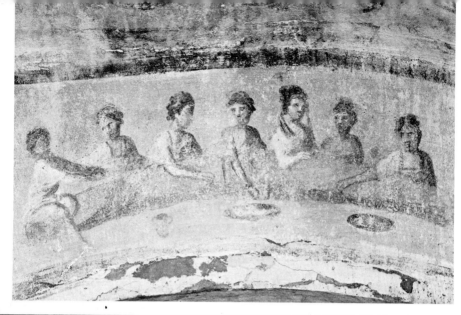

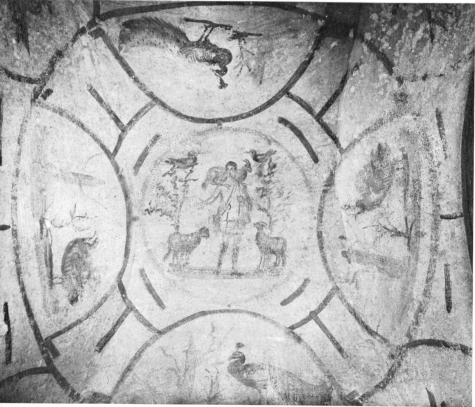

In all the paintings which cover the walls and ceilings of the catacombs the Resurrection, salvation, and life after death are constantly implied. In the catacomb of Lucina on the Via Appia, where Pope Cornelius (d. 253) was buried, dating from the second or third decade of the third century, the story of Jonah appears again, and Daniel between the lions. In the so-called Flavian gallery in the catacomb of Domitilla – the assumption that Flavius Clemens and Flavia Domitilla, mentioned by Eusebius of Caesarea, were responsible for this gallery is probably correct – the same scenes occur. Though the gallery may date from the middle of the second century, scholars are agreed that there is no visual trace of Christianity in the catacombs before the end of the century. The catacomb of Priscilla contains a chapel – the Cappella Greca – with paintings dating from the end of the second century, including a 'breaking of bread' [2], and another, the Cappella della Velata, provides a Good Shepherd [3] represented with quick, almost vivacious brush-strokes, a remarkable *Orans* [4], and possibly a very early Virgin and Child [5] of about the same date. In the catacomb of Callixtus, dating from the middle of the third century, the Good Shepherd appears again with delicate modelling of form, face, and drapery. Shepherds were common enough as garden figures in pagan villas; they represented a romantic ideal of the bucolic way of life and the more solid merit of good husbandry and economy, but they could equally well be adapted to Christian symbolism. The portraits of the dead multiply; the faithful stand usually with arms raised in prayer, surrounded sometimes by sprays and garlands of flowers and foliage, and accompanied by inscriptions stating that the soul lives in peace. One of the most striking of

2–5. The Breaking of Bread (*opposite, above*),
The Good Shepherd (*opposite*),
Orans (*above*), and The Virgin and Child (*right*).
Wall-paintings. Late second or third century.
Rome, catacomb of Priscilla

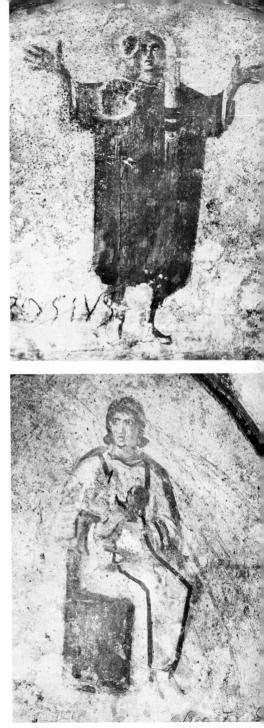

these portraits is that of a woman in the cata-
comb of Thraso, dating from the fourth cen-
tury [6]. In the catacomb of Priscilla the story of
the three youths in the furnace, dating from the
early fourth century, stresses again the theme
of redemption and recalls the *commendatio
animae* in the liturgy of the Church: 'Libera
animam servi tui, sicut liberasti Noe de diluvio
. . . sicut liberasti Danielem de lacu leonum . . .
sicut liberasti tres pueros de camino ignis et de
manu regis iniqui . . . sicut liberasti Susannam

6. Orant Woman. Wall-painting. Mid fourth century.
Rome, catacomb of Thraso

7 (*below*) Adam and Eve, and 8 (*opposite*) Noah.
Wall-paintings. Mid fourth century.
Rome, catacomb of St Peter and St Marcellinus

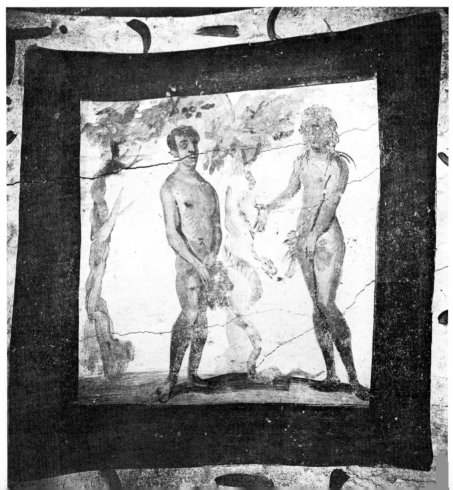

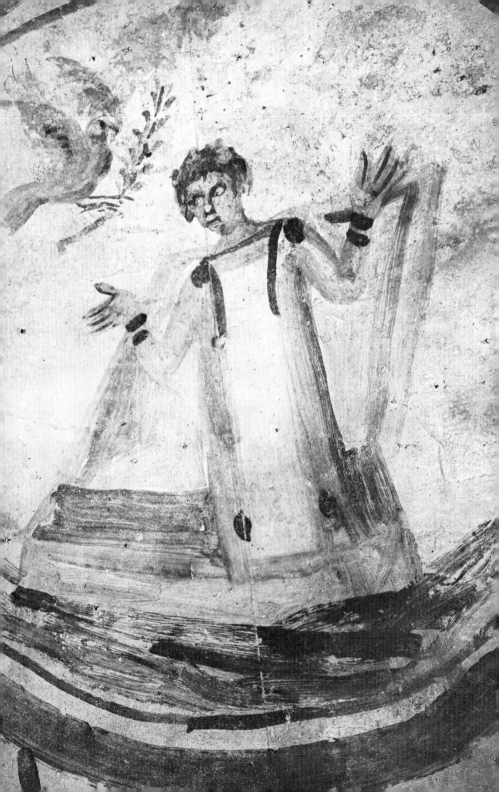

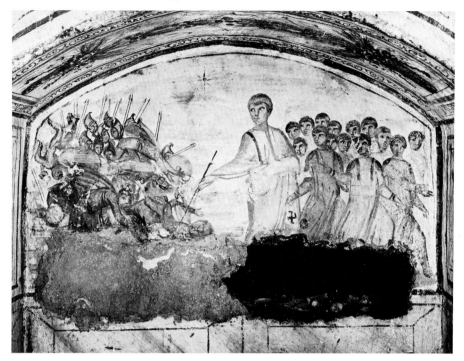

9. The Crossing of the Red Sea. Wall-painting. Mid fourth century.
Rome, catacomb on the Via Latina

de falso crimine.' The presence of Adam and Eve in the catacomb of Peter and Marcellinus, martyred in 304 – the decoration continued through the century – underlines the necessity for the redemption of Man by Christ from the consequences of the Fall, but this solemn theme is represented with all the flaccid superficiality of style current at the time [7]. In the same catacomb Noah [8] appears wide-eyed, improbably youthful, gesticulating, painted in a sketchy, impressionistic technique none the less telling in its symbolism. In a catacomb on the Via Latina built for a restricted group of families, both Christian and pagan, there are four series of paintings – different hands of varying quality working at different periods – ranging in date between 320 and 350. They include a large number of Old and New Testament scenes, some profane, and some mytho-

logical scenes. In the largest group – forty-one pictures in all – about half of the Old Testament stories and figures are completely new to catacomb painting. One new scene, the Crossing of the Red Sea [9], is found on the sarcophagi, but here its treatment and details are unique. Of the thirteen New Testament scenes two, the Sermon on the Mount and the soldiers casting lots for Christ's clothes at the Crucifixion, are wholly new, and another scene, the Raising of Lazarus, is represented with an unusually large crowd of onlookers, of whom in one case eighty can be counted. There are scenes of daily life including the practice of medicine. The pagan pictures show Ceres/Abbundantia twice and six illustrations of the Labours of Hercules. There can be little doubt that the models existed in the paintings and mosaics of the contemporary basilicas, of which few have survived.[2]

10. Scenes from the life of Jonah and portraits of the sons of Constantine the Great. Gilded glass dish found at Cologne. Fourth century. *Cologne, Wallraf-Richartz Museum*

Large quantities of gilded glass, ranging in date from the third to the fifth centuries, have been found in the catacombs, with many examples bearing Christian subjects. Sometimes the portrait medallions were made for their own sake, but the majority formed the bottoms of cups or plates, or were fused into the sides of glass vessels. These were mostly made for domestic use and, as the inscriptions show, were presents for weddings, birthdays, and other anniversaries. In many cases they were used as a kind of seal set in the mortar which closed a tomb. It has been suggested that the labels on the earliest of these glasses – for example, the family portrait on the great cross in the Museo Cristiano at Brescia – show peculiarities of Egyptian Greek, and, combined with iconographical details and similarities to the Faiyum mummy portraits, a case has been made for Alexandrian influence and craftsmen working in Italy. But family portraits in different media are common enough in Rome and, since there is no doubt that all kinds of Greek might have been written in the metropolis, the main sequences suggest a Roman origin. Nevertheless, this type of work was also produced in other centres, particularly Cologne. Among a number of examples found in northern France and the Rhineland the gilded glass disk with scenes from the Old and the New Testaments, found in Cologne, now in the British Museum, and a dish with the portraits of the sons of Constantine I [10], also found in Cologne, now in the Wallraf-Richartz Museum, were almost certainly locally made. Although undoubtedly the most beautiful are the stern, melancholy portraits of individuals or family groups which gaze at the spectator, as it were, from a third-

century limbo with all the intensity of an early photograph, the later sequences with their mixture of pagan, Jewish, and Christian symbolism reflect the popular taste of cosmopolitan Rome. Among the Christian examples twin busts of Peter and Paul seem to have been particularly in demand.[3]

The style of all these paintings is that of the declining art of cosmopolitan Rome. There was no attempt to create a specific Christian style with formal standards harking back to the age of Augustus or even beyond; there was no question of a new style breaking away from the traditions of the past. The early Christians merely borrowed and 'baptized' the symbolism of their pagan and Jewish neighbours to express their own beliefs and hopes. It is quite clear that in the second and third centuries a very high proportion of the well-to-do middle classes in Rome was of east Mediterranean stock, and that a substantial percentage of this number was of servile origin. This accounts in part for the eclecticism of late antique art but, in any case, aesthetic standards were low. Constantine in one of his laws complained that he needed a large number of architects but that none existed, and he gave instructions for young men to be encouraged to learn the art. In another law he gave immunities to a whole range of skilled craftsmen – sculptors, painters, mosaicists, cabinet makers, gold- and silversmiths and the like – so that they might have 'leisure to learn their arts' and might 'both themselves become more skilled, and train their sons'. When big churches were at last built on both basilican and central plans great importance was given to luminosity, to the inlaying of precious metals, to mosaics gleaming with gold and colour, to stucco work. St Gregory of Nyssa, when writing his eulogy of St Theodore Martyr in the second half of the fourth century, emphasized the beauty of places of worship as an element of great importance to religious experience. In the matter of images it was not a question of presenting divinity directly but of narrating events in order to edify the soul of the observer.[4]

The Emperor Constantine was responsible for the first large Christian churches. St John Lateran, the episcopal church of Rome, was almost certainly the first substantial church to be built under the Emperor's patronage and is a basilica of standard early Christian type. No less than three of Constantine's later foundations – the churches of the Holy Sepulchre, of the Nativity, and of St Peter – were built to a common pattern, and Eusebius leaves no doubt of the Emperor's direct and detailed concern with the form and progress of these undertakings. Apart from St John Lateran, Constantine built at Rome the Fons Constantini, St Peter's on the Vatican Hill, S. Paolo fuori le Mura, the church of the Holy Cross at Jerusalem, S. Lorenzo and SS. Pietro e Marcellino in Rome besides churches at Ostia, Albano, Capua, and Naples. He or his mother, the Augusta Helena, built churches at Jerusalem on the site of the Holy Sepulchre, on the Mount of Olives, at the place of the Ascension, at Bethlehem over the cave of the Nativity, and at Mamre at the place where according to tradition Abraham had entertained the Son of God with two angels. At Constantinople, among others churches were built to Holy Wisdom, Holy Peace, and the Holy Apostles. At Nicomedia a new church was erected to replace the one destroyed by Diocletian in 303. At Antioch Constantine began the famous Golden Church, believed to have been one of the most important buildings of his reign, although it was not completed until the time of Constantius II. Today the exact site of this church is unknown, but some believe that it may have served as a model for the church of St Sergius and St Bacchus at Constantinople and that of S. Vitale at Ravenna in the sixth century. We know from the *Liber Pontificalis* how the interior of St Peter's looked. The shrine of the Apostle was of gold and precious marbles, the apse was decorated with gold mosaic. There was a great cross of solid gold, and the altar was silver-gilt set with four hundred precious stones. There was a large golden dish for the offertory, and a jewelled 'tower' – possibly a tabernacle to house the Blessed

Sacrament – with a dove of pure gold brooding over it. Before the Apostle's tomb was a great golden corona of lights and four large candlesticks with scenes from the Acts of the Apostles wrought in silver. The nave was lit by thirty-two hanging candelabra of silver, and the aisles by thirty more. St Peter's was one of the great shrines of Christendom but its furnishings were not exceptional among churches of this class.[5]

The mosaic in the semi-dome of the apse of St Peter's bore an inscription inferring that the church was completed under Constans (337–50) and read: 'The seat of justice, the house of faith, the hall of modesty, such is [the church] that you see, the abode of all piety. It proclaims its joy and pride in the merits both of father and son for both alike it honours as its founders.' The inscription was still in position in 794, since Pope Hadrian I in a letter to Charlemagne quotes the first line, but it seems to have disappeared before the twelfth century. The mosaic, which may have been damaged in the fifth century and was certainly restored by Pope Severinus (640), was replaced by Innocent III (1198–1216), and this replacement was demolished by Clement VIII in 1592. Except in such details as the insertion of the figures of Innocent himself and the Roman Church, there is good reason to believe that the thirteenth-century mosaic, of which an official copy was made just before its demolition, followed closely the model established by its predecessor; and that, like it, the early medieval mosaic, which may well go back substantially to the fourth century, portrayed a central figure of Christ, seated in majesty below the heavenly canopy, and flanked by St Peter and St Paul and two palm-trees; below, echoing this upper scene, the Agnus Dei stood among the twelve Apostle-lambs between the cities of Jerusalem and Bethlehem, symbolizing the Churches of the Jews and the Gentiles. The symbolism is certainly that of the fourth century, and it has been pointed out that precisely the same scenes occur, significantly enough, on the face of the Pola casket opposite to that which portrays the

Constantinian shrine of St Peter. Pope Sixtus III (432–40) enriched St Peter's still more with gifts of precious metalwork, and the church may have undergone minor changes when it was restored under Leo the Great, who reigned from 440 to 461. When the Goths and the Vandals sacked Rome in 410 and 455 we are specifically told that the 'holy places', and in particular the churches of St Peter and St Paul, were treated as places of sanctuary. It was left to the Arabs in 846 to occupy and to loot St Peter's.[6]

Very little has survived of these Constantinian buildings. In Rome, however, the mausoleum of Constantine's daughter, Constantina or Constantia, contains some vault mosaics which imply that religious and secular subjects might be mixed without any sense of impropriety. The dome mosaics are now lost, but from a water-colour copy made by the Portuguese Francesco d'Ollanda about 1538-40 we know that some of the subjects were Susanna and the Elders, the Sacrifice of Cain and Abel, the Sacrifice of Elias on Mount Carmel, Tobias, possibly Lot receiving the Angels, Moses striking the rock for water, and possibly Noah building the Ark. Since an upper row of mosaics contains the Miracle of the Centurion we may presume that this upper row was given to scenes from the New Testament. The scenes are framed by caryatids and acanthus-scrolls; there was a calendar of saints and below were aquatic scenes. The whole programme stresses only partially the *commendatio animae* and the purpose of the building as a mausoleum. It was built in two stages: the first between 337 and 351, the second after the death of Constantina in 354 but before the death of Constantius II in 361. The mosaics surviving in the vault of the ambulatory are secular in tone: patterns of 'objets trouvés' scattered on a ground amid birds, branches, and fruit, interlaced medallions with birds and mythological figures, putti harvesting grapes [11], and two portrait heads which may be those of Constantina and her husband Gallus. The mosaics in the lateral apses appear to be seventh-century restoration

11-13. Vintage scenes (*above*),
Christ delivering the Law to Moses, or Christ
giving the Keys to St Peter (*opposite, above*),
and Christ delivering
the Law to St Peter and St Paul (*opposite*).
Mosaics in the ambulatory vault
(mid fourth century) and in apsidal chapels
of the ambulatory (possibly seventh-century
restorations of fifth-century originals).
Rome, Mausoleum of Constantina

of fifth-century work [12, 13] and show two
kinds of *traditio legis*, Christ seated on a globe
delivering the Law to Moses, and Christ de-
livering the Law to St Peter and St Paul. All
these mosaics were tidied up and restored under
Pope Gregory XVI between 1836 and 1843.[7]

Constantina's sarcophagus of porphyry [14]
is a remarkable example – quite apart from its
size and grandiloquence – of imperial religious
reticence, or perhaps even ambivalence. Winged
putti amass bunches of grapes in tubs framed
by massive acanthus-scrolls, press grapes into
vats, and hold garlands; two peacocks and a
lamb may have a Christian significance, but

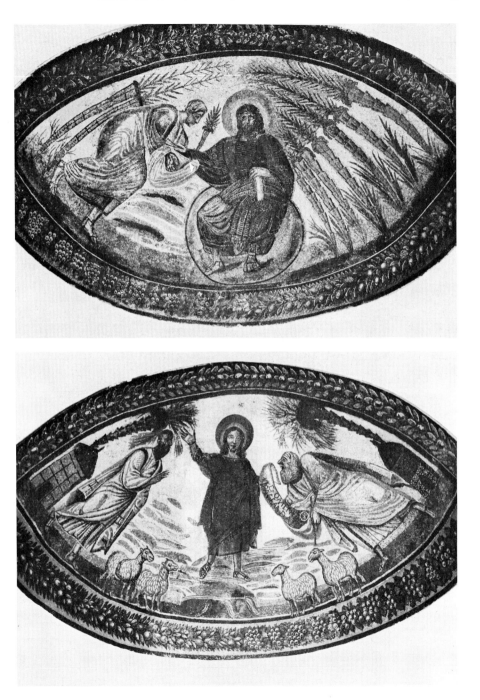

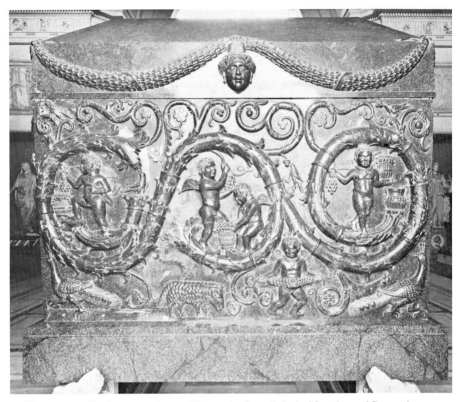

14. Vintage scenes. Porphyry sarcophagus of Constantina formerly in the Mausoleum of Constantina.
Mid fourth century. *Rome, Museo Sacro Vaticano*

more swags and Dionysiac masks decorate the
lid. This, in conjunction with the Dionysiac
motifs known to have been depicted on the
floor mosaic and more Dionysiac scenes in the
vault of the ambulatory, earned the building in
Renaissance times the understandable title
'Temple of Bacchus'. The style is similar to a
fragment of a porphyry sarcophagus found at
Constantinople and believed to have been the
tomb of Constantine, and it would appear that
the daughter's tomb is a copy of the father's. In
late antiquity porphyry, quarried solely at
Mons Porphyriticus, near Coptos in Egypt, was
reserved for imperial use. Various examples of
porphyry sculpture have been found near Alex-
andria, and it may be presumed that workshops

in that city used to handling the material may
have been responsible for the examples found
in Egypt. On the other hand, it seems reason-
able to suppose that blocks were sent overseas
and worked at Rome and Constantinople, pos-
sibly elsewhere. The quarries were destroyed
about 360.[8]

In January 350 the Emperor Constans was
overthrown by a palace revolution promoted
by Marcellinus, his *comes rei privatae*, and Mag-
nentius, an officer of Germanic descent, was
proclaimed Augustus. Constans was murdered
by Magnentius in Gaul and perhaps buried
near Tarragona. Some fragmentary mosaics
and wall-paintings in what appears to be an
imperial mausoleum, dating from about 353–8,

at Centcelles near Tarragona, produce again a combination of secular and religious subjects: the Four Seasons involving hunting scenes in an upper register and two registers of Christian scenes. Incidentally, the Four Seasons also occur in mosaic in an early-fourth-century basi-

So far Christ has appeared as a sun-god, a fisher of souls, a shepherd, and a law-giver. At Milan in the chapel of S. Aquilino in S. Lorenzo [15] Christ is revealed as a teacher in a college of Apostles with a basket of scrolls in front of Him. A similar representation occurs at Rome in the

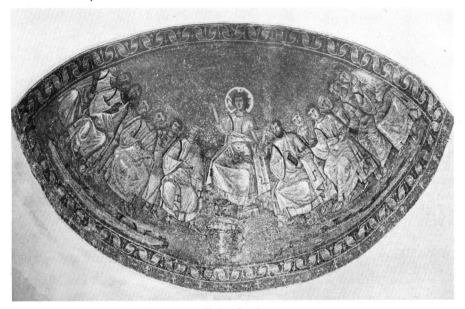

15. Christ teaching the Apostles. Mosaic. Probably late fourth century.
Milan, S. Lorenzo, Chapel of S. Aquilino

lica at Aquileia. The mosaics and wall-paintings at Centcelles are so fragmentary that not unnaturally opinions have differed over the meaning of the cycles. One scholar considers that both profane and Christian programmes have a funerary significance; another considers the Christian cycle only to refer to the purpose of the mausoleum and is sceptical about an imperial occupant – he believes the building to have belonged to a rich landowner and refers to similar '*cycles de latifundia*' in North Africa, Sicily (Piazza Armerina), and Syria. The villa at Piazza Armerina seems, however, to have been built under imperial patronage, and the fact that the near-by village to Centcelles is called Constantí suggests imperial connexions.[9]

catacomb of Giordanus [16] in the fourth century. The mosaic at Milan dates either from the time of the Arian Bishop Auxentius (355-73) or from that of St Ambrose (374-97). Clement of Alexandria had referred to Christ as the bringer of a new and purer knowledge of God; for Tertullian Christ is 'magister, perfectus magister' who comes 'ad reformandum et inluminandum disciplinam', and law-giver – 'ad legem propre nostram, id est evangelium'. Apart from the Chi-Rho monogram and the letters Alpha and Omega, and His raised position in the centre of the group, there is little attempt to distinguish teacher from taught. Christ has a youthful appearance, beardless, comparatively short-haired, and differs hardly at all from the younger

Apostles, who are depicted at various ages with some degree of naturalism. The young teacher is still a far cry from the awe-inspiring Christ Pantocrator of Byzantine art. The company is seated on a rocky ledge, but otherwise there is

400, when it was originally known as the church of the Archangels or Asomati, being in the quarter of the Asomati. Before architectural fantasies of considerable complexity saints [17] sometimes military, sometimes ecclesiastic,

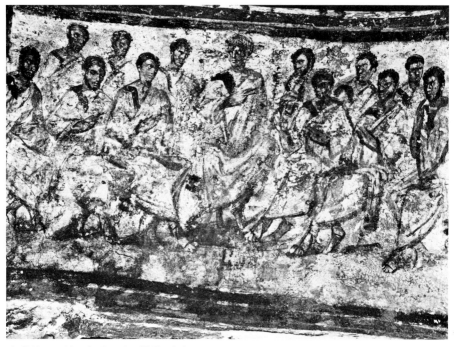

16. Christ teaching the Apostles. Wall-painting. Fourth century. *Rome, catacomb of Giordanus*

no attempt to define time or place. In its brevity of statement the message of the apse of S. Aquilino is still that of the catacombs.[10]

We know that in the dome of the imperial mausoleum of Constantina a calendar of saints had been represented. At Salonika in the rotunda now known as Hagios Giorgios there is another calendar, and with it Early Christian art soars from the arcosolium of the private tomb to the domes of an imperial palace. The building was almost certainly part of the palace built by Theodosius I towards the end of the fourth century, although some believe that the rotunda was not transformed into a church until about

sometimes just civilian, stand in attitudes of prayer, richly dressed and barbered. When depicted as young men, they appear in unearthly beauty of form and face, like young princes of the Theodosian house gesturing before an imperial pavilion. In the years of its triumph the Church turned naturally to the ceremonial of the imperial court for the symbolic expression of divine authority and power. The mosaics of Hagios Giorgios express the glory of *Roma aeterna* in a new Christian guise and pay homage to Christ who is the true founder of the Holy City. In this case we have a direct expression of the art of the imperial court, and before these

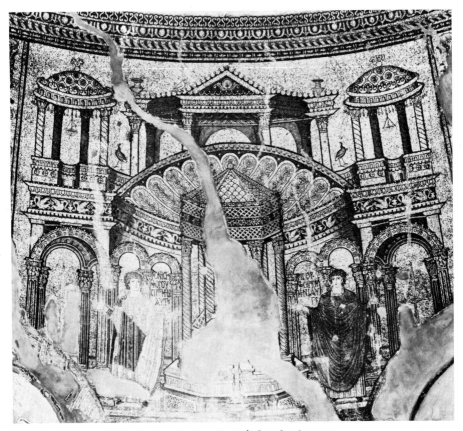

17. St Onesiphorus and St Porphyrios. Mosaic on the vault. Late fourth century.
Salonika, Hagios Giorgios

lofty, serene, exquisite images the art of the catacombs fades into pious pictographs of faith.[11]

The mosaic in the apse of S. Pudenziana in Rome, executed under Pope Innocent I (401–17), although greatly restored and although there is no reason to suppose that it is the work of a court workshop, extends the atmosphere of imperial majesty. Below the canopy of heaven out of which loom the symbols of the Evangelists and in front of a Golgothic mound bearing a jewelled cross and the walls and palaces of the heavenly Jerusalem, Christ, bearded, long-haired, and haloed [18], sits enthroned in majesty holding a scroll which proclaims Him 'dominus ecclesiae'. He is surrounded by the Apostles and two allegorical female figures representing the *Ecclesia ex Circumcisione* crowning St Peter and the *Ecclesia ex Gentibus* crowning St Paul. The interpretation of the symbols of the Evangelists has an old tradition reaching back to St Irenaeus in the second century. The four beasts of the Revelations to Ezechiel and to St John the Evangelist were rationalized as follows: St Matthew was the man because his Gospel begins with the genealogy of Christ after the flesh; St Mark, whose opening sentences tell the mission of St John the Baptist, 'the voice crying out in the

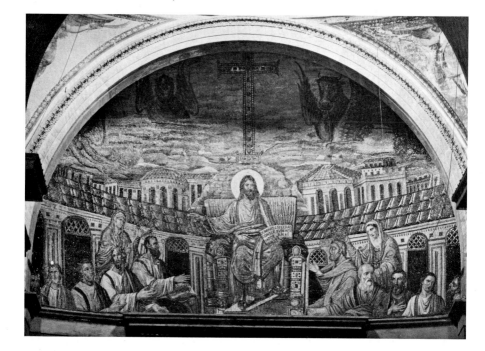

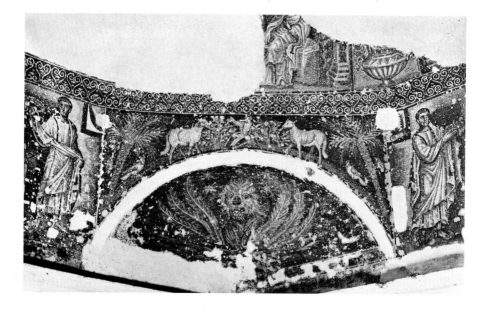

18. Christ in Majesty.
Mosaic in the apse. Early fifth century.
Rome, S. Pudenziana

wilderness', was typified by the lion; the ox was given to St Luke because it was the animal of sacrifice and his Gospel begins with the sacrifice of Zacharias; St John is the eagle because his spiritual message transports us aloft to the very heart of divinity. St Jerome seems to have been the first of the Latin Fathers to distribute them in this fashion and at the same time to justify them in the manner described. Official Greek theology did not recognize as early as the West the Apocalypse as a canonical scripture and accordingly neglected the apocalyptic beasts. This interpretation belongs, therefore, chiefly to the West.[12]

The symbols of the Evangelists appear again in the mosaic decoration of the baptistery, S. Giovanni in Fonte, on the east side of the apse of S. Restituta, a Constantinian foundation, at Naples. The mosaics were executed under St Severus (362–408) in the last years of his episcopate. The symbols occur also in the chapel of S. Matrona at S. Prisca near Capua in the first half of the fifth century, in the Mausoleum of Galla Placidia at Ravenna, and in S. Maria Maggiore in Rome about 432–40. The emblem of St Mark [19] at Naples is a superb evocation of an apocalyptic vision. The whole decoration of S. Giovanni in Fonte, fragmentary though it is, is important, since not only does it parallel in many ways the paintings in the humble little baptistery at Dura-Europos in Mesopotamia, dating from the middle of the third century, but also it presents a series of New Testament scenes – the marriage at Cana, Christ and the Samaritan woman, the miraculous haul of fish, Christ walking on the lake, the holy women at the Sepulchre – with the familiar themes of the

19. The symbol of St Mark.
Mosaic. Early fifth century.
Naples, S. Restituta, S. Giovanni in Fonte (baptistery)

Good Shepherd, harts drinking the waters of life, the *traditio legis*, rows of Apostles, and a rich incidental ornament of vases, curtains, swags of fruit and flowers, various kinds of birds. The main emphasis lies on the sacramental nature of the building, placed in a setting of quasi-imperial grandeur, but it is also clear that by the early fifth century Early Christian decoration was highly complex, logical in its application, and rich in its artistic heritage.[13]

Imperial grandeur comes to the fore again in the little mausoleum built by the Empress Galla Placidia at Ravenna about 425–6, which, in spite of the restorations undertaken in the nineteenth century, still remains one of the most enchanting of all early Christian buildings. Galla Placidia accompanied her half-brother, the Emperor Honorius, to Ravenna in 402, but she was taken captive in 410 by Alaric the Goth and abducted to southern Italy, where she was forced to marry Ataulf. He took her to Spain and died there in 415. Galla Placidia returned to Ravenna and married a patrician, later the Emperor Constantius III. In 421 or 422 Constantius died, followed by Honorius in 423. Galla Placidia, who had quarrelled with Honorius, was then at Constantinople with her young son Valentinian III, but she returned at once to Ravenna and decided to erect a mausoleum for the family. It has been suggested that the mausoleum was part of a monastery dedicated to St Lawrence, but this has not been accepted by recent scholarship, which considers that the little building was attached to the narthex of the church of S. Croce built by Galla Placidia about 417–421/2, now destroyed. The numerous sepulchral motifs in the mosaics and the three sarcophagi in the side-arms of the building suggest that the structure was intended to be a mausoleum. The size and proportions of the sarcophagi correspond to the architectural setting. The Empress, having ruled the Western Empire during her son's minority for some ten years, died in Rome in 450, and it is not certain where she was buried. The iconography of the mosaics is personal and intricate – scholars differ over the interpretation of the scene refer-

ring to St Lawrence [20] – but the figures of the Apostles, the harts drinking from the Fountain of Life, doves drinking from vases, and above all the Good Shepherd over the entrance [21] reaffirm the programme of the *commendatio animae*, by now the old tradition of salvation

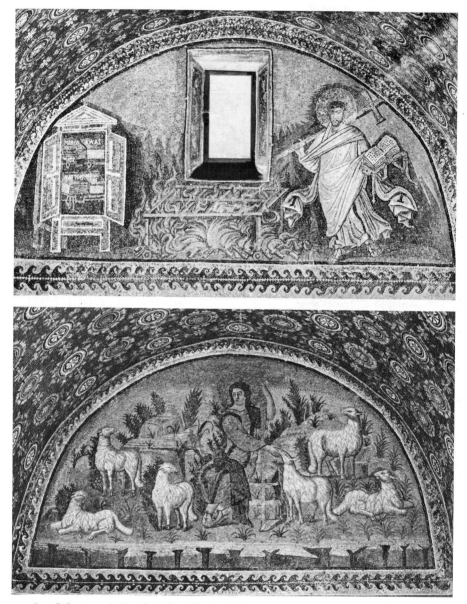

20 and 21. St Lawrence (*top*), and the Good Shepherd. Mosaics on lunettes.
Second quarter of the fifth century. *Ravenna, S. Vitale, Mausoleum of Galla Placidia*

and grace through the sacraments, the teachings of the Apostles, the martyrdom of the Saints, and the direct intervention of Christ.[14]

the church with mosaics [22, 23]. In the past the mosaics in the nave have been assigned to the time of Pope Liberius and also to the pontificate

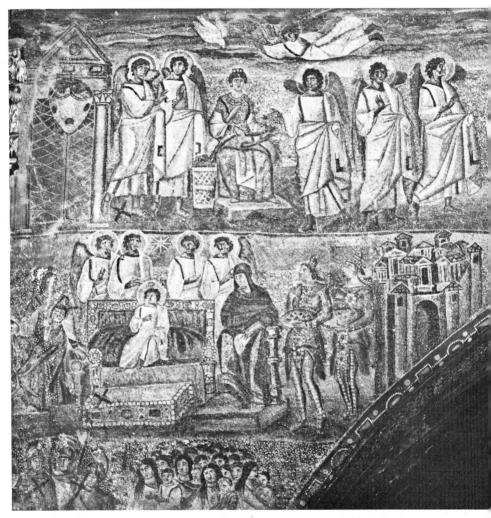

22. The Adoration of the Magi. Mosaic on the triumphal arch. *c.* 432–40. *Rome, S. Maria Maggiore*

In 431 the Council of Ephesus had declared the Virgin Mary to be the Mother of God, and at Rome Pope Sixtus III (432–40) lost no time in building a great basilica to S. Maria Maggiore, probably on the foundations of an earlier church built by Pope Liberius (352–66), and adorning

of Leo the Great (440–61), but the work is now generally accepted as dating from the fourth decade of the fifth century. The triumphal arch, because of the inscription, was certainly decorated under Sixtus III. The influence of imperial iconography is once again evident. In the scenes

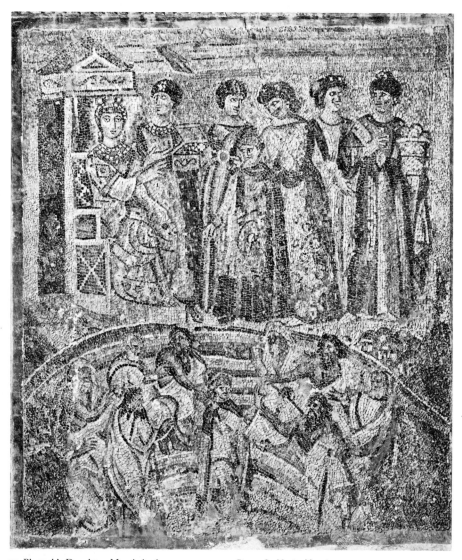

23. Pharaoh's Daughter. Mosaic in the nave. *c.* 432-40. *Rome, S. Maria Maggiore*

depicting the childhood of Christ the Virgin is represented as an Augusta and the Adoration of the Magi is interpreted in the terms of an imperial audience. In the mosaics down the nave Pharaoh's daughter [23] is represented not as an Egyptian princess but again as a Roman Augusta. Of the original forty-two panels only twenty-seven are more or less completely preserved: on the left, scenes from the lives of Abraham and Jacob; on the right, scenes from the lives of Moses and Joshua. In view of the Virgin's lineage it is perhaps rather surprising that there is no reference to David or Solomon. The narrative style is vivacious, touched in

with an expressionist exuberance quite unlike any other surviving mosaic cycle, and scholars have been prompt to detect the influence of the Greek East, the reflection of Constantinopolitan court art, and, of course, a Jewish illustrated copy of the Septuagint. The difficulty in these hypotheses lies in the fact that there is little enough in the Greek East from which to draw conclusions: there is no Constantinopolitan mosaic, wall-painting, or manuscript illustration dating from this time. There seems reason to believe, however, that there was current in hellenized Jewish circles of the third century an illustrated edition of the Septuagint, and the frescoes of the synagogue at Dura-Europos, crude and provincial though they are, establish a Jewish Old Testament cycle in wall-painting. These paintings have little to do with the mosaics of S. Maria Maggiore. The reference to imperial iconography suggests a far more exalted model or intermediary. The fact remains that the mosaics are in the grand tradition of Roman imperial art - one which was to come to an end by the turn of the century.[15]

Imperial iconography appears to be reflected in the scheme of decoration in the dome of the Orthodox Baptistery at Ravenna [24]. The baptistery was built in the early fifth century, at

24. The Baptism of Christ. Mosaic on the dome. Mid fifth century. *Ravenna, Orthodox Baptistery*

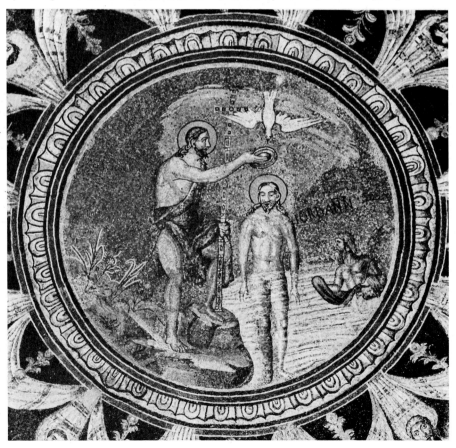

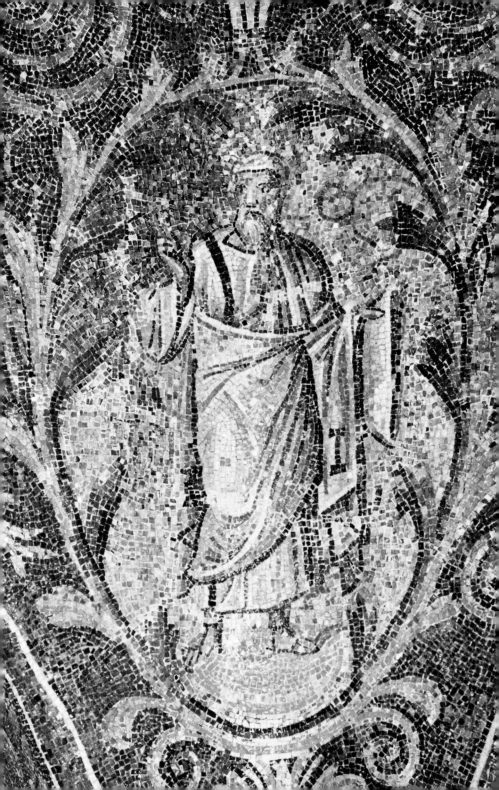

the same time as the cathedral, by Bishop Orso, who took as his model the Milanese basilica of St Thecla. Bishop Neon (449–58) added a dome to the baptistery and decorated it with mosaics, now much restored, which are closely related in colour and style to those in the mausoleum of Galla Placidia. It has also been suggested that the scheme of decoration in the dome should be compared to that in Hagios Giorgios at Salonika. The stucco ornament in the baptistery at Ravenna, now appearing crude because the top surface of paint and gilding has been stripped away, may date from the time of Bishop Orso, since Agnellus states that he had a taste for this kind of work. In the centre of the dome is the Baptism of Christ; below the Apostles move gravely in an adoring circle between garlands of flowers and draped curtains. In the lowest zone an architectural frieze, reminiscent indeed of Hagios Giorgios, serves as a rich background for the four Gospels ritually displayed on altars and alternating with four episcopal thrones which symbolize, no doubt, the earthly and the celestial spheres of the *domus Dei*. On the walls lush acanthus-scrolls frame the figures of the Prophets [25], although only the branches immediately surrounding the medallions of the Prophets are original. The intermediate sections are a restoration made in the 1860s. The whole scheme affirms the continuity of the prophetic and apostolic traditions culminating in the Gospels and epitomized in the Baptism of Christ by the last of the Prophets.[16]

Although valiant and sometimes cogent attempts have been made to establish a series of illustrated rolls in classical literature, it is not without interest that Seneca, in writing against the tendencies to luxury of classical bibliophiles, has not a word to say about rolls or codices embellished by pictures or ornaments. With a few significant exceptions all the illustrated classical books which have survived are known to us through Carolingian or Middle Byzantine

25. A Prophet. Mosaic. Mid fifth century.
Ravenna, Orthodox Baptistery

copies; the exceptions are the *Ilias Ambrosiana*, dating from the fifth or early sixth century and presumed to be based on a third-century prototype, the Vatican Vergil (lat. 3225), and the *Vergilius Romanus* (Vat. lat. 3867), the former dating from the early fifth century and the latter from the late fifth century. Now it has been claimed that the illustrations in the Vatican Vergil (lat. 3225) are original creations of the fifth century, and that most of the miniatures do not illustrate Vergil's text as closely as has been generally assumed. Moreover, it has been noticed that there are close similarities in style between the illustrations of the Vatican Vergil and the mosaics of S. Maria Maggiore. Both seem to derive from a common model not much older than the Vatican Vergil, and this model would appear to be a copy of the Bible, not a mythological cycle. The miniatures in the Vergil are an *invention* of late date, probably soon after 400, and many of them have nothing to do with the Vergilian tradition. It has further been claimed that the Vatican Vergil is a unique article of luxury never to be repeated. In view of these claims it is perhaps of interest to note that a similar verdict by a different scholar has been passed on Filocalus's Chronograph of 354, which we know only through sixteenth- and early-seventeenth-century copies based on a Carolingian intermediary lost since 1637. The original almanack in current use was intended for a person of rank living at Rome under Constantius II and was put together as a codex in 353. The almanack listed pagan and imperial feasts, but it was made for a Christian patron. None of the models of this codex may be dated before the second quarter of the fourth century; the illustrations of the calendar were, therefore, a completely 'modern' work in 354. The codex, planned as such, was a luxury article created and executed for a precise occasion by an artist of considerable merit. No doubt there were other illustrated calendars in codex form current in Rome at the time, but this particular calendar is none the less quite individual. The style of the illustrations, which include portraits of Constantius II and Gallus in consular

dress and personifications of cities and of the months, is a product of the cosmopolitan art of Rome wherein Greek, oriental, and Latin elements combine in a decorative system.[17]

Eusebius of Caesarea was specially commissioned to provide fifty finely written and splendidly bound copies of the scriptures for the new churches at Constantinople. It may be that the purely decorative illuminated ornament derived originally from the desire to have a monumental framework round the Eusebian canon tables and the prologue pages. The Eusebian canon produced in Caesarea in the second quarter of the fourth century became known in Italy in the late third quarter of the century through the Vulgate of St Jerome. The oldest extant canon tables date, however, from the sixth century and are to be found in Latin, Greek, and Syrian manuscripts. The decoration of initials appears to be of Western, probably Italian, origin. With one exception, they do not occur in the older Greek manuscripts but they turn up in Latin codices of the fourth and fifth centuries, increase considerably in the sixth century, and are adopted in earnest in the seventh century. The author portrait has a good classical tradition which was taken over probably in the fourth century by the Church. Eusebius's copies of the Gospels may well have contained portraits of the Evangelists, although the earliest surviving do not date from before the sixth century. Indeed, from the fourth and fifth centuries only three Christian illustrated manuscripts – and of these two in the most fragmentary condition – are extant: the Quedlinburg-Itala fragment of a pre-Vulgate Latin version of the Old Testament ranging possibly from the Pentateuch to the Prophets and now consisting of portions of the tenth and fifteenth chapters of I Samuel, the second of II Samuel, and the fifth of I Kings; the charred fragments of the Cotton Genesis [26], almost universally regarded as the work of an Alexandrian painter of the early fifth century; and St Ambrose's De Fide Catholica written in a fine uncial before the end of the fifth century in North Italy and containing a crude illustration of Christ, beardless, without a nim-

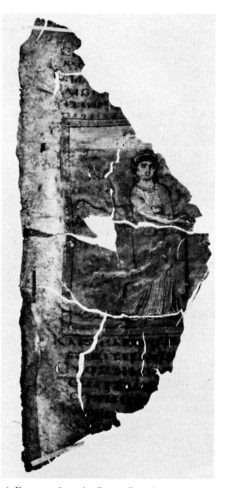

26. Fragment from the Cotton Genesis, Cotton MS. Otho B.VI, fol. 4. Early fifth century (?). *London, British Museum*

bus, seated on a globe and flanked by St Peter and St Paul each carrying a cross, which may well be considerably later in date than the script. The earliest surviving Psalters are the Verona Codex, which has been dated between the fifth and the eighth centuries and is illustrated only in a symbolic manner, and the Latin Psalter of St Augustine of Canterbury with an Anglo-Saxon interlinear translation. St Jerome refers

to purple codices in terms of contempt, partly because he found them not always accurate in textual matters and partly because he found them difficult to read. Purple codices were probably not intended to be read; they were works of the highest luxury and cost, almost certainly the result of imperial patronage, and destined for ritual display. In view of what has been said above about 'modern' copies of books in the fourth and fifth centuries, it is of interest to note that in some of the miniatures of the Itala fragment where the paint has flaked off, preliminary drawings and instructions to the artists are to be found. For example, in the miniature depicting Samuel's execution of Agag the inscription reads: 'facis civitatem et extra civitatem ubi propheta dextra cecidit Agam', which suggests that, whatever the model at hand, the miniature was the result of instruction.[18]

The main reason why the third century produced no important pagan historical sculptured reliefs is that events were either not worth commemorating or were overtaken by a change of emperor. On the other hand, the third century is the great age of the sarcophagus adorned with reliefs. The portrait head also reveals new

artistic possibilities. Nevertheless, the low standard of technical skill at the beginning of the fourth century is amply displayed even in important public monuments, such as Constantine's triumphal arch set up in Rome in 315. The Peace of the Church combined with the formidable will of Constantine provided the atmosphere of a liberated and rapidly expanding Christianity within which a renascence of the arts was possible. In sarcophagi carving many of the old traditions of the third century were reinvigorated, but it is not until the middle of the fourth century that a change for the better can be seen. The sarcophagus of Adelfia [27] of about 340, now at Syracuse but almost certainly carved in Rome, presents portraits of Adelfia and her husband firmly in the centre framed by a shell and applied to a double frieze which reproduces a jumble of scenes from the Old and New Testaments. The atmosphere is quite different from the imperial reticence of the porphyry sarcophagi, but there is, nevertheless, a marked worldliness of approach. The noble husband and wife, the winged genii holding the *tabula ansata* which gives Adelfia's name, dominate the trite and humble expression of early Christian beliefs. On the other hand, the sar-

27. Scenes from the Old and the New Testaments. Marble sarcophagus of Adelfia. Rome, *c.* 340. *Syracuse, Museo Archeologico Nazionale*

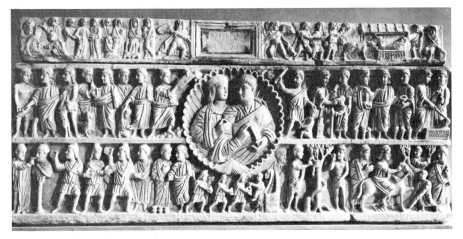

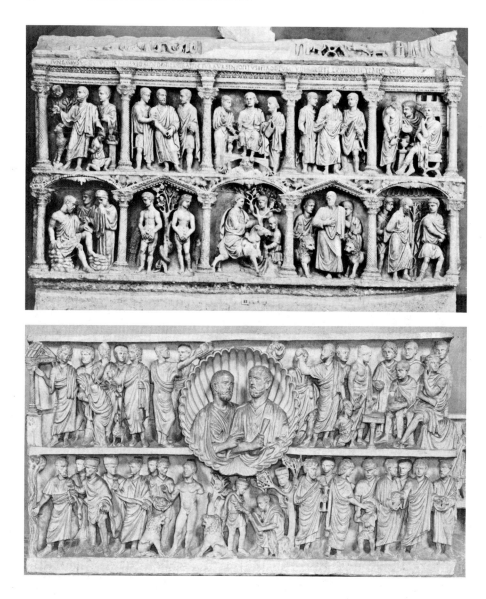

28. Scenes from the Old and the New Testaments. Marble sarcophagus of Junius Bassus. Rome, *c.* 359. *Rome, Grotte Vaticane*

29. Scenes from the Old and the New Testaments. Marble sarcophagus of the Two Brothers. Rome, mid fourth century. *Rome, Museo Lateranense*

cophagus of Junius Bassus, who died in 359, now in the Grotte Vaticane [28], is of higher quality, and shows less of the rigidity and decadence of Adelfia's sarcophagus and more sense of space, volume, and plastic rendering of form and drapery. A considerable number of

Early Christian sarcophagi have survived and attempts have been made to classify them according to stylistic and iconographic affinities, though some stubbornly elude such an attempt. The 'Bethesda' group, of which the majority have been found in Gaul, appears to have been turned out by the same workshop which produced a 'Red Sea' group, also found mostly in Gaul. A 'star and wreath' group may have been produced by a workshop at Arles. Others may be connected with a 'city-gate' group, most of which are in Italy, though they were copied in Gaul. The 'city-gate' and 'columnar' groups in their purest examples tend to present one unified scene on the front, but it has been pointed out how quickly the 'columnar' sarcophagi lose

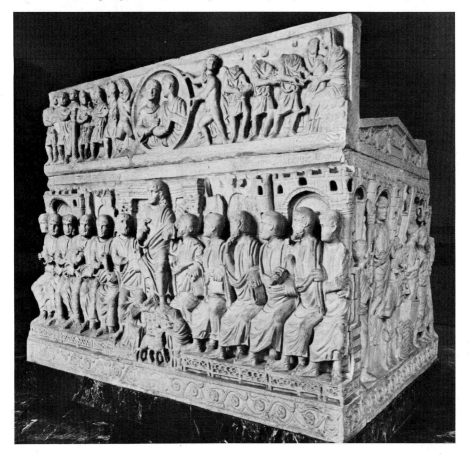

30. Christ teaching the Apostles.
Marble sarcophagus of Stilicho (?).
Milan, late fourth century. *Milan, S. Ambrogio*

their architectural consistency and become assimilated with a 'frieze' series, of which the great majority are in Rome and which again subdivides into those with single or double registers of frieze. The 'frieze' type, deriving from the catacomb tradition, presents, as we

have seen, a medley of small unrelated scenes with no attempt at formal organization of the surface. The development of the double register frieze in Rome is the work approximately of a single generation and culminates in the fifties with the sarcophagus of the Two Brothers [29] and of Junius Bassus, in the latter case a synthesis of 'columnar' and 'frieze' traditions. The so-called sarcophagus of Stilicho in S. Ambrogio at Milan is a 'city-gate' type of considerable quality with a superb unified vision of Christ and the Apostles across the front [30]. Since the marble has been identified as coming from a quarry in neighbouring Como it seems reasonable to suppose that the sarcophagus was executed in or near Milan. Stilicho, supreme commander of the West, trusted friend of the Emperor Theodosius I, married to his niece Serena, fell from power in 408, but the sarcophagus is certainly earlier in date, probably some time between 387 and 390. The solid, measured rhythms, the greater sense of modelling, the monumentality of form, all point to the general revival of the arts which took place in the East and the West under the Emperor Theodosius the Great.[19]

The sarcophagi at Ravenna are generally simpler in design, consisting of a seated or standing Christ and Apostles in arcades, like that of Bishop Liberius (d. 387) in S. Francesco [31], the *traditio legis* between palms, as in the sarcophagus of San Rinaldo in the cathedral (420–30), a trinity of lambs between palms like that of Constantius III (d. 421 or 422) in the mausoleum of Galla Placidia [32], or peacocks and vine-scrolls on either side of a medallion carved with a Chi-Rho monogram and the letters Alpha and Omega, such as that of Archbishop Theodore in S. Apollinare in Classe [100]. The quality of the carving is often higher than the general run of fourth- and fifth-century sarcophagi, and scholars have been quick to suggest influence from Constantinople; this may exist, although it must be remembered that the ornamental repertory was current in Italy and the difference may be that the carvings came from a court workshop. Judging from the fragments of decoration which have survived from the church of Hagia Sophia at Constantinople rebuilt after the fire of 404 by Theodosius II there are close similarities between sculpture at Ravenna and that at Constantinople,

31. Christ enthroned between Apostles. Marble sarcophagus of Bishop Liberius III (d. 387). Ravenna, second half of the fourth century. *Ravenna, S. Francesco*

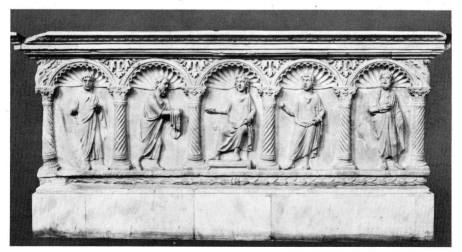

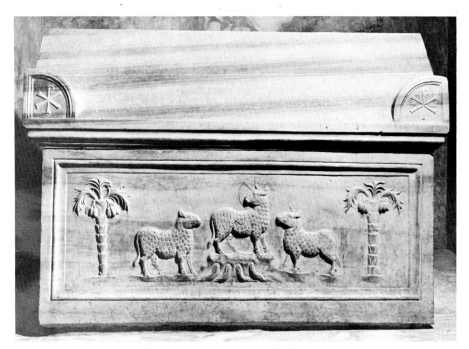

32. The Lamb of God between Apostles represented as lambs. Marble sarcophagus of Constantius III (d. 421 or 422). Ravenna, first quarter of the fifth century. *Ravenna, S. Vitale, Mausoleum of Galla Placidia*

33. The Sarigüzel sarcophagus. Marble. Found near Fenari Isa Djami.
Constantinople, second half of the fourth century. *Istanbul, Archaeological Museum*

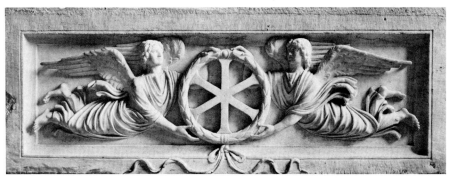

hardly surprising considering the close links between the two courts. Nevertheless, there is nothing at Ravenna to compare with the sheer beauty and technical subtlety of the Sarigüzel sarcophagus [33], now in the Archaeological Museum at Istanbul, executed in the second half of the fourth century. The angels bearing the monogram of Christ in a garland seem to be conceived in a full classical tradition; the foreshortening, the handling of the drapery and the

ribbon below the garland, the marvellous sense of space are unrivalled in the West and herald the age when Constantinople was the zenith of civilization for some six hundred years.[20]

The wooden doors of S. Sabina in Rome [34] date presumably from shortly after 432. A mosaic inscription over the door states that the church was built in the time of Pope Celestine I

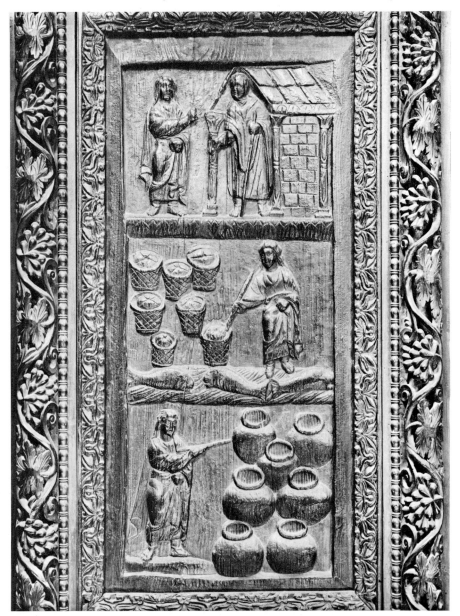

34. The Multiplication of the Loaves and Fishes, detail of the wooden doors. c. 432. *Rome, S. Sabina*

(422–32) by an Illyrian named Peter, but it is probable that the church was not completed until the time of Pope Sixtus III (432–40), who, according to the *Liber Pontificalis*, consecrated

detected Syrian influences, but there seems no reason to doubt their origin in Rome. Of the twenty-eight original panels only eighteen are left, and the principle which ruled the choice of

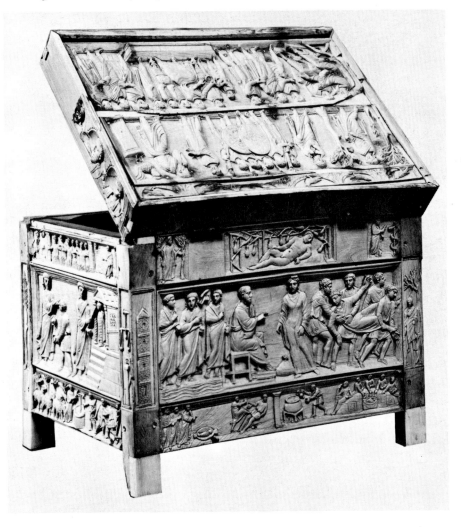

it. Some scholars have suggested a North Italian provenance for the doors, presumably because of the wooden doors carved with scenes from the life of David in S. Ambrogio, though these are in a battered and fragmentary condition and rather different in style; others have

35. Scenes from the Old and the New Testaments. Ivory casket. North Italy or Rome, third quarter of the fourth century. *Brescia, Museo Cristiano*

scenes is therefore hard to detect. Some of the subjects remain enigmatic but, generally speaking, the programme seems to combine parallels between the Old and the New Testaments with scenes from the Passion and the Resurrection of Christ. In the Adoration of the Magi the wise men approach the Virgin in a single file similar to the scene on catacomb frescoes and sarcophagi at Rome. The style of the wood carving may also be compared to a number of ivory carvings which appear to have been produced in Rome.[21]

Probably the finest carvings in ivory in the Early Christian period issued from Roman workshops. Most scholars agree that the Brescia casket [35] should be dated to the third quarter of the fourth century, although an attempt has been made to place it as early as the second quarter. Scenes from the Old and New Testaments are reproduced in cold replica of many sarcophagus reliefs but the quality is considerably higher. In the precise statement of form, in the use of space, in the treatment of drapery and hair, the artist seems to be reaching back to past aesthetic standards. Opinions differ over the place of workmanship - North Italy, Italo-Gallic, Milan - but Rome seems the most likely centre. On the other hand, a small group of particularly distinguished carvings in ivory dating from the end of the fourth century differs slightly in style and yet seems unquestionably Roman. The magnificent relief carved with a representation of the Maries at the Sepulchre, formerly in the Trivulzio Collection, now in the Castello Sforzesco at Milan [36], is closely related to a diptych carved with the figures of priestesses sacrificing at altars and executed for two of the most important pagan families in Rome, the Nicomachi and the Symmachi, and the diptych of Probianus, a formal expression of office assumed as Vicar of Rome about 400. The group, which includes the Aesculapius–Hygeia diptych at Liverpool and a small casket in the Bibliothèque de l'Arsenal at Paris, shows that in spite of pagan tenacity in Roman circles the workshops served both the old and the new religions and that in the late fourth century there was a revival of hellenistic excellence per-

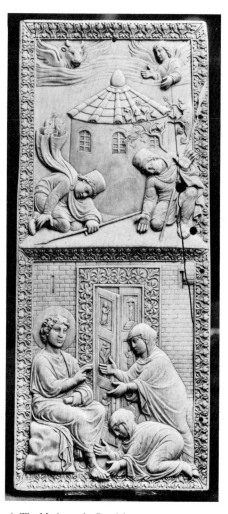

36. The Maries at the Sepulchre.
Ivory panel. Rome, late fourth century.
Milan, Castello Sforzesco

haps to be expected in the golden age of Early Christian humanism. A relief of the Ascension [37], now in the Bayerisches Nationalmuseum at Munich, and possibly a diptych revealing Adam in Paradise and scenes from the life of St Paul may also belong to the same Roman group. The theme of the Ascension is paralleled to a certain extent on the wooden doors of S.

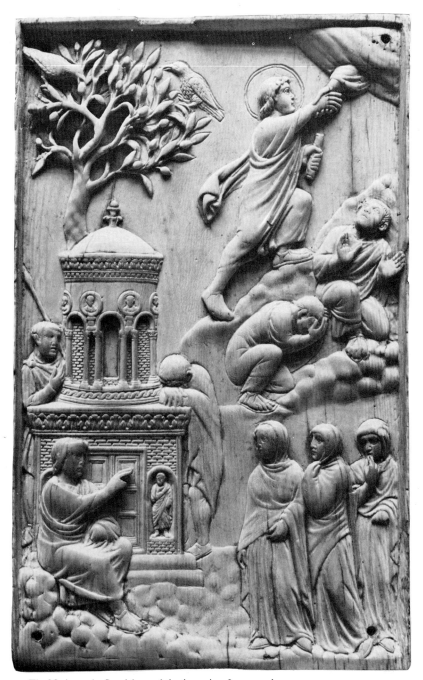

37. The Maries at the Sepulchre and the Ascension. Ivory panel.
Rome, late fourth or early fifth century. *Munich, Bayerisches Nationalmuseum*

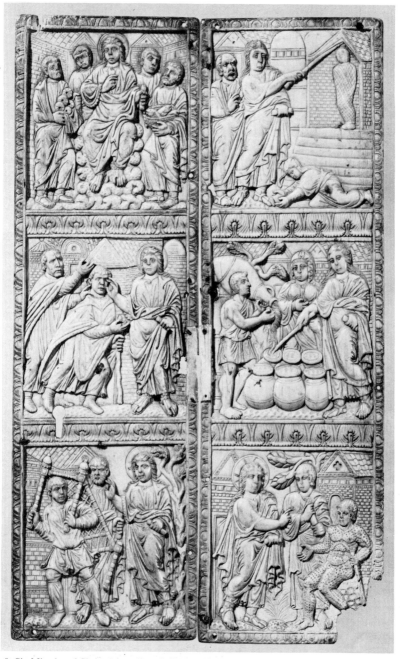

38. Six Miracles of Christ. Ivory diptych. Rome, third quarter of the fifth century.
London, Victoria and Albert Museum

Sabina, except that on the doors angels appear out of heaven to draw Christ in. The beautiful Adam–St Paul diptych has also been compared in style with the doors of S. Sabina, but a comparison with the Brescia casket and the Roman group of ivory carvings is perhaps more telling. Slightly later, but closely allied to the Probianus diptych, appear to be the panels with scenes of the Passion and Resurrection of Christ, now in the British Museum. These may not be far removed from the consular diptych of the Lampadii in the Museo Cristiano at Brescia, probably of about 410. To between 430 and 440 may be assigned the Berlin–Paris–Nevers panels with scenes from the life of Christ, the Moses, St Peter, and St Thecla panels in the British Museum, and the Pola casket with its interesting representation of the shrine of St Peter's as Constantine built it. This last group should be compared stylistically with the doors of S. Sabina. A final group includes a Bellerophon panel and Apotheosis leaf, both in the British Museum, and the Andrews diptych carved with scenes depicting the Miracles of Christ [38], over the dating of which there has been considerable controversy; however, the group as a whole appears to have been executed in the third quarter of the fifth century. After

the capitulation of Romulus Augustulus to Odovacar the Ostrogoth in 476 no more Christian ivory carvings may be assigned to Roman workshops, and although four authentic consular diptychs are known – Basilius (480), Boethius (487) [66], Sividius (488), and Rufus Gennadius Probus Orestes (530) – there is a marked decline in quality and the last is merely a coarse copy of a Constantinopolitan diptych of Clementinus (513).[22]

Roman workshops also produced some remarkable silver. A large proportion of this is chased with pagan and mythological subjects. Projecta's casket, found with other silver treasure on the Esquiline Hill, is a typical example of Christian ambivalence towards the end of the fourth century. Projecta, a Roman lady of rank, was married to Secundus, a member of the great family of the Asterii, and the casket [39] was intended as a wedding present. On the lid the Chi-Rho monogram precedes an inscription which exhorts the pair to live in Christ but the decoration consists of representations of Venus, nereids, tritons, and sea-monsters. Portrait busts of Projecta and her husband are understandably present and, perhaps, the entry of the bride into her husband's house. On the sides of the casket Projecta is

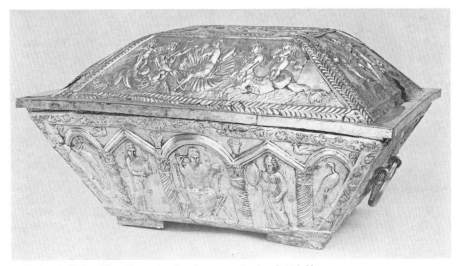

39. Projecta's Casket. Silver. Rome, late fourth century. *London, British Museum*

portrayed once again with her maids in attendance. The old pagan custom of conducting the bride to the wedding in a procession accompanied by song and dance was continued by the

40. The Multiplication of the Loaves (?).
Silver reliquary box.
Reputed to have been sent by Pope Damasus
to St Ambrose with relics of the Apostles.
Rome, c. 382. Milan, S. Nazaro

Christians; many of the social aspects of pagan life were adapted as a matter of course. The small silver casket in the church of S. Nazaro at Milan, dating probably from about 382, when relics were given to the church, is wholly Christian in character and iconography [40]. The style, however, is typical of the Theodosian revival of the arts, classicizing in spirit, the forms transformed nevertheless in the Theodosian idiom, suspended in space, the drapery sliding

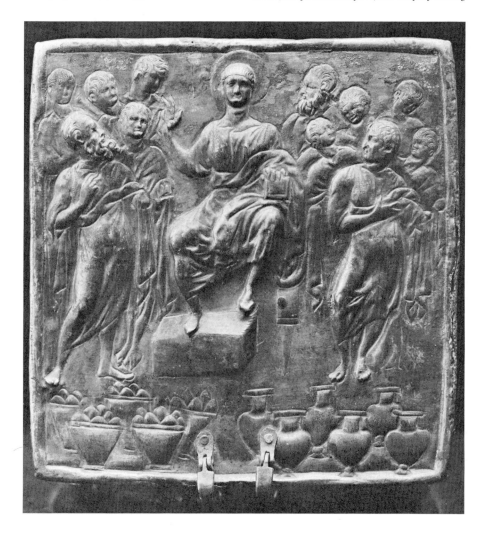

over the forms in soft folds, faces rounded in mild contours. Among the treasure of Traprain Law, now in the Museum of Antiquities, Edinburgh, a flagon chased with representations of the fall of Man, Moses striking the rock, the Adoration of the Magi, and a fourth scene difficult to identify, dating from the late fourth or early fifth century [41], may also have been made in Rome. It should, at the same time, be stressed that silver plate found in all parts of the Empire is so similar that it is frequently difficult to distinguish its place of manufacture.[23]

Early Christian art was born in the common market of late antique art. Christian teaching added new dimensions to religion and philosophy, but the artistic forms were drawn from the traditions of widespread paganism; their very familiarity gave them meaning and made them ready instruments for the new faith. Hellenistic Jewish traditions were added to the patrimony of the classical world, and gradually between the third and the fifth centuries a remarkably complex Christian illustrative cycle came into being. The cycle was not necessarily tied to the scriptures but might reflect learned comment from the Fathers of the Church, the customs and tastes of the imperial court, as well as Jewish and pagan philosophical teaching. By the time of the Emperor Theodosius the Great the graph of stylistic excellence began once more to ascend and Constantinople showed signs of artistic hegemony. If Christian art rising from the catacombs and house-churches of the third century assumed the purple by the will of Constantine, towards the end of the fourth century under the Theodosian house the purple was beginning to be transfigured by the light of the new faith.

41. The Fall of Man.
Silver flagon found at Traprain Law.
Probably Rome, late fourth or early fifth century.
Edinburgh, Museum of Antiquities

EARLY CHRISTIAN ART: THE EASTERN PROVINCES

OF THE EMPIRE AND THE FOUNDATION OF CONSTANTINOPLE

The early Christians had no holy city nor did the cult for the Holy Places develop for some considerable time. After the revolt of the Zealots the Emperor Titus ordered the complete destruction of Jerusalem, the holy city of the Jews, in the year 70. Whatever survived remained as an appendix to the new garrison town which was laid out like a Roman camp and renamed Aelia Capitolina. The Christian community, which had moved to Pella at the beginning of the siege, returned to the new town to continue a succession of bishops. Since, however, the Church was organized along the lines of the civil administration, the metropolitan bishop of Palestine resided at Caesarea and the bishops of Jerusalem came under his jurisdiction. The Christian community was small and was content to use as its church one of the houses on Mount Sion, then a suburb outside the walls. With the conversion of Constantine the small, provincial garrison town suddenly regained its ancient name and received lavish imperial patronage. Constantine made Jerusalem the Holy City of the Christians. At the Council of Nicaea in 325 Bishop Macarius of Jerusalem aroused the interest of the Augusta Helena in the neglected sites associated by tradition with the last days of Christ. Her journey to the Holy Land was rewarded by the discovery of sacred relics, including the True Cross and the Instruments of the Passion – discoveries accepted without public question and evidently meeting the need for tangible objects of devotion – and she in her turn became a great benefactress. The large basilica of the Holy Sepulchre was built east of the rotunda of the Resurrection and decorated with marble, gold, and mosaics. More churches, monasteries, hospitals, and pilgrim caravansaray rapidly sprang up, and by the middle of the fourth cen-

tury Jerusalem had become the only purely Christian city throughout the whole of Palestine.[1]

Events in the fifth century only intensified the Christian character of the city. During the religious controversies the monks in the neighbourhood were for the most part Monophysite in sympathy, but the Bishops of Jerusalem tended to remain orthodox. Juvenal, Bishop of Jerusalem, was at first inclined to heresy, but his visit to the Council of Chalcedon in 451 reclaimed him for orthodoxy, and, no doubt as a reward, he was later created Patriarch with authority over his former superior, the Archbishop of Caesarea. Any monastic opposition was quelled by imperial troops but the seeds of dissidence were never destroyed. Eventually Jew and heretic were to welcome the Persian and Arab invaders as liberators from the constraint of orthodoxy. In spite of these troubles the city enjoyed prosperity. In addition to the attraction of pilgrims Jerusalem became a place of retirement for grand Roman ladies and for courtiers no longer in favour at Constantinople. After her dismissal from the court in 438 the Empress Eudocia, wife of Theodosius II, made her home in Jerusalem. She enlarged the city walls and built a church in honour of St Stephen and a palace near the church of the Holy Sepulchre. In all these undertakings no expense was spared, and it has been estimated that the Empress spent more than half a million pounds of gold on improving the amenities of the city. In the sixth century Justinian rebuilt the churches of St Thomas and St George which had been burnt down in the outskirts of Jerusalem during a Samaritan revolt, the church of the Nativity at Bethlehem some time after 560, and erected in Jerusalem itself a new church, the Nea, in honour of the Mother of

God. This was the last stage in the aggrandisement of early Christian Jerusalem.[2]

In 614 the Persians, accompanied by Jewish auxiliaries, occupied and plundered the city. All the churches in the neighbourhood and most of those within the walls were destroyed. The Patriarch, the survivors of the massacre, and the relic of the True Cross were carried off into Persia and the city was given to the Jews. The Christian priest Modestus eventually gained control of the administration and a modest attempt was made to rebuild some of the churches. After the Emperor Heraclius's final victory over the Persians the Patriarch, the Christian prisoners, and the relic of the True Cross returned to Jerusalem in 621 but the Byzantine glories of the city were never to be repeated. Within a few years Islam was triumphant in the Near East and in 637 Jerusalem was captured by the Arabs. Since the Arabs also claimed the city as holy, the surrender was peaceful, based on an agreement permitting freedom of worship between the Patriarch Sophronius and the Caliph Omar.[3]

Nothing is left today of Early Christian and Byzantine Jerusalem: the great basilicas of Constantine and Helena, the pious works of Eudocia, of Marcian and Zeno, the great undertakings of Justinian. Mosaic pavements have been found in or near Jerusalem but these are secular rather than religious; the floors of the church of the Nativity at Bethlehem, which date probably from the first half of the fifth century, are decorated with an abrupt juxtaposition of geometric and floral motifs. Such geometric floors with the addition of animal and bird panels are common enough in the East Mediterranean: Greece, the Balkans, the Aegean islands, Syria, and Palestine all provide examples. Indeed, mosaic pavements are not very satisfactory as evidence for Early Christian art. No wall mosaics, no frescoes, no sculpture have survived. All that remains today are groups of silver flagons and stamped earthenware medallions now in the treasuries of St John the Baptist at Monza and in the monastery of St Columban at Bobbio, near Piacenza. Local tradition has it that the flagons at Monza were

a gift from Pope Gregory the Great (590–603) to Queen Theodelinda (d. 625). Bobbio was not founded until 614, and it seems probable that the flagons were a gift from Theodelinda. The earthenware medallions contained dust from the Holy Land and were stamped with a variety of scenes from the life of Christ and Greek inscriptions; they were produced for the pilgrim market and rate as works of art little more than a hot cross bun, but it is clear that such style as they possess may be related to the silver flagons. The flagons contained holy oils and were again intended for the pilgrim market – the blessed oil was issued at the Holy Places and the pilgrim suspended the flagon round his neck. The iconography of the scenes stamped on these flagons is varied, though understandably with particular emphasis on scenes connected with the Holy Places; the style is lively and the

42. The Adoration of the Magi. Silver flask. Palestine, late sixth or early seventh century. *Monza, cathedral treasury*

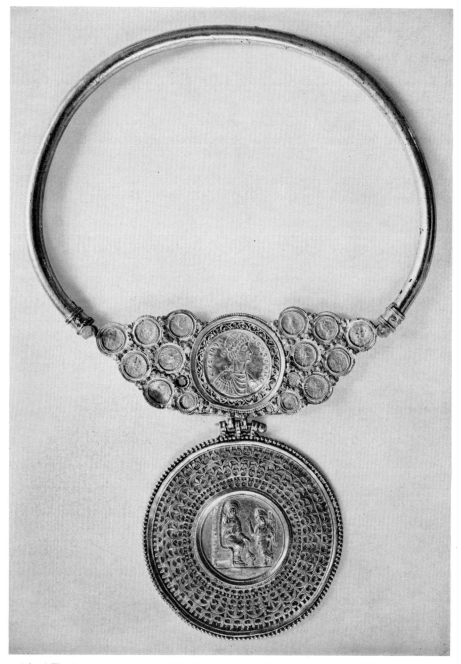

43 (*above*) The Annunciation; (*opposite*) The Miracle at Cana. Gold medallion. Found in Egypt.
Probably Constantinople, sixth century. *Berlin, Ehemals Staatliche Museen*

Greek inscriptions have a certain panache. Sometimes a single scene will occupy the greater surface of the flagon: the Virgin and Child enthroned, adored by the Magi and the Shepherds [42], in which the taut stillness of the central figures, enmeshed in wiry pleats of drapery, contrasts with the frenetic agitation of angels, Magi, and herdsmen; or the Ascension with Christ enthroned in a mandorla supported by four angels and the Apostles distributed symmetrically on either side of the Virgin below – again the imperial reserve of Christ contrasts with the flurry of angels, all wings and swirling drapery, and the agitation of the Apostles. Sometimes there are two scenes: the Crucifixion represented by a bearded bust of Christ resting on the top of a cross, either plain or gnarled, which is erected between the crucified thieves; and below the Holy Women approaching the Sepulchre and the angel wait-ing to greet them. Sometimes seven scenes in roundels disposed about a central medallion present those moments in the life of Christ which have particular bearing on the pilgrim's intention to see and touch the landmarks of epiphany. It is probable that some of the iconographical details on these flagons represent local taste, but the main themes and the style of the main themes equally probably reflect metropolitan fashion in metalwork at Constantinople. From the time of Constantine onwards there was a constant stream of precious offerings from the metropolis to the Holy Places, and Justinian sent a team of master craftsmen to work in Jerusalem. From the sixth century onwards religious subjects begin to appear on imperial commemorative medallions in gold [43]. After a treaty with the Persians in 562 Constantinople held the monopoly for gold coinage in the eastern Mediterranean. Although

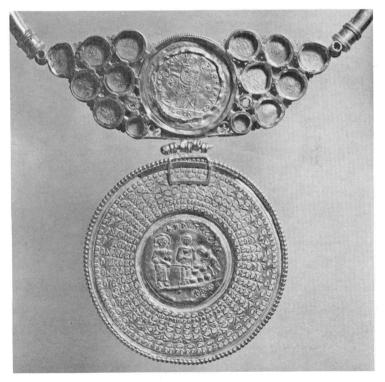

there is evidence for provincial working of gold in Isauria and Cilicia about this time, the models undoubtedly came from Constantinople. All the historical evidence emphasizes the importance of the imperial impetus from Constantinople to Jerusalem, and in no sense can the latter be regarded as a style-creative city.[4]

Among the relics and reliquaries placed under the altar of the Sancta Sanctorum in the Lateran at Rome a small painted wooden box is again an example of a pilgrim's souvenir. The box contained earth from the Holy Land in which were set small stones and scraps of cloth and wood, many of them labelled 'from the life-giving place of the Resurrection', 'from Sion', 'from the Mount of Olives', 'from Bethlehem'. The cover [44] is painted with scenes from the life of Christ most particularly connected with the Holy Places: the Nativity at Bethlehem; the Baptism in the Jordan; the Crucifixion on Golgotha – note that Christ is wearing the *colobium*, the long tunic which appears to be Syro-Palestinian in origin and, unlike the *ampullae*, is represented crucified in person between the two thieves; the Maries at the Sepulchre, which seems to follow the descriptions of sixth-century pilgrims in *Breviarum de Hierosolyma* and the *Itinerarium Antonini*, where it is related that the tomb was surrounded by a grille and covered with a conical roof which presumably was supported by columns behind which is the

dome of Constantine's church of the Resurrection; and finally the Ascension from the Mount of Olives. Since the churches were destroyed by the Persians in 614 and we know that Modestus when he began to rebuild could not emulate the patronage of the Caesars, it is arguable that the box dates from before the sack. In any case the style should be compared with that of the miniatures in the Rabbula Gospels, a Peshitta version completed in the monastery of St John at Zagba in northern Mesopotamia by 586 [45]. Although there are differences in iconographic detail – note, however, that Christ is wearing the *colobium* and is crucified in person – there are some remarkable stylistic similarities in the treatment of form and drapery. Both are provincial, monastic versions of some superior model. The paintings on the box are certainly cruder than the Rabbula miniatures, but a date in the late sixth or early seventh century seems not unreasonable for the pilgrim's souvenir. It is not necessary to infer that the Gospels and the box came from the same model; it is evident from the scene of the Ascension [46] in the Rabbula Gospels that the prototype was quite different: Christ is standing, not sitting, in the mandorla which is supported by the apocalyptic beasts as well as angels, the angels admonishing the Apostles on earth are missing on the box, and the whole scheme is more ambitious and elaborate. It is equally clear that great works

44. Scenes from the life of Christ.
Painted wooden box containing pilgrims' mementoes
of the Holy Land.
Palestine, late sixth or early seventh century.
Rome, Vatican, Museo Sacro Cristiano

45. The Crucifixion. From the Rabbula Gospels, MS. Plut. 1, 56, fol. 13a, completed at Zagba, c. 586.
Florence, Biblioteca Laurentiana

of art were not to be expected from the further reaches of the Empire.[5]

In the eyes of the Greeks and the Romans Jerusalem had never been a city of great importance. After Rome the principal cities were Antioch and Alexandria; to these cities the Apostles were quick to take the Gospel, and Eusebius of Caesarea was later to give a glowing account of the spread of Christianity in the hellenistic capitals of Syria and Egypt. Antioch

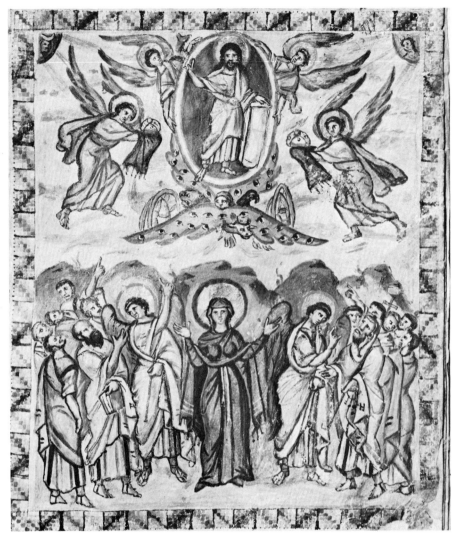

46. The Ascension.
From the Rabbula Gospels, fol. 13b

was soon almost the headquarters of early Christianity. St Luke was traditionally a native. St Paul and St Barnabas used Antioch as a base for their missions in the course of which Christianity began to free itself from Judaism and sprang to the conquest of the world. In the fourth and fifth centuries Antioch was more the capital of the Near East than Constantinople, the favourite city of Constantius II, the seat of the 'Count of the East' and of the commander-

in-chief of the troops of the eastern prefecture. It was, nevertheless, dangerously open to Persian attack. It had fallen to Shapur I in 260 and was later to be occupied and sacked by Khusrau II in 538-40. The remnant left by this calamity was again occupied in 611, and finally in 636 the Arabs seized the city.

There is no certain archeological evidence of any church structure in Syria before 344 and this does not refer to Antioch. The great octagonal church at Antioch begun by Constantine in 326 or 327 near the imperial palace and completed in 341 under Constantius II is believed to have been one of the most important buildings of the time. Dedicated to Harmony, constructed with a narthex, an ambulatory, and exedrae on two levels, the church appears to have been a 'blueprint' for those of St Sergius and St Bacchus at Constantinople and S. Vitale at Ravenna some two hundred years later; but today even the exact site of the Antiochene church is unknown. The first translation of relics mentioned by the historians appears to be that of St Babylas at Antioch. The Caesar Gallus (351-4) in an attempt to confound the cult of Apollo at Daphne built a church there and translated the body of the saint. The oracle was to be silenced by the presence of the martyr. Indeed, when the Emperor Julian consulted the oracle after his accession in 361 he was told that Babylas was obstructing the powers of the god, and the body was returned at once to Antioch. Julian found the Christian cult for relics particularly repellent and often referred astringently to their 'charnel-houses'. Shortly afterwards, however, the temple of Apollo was burnt down and, of course, the Christians were held responsible. Eventually a church was built for St Babylas across the Orontes, possibly about 379-81, since it is known that Bishop Miletius of Antioch was buried there after his death in Constantinople. On the other hand, if this building is to be identified with the cruciform church at Kaoussie an inscription in the north aisle states that the foundation was in 387 at the time of Bishop Flavianus, and another inscription refers to a room added by Bishop Theodotus (420-9). There was further rebuilding after the earthquake of 526. The floor mosaics are exclusively geometric in pattern. It was, after all, hardly fitting that the faithful should walk on the images of Christ and the saints.[6]

A martyrium at Seleucia, a suburb of Antioch, possibly the shrine of St Thecla, built by the Emperor Zeno (479-91), contains a fragment of a floor mosaic in the north ambulatory which seems to have belonged to the original construction. The decoration consists of an animal frieze, two series of animals opposed back to back, one series facing the walls, the other moving east towards the chancel. The presence of trees and shrubs and numerous birds suggests that Paradise was intended, although the effect is that of a zoological copy-book containing a wide assortment of birds and beasts in various postures. The frieze is framed by an undulating vine-scroll inhabited by birds following without interruption the curves and angles of the architecture. The church was clearly one of the most important in Seleucia, not only for its size but because of its prominent position near the colonnaded main street. Some marble reliefs have also survived, but they are in a most fragmentary state and of rather poor quality. They have been claimed to represent an Old Testament cycle corresponding to three types of manuscript: an Octateuch, a Book of Kings, and a Psalter; and a New Testament cycle – a group of particularly damaged pieces – among which the scale appears to be twice as large as that of the Old Testament cycle; groups of saints of varying sizes mostly standing *en face*, a series of archangels, and a Christ Pantocrator probably much later in date than the rest which may well be sixth-century.[7]

Christian finds at Antioch made by responsible authorities have so far been disappointing and are certainly not enough to establish an Antiochene Christian style or system of iconography. Nor does the silver hoard said to have been found by Arab workmen in 1910, if its authenticity is accepted, advance knowledge much farther. The 'Great Chalice of Antioch'

[47], decorated with twelve seated figures, including two representations of Christ, the four Evangelists, and six Apostles set between vine-scrolls, vases, and birds, has been variously dated between the fourth and the sixth centuries. Rubbed and damaged, provincial in execution, lacking any real stylistic definition, it is perhaps not surprising that there have been doubts over its date. The silver book-covers, either with saints in arcades or in pairs holding a cross [48, 49], are equally crude in execution. They are worked in a late classical idiom showing every sign of exhaustion, and date probably from the late sixth or early seventh century. A plain cross with Greek inscriptions and a plain chalice also with a Greek inscription complete the hoard.[8]

Mosaicists from Antioch may conceivably have been responsible for the floor in a church at Mopsuestia, near Adana in the Cilician plain. It has been claimed that the church dates from the time of Bishop Theodore (392–428), but other scholars have considered the dating at least a half century too early. The floor is important because, in spite of the apparent reluc-

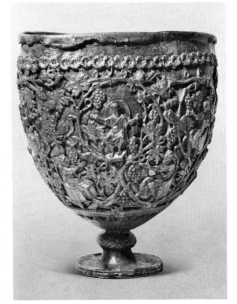

47. The Chalice of Antioch.
Silver-gilt. Late sixth or early seventh century.
New York, Metropolitan Museum

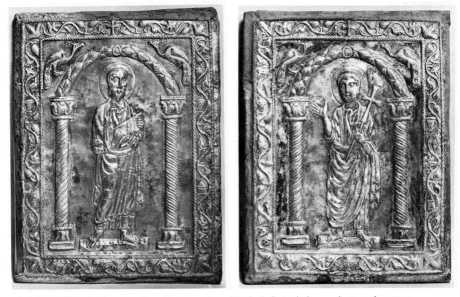

48. A Saint. Silver book-cover. Found in the region of Antioch. Late sixth or early seventh century.
New York, Metropolitan Museum
49. A Saint holding a cross. Silver book-cover. Found in the region of Antioch.
Late sixth or early seventh century. *New York, Metropolitan Museum*

50. Scene from the life of Samson.
Floor mosaic. Second half of the fifth century (?).
Misis-Mopsuestia, church

tance elsewhere to place sacred subjects under the feet of the faithful, here is a complete cycle of scenes from the life of Samson [50] and a representation of Noah's Ark with animals but no human figures. There is an inscription referring to the story of Samson. Two other parts of the floor were decorated with more usual ornamental motifs, some including leaves, flowers, fruit, and birds. The style of these mosaics appears to be in the common artistic language of the time and from the evidence to hand there is nothing specifically Antiochene in their accent.[9]

In the numerous churches which have been discovered in Syria, Palestine, and Transjordan mosaic floors tend to be secular in tone. Isolated figures of animals and birds in a geometric framework are fairly common in the fifth century; they occur in several churches at Gerasa, for example the church of the Prophets, Apostles, and Martyrs (464–5), the church of Procopius (526), and that of St George (529–30). But at Tabgha on the Sea of Galilee the church of the Multiplication of the Loaves and Fishes contains a mosaic floor with a Nilotic landscape in the left and right transepts, dating from the second half of the fifth century, which would seem more suitable for a house than a church, unless the idea behind it was similar to that of the martyrium of Seleucia, where the decoration may refer to Paradise. On the other hand, the mosaic floor in St John the Baptist (531) at Gerasa presents a Nilotic landscape with the addition of a city labelled Alexandria and coupled with representations of the months and the seasons. St Peter and St Paul, probably about the same date, has an abbreviated version of the same programme but with two views of cities labelled Alexandria and Memphis. Geography makes its appearance about the same time in the basilica of Dumetios at Nikopolis in Greece. A panel in the northern wing of the

church depicts the earth, represented by trees and birds, surrounded by the sea, a broad frame of water inhabited by numerous fish and two fishermen. The inscription reads:

> Here you see the famous and boundless ocean
> Containing in its midst the earth
> Bearing in the skilful images of art everything that breathes and creeps,
> The foundation of Dumetios, the greathearted arch-priest.

The mosaic is actually a diagram of the world in which the landscape and the fishing scenes play the role of symbols. These maps seem to have been particularly popular in Palestine. At Haditha a mosaic floor has a Nilotic landscape with a city view labelled 'Egypt', while another inscription in the central field proves that the context is Christian. Similar scenes on pavements occur at Ma'in, el-Muhayet, and above all at Madaba, which provides a detailed map of Palestine, parts of Egypt, and originally perhaps other parts of the inhabited world.[10]

In addition to these Nilotic scenes and maps, other elements of cosmography occur: the sun and the moon, the months, the seasons, and sometimes hunting and vintage scenes. These are really nothing more than life on the open range – '*scènes de latifundia*' – commemorating the pastoral and agricultural pursuits of the time, also common in North Africa, but scholars have tried to explain the choice of subject by a specific religious reason even though the design is secular. The Madaba map with its numerous scriptural references has been connected with the cult of Moses on Mount Nebo near by. It has been rather implausibly suggested that the presence of Egypt may have something to do with ecclesiastical politics of the time. It seems more likely that the presence of craftsmen who had been trained to do certain types of floor decoration originating no doubt in Egypt was responsible for such schemes. The house-church tradition died hard in Near Eastern ecclesiastical decoration. Nevertheless, it has been argued that the programmes seem to show

a concern with the facts of the physical universe in a way not displayed by Christianity at any previous stage. It has been pointed out that a Syriac hymn of the seventh century describes the sixth-century church of Hagia Sophia at Edessa in terms partly symbolic of the cosmos, and reflects the teaching of the mystic known to us as Pseudo-Dionysius, who identified the church building with the cosmos. Moreover, this development of mosaic decoration coincides with the lifetime of Cosmas Indicopleustes, who for the first time attempted to create a complete and systematic cosmography on a purely Christian basis. There seems, it has been concluded, that there was in the sixth century a strong desire to bring the physical world within the confines of the church. This may in certain instances be so. But the mosaic floor in the monastery of the Lady Mary at Beth-Shean, about 567, presents a vine trellis framing various pastoral occupations and including a Negro leading a camel which seem to be merely carrying on a tradition of representing aspects of rural life so popular in North Africa and, no doubt, throughout the Mediterranean area, without any wider mystical or cosmographical connotations.[11]

The mosaics at Antioch, although disappointing from an Early Christian point of view, at least give some idea of the secular taste of the city ranging from the first century A.D. until the Persian sack of 540. Not so at Alexandria. The greatest city of the hellenistic world still remains an enigma. A large part of the Ptolemaic city, including the palace, is submerged in the Mediterranean Sea and the remainder is buried deep below the modern town. Some of the surviving evidence suggests that the hellenistic style degenerated more quickly than at Antioch, but we have no evidence at all of Early Christian art in the Egyptian metropolis. And yet we know that in the third century the patriarchate of Alexandria was one of the most highly organized in the Church and the city was perhaps the leading centre of Christian thought. Since St Mark was supposed to have been buried there, there must have been an important martyrium in his honour. In 391 the Patriarch Theophilus destroyed the Serapeum in which was housed the famous 'Daughter' Library and on the site erected an octagonal church dedicated to St John the Baptist and a convent. Nothing has survived. Although the Emperor Arcadius (395-408) enlarged the great church of St Menas in the Mariut, begun under Jovian (363-4) and substantially completed before the death of Valentinian in 375, the period of growth and development in that area came to an end with the close of the fifth century. The surviving material presents a decided, if decadent classical style. The relief of St Menas [51] from the associated monastery of St Thecla at Ennaton, near Alexandria, is possibly a copy of that in the present shrine. The style appears to be contemporary with that of the church of Theophilus, built under the patronage of the Emperor Arcadius and consecrated about the first decade of the fifth century. In treatment of

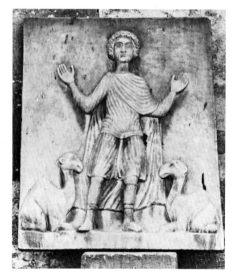

51. St Menas. Marble.
From the monastery of St Thecla at Ennaton, near Alexandria. Early fifth century.
Alexandria, Greco-Roman Museum

form and drapery the sculpture echoes work done at Constantinople at just about the same time. A carved wooden lintel from the church of

52 and 53. The Entry into Jerusalem and the Ascension. Details from a wooden lintel from the church of al-Mo'allaqa, Old Cairo. Late fourth or early fifth century (?). *Cairo, Coptic Museum*

al-Mo'allaqa in Cairo, dating possibly from the late fourth or early fifth century (some scholars would prefer a date in the sixth century), may also reflect Early Christian style at Alexandria. The lintel is carved with representations of the Entry into Jerusalem and the Ascension [52, 53] and is accompanied by a Greek inscription quoting the text of a hymn which refers to Christ as all Divinity and the Virgin as θεομήτωρ rather than θεοτόκος. There was also a date,

always difficult to read, and now replaced by a modern restoration. Since there is no reference to the two natures of Christ and the inscription is in Greek and not Coptic, it is just arguable that the lintel must date before the Council of Chalcedon in 451, when the Alexandrian Church became Monophysite, but the use of the word θεομήτωρ might imply a date before the Council of Ephesus in 431, when the Virgin was formally declared θεοτόκος. The hymn on the lintel appears to reflect Athanasian teaching, either after the Council of Nicaea in 325 or after the first three discourses of Athanasius promulgated in either 335 or 356. The iconography of the scenes is certainly peculiar. The Entry into Jerusalem does not correspond with the text of the canonical Gospels and takes place inside rather than outside the walls of the city. The dancing woman is the 'daughter of Sion' saluting her King in exultation (John xii:15). Christ is beardless and without a halo. In the Ascension Christ, again beardless, enthroned within a mandorla supported by angels, accompanied by two symbols of the Evangelists, is separated from the Virgin by curtains, which suggests the influence of imperial iconography. On the left stands the Virgin; on either side twelve spectators, including two bearded men with a cross, engrossed in the scene, and two beardless men with a book turning away and appearing to comment on the scene to the remainder. The style is similar to that of an ivory comb found at Antinoë, Upper Egypt, carved with representations of the Healing of the Blind Man and the Raising of Lazarus, and on the other side angels holding a garland which frames a rider saint [54]. Both echo the declining standards of a classical tradition remote from metropolitan impulses. If Alexandria contributed at all to the artistic heritage of which Constantinople, after the collapse of Rome in the fifth century, was to become the principal guardian, it is arguable that her role as a metropolis of creative Christian art had been played out long before the fifth century.[12]

Certainly an appreciation of that role is not advanced by the vestiges of wall-painting which have survived. The frescoes in the cata-

comb of Karmuz in Alexandria, discovered about the middle of the last century and now ruined, are obscurely reflected in watercolour copies which give the sketchiest impression of the original and are, indeed, difficult to date. Those in the underground church at Deir Abu Hennis at Antinoë also survive fragmentarily in copies and, while it is possible to identify some of the scenes from the infancy of Christ and John the Baptist and some of Christ's miracles, again they are difficult to date – probably not before the sixth century. Nor are they neces-

54 (A) Christ on the donkey or a rider saint;
(B) The Raising of Lazarus
and the Healing of the Blind Man.
Ivory comb. Found at Antinoë. Fifth century.
Cairo, Coptic Museum

55. The Ascension. Wall-painting from the monastery of Apollo at Bawit.
Probably second half of the sixth century. *Cairo, Coptic Museum*

sarily a pointer to an Alexandrian style. The
necropolis of al-Bagawat in the Kharga Oasis
in Upper Egypt is a Late Roman and Byzantine
cemetery of the type already well known in Italy
– in particular, the Isola Sacra near Ostia. The
wall-paintings date from well within the fifth
century. The scenes tend to be related to the
commendatio animae, as in Western cemeteries,
but they have also been related to the Jewish
element in Christian conversion and to the cult
of the Holy Places. The paintings in one chapel
provide an extended cycle of Old Testament
scenes, rough grist to the mill of iconographic
speculation, chosen rather casually and sited at
random in a tangle of vine-scrolls; apocryphal
themes, with the martyrdoms of Thecla, disciple
of St Paul, and Isaiah, are thrown in. The style
of these paintings is utterly crude and provin-
cial. Items of Early Christian iconography have

merely been noted in the dregs of late antique
imagery; even the hellenistic personifications
of Peace, Justice, and Prayer have been tran-
scribed in the idiom of a barely educated
peasant. It must be remembered that even
Alexandria in the fourth and fifth centuries was
at the mercy of formidable communities of
Coptic monks, who occasionally made raids on
civilization much as the Bedouin were to do
later. These monks had some knowledge of
theology, and were prepared to decorate their
monasteries in a rather haphazard fashion, but
they were opposed to hellenistic culture in its
higher sense. At the same time, the heathen
cults, debased and decadent though they were,
lingered on in Egypt; pockets of paganism sur-
vived until well after the Arab Conquest. The
frescoes in the chapels of the monastery of
Apollo at Bawit in Upper Egypt [55], because

of the type of basket capital employed in the buildings, cannot date from before the middle of the sixth century, and may conceivably be anything up to a hundred years later. The style reflects metropolitan traditions at Constantinople – they key to which is given by the mosaics and icons in St Catherine's monastery on Mount Sinai [75, 76, 85] dating from the middle to the second half of the sixth century, mosaics in Rome and Salonika [125, 141] dating from the sixth and seventh centuries, and

these metropolitan influences. Of course, by the late sixth and seventh centuries the inscriptions in these Egyptian monasteries are in Coptic and there were local interests in particular saints, but there can be no doubt that behind the idiosyncrasy of provincial piety the germinal centre was Constantinople.[13]

With the historical background in mind and with such evidence as there is, it may perhaps be wondered whether indeed the famous Cotton Genesis [26] is of Alexandrian origin. Most

56. Saints. Wall-painting from the monastery of St Jeremias at Saqqara. Late sixth or seventh century. *Cairo, Coptic Museum*

the mosaic of the Virgin and Child between angels in the little church at Kiti on Cyprus [71] dating probably from the seventh century. The frescoes from the monastery of Jeremias at Saqqara [56] are an even paler reflection of

scholars have assumed this to be the case and have dated the manuscript to the early fifth century, but since the fire of 1731 the codex has been almost totally ruined; the majority of the miniatures are so damaged as to be valueless

57. Fragments from the Alexandrian World Chronicle.
Variously dated between the fifth and seventh centuries. *Moscow, Municipal Museum of Fine Art*

from a stylistic point of view. Originally the codex must have been a luxurious production decorated with two hundred and fifty – some say more than three hundred – miniatures in delicate colours picked out in gold and painted in a good late antique tradition. This or a similar codex must have been held in high repute in the Middle Ages, since it has been proved that the mosaicists at S. Marco in Venice used it as a model for their Genesis cycle in the vestibule.

In Cotton's day there was a tradition that the codex had been brought to England by Greek bishops from Philippi and presented to Henry VIII. Queen Elizabeth gave the manuscript to her Greek tutor, Sir John Fortescue, who in turn gave it to Sir Robert Cotton. Attempts have been made to compare the surviving fragments with papyri found in Egypt, with the Alexandrian World Chronicle, which has been variously dated between the fifth and the seventh centuries [57] and is utterly provincial in style, with ivory carvings not necessarily made in Egypt, and indeed with textiles found in Egypt, but none of the arguments is overwhelming. The origin of the Cotton Genesis still remains in doubt and the manuscript is certainly no guide to a hypothetical Alexandrian style. The close affinity pointed out by some with the mosaics of S. Pudenziana and S. Maria Maggiore at Rome in an attempt to narrow the date brackets is not without its irony.[14]

North Africa provides another sequence of splendid secular mosaics ranging from the second century A.D. until the Arab Conquest, but purely Christian subjects are rare and by the time they appear standards have plunged downhill. Thus, the mosaic showing Daniel between the lions in the museum at Sfax, dating probably from the sixth or seventh century, is little more than folk art with naïve charm, but it is claimed to have been executed with greater care than most African Early Christian mosaics. A number of tomb mosaics have been found at Tabarka; their dating is controversial, but none seems to be earlier than the fifth century. The dead are represented in the merest shorthand of style, crude pictographs of faith with flattened anonymous forms outlined uncertainly. The tomb mosaic of the deacon Crescentinus presents horsemen, various birds, and one tree and odd sprays of leaves of which the Christian significance is difficult to interpret; nor does the inscription with its reference to angels and martyrs help elucidation. Hunting scenes, and crude enough they are, turn up in quite a number of Christian buildings at Carthage in the sixth century, after the Byzantine reconquest. At Oued Ramel a pavement in a Christian structure commemorated various stages in building and is related to the genre scenes so familiar in the secular mosaics. Although there is evidence of a revival after the Byzantine reconquest – some of the pagan silver is handsome in a heavy, coarse way – Carthage was too remote to enjoy to the full benefits of any renascence under Justinian and was spared little enough time, indeed, to take advantage of it. The Justinianic mosaics of Cyrenaica vary considerably in quality but appear to be the work of master craftsmen, imported possibly from Syria, and of local assistants. The repertory is a curiously haphazard collection of motifs, of which surprisingly few are Christian in content. The mosaics in the church at Qasr el Lebia, c. 539, for example, contain Nilotic scenes, figures of birds, beasts, and fish, a naked satyr, a view of a city inscribed *Polis Nea Theodorias*, and personifications of Foundation, Renewal, and Adornment. All three could have been represented in a church, a law-court, or a public bath. Before long the desert, whether in the form of Arabs or as sand from the Sahara, engulfed the once prosperous cities of North Africa.[15]

There was, then, almost throughout the Roman Empire a decline: decline of cities, decline of population, decline of morale, decline of art. The West was subjected to relentless waves of barbarians for some five hundred years and was harassed by Islam from the seventh to the eleventh centuries. The eastern half of the Empire managed to survive because it possessed greater economic resources; it was able to raise large armies from its own subjects and could if necessary pay large sums of blackmail to buy off the barbarian onslaught. But one of the chief causes of the stability of the Eastern Empire was the siting and impregnability of its capital.[16]

After the Peace of the Church had been settled in 312–13 Constantine was still far from being master of the Empire. This uneasy situation dragged on until 324, when he decided to attack his co-Emperor Licinius. His troops went into battle preceded by the labarum bearing the monogram of Christ, while those of Licinius still carried the emblems of the old

gods. Licinius was defeated at Chrysopolis on the Asiatic shore and the little town of Byzantium was won after a naval battle in the straits. After some deliberation, during which the potentiality of Nicomedia was weighed in the balance, Constantine decided to found a new city on Byzantium as a memorial of the final

the most beautiful, the most secure, and the most prosperous of cities. The consecration took place in 325, the position of the land walls was marked out personally by the Emperor, and the Empire was ransacked for columns, marble, sculpture, and treasure of all kinds to adorn the city. Gifts of land and housing concessions

58. Constantinople, general view

victory which had given to him, God's friend, dominion over the world. As a matter of course the new city was dedicated to the new faith, and there is no reason to doubt Eusebius's assertion that it was never sullied by pagan worship. Although Constantinople was given the official title 'Roma Secunda' it did not share the constitutional position of Rome, and for some time the city was no more than an imperial residence like Trier, Sardica, or Nicomedia. It seems to have been Constantine's intention, however, for the city to become the normal residence of the Emperor in the eastern parts of his dominion, and no time was lost nor expense spared to make it the permanent seat of government.[17]

The site was superb [58]. Set on a triangular peninsula at the junction of many waters, both sweet and salt, Constantinople was to become

were made liberally to attract citizens. Some of the more prominent positions were reserved for Christian emblems, and among the churches two were dedicated to Holy Wisdom and Holy Peace. When the city was dedicated on 11 May 330 a bronze statue of Apollo, whose head had been replaced by that of Constantine encircled by the rays of the sun – the rays being the nails which had pierced Christ – was placed in position on a huge porphyry column in the Forum of Constantine. At the base of this column were buried the relics of saints, crumbs from the bread with which Christ had fed the five thousand, the crosses of the thieves, the alabaster box of ointment, the adze with which Noah had built the ark, the rock from which water sprang when touched by the rod of Moses, and the palladium which Aeneas had taken from Troy

to Italy. An inscription on the base read: 'O Christ, Ruler and Master of the World, to You now I dedicate this subject City, and these sceptres, and the Might of Rome, Protector, save her from all harm.'[18]

The main layout of the city built by Constantine was to remain the same throughout Byzantine history. The walls were extended in a huge triple line [59] in the reign of Theodosius II, and they stand today, reaching from coast to coast in splendid ruin. On the other hand, the details of the city have changed considerably.

judgement, for it is equal to sacrilege to doubt if that man is worthy whom the Prince has chosen'; the Sarigüzel sarcophagus [33] found near Fenari Isa Djami, with magnificent angels bearing the monogram of Christ, carved in a full hellenistic tradition quite different from the modish conceptualism of the imperial image; and some marble jetsam now in the Archaeological Museum at Istanbul. The jetsam ranges from columns and capitals to fragments of reliefs depicting Christ between two Apostles or the Delivery of the Law. From the

59. Constantinople, the walls of Theodosius II (408–50)

So determined was Constantine to complete his work that many of the buildings were shoddily constructed and soon needed repair. Frequent earthquakes and fires took their toll; the most serious fire occurred at the time of the Nika riots in 532, when more than half the city was burnt to the ground. Today, of Constantine's city nothing but foundations remains. A fragment of a porphyry sarcophagus, decorated with Erotes and garlands, is all that survives of what is thought to be the founder's tomb.[19]

Very little remains even of Theodosian Constantinople: the great marble base of an obelisk in the Hippodrome with its representations of the Augusti in the imperial box, grave, stiffly seated, surrounded by bearded patricians and long-haired warriors, receiving the tribute of the provinces; the head of the Emperor Arcadius from the Forum Tauri, wistful but wide-eyed beneath the imperial diadem, the son of the Emperor Theodosius who had decreed in 385 that 'it is not fitting to discuss the princely

best of these reliefs (and there is considerable variety of style) certain mutations may be detected through the screen of conscious classicism. The deliberate preservation of classical traditions is firmly stated on the Sarigüzel sarcophagus, but the slow change of this tradition may be seen in both official and religious reliefs. The drapery slides in spare folds over the soft, rounded forms, postures are in measured rhythms, and there is always evident a feeling for texture and a sense of space. Even in a frieze of lambs, formerly on the architrave over the entrance to the outer hall of Hagia Sophia rebuilt after the fire of 404, this sense of space, measured rhythms, and tactile values is present. As far as we may judge from the surviving fragments there was in the Theodosian period a cult for refined elegance, typified by the stressed youth of the Augusti, their imperial gestures seized, as it were, in a golden web, the prosperity of the Empire, the indefinable mystique of the Sacred Presence secure in the wisdom of coun-

sellors and the might of the army. The cult is epitomized, indeed, in the great silver dish chased with the representations of Theodosius I, Valentinian II, and Arcadius [60], issued to celebrate the Decennalia in 388. Before an elegant screen like a stage property the figures of the Sacred Family, wearing the diadems and fibulae of imperial majesty, Theodosius himself haloed like a god, lean forward from their thrones, almost suspended in space, to strike awe into the mind of the spectator, to command peace by the force of their army, of which representatives stand caught also in the web of eternal youth, and to foster Abundance, who reclines with indolent assurance at the feet of the Sacred Presence. Although the Theodosian house was devout and orthodox Christian, there is no trace of Christian symbolism. The Emperor Theodosius is handing a diploma to an official, and, albeit seated, towers in stature over subject, co-Caesar, and guard. The scene is, then, an epiphany, the Sacred Presence made manifest, and an icon, an image to be adored *in loco maiestatis*. Byzantine art begins here.[20]

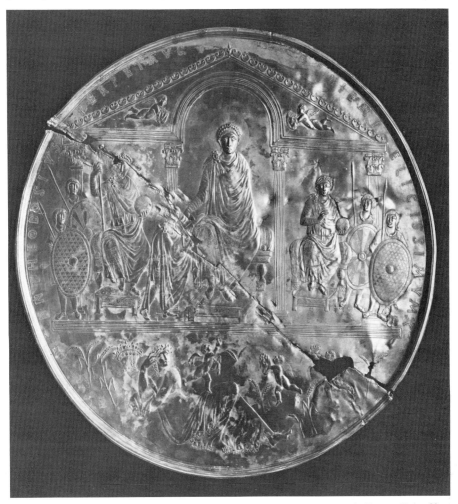

60. Theodosius I, Valentinian II, and Arcadius. Silver dish issued to commemorate the Decennalia in 388. *Madrid, Academia de la Historia*

EARLY CHRISTIAN ART:

THE SYNTHESIS OF THE SECULAR AND THE RELIGIOUS IMAGE

The integration of Christian imagery and official iconography was a slow and intermittent process. The Emperor and the imperial administration had only to state that he was Vicar of God for the elaborate ritual enacted before the imperial image to be, so to speak, baptized. The imperial portrait, the *lauraton*, represented the Emperor by proxy and received the same honours, lights, incense, and proskynesis as if the Emperor were there in person. An insult to the *lauraton* was an insult to the Emperor. The *lauraton* was not thought of as an idol and the

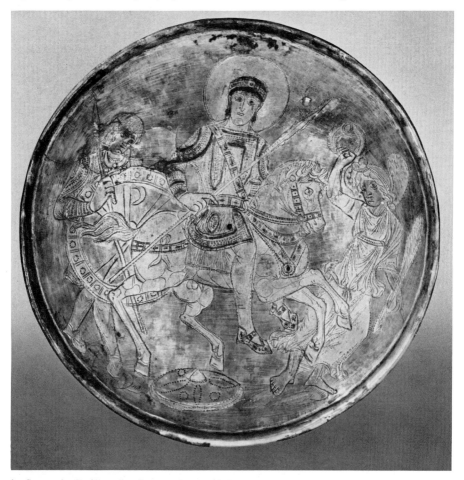

61. Constantius II. Silver dish. Found at Kertch. Mid fourth century. *Leningrad, Hermitage*

Church tolerated its veneration even when the worship of religious images was troubling the consciences of the faithful. For a long time official issues of ivory diptychs, silver plate, and consular medallions were wholly secular in tone. There were, however, exceptions. From the time of Constantine the Great coins might bear the Christian *labarum* or the Chi-Rho monogram. The great silver dish, found at Kertch, with a representation of Constantius II (337–61) acclaimed by a Victory [61] reveals also a soldier carrying a shield marked with a Chi-Rho monogram. If the attribution is correct, the same Emperor is depicted on the Roths-

child cameo wearing a diadem inset with a Christian monogram [62]. Both objects presumably date from the middle of the fourth century. On the diptych of Probus, issued probably at Rome in 406, the Emperor Honorius is represented as a general holding the *labarum*, a rectangular banner inscribed with the words 'In nomine Christi vincas semper' and surmounted by a Chi-Rho monogram. The orb held by the Emperor does not yet bear a cross but supports a Victory carrying both palm and wreath. About 420 a gold consular *solidus* was struck at Constantinople with an indifferent portrait of Theodosius II but, on the reverse,

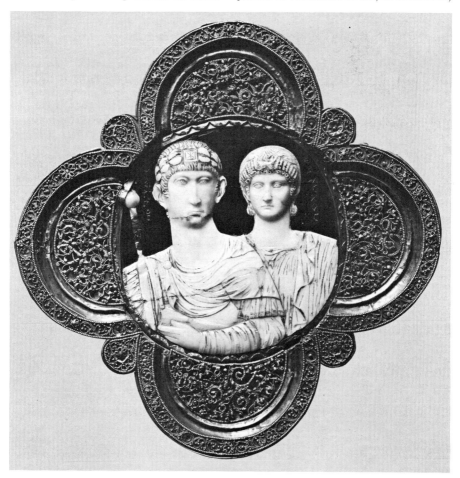

62. Constantius II and his Empress. Chalcedony. Constantinople, *c.* 335. *Paris, Musée du Louvre*

for the first time, a Victory holding a large cross. This formula was greatly approved of. Indeed, when Justin II (565-78) substituted the personification of Constantinople for the cross and Victory the people complained, and a convenient vision came to Tiberius II (578-82) to the effect that the cross should be reinstated. The new formula proved to be a cross potent raised on steps with the legend 'Victoria Augustorum'; the type of cross was probably inspired by the monumental cross set up by Constantine I in the Forum of Constantine and for long deeply venerated. It was to be the one image which did not arouse the fury of the Iconoclasts.[1]

On Basil's diptych, issued at Rome in 480, the consul is revealed in debased style holding a sceptre surmounted by a cross. Of the six diptychs issued for Areobindus at Constantinople in 506 only one bears a Christian emblem – a small cross – between two sizeable horns of plenty with a large basket of fruit placed below. Abbundantia dwarfs the symbol of salvation. In Clementinus's diptych – again at Constantinople but some years later, in 513 – the cross appears for the first time on these official issues in an exalted position between, but on the same level as, the busts of the Emperor Anastasius and the Empress Ariadne above the *tabula ansata* which bears the consul's name. Once this formula had appeared its use was by no means constant. When Flavius Anastasius became consul in 517, his diptych reverted to the usual type, with one small difference on one leaf by which it appears that banners with crosses were borne in the processions at the Hippodrome. In the two superb ivory reliefs, dating probably from the early sixth century, which reveal so clearly the attitude of the time towards the imperial image, the Empress Ariadne [63] is displayed as a cult-image, bedizened with jewels and regalia, framed by an ornate baldacchino, but this time the imperial orb is surmounted by a large cross. Justinian's diptych of 521 – one of the most beautiful of all the consular ivory carvings, original and subtle in design with its four devices of lion's masks set in a cradle of leaves – bears two small crosses in the central medallion and another precedes the inscription on the *tabula ansata*; the crosses, indeed, are really more part of the inscriptions than part of the design. It is not until 540, on the diptych issued by Justin at Constantinople, that the bust of Christ, bearded, long-haired, the head and shoulders backed by a cross-

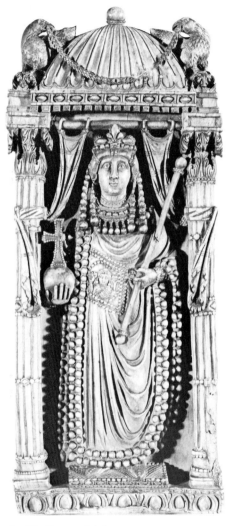

63. The Empress Ariadne.
Ivory panel of an imperial diptych. Constantinople, early sixth century. *Florence, Museo Nazionale*

nimbus [64], appears between the portraits of Justinian and Theodora. Like the cross on Clementinus's diptych, the head of Christ is placed on the same level as those of the Augusti but, curiously enough, all three are placed below the *tabula ansata*. Even in the sixth century the hierarchy of beings which in later times was to become so sacrosanct was not yet properly worked out; it is particularly surprising that Justinian and Theodora, so meticulous in

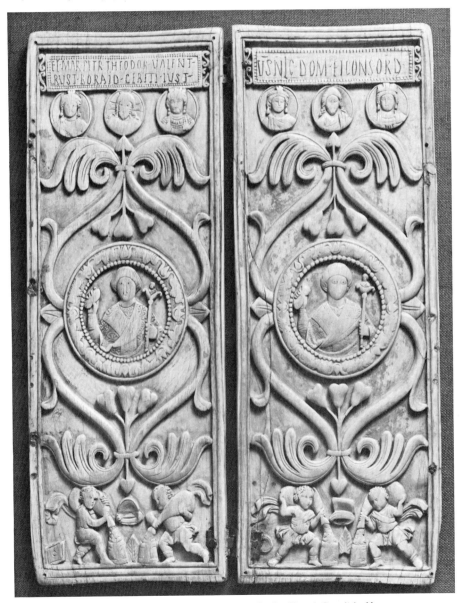

64. Consular diptych of Justin. Ivory. Constantinople, 540. *Berlin, Ehemals Staatliche Museen*

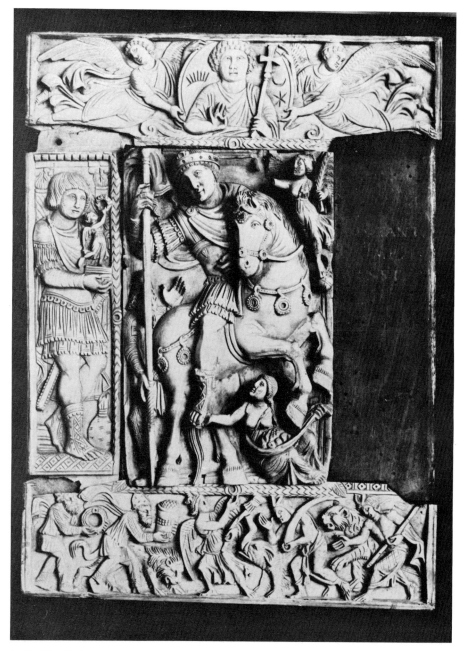

65. Justinian (?). Ivory leaf of an imperial diptych. Constantinople, 527.
Paris, Musée du Louvre

66. The Raising of Lazarus, and St Jerome, St Augustine, and St Gregory. Paintings executed on the interior of the consular diptych of Boethius (487) in the seventh century. *Brescia, Museo Cristiano*

court protocol, should have permitted their nephew to issue such an oddity. The imperial diptych which may or may not represent Justinian as a victorious general (Zeno and Anastasius have also been mooted) is constructed with a top register [65] on which two angels support a medallion containing a bust of Christ, beardless, short-haired, without a halo, and holding a cross-sceptre. But even imperial diptychs were far from rigid in their iconography. The upper register might equally well be carved with two Victories supporting a medallion which contains a Tyche or some other personification.[2]

67. The Virgin and Child enthroned between Angels; Christ enthroned between St Peter and St Paul. Ivory diptych. Constantinople, mid sixth century. *Berlin, Ehemals Staatliche Museen*

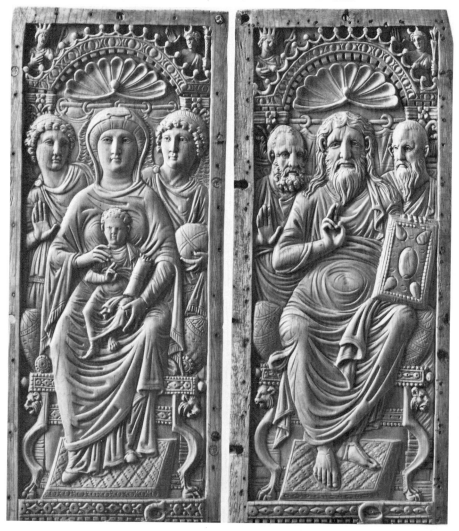

In Early Christian times ivory diptychs came to be used as part of the liturgy, though their importance was always greater in the East than in the West. It became customary to write on the diptychs the names of those, living or dead, who were particularly illustrious as members of the Church. There were 'diptychs of the living' and 'diptychs of the dead' whose names were read out during the eucharistic liturgy. The custom survives today in the commemoration of the living and the dead in the Canon of the Mass. From such diptychs came the first ecclesiastical calendars and martyrologies. Occasionally special diptychs were made to contain only the names of certain bishops. Exclusion from these lists became a grave ecclesiastical penalty, and in the fifth, sixth, and seventh centuries at Constantinople the diptychs were the instrument of a good deal of ecclesiastical venom. Several of the consular diptychs were adapted for Christian use. The diptych of Boethius, issued in Rome in 487, was in the seventh century painted on the back with portraits of St Jerome, St Augustine, and St Gregory, the Raising of Lazarus [66], and a *commemoratio pro vivis* with names. Clementinus's diptych received on the back in 772 a Greek prayer 'for the living' and a reference to a monastery of St Agatha, patron of Catania. The diptych of Philoxenus, issued at Constantinople in 525, was inscribed probably in the ninth century with the text of the *Kyrie eleison*, the *Gloria in excelsis*, and musical notation. But as we know from the Roman diptychs of the late fourth and fifth centuries, there were also examples with religious intention from the outset. One of the finest, almost certainly produced at Constantinople in the middle of the sixth century, presents a majestic bearded Christ enthroned between St Peter and St Paul and the Virgin and Child enthroned between angels [67]. This serenely beautiful work is an example of the *renovatio* of the arts which occurred during the reign of Justinian. Here, indeed, the consular diptych has been transformed. Before an architectural setting redolent of the court, seated on thrones of intricate workmanship, Christ and the Virgin are displayed as cult-

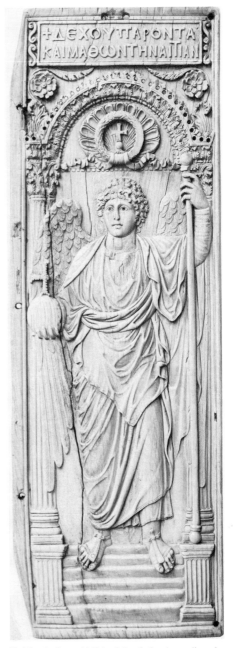

68. The Archangel Michael. Leaf of an ivory diptych. Constantinople, between 519 and 527. *London, British Museum*

images. Although the treatment of hair and drapery is detailed and precise, the modelling of the forms skilled and authoritative, the figures at the same time have an almost ghostly lack of weight. It is difficult to believe that either person is sitting on the throne or that the feet are really resting on the footstool. The diptych is a vision of theophany, beheld with awe by the Sun and the Moon peering over the archway, contemplated in calm rapture by the angels and the saints. So, too, the leaf of a diptych carved with a representation of the Archangel Michael [68], surely from the same workshop at Constantinople, presents another form of vision. For all the intricacy of architectural detail, the authority of the Greek inscription, the grasp of human form, the rich sweeps of drapery, the beauty of countenance – human and yet divine – the archangel is not standing in reality. The heavenly being floats above the steps, suspended before the archway, the divine messenger made manifest to the faithful.[3]

According to Eusebius of Caesarea painted icons of Christ, St Peter, and St Paul were widespread in the early fourth century. It is clear from his reply to the Empress Constantia, who had asked for a painted image of Christ, that Eusebius did not approve of such images. Nevertheless, in certain quarters images became objects of intense personal devotion. They were carried in processions, were used as palladia in battle, and were considered at times of personal crisis to be sources of divine protection. Some idea of these processions may be gathered from the illustration over the Priscillian Prologue to the Gospel of St Matthew executed at the court of Charlemagne in the early ninth century [69], which is certainly based on an earlier model. Those images 'not made by hands' or those miraculous in other ways possessed magical properties from the start, and in certain cases were considered to be extensions of the personality of Divinity or the Saints. Obviously an image which was believed to be a 'dwelling of the Holy Ghost' was a very different thing from one that was merely an instrument of instruction. From early times there was a considerable body of opinion in the

69. A Procession of Icons showing the Ancestors of Christ and including portraits of Abraham, David, and Jechonias. From the Priscillian Prologue to St Matthew in the Lorsch Gospels, Batthyaneum, p. 27, executed at the Court School of Charlemagne. Early ninth century. *Alba Julia*

Church which disapproved of the cult of icons and the superstitious practices so often attached to them. Those of the early Fathers who had spoken in defence of artistic representations based their case primarily on the value of images in the education of the faithful. St Gregory of Nyssa, in his eulogy of St Theodore Martyr, pointed out that it was not a question of presenting Divinity directly but of narrating events in order to edify the soul. Popular opinion was not nearly so high-minded; objects of devotion, not instruction, were required by the laity, particularly the women.[4]

The portrait of Christ at Edessa, which was miraculously made for Abgar the Black, King of Osrhoene, was accepted by many as the true image, the Vera Icon, of Christ, bearded, longhaired, dark, imprinted on a veil, and became one of the most revered. Its origins are shrouded in mystery. The image and a letter from Christ to King Abgar together with a lamp which had continued to burn for centuries were found walled up in a niche above the gate of the city in 544 after a dream sent to the Bishop of Edessa at a time when the city was threatened by the Persians. By the intervention of the icon the Persians raised the siege and the city was saved. Apparently the people of Syria were more devoted to the letter from Christ than to the icon. Other legends refer to this letter, copies of which tended to be placed over the gates of a city. In the fifth and sixth centuries copies were placed not only over city-gates but over doors

INCIPIT · ARGVMEN[T]

MATHEUS EX
IIUDAEA QUI
ET LEUI SICUT IN
ORDINE PRIMUS
PONITUR ITA EUAN
GELIUM IN IUDAE
PRIMUS SCRIPSIT
CUIUS UOCATIO A
DM EX PUBLICANIS
ACTIBUS FUIT
DUORUM IN GENE
RATIONE XPI PRIN
CIPIA PRAESUMEN
UNIUS CUIUS PRI
MA CIRCUMCISIO
NE IN CARNE ALTERI
US CUIUS SECUNDU
COR ELECTIO FUIT

ET EX UTRISQUE
IN PATRI XPS
SIC QUE QUATERNA
RIO DENARIO NU
MERO TRIFORMI
TER POSITO. PRIN
CIPIUM A CREDEN
DI FIDE IN ELECTIO
NIS TEMPUS POR
RIGENS ET EX ELEC
TIONE USQUE IN
TRANSMIGRATIO
NIS DIEM DIRI
GENS ATQUE A
TRANSMIGRATIO
NIS DIE USQUE
IN XPM DEFI
NIENS

and tombs in Syria, Asia Minor, and Macedonia. There was no attempt to copy the icon in Syria, but other versions are known, either as Veronica's veil or as the Kamouliana, an image of Christ 'not made by human hands', which was translated in 574 from Cappadocia to Constantinople, where it became a palladium of the city. The icon was probably destroyed during the Iconoclast Controversy. Another version was the Keramion, the printing of the head of Christ on a tile which was removed from Hieropolis or Emesa to Constantinople in 968 by the Emperor Nicephorus Phocas. The Edessa portrait, known as the Mandylion, because the image was printed on a veil, was translated to Constantinople in 944, and it is probably about this time that the icon showing King Abgar holding the veil [188], now on Mount Sinai, was painted. The Byzantines had little use for the letter of Christ which accompanied the icon and paid their respects to the image. In spite of the preservation of the classical heritage at Constantinople, it occurred to no one that the probable source of this venerable image was the apotropaic Gorgoneia of pagan times which was constantly placed over a city-gate.[5]

The icon of the Theotokos Hodegetria was the object of special veneration at Constantinople. Supposed to have been painted by St Luke, the image of the Virgin and Child was sent from Jerusalem in 438 by the Empress Eudocia to her sister-in-law, the Empress Pulcheria, who deposited it in a church built specially within the Great Palace. This tradition, however, does not reach farther back than the early-sixth-century historian Theodore Anagnostes, and his work survives only in excerpts 'dictated' in the fourteenth century by Nicephorus Kallistos Xanthopoulos. Nevertheless, there are unmistakable references to the icon in the late twelfth century by Nikolaos Mesarites and Anthony of Novgorod, and in the tenth century by Theophanes Continuatus. It was the firm belief of the faithful that this icon survived the Iconoclast Controversy, and after the return to orthodoxy Michael III (842–67) built a church in the Manganes quarter for the image within a sanctuary for the blind. There

70. The Virgin and Child (Theotokos Hodegetria). Painted icon. Rome, c. 609. *Rome, Pantheon*

71 (*opposite*). The Virgin and Child between Archangels. Mosaic in the apse. Second half of the seventh century. *Kiti, Panagia Angeloktistos*

was a miraculous spring or well near by in which the blind used to bathe in the hope of recovering their sight. For this reason the church was called that of the Hodegoi, the pointers of the way, and the icon the Hodegetria. The Patriarch Photius was later to describe the image as that of 'a virgin mother carrying in her pure arms, for the common salvation of our kind, the common Creator reclining as an infant' and fondly 'turning her eyes on her begotten Child in the affection of her heart'. Frequently, however, the Virgin looks straight ahead with her hand pointing to the Child, showing the Way, the Truth, and the Life. The earliest copy of this

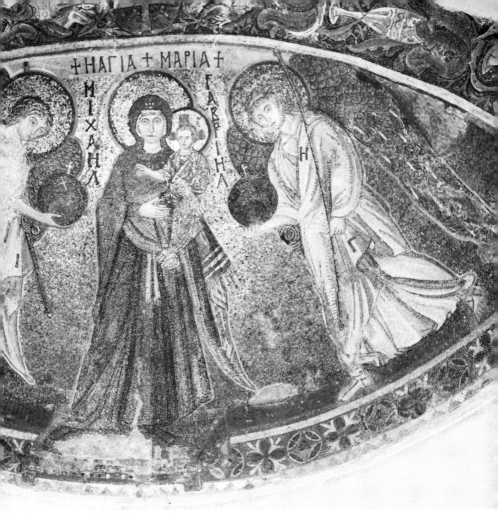

type of icon is the Virgin and Child of the Pantheon at Rome [70] probably executed when the former temple was dedicated in 609 by Pope Boniface IV to Sancta Maria ad Martyres. The icon has been compared with the seventh-century mosaic in the apse of the little church of the Panagia Angeloktistos (built by the angels) at Kiti in southern Cyprus. Here the Virgin [71] is shown full-length between the Archangels Michael and Gabriel. She is not designated Hodegetria but Hagia Maria, which is unusual for this date, on which scholars are by no means agreed. The mosaic is of singular beauty and must have been the work of a team from Con-

stantinople, but the dryness of the modelling and the stiffness of the drapery suggest a date after the mid sixth century. On the other hand with reference to another representation of the Virgin and Child in northern Cyprus it has been observed that 'the bold schematization of this composition, the use of large tesserae, even in the faces, and the highly decorative borders which enclosed it claim the Lynthrankomi mosaic on Cyprus for the first half of the sixth century' (Megaw). The icon, which may once have been full-length figure, was almost certainly painted in Rome, but it reflects the classical revival of the reign of Justinian at Constantinople.

While the head of the Virgin in its present condition appears to be painted in a rather stylized manner, that of the Child is executed in a full hellenistic tradition: soft curls, delicate modelling, wide eyes, and gentle expression. Originally the right hand of each figure was painted in gold. The gesture of stretching out the right hand had long been the act of authority for an Emperor and of salvation for a god: gold, therefore, was used to stress the hand which made the gesture. A second icon of the same type, also attributed to St Luke, dating probably from about 640, is now in the sacristy of S. Francesca Romana. This church was built into the ruins of the Temple of Venus and Roma and was known in the Middle Ages as S. Maria Nova to distinguish it from S. Maria Antiqua, from which it took over the diaconate. S. Maria Antiqua had been partially buried under the collapse of imperial buildings on the Palatine after the serious earthquake of 847. The icon, however, is believed to have been transferred from the old to the new church. Today only fragments of the heads of the Virgin and Child [72] have survived and, although it has been pointed out that their style corresponds to the earliest full cycle of frescoes in S. Maria Antiqua dating from the second quarter of the seventh century, conclusions are difficult to draw from such vestiges.[6]

Apart from the hoard placed at the foot of the column in the Forum of Constantine, the metropolis was not at first rich in relics. Through the good offices of Artemius, prefect of Alexandria, the relics of St Timothy arrived at Constantinople in 356, and those of St Andrew and St Luke in 357. Other relics followed. The whole city turned out to greet them and they were received with imperial pomp. Two of the most deeply venerated were relics of the Virgin, the Protectress of the City: the maphorion and the girdle. The Emperor Leo I (457–74) and the Empress Verina built a church by the convent of Blachernes to house the maphorion and, no doubt, an icon – the Panagia Blachernitissa – was invented at this time. It is not, however, until the reign of Leo VI (886–912) that the gold

72. The Virgin and Child (Theotokos Hodegetria). Painted icon. Rome, c. 640
Rome, S. Maria Nova (S. Francesca Romana)

solidi issued by him provide the formula: the Virgin Orans, with or without a nimbus, wearing the maphorion over a long-sleeved chiton. According to one tradition the girdle, enclosed in a reliquary (ἡ ἁγια σορός), had been deposited in the Church of the Chalkoprateia near Hagia Sophia by the Emperor Arcadius (395–408). In the last years of the ninth century when the Empress Zoe Zaoutzina, the second wife of Leo VI, fell ill, the reliquary was opened, the girdle was taken to the palace, and the Empress was healed. In the reliquary a document had been found which stated that Arcadius had placed the girdle in the soros. The icon, which was, no doubt, invented for the occasion, was called the Panagia Hagiasoritissa or the Panagia Chalkoprateia. The oldest copy of this type is again in Rome, in S. Maria del Rosario, actually in the

73. The Virgin
(Panagia Hagiasoritissa or Chalkoprateia).
Painted icon. Rome, late eighth century.
Rome, S. Maria del Rosario

chapter house of the Dominican nuns but set on a frame which can be turned so that the public may see it through a window in the church. The painting was originally in the *Monasterium Tempuli* first mentioned in the early eighth century and it was already famous in 905, when Pope Sergius III (904–11) inaugurated an annual donation of oil to burn in a lamp in front of it. The Virgin is represented in three-quarter view [73], head turned towards the spectator, her hands raised in prayer. The icon dates probably from the late eighth century and is almost certainly Roman work at a time when images were forbidden in Constantinople. After the Iconoclast Controversy there are several variants of the type: the Virgin standing, turning to the left or right, raises her hands in a gesture of intercession or prayer to the bust

of Christ depicted in a segment of the sky; or only the half figure is represented in the same attitude, praying to Christ or to the Hand of God emerging from the segment of sky. The icon of the Theotokos Nikopoia, one of the few never to have been attributed to St Luke, was the special palladium of the Byzantine Emperors and had its own chapel in the Great Palace. The tradition for the icon goes back to the Emperor Maurice (582–602), but it seems probable that the image now preserved in S. Marco at Venice, part of crusader loot, is based on a model dating from some time after the Iconoclast Controversy. Incidentally, even in the Emperor Maurice's day there was still a great hunger for relics in the capital. The Empress Constantina, wife of the Emperor Maurice, asked Pope Gregory the Great for the head of St Paul or some part of his body – 'caput eiusdem sancti Pauli aut aliud quid de corpore ipsius' – which would be placed in a new church in the palace dedicated to St Paul, but the Pope refused, saying that he neither could nor dared.[7]

The image of Christ Chalkites, an icon set above the main entrance of the Great Palace, was widely believed to have been first installed by Constantine I but the tradition had little foundation in fact. There is some reason for thinking that the image was already in existence in the reign of the Emperor Maurice. If the curious carving in ivory now at Trier representing a translation of relics at Constantinople [74] is any guide, the image was a bust of Christ, long-haired, bearded, with a cross-nimbus. Whenever there was an outburst of Iconoclasm this image was the first to go. Its removal in 726 by members of the court aroused a murderous onslaught of enraged women, and Theophanes, writing long after the event, maintained that the destruction of the image led to a persecution of the educated class and contributed to the decline of higher learning – a curious statement considering that Iconoclasm was partly an intellectual movement. After the Council of Nicaea in 787 the image was among the first to be reinstated by the Empress Irene, but Leo V removed it again about 815. The Empress Theo-

74. A Translation of Relics at Constantinople. Ivory. Byzantine, probably sixth century. *Trier, cathedral treasury*

dora once more replaced the image over the Brazen Gate after 843, this time in mosaic with Christ represented full-length with a cross-nimbus. The icon must always have been held in high repute by orthodoxy. As late as the second decade of the fourteenth century Christ Chalkites was depicted in mosaic in the inner narthex of St Saviour in Chora.[8]

In the monastery of St Catherine on Mount Sinai three icons may conceivably date from the sixth century, although some scholars prefer a date in the succeeding century. The first, a large painted panel with the bust of Christ Pantocrator, dark, long-haired, and bearded, has been proposed as a copy of the Christ Chalkites, is a type which occurs throughout Byzantine art history, and is only important in so far as the date is justified. The second [75] is a painted panel with a representation of the Virgin and Child enthroned between St Theodore and St George; behind the Virgin two angels look up towards the hand of God emerging from heaven in a beam of light. The icon is a curious mixture. The Virgin and Child, both nimbed, are represented with some degree of naturalism, although the proportions of the

Virgin fall into two halves and the artist has been troubled by problems of foreshortening, in the treatment of hands. Interest is concentrated on the face and the regard. Neither Virgin nor Child is looking at the spectator. Grave, impersonal, detached, withdrawn, these unearthly beings look past and beyond into infinity. The saints, on the other hand, their narrow attenuated forms richly draped in cloak and tunic, hands holding crosses in improbable grip, their small unlikely feet set in mere tokens of stance, gaze hypnotically at the spectator, apparitions without weight or substance yet generating intensity. The whole group maps out the contours of the religious style which was being evolved at Constantinople throughout the sixth century and which was to be adopted wherever Byzantine influence was felt for the next three hundred years. The angels are represented in an entirely different mode: heavily modelled, caught in movement, breathing with barely closed lips the spirit of the classical tradition. They set up a curious counterpoint behind the solemn liturgy of the Virgin, Child, and Saints; their upward glance, their movement outward and away emphasizes the apparition of the hand

75. The Virgin and Child enthroned between St Theodore and St George. Painted icon. Constantinople, sixth or seventh century. *Mount Sinai, monastery of St Catherine*

of God which in a curious way, because it is quite small, dominates the scene. The third, again a painted icon of some size, represents St

76. St Peter. Painted icon.
Constantinople, sixth or seventh century.
Mount Sinai, monastery of St Catherine

Peter [76], haloed, bearded, and holding a long cross. At once the atmosphere of the court portrait and the consular diptych is evoked. Like the consuls, St Peter, placed before an exedra, represents authority, and as in the diptych of Justin [64] authority is overshadowed by the images of ultimate power. The bust of Christ or God the Father is in the centre, but instead of the portraits of the Augusti those of the Virgin and a young saint, possibly Christ, are placed on either side. Here, then, is a clear case of the religious icon adopting the formula of secular portraiture. All four figures gaze intently at the

spectator, and by this concentration of gaze ethereal power might be said to emerge from the painted panel, which was believed to draw its energy from the prototype. This was the kind of image which watched over the safety of the home, which might be paraded on the walls of cities in times of siege, and which might be expected to work miracles. Just as the diptych of the Augusta Ariadne revealed the Empress as a cult-image of secular power [63], the icon of St Peter is the equivalent of the old pagan cult-images. This type of image above all incurred the wrath of the Iconoclasts.[9]

In Rome the fusion of the secular and religious image was even more complete. Already in the fifth century the mosaics of S. Maria Maggiore represented the Virgin as a Roman Augusta. By the sixth century a special cult-image had been evolved of which even the orthodox in the East would have disapproved. The Virgin was venerated as Queen. One of the earliest paintings in the church of S. Maria Antiqua, dating from the first half of the sixth century, reveals the Virgin and Child enthroned, adored by angels. The Virgin wears the imperial diadem and the robes and jewels of state, but the intention was not to depict her as Augusta, Basilissa, or Imperatrix. She is *Maria Regina*. In spite of a reference in the *Hymnos Akathistos* – the great hymn to the Virgin in the Greek liturgy – this image was never acceptable to the Byzantine orthodox, since by investing the Theotokos with the insignia of earthly power the supernatural and the natural orders were too closely juxtaposed. Unlike the Roman icons previously discussed, the image of Maria Regina, notwithstanding all the Byzantine court regalia, is an original Western creation. In the early eighth century Pope John VII (705–7), who had a particular devotion to the Virgin and referred to himself as the 'servus sanctae Mariae', commissioned a great icon, now in S. Maria in Trastevere, which showed him kneeling before the Virgin crowned as Queen [77]. This image is even more remote and abstract than the Mount Sinai icon. Again the form of the Virgin divides into half: the head and shoulders might be part of a standing

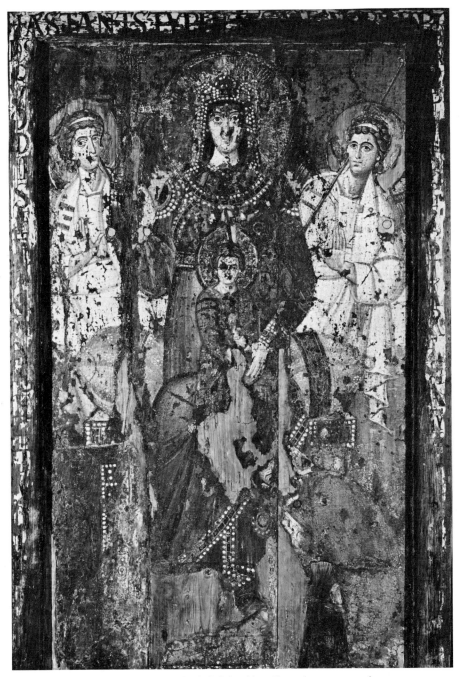

77. The Virgin crowned as Queen (Maria Regina). Painted icon. Rome, between 705 and 707.
Rome, S. Maria in Trastevere

figure, the lower half that of a seated figure. There is considerable elongation of the form and for all the monumentality an almost total lack of weight. The angels, making gestures of acclamation, lean outwards and gaze past the divine apparition to mesmerize the onlooker, who already must have been held by the wide, staring eyes of the Virgin. Like an imperial audience when the Emperor was hidden by curtains and suddenly revealed to the people, the icon was kept veiled and only at a special moment in the liturgy was disclosed to the faithful. Like the Augusti on the great silver dish of Theodosius I [60] the face of the Virgin is a serene mask looming out of space to strike awe in the hearts of men. The icon is one of the key monuments of Roman papal art in the early Middle Ages.[10]

The contrast between religious and secular styles is well illustrated by Byzantine metalwork in the sixth and seventh centuries. Among the secular silver dishes bearing control stamps of

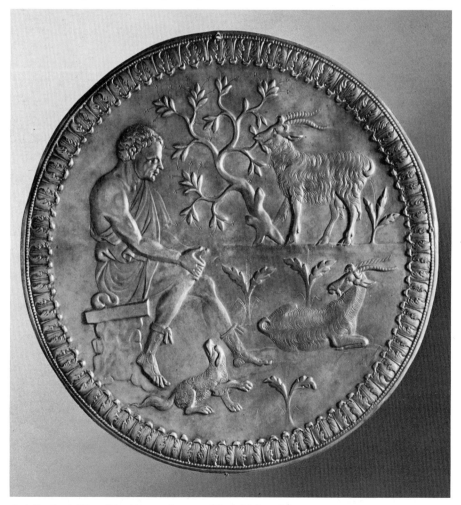

78. A Goatherd. Silver dish with control stamps of Justinian (527–65). *Leningrad, Hermitage*

the Emperor Justinian there is clear evidence of a classical *renovatio* typified by the exquisite pastoral scene showing a goatherd seated among his flock [78] or by the silver fragment of a dish with a representation of Silenus. Both are astonishingly classical in approach: the sense of space, the treatment of the human form, the soft, intricate drapery folds, the grasp of animal form, the evocation of languor in the pose of Silenus, of calm repose in the seated goatherd. Side by side with this deliberate revivifying of the old hellenistic forms and patterns, there was also a more cursive, more simplified, less virtuoso style. This may be seen in a dish chased with the scene of Aphrodite visiting Anchises in his tent, also with control stamps of Justinian, but it ranges from Anastasian to Heracleian silver well into the seventh century. The religious silver also subdivides. There is a large sequence of plain, severely formal chalices, dishes, bowls, candlesticks, spoons which have the minimum of decoration, sometimes a Greek

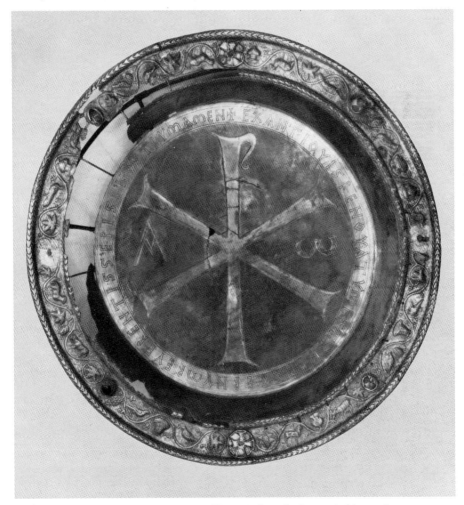

79. Dish of Paternus, Bishop of Tomi (517-20). Silver and silver-gilt. Constantinople, *c.* 518 but with later additions probably made at Tomi. *Leningrad, Hermitage*

inscription, sometimes a small, nielloed cross in the centre of the dish or a monogram within a vine-scroll. There is a splendid series of large silver-gilt dishes, with imperial control stamps, decorated with large Chi-Rho monograms, Alpha and Omega, Greek inscriptions, and a richly decorated border of vine-scrolls inhabited by birds and beasts, like the dish of Paternus, Bishop of Tomi (517–20) [79], or those found recently in the great hoard near Antalya. Silver *flabella* may be incised with stylized peacock's feathers and a seraph in the centre. Vases, like that found at Homs in Syria, may be almost entirely plain with the exception of a central band containing devices of foliated scrolls and medallions with busts of Christ, the Virgin, Archangels, and Saints [80], in a style

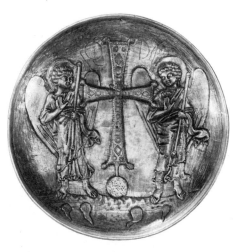

80. Vase decorated with busts of Christ, the Virgin, Archangels, and Saints. Silver.
Found at Homs in Syria. Sixth century.
Paris, Musée du Louvre

81. Angels on either side of a cross.
Silver dish. Constantinople, sixth century.
Leningrad, Hermitage

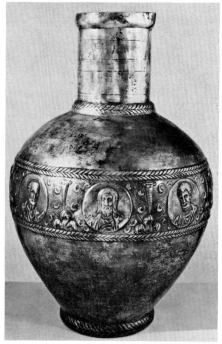

not far removed from the simplified hellenistic sequence of secular silver. But more ambitious scenes also appear on dishes and vases: pairs of angels holding between them a large cross [81], the Communion of the Apostles, as in the Stuma and Riha patens, both with the control stamps of Justin II (565–78) and yet differing from each other in style [82]. Throughout these religious sequences, however, the same principles already observed in the icons are evident: a tendency towards stylization, an avoidance of a sense of weight or volume, a statement of intellectual perception rather than visual record. There is also a considerable range in quality; sometimes the silver may be bad in design and inferior in craftsmanship. The silver-gilt cross generally believed to have been presented by Justin II to Rome [83] carries two imperial portraits, two busts of Christ, and an Agnus Dei separated by foliate devices. These hunched little puppets, the stylized faces and draperies, and the schematic effect presumably received the approval of the Augusti Justin and Sophia, who must have been aware of the hellenistic styles current at Constantinople at the same time. In the

82. The Stuma Paten, decorated with the Communion of the Apostles. Silver and silver-gilt.
Constantinople, between 565 and 578. *Istanbul, Archaeological Museum*

attempt to evoke the religious image without danger of iconoclast protest a new convention was being established, and as in all beginnings there was some fumbling on the way. Perhaps the most splendid of the early Byzantine works in silver are those chased with scenes from the

83. The Cross of Justin II. Silver-gilt. Constantinople, between 565 and 578, with later additions and restorations made in Rome. *Vatican, Treasury of St Peter's*

84. The Anointing of David. Silver dish. Found in Cyprus. Constantinople, between 610 and 629.
New York, Metropolitan Museum

life of David and bearing the control stamps of the Emperor Heraclius between the years 610 and 629. The style of these dishes is wholly in tune with the various sequences of secular plate. In spite of the religious subject matter and in spite of the new religious convention of artistic representation, these Biblical scenes are interpreted in the grammar of the late classical style. In the use of arcades like a stage property, in the division of the surface of the dish into zones, in the treatment of face and form [84], there seems to be a return to Theodosian classicism. With the organization of some of the scenes within the entire circumference of the dish, with the deep chasing of crumpled drapery, with the vivacity of human and animal forms, even earlier traditions are evoked, the art of Augustus, Hadrian, and the Antonines. Thus, some seven hundred years after the birth of Christ, some four hundred years after the Peace of the Church, the Christian image and the secular theme achieve both synthesis and identity.[11]

THE AGE OF JUSTINIAN

In January 532 at Constantinople a fight between circus factions suddenly flared up into a full-scale riot against the imperial administration. Police and guards were lynched, Procopius reports that 'the city was put to the flames just as if it had fallen into the hands of the enemy', and the Sacred Palace was threatened. 'Wishing to win over the people' Justinian dismissed Eudaemon, the prefect of the city whose firm but severe action in the initial stages had been wholly admirable, John of Cappadocia, the praetorian prefect of the East, and the quaestor Tribonian. The last two ministers were strongly disliked by the aristocracy but there is no reason to think that they were particularly unpopular with the lower classes, and it may be that the agitation against them was encouraged by the patricians. The nephews of the old Emperor Anastasius, Hypatius and Pompeius, may also have come under suspicion, since they were ordered to leave the palace, and, indeed, on the next day Hypatius was acclaimed Emperor by the people. By the sixth day it began to look as though the rioters' watchword *Nika* (conquer) had been well chosen. Justinian, in a state of panic, took counsel. All his ministers advised flight from the Sacred Palace and the city until she whom the civil servant John Lydus judged as 'surpassing in intelligence all men who ever lived', the Empress Theodora, intervened. Procopius gives the gist of her words on that crucial day. 'As to whether it is wrong for a woman to put herself forward among men or show daring when others are faltering, I do not think that the present crisis allows us to consider one view or the other. For when a cause is in the utmost peril there seems to be only one course – to make the very best of the immediate situation. I hold that now if ever flight is inexpedient even if it brings safety. When a man has once been born into light it is inevitable that he should meet death. But for an Emperor to become a fugitive is a thing not to be endured. May I never put off this purple or outlive the day when men cease to call me Augusta. If you wish to flee to safety, my Lord Emperor, it can easily be done. We have money in abundance; over there is the sea; here are the ships. However . . . as for me, I hold with the old saying that purple makes a fine shroud.'

At once her audience gained heart. The household troops could not be trusted but Belisarius, supreme commander of the East, and Mundus, *magister militum per Illyricum*, with their own bodyguard made their way to the Hippodrome and surprised the mob which had gathered there. Thirty thousand are said to have perished in the massacre. Hypatius and Pompeius were arrested and on the next day executed and their bodies, like those of the victims of so many later Emperors and Sultans, were thrown into the sea. The patricians who had supported them were exiled and their property confiscated. Justinian was seldom for long vindictive and later, according to Procopius, he restored to them all, including the children of Hypatius and Pompeius, 'both the distinctions they had previously enjoyed and all of their wealth that he did not happen to have presented to any of his friends'. The ministers dismissed – Eudaemon, John of Cappadocia, and Tribonian – were soon restored to office. That was the end of the Nika revolt. But the city of Constantine, embellished by Theodosius, was a smoking ruin. More than half of the metropolis, including the Constantinian foundations of Holy Wisdom, Holy Peace, and the Twelve Apostles, had been laid waste.[1]

Justinian at once began to rebuild. The little church of St Sergius and St Bacchus had been begun before his accession in 527 and was the centre of a complex which included the church

of St Peter and St Paul, begun before 519, and the Hormisdas Palace, Justinian's residence as heir to the throne. St Sergius and St Bacchus, however, adumbrated many of the principles which were to govern the great undertakings of the reign. Built on a central plan, the space expanding into niches and floating into galleries, the church was iconoclastic in its severity. As far as we know there were no images in mosaic; only expanses of gold tesserae bordered probably with floral and vegetable ornament. The shapes of the capitals, the relation of architectural detail, the ornamental motifs are either an innovation or a change of presentation. The traditional Ionic, Corinthian, or composite capital has become a basket-shaped form over which spreads a wiry network of stylized leaves deeply undercut. Later, in other buildings, these capitals were to change into swirls of wind-blown acanthus, lush, rippling, fantastic. The ornament, nearly always a distillation of the acanthus form, may spread farther over impost block and entablature, running counter to the vertical thrust of column or pier. A superb inscription referring to Justinian and Theodora marches round the building on the frieze beneath the gallery, and their monograms occur on the capitals. Subtle planning, elegant ornament, harmonious use of marble, semi-precious stones, and colour, visual and tactile contrast between marble and mosaic, between light and dark, mass and void – these were the principles which guided the structures of Justinian.

His crowning monument in architecture is the great church of Hagia Sophia, built between 532 and 537. Whoever planned St Sergius and St Bacchus was clearly a genius and a new spirit, although the awkward proportions and the clumsy use of the site suggest that a second-rate master mason was in charge of the construction – perhaps the dream of a brilliant engineer marred by an insensitive architect. Not so Hagia Sophia. Built apparently by an engineer rather than an architect – Anthemius of Tralles was 'the man most learned in what is called the mechanical science not only of the men of his time but of all men for many generations back'

(Procopius); he 'applied geometry to solid matter' (Agathias) – the church was technically daring, perfect in harmony, 'marvellous and terrifying', and one of the largest in Christendom. It was a court church. The vast central space enveloped by the huge dome and half-domes was reserved for the clergy of the Patriarch and for the Emperor and his retinue. The Empress and her cortège sat in the gallery at the west end facing the distant altar. The public – and one wonders how many of the common people were admitted in the sixth century – were confined to some of the aisles and galleries. Once again there is no evidence to suggest that there were religious images in the mosaic which covered the upper parts of the walls, vaults, and domes of the church. Vast areas of gold tesserae were confined by borders of foliate sprays, fruit, and geometric ornament. The first dome was coated in plain gold mosaic. After it collapsed in 558 and a new dome was constructed on different principles by the younger Isidore of Miletus, the mosaic bore the outlines of a huge cross. Below this mosaic canopy the walls were sheathed with carefully chosen, carefully matched sheets of marble, porphyry, and other stones. In his panegyric on the church Paul the Silentiary places particular emphasis on this choice: 'the fresh green from Carystus, polychrome marble from the Phrygian range, in which a rosy blush mingles with white, or it shines bright with flowers of deep red and silver. There is a wealth of porphyry, too, powdered with bright stars, that once had laden the river boat on the broad Nile. . . . There is the precious onyx, as if gold were shining through it; and the marble that the land of Atrax yields, not from some upland glen, but from the level plains; in parts fresh green as the sea or emerald stone, or again like blue cornflowers in grass, with here and there a drift of fallen snow – a sweet mingled contrast on the dark shining surface.' The groups of columns in the nave and galleries are linked by a horizontal mesh of twisting, curving, stylized acanthus leaves flowing, as it were, from the capitals which are of the new basket form on which the monograms of

Justinian and Theodora abound. The total effect was rich in light and colour enhanced by the silver-plated synthronon rising in three tiers in the apse over the golden altar inlaid with precious stones and raised on columns of gold, by the silver-plated screen before the chancel, by the golden lamps hanging between columns over the altar, in the aisles and galleries, the golden votive crowns hanging over the altar, by the great pulpit faced with ivory inlaid with silver, by curtains of silk and gold. There were presumably isolated images in Hagia Sophia. Paul the Silentiary describes a hanging placed by Justinian in the church which appears to have been embroidered with the images of Christ between St Peter and St Paul and bordered by representations of imperial philanthropy. The Silentiary also states that the altar screen bore reliefs of Christ, the Virgin, angels, prophets, and saints. 'Nor had the craftsmen forgotten the forms of those others whose childhood was with the fishing basket and the net.' In short, Hagia Sophia was the largest and most expensive religious theatre imaginable, built and furnished for the semi-private performances of the sacred and imperial liturgy. The audience was God.[2]

Procopius in his *Buildings* gives an astonishing list of the churches, hospitals, and palaces thrown up by Justinian after the Nika riots. Of the larger churches Hagia Irene was begun on the site of the former basilica. Rebuilding or repairs were necessary after another fire in 564, and more repairs after an earthquake about 740. Today, the handsome domed basilica is little more than an impressive shell with vestiges of an Iconoclast cross in mosaic in the apse but otherwise stripped of its adornment. The church of the Holy Apostles was rebuilt on the site of Constantine's Apostoleion about 536 and dedicated in 550. By the tenth century the church was in need of repair, and some reconstruction was done shortly after 960. Further repair was needed in 1300 after the Latin Interregnum, but the church was in a ruinous state by the fifteenth century. When Buondelmonti visited Constantinople in 1420 the church of

the Holy Apostles was 'ecclesia iam derupta'. Finally the whole building was cleared away in 1469 to make room for the mosque erected in honour of Mehmet II the Conqueror (al Fatih). The church of the Holy Apostles was of great importance. Not only was its plan followed at Ephesus when Justinian built the church of St John the Evangelist, completed about 565, but it served as a model for the three consecutive basilicas of S. Marco at Venice, which in turn influenced the building of the cathedral of Saint-Front at Périgueux in the twelfth century. Apart from housing the relics of the Apostles Andrew, Luke, and Timothy, the church was the pantheon of the Byzantine emperors until the early eleventh century. The last Emperor to be buried there was Constantine VIII (d. 1028). Nikolaos Mesarites wrote a description of the church some time between 1198 and 1203, but like most Byzantine panegyrics the text is more evocative than enlightening from an art-historical point of view.[3]

Procopius makes it abundantly plain that Justinian's mania for building was not confined to his capital, nor was this mania necessarily generated by aesthetic reasons. A large part of the *Buildings* (Books II-VI) is concerned with towns rebuilt, frontier fortifications, aqueducts, roads, bridges, but churches were always a major concern: Ephesus, Jerusalem, Bethlehem, Sabratha in Tripoli, Carthage, churches in Bithynia and Galatia, churches in the Balkans. Building in the provinces under Justinian rarely shows the full impact of the contemporary architecture in the capital. Local traditions were maintained by local craftsmen, but sometimes there was a wholesale export of masons and materials from the metropolis. Sometimes only the marble furnishings, panellings, capitals, screens, were exported from the imperial quarries in the Proconnesus. Thus, off the coast of Sicily a sunken ship has been discovered, loaded with columns of Proconnesian marble, ambo, chancel screens, all – to use a modern term – prefabricated for some church in the West. On Mount Sinai Justinian built a church which he dedicated to the Mother of God and

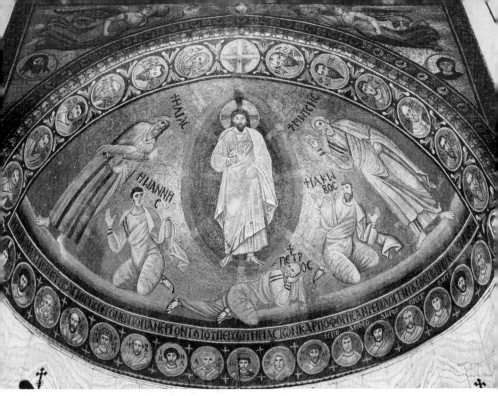

85. The Transfiguration. Mosaic in the apse. Between 548 and 565.
Mount Sinai, monastery of St Catherine, church

'a very strong fort and stationed there an important garrison so that the wild Saracens might not be able to take advantage of the district being uninhabited and use the place as a base for invading with all possible secrecy the districts towards Palestine'. Today, within the monastery of St Catherine on Mount Sinai, Justinian's church is one of the best preserved of all his undertakings. Inscriptions referring to the Emperor and 'his late Empress' and to the architect Stephen of Aila establish a date between 548 and 565. As in the churches at Constantinople the walls were sheathed with carefully matched marble panels, but unlike Hagia Sophia the apse was decorated with a magnificent representation of the Transfiguration in mosaic [85]. Christ is represented between Elias and Moses, an epiphany shimmering in white and gold framed by a mandorla in shades of blue from which emerge broad rays of light. Below this awe-inspiring apparition the Apostles John and James kneel and make gestures of astonishment and acclamation; St Peter sprawls beneath the feet of Christ. The whole scene is framed by bands containing medallions; these in turn frame busts of the twelve Apostles, sixteen Prophets, King David, and two incumbents, Longinus the Hegoumenos and John the Deacon. In the spandrels two angels fly towards a medallion containing the Agnus Dei and below two more medallions frame busts of the Virgin and St John the Baptist. Above, on either side of two small windows, Moses takes off his sandals before the burning bush and receives the Tables of the Law. Although the capitals and the columns in the church are of poor local workmanship, there seems every reason to suppose that the team of

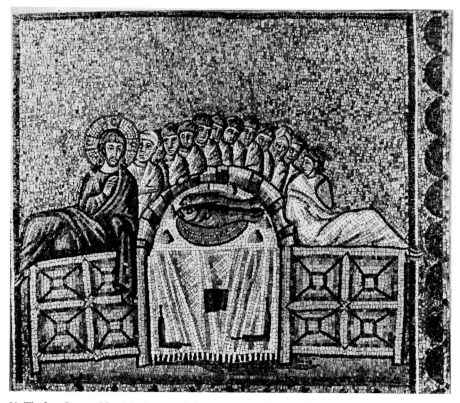

86. The Last Supper. Mosaic in the nave. Early sixth century. *Ravenna, S. Apollinare Nuovo*

mosaicists and the materials were sent from the metropolis and that at Mount Sinai is preserved the only example of pure Byzantine style in mosaic dating from the middle of the sixth century. Certainly the treatment of form and drapery and the modelling of the faces appear to differ from the style at Ravenna (S. Vitale) or at Salonika (Hosios David), both cities with local traditions of craftsmanship. Indeed, it is not without interest to note that the tendency to outline the form, the elliptical rendering of the thigh, the assembling of the form by a sort of juxtaposition of the component parts, is reflected in the genre scenes in the mosaic floor of the Great Palace at Constantinople [142] which dates probably from the second half of the sixth century.[4]

Although there is no evidence of direct imperial patronage in the building and decoration of the churches, Ravenna is the next important mirror of the age of Justinian. In 493 the Goths had entered the city but their king Theodoric, who had been a hostage for ten years at Constantinople during the formative period of his life, built and decorated under the full influence of the metropolis. As a matter of course he used local workmen. In all the monuments at Ravenna there is inevitably an intricate synthesis of the old imperial traditions of the Theodosian court, the legacies of Rome and Milan, and the new stream of inspiration from Constantinople. Theodoric, whose minister was Cassiodorus, was the classic example of the enlightened barbarian. Although Arian in

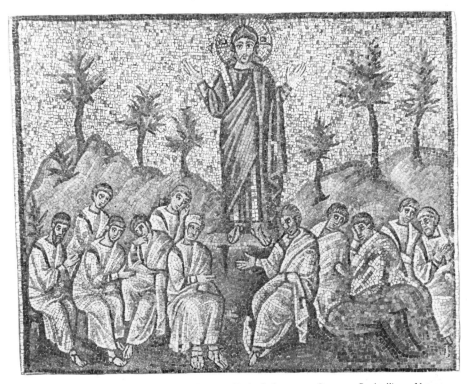

87. The Garden of Gethsemane. Mosaic in the nave. Early sixth century. *Ravenna, S. Apollinare Nuovo*

belief, he was impartial in religious matters. He acknowledged Byzantine suzerainty and his reign, after the initial wars against the Goths, was a time of happiness and prosperity throughout Italy. Agriculture was improved, marshes were drained, harbours formed, and taxes were lightened. Theodoric understood something of the Byzantine mystique but he was equally sensitive to patrician thought in Italy. Thus, the church of S. Apollinare Nuovo, which was originally dedicated to the Saviour, a court church attached to the palace, was built on a Western basilican plan in a brick technique originating at Milan, sheathed in marble by workers summoned according to Cassiodorus from Rome, and the capitals were presumably imported from Constantinople. Beautiful though the church is in structure alone, its chief glory is the mosaic decoration in the nave, where the walls are covered in three tiers. The highest tier, above the windows, consists of a series of twenty-six panels – thirteen on each side of the nave – depicting scenes from the life of Christ, the oldest surviving in mosaic. Each panel is flanked by similar motifs which by their similarity strike a rhythmic beat: the motif is a kind of niche surmounted by a small silver cross flanked by doves. The scenes follow in chronological order starting from the apse and moving towards the façade. Some scholars have suggested that these scenes correspond with Syro-Jacobite or North Italian liturgical texts but, in fact, the order does not fit the texts; it seems reasonable to suppose that the intention

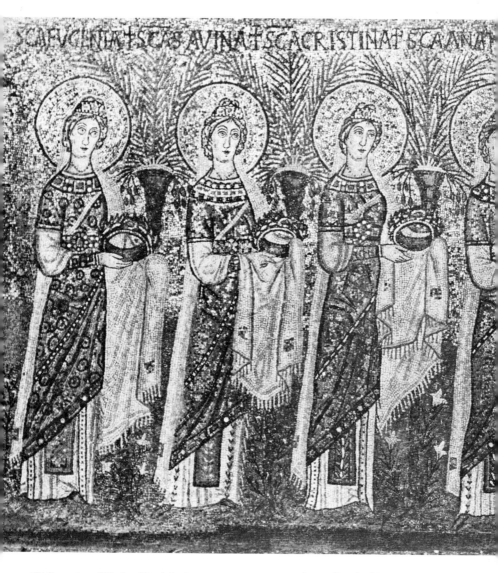

88. Procession of Virgins. Mosaic in the nave.
Between 556 and 569.
Ravenna, S. Apollinare Nuovo

was merely to relate the life of Christ. There are differences of style in the panels. The mosaics appear to be the work of two teams; some have claimed that one master was responsible for the Miracles and another for the Passion. The style of both teams depends on Roman models and traditions – it is not without interest that a comparison has been made with the representation

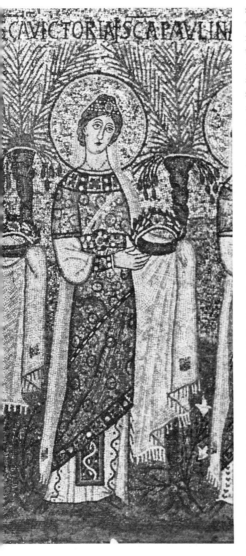

CAVICTORIAISCAPAVLIN

of the Miracles carved in ivory on the Andrews diptych [38], Roman work of about 460 – with an economy in relating an historical event reminiscent of mosaics in S. Maria Maggiore, S. Paolo fuori le Mura, and SS. Giovanni e Paolo. A scene may be the merest notation of an event, as in the Last Supper [86], or it may expand into a landscape as in the Garden of Geth-semane [87]. Christ is usually beardless, some-times short-sometimes long-haired, and dressed in the imperial purple. The representation of the Apostles in a number of these extracts of narrative recalls those in the apse of S. Aquilino at Milan [15]. Between the upper windows, the second tier presents isolated figures of Apostles and Prophets. The third tier, the largest and most striking of all [88], shows on one side the procession of Virgins moving along the wall from Classis, the port of Ravenna, to the Virgin and Child enthroned, adored by the three Magi, and on the other side Martyrs moving in pro-cession from the Palace of Theodoric towards Christ enthroned. The Virgins are dressed in the costume of an Augusta, and some scholars have detected Constantinopolitan influence in the representations of Christ and the Virgin, which date from the time of Theodoric. The Virgins and Martyrs and the three Magi do not date from his time. After the Byzantine recon-quest in 540 the church was eventually con-verted from Arianism to orthodoxy. This *recon-ciliatio* occurred during the episcopate of Agnellus (556-69) following an edict of Jus-tinian. The church was rededicated to St Martin of Tours, the hammer of the heretics, and the Virgins and Martyrs led by St Martin and the three Magi replaced the previous figures, which, considering that they are walk-ing away from the palace and the port of Ravenna, probably represented Theodoric and his court and possibly other Arian worthies. In spite of drastic restoration the lofty beauty of these mosaics, gleaming in shades of white and grey, green, blue, red, and gold, haunt the mind long after the visitor has left the church. Also dating from the time of Agnellus, probably about 561, a portrait of Justinian represents him older and stouter than the portrait in S. Vitale and, indeed, at that time the Emperor would have been in his late seventies. During the second quarter of the eighth century, as the result of an earthquake, the roof of the apse collapsed. In the ninth century a crypt was added, and, probably because of the translation of relics, the church was finally dedicated to Sant'Apollinare.[5]

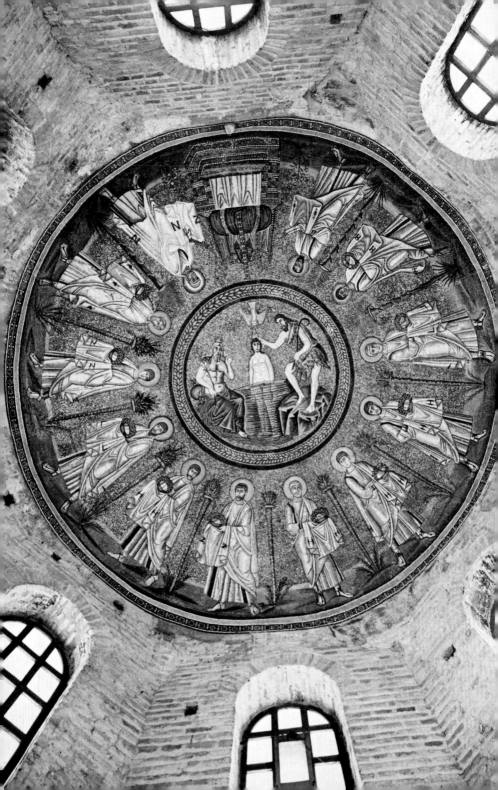

The Arian Baptistery, built during the reign of Theodoric – the present church of S. Spirito was the Arian Cathedral – was decorated with mosaics in the dome which depend upon but differ from those in the Orthodox Baptistery. It has been argued that the decoration of the dome was done in two periods of time (the distance between the two periods is difficult to determine) by five mosaicists. As in the Orthodox Baptistery [24] the centre of the dome is dominated by the Baptism of Christ [89] around which the Apostles, holding crowns or garlands, move in stately procession. Unlike the Orthodox Baptistery, however, the Apostles move towards an altar-throne, draped and cushioned, on which rests a jewelled cross. This scene, the Etimasia, 'the throne set in heaven' of the fourth chapter of the Apocalypse, first appears upon the triumphal arch of S. Maria Maggiore in Rome, but no doubt there were earlier representations in the East in Constantinian times. The style of the mosaics in the Arian Baptistery is more simplified, both in form and drapery, than that in the Orthodox Baptistery; subtleties of light and shade, of modelling and movement, in composition and sense of space are all missing in this nonetheless impressive vision.[6]

Probably one of the most beautiful of all church interiors, even though posterity has meddled and marred, is that of S. Vitale at Ravenna. There is no evidence, in spite of the imperial portraits in the apse, of imperial patronage for the construction, although the plan comes very close to Justinian's court churches. The church was begun after the return of Bishop Ecclesius (521–32) from an embassy to Constantinople about 525 and was financed by a local banker, Julianus Argentarius. When Ecclesius died the construction was continued under Bishop Victor (538–45), whose monogram appears with that of Ecclesius on the capitals of the ground floor. The church was not completed and consecrated until 547, at the beginning of Maximian's episcopate (546–56) whose portrait appears in the imperial suite in the apse and whose ivory chair which bears his monogram stands today in the Archiepiscopal Palace. Centrally planned, octagonal, with an apse, a narthex, and galleries, S. Vitale is unquestionably Byzantine in conception and has often been considered a sister building of St Sergius and St Bacchus at Constantinople. The plan is close enough, but the construction is more subtle than that of the metropolitan church, with its breathtaking swoops into space, its elegant loftiness, its caressing light. There is no doubt that the column shafts and capitals were imported from the Proconnesian workshops. On the other hand, the workmen appear to have been local, much of the material used is local even though the bricks imitate those of Constantinople, and it is possible that the architect

89. The Baptism of Christ; below, the Apostles. Mosaic in the dome. Early sixth century. *Ravenna, Arian Baptistery*

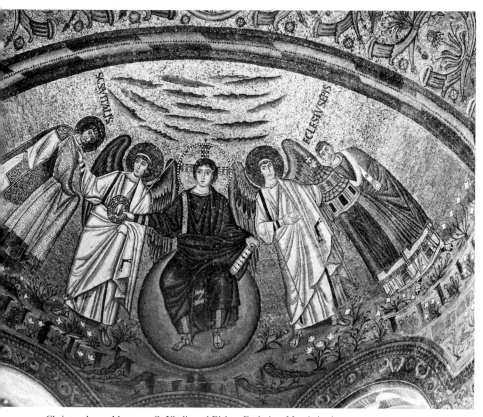

90. Christ enthroned between St Vitalis and Bishop Ecclesius. Mosaic in the apse.
Second quarter of the sixth century. *Ravenna, S. Vitale*

was a Latin who had served his apprenticeship in the metropolis. Once again the crowning glory is the mosaic and marble decoration in the chancel. Since Bishop Ecclesius is depicted at the left hand of Christ in the apse [90] it is arguable that this part of the mosaic decoration dates from his lifetime, but many scholars consider the entire decoration to have been done under Maximian. Christ, beardless, short-haired, cross-nimbed, clothed in imperial purple, is seated on a globe between archangels who present St Vitalis and Bishop Ecclesius. St Vitalis stands on the right of Christ in court dress with hands veiled by the chlamys ready to receive the crown offered by Christ; on the left

of Christ Bishop Ecclesius offers his church. Beneath the globe is a flowery terrace on which the archangels, the saints, and the bishop stand, and from which the Four Rivers of Paradise emerge. Above, in the spandrels, are the cities of Jerusalem and Bethlehem. The theme of the other scenes in the chancel is, on the whole, eucharistic. On the left tympanum Abraham receives the three Angels under the oak at Mamre and prepares to sacrifice Isaac [91]; in the spandrels there is a representation of Jeremiah and Moses receiving the Tables of the Law with the Israelites below; at the top of the tympanum two angels bear a medallion containing a jewelled cross. On the right tympanum

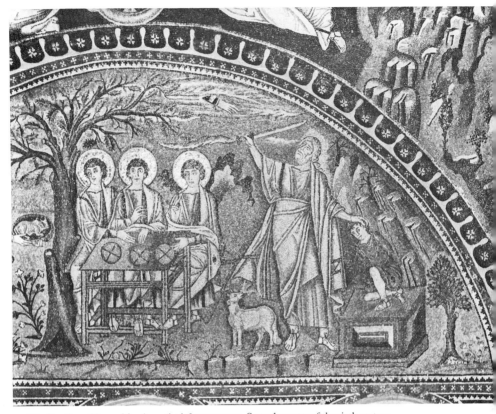

91. The Sacrifice of Isaac. Mosaic on the left tympanum. Second quarter of the sixth century.
Ravenna, S. Vitale

Abel and Melchisedek make sacrifices; in the spandrels Moses unlooses his sandal before the burning bush and tends the flocks of Jethro and there is a representation of Isaiah; the angels bearing the cross and medallion are repeated. In the vault of the chancel four angels on globes support a central garland framing the Agnus Dei. On the soffit of the arch at the centrance to the chancel a chain of medallions with busts of Apostles and Saints, including St Gervase and St Protase, sons of St Vitalis – Milanese influence here – mount to the crowning bust of Christ, bearded, long-haired. On the walls between the gallery openings and the entrance and at the apsidal ends of the chancel the four Evan-

gelists are revealed seated in a rocky landscape with their symbols above them. In between these major scenes there is an astonishing wealth of incidental ornament: vases filled with fruit pecked by birds, peacocks, crossed cornucopias, flowers, acanthus-scrolls inhabited by a positive zoo of birds and beasts – the whole a blaze of gold and rich colour which waxes and wanes with the light of day, and night – with all the silver and gold lamps which must have hung within the chancel area – overwhelming in flickering radiance. And then the imperial portraits . . .

Within the apse, to the left and right of the large windows, above the marble and porphyry

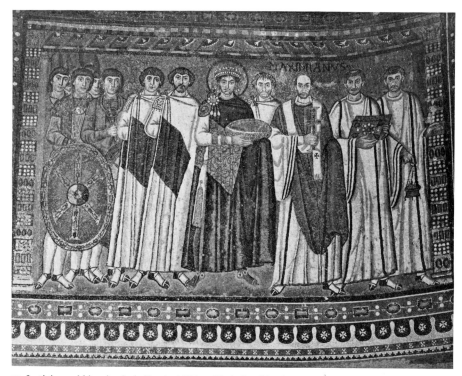

92. Justinian and his suite, including Archbishop Maximian. Mosaic panel in the chancel. Probably *c.* 547. *Ravenna, S. Vitale*

sheathing of the walls which serves as a background to the bishop's throne, the imperial epiphanies are revealed to the people. On the Gospel side the Emperor Justinian [92], haloed, stands in full regalia holding a great gold dish. On his right and slightly behind him on his left stand two ministers of state and a secretary; on his left again Archbishop Maximian and two members of his clergy, one of them holding a great book bound in gold and precious stones; on his far right, a group of the imperial guard. They stand poised on a green ground, caught for a moment and, we hope, for numbers of years, in the slightly swaying movement of a slow procession which has suddenly turned as one man to confront the spectator. In this act of slightly swaying, suddenly turning, all members of the imperial cortège bend their proud, stern, yet kindly gaze on the subject faithful. There is

no attempt, as there is in the Theodosian Missorium, to differentiate the Emperor by height or isolation. Justinian appears to be slightly shorter than Maximian, and his retinue crowd in closely round the central figure, whose chlamys, purple with a great gold, green, and red tablion and pinned with an outsize gold and jewelled fibula, is nevertheless allowed more room in width and scope of gesture – the veiled left hand supporting the bowl moves in front of Maximian's elbow. But the contrast between this richly jewelled, purple-draped figure and the rest of the suite, whose dress is predominantly white, is dramatic enough. All the figures are slightly elongated and their length is accentuated by the straight-falling, severe lines of their robes, which mask the form and and emphasize the sharp characterization of the heads above them. At the same time the natural and

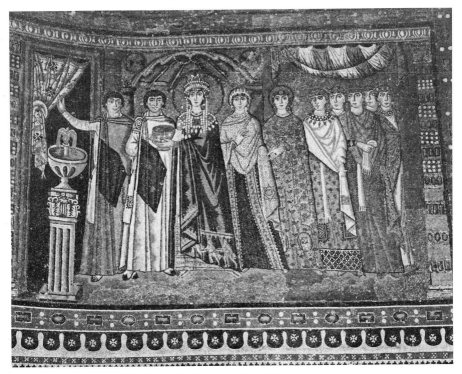

93. Theodora and her suite. Mosaic panel in the chancel. Probably *c.* 547.
Ravenna, S. Vitale

the supernatural image is evoked. Justinian, the Vicar of God, is the imperial ideal incarnate. In the setting of the scene there is no attempt to suggest place. The imperial epiphany is revealed before a golden background on a green floor. The finite forms, the attributes of power, the portraits from life, suggest a moment of time, but this vision emerges from and radiates light, colour, and harmony in infinity.

On the Epistle side the Empress Theodora [93], a towering figure bedizened in jewels, diadem, catatheistae, necklace, her purple chlamys embroidered in gold with the figures of the three Magi – note the accent on epiphany – holding a great gold chalice, preceded by two chamberlains and followed by seven ladies in waiting, also pauses in procession. As in the opposite panel, the whole cortège seems to have turned in a moment of procession to bend their

gaze on the faithful. But there is less concert of intensity. Some of the ladies have their eyes on the Augusta, others gaze in different directions; one of the chamberlains is reaching out to a knotted curtain in the doorway but looks towards the Empress. Only Theodora, the chief chamberlain, and the principal ladies in waiting are engaging the onlooker with their proud, impassive stare. Except for her exaggerated height in the panel, Procopius's description of the Augusta reverberates through time: 'she was fair of face and charming as well, but short and inclined to pallor, not indeed completely without colour but slightly sallow. The expression of her eyes was always grim and tense'. In this panel time and place tend to obtrude as incidentals. When and where is this scene supposed to have occurred? The Empress is standing in a niche surmounted by a conch, the ladies wait

under a swathed canopy, a small fountain plays on the left in front of the doorway – the setting appears to be wholly secular, as though the Augusta were about to leave the palace for a dedication ceremony. Some have argued that the background is not to be taken for an 'architectural reality' but merely an imperial attribute and symbol. Some have assumed the background to be ecclesiastic and that the two panels should be interpreted as the Grand Entry of the Emperor during the Mass – the portraits would then fit in to the general eucharistic scheme of decoration in the chancel. Others have flatly denied this theory, maintaining that the Grand Entry of the Emperor was not introduced until the time of Justin II and that at no time did the Empress take part in the procession of oblates – no woman was permitted to cross the choir barrier. This again has been countered by the assertion that the Grand Entry was in practice before Justin II, and that the panels portray the procession before entering the sanctuary so that the presence of the Empress was possible. On the other hand, at Constantinople when the Empress went in state to Hagia Sophia she usually moved from the palace to the gallery at the west end and did not descend into the nave of the church. Most of these discussions are really disagreements over the interpretation of Constantine VII's *Book of Ceremonies*, compiled in the tenth century, and need not detain us here. The panels more likely record imperial interest in the recent Byzantine reconquest of Italy, their support of the viceroy Maximian, an imperial nominee, the presentation of gifts to the church of S. Vitale, and the stressing of the two spheres of authority, the *imperium* and the *sacerdotium*. It is certain that Justinian and Theodora never went to Ravenna; the portraits must have been sent from Constantinople to be copied in mosaic as a *lauraton* to confirm the imperial presence and, since Theodora died in 548, they were presumably executed in time for the dedication of the church by Maximian in 547.[7]

Of all the gifts sent by Justinian to his viceroy Maximian only one remains: an ivory chair carved on the front with the monogram of the bishop. Moreover, Maximian's chair is the only one to have survived almost in its entirety from the Early Christian period. The carved ivory panels which cover the wooden core present a series of styles within a strong hellenistic tradition, and a series of scenes from the life of Christ and from the life of Joseph; St John the Baptist between the four Evangelists dominates the front of the chair; in addition, there is a rich vocabulary of incidental ornament [94]. Unfortunately the chair is no longer in its original state. The panels depicting the life of Joseph appear to be intact – perhaps the parallel to be drawn from these scenes is that Maximian was expected to be to Justinian what Joseph was to Pharaoh – but of the original thirty-nine panels carved with the life of Christ, only twenty-seven have survived, though in a few cases these may be supplemented by eighteenth-century drawings. The disposition of the surviving panels has been the subject of controversy. In addition, parts of the ornamental borders and intervening strips of ornament have disappeared. The chair was ineptly restored in 1884, at which time most of the original wooden framework was destroyed and the surface of the ivory was allowed to deteriorate, probably through injudicious cleaning. In 1919 the chair was again reconstructed, a number of panels which had found their way into other collections were returned, and a final restoration was completed in 1956. The assembly marks on the backs of the panels are Greek letters contemporary with the carving. While most scholars have been in agreement over the date, shortly before 547, there has been considerable controversy over the place of origin: Antioch, Alexandria, Ravenna, or Constantinople. There is no doubt, however, that the chair must be considered with the Barberini leaf, various parts of imperial diptychs, the

94. Maximian's Chair. Ivory.
Constantinople, *c.* 547.
Ravenna, Archiepiscopal Museum

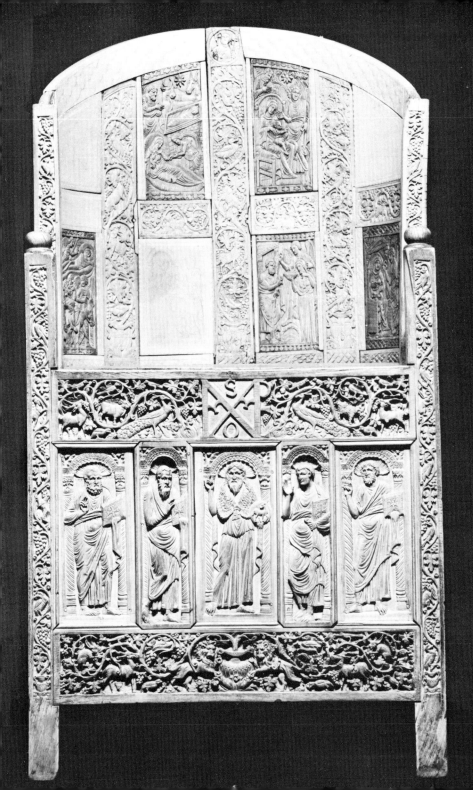

sacred diptych now in Berlin, and the great silver dish of Bishop Paternus [79], which provides interesting parallels with ornament on the chair – all official works whose provenance in Constantinople now seems certain – with fragments of marble carving in the Archaeological Museum, Istanbul, and it must be placed within the atmosphere of *renovatio* unquestionably generated in the reign of Justinian at the metropolis. There are, of course, differences of style in these various artefacts, just as there are among the consular diptychs and in the silver bearing imperial stamps. It must be remembered that there was no rigid homogeneity of style at Constantinople in the sixth century. Art was still eclectic. There seems no reason to doubt that there was a school of ivory carvers working for the Emperor and the court capable of producing Christian subjects within the hellenistic tradition which makes the silver of Justinian so remarkable. There is no documentary evidence stating that the chair was a gift from the Emperor but it seems likely that it was sent as a symbol of the Emperor's benevolence – it was surely not intended to be sat on but was probably carried in procession decked with drapery and cushions on which rested the Gospels or a jewelled cross – to mark the restoration of Byzantine power in Italy and, more particularly, to confirm the position of Maximian as Bishop of Ravenna. Maximian was a poor deacon from Pola who rose to high position through his political adroitness. He won the favour of both Justinian and Theodora – to impress both of them was no easy task – and he was appointed bishop of Ravenna against the wishes of the people, who were eventually mollified by his discretion, generosity, and public works. Maximian's chair should thus be seen as a symbol of many aspects of Early Byzantine style and history, a monument in the late antique tradition and yet no longer late antique, representing the cult of hellenism so constant in the metropolis, Christian in spirit yet in heritage Greek, a symbol of the combined rule of the *sacerdotium* and the *imperium*. The chair stands today in the Archiepiscopal Palace

near a chapel containing a curious representation of Christ dressed as a warrior treading beasts, now heavily restored, and with a vault of which the mosaic decoration parallels though with a reduced colour range that of the chancel in S. Vitale: angels on a globe reaching up to support a garland framing the Agnus Dei. The chapel was built under Bishop Peter II between 494 and 519/520 and the mosaic decoration dates from the same time, but the chapel vault, the chain of medallions containing busts of Apostles, which were to appear also in S. Vitale, at Poreč (Parenzo) on the Dalmatian coast, in the church of the Panagia Kanakaria on Cyprus, in the church decorated by Justinian on Mount Sinai, all confirm that Constantinople was the hub of style and iconography.[8]

S. Vitale was not the only church in Ravenna to have been built or decorated under the patronage of the banker Julianus Argentarius. He was the donor of the mosaics in the apse and arch of S. Michele in Affricisco about 545, now removed to Berlin, where they may be seen restored after much damage – the church was in a ruinous state in the middle of the nineteenth century. The mosaics present in the apse a youthful Christ with a jewelled cross-nimbus holding a large cross-staff between angels in a remote landscape. On the arch, above the figures of SS. Cosmas and Damian, a long-haired, bearded Christ enthroned between nine angels of which seven blow trumpets, forecast later representations of the Last Judgement. Under the arch, twelve doves move towards the Agnus Dei – part of the common grammar of Early Christian symbolism.

Symbolism is particularly rampant in S. Apollinare in Classe, another church decorated at the expense of Julianus Argentarius and consecrated by Archbishop Maximian in 549. Although the church is preserved in all its simplicity of space and form – one of the most beautiful of Early Christian basilicas – and much of the original marble sheathing, columns, and capitals, all from the Proconnesian quarries, survives, the mosaics in the apse have been particularly insensitively restored. St Apollinaris

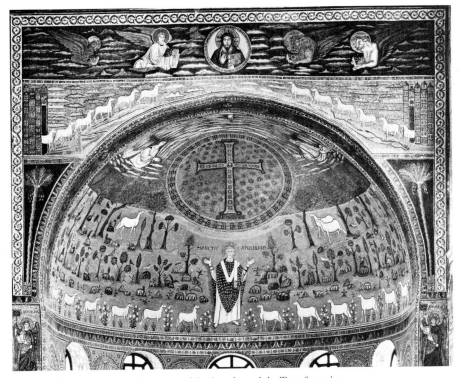

95. St Apollinaris in prayer amid symbols of the Apostles and the Transfiguration. Mosaic in the apse. Shortly before 549. *Ravenna, S. Apollinare in Classe*

stands in prayer in the centre, six lambs on either side, in an idealized landscape; above looms a large jewelled cross in a starry medallion between the busts of Moses and Elias emerging from the heavens – a curious, almost iconoclastic metaphor for the Transfiguration – with three lambs below representing Peter, James, and John [95]. Between the windows of the apse bishops of Ravenna are represented, and, indeed, many bishops are buried in the church. On the arch the mosaics, which may date from the seventh century, possibly even the ninth century, comprise a bust of Christ Pantocrator in a medallion appearing in the heavens with the symbols of the Evangelists; below, twelve lambs emerge from Bethlehem and Jerusalem and proceed towards Christ;

below again, palm-trees. On either side of the apse archangels in court dress hold a banner inscribed 'Hagios, Hagios, Hagios' and below them are half-figures of the Evangelists. The church is an interesting combination of imported materials and local construction, of Western Early Christian iconography with Byzantine injections, of local portraits and Byzantine imagery. In the seventh century Archbishop Reparatus paid tribute to the decorations in S. Vitale by adding on the side walls of the apse a reduced and conflated version of the Old Testament scenes of sacrifice involving Abel, Melchisedek, and Abraham, and a second imperial epiphany: Constantine IV Pogonatus (668–85) conferring privileges on the church, accompanied by his brothers Heraclius and Tiberius

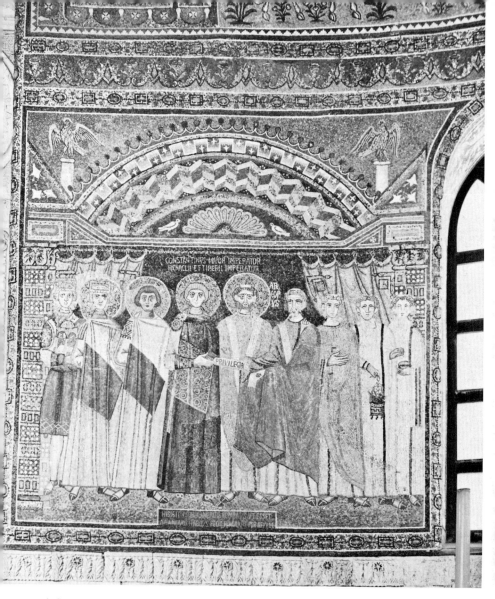

96. Constantine IV Pogonatus conferring privileges on the church of S. Apollinare in Classe, accompanied by his brothers Heraclius and Tiberius and by his son Justinian II, and attended by Archbishop Reparatus, a priest, and three deacons. Mosaic panel in the apse. Between 668 and 685. *Ravenna, S. Apollinare in Classe*

and by his son Justinian II; with him is Reparatus accompanied by a priest and three deacons [96]. But these images have none of the subtlety of modelling, the breadth and depth of vision of the S. Vitale *laurata*; the figures of the seventh-century Augusti and the clergy have been reduced to flat rectangles of colour, almost depersonalized but for the piercing gaze, entirely incorporeal, mere paradigms of form.[9]

Across the sea on the Dalmatian coast at Poreč (Parenzo) the entire complex of a bishop's church has been preserved: basilica, atrium, baptistery, a martyr's chapel, and an audience hall. Once again, the marble sheathing – particularly handsome marble and mother-of-pearl incrustation below the windows – and the capitals and columns came from the imperial quarries, and once again the workmen were local, this time not remarkably expert. According to the inscription the church was rebuilt by Maurus, an Istrian saint, and three others unnamed offer garlands or crowns or a book [97]. Bishop Euphrasius offers his church, followed by the deacon Claudius and his son Euphrasius, who offers a book. Above the Virgin a hand holding a garland emerges from the heavens. Beneath this scene, between the windows, are the isolated figures of the Archangel Michael holding an orb, Zacharias bearing a small box and a censer, and St John the Baptist with a cross. To the left and right are striking repre-

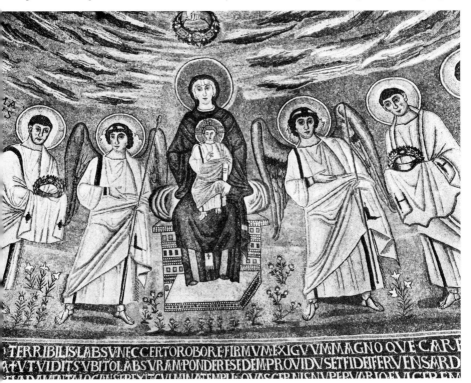

97. The Virgin and Child enthroned between archangels and saints. Mosaic in the apse. *c.* 550. *Poreč, Euphrasian basilica*

Bishop Euphrasius, whose portrait appears in the mosaic in the central apse, probably about 550. The dominant personalities in the apse mosaic, however, are the Virgin and Child enthroned between archangels, to whom St sentations of the Annunciation and the Visitation. In the lower part of the triumphal arch twelve medallions contain busts of female saints mounting towards an Agnus Dei at the top. Above, the young, beardless Christ, seated on a globe, is flanked by the twelve Apostles. In the north apse a young Christ blesses St Cosmas and St Damian, and in the south apse He blesses St Ursus and St Severus. At one time there was

a large representation of the Transfiguration on the eastern façade above the central apse, and on the western façade Christ was depicted with the twelve Apostles and the Apocalyptic candelabra, presumably another early version of the Last Judgement, but these are almost entirely destroyed. On the eastern façade the Transfiguration is almost impossible to read, but on the western façade four figures of the Apostles remain and a little vegetable decoration. It has been suggested that the entire programme stresses the Incarnation of the Son of Man and the Divine Nature of Christ. In the middle of the sixth century the Monophysite heresy attracted a good deal of attention – after all the Empress Theodora's leanings towards the heresy had caused a good deal of scandal among the orthodox – and a number of bishops, not only Eastern but African and Western, including Bishop Euphrasius, had subscribed to the belief. For this the Dalmatian bishop came under papal censure. It is possible that the programme of decoration in the Euphrasian basilica was intended to proclaim his return to orthodoxy. On the other hand, the mosaics in the apse appear to pay particular respect to the Virgin, a respect emphasized by the unusual sequence of female saints in medallions on the triumphal arch. Although the mosaics have been restored in many areas inside the church, the style may be compared well enough with work done in the churches of Ravenna; the accents of style in the Annunciation and Visitation scenes come close to scenes in S. Apollinare Nuovo. The same school seems to have been responsible for both schemes of decoration. Nevertheless, a representation of the Virgin and Child enthroned, flanked by archangels, occurs in the apse of the little church of the Panagia Kanakaria at Lynthrankomi on Cyprus, dating from the middle of the sixth century, and there is the customary chain of medallions bearing the busts of the twelve Apostles [98] bordering the arch of the apse, familiar at Ravenna and on Mount Sinai. Whatever the school, it seems likely that Constantinople must have been the source.[10]

98. St Andrew. Detail from the mosaic border on the arch of the apse. Mid sixth century. *Lynthrankomi, Panagia Kanakaria*

Sculpture at Ravenna in the course of the sixth century is almost entirely symbolic. On the sarcophagi and on chancel reliefs much play is made with vine-scrolls inhabited by birds, palms, Chi-Rho monograms framed by garlands, lambs, plain crosses, birds on either side of an amphora, many of these symbols set before an architectural screen which may consist of arches and gables, conches, columns, and capitals. The style has a certain robustness: fleshy vines growing from a ponderous amphora [99], sturdy guinea-fowl on either side of a monogram of Christ in the church of S. Agata, or peacocks on either side of a Chi-Rho monogram with vine-scrolls as on the sarcophagus re-used by Archbishop Theodore [100] in the seventh century and now in S. Apollinare in Classe. The ambo of Agnellus [101] in the cathedral at Ravenna is carved with a series of panels bearing an assortment of fish, birds, and animals, framed by strips of a dry foliate ornament reminiscent

99. Peacocks on a vine-scroll issuing from an amphora; between them a cross. Marble relief. Mid sixth century. *Ravenna, S. Apollinare in Classe*

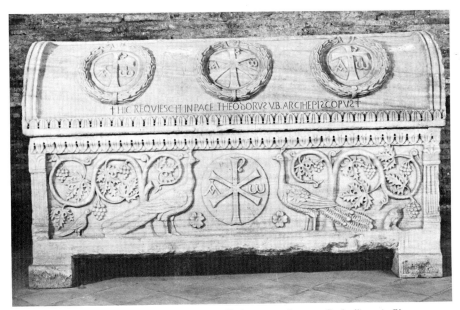

100. Sarcophagus of Archbishop Theodore. Marble. Sixth century. *Ravenna, S. Apollinare in Classe*

101. Ambo of Archbishop Agnellus. Marble. Between 556 and 569. *Ravenna Cathedral*

of that on some of the consular diptychs. Indeed, close parallels to these flattened forms in panels and similar ornament is to be found among the *disiecta membra* of marble decoration in the Archaeological Museum, Istanbul, and the origins no doubt were the workshops in the Proconnesus. On the other hand, the stucco ornament in S. Vitale with its coarse, loose studies of vine- and acanthus-scrolls is presumably local work and recalls the inferior quality of the stucco produced about the middle of the fifth century in the Orthodox Baptistery. After the sixth century there seems to have been a general decline at Ravenna. There was a tendency to re-use old sarcophagi. By the time it was necessary to bury Archbishop Felix (d. 724) local craftsmen could produce little more than a naïve, vapid, and blundering evocation [102] of past forms and types.[11]

of the apse decoration shows the familiar row of twelve lambs converging on the Agnus Dei, but above a tremendous and, for us, a new vision is revealed. Christ, bearded, long-haired, haloed, dressed in white and gold robes and holding a roll in His left hand, the right hand raised in a gesture of authority, stands in the midst of the heavens [103] from which at one time emerged the hand of God holding a wreath. On either side St Peter and St Paul make gestures of acclamation and introduce the titular saints Cosmas and Damian, who are followed by St Theodore Stratelates – essentially a Byzantine saint – and Pope Felix IV on the banks of the Jordan. It is instructive to compare the physiognomy of Christ with that of the transfigured Christ on Mount Sinai [85]: the Roman version is heavier, more blunt, more 'academic', but there is no question that in all the glinting haze

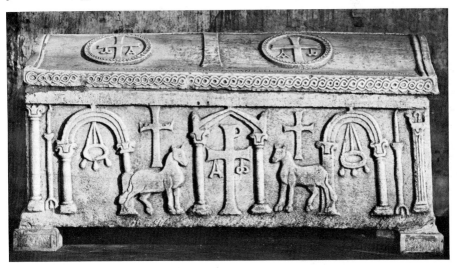

102. Sarcophagus of Archbishop Felix (d. 724). Marble. *Ravenna, S. Apollinare in Classe*

At Rome under the patronage of Pope Felix IV (d. 530) the church of St Cosmas and St Damian was decorated with mosaics in the apse and arch which suggest that the old Roman traditions were beginning to feel the impact of the *renovatio* at Constantinople. The lower part

of blue, green, white, and gold, the figures in the Roman church dominate the apse with a monumental authority set in space which predicates eternity. If the authority derives from the great mosaic in the apse of S. Pudenziana [18], there are nevertheless new ingredients in the treatment

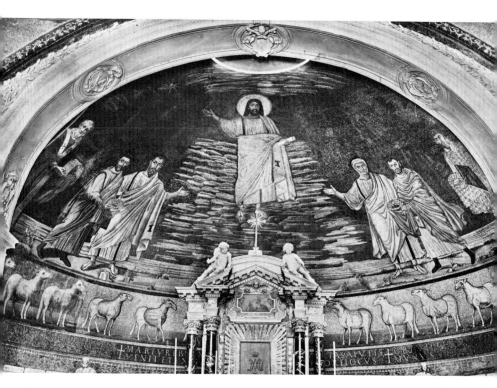

103. Christ acclaimed by St Peter and St Paul,
who introduce St Cosmas and St Damian,
St Theodore Stratelates, and Pope Felix IV
on the banks of the Jordan. Mosaic in the apse.
c. 520–30. *Rome, St Cosmas and St Damian*

of form and drapery. Although the Apostles and
the titular saints are conventionally dressed, St
Theodore wears contemporary Byzantine court
costume. Unfortunately this magnificent mosaic
has more than once been tampered with. Pope
Gregory XIII (1572–85) removed the figure of
Pope Felix and substituted an image of Pope
Gregory the Great, but later the original image
was restored under Alexander VII (1655–67)
by Cardinal Francesco Barberini, who had a
copy of the original in his possession. Pope
Urban VIII (1623–44) also meddled with the
mosaic. During his pontificate the arch was

abbreviated, the present Baroque archivolt was
inserted under the soffit of the arch, and an oval
window was cut into the top of the vault of the
apse. These operations concealed the border
and removed at the summit of the apse the
monogram and the hand of God with the
wreath. On the triumphal arch may be seen
today only a truncated version of the Apocalyp-
tic Adoration of the Lamb. The Lamb is re-
vealed on an altar in front of a cross with a scroll
at the foot of the altar; on either side are the
seven candlesticks, the four angels, but only
two of the symbols of the Evangelists, those of
St Matthew and St John; the twenty-four
Elders offering crowns have been reduced to
the merest vestige. Nevertheless, the mosaics of
St Cosmas and St Damian are some of the most
beautiful and impressive in Rome; they were
copied more than once in the ninth century
under Paschal I and Gregory IV. In the sense

of space, in the treatment of face and form, in the handling of drapery, the impact of new aesthetic forces is evident. Indeed, a comparison of this mosaic with the fresco in the catacomb of Commodilla [104] which shows the Virgin and Child enthroned between St Felix and St Adauctus with the deceased lady Turtura standing at one side, dating from about 528, makes the difference clear enough. Granted that the wall-painting is a comparatively humble votive offering and the artist not of the same standard as those working for Pope Felix, the style is nevertheless drier, more schematic, and remote from any sense of artistic renewal. The forms are elongated, lacking in weight, and depend for their dramatic intensity upon the mesmeric gaze of Divinity, saints, and donor – characteristics to be found in metropolitan icons of the time – but there is a marked atmosphere of provincialism.[12]

By the sixth century the production of illuminated books at Constantinople must have been considerable. Unfortunately those surviving today may be numbered on the fingers of one hand, and three have been subject to controversy. The copy of Dioscurides's *Materia Medica*, executed at Constantinople in 512 for the Princess Juliana Anicia – she was a granddaughter of the Emperor Valentinian III and the wife of Areobindus, consul in 506 – contains some four hundred and fifty pictures of plants, birds, and poisonous beasts preceded by seven miniatures including two portraits of the author, a physician and chemist from Cilicia living in the first century, two groups of famous physicians, and a portrait of the Princess Juliana Anicia seated between Magnanimity and Prudence, attended by Gratitude of the Arts and Love of the Foundress of a church at Honoratae, a suburb of Constantinople. It has been suggested that the sixth-century copy was based on a compilation of the third or fourth century, since only a portion of the codex is devoted to Dioscurides's treatise; a lost herbal of the physician Crateuas seems also to have been called upon when the codex or its prototype was assembled. While the portraits of

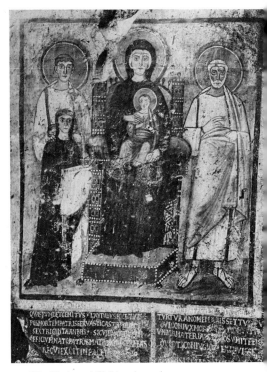

104. The Virgin and Child enthroned between St Felix and St Adauctus and attended by Turtura. Wall-painting. *c.* 528. *Rome, catacomb of Commodilla, church of St Felix and St Adauctus*

Dioscurides and the physicians appear to be in a full hellenistic tradition – they are today badly flaked – that of the Princess Juliana seems to depend upon Theodosian style of the late fourth century [105]: the set of the head, the sloping shoulders, the soft folds of sliding drapery.[13]

Three purple codices appear to date from about the middle of the sixth century. These manuscripts are works of great luxury. The parchment has been painted purple, the script is in gold or silver, and the illuminations are executed in a singular, refined style. The Vienna Genesis, now only a quarter of the

105. Princess Juliana Anicia between Magnanimity and Prudence attended by Gratitude of the Arts and Love of the Foundress of a church at Honoratae, a suburb of Constantinople.
From a copy of Dioscurides's *Materia Medica*, MS. Med. gr. 1, fol. 6 verso. Constantinople, 512.
Vienna, Österreichische Nationalbibliothek

original codex, certainly reflects an earlier model – some suggest a Jewish version produced in Syria or Palestine, since the Greek text is a variant of the 'pure' Septuagint tradition. Indeed, later Byzantine manuscripts illustrating Genesis are evidently based on other compositions. It is not surprising, therefore, that scholars should have differed over the provenance of the manuscript at Vienna: some have suggested Antioch or Asia Minor, others have preferred Jerusalem. But a purple codex in late antiquity or the early Byzantine period predicates imperial patronage, and it seems

likely that this Greek copy of Genesis, albeit a variant of the 'pure' Septuagint tradition, was produced at Constantinople and was intended as an imperial gift. The illustrations, placed in the lower half or part of the page, sometimes in two registers, are painted in soft, glowing colours; the scenes are condensed to the point of the narrative and sometimes telescope one into another; there is a sharp sense of movement and gesture, a lightness of touch, and an extraordinary evocation of atmosphere – as in the story of Rebecca [106] or when Joseph presents

106. The story of Rebecca. From a copy of the Book of Genesis, MS. Theol. gr. 31, fol. 13. Probably Constantinople, sixth century. *Vienna, Österreichische Nationalbibliothek*

107. Joseph presents his father to Pharaoh. From a copy of the Book of Genesis, MS. Theol. gr. 31, fol. 36. Probably Constantinople, sixth century. *Vienna, Österreichische Nationalbibliothek*

his father to Pharaoh [107]. Pharaoh, be it noted, is represented as a Byzantine Augustus, wearing a Theodosian imperial diadem, whose guards recall the retinue on the Theodosian Missorium. It has been pointed out that the paintings were not intended to illustrate the text; the text was intended to explain the pic-

tures, which were to be used as an aid to meditation and prayer like some of the later icon cycles or the rosary in the West. Throughout the fragments of the codex there is an atmosphere of exalted intimacy and private devotion.[14]

The Codex Rossanensis and the Codex Sinopensis are probably the earliest surviving

108. Christ before Pilate; below, the Repentance of Judas. From an Evangelistary, Codex Rossanensis, fol. 15. Probably Constantinople, sixth century, *Rossano*

109. St Mark. From the Codex Rossanensis, fol. 241

illustrated Greek Gospel texts, and they are far from complete. In the Codex Rossanensis the surviving illustrations appear to provide visual meditations on extracts from the Gospels read aloud during Lent: the Healing of the Blind Man, the story of the Good Samaritan, the Raising of Lazarus, the Entry into Jerusalem, the Cleansing of the Temple, the parable of the

Wise and the Foolish Virgins, the Last Supper and the Washing of the Feet, the Communion of Bread and Wine in separate scenes, Gethsemane, Christ before Pilate and the story of Judas [108], the choice made between Christ and Barabbas. Within this sequence several folios are missing, as are the canon tables, although there is a frontispiece with busts of the four Evangelists set in a circular frame. All the illustrations probably preceded the canon tables – during rebinding at a later date the order has been disarranged; they occupy the upper half of the page, of which the lower half is decorated with busts of four Prophets each holding scrolls bearing texts relevant to the New Testament scene above, or, in two cases, the New Testament scene occupies the whole page. The one has Christ before Pilate in the top register, the repentance and death of Judas in the lower, the other has the choice between Christ and Barabbas dominating the whole page, although divided into two registers. After the canon tables came the text of St Matthew, probably with a portrait at the beginning, but it has not survived. The text of St Mark (which

breaks off after chapter xvi:14) is preceded by his portrait [109]; he is seated in a wicker chair in a simplified architectural setting, penning a scroll at the dictation of a female figure standing near by – presumably adapted from an earlier portrait of a poet and his muse.[15]

The arrangement of the illustrations in the Codex Sinopensis is different. All that has survived is a fragment of the text of St Matthew, and in this case the five extant miniatures are set at the foot of the page, as in the Vienna Genesis, and come either before or after the relevant parts of the text. These small scenes – the Beheading of St John the Baptist and Herod's Feast, a first and second Multiplication of Loaves and Fishes [110], the Healing of the Blind Man (Matthew ix:27), and the Cursing of the Fig Tree – are all placed between two busts of Prophets holding scrolls inscribed with texts adumbrating the New Testament scene which they frame. In both codices, however, the same principles of decoration obtain: the purple parchment serves as a background to the scenes, which are touched in with gold and glowing colours with considerable economy of effect on a ground line; architectural detail and elements of landscape are presented like theatrical properties; and the figures are evoked in compact miniature forms which flow into movement or smoulder like embers of energy. Occasionally there are exceptions to this evocation

110. The Multiplication of the Loaves and Fishes.
From an Evangelistary,
Codex Sinopensis, MS. suppl. gr. 1286, fol. 15.
From Sinope. Probably Constantinople, sixth century.
Paris, Bibliothèque Nationale

111. A canon table. From the Rabbula Gospels, MS. Plut. I, 56, fol. 4 verso. Completed at Zagba c. 586. *Florence, Biblioteca Laurentiana*

112. A canon table. From a Gospels, MS. Add. 5111, fol. 11. Probably Constantinople, late sixth century. *London, British Museum*

of a scene, exceptions which appear to occur more frequently in the Vienna Genesis, but the fragmentary state of the two Evangeliaries must be kept in mind, where the purple page is 'pierced' by an illusion of space which includes sky, landscape, architecture, and the activity of the characters: the illustration is a window on to a particular world. This rectangular view on to a section of narrative was to be taken up constantly by later Byzantine artists, whether they were dealing with scenes from the Holy Scriptures or incidents in the lives of saints. There are, moreover, intermediate stages in the Vienna Genesis where the window is less obvious but the scene remains a complex, particular world in miniature without contracting into a shorthand notation of confronted forces. On the other hand, a number of scenes in the Genesis are narrated in the mode of distillation so typical of the two Gospel texts. Most scholars are agreed that the Vienna Genesis is the earliest of the three manuscripts and that it appears to synthesize earlier traditions about which only surmise is possible today, but the mode of distillation which occurs in all three may well be an invention of the sixth century.[16]

It is quite clear that the decoration of the Rabbula Gospels, dating from the year 586, whose provincial provenance is mercifully not subject to speculation, though the date has not escaped scholastic questioning, comes from a different tradition. Written at the monastery of St John at Zagba in northern Mesopotamia the Gospel book is not a purple codex, not written in Greek, and the set of canon tables [111], the sequence of illustrations, and, indeed, the whole text is arranged to read in the Syriac tradition from right to left. The scenes illustrating the life of Christ placed on either side of the canon tables – small, lively vignettes in rich colours and a sketchy technique (similar decoration occurs in Paris, syr. 33, another early Syriac manuscript) – forecast the decoration of a sequence of post-Iconoclastic psalters starting in the ninth century with the Chludov Psalter [149] and continuing in the eleventh century with Paris, gr. 74 and British Museum, Add. MS. 19352, executed in the monastery of St John

of Studius at Constantinople in 1066. The canon tables themselves offer a richness of decoration in marked contrast with those believed to have been executed in Constantinople about the same time or a little later – for example, British Museum, Add. MS. 5111, where the decoration [112], though elaborate, is severe, precise, spare, and devoid of fantasy; the tables in the Rabbula Gospels appear to have more affinities with those in Armenian manuscripts dating from the tenth century. In addition to the small scenes accompanying the canon tables, the Rabbula Gospels contains a series of full-page miniatures which in part continue the narrative – the Crucifixion [45] and Resurrection, the Ascension [46] and Pentecost – in part refer to the recruitment of Apostles, with a most unusual scene depicting the election of Matthias, in part to the authorship of the canon tables with portraits of Ammonius and Eusebius, and in addition offer portraits of the Virgin and Child standing beneath a baldacchino and Christ enthroned between four monks. Whereas the small scenes are sketched in with economy of effect, the full-scale miniatures of the Crucifixion, Resurrection, and Pentecost are worked out with considerable detail in an illusion of space and are at the same time quite different from similar illusionistic scenes in the purple codices. The atmosphere of decoration in the Rabbula Gospels is unquestionably monastic. Even so, the models for these full-scale miniatures must have been steeped in sophisticated east Mediterranean traditions, but in view of the almost total lack of evidence as far as manuscript decoration is concerned it would be rash to draw any peremptory conclusions on the source of these models. On the other hand, in view of the attempts of scholars in the past to assign the purple codices to an East Mediterranean workshop – Antioch, Jerusalem, or just Asia Minor – it should be stressed that the decoration of the Rabbula Gospels runs counter to such hypotheses. Moreover, in the portrait of Christ enthroned between four monks [113] He is revealed with short, curly, dark hair and a slight beard quite different from the so-called Syrian type with long hair and beard, which

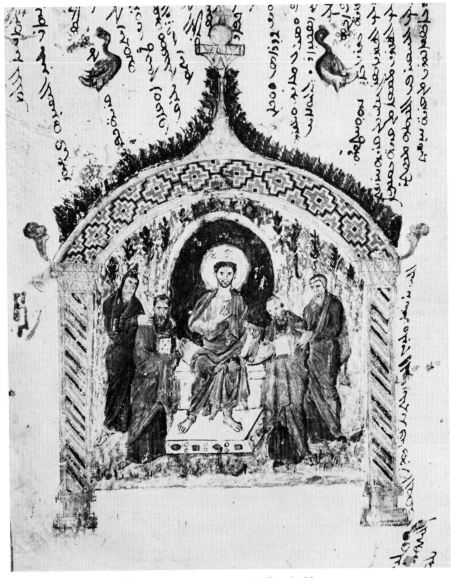

113. Christ enthroned between four monks. From the Rabbula Gospels, fol. 14

suggests also that attempts at establishing regional iconographic types in this period are a waste of time. This short-haired, short-bearded Christ is not isolated in the Rabbula Gospels; the type appears again in a standing version between cypresses and framed by a large medallion in a now incomplete Syriac Gospels in the church of St James of Sarug at Diarbakr in northern Mesopotamia dating from the late sixth or seventh century.[17]

The difficulties of unravelling the complex overlay of traditions which might occur in various parts of the Eastern Empire are notorious. Constantinople, as metropolis, might be expected to attract more discrete elements than a provincial city or monastery, and it has been shown that in the sixth century the capital was the source of the new elements, but the illustrations in Paris, syr. 341, a Bible now incomplete but dating probably from the late sixth or early seventh century, allowing for differences of hand, suggest that a number of traditions might be synthesized in a provincial scriptorium. The illustration of Moses before Pharaoh [114], in spite of a certain crudeness of facture, is a remarkably faithful copy of a late antique model – Pharaoh is dressed as an early Byzantine prince – and not far removed from the tradition of the portraits in the copy of Dioscurides's *Materia Medica* produced for Princess Juliana Anicia at Constantinople [105]. On the other hand, the miniature revealing the Virgin as the Source of Wisdom [115], standing holding the Child Christ in a shield reminiscent of the icon of the Theotokos Nikopoia, between the personification of the Church and Solomon dressed as a sixth-century Augustus, establishes that a more up-to-date metropolitan model was at hand.[18]

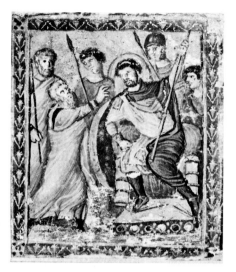

114. Moses before Pharaoh.
From a Syriac Bible, MS. syr. 341, fol. 8 recto.
Probably late sixth or early seventh century.
Paris, Bibliothèque Nationale

115. The Virgin as the Source of Wisdom.
From a Syriac Bible, MS. syr. 341, fol. 118 recto.
Probably late sixth or early seventh century.
Paris, Bibliothèque Nationale

ܡܢ ܐܠܗܐ ܣܓܝ
ܕܚܠܬܐ ܠܘܬ ܡܪܝܐ
ܐܠܗܐ ܕܟܠ ܘܩܠܐ
ܪܚܡܬܐ ܕܚܘܒܐ ܠܘܬ
ܟܠ ܐܢܫ ܕܗܘ ܠܐ ܙܥܘܪ
ܡܢ ܗܠܝܢ ܕܐܡܪ ܐܢܐ
ܠܟ ܐܘ ܚܒܝܒܐ ܕܝܠܝ
ܕܟܠ ܐܢܫ ܕܗܘ ܠܘܬ
ܢܦܫܗ ܘܠܘܬ ܟܠ
ܐܢܫ ܕܚܠܬܐ ܕܡܪܝܐ
ܐܠܗܐ ܗܝ ܪܝܫ ܟܠ
ܛܒܢ ܘܟܠ ܚܟܡܬܐ
ܒܗ ܐܝܬܝܗ ܘܡܢܗ
ܘܗܘܝܐ ܘܟܠ ܕܕܚܠ
ܡܢ ܡܪܝܐ ܐܠܗܐ
ܠܐ ܡܨܛܠܐ ܘܠܐ
ܕܚܠ ܡܢ ܟܠ ܕܗܘ
ܡܛܠ ܕܡܪܝܐ ܐܠܗܐ
ܐܝܬܘܗܝ ܣܒܪܗ ܘܟܠ
ܕܡܬܬܟܠ ܥܠ ܡܪܝܐ
ܐܠܗܐ ܠܐ ܢܚܣܪ ܡܢ
ܟܠ ܛܒܢ ܘܠܐ ܢܬܟܠܐ
ܡܢܗ ܟܠ ܕܫܦܝܪ
ܠܐ ܡܢ ܗܪܟܐ ܘܠܐ
ܡܢ ܬܡܢ ܡܛܠ ܕܡܪܝܐ
ܐܠܗܐ ܡܣܦܩ ܠܟܠ
ܘܕܚܠܬܗ ܡܢܛܪܐ
ܠܟܠ ܘܚܘܒܗ ܡܚܝܐ
ܠܟܠ ܘܪܚܡܬܗ ܡܚܝܐ
ܠܟܠ ܘܪܚܡܘܗܝ
ܣܓܝܐܝܢ ܘܡܪܚܡܢܘܬܗ
ܥܠ ܟܠ

ܠܡܪܝܐ ܐܠܗܐ ܢܣܓܘܕ
ܘܠܗ ܢܫܒܚ ܘܠܗ
ܢܩܠܣ ܘܠܗ ܢܘܕܐ
ܘܠܗ ܢܗܕܪ ܘܠܗ
ܢܪܡܪܡ ܘܠܗ ܢܥܠܐ
ܘܠܗ ܢܒܪܟ ܘܠܗ
ܢܩܕܫ ܕܠܗ ܝܐܝܐ
ܬܫܒܘܚܬܐ ܘܠܗ
ܦܐܐ ܐܝܩܪܐ ܘܠܗ
ܙܕܩ ܣܓܕܬܐ ܡܢ
ܟܠ ܦܘܡ ܘܡܢ ܟܠ
ܠܫܢ ܗܫܐ ܘܒܟܠܙܒܢ
ܠܥܠܡ ܥܠܡܝܢ
ܐܡܝܢ

ܥܠ ܬܘܟܠܢܐ
ܐܡܝܢ ܘܐܡܝܢ
ܫܒܚܘ ܠܡܪܝܐ

As in earlier times, once the provincial artist has taken over a type the result may evoke comparisons from one part of the Empire to another. The four full-page illustrations on two leaves, bound into the tenth-century Etchmiadzin Gospels produced in the Armenian monastery of Noravank', are presumably contemporary with the Rabbula Gospels, but the style is completely different and has little in common with other Syriac manuscripts about this time. The ivory covers [116] which bind the Etchmiadzin Gospels date unquestionably from the sixth

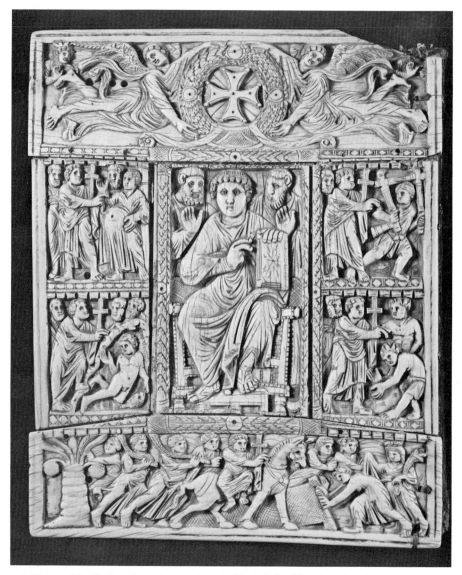

116. Christ and the Virgin enthroned; scenes from the life of Christ. Diptych used as a book-cover for the Etchmiadzin Gospels, MS. Matenadaran 2374. Byzantine, sixth century. *Yerevan*

century; they are a five-part sacred diptych representing a beardless, short-haired Christ enthroned between St Peter and St Paul, surmounted by angels bearing a garlanded cross and framed by scenes from the life of Christ, and the Virgin and Child enthroned between archangels, again surmounted by angels bearing a garlanded cross and framed by scenes from the infancy of Christ. The diptych is a crude example of the style set by the Barberini diptych and other fragments of imperial diptychs, Maximian's chair at Ravenna [94], and by the sacred diptych now in Berlin [67], all Constantinopolitan work dating from the first half of the sixth century. The miniatures represent the Annunciation to the Virgin, the Annunciation to Zacharias, the Adoration of the Magi, and the Baptism of Christ. Unlike the Rabbula cycle, which is narrative, the Etchmiadzin group emphasizes the theophanic mysteries and recalls the holy places commemorated on the silver ampullae now at Monza and Bobbio and, no doubt, in the *martyria* of Palestine. On the other hand, the centralized treatment of the Adoration of the Magi [117] is paralleled by ivory carvings usually assigned to Syria or Egypt, the handling of feature, form, and hairstyle is reflected in Coptic paintings at Bawit and in Coptic sculpture in Cairo, and the representation of the Child Christ in a shield-like mandorla appears again at Bawit and Saqqara but is also to be found on an icon on Mount Sinai, in S. Maria Antiqua at Rome, and in Paris, syr. 341. The Baptism of Christ evokes a beardless youthful Christ [118] with bushy, curly hair – very Coptic in appearance – framed by a border containing rows of pelicans piercing

their breasts beneath a paten and above a chalice, and the four Evangelists. Not only the theophanic mystery is represented – the hand of God, the Dove, the youthful Christ – but the Eucharist is symbolized and the Passion is adumbrated. Armenian scholars consider these

117 (*above right*). The Adoration of the Magi. A page bound in to the Etchmiadzin Gospels, MS. Matenadaran 2374. Armenia, late sixth or seventh century. *Yerevan*

118. The Baptism of Christ. A page bound in to the Etchmiadzin Gospels, MS. Matenadaran 2374. Armenia, late sixth or seventh century. *Yerevan*

miniatures to be the work of an Armenian artist and compare them to vestiges of wall-paintings in the seventh-century churches of Lmbat, T'alin, and Arudj, but there seems to have been a strong connexion with Egypt, from which the model may have come.[19]

119. St Luke framed by scenes from the life of Christ. From the Gospels of St Augustine, MS. 286, fol. 129 verso. Italy, late sixth century. *Cambridge, Corpus Christi College*

In the West the problems of provenance and models set by illustrated manuscripts are no less intricate. Paleographers agree that the Gospels of St Augustine, the Apostle of the English, who landed in Thanet in 597, was written in Italy in the sixth century, and it is probable that the fragment of the manuscript no. 286, now in the library of Corpus Christi College, Cambridge, was either brought to England by the early missionaries or sent to them shortly afterwards by Pope Gregory the Great (590-603).

Only two pages of miniatures have survived: fol. 125 with scenes from the life of Christ arranged in squares starting with the Entry into Jerusalem and ending with Simon of Cyrene bearing the Cross, and fol. 129 verso with the portrait of St Luke seated under an arch, his symbol appearing in the conch, and on either side scenes from the ministry of Christ [119]. But there seems no reason to doubt that originally the manuscript contained four portraits of the Evangelists and at least three sets of composite miniatures, one before the Gospel of St Matthew illustrating the early life of Christ, the set before St Luke, and a third illustrating the Passion at the end of the Gospel of St John. Since twenty leaves are missing from the beginning of the codex there must have been the usual prologues to the Gospels including a set of canon tables. In all there may have been seventy-two, possibly even eighty-four New Testament scenes. Whereas in the composite miniature each square has a single scene, in the miniatures framing St Luke each rectangle contains two scenes set one above the other. Some of the latter illustrate already familiar subjects such as Zacharias and the Angel and Christ among the Doctors, but one panel combines the parable of the fig-tree (Luke xiii:6) with a representation of Christ addressing three persons which it would be baffling to identify were it not for the inscription referring to Christ saying 'Foxes have holes, and the birds of the air have nests but the Son of Man hath not where to lay his head' (Luke ix:58). The portrait of St Luke is conventional enough in the stylistic idiom of the time – simplification of feature, form, and drapery, loss of weight, and a certain weakness of line – but the little figures in the narrative miniatures have no close parallels. In a sense they recall the five-part sacred diptych executed in Rome about 430 and the large five-part diptych now acting as a book-cover in the cathedral treasury at Milan, probably North Italian and dating from the sixth century [120], but by the nature of the medium the ivory carvings are more defined, and such a comparison is inevitably tangential. In the manuscript there is little attempt at modelling, the illusion of landscape is reduced to a series of billows of different colour, and every scene has been condensed into a dry pictograph of an incident.[20]

120. Scenes from the life of Christ. Ivory diptych used as a book-cover. North Italy, sixth century. *Milan, cathedral treasury*

121. The Legislation on Mount Sinai and
the Tabernacle. From the Ashburnham Pentateuch,
MS. nouv. acq. lat. 2334, fol. 76 recto.
Probably Italy, late sixth or seventh century.
Paris, Bibliothèque Nationale

The illustrations of the Ashburnham Penta-
teuch, dating probably from the late sixth or
seventh century, are more ambitious but are
equally baffling as to their model and their
provenance. Again paleographers agree on the
date of the uncial script, which was apparently
written in a centre outside the main Latin

stream, possibly east of Italy, but art-historians have been at a loss when faced by the miniatures, of which some are encaustic, and Spain, southern Gaul, Italy, and North Africa have all been mooted. The text of the Scriptures is the Vulgate, but the labels under the miniatures follow the old Latin version. The title page on fol. 2 recto presents a list of the sacred books with their Jewish and Latin names in a frame between parted cherry-red curtains draped round columns, believed by some to be a reference to the Torah in a synagogue. Nineteen full-page miniatures have survived, ranging from the Creation of the World to Moses expounding the Law to the Jews. In some cases one scene such as the Flood (fol. 9 recto) may occupy the whole page, but more frequently a number of scenes follow upon each other reading from left to right (although there are exceptions to this), which presupposes a Western tradition. Nevertheless, more than one scholar has invoked Jewish traditions and influences on the Pentateuch, and most scholars consider that the artist was familiar with the East – or North Africa. Characteristic of the decoration is a persistent and complex use of architecture with incidental curtains, hanging crowns, and lamps [121] which looks forward to aspects of Carolingian

illumination and drawing. The manuscript was restored in eastern France in the eighth century, and by the ninth century it had reached Tours, where it seems to have exercised no influence at all until the late eleventh century. The Moutiers-Grandval Bible executed at Tours between 834 and 843 clearly followed a different model, and the Bamberg Bible with its Genesis cycle reading from right to left suggests that there was some other Syriac model in the scriptorium. The costume of the women in the Ashburnham Pentateuch, particularly the mantilla draped over high, braided hair, recalls the orant ladies in Roman catacombs of the fourth century [6], and the vertical bands on the long tunics running from shoulder to foot may be seen on many Coptic grave-clothes dating from the fourth to the early seventh century. Much of the male costume looks uncompromisingly Western, almost Frankish. Wherever the Ashburnham Pentateuch was copied, it seems probable that a fourth-century Roman model was at hand, and whatever else was brought to bear on it in the course of production, the result is far removed from the Eastern manuscripts which have survived. The artists of the Vienna Genesis, though equally retrospective, were living in a different world.[21]

THE FORSAKEN WEST AND THE EMERGENCE

OF THE SUPREME PONTIFF

The late sixth and seventh centuries were times of great trouble and unrest. In 586 the Lombards invaded Italy – the first barbaric horde to arrive with no kind of imperial sanction. In vain the Pope appealed for help to the Emperor. Pope Pelagius II (579–90) sent the deacon Gregory, later Pope Gregory the Great (590–603), to Constantinople with instructions to haunt the palace night and day, but the imperial administration acting for Justin II, who was mad, and later the Emperor Maurice, conscientious, able, and soon on cordial terms with Gregory, was fully occupied by the Persian menace on the eastern front. No troops could be spared; the exarch in Italy admitted that he was hardly equipped to defend Ravenna, still less Rome. For the next three centuries the situation of the Papacy was precarious indeed. Until well into the eighth century few Popes, not even Gregory the Great, dared to be consecrated without the approval of the Emperor or the exarch. Loyalty to the imperial concept continued long after all hope of sustained military intervention had evaporated and was not without peril. Throughout the seventh century the Monothelite heresy over the distinction of the Divine and human wills of Christ disrupted Christian peace. The heresy received imperial support. More than once the Popes were summoned to Constantinople to give an account of themselves and their theological position; more than once they were humiliated and treated with contempt. Pope Honorius I (625–38), a man of integrity and untarnished reputation, was condemned as a heretic because of an injudicious letter by the sixth general council at Constantinople in 680; Pope Martin I was seized in Rome, and on his arrival in the metropolis in 653 or 654 was brutally molested until

he died, a forsaken and starved martyr, in the Crimea in 655. The last Pope to be summoned to Constantinople was Constantine (708–11), who took with him the future Pope Gregory II (715–31), but this time the papal party was received honourably by Justinian II and they returned safely to Rome in 711. Greek historians were to accuse Gregory II of breaking off relations with the Byzantine Emperor and taking the West with him, but in fact he remained loyal to the imperial concept while protesting strongly against Leo III's attempts at illegal taxation and his Iconoclastic decrees. Indeed, the Iconoclastic Controversy which began officially in 725 created a permanent rift between East and West. Eventually the Lombards occupied Ravenna, and by 751 the exarchate had come to an end. The Popes were forced to treat – not unprofitably – with the Lombards; a large part of the exarchate became papal territory, but they never trusted them. They turned instead, as they had done intermittently since the sixth century, to the Franks. The anointing of Pepin by Pope Stephen II at Paris in 753 – which confirmed a previous anointing by St Boniface, acting on papal instructions – was the cornerstone of the medieval theory of kingship by the grace of God and of papal superiority over the temporal power. In less than fifty years the Frankish kingship was converted into the renewed Western Empire of Rome, and, *mirabile dictu*, Charlemagne was recognized by the Emperor of East Rome.

The foundations of papal power, not only in the spiritual but in the temporal sphere, had in fact been laid by Pope Gregory the Great. His personality transformed the Roman bishop of the Early Christian Church into the medieval

sovereign pontiff. The son of a rich nobleman, he had been Prefect of Rome before he became monk and deacon. His six years as papal nuncio at the imperial court between 579 and 585 gave him a profound insight into politics and diplomacy. It is not without significance that in spite of his mission Gregory never troubled to learn Greek and was to complain (Ep. vii:27) that there was no one at Constantinople who could translate Latin competently. After his consecration as Pope the maintenance of imperial power in the West depended more on him than upon the exarch, and by the time of his death the incessant energy of Gregory had switched the reality of power into his own hands. The Lombards were supreme in northern Italy but Gregory ruled the central territories. The bishops, moreover, all over the Empire reported to Rome. In all the advice which issued as a result of these reports Gregory pressed relentlessly the authority of the Church: the Pope was above the exarch; the Church was above the State; a wrong against man was a wrong against God. His *Regulae Pastoralis Liber* became part of the ordinary training of a bishop, and the Emperor Maurice ordered a translation into Greek. His *corpus* on Divinity, the *Moralia in Job*, which he wrote at Constantinople, was to become a popular classic. The fourteen books of his letters, known as the *Registrum Gregorii*, became a standard work of reference on Roman religion and diplomacy. He became the most popular of all the Fathers of the Church, probably more influential than St Ambrose, St Augustine, or St Jerome. Few libraries in the Middle Ages were without a complete set of his works. His keen interest in the missions to the barbarians, particularly the English, led to the triumph of Rome over Celtic practice at the Synod of Whitby in 664, to the success of the Anglo-Saxon missions among the German and Frisian tribes, and to the apostolate of St Boniface, who before setting out on his work in 718 went to Rome to receive a letter of recommendation from the reigning Pope, Gregory II.

St Gregory the Great was monk and abbot before he became Pope. In the second book of

his Dialogues he paid tribute to another great saint, Benedict of Nursia (d. about 547), whose Rule for Monks became the basis for Western monastic life. Previous rules had been little more than collections of religious precepts. St Benedict was the first to write a true monastic code. With the direct approval of St Gregory, who commended it for its moderation and lucidity, the code gradually came into use. Charlemagne, who visited Montecassino in 787, obtained a copy of the Rule and, in that general effort towards organization and uniformity which characterized his government, saw to its dissemination in the re-established Western Empire. By the year 817 at a chapter held at Aachen the assembled bishops and abbots were asked: 'Can there be any monks besides those who observe the Rule of St Benedict?' Benedictine monasticism was eventually to become the chief cultural force almost everywhere in Europe and the backbone of resistance to Western imperial paternalism. If the foundations of papal power were laid by Gregory the Great, the structure was stabilized by those who observed most faithfully the Rule of St Benedict.[1]

In spite of the troubled times and the constant fear of Lombard occupation – the Lombards passed from paganism to orthodoxy via Arianism, but their presence in Italy was a serious menace to papal stability – artistic production still continued in Rome. Pope Pelagius II embellished the Shrine of St Peter and rebuilt S. Lorenzo fuori le Mura. The mosaic on the triumphal arch represents Christ enthroned between the SS. Peter and Paul, Lawrence, Stephen, Hippolytus, and Pope Pelagius himself [122]; in the spandrels are the towns of Bethlehem and Jerusalem. The mosaic was restored on several occasions during the medieval period, and today only the figures of St Lawrence and the Pope date from the sixth century; the head of St Hippolytus appears to be a restoration made at some time between the seventh and ninth centuries; the other figures were repaired about 1100. In general the disposition has been compared to the apse mosaics in S. Vitale at Ravenna, but the figures of the Pope

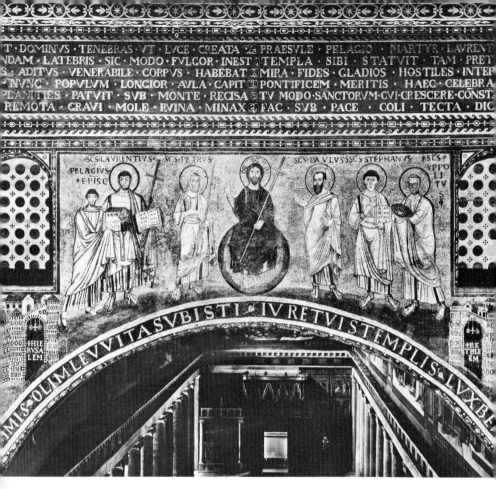

122. Christ enthroned between SS. Peter,
Paul, Lawrence, Stephen, Hippolytus,
and Pope Pelagius II; in the spandrels,
the towns of Bethlehem and Jerusalem.
Mosaic on the triumphal arch. Between 579 and 590,
largely restored during the medieval period.
Rome, S. Lorenzo fuori le Mura

and St Lawrence are more elongated and less
massive. The Old Library in the Lateran Palace
was redecorated under Pope Gregory I towards
the end of the sixth century with simulated cur-
tains hanging from a bar and portraits of the
Fathers of the Church, including St Augustine
[123] which presents a marked simplification of
form and drapery, an improbable relationship
between the saint and the book he appears to be
blessing, and an almost complete loss of depth.[2]

According to the *Liber Pontificalis* Pope Hon-
orius I (625–38) was particularly active in pre-
serving and restoring the churches of Rome.
That of S. Agnese fuori le Mura was rebuilt,
like S. Lorenzo, as a galleried basilica, about
630. The mosaic in the apse reveals St Agnes

dressed as an Augusta [124] between Pope Honorius and Pope Symmachus; above, the hand of God emerges from a cloud in a starry firmament. The grave, impassive, elongated figures stand well spaced against a gold ground, the Popes turning slightly inward on minute feet towards the saint, who stares like a bedizened doll into the body of the church. Lofty, remote, impersonal, the forms merely make a statement of sanctity and papal patronage.

Strong Byzantine influences may be detected throughout the architecture in proportions and measurements and in the mosaic. It may well be that Byzantine workmen, perhaps even a Byzantine architect, were called upon. The mosaic, repaired to a certain extent by Pope Hadrian I (772-95), looks straight past the Iconoclast Controversy towards the art of Constantinople in the tenth century: Byzantine art in its most static aspect.[3]

123. St Augustine. Wall-painting. Late sixth century. *Rome, Lateran Palace, Old Library*

124. St Agnes. Mosaic in the apse. *c.* 630 (?). *Rome, S. Agnese*

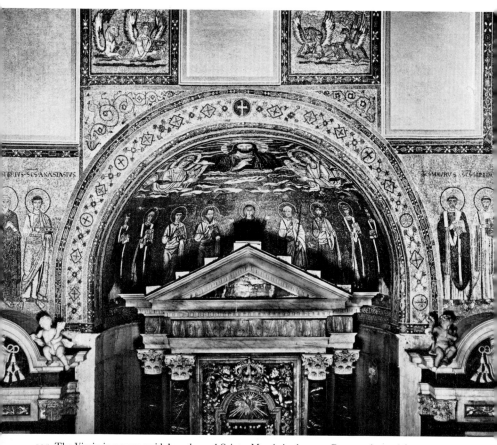

125. The Virgin in prayer amid Apostles and Saints. Mosaic in the apse. Between 640 and 642.
Rome, S. Giovanni in Laterano, Baptistery, Oratory of S. Venanzio

Pope John IV (640–2) was a Dalmatian, the son of the *scholasticus* – an advocate – Venantius, and because the Slavs were overrunning the country of his birth, he arranged for the relics of the more important Dalmatian saints to be brought to Rome. They were housed in the Oratory of S. Venanzio in the baptistery of S. Giovanni in Laterano, and a mosaic was commissioned to decorate the apse. The bust of Christ, bearded, long-haired, haloed, emerges from clouds between busts of angels; below, the Virgin stands in prayer with Apostles and other saints [125] on either side – these extend beyond the apse on to the walls of the chapel. The design appears to be an adaptation of the theme of the Ascension with a number of later saints added; many of these are dressed in Byzantine court costume. The impression given by the mosaic, if compared with those of slightly earlier date in the church of Hagios Demetrios at Salonika, is that local artists were responsible, mixing local traditions with strong Byzantine influences. Once again the figures of the saints lack the sense of sheer bulk in contrast with the saints and donors in Hagios Demetrios, the drive of the line is less certain, and the modelling of the faces strikes one as slight and indecisive.[4]

Equally provincial in flavour is the apse mosaic in S. Stefano Rotondo probably executed during the reign of Pope Theodore I (642-9). Theodore, the first Pope to be named Sovereign Pontiff, was a Greek from Jerusalem, the son of a bishop. It is not without interest that the Pietro in Vincoli, usually dated about 680, has become a dry, schematic notation of the human form [127], the drapery mapped out into segments, the head out of proportion with the rest of the body. The mosaic decoration formerly in the Chapel of the Virgin in Old St Peter's ex-

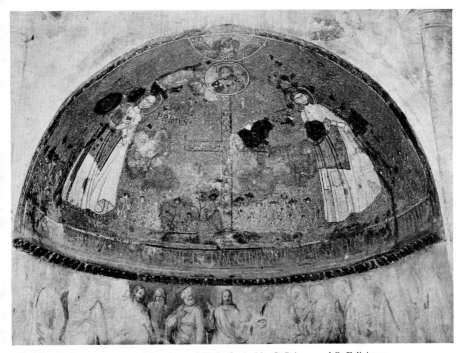

126. A jewelled cross surmounted by a bust of Christ flanked by St Primus and St Felicianus. Mosaic in the apse. Between 642 and 649. *Rome, S. Stefano Rotondo*

jewelled cross surmounted by the bust of Christ [126] recalls the pattern of iconography found in the Crucifixion on the silver ampullae from Palestine. The cross is placed in a stylized garden and is flanked by St Primus and St Felicianus dressed in simplified Byzantine court costume. No doubt there were similar representations in Jerusalem, possibly even in Constantinople, but the Roman mosaic, now considerably damaged and restored, follows the etiolated forms already seen in S. Lorenzo and in the Oratory of S. Venanzio. Further stages in the decline of mosaic technique in Rome may be charted. The portrait of St Sebastian in S. ecuted for Pope John VII (705-7) and now scattered in the crypt of St Peter's, in the Lateran Museum, in S. Maria in Cosmedin, and at Florence in the church of S. Marco, presents similar characteristics. The fragment of the Adoration of the Magi, now in S. Maria in Cosmedin, with its uncertain evocation of form, weak line, and vapid faces [128], suggests that the workshop traditions were running thin. The decline of aesthetic vision and force was accompanied by a decline in skill.[5]

This decline seems to have closed in quite rapidly at Rome during the second half of the seventh century in spite of the almost certain

152

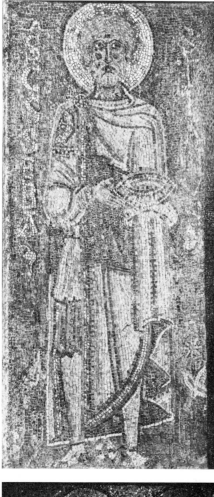

127 (*above left*). St Sebastian. Mosaic panel.
c. 680. *Rome, S. Pietro in Vincoli*

128 (*left*). The Virgin and Child enthroned.
Fragment of an Adoration of the Magi.
Part of the decoration
in the Chapel of the Virgin in Old St Peter's.
Between 705 and 707. *Rome, S. Maria in Cosmedin*

129 (*above*). St Anne. Wall-painting. 649.
Rome, S. Maria Antiqua

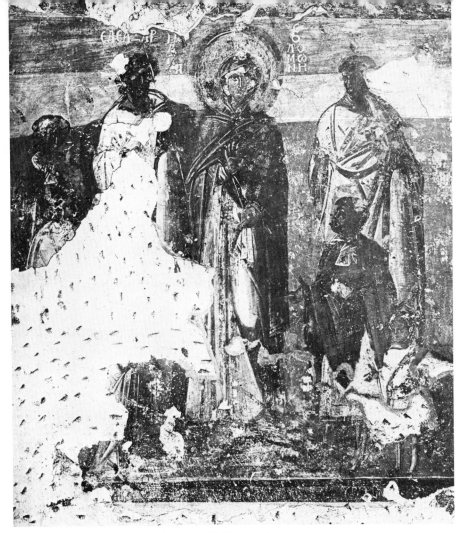

130. The Maccabees. Wall-painting. 649. *Rome, S. Maria Antiqua*

presence of Greek fresco painters in the city. The decoration of S. Maria Antiqua was continued under the patronage of a succession of Popes. Pope Martin I (649–55), of noble birth, from Todi on the Tiber, and one of the noblest of the Popes, was consecrated without waiting for imperial confirmation and, having summoned the Lateran Council which condemned the Monothelite heresy in defiance of the Emperor, he gave instructions for the Council to be recorded on the walls of S. Maria Antiqua. The paintings also include a fine St Anne bearing the Virgin in her arms, identified by a Greek inscription [129], and the equally fine representation of the Maccabees [130], again with Greek inscriptions, which bear witness to a sturdy Byzantine intervention. The serene modelling of the faces, the handling of the drapery and the form beneath the drapery – note, in particular, the figure of Solomone, the mother of the Maccabees – and the overall luminosity are clearly foreign to the local output. Moreover, the elongation of the forms, the use of highlights to emphasize folds of drapery, the grave

of learning and eloquence. He seems also to have learnt that discretion is the better part of valour, for he declined to comment on the decrees of the Quinisextine Council 'in which were many articles against the See of Rome' and simply returned them unanswered, unconfirmed, to the truculent Justinian II. He called himself the servant of the Mother of God, and

131. The Angel of the Annunciation.
Wall-painting. 649. *Rome, S. Maria Antiqua*

132. St Luke. Wall-painting. Between 668 and 685.
Rome, catacomb of Commodilla

sense of purpose, as in the mosaics of S. Agnese, look forward to Byzantine art after the Iconoclast Controversy. The message of these paintings may also have been read by Carolingian artists. The style of drapery and the treatment of form of an angel in the Annunciation group in the nave [131] give intimations of an idiom which was to be crystallized in the drawings of the Utrecht Psalter produced at Reims about 820. This strong Greek tradition continued under Pope John VII (705–7). He was the son of a Byzantine official, Plato, the curator of the imperial palace at Rome. He had been educated at Constantinople and returned to Rome a man

his chapel in Old St Peter's and the great icon in S. Maria in Trastevere [77] bear witness to this devotion. He also decorated S. Maria Antiqua and called in Greek artists to do some of the work. The great Adoration of Christ on the Cross painted on the triumphal arch is now difficult to read, but the head of a seraph with its delicate modelling and hellenistic overtones suggests the collaboration of a Byzantine trained in the workshops of Constantinople. The busts of Apostles in medallions on the left wall of the presbytery, the types vividly evoked in an impressionist technique, are in marked contrast with the portrait of St Luke in the catacomb of

Commodilla [132] dating from the reign of Constantine IV (668–85), where the schematized, simplified form betrays the local Roman tradition. It seems certain that different sorts of artists worked for John VII. The Adoration of the Magi on the left wall of the presbytery appears to be fairly close in style to the mosaic panel of the same subject in S. Maria in Cos-

medin, which is on a different level of accomplishment from that of the Byzantine artists.[6]

In spite of the Byzantine interventions the local traditions prevail. The prothesis or chapel of Theodotus in S. Maria Antiqua was redecorated under Pope Zacharias (741–52), a Greek by birth, but the Crucifixion panel [133], although Christ is wearing the *colobium* familiar

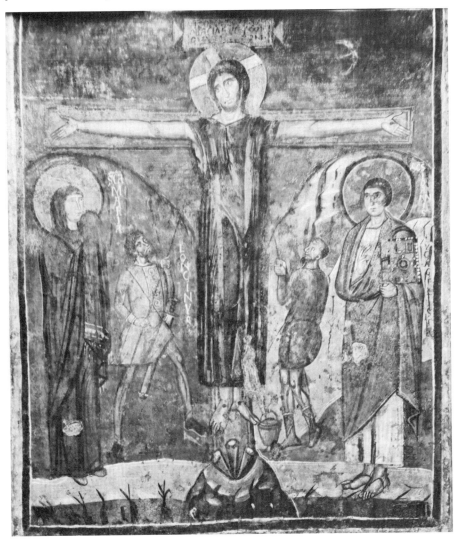

133. The Crucifixion. Wall-painting. Between 741 and 752.
Rome, S. Maria Antiqua, prothesis or chapel of Theodotus

in Syriac manuscripts, carries Latin inscriptions and seems to be the work of Roman rather than Eastern artists. The portraits below of the Pope Zacharias, the donor Theodotus, an official of the *diaconia*, and SS. Quiricus and Julitta, Peter and Paul on either side of the Virgin and Child enthroned are executed in the Byzantine idiom, yet the general effect is arid and mechanical. Moreover, in the scenes from the life of St Quiricus and St Julitta, the forms, with the lengthening of the thigh and the shortening of the shin, the lack of modelling and the segmentation of the drapery are entirely local. These characteristics appear also at S. Saba and at S. Maria in Via Lata in the middle of the eighth century and were to continue in Roman art until the high Middle Ages. More paintings were executed in S. Maria Antiqua in the apse and in the right and left aisles under Pope Paul I (757-67), and again the Byzantine models are desiccated and simplified, although the series of Eastern saints in the left aisle with their Greek inscriptions are not without a sense of monumentality and power. The fresco of the Virgin and Child enthroned between saints and Pope Hadrian I (772-95) in the atrium illustrates the increasing stylization: flattened forms mapped out by monotonous vertical lines. Pope Leo III (795-806) had placed a silver ciborium over the high altar, but towards the middle of the ninth century S. Maria Antiqua was abandoned. A severe earthquake in 847 undermined the imperial buildings overlooking the church on the north-eastern edge of the Palatine hill, and S. Maria Antiqua was partially buried under the rubble. The *diaconia* was transferred under Pope Leo IV (847-55) to a new building on the Via Sacra, called at first by the name of the old church but later changed to S. Maria Nova, and later still to S. Francesca Romana. S. Maria Antiqua was finally and completely buried during the fire which devastated that part of Rome after the Norman sack in 1084.

In northern Italy the influence of the Lombards on art tended to be barbaric. Like most barbarians, they preferred portable objects in gold and silver, often highly wrought. The sculpture executed under their dominion, if we

are to consider the grave-slab of St Cumianus at Bobbio (713-44), the altar of Ratchis at Cividale (737-44), or the altar slab of Sigualdus in the same town (762-76), is crude, provincial, and rebarbative. But the little church of S. Maria on a hill near the village of Castelseprio, since its frescoes were discovered in 1944, has become a bone of art-historical contention. The church itself has been described with reason as 'one of the poorest pieces of construction on Italian soil' and there seems little reason to question the date in the seventh century assigned to it in the first place. The frescoes, as the inscriptions witness, are the work of a Greek, small in scale, their fresh, delicate colours now much faded, but wholly competent and worthy of comparison with those done for Pope Martin I in S. Maria Antiqua about 650 or the Byzantine production for John VII in the same church. Nevertheless, dates in the fifth or sixth, eighth, ninth, and even tenth centuries have been canvassed by art-historians. A graffito cut into a border referring to Ardericus, Archbishop of Milan (938-45), has prevented anyone from suggesting a later date and would seem to nullify the tenth-century proposition. Nor are the arguments for a ninth-century date, based largely on iconographic speculation, at all convincing. The fifth- or sixth-century date would appear to be ruled out by the rusticity of the building; it seems hard to believe that a church so close to Milan could have been so shoddily built in those centuries. Nor does the style parallel in any way Byzantine sixth-century modes, about which we are tolerably well informed. A comparison of the Flight into Egypt [134] with the outlines of the same subject in the church of S. Salvatore at Brescia provides an interesting parallel, but unfortunately the date of the frescoes of S. Salvatore is equally open to speculation, though the proposal by some for the second half of the eighth century seems plausible. In any case, the frescoes which are at all legible in that church seem closer in style to the local manifestations in Rome, to frescoes in S. Maria in Valle at Cividale, also highly controversial, difficult to read, but possibly second half of the eighth century, and to those in the

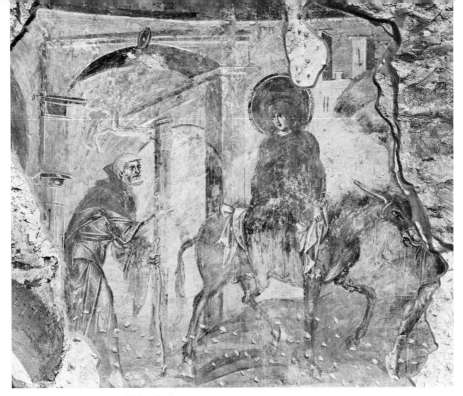

134. The Flight into Egypt. Wall-painting. *c.* 700.
Castelseprio, church

135. Christ Pantocrator. Wall-painting. *c.* 700.
Castelseprio, church

church of St John the Baptist at Müstair in the early ninth century. On the other hand, the Byzantine frescoes at Castelseprio seem to fit more readily into place between the work done for Martin I and that done for John VII, and art-historical opinion appears to be settling for a date about 700. The surviving scenes are devoted to the infancy of Christ, ranging from the Annunciation to the Presentation in the Temple, set in an illusion of landscape or architectural space very subtle for the time, with a remarkable handling of form, drapery, and incidental detail, and a spirited sense of movement. The drapery folds, nevertheless – a complex series of angular ridges emphasized by highlights – make a decidedly metallic impression and betray the copyist, who foreshadows in a disturbing way tenth-century mannerisms. A fine bust of Christ Pantocrator [135], bearded, long-haired, cross-haloed, in a medallion, the face sensitively modelled with large luminous eyes, small delicate mouth, and a refined nose, indicates the tenacity of Byzantine craft traditions.[7]

Traditions in North Italy, as at Constantinople and at Rome, might exist side by side without necessarily influencing each other. A Greek worked at Castelseprio about 700, but artists at Milan, Bobbio, or Nonantola show little appreciation of the fact. The crucial factor was the model under the artist's nose. Thus, the illustrations in a copy of St Gregory's Sermons on the Gospels, produced at Nonantola about 800, show the weakening in the grasp of the human form [136], the reluctance to look at

siderably higher quality than the illustrations produced at Nonantola, but the main principles of style are the same and these owe nothing to Byzantine artists either living or dead. Farther north Salzburg managed to maintain its 'private' link with the East. Aquileia was not far away and books from the East could be procured. Yet such influence might prove barren. A copy of St John Chrysostom's Sermons on St Matthew in Latin translation includes a portrait of the author [137] which presumably was

136. St Peter presenting the deacon David Peter. From a copy of St Gregory's Sermons on the Gospels, MS. CXLVIII, fol. 7 verso. Nonantola, c. 800. *Vercelli, Biblioteca Capitolare*

137. St John Chrysostom. From a Latin copy of St John Chrysostom's Sermons on St Matthew, MS. cod. 1007, fol. 1. Salzburg, early ninth century. *Vienna, Österreichische Nationalbibliothek*

nature, and the painstaking yet incompetent tracing of line familiar in Roman wall-paintings of the same time. The figures of St Peter and the deacon David Peter owe nothing to the Greek who worked at Castelseprio; they are mere diagrams of an earlier model in a Western tradition. The portrait of Apollo Medicus, square-nimbed, seated under an arch, in a North Italian copy of Isidore of Seville's *Etymologiae* of about the first quarter of the ninth century, is of con-

taken from a seventh-century Byzantine version, but the model has been reduced in colours of green, yellow, rust, and blue to a flat pattern, decorative but sterile. No manuscript produced in Italy and certainly none of the great insular manuscripts – such as the Codex Amiatinus and the Lindisfarne Gospels executed in the north of England in the late seventh or early eighth century or the Codex Aureus at Stockholm produced at Canterbury in the third quarter of the

eighth century – 'explains' Charlemagne's great Coronation Gospels, now at Vienna, dating from some years before 800. The conclusion seems inescapable that there were Greeks and Syrians at his court. The portraits of the Evangelists in the Vienna Gospels [138] are the expression of a living hellenistic tradition which, in spite of the Iconoclast Controversy, could only have survived at Constantinople. Even so, this Byzantine tradition was not easily assimilated by the northern artists. A generation later at Reims all they could do was to produce a caricature of Byzantine style, and this caricature proved to be one of the main lifelines in the development of north-west European art.[8]

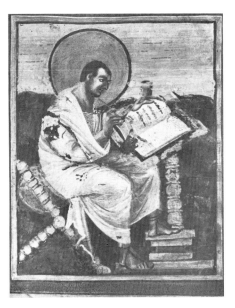

138. St Matthew. From the Coronation Gospels of the Holy Roman Empire, fol. 15.
Aachen, before 800.
Vienna, Weltliche und Geistliche Schatzkammer

THE TROUBLED EAST

The seventh and eighth centuries were times of trouble and unrest for East Rome. Almost at the same time that the Lombards were occupying Italy, the Slavs and the Avars invaded the territories west and north of Constantinople, surged over the Balkans destroying towns and communications, and in 626 besieged the metropolis. The defeat of the barbarians by the Emperor Heraclius outside Constantinople broke Avar power, but for centuries the Balkans were in the hands of different groups of Slavs. Their presence, cutting the great Via Egnatia which linked Constantinople and Salonika with the West, was one of the chief causes of the estrangement between East and West. In the late seventh century the Bulgars appeared in the northern Balkans and for three centuries were to be a constant menace to the imperial organization. On the eastern front the Persian victories between 611 and 618, which engulfed Antioch, Jerusalem, and Alexandria, were countered by Heraclius at Nineveh in 627, but barely had the Persian danger been eliminated when Islam and the Arabs erupted in the Near East, and by 646 the Byzantine Empire was shorn of Mesopotamia, Syria, Palestine, and Egypt. In the spring of 669 the Arabs attacked Constantinople; between 674 and 677 there were yearly onslaughts. The final siege came in 717–18, when the Emperor Leo III decimated the Muslim army and destroyed the Arab fleet. More than once during these times the Byzantine Emperors had contemplated abandoning the metropolis. Heraclius, the son of the Exarch of Africa, swept to power by the African fleet, had considered moving the capital to Carthage. His grandson, Constans II, went to Rome in 667 and was the first Emperor to be seen in the old capital for a hundred and ninety years, but he settled in Syracuse, causing open dissatisfaction at Constantinople. Byzantine military and civil servants had long since lost interest in the West; they looked to the East.

Asia Minor was the basis of the medieval Byzantine state. Here the theme system – the new military and civil organization which gave the shrunken Empire its special strength – came into being; it was gradually extended to the Balkans in Thrace about 680 and in Central Greece some time after 687. Byzantine diplomacy was concerned first with the new Umayyad Caliphate and secondly with the peoples of Eastern Europe and Western Asia: Bulgar and Turkic nomads, Caucasian tribes, and not least the Armenians. With the Khazar principality in the Caucasus relations were particularly friendly. Heraclius called the Khazar prince his son and promised him his daughter Eudocia in marriage. When shown a portrait of the 'Augusta of the Romans', the Khagan was consumed with love for its 'archetype'. Happily for the little princess, perhaps, the Khagan died before the marriage could take place; but later in the century, when Justinian II was in exile at the Khazar court, he married the Khagan's sister, and on his restoration in 705 crowned her Augusta, making his son by her co-Caesar. Constantine V also married a Khazar princess, and his son Leo IV was known as 'the Khazar'. In addition to this alliance with the Khagan the Byzantine administration set great store by Cherson on the south coast of the Crimea; in the ninth century it was to become a theme. From Cherson the nomadic tribes of the East European plain could be kept under observation. Byzantine control over Armenia had been established by the sixth century, but the rise of the Arabs altered the situation, and a large part of Armenian territory was lost to the Empire. Nevertheless, Constantinople served as a place of refuge for Armenian bishops and noblemen, and at various times numbers of

Armenian families were forcibly removed from their country to colonize other parts of the Empire, including Thrace and Cyprus. The Armenian element in the Byzantine army was of the greatest importance: in the sixth century Procopius mentions by name no less than seventeen Armenian commanders, including the great Narses. Some rose to the highest power. Several Byzantine Emperors were of partially or wholly Armenian descent.

Under Heraclius Greek became the official language of the state, and culturally the state was Greek; but the Byzantine Empire was multi-racial and, at the same time, jealously preserved its claims to the inheritance of Rome. To the Arabs and to other peoples of the East the Byzantines were Romans – *Rumi*. The chief unifying factor was Christian orthodoxy, although this was frequently split by heresy – Monophysism, Monothelism, and Iconoclasm – with inevitable repressive measures and counter-measures. For all its snobbish attitude to education and Greek culture, medieval Byzantine society could not avoid a certain disintegration of standards of behaviour. By keeping close watch over the abyss of barbarism the Byzantines hoped to control it and, if possible, baptize it, but in so doing the abyss sometimes enveloped them, and they appear to the modern eye not infrequently as savage and violent as any barbarian. With their fierce, intellectual, gloomy Christianity – neither God nor His Saints ever smiles – went often a concern with magic, prophecy, and all kinds of witchcraft which affected the aristocracy as well as the common people. But the achievement must always be kept in mind; the city itself, the first great stable government in modern history, the rule of law, the diplomatic triumphs from which modern statesmen might learn, a gold currency which was standard for more than eight hundred years, a remarkable civil service open to all the talents, an almost Scottish respect for education, and a way of life which aroused the envy and admiration of all who saw it.[1]

Salonika was to become the second city of the Empire. Like Constantinople it was 'the city guarded by God', with a privileged place 'in the heart of the Emperor'. Galerius built a palace there and raised an arch of triumph; Constantine I made a harbour; Theodosius I fortified the town and made it a seat of imperial government. The city was a military and naval base and a great port and centre of commerce, rich, populous, and proud of its traditions. The rotunda of Hagios Giorgios with its magnificent mosaics was part of the imperial palace, but there were other great churches. The church of the Acheiropoeitos, built about 470, was a galleried basilica with aisles and an inner and an outer narthex. Dedicated to the Virgin – the church is sometimes referred to as that of the Hodegetria – the building housed an icon 'not made by human hands' of the Virgin Hodegetria. The walls were sheathed with marble. The half-dome of the apse and the soffits of the ground-floor arcades were covered with mosaics. Of this splendid late-fifth-century decoration only the soffit mosaics have survived: ornamental patterns of vine and acanthus leaves issuing from vases, geometric and floral interlace inhabited by birds, rosettes, sprays of leaves and flowers, with sometimes a cross in a medallion at the head of the arch. This type of decoration developed from similar patterns in Hagios Giorgios, and since it is to be found at a later date in the ornamental frame of a mosaic in the comparatively humble church of Hosios David, we may assume that there was a local school of mosaicists working at Salonika in the fifth and sixth centuries. The apse of the church of Hosios David in the Latomos Monastery is decorated with mosaic [139] representing the vision of Ezechiel. Christ, beardless, long-haired, cross-haloed, holding a scroll with a text from Isaiah, is seated in a circular mandorla from which emerge the symbols of the Evangelists. The apparition is poised over a terraced landscape bordered by a stream well stocked with fish. On either side Ezechiel and Habakkuk witness the scene, their small scale emphasizing the cataclysmic grandeur of Divinity revealed. Nevertheless, the treatment of the drapery and figure of Christ, of the Angel of St Matthew,

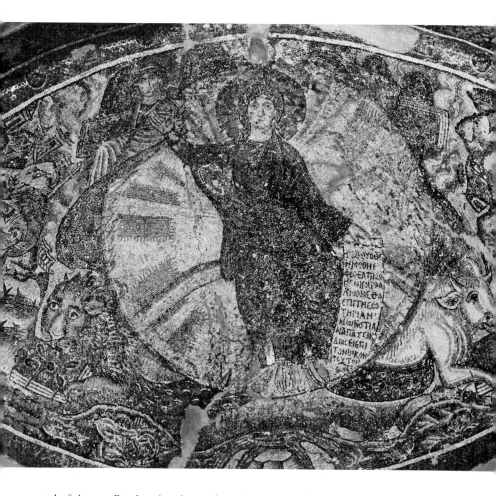

and of the two Prophets is a far cry from the majestic apparitions in Hagios Giorgios a century earlier and approaches the more diffuse linearism of the now lost aisle mosaics in the church of Hagios Demetrios dating from about the late sixth or early seventh century.[2]

Why St Demetrius, an obscure saint martyred in 303, should have become the patron of Salonika has never been satisfactorily explained, although the fusion of pagan divinity and therapeutic cults with that of the Christian martyr seems probable. Tradition states that Leontius, Prefect of Illyricum, was miraculously healed of paralysis at the tomb of the saint and in grati-

tude built a great church about 412–13 over the humble *martyrium*. From this time the cult grew until St Demetrius came to be venerated more than Christ. He saved the city from plague, famine, and the barbarian; he walked on the sea, raising a storm to disperse an enemy fleet; he gave sight to the blind and reason to the insane. He 'dwelt' in a ciborium plated with silver situated on the left side of the nave, and pilgrims flocked from all parts of the Empire to light candles in his presence. The holy oil procured at the 'dwelling' was regarded as a panacea against all evil. In the late sixth and seventh centuries the Slavs and the Avars made six

139 (*opposite*). The Vision of Ezechiel. Mosaic in the apse. Probably sixth century. *Salonika, Latomos Monastery, Hosios David*

140. St Demetrius, a donor, and a child. Mosaic panel in the south aisle. Probably late sixth or early seventh century. *Salonika, Hagios Demetrios*

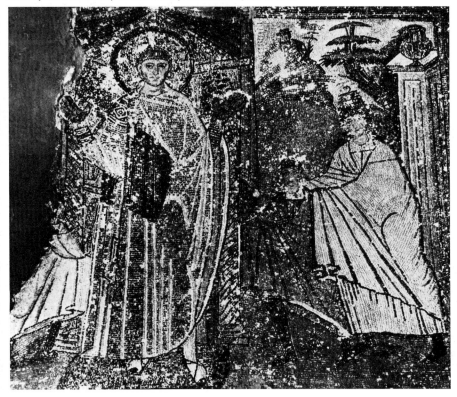

attempts to storm the city and were foiled each time by St Demetrius. The Arabs were powerless against him until 904, when they pillaged the city and sold twenty thousand souls into slavery. There was always the comforting legend that if St Demetrius could not save the city he would die with her. This he was called on to do in 904, in 1185, when the city was sacked by the Normans, and in 1430, when it was finally captured by the Turks.

The church of Hagios Demetrios, a complex cross-transept basilica, must have been one of the most impressive buildings of the Empire. It was burnt down in 1917, and the present church is a brash replica but includes large portions of the original walls, the original columns and capitals, and part of the original decoration. The aisle mosaics, now lost, were all ex-voto panels offered in honour of St Demetrius by the citizens of Salonika and included a Virgin and Child enthroned between angels receiving a citizen presented by the saint, four scenes referring to a miracle worked on an aristocratic young girl, Maria, showing St Demetrius 'dwelling' in his ciborium, and other scenes commemorating St Demetrius's care for children. The style of these mosaics is far from homogeneous, and it is conceivable that they

date from various times ranging from the late fifth into the sixth century. A panel in the south aisle, which has survived the fire, representing St Demetrius, a donor, and a child [140] – the saint standing before his 'dwelling', the donor and the child moving towards him in a stylized landscape – appears from the organization of the form and drapery, the schematic folds, the small heads set on the long ungainly bodies, to date from the late sixth or early seventh century and reflects mannerisms current in Rome. It is, perhaps, useful to remember that for a long time Salonika was under the ecclesiastical jurisdiction of Rome. After a fire which occurred some time between 629 and 634 and a naval attack probably in 647 the church was restored, and a new series of ex-voto panels were commissioned. Medallions containing portraits of the bishop and deacon who held office at the time of the restoration interrupt the earlier decoration in the aisle. These new undertakings reflect the metropolitan style of East Rome as we know it on Mount Sinai and in Cyprus. 'There is in the later panels a firmness and precision of line, a tightness in the overall arrangement, noticeable particularly in the rigid enframement of the figures by their backdrops, a frank and bold use of geometric principles as a positive means of organising forms, and a vigour and liveliness of colour such as cannot be found in the earlier ones. In terms of the Salonikan past, at least as far as we know it, there is a new departure' (Kitzinger). Although some of these new panels continue to stress St Demetrius's interest in children, the portraits of the officials and the inscriptions which accompany them refer not so much to personal favours from the saint as to his actions in the interest of

141. St Demetrius between donors. Mosaic panel. After 647. *Salonika, Hagios Demetrios*

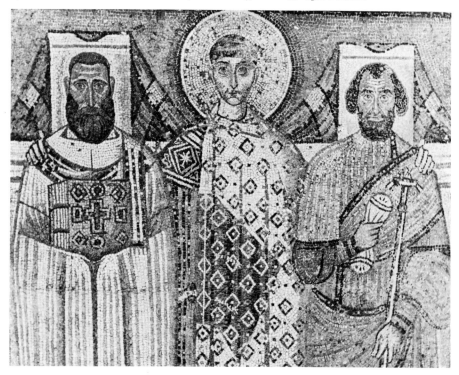

the city. He had averted the storm of the barbarian's fleet and had saved the city. Some of the portraits, therefore, are expressions of official policy, and it is reasonable to suppose that they were inspired by the court art of Constantinople. St Demetrius is still portrayed as an idealized young man in Byzantine court dress, but the donors [141] are revealed as grave, troubled, determined forces quite unlike the vapid symbols of the earlier local phase. More than once in the history of the art of the second city of the Empire metropolitan styles were to intrude among the local traditions. And yet when the Iconoclast Controversy broke out with all the violence of exacerbated puritanism, the traditions of the city were strong enough to keep the church of St Demetrius from harm. In some of the churches images were stripped from their walls, but the 'dwelling' of St Deme-

trius was left untouched, and Salonika remained at heart iconodule and orthodox.[3]

In the metropolis itself very little evidence has survived from the late sixth to the ninth century. The date of a mosaic floor discovered in the area of the Sacred Palace has been the subject of controversy, but it was probably laid down in the second half of the sixth century. It provides a salutary reminder of the complexity of the artistic currents viable in the city. The floor presents scenes of country life [142], reminiscent of the North African and Syrian 'life on the open range' series, in a highly naturalistic style – bodies superbly modelled, drapery worn and felt, complex in movement and posture, varied in tone and shade – all framed in a lush border of acanthus-scrolls inhabited by birds and beasts and occasionally interrupted by a mask peering through foliage. This type of floor

142. Pastoral scenes. Mosaic floor. Second half of the sixth century (?). *Istanbul, Great Palace*

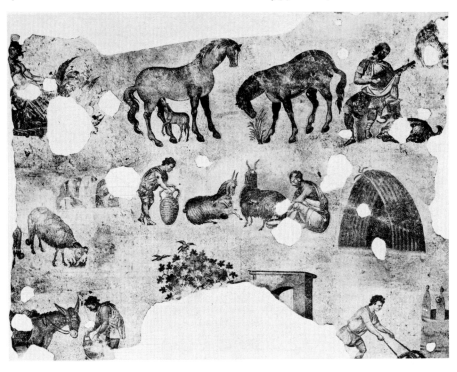

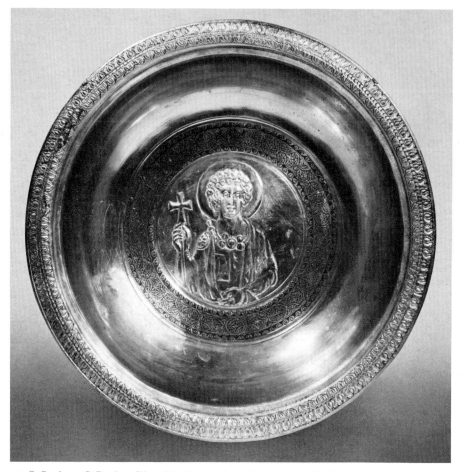

143. St Sergius or St Bacchus. Silver dish. Between 641 and 651. *London, British Museum*

decoration must have been common enough in the palaces at Constantinople; there is no reason to suppose that it was confined to an imperial pavilion. This style – hellenistic, pastoral, idyllic – runs in direct contrast to the modes which were considered suitable for religious and official representation; it is a parallel expression which continued, probably with little change, for several centuries. Nor was it confined to the medium of mosaic. Silver with Heraclian control stamps (610–629/31) is decorated with a wide range of classical imag-ery, pagan gods and goddesses, Silenus and Maenads, Atalanta and Meleager, all chased in a free, naturalistic style in a spirit of pagan revelry far removed from the atmosphere of high-minded gloom suggested by the official portrait or the icon. The standards established by the Heraclian silver were continued in the seventh century. A jug chased with Nereids on sea-monsters, bearing the control stamps of Constans II between the years 641 and 651, is perhaps less elegant in style than the Heraclian silver, but it is wholly classical in spirit. At the

same time a dish chased with the bust of a saint, possibly St Sergius or St Bacchus [143], bearing stamps contemporary with the jug, shows that the synthesis between religious and secular modes established by the Cyprus treasure with scenes from the life of David [84] was maintained in the mid seventh century. Silver, jewellery, and coins apart, there is nothing in any medium which may be assigned with confidence to the metropolis in this century; no building, no wall-painting, no mosaic has survived except for a small mosaic panel recently found in Kalenderhane Camii with a version of the Presentation in the Temple which may date from the seventh or early eighth century. If so, it is the only surviving pre-Iconoclastic programmatic church mosaic in Constantinople and the earliest surviving *Hypopante* representation in Byzantine art. And yet we know that Justinian II in the first part of his reign (685–95), wishing to emulate his distinguished namesake, undertook a number of building enterprises, and by pulling down a church to make room for one of his projects antagonized the clergy of Constantinople. To raise money the treasurer Stephen, a Persian eunuch, and Theodotus, the public logothete, resorted to torture and imprisonment. Overseers and workmen alike were flogged and stoned if they did not measure up to the requirements of the imperial administration. Eventually the people rioted. The Blues led the revolt, releasing from his confinement the general Leontius, who had commanded with distinction in Armenia in 687, and making him Emperor. Justinian was hauled to the Hippodrome, branded on the nose and tongue, and banished to Cherson. The mob wanted his life, but Leontius was firmly clement. The ministers, on the other hand, were handed over to the people, and Stephen and Theodotus were dragged through the streets of the city until they were dead. It is not impossible that the people in their fury tore down whatever Justinian II had put up.[4]

Some impression of the type of mosaic decoration which was fashionable during the reign of Justinian II may perhaps be gained from

work done under the Umayyad Caliphs at Jerusalem, Bethlehem, and Damascus. By the end of the seventh century the Caliphs were trying to emulate the Byzantine Emperors. Not only did they adopt Byzantine techniques of administration, Byzantine legal usage, and the collection of revenue, but they were also determined to erect religious monuments which were imperial in scale. The annual attacks on Constantinople showed clearly enough that the Caliphate hoped to establish its own imperial dynasty in the metropolis. After Leo III's resounding defeat of Islamic power in 718 the Umayyad Caliphate abandoned this ambition and concentrated their attention on the eastern provinces. If they could not rule at Constantinople they might assimilate the heritage of the Sasanid kings of Persia. Before this switch of policy, which was to be confirmed by the Abbasid dynasty ruling from Baghdad after 750, the pseudo-imperial monuments had been built: the Dome of the Rock in the Haram ash-Sharif at Jerusalem, the great mosques at Medina and Damascus. The Dome of the Rock was built by 'Abd al-Malik about 690; the mosques of Damascus and Medina were built by his son al-Walid I between 705 and 712. While there is no textual reference on the source of the decoration of the Dome of the Rock, there is clear evidence that the Caliph asked and obtained help from the Byzantine Emperor in decorating the mosques at Medina and Damascus. One source, al-Tabari (d. 923), based on a good tradition, states that the Emperor sent 100,000 *mithqals* of gold, 100 workmen, and 40 loads of mosaic cubes. Another source, supported by an imposing list of excellent authorities, reports that the Emperor sent loads of mosaic cubes and some twenty-odd workmen – 'but some say ten workmen, adding "I have sent you ten who are equal to a hundred", and [sent also] 80,000 dinars as a subvention for them'. It seems, therefore, reasonable to suppose that the mosaic decoration now surviving in the Dome of the Rock is Byzantine in spirit and Byzantine in execution. The lush acanthus-scrolls in green and gold, the jewelled

trees hung with Byzantine and Sasanid imperial insignia, the florid palmettes, the vases studded with pearls are an elaboration of the mosaic decoration in a room over the south-west ramp in Hagia Sophia and the border of the mosaic in the Sacred Palace at Constantinople. The architectural fantasies and idealized landscapes in the courtyard of the Great Mosque at Damascus are in direct line of descent from those of Hagios Giorgios at Salonika. For all the proud assertion of the Kufic inscription coursing round the walls of the Dome of the Rock that the Divine Person is a unity, the ornament, paradisal, reminiscent of ciboria, canon tables, perhaps even local *martyria* and *memoriae*, is redolent of Byzantine Christianity.[5]

The church of the Nativity at Bethlehem was in the peculiar position of being shared by Christian and Muslim. The Caliph Omar after the fall of Jerusalem had agreed to this double occupation in 638. The south side of the transept, which faced Mecca, was reserved for Muslim worship; the rest of the church was left to the Christians. The basilica had been a Constantinian foundation, but Justinian rebuilt it in the sixth century, though some consider that it was in part based on the church of the Virgin in the Blachernae at Constantinople remodelled in the reign of Justin II. The mosaics covering the walls of the nave, now in wretched condition, were restored in the twelfth century, but the originals representing the six General Councils of the Church and six provincial councils must date from shortly after the Quinisextine Council at Constantinople in 692. The councils are represented by schematic evocations of the church in which they took place with the name of the city above the roof. Below, the Gospels are displayed on an altar beneath a baldacchino, and in the space between the altar and the arch of the baldacchino inscriptions summarize the decisions of the Council. In between the symbols of the Councils there may be a large jewelled cross before a stylized landscape or complex 'pillars' of vases, splayed Sasanid wings, foliage, jewels, or splayed acanthus leaves similar to the decoration in the Dome of the Rock. Presumably the craftsmen

who worked at Jerusalem in 691 went on to Bethlehem some time after 694. The fashion for representing the Councils of the Church was already current at Constantinople. In the tetrapylon known as the Milion, from which all roads of the city and the Empire branched, the vault was decorated with mosaics (or paintings) representing the six General Councils of the Church, and similar images were commissioned for the Sacred Palace. Presumably these images were produced shortly after 694; they were imitated at Rome in the narthex of St Peter's in 712 after the concordat between Justinian II and Pope Constantine, and at Naples in the church of St Peter about 766-7. Since the seventh century it had become the custom at Constantinople to pin up the decrees of the Councils in the narthex of Hagia Sophia, but the choice of the Milion, which bore at the same time the figures of Constantine and Helena, holding the True Cross, and the Tyche of the city, suggests that more than dogmatic information was intended: it was a political manifesto with some magical implications. Constantine V, the most thorough of the Iconoclast Emperors, had no hesitation in removing these images and replacing them with a portrait of his favourite charioteer amid sporting events in the Hippodrome. The games here were sponsored by the imperial administration and were a manifestation of imperial benevolence. The new images were by no means the expression of frivolity; they were a form of imperial propaganda.[6]

The rumblings of Iconoclasm had begun in the early eighth century. Justinian II was the first Emperor to introduce the image of Christ on the Byzantine coin, and during his reign two different types were prevalent: one full-bearded, long-haired – the classic type of Christ Pantocrator – and the other slightly bearded, with short curly hair. But these images were not retained by Justinian's immediate successors. The coins of the Emperors immediately preceding the Isaurian or Syrian dynasty, those of the Armenian Philippicus Bardanes (711-13), of Anastasius II (713-16), and Theodosius III (716-17), showed a cross potent on steps instead of the two types of Christ, and this version

was maintained throughout the Iconoclast period. There were variants, but these reflect dynastic rather than religious policy. Philippicus Bardanes had refused to enter Constantinople until the image of the Sixth Council (680–1) had been erased from a wall in the Sacred Palace, but, since he also insisted on the names of Sergius and Honorius being reinscribed on the diptychs and their portraits reinstated in churches, this was more an expression of Monothelism than Iconoclasm. When the Syrian Emperor Leo III (717–41) came to the throne after twenty years of anarchy and revolution, his immediate tasks were to provide for the defence of the frontiers, to check Arab aggression, which threatened the metropolis a few months after his accession, and to consolidate the new dynasty by restoring the prosperity of the Empire. Within a year the Arabs suffered a crushing defeat and, although they remained formidable during the reign of Leo and his son Constantine, their attacks came to nothing. The collapse of the Umayyad dynasty in 750 followed by the removal of Islamic power from Syria to Mesopotamia set the seal on these defeats. To reassert the imperial administration and to defend the frontiers Leo III extended the system of the themes, reducing them in size, and took care that the governors were capable and loyal. From these themes Constantine V was able to draw contingents to form an imperial army removed from the influence of local leaders and provincial ties. To cover the heavy costs of administration and the army Leo had to resort to severe, sometimes illegal, taxation, which led to a serious clash with Pope Gregory II long before the Iconoclast Controversy.

The Controversy involved more issues than an attack on the superstitious practices connected with images. There was an attempt to reassert imperial power over the Church and a direct attack on the monasteries, their immunity from taxation, their drain on the manpower of the Empire, and their influence, which frequently opposed the imperial will. The new men at the head of the administration were drawn largely from the Eastern provinces, which had long been hostile to the veneration of images. To them the Iconoclast edicts were an attempt to purify a religion which had become sullied by superstitious, magical practices. Ironically enough, Leo III, a great statesman and general, was led to take the first steps in the Controversy by a serious volcanic eruption between Thera and Therasa in 726, which he regarded as an expression of the wrath of God. The consequences were in many ways disastrous. At Constantinople the people led by the women rioted, and the Patriarch Germanus refused to agree with imperial policy. Greece and the Cyclades set up a rival Emperor, although the rebellion was quickly crushed by the imperial army and the fleet. In 730 Germanus the Patriarch was deposed and the Iconoclast Athanasius elected in his place. There was universal outcry in Italy. Pope Gregory II, already on bad terms with the imperial government, excommunicated the exarch, refused to recognize the new Patriarch, and denounced the decrees as heresy. In 731 Pope Gregory III called a synod to Rome, where all Iconoclasts were excommunicated. To Leo this was impudent rebellion. He dispatched the fleet on a punitive expedition, but a storm in the Adriatic created havoc among the ships. In 738 Gregory III appealed to Charles Martel. In fact, the decree of 730 was enforced with moderation. There was no systematic persecution. When Leo III died in 741 the Patriarch's palace and many of the churches in Constantinople still retained their mosaics and wall-paintings. The chief cause for scandal was the portable icon with its magical powers of speaking, bleeding, moving, and curing.

Even Constantine V (741–75), one of the ablest of the Iconoclast Emperors, adored by the largely Iconoclast army, took his time over enforcing the decrees. The revolt of his brother-in-law Artavasdus, supported by the Iconodules, shortly after Constantine had left the city to lead a campaign against the Arabs, might justifiably be regarded as a stab in the back, but after its suppression the Emperor turned to more important matters: the safety of the frontiers and the prosperity of the Empire. In a series of campaigns against the Arabs he estab-

lished Byzantine power to such an extent that by 757 the mere mention of his name caused them to lose heart. Nine campaigns against the Bulgars made them sue for peace in 765, and a final victory in 772 earned him a triumphal entry into Constantinople. The finances of the Empire were maintained by severe taxation and strict government. When Leo IV inspected the treasury after his father's death he was gratified by the sight of an immense store of gold. And yet Constantine kept great state in the Sacred Palace and sponsored buildings and secular works of art, including imperial portraits to which honours were paid *in loco majestatis*. Nothing has survived. He had received the education considered suitable for a Byzantine prince and was, therefore, a man of letters and a theologian. He considered the cult of the Virgin and the saints as useless as the monks themselves and wrote sermons on the matter which were ordered to be read in churches. He disapproved strongly of men withdrawing from the world, from official life, from service in the army, and he extracted an oath from his devoted troops that they would have nothing to do with images or monks. In 753 Constantine called a council to consider the worship of images. The bishops attending refused to accept the Emperor's views on the Virgin and the saints, but they excommunicated all Iconodules and recommended further that they should be punished by the secular authority. But serious persecution did not begin until 765. 'In that year', wrote Theophanes, 'the Emperor raged madly against all that feared God.' All the churches in Constantinople were stripped of their decoration, some of them, like St Euphemia, were secularized, and all writings in favour of images were ordered to be destroyed. Icons, relics, amulets were ferreted out and the owners punished by blinding, branding, nose-slitting, tongue-cutting, or flogging. Constantine tried to destroy the monastic order. The property of the monks was confiscated, monasteries were secularized, some were turned into barracks, others handed over to private persons. Not only the monks but many high officials suffered martyrdom in the Hippodrome; others fled to Italy.

With the accession of Leo IV (775–80) there was a merciful lull, but towards the end of his reign the persecutions were renewed. After his death the Iconodules could breathe again. The Empress Irene the Athenian was determined to return to orthodoxy, and after careful preparation the seventh General Council of the Church was held at Nicaea in the presence of papal legates in 787. Within a month the Council recommended the veneration of images, worked out doctrine to support it, and considered matters of ecclesiastical discipline. It was a triumph for the Empress Irene, for Plato, Abbot of Sakkudion, and for his nephew Theodore of the monastery of St John of Studius, where already in 786 the monks had been reinstated. When the old controversy broke out anew under the Armenian Emperor Leo V in 815, the monks of the Studion defied the Emperor and were again dispersed, but a palace revolution set the Phrygian Michael II (820–9) on the throne and the exiles were recalled. Under his son and successor Theophilus (829–42) persecutions were renewed with bouts of savagery and terrorism, but orthodoxy had by now gained both confidence and ground. There was a strong body of opinion in the Sacred Palace in favour of the forbidden images. Even before the death of her husband, whom she loved and respected, the Empress Theodora and her daughters prayed secretly before icons in their apartments, and it was during the period of her regency that orthodoxy was finally restored in 843.[7]

Like Constantine V, Theophilus had kept great state. He made a number of alterations in the Sacred Palace; new pavilions were built and decorated with marble, mosaic, or wall-painting, and given romantic names, Love, the Pearl, Camilas, Mousikos, and Harmony. Ambassadors to the Abbasid court at Baghdad were instructed to take note of palaces, decoration, ceremony, and dress. The palace at Bryas on the Asiatic coast opposite the metropolis appears to have been a copy of an Abbasid building. Abbasid silks were imported for new fashions in dress at the court. Following Abbasid court ritual, which was based on Sasanid ceremony,

Theophilus placed in the Magnaura, one of the halls of audience in the Sacred Palace, a golden plane-tree on which perched golden birds near to the golden throne itself supported or flanked by lions and griffins in gold. In the same hall were two organs gleaming with enamels and precious stones, and the Pentapyrgion, which housed part of the imperial regalia. Many of these were automata. When the Emperor gave audience in the Magnaura, during the acts of proskynesis, the birds sang and fluttered their wings, the lions roared and thrashed their tails on the ground, the griffins reared up and pawed the air, and the throne itself soared into space with the Emperor seated upon it like a great golden idol. Later in the century, when hard up for money to pay the army, Michael III melted down the gold automata, including the tree, the lions and griffins, and they were not replaced until the tenth century. There is considerable evidence of Byzantine and Arab study of hellenistic technical writers, particularly Heron of Alexandria, whose most popular works were the *Pneumatica* and the *Automata*. Hydraulic devices were common enough in Constantinople. Chinese ambassadors from the T'ang court have left a description of the city: 'There is a gate two hundred foot high, entirely covered with bronze [the Golden Gate]. In the imperial palace there is a human figure of gold which marks the hours by striking bells. The buildings are decorated with glass and crystal, gold, ivory, and rare woods. The roofs are made of cement and are flat. In the heat of the summer machines worked by water power carry up water to the roof, which is used to refresh the air by falling in showers in front of the windows.' Interest in automata naturally coincided with the invention and construction of engines of war. The use of Greek Fire and the development in the methods of throwing it had been a major factor in Leo III's defeat of the Arabs in 718. The perfection of siege instruments for defence and attack, the system of Byzantine fortification which preserved the city for centuries, depended on Byzantine interest in mechanics and logistics. In this they were more advanced than their neighbours.[8]

Nothing has survived of all these wonders. From the Iconoclast period no mosaic, except for a representation of a large cross in the church of Holy Peace and some crosses let into mosaic in a room over the south-west ramp in Hagia Sophia, remains in the city. Vestiges of an Iconoclast cross could once be seen in the apse of the now destroyed church of the Dormition at Nicaea, and other vestiges may still be seen in Hagia Sophia at Salonika. It is possible that this church was built in the early eighth century, but the decoration of the apse and vault of the choir is dated by inscription to the reigns of the Empress Irene and her son Constantine VI, with whom Bishop Theophilus is associated, between 780 and 797. In spite of the Iconodule policy of the Empress there were no images of saints in this decoration, which consisted of a large cross in the conch of the apse and a green and gold 'carpet' of mosaic in the vault: an all-over pattern of small crosses, geometric devices, and stylized leaves. According to imperial custom Irene was prepared to set up her own image and that of her son in mosaic. Such a portrait was commissioned for the convent of the Virgin of the Spring outside Constantinople after the waters of the spring had miraculously cured the Empress of a haemorrhage which threatened her life. On two sides of the church Irene and Constantine were depicted bearing in their hands offerings, presumably in the tradition of the imperial portraits at Ravenna. In addition the Empress gave to the convent vestments and curtains in cloth of gold and, jointly with her son, offered a crown and liturgical vessels, also gold, with precious stones and pearls. These gifts were in the tradition of imperial largesse and had little bearing on the Iconoclast Controversy. The bronze doors at Hagia Sophia bear the inscriptions of Theophilus, Theodora, and Michael III; the doors themselves are of earlier date and were only restored in 841. A copy of Ptolemy's astronomical writings (Vatican, cod. gr. 1291) may be dated to the years 813–20, but by its nature offers little evidence of the state of the arts in Constantinople apart from showing in that category the maintenance of a Late Antique tradition.[9]

A few textiles preserved in the West, mainly with secular subjects, may date from the Iconoclast period. The great imperial silk from Mozac [144], now at Lyon, woven with two Augusti on

Pepin from Constantine V in the middle of the eighth century. The Emperors, beardless, wear stiff, heavily ornamented dress, and their stylization contrasts with the naturalistic treatment

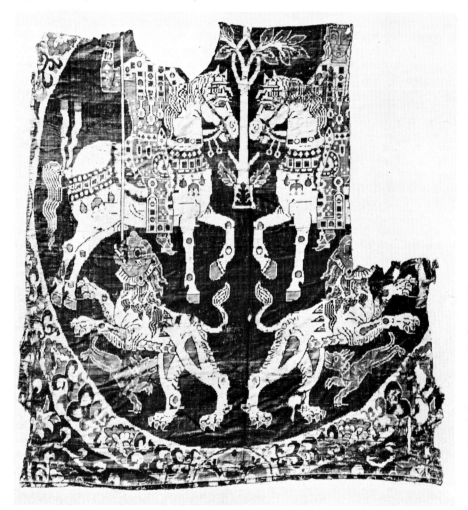

144. Emperors hunting. Silk compound twill.
Constantinople, mid eighth century.
Lyon, Musée Historique des Tissus

horseback spearing lions, is traditionally supposed to have been wrapped round a relic presented by Pepin the Short; the silk was a gift to

of the horses, which are caparisoned in the Persian manner. The Charioteer silk [145], divided between Aachen and the Musée de Cluny, Paris, which probably came from the tomb of Charlemagne (d. 814), also combines 'hellenistic' and Persian motifs and appears almost certainly to have been woven at Constantinople in the late

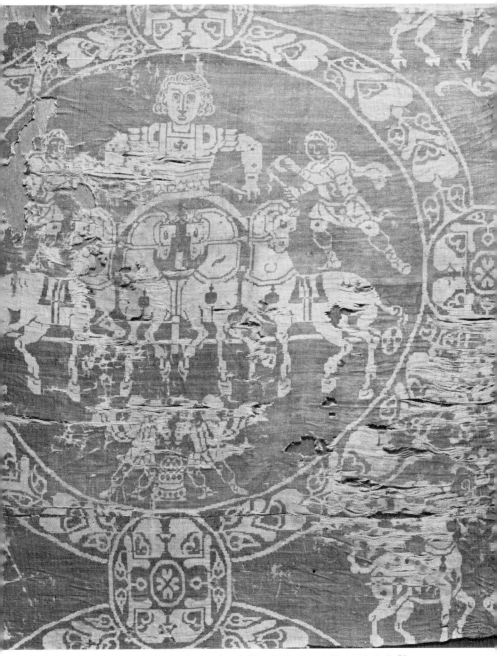

145. A Charioteer. Silk compound twill. Constantinople, late eighth century. *Paris, Musée de Cluny*

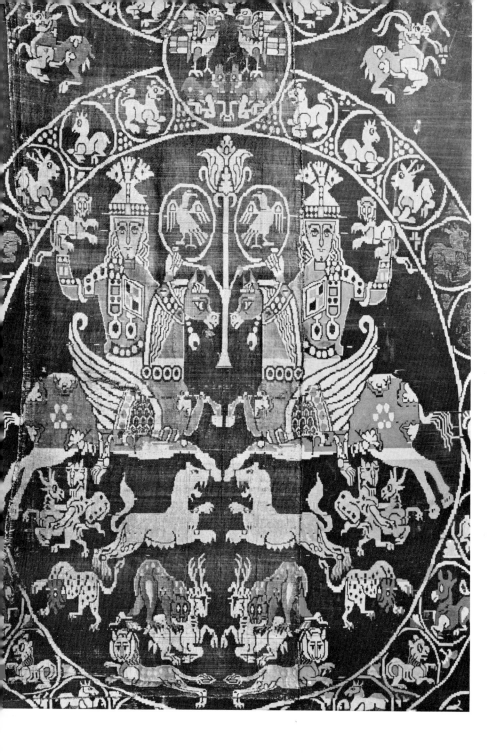

eighth century. A quadriga silk with the figure of an emperor in fragmentary condition, found in a shrine at Verdun, now in the Victoria and Albert Museum, also seems to date from this time or into the ninth century. A silk woven with a lion and leopard hunt in which the hunters appear to be imperial, found in the Sancta Sanctorum at Rome, is coarser in style and may be of later date, but the workshop was probably at Constantinople. A group of large 'royal hunting' silks produced under strong Persian influence with the hunters sometimes wearing Sasanid regalia [146] appears to date from the eighth or ninth century, but their provenance is uncertain. An important series of polychrome silks on a red ground has been assigned to various dates from the sixth century onwards. They include an Apotheosis scene found in the shrine of St Landrade, abbess of Münsterbilsen (d. about 680-90), and of St Amour, deacon and confessor at Liège in the ninth century, a lion-strangler, of which examples have been found at Chur, Trent, and Ottobeuren, and the finest of them all, an Annunciation and Nativity silk [147, 148] from the Sancta Sanctorum. In this group there is a marked variation in quality, and it may be that some of the silks were woven in the provinces. An entry in the *Liber Pontificalis* refers to a textile woven with the scenes of the Annunciation and the Nativity which was presented by Pope Leo III (795-806). The Trent silk lines the book-cover of a ninth-century Gregorian Sacramentary. The Ottobeuren silk is connected with a tradition that it served to wrap the relics of St Alexander when they were brought in the time of Charlemagne from Rome to Vienne and from there by Toto, first Abbot of Ottobeuren, to his abbey. All this circumstantial evidence suggests that the silks date from the late eighth or early ninth century and, if they were produced at Constantinople, as seems likely, are indicative, in the case of the Sancta Sanctorum silk, of a return to images shortly after the Council of Nicaea in

787. It is equally possible that this type of silk was woven well into the ninth century. From what we know of later Byzantine silk production, once a pattern had been established the looms repeated it over a considerable span of time.

One of the first images to be reinstated after the return to orthodoxy in 843 was that of Christ over the Chalke Gate, for which the Patriarch Methodius (843-7) composed an epigram. But it took time, apparently, before an extensive programme of religious decoration could be implemented. In the Sacred Palace the Chrysotriclinion was decorated between 856 and 867, after the retirement of the Empress Theodora, since she is not mentioned in the epigrams, and another hall also before 867. New work in the church of the Theotokos of the Pharos was completed by 864. Mosaics in Hagia Sophia were not begun until shortly before 867 and were probably not completed before the end of the century. During the ten years (856-66) that Theodora's brother Bardas exercised supreme power there was a great intellectual revival. Theophilus had done much to encourage this revival, but Bardas founded the school of the Magnaura, where he gathered the most distinguished scholars of the day. Leo of Salonika, one of the outstanding minds of the ninth century, skilled in mathematics, medicine, and philosophy, was made director, and with him were associated professors of geometry, astronomy, and philology. Bardas visited the school constantly, and under his influence the renewal bore a marked secular and classical character, causing some alarm in ecclesiastical circles. The brilliant, learned, and unscrupulous Photius owed his elevation to the patriarchate to the Caesar Bardas. Between them they accomplished the conversion of the Slavs. Bardas and Photius sent Constantine, later known as Cyril, who was then teaching philosophy in Constantinople, and his brother Methodius to apostolize the barbarians. They were natives of

146. Emperors hunting. Silk compound twill. Constantinople (?), late eighth or ninth century. *Berlin, Ehemals Staatliche Museen*

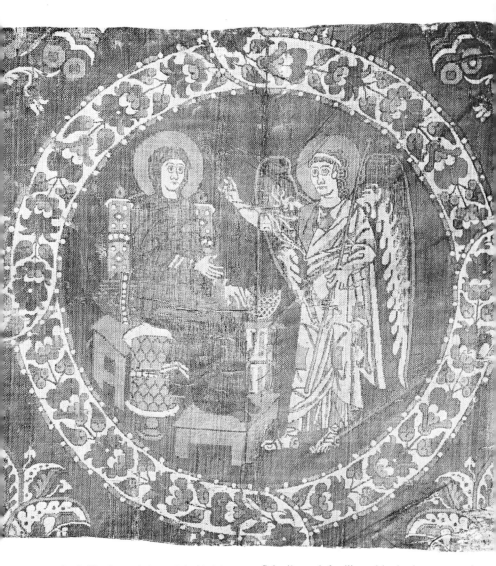

147 and 148. The Annunciation and the Nativity.
Silk compound twill.
Constantinople (?), late eighth or ninth century.
Vatican, Museo Sacro Cristiano

Salonika and familiar with the language and
customs of the Slavs. They translated the Gos-
pels into a Slav dialect in a script which they
invented, they preached in Slav, introduced a
Slav liturgy, and trained Slav priests. In 864 the
Tsar Boris of Bulgaria was baptized, and in
spite of the resistance of the Bulgar aristocracy,
he compelled his people to adopt Christianity.

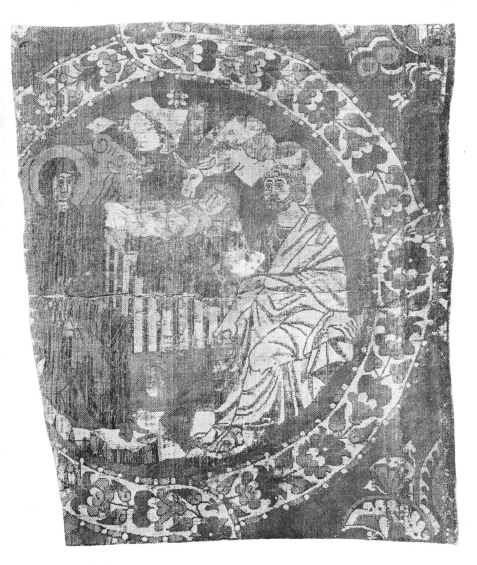

These two conversions were a triumph for the Byzantine administration. Both Bardas and Photius were keenly aware of their importance. The prestige of the Empire had been notably increased. The Bulgars were still to be a menace to the peace of the Empire, but their adoption of Christianity placed in the hands of the imperial administration a diplomatic trump card which more than once saved the city. The great Byzantine glories of the tenth century, the so-called 'Macedonian Renaissance', owe much to the influence of the Caesar Bardas and the Patriarch Photius. Moreover, there was to be little or no interruption in this intellectual and artistic hegemony until the Franks and the Venetians destroyed it in 1204.[10]

THE TRIUMPH OF ORTHODOXY

The triumph of Orthodoxy was celebrated on the first Sunday in Lent, 11 March 843, and has remained one of the great feasts of the Eastern Church. The Empress Theodora had insisted on certain conditions, of which the main theme was the necessity for moderation, and these had been accepted by the Patriarch and the Church. But throughout the ninth century the peace of the Church was troubled by the conflict between the extreme party of Iconodules, based for the most part on the monastery of St John of Studius, and the moderates, who were as a rule the court party. The conflict was further complicated by the ambitions of the protagonists, both ecclesiastical and lay, the incompatibility of temperaments between good men on both sides, and the rivalries of court factions intriguing round a young Emperor, dissolute and a sot, who seemed to be incapable of fulfilling his destiny and went out of his way to affront the dignity of the Church. Some reflection of the bitterness of the religious conflict may be seen in the decoration of a small group of psalters – the Chludov Psalter, Pantocrator 61, and Paris, gr. 20 – dating probably from the second half of the ninth century but believed to be copied from a prototype worked out in the patriarchal offices at Constantinople either by Methodius (843–7) or during the first term of Photius (858–67). The decoration of these psalters consists of small illustrations, probably as many as three hundred, set in the margins of the page adjacent to the text and representing scenes from the Old and New Testaments. In addition a number of the scenes refer to the struggle over images, in particular the Council of 815 and the final victory of the Iconodule Patriarch Nicephorus over the Iconoclast Patriarch Theodotus (d. 821), the Emperor Leo V, and John the Grammarian, who had been active against images from 813 and became

Patriarch in 837. The artist represents in the spirit of a modern cartoon Nicephorus, sometimes holding an icon of Christ in his hand, trampling on his adversaries [149], an indignity which not even the Emperor was spared, while John the Grammarian is given diabolical traits. Later, in 1066, this type of psalter was to be copied in the monastery of Studius, where Theodore of Caesarea, probably on the instructions of the *synkellos* Michael, then introduced in his pictures Abbot Theodore of Studius, implying that he was just as important in the Controversy as Nicephorus. Now the Studite monks had not always seen eye to eye with Nicephorus, and their attitude to Methodius verged on rebellion. The Studite copy (British Museum, Add. MS. 19352) is the only one of the sequence of psalters which deliberately elevates Theodore of Studius in this manner, which suggests that the prototype was not Studite. It has been argued cogently that Methodius, who in his early years had copied psalters, is the most likely person to have worked out the programme of illustrations – not only to celebrate the triumph of Orthodoxy but as propaganda for the theological justification of image worship against entrenched Iconoclasts and to glorify Methodius's teacher Nicephorus in the teeth of Studite opposition. Although copies of the prototype were made as late as the thirteenth century – for example, the Hamilton Psalter (Berlin, Staatliche Museen, Kupferstichkabinett, 78 A.9) – it is hard to believe that these psalters had a wide circulation. The propaganda, if such it was, cannot have been intended for the general public but only for a small circle of ecclesiastics with access to the material. Nevertheless, the complexity of the programme required a number of scribes and artists and a large reference library for the selection of pictorial models. This small group of ninth-cen-

149. The Patriarch Nicephorus triumphant over John the Grammarian. From the Chludov Psalter, MS. 129 D, fol. 51 verso. Second half of the ninth century. *Moscow, Historical Museum*

tury psalters embodies the earliest Byzantine examples of the genre to have survived, and it is difficult at the present extent of our knowledge to establish the nature of the models used. Certain small scenes – the Last Supper, for example – echo similar scenes in the sixth-century purple codices, but the general principle of marginal decoration, the vivid colours, the sketchy, impressionist technique recall the illustrations in the margins of the canon tables of the Rabbula Gospels. No doubt a fully illustrated pre-Iconoclast psalter provided the main model, but the polemical scenes are clearly 'inventions' of the ninth century.[1]

Moreover, this polemical aspect of Byzantine art in the ninth century was not confined to a small group of psalters. It seems probable that the rival factions produced single pieces of pictorial propaganda which were designed for the general public or with a single recipient in mind. During the unedifying struggle between the rival Patriarchs Ignatius and Photius a friend and colleague of the latter, Bishop Gregory Asbestas, prepared with his own hand the illustrations of a luxurious publication of the acts of a local council at Constantinople with the intention of discrediting Ignatius. Like John the Grammarian Ignatius was associated with the Devil. This glossy expression of ecclesiastical venom was destined for the attention of Pope Nicholas I, but it never reached him. In 861, as soon as the Ignatians were in power again, the offending images were destroyed. Nor were polemics confined to parchment, paint, and astringent verse. When the Chrysotriclinion in the Sacred Palace was redecorated with mosaic between the years 856 and 867 – probably about 859, the time of Photius's enjoyment of supreme power with the Caesar Bardas – the figure of Christ enthroned was set in mosaic as in former times over the imperial throne and above the door opposite was placed the Virgin – the epigram in the Palatine Anthology stresses that the Virgin was a sacred gateway which referred, of course, to the Incarnation – and at her feet were portrayed Michael III, the Patriarch, and other Iconodule notables. The simultaneous appear-

ance of the Emperor and the Patriarch in one of the principal halls of state in the Sacred Palace is interesting because during the second half of the ninth century the principle of diarchy, the theory of two powers, spiritual and temporal, was much in the air. The theory was published in the *Epanagoge*, certainly the work of Photius, which served as an introduction to the *Basilica*, a manual of law finally issued under Leo VI. The rights and duties of Emperor and Patriarch were defined in a manner which must have given great satisfaction in Rome, since the independence of the spiritual power was carefully stressed, but cannot have given pleasure to the imperial administration. In fact, the distasteful theory which verged on treason was quietly shelved. In 886, when Leo VI came to the throne, he lost no time in deposing Photius and replaced him with his own brother Stephen, then nineteen years of age. The appointment had already been planned by Basil, and it is clear that the imperial administration was not prepared to tolerate a patriarch determined to overreach his position and resist the imperial will. Later Romanus I was to repeat the policy and assigned his young, wholly unsuitable son Theophylact to the patriarchal throne. However unworthy the appointment, it was essential for the Vicar of God to be master in his own house.[2]

Naturally, luxurious illustrated manuscripts were prepared with the express intention of flattering the imperial person. The splendid copy of the Sermons of St Gregory Nazianzen (Paris, gr. 510) executed for Basil, who could neither read nor write, is unique among the manuscripts of the homilies. Because of the por-

150. The Vision of Ezechiel in the Valley of Dry Bones. From a copy of the Homilies of St Gregory Nazianzen, MS. gr. 510, fol. 438 verso. Between 880 and 882. *Paris, Bibliothèque Nationale*

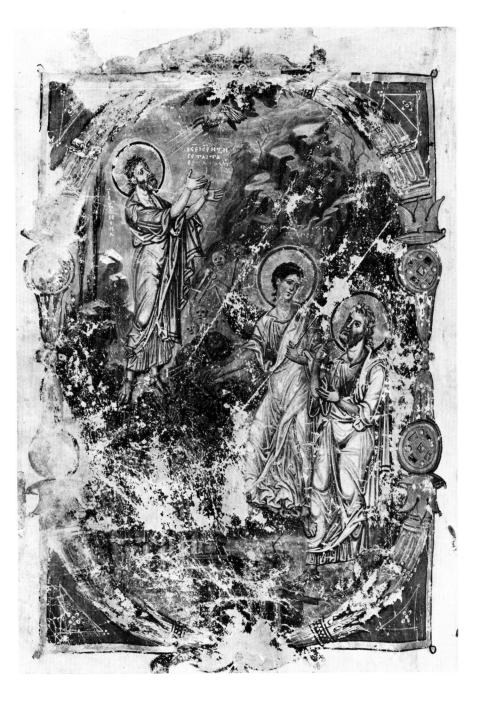

traits of Basil, his wife Eudocia Ingerina, and their sons Leo and Alexander the manuscript may be dated between the years 880 and 882, since it evidently predates the marriage of Leo VI and Theophano which took place in that year, or even 879 because of the portrait of Constantine, and in the illustrations to the text more than once the idea of the Emperor as defender and propagator of the faith, the successor of Constantine the Great, is underlined. The approach to the illustrations is similar to that in the psalters, with the same interest in theological speculations and echoes of contemporary events. It is clear that during the preparation of the manuscript old models of varying dates and origins were consulted, including an illustrated Life of St Gregory Nazianzen by Gregory Presbyter, an illustrated history of the Christian emperors as well as the Old and New Testaments, but in some cases the artists were not just passive interpreters; they adapted their models to suit a particular scene. A variety of styles in the manuscript suggests a number of artists as well as models, but above the often ponderous rescripts may be sensed an atmosphere of novelty. The entire conception of the illustrations as theological exegesis, demanding great learning and subtle thought in the selection of subjects, appears to be new. The influence of Photius, the most learned man of his time and, while the manuscript was being prepared, reconciled with Basil, seems probable; he is known to have greatly admired St Gregory Nazianzen. There is also a strong sense of classical revival in some of the miniatures, particularly in the well-known Vision of Ezechiel [150], where the modelling of the faces, the soft, fluttering drapery, the feeling for form, the illusion of landscape propose that at least one artist was thinking quite freshly about his prototype.[3]

Much in the same spirit and close in style, dating possibly from a few years earlier than the copy of the Sermons of St Gregory Nazianzen, a copy of the Christian Topography of Cosmas Indicopleustes (Vatican, gr. 699) is of cardinal importance for our understanding of Byzantine style in the second half of the ninth century. The original was written between 543 and 552 at Alexandria and is a strange mixture of pseudo-science, Chaldaean legend, religious doctrine, and theories of a Christian cosmogony based on the Scriptures. Photius held the work in low repute, but others must have thought differently, since Vatican gr. 699 is one of the most splendid of Byzantine manuscripts, and more handsome copies, now in Florence (Laurenziana, Plut. IX, cod. 28) and on Mount Sinai (cod. 1186), were produced in the eleventh century. The illustrations are equally varied: Ptolemaic maps, plants, animals, cosmographic diagrams, portraits of prophets, and large symbolic scenes from the Old and New Testaments. Theological exegesis comes to the fore again. Melchisedek, portrayed as a sixth-century Augustus, bearded, wearing the diadem and the imperial chlamys, represents the eternal priest-king, the Sacrifice of Isaac is the type of the Passion, the Ascension of Elijah is the type of the Ascension of Christ. In all these scenes blows a strong classical wind, Abraham splendidly hellenistic with flowing hair and beard, drapery crumpled and flying in movement, Isaac [151] represented with a modelling of limb and face which recalls the sixth-century mosaics in the Sacred Palace, and the superb Conversion of St Paul with its mixture of proskynesis, declamation, and conversation. On the other hand, the various visions of Christ enthroned – Isaiah, Ezechiel, and the Resurrection of the Dead [152] – establish the ninth-century shape of Divinity as it was portrayed in the churches of Constantinople and Salonika. Indeed, the Resurrection of the Dead mapped out in tiers of angels, prophets, and saints in descending order is a microcosm of a certain type of contemporary church decoration. The magnificent page with the portraits of Anna and Simeon in roundels, echoing no doubt current types of circular icon, of which none have survived, and the full-length figures of the Virgin, Christ, St John the Baptist, Zacharias and Elizabeth not only look back to the wall-paintings in S. Maria Antiqua in Rome but straight ahead to the prophets and saints which were

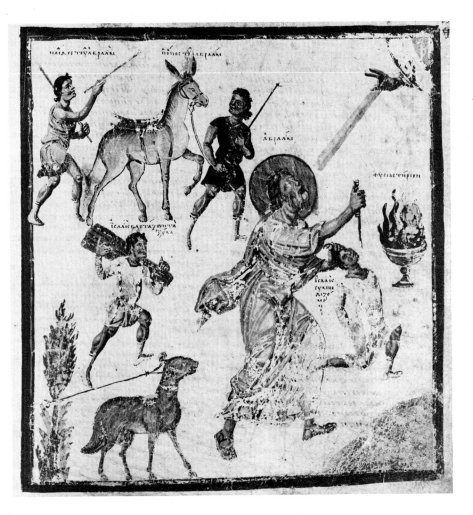

151. The Sacrifice of Isaac. From a copy of the Christian Topography of Cosmas Indicopleustes,
MS. gr. 699, fol. 59 recto. Second half of the ninth century. *Vatican, Biblioteca Apostolica*

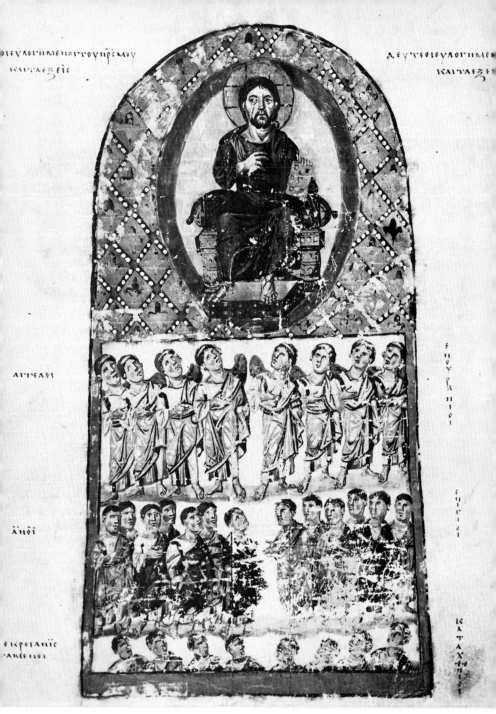

152. The Resurrection of the Dead. From a copy of the Christian Topography of Cosmas Indicopleustes, MS. gr. 699, fol. 89 recto. Second half of the ninth century. *Vatican, Biblioteca Apostolica*

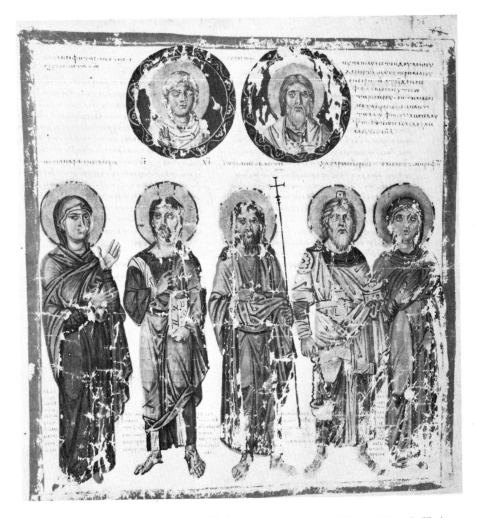

being set up in mosaic there and then in Hagia Sophia at Constantinople. These truly monumental figures might well have stepped down from the walls of a church [153]. Severe, sombre, devoid of emotion, Divinity and the attendants of Divinity were revealed as a solemn statement of fact before which the denials and jeers of the Iconoclasts were intended to evaporate like the smoke which had at one time consumed the holy images.[4]

On 29 March 867 Photius had delivered a sermon in Hagia Sophia before the Christ-

153. Above, Anna and Simeon; below, the Virgin, Christ, St John the Baptist, Zacharias and Elizabeth. From a copy of the Christian Topography of Cosmas Indicopleustes, MS. gr. 699, fol. 76 recto. Second half of the ninth century.
Vatican, Biblioteca Apostolica

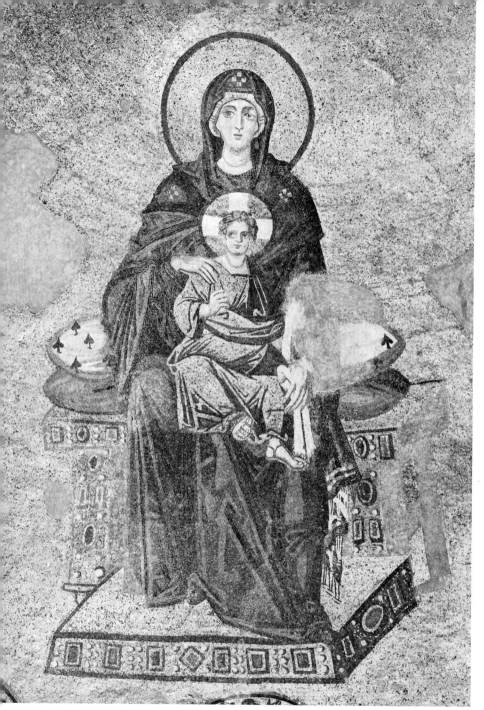

154. The Virgin and Child enthroned. Detail from the mosaic in the apse. Before 867.
Istanbul, Hagia Sophia

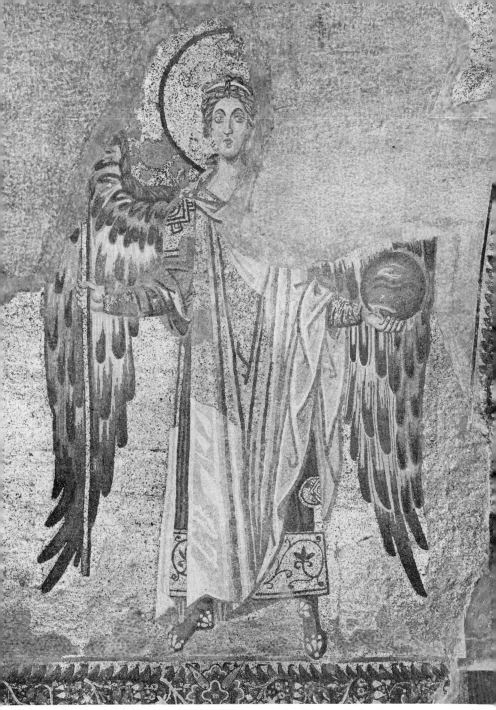

155. The Archangel Gabriel. Fragments of a mosaic on the south side of the apse. Before 867.
Istanbul, Hagia Sophia

loving Emperors Michael and Basil when the form of the Theotokos had been depicted and uncovered. The image was the symbol of the defeat of Iconoclasm and the inauguration of a new era. 'If one called this day', said Photius, 'the beginning and day of Orthodoxy (lest I say something excessive) one would not be far wrong.' Until this day, the Patriarch pointed out, Hagia Sophia had remained deprived of representational images. Its 'visual mysteries' had been scraped off by the Iconoclasts, and 'it had not yet received the privilege of pictorial representation'. Melancholy was the aspect of the Church shorn of its glory, disfigured by the scars of heresy, but now, raised from the depths of oblivion, the image of the Theotokos had been restored and in like manner the images of the saints would also rise. There seems no reason to doubt that Photius was referring to the great Virgin and Child enthroned [154] between the Archangels Michael and Gabriel which still survives in the apse of the church. The inscription on the face of the semidome is fragmentary but the full text in the Palatine Anthology reads: 'The images which the impostors had cast down here the pious emperors have again set up', referring, of course, to Michael III and Basil I. The splendid garland borders framing the inscription and similar borders coursing round the interior edges of the windows of the apse emphasize the sense of triumph redolent throughout the decoration. Today large areas of gold background have vanished; only vestiges of the Archangel Michael remain. Much of the original sixth-century mosaic still survives in parts of the church, and it has been proved that the second major campaign of work occurred in the second half of the ninth century; the great figures that survive have not been subjected to later restoration during subsequent periods of Byzantine history. These ninth-century images are among the most majestic visions in the whole development of Byzantine art. The sensitive modelling of the faces, the treatment of form and drapery, the rich yet delicate use of colour, all combine in a serene harmony of light and tone. The

Archangel Gabriel [155] is in a sense more resplendent than the Mother of God, framed by huge wings in shades of purple, brown, blue, white, grey, and green, the folds of the white and gold chlamys magnificently managed as the hands stretch out to display orb and sceptre – a Byzantine court official transfigured by wings and halo. The figures are three times life size and yet, such is the size of Hagia Sophia, may hardly be appreciated from the ground. They relate, in fact, badly to the building which was never intended to be adorned with figurated mosaics, and they must always have been difficult to read. From recent reports it is clear that the artist designed his figures from a platform more or less level with the windows of the apse semidome, giving them the proportions which looked correct from his scaffold and which today only look reasonably correct if the visitor stands immediately below the mosaic – a position inaccessible to a Byzantine worshipper. The artist laid out the figure of the Virgin as if it were meant for the lower ring of a dome, to be viewed straight up, as in the dome of Hagia Sophia at Salonika [162], where the figures of the Virgin and the Apostles watching the Ascension of Christ are elongated along the curve of the dome to be read quasi-correctly in proportion by the viewer directly beneath.[5]

The north and south tympana of Hagia Sophia at Constantinople provide almost the only vertical wall space in the nave suitable for figurated mosaics, and this space is confined by the form of the tympana, of which the surface is broken by a row of flat niches at the base and two rows of windows above. The mosaic decoration, therefore, had to conform to a horizontal division into three superimposed registers. Because of the niches and the windows only single figures could be considered: in the niches a row of bishops, in the middle window zone a row of prophets, in the upper zone angels including four archangels acting as bodyguard to the Pantocrator in the dome. A large part of this decoration no longer exists, but it is known that on the south tympanum among the bishops represented

were St Anthimus of Nicomedia, St Basil, St Gregory Nazianzen, St Dionysius the Areopagite, St Nicholas, and St Gregory of Armenia; among the prophets, Isaiah. On the north tympanum among the bishops were St Ignatius the Younger, St Methodius, St Gregory Thaumaturge, St John Chrysostom, St Ignatius Theophoros, St Cyril, and St Athanasius; among the prophets were Jeremiah, Jonah, Habakkuk, and Ezechiel. Among the bishops on the north tympanum three and the fragments of a fourth still exist: St Ignatius the Younger [156], St John Chrysostom [157], St Ignatius Theophoros,

and vestiges of St Athanasius. A decorative border of geometric ornament following the recesses and projections of the lower surface of the tympanum gave the impression of a continuous parapet in front of which the bishops stood, just as standing saints are often placed in front of a recessed wall in the miniatures of Byzantine calendars. All three bishops, haloed, dressed as priests, wear the pallium and carry jewelled codices in the crook of the left arm; the right hand is raised to bless – with the exception of St Ignatius, who places his right hand on the top corner of the codex. They stare hypnotically

156 and 157. St Ignatius the Younger and St John Chrysostom. Mosaic panels on the north tympanum. Late ninth century. *Istanbul, Hagia Sophia*

into the nave with some differentiation of physiognomy, but the movement and fall of the drapery is almost identical, naturalistic, with widely spaced folds following the posture of the body. Again, such is the immensity of Hagia Sophia that these mosaics are difficult to read from the floor of the nave, and even from the galleries appear dwarfed by the vast structure. The portraits are close in style to those in Basil's copy of the Sermons of St Gregory Nazianzen, and it seems probable that the mosaics were executed towards the end of Basil's reign or during that of Leo VI (886–912).

In three cases the choice of the bishops is unusual, but these are all commemorated in the Typicon of Hagia Sophia (Patmos, cod. 266) dating from about 890. St Methodius (d. 843) was the Patriarch who is described in the Typicon as having 'set up orthodoxy and driven away error'. The Patriarch Ignatius (d. 877) had been canonized and his name had been inscribed on the diptychs by his old enemy Photius before 886. The inclusion of St Gregory the Illuminator, the apostle of Armenia, in the Typicon and in the decoration of Hagia Sophia is apparently the earliest evidence for the official recognition of this saint by the Byzantine Church. An Armenian legend states that the relics were discovered in Constantinople during the reign of Michael III (842–67), but Basil sponsored the cult for political and dynastic reasons. Certainly Photius, who also had Armenian blood and believed himself a descendant of St Gregory's family, used his influence. In a letter to Zacharias, catholicos of Armenia, he had praised the saint and, when inventing a gratifying genealogy for Basil, an upstart of Armenian and Slav parentage who began his road to fortune as a groom, he had traced Basil's descent to 'Tiridates the great king of the Armenians who was in the time of the holy martyr Gregory'. Thus, it may be seen that even in the decoration of Hagia Sophia political overtones might be struck.[6]

The new work in the nave was completed by a representation of Christ Pantocrator in the dome surrounded by seraphim, of which fragments still exist, in the pendentives. The intention was obvious, but Leo VI stressed the meaning in a sermon during the consecration of a church built by his father-in-law Stylianus Zaoutzes. Christ reigned in the dome of heaven surrounded by His celestial court arrayed before Him in proper order – angels, prophets, and bishops. This decoration, however, was complemented by a number of scenes in the galleries. In the vaults of the south gallery there was another Christ Pantocrator surrounded by seraphim and cherubim and a representation of Pentecost; in the north gallery the vaults were decorated with the Baptism of Christ and (possibly) the Transfiguration. All the scenes, be it noted, are theophanies. After the return to Orthodoxy the representation of direct visions of God had assumed particular importance. Indeed, since the time of Constantine V the chief problem of the Controversy had been the nature of the true image. If the Divine Power could be confined by the flesh of man, then why should He not be represented by an image? After 843 there was a continuous stressing of the Incarnation of God and the necessity of circumscribing Him by an image. At a council in 869–70 it was even ruled that to deny images, especially those of Christ, was to risk failure to recognize Him on the day of resurrection.

Hagia Sophia had four vestibules, of which only one, the south-western, is decorated with mosaic today, and this is of a later period than the late ninth or early tenth century; but the south-eastern vestibule is known to have had a mosaic with an unidentified subject over the 'Door of the Poor'. The mosaic over the imperial doorway leading from the narthex into the nave is probably the most famous of all. A bearded Emperor crowned with the *stemma* is prostrate before Christ enthroned [158]. Christ holds an open book in which is written 'Peace be unto you. I am the Light of the World.' Slightly below and on either side of the head of Christ are roundels enclosing the busts of the Virgin and the Archangel Gabriel. Attempts have been made to identify the Emperor as Basil I, but most scholars prefer Leo VI, who is

158. Leo VI making proskynesis before Christ. Mosaic in the lunette over the imperial doorway. Late ninth century. *Istanbul, Hagia Sophia*

known to have set up metrical inscriptions (now lost) in central parts of the church which probably commemorated work undertaken by him. Moreover, Leo preached a sermon on the Annunciation early in his reign which appears to elucidate the iconography of the panel. The prophecy of an Archangel had been made fact. He who had been sent to Nazareth, a provincial town of Judea, was now 'in the city of Our Lord Emperor' Christ to acclaim his glory in the Sacred Palace. The Virgin's Son, the Saviour of the World, reigned not only over one people but all the peoples of the earth – a reference to the pan-nationalism of the Byzantine Empire, a view much to the fore after the conversion of the Slavs and the Bulgars – and all those in Heaven and Hell. The Virgin was glorified by the light she had given to the world. That light was none other than Christ himself, who is

Divine Wisdom. The Virgin as Mother of an Emperor is herself an Empress, and to her Leo owes everything he possesses, especially his empire, and he implores her to protect and guide him. In the mosaic Leo the Wise makes proskynesis before Christ who is Wisdom, Light, and Peace, while the Archangel Gabriel and the Virgin, Messenger and Instrument of the Incarnation, make constant intercession for him who is Christ's Vicar on earth. The quality of the mosaic is perhaps less fine than that in the apse, but the majesty of the design, the lofty vision of Christ enthroned with the great Emperor crouched at His feet is unforgettable. The style of this delineation, particularly the head and form of Christ, comes close to similar representations in Vatican, gr. 699 and Paris, gr. 510; the head of Leo is reflected in the coins of the period.[7]

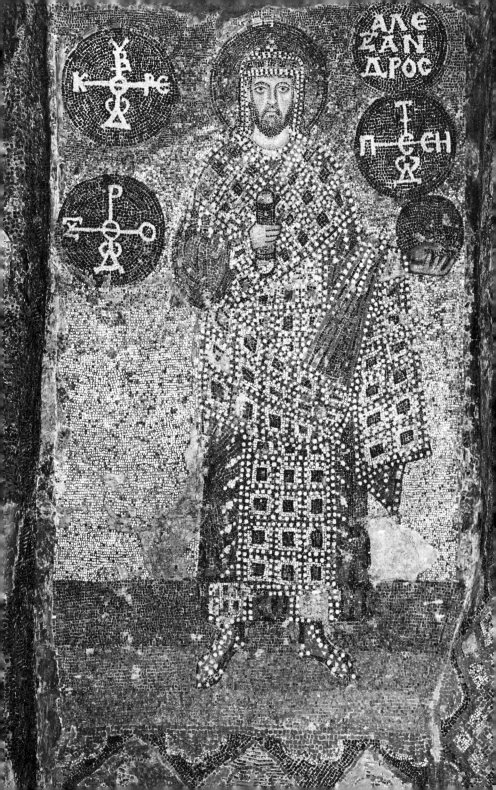

159. The Emperor Alexander.
Mosaic in the north gallery. 912-13.
Istanbul, Hagia Sophia

It is not without irony that one of the finest
representations of a Byzantine Emperor to have
survived should be the portrait of the Emperor
Alexander, the worthless brother of Leo VI,
who reigned as Leo prophesied for thirteen dis-
astrous months (912-13). The mosaic [159] in
the north gallery of Hagia Sophia reveals the
personification of Byzantine majesty: the hand-
some, stern, bearded face framed by the crown,
perpendulia of pearls, and halo, the tall, broad
form swathed in the purple *skaramangion* and
the *loros* loaded with jewels and pearls, the feet
in scarlet and jewelled buskins, the hands hold-
ing orb and *akakia*. In this manner, according
to the Book of Ceremonies, the Augustus was
apparelled when he went in procession on
Easter Sunday for the services in Hagia Sophia.
The Emperor is identified by an inscription
giving his name and monograms which read:
'Lord help thy servant, the orthodox faithful
Emperor.' It seems reasonable to suppose that
the portrait was set up during Alexander's
mercifully brief reign. He had been crowned
co-Emperor at the age of nine in 879, thus
sharing the throne with his father and his elder
brother. Leo VI, however, kept him firmly in
the background of affairs, and Alexander led a
life of dissipation. No succeeding member of
the imperial house, certainly not his nephew
Constantine VII, would have wished to com-
memorate him. As a result this mosaic and the
surrounding areas in the north gallery have the
unusual distinction of being datable to one
year.[8]

Above the south-west vestibule and ramp in
Hagia Sophia are two rooms which were part of
the patriarchal offices. The large *secreton* over
the vestibule contains mosaics which date prob-
ably from the late ninth or early tenth century.

In the lunette over the door leading to the west
gallery there are the remains of a Deesis: Christ
enthroned with the Virgin standing on His
right. St John the Baptist no longer survives,
and all the gold ground has disappeared. In the
lower zone of the vaults were originally busts
of the twelve Apostles and the four Patriarchs
of Constantinople who took a leading part in the
Iconoclast Controversy: Germanus, Tarasius,
Nicephorus, and Methodius. Of the Apostles
only the busts of St Peter, St Andrew, St
Simon Zelotes, St James, and another unidenti-
fied have survived. In the upper zone of the
vaults five standing figures remain: Ezechiel, St
Stephen, the first Christian martyr, the Em-
peror Constantine the Great, portrayed as a
bearded Byzantine Augustus, an unidentified
saint, and a bishop, but originally there must
have been twenty standing figures. The pro-
gramme once again appears to celebrate the
triumph of Orthodoxy, but the importance of
theophany is also stressed, and the general
trend is symbolic rather than narrative.

This type of decoration, however, was not
confined to Hagia Sophia. From a sermon de-
livered by Photius during the inauguration of a
church built within the precincts of the Sacred
Palace, possibly the Nea (though this has been
doubted) completed by Basil in 876, we learn
that Christ Pantocrator amid concentric circles
of angels reigned in the dome, the Virgin orant
was placed in the apse, and the rest of the church
was decorated with a hierarchy of apostles,
martyrs, prophets, patriarchs, and bishops. For
Photius the church was 'another heaven' on
earth, and Christ ruled in His palace on earth
as He reigned in heaven – an idea of the im-
perial court of heaven taken up by Leo VI in
more than one sermon. In a church built
and decorated in the monastery of Kauleas
Leo makes it clear that the programme was
hierarchic, symbolic, with no suggestion of nar-
rative scenes from the Gospels. The ninth-
century decoration, sponsored by a certain
Naukratios, of the church of the Dormition at
Nicaea also stressed the atmosphere of a
heavenly court. The four angels in the choir

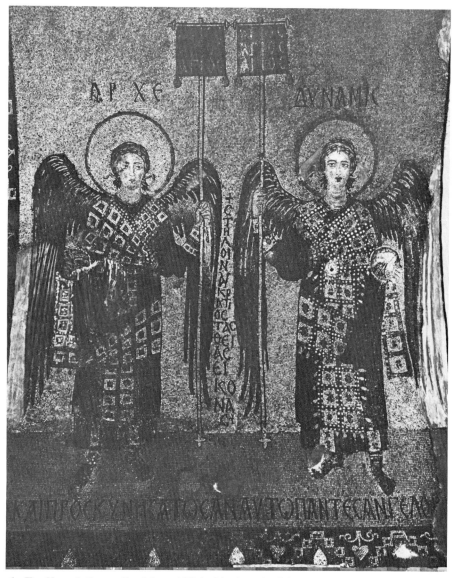

160. Two Heavenly Powers, Dominion and Might. Mosaic on the choir vault.
Second half of the ninth century. *Nicaea, church of the Dormition*

vault [160], dressed in imperial court dress, holding the *labarum* and an orb and identified by inscriptions as Heavenly Powers – Domin-

ion, Might, Sovereignty, and Strength – contemplate the throne of God in the centre of the vault. Another inscription refers to Psalm

103:xix–xx: 'The Lord has prepared his throne in the heavens; and his kingdom ruleth over all. Bless the Lord, ye his angels, that excel in strength, that do his commandments, hearkening unto the voice of his word.' These magnificent images were complemented in the apse by a great apparition of the Virgin standing on a dais [161] and presenting the Child to the world. Above her head a hand emerged from heaven and three rays of light through which an inscription read: 'Thou hast conceived Him before Time.' The hand of God and the three rays represent the Trinity, the procession of the Son from the hand of the Father, the Logos which existed before Time and the divine origin of the Child which was made flesh by the consent of the Virgin. Moreover, the words of the inscription repeat the first words of a hymn sung during the office for the feast of the triumph of Orthodoxy. No Byzantine mosaic gave better evidence of the lofty theological atmosphere in which the first works of church decoration were undertaken after the end of the Controversy, and the destruction of the church of the Dormition at Nicaea must be regarded as one of the major artistic losses of modern times.[9]

In Hagia Sophia at Salonika, restored towards the end of the ninth century, the Virgin and Child are enthroned in the apse as in Hagia Sophia at Constantinople [154], but the proportions of the forms and the setting in the vault are even less satisfactory. It has, indeed, been suggested that the upper half of the Virgin and Child are a restoration of the eleventh or twelfth century. Certainly the outsize head of the Virgin, finely drawn but out of proportion with the rest of the body, seems to be very different in style from the figure of the Virgin in the cupola. The general effect is undeniably botched. The mosaic representation of the Ascension [162], on the other hand, in the cupola is remarkable for its attempt, not entirely successful, to adjust the proportions of the body to the curve of the dome; in photographs, all the figures standing look absurdly elongated. The Virgin and the Apostles are set in a striking stylized landscape of trees and undergrowth, their varied move-

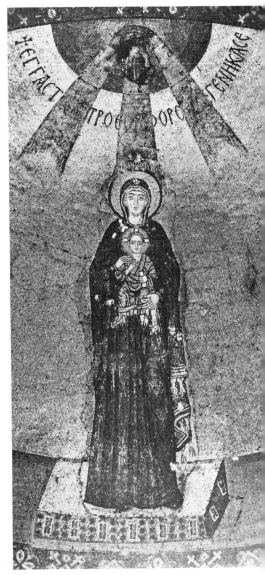

161. The Virgin and Child. Mosaic in the apse. Second half of the ninth century.
Nicaea, church of the Dormition

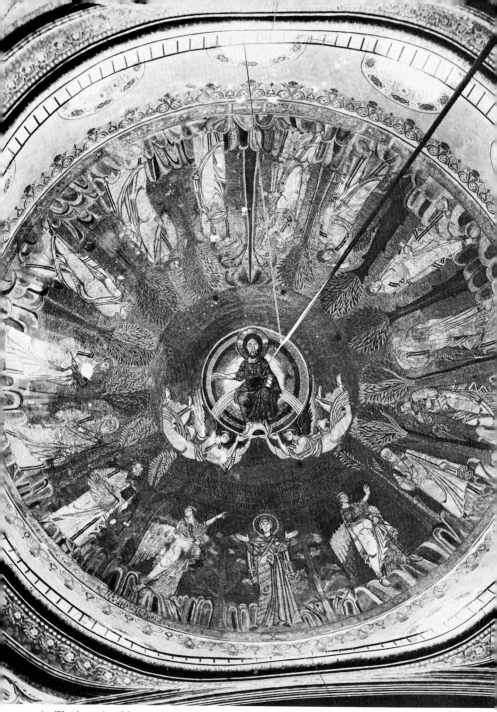

162. The Ascension. Mosaic in the cupola. Late ninth century. *Salonika, Hagia Sophia*

ments of wonder stressed by complicated rhythms of drapery as they gaze up at Christ seated in a mandorla supported by angels. The head of Christ is close in style to the head of Christ in the imperial lunette in Hagia Sophia in Constantinople, but here again there is a disproportion between head and body and the angels, whether flying or standing, though delineated in brilliant colours, lack the majesty of the Archangel Gabriel in the apse of Hagia Sophia. Nevertheless, the whole vision caught in vivid tones of green and blue against a gold ground shimmers magically in a green-gold light. An inscription states that the work was done under Archbishop Paul. There were two Archbishops of Salonika named Paul, one living in the ninth century, a contemporary of Photius with whom he corresponded in 885, and another living in the eleventh century. The stylistic mannerisms of the mosaic, the handling of form and drapery, suggest that the earlier Paul was responsible.[10]

Among the so-called minor arts a few important works have survived from the reign of Leo VI. A fragment of an ivory sceptre [163], now in Berlin, reveals the Emperor being crowned by the Virgin with the Archangel Gabriel by her side; on the obverse is represented Christ between St Peter and St Paul; on the ends St Cosmas and St Damian. Inscriptions refer to the Basileus Leo twice and suggest that the sceptre was carved early in the reign: 'May you strive [for prosperity], Lord Emperor Leo, and may you succeed.' The fragment is important because ninth-century carvings are either lost or difficult to recognize and the style of this particular piece is. unlike the tenth-century and later sequences of Byzantine ivory reliefs. The figures are hunched, thick-set, intensely gazing, and recall a little those chased on the sixth-century silver-gilt cross of Justin II in the Vatican [83]. This broad, stunted style is paralleled on a jasper carved with a representation of a standing Christ blessing and bearing an inscription on the back referring to the Emperor Leo, formerly in the Vatican and now in the Victoria and Albert Museum [164]. A second

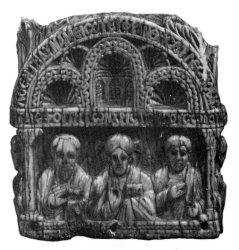

163. (A) Christ between St Peter and St Paul;
(B) Leo VI crowned by the Virgin
and accompanied by the Archangel Gabriel.
Fragment of an ivory sceptre.
Late ninth century.
Berlin, Ehemals Staatliche Museen

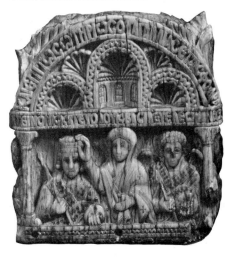

jasper, also in the Victoria and Albert Museum, carved with Christ on the Cross between the Virgin and St John [165] was almost certainly executed in the same workshop, and the quality

164 (*left*). Christ Pantocrator. Jasper.
Late ninth century.
London, Victoria and Albert Museum

165. Christ on the Cross between the Virgin
and St John. Jasper. Late ninth or tenth century.
London, Victoria and Albert Museum
166 (*below*). Leo VI and Saints.
Detail from a votive crown in enamel and silver-gilt.
Late ninth or early tenth century.
Venice, S. Marco, treasury

167. Christ on the Cross amid Saints and Archangels. Enamelled and silver-gilt book-cover, cod. lat. 1. 101, gia Reserv. 56. Late ninth or early tenth century. *Venice, Biblioteca Marciana*

of both reliefs hints at palatine production. The close similarity of these carvings suggests that there was a definite trend in the reign of Leo VI towards a simplified style concerned with mass, solidity, and plastic volumes from which the more refined and elegant characteristics of work produced for Constantine VII were to develop.[11]

Similarly in gold and enamels the style, in spite of the finicky aspect of the technique, is broad and simplified. The small votive crown with a portrait of Leo VI and various saints [166], now in the treasury of S. Marco at Venice, is far from complete, but the heavy pearl framework dominates the offering on which stylized images mapped out in segments of brilliant colour against a green ground emerge as pious symbols. On a book-cover of the same date, in the Biblioteca Marciana [167], the gold base and the closely packed pearl borders almost overwhelm the little image of Christ crucified, clothed in the colobium, vivid against the same green ground, and the stylized busts of archangels and saints. Even in secular jewellery like the superb ninth-century arm-bands of gold and enamels, found at Salonika, decorated with stylized leaves, flowers, and birds set against a green ground [168] – a technique which disappeared in the tenth century – one is conscious of a separate artistic impulse which seems to have been generated during the reign of Leo. The arm-bands are surely part of a court apparel. The treatment of the intertwined gold strands separated by dotted bands, the delicacy of the enamels, the beauty and charm of the design combine in ornaments of the highest quality. All the splendour and wealth of the ninth-century Byzantine imperial court is epitomized for us today by one ivory sceptre,

168. A pair of arm-bands. Enamel and silver-gilt. Found at Salonika. Ninth century.
Salonika, Archaeological Museum

a little votive crown, two jasper cameos, and a pair of gold and enamel bracelets fit for an Augusta to mime in as she acknowledged the chants of the factions.[12]

THE SCHOLAR EMPEROR

AND THE TRIUMPH OF THE IMPERIAL IDEAL

The premature but timely death of the Emperor Alexander left his nephew Constantine Porphyrogenitus, a child of seven years, in supreme power. At once there was a running struggle for control by the Empress-Mother Zoe, who was not well liked, the Patriarch Nicholas, a pushing and shifty politician, aristocratic generals like Constantine Dukas and Leo Phocas, and eventually an admiral risen from the ranks, Romanus Lacapenus. The child was sickly, and this poor state of health undoubtedly saved his life. The contestants for power did not expect him to live long, so no one troubled to murder or mutilate him. Moreover, in spite of Alexander the reigning dynasty was adored by the populace, and it would have been impolitic to end it with a child murder. At the time there were other more pressing matters to deal with. The Bulgar war, provoked by Alexander, set the imperial administration at once at a disadvantage, and before long the city was besieged by the Tsar Symeon, who demanded nothing less than the imperial crown and the marriage of Constantine to one of his daughters. To the enraged alarm of the Empress Zoe, who had been for the time confined to a convent, the Patriarch Nicholas agreed to these proposals and even undertook a makeshift coronation in the Bulgar camp. When these secret and highly improper negotiations leaked out the city was appalled. Zoe seriously considered the deposition of the Patriarch, but, as there was no one suitable to take his place, she had to be content with an outburst of fury and instructions to meddle no more in affairs of state. The Tsar Symeon raised the siege, but in 917 a combined Byzantine military and naval operation in the Chersonese came to a miserable end with a strong smell of treachery on the part of Romanus Lacapenus and the Bulgar Tsar triumphant. For three years the walls of the city were the sole defence of the Empire. By this time Zoe, the Patriarch, and Leo Phocas were equally discredited, and in 919 the admiral Romanus Lacapenus seized power. He at once married his daughter Helen to Constantine, who was barely fourteen years old, and in 920 assumed the imperial crown. For the next twenty-five years Constantine, quasi-maintained in state as senior and orthodox Emperor, was deprived of power and not infrequently insulted on ceremonial occasions by the implication that his father was a lecher, his mother a whore, and himself a bastard. But he was not murdered. He was allowed to work in his library and in his studio, for he was an artist as well as a scholar, he was assigned secretaries and craftsmen, and his marriage eventually was happy. Moreover, his father-in-law proved to be a great Emperor, strong, vigorous, and wise. Romanus I turned the tide against the Bulgars and began a series of conquests which were to continue for a hundred years. The prestige of the Byzantine imperial mystique was never better illustrated than on that day, 9 September 924, when the usurping Emperor, dressed in full regalia and carrying the maphorion of the Virgin, sailed in the imperial barge up the Golden Horn to meet the Tsar Symeon at a jetty and there to harangue the barbarian on mortality, bloodshed, and Christian peace. Without more ado, without bargaining for ransom or hostages, without even attempting to call the Emperor to question, the terrible Tsar led his army home.[1]

Constantine immersed himself in classical studies. The revival of learning begun under Bardas and Photius reached its height in the tenth century under the scholar Emperor. He collated encyclopedias of classical texts, he supervised the continuators of Theophanes the

historian, and his great book on the ceremonies of the court leaves the world immeasurably in his debt. His minute to his son Romanus II on the administration of the Empire, with its penetrating sense of geography, of the peoples dangerous to the Empire and the diplomatic means of dealing with them, is a masterpiece of Byzantine intelligence. He was also a painter of renown, though none of his works has survived, and he interested himself in all kinds of craftsmen: stonemasons, carpenters, metal workers, even blacksmiths. Palace gossip hinted that he sold his paintings to buy food and drink, of which he was reputed to be too fond. Constantine was neither a glutton nor a sot and he was no prig. He liked to relax in good company, he enjoyed the exhibitions of wrestling and juggling which were sometimes given after dinner in the Sacred Palace, and it is clear that Liutprand of Cremona on his first embassy to the Byzantine court thought him a capital fellow. His wife and children adored him, the Empress Helena always on the watch for intrigues against her husband, and the purple-born princesses, once grown up, enthusiastically acted as his secretaries and research assistants. When he finally became autocrat, after his brothers-in-law had ousted their father and were in turn circumvented by their sister, Constantine governed well for fifteen years. He preferred diplomacy to war, fulfilled in splendour the palatine rites, and was truly Roman in sponsoring justice, peace, and prosperity. Although Romanus I had been a great Emperor, he had never been loved by his people, he was unlettered and ill at ease amid the ceremonies of the court. Constantine had inherited his grandfather's handsome looks – tall, broad-shouldered, the long face with its aquiline nose, piercing eyes, and long black beard and hair which were so well suited to the imperial regalia. To the people of the city, who were always impressed by beauty and learning, Constantine VII Porphyrogenitus epitomized Byzantine imperial majesty.[2]

Just as in the histories supervised by him and in his own biography of his grandfather, where a third dimension was introduced in the study of character, so too in the works of art produced for him an extra depth may be detected. Possibly one of the most beautiful sequences of drawings of all time, the Joshua Rotulus (Vatican, gr. 431) with its sensitive washes of brown, blue, white, and purple, its delicate grades of tone, its studies of landscape and architecture caught in a mirage of classicism, its feeling for form in the round, brings us very close to the personality of Constantine. On the first sheet, where Joshua is depicted leading the Israelites towards the Jordan [169], the illusion of landscape, the distant view of buildings, the evocation of trees, the modelling of men and horses

169. Joshua leading the Israelites towards the Jordan. From the Joshua Roll, MS. gr. 431, sheet 1. Constantinople, tenth century. *Vatican, Biblioteca Apostolica*

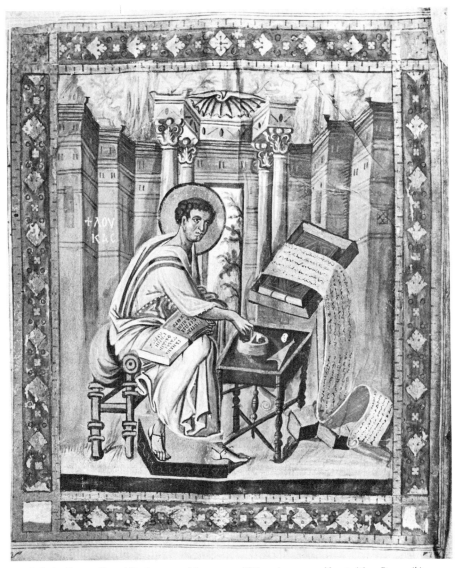

170. St Luke. From a Gospel Book, MS. 43, fol. 12 verso. Mid tenth century. *Mount Athos, Stavronikita*

establish at once the new standards. And yet there is much throughout the drawings in the treatment of drapery and the representation of movement, not to speak of direct misunder-standing of the classical model, which betrays the tenth-century copyist. Constantine was one of the few Byzantine scholars who was able to identify himself and his writings with the

authors of antiquity, but his artists, for all his encouragement and advice, could never quite make that leap into the past. Nor for that matter did they trouble much to take their eyes from the illustration before them and look at the world in which they lived. Constantine could sharpen their vision of the models, he was the best teacher and could correct their efforts, he could insist on an exact replica, and that was all. Even the superb portraits of the Evangelists in the Gospels (cod. 43) now belonging to the Stavronikita monastery on Mount Athos, which appear to be almost direct copies of classical philosophers – only St Luke [170] is preparing to write on a roll, the others are addressing themselves to codices – show by a stiffness of posture, an uncertainty in matters of perspective, an incipient mannerism in the treatment of drapery that the artist was cramped by the inadequacy of his perception or his skill in execution. Nevertheless, the evocations of classical architecture before which the Evangelists sit are indeed striking and far more skilled than any similar attempt by a contemporary artist in other parts of the western world. Once again these portraits establish a standard which was to be more or less maintained at Constantinople for the rest of the Middle Ages. Their noble faces, the harmonious proportions of form and structure, whether of the body or of buildings, the subtle and rich colours, the sense of space and atmosphere are set down with an authority which only an artist trained at the court of Constantine could command. The great Psalter now in the Bibliothèque Nationale (Paris, gr. 139) was a Psalter probably never equalled. One after another the large-scale illustrations depicting scenes from the lives of David and Moses, the prayer of Hannah, the story of Jonah, the prayers of Isaiah and Hezekiah astonish the onlooker by their vivid sense of antiquity. Gone for the moment are those sombre portraits of prophets and saints, the haughty lowering of the official image, those paradigms of brooding and distant Divinity. Instead, David plays his harp in a pastoral setting which might have come from the house of Livia, nymphs and

personifications abound, the daughters of Israel pirouette before a classical portico, and in the Crossing of the Red Sea there is a study of male and female nudes which is surprising and masterly. Perhaps the most beautiful of all is the miniature representing the prayer of Isaiah [171], where the prophet stands between the personifications of Night and Dawn, raising his hands and gazing up to the hand of God appearing from the heavens. The figure of the prophet in all its nobility of conception may be compared with similar portrayals of the Evangelists in a fine Gospel in Paris (gr. 70) and in another in the British Museum (Add. MS. 28815) both dating from the middle of the tenth century and surely from a palatine workshop. The artists were making a virtue out of a formula, glorifying a tradition already sacred. But the representation of Night typifies a new injection of classical elements, a new understanding of sensuous beauty, and a heightening of technique to deal with these new calls on the artist's ability. The treatment of trees and plants, the illusion of space, echo the Joshua Rotulus, and all these classicizing elements point to the supervision of Constantine. There is no textual evidence that any of these manuscripts were executed for the Emperor, and it must be remembered that the illustrations in a Bible produced for the patrician Leo about 940 (Vatican, Reg. gr. 1) vie in quality with those of the Paris Psalter. The miniature showing Moses receiving the Tables of the Law [172] surpasses in vision and technique the same subject in the Psalter. Indeed in all the Psalter illustrations there is a spirit of academicism, of painstaking labour to achieve authenticity, of firm reins on aesthetic invention which is less conspicuous in the Bible of the patrician Leo. And yet so identical in atmosphere are the two productions that it is difficult to believe that the same scriptorium was not responsible. Perhaps the artist working on Leo's Bible was a fraction more talented than his colleague working on the Psalter. Whatever the circumstances, the mid-tenth-century output was to dominate the future, and as late as the fourteenth century

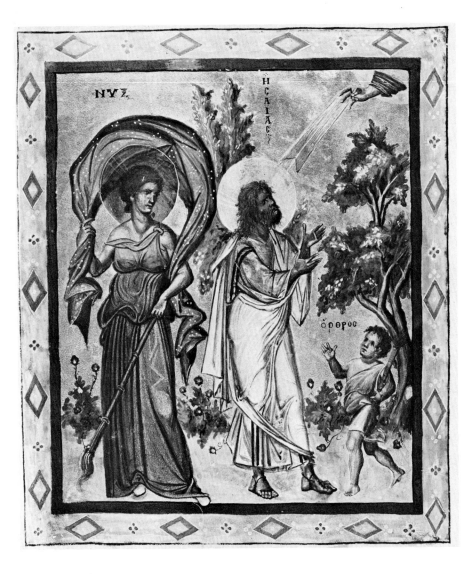

171. Isaiah between Night and Dawn. From a Psalter, MS. gr. 139, fol. 435 verso.
Constantinople, mid tenth century. *Paris, Bibliothèque Nationale*

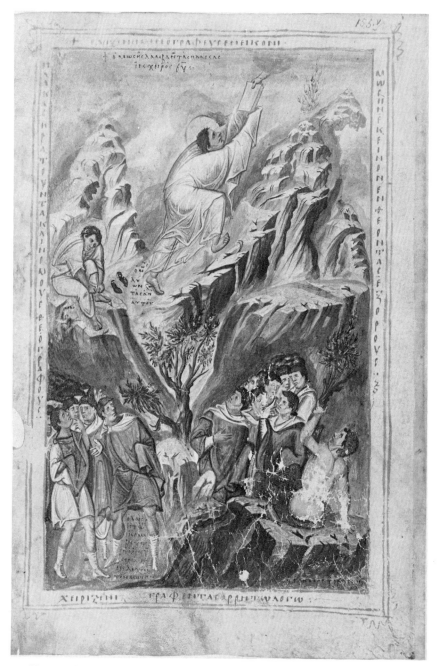

172. Moses receiving the Tables of the Law. From the Bible of Leo the Patrician,
MS. Reg. gr. 1, fol. 155 verso. Constantinople, c. 940. *Vatican, Biblioteca Apostolica*

artists were turning for inspiration to the palatine standards reanimated by Constantine.[3]

In ivory carvings there are clear points of reference. The panel carved with a representation of Christ crowning a bearded Emperor in full regalia, now in Moscow [173], is identified by inscriptions: Constantine, Autocrat, Basileus of the Romans. The coronation of Constantine occurred in his father's lifetime when he was a child, and it is obvious that the panel cannot refer to this ceremony. The panel must have been executed after the Emperor had been rid of his father-in-law and his brothers-in-law and

173. The Epiphany of the Emperor
Constantine VII Porphyrogenitus.
Ivory relief. *c.* 945. *Moscow, Museum of Fine Art*

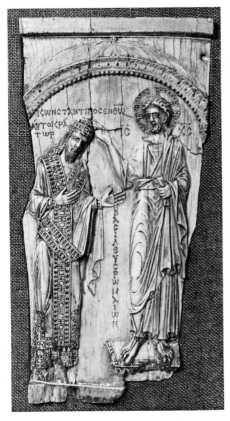

before he had created his son Romanus Augustus and co-Emperor, which suggests a date about 945; it is an *ex-voto* relief proclaiming sole sovereignty. Many of the characteristics visible in the manuscripts come to the fore: the new feeling of depth, a kind of third dimension, the emphasis on personality, a firm sense of modelling, a naturalistic approach to draperies, whether it is the stiff switch of the jewelled *loros* or the softly falling folds and the horizontal creases of the robe of Christ, and always an advance in technical ability. A triptych in the Palazzo Venezia, in Rome, carved with the Deesis and rows of saints set in hierarchy [174], also carries an inscription asking Divinity to preserve Constantine from harm and to give him peace. The style of the carving is such that there can be no doubt that Constantine is the Emperor, and it is conceivable that the relief was executed slightly earlier than the *ex-voto* panel. Two other triptychs, one in the Louvre, the other in the Vatican, carry no reference to Constantine, but the subject matter is the same, the quality is if anything higher, the ornament richer, and there can be no doubt of their palatine origin. All three are litanies or suffrages for the Emperor; the slight differences of style are a matter of hands rather than of place. The theme of prayer for the safety of the Emperor is taken up again on three ivory panels representing some of the finest work of the palatine artists. The panel in the Museo Archeologico at Venice carved with portraits of St John the Evangelist and St Paul [175] standing on an arcaded dais and holding codices in their hands bears an inscription: 'The instrument of God [St Paul] holds colloquy with the chaste man [St John] to preserve the Emperor Constantine from harm.' The second panel in the Kunsthistorisches Museum at Vienna reveals St Andrew and St Peter standing on a similar dais but holding scrolls, and states: 'Your blood brother [according to St Matthew iv:18 Peter and Andrew were brothers], the proclaimer of Divine Mystery, absolves the Emperor Constantine from sin.' The third panel in the Grünes Gewölbe at Dresden is carved with the same

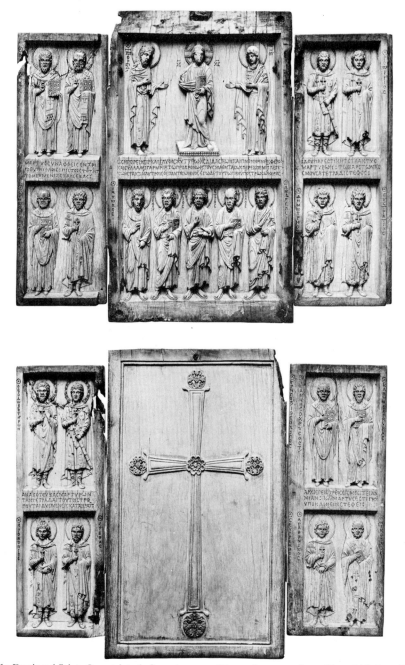

174. The Deesis and Saints. Ivory triptych. Second quarter of the tenth century. *Rome, Museo del Palazzo Venezia*

portraits: the image of Constantine and those of his son Romanus and daughter-in-law Eudocia [176], the latter panel carved between

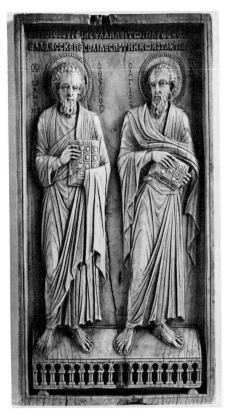

175. St John the Evangelist and St Paul.
Ivory panel. Mid tenth century.
Venice, Museo Archeologico

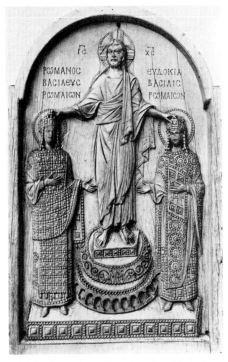

176. The Coronation of Romanus II and Eudocia.
Ivory relief. Between 945 and 949.
Paris, Cabinet des Médailles

subjects as the first, though there are differences of presentation and gesture, and the inscription is the same. Superb in quality, monumentally conceived, carved with the authority of an artist who seems to have had a feeling for his classical models akin to that of his imperial patron, these noble representations with their elongation of form swathed in softly pressed folds which fall diagonally in close pleats to the feet are signposts of aspects of Middle Byzantine style which were to become more exaggerated under the Comnenes two centuries later. Indeed, this is predicated by the imperial

945 and 949, with their elongated slenderness of form and the accent on the richness of the imperial regalia, herald those lofty portraits of Comnene majesty which were to be set up in mosaic in the south gallery of Hagia Sophia. Like so much else in literature and the arts, the mode was struck by Constantine. Moreover, the death of Constantine in 959 did not entail a sudden collapse of standards, as happened so frequently in the West. The evidence is provided by the large ivory reliquary of the True Cross [177], carved with a representation of the Deesis and saints and inscriptions referring to

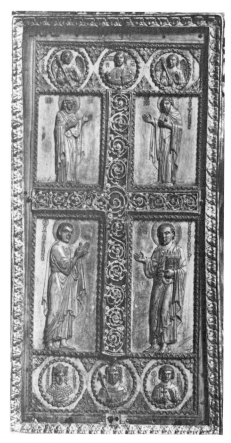

177. The Deesis and Saints. Ivory reliquary of the True Cross. Between 963 and 969. *Cortona, S. Francesco*

stones, bears inscriptions stating that 'The Emperors Constantine and Romanus, in a setting of translucent gems and pearls, have given this sacred Wood a home of wonders' and 'In deepest honouring of Christ Basil the Proedros caused this repository to be decorated'. The first inscription presumably refers to the actual mounting of the cross, which must have been done after Romanus II had been made co-Emperor in 948. The second inscription is on the outer case, which contained many other relics besides the True Cross: fragments of clothing belonging to Christ and the Virgin, the sponge, fragments of the Crown of Thorns, and the hair of John the Baptist. Basil the *Proedros*, a bastard of Romanus I and a eunuch, had been made a patrician by Constantine in .944 and later *parakoimomenos*. He was created *Proedros* – President of the Council – by Nicephorus Phocas after the palace revolution which brought the general to power, and for many years Basil was one of the leading figures of the court, himself an able general and a gifted statesman. It seems probable therefore that the outer case [179] of the reliquary dates from 964–5. Basil was a patron of the arts: a jewelled cup bearing his name is now in the treasury of

178. Onyx chalice decorated with silver-gilt, enamels, and pearls. Second half of the tenth century. *Venice, S. Marco, treasury*

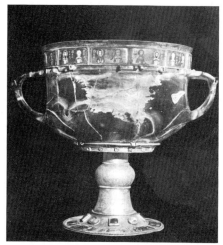

the Emperor Nicephorus Phocas (963–9) and to Stephen, Keeper of the Treasury of Hagia Sophia, now in S. Francesco at Cortona. The usurping Emperor was notorious for his lack of interest in works of art, his miserliness, and his uncouthness, but the administration maintained the workshops, and the reliquary at Cortona still breathes the spirit of the Porphyrogenitus, classicizing, monumental, and serene.[4]

This same spirit speaks in terms of gold and enamel. The great reliquary at Limburg, silver-gilt, enamelled, set with pearls and precious

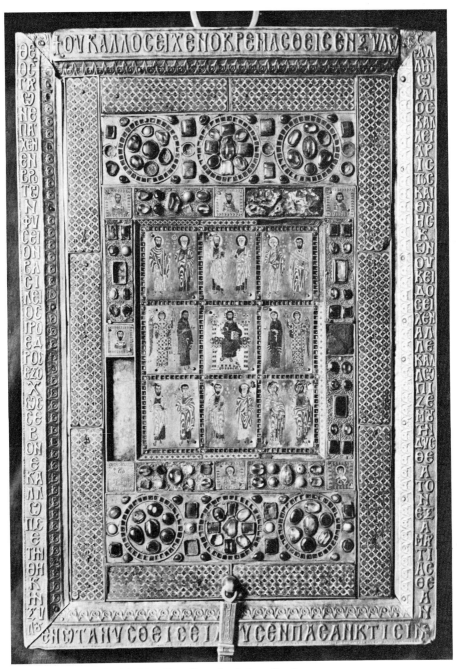

179. Container for a relic of the True Cross. Enamel and silver-gilt. 964-5.
Limburg an der Lahn, cathedral treasury

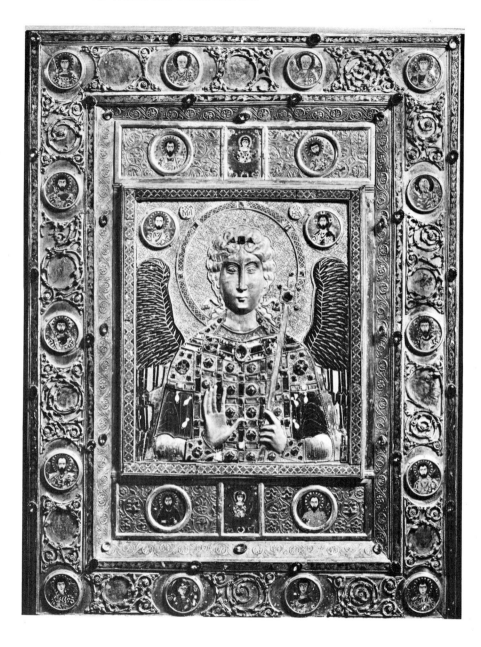

180. The Archangel Michael. Silver-gilt, enamelled icon. Second half of the tenth century.
Venice, S. Marco, treasury

S. Marco at Venice and a copy of the Homilies of St John Chrysostom, now in the Dionysiou monastery on Mount Athos, was written for him in 955. After the death of Constantine, Basil may well have taken over the supervision of the imperial workshops. The reliquary, which has been somewhat restored in modern times, is decorated with magnificent enamels, but the chasing of the silver on the back of the box is equally fine. For all the minuteness of detail, the richness of colour, the ability to suggest modelling, tone, fold, and form in a network of gold cloisons and enamel, there is a subtle sense of space and a sheer sensuous tactile joy. The figures of the saints, differentiated with finesse and ingenuity, are revealed against a gold ground in much the same way as the Evangelists in a court Gospels of the time (Paris, gr. 70). Similar enamels set in gold embellished with pearls and precious stones and mounted on two onyx chalices [178] bearing inscriptions which probably refer to Romanus II (959–63), now in the treasury of S. Marco at Venice, reinforce the atmosphere of court patronage. The busts of the Virgin, archangels, and saints are traced in delicate gold wires which confine the rich colours, often in two shades of brilliant blue, so that the beholder receives the impression of a refulgent microcosm of sanctity. There was, of course, much play with gold for its own sake. A reliquary of the True Cross, formerly at Maastricht, now in the Vatican, with an inscription referring to Romanus II, is entirely in gold relief. The superb gold and enamel icon of the Archangel Michael [180] in the treasury of S. Marco is an evocation of angelic majesty in which gold plays the major part and the gold filigree, the little enamelled busts of saints, the precious stones are merely a lavish trimming. These miracles of the goldsmith's craft rightly attracted the admiration of all visitors to Constantinople. The sheer massing of gold ornament in the churches of the city, even if the ordinary folk never penetrated farther than the outer courts of the Sacred Palace, were enough to confirm the impression of boundless wealth, mastery over the world, and endless favour to the God-guarded city. Nor were these gold arte-

facts confined to the city; many were sent to persons and places as gifts. The great book-cover on a Gospel Lectionary now kept as a relic in the treasury of the Great Lavra on Mount Athos is today only a fraction of its former glory: the figure of Christ [181] chased in gold, nimbus

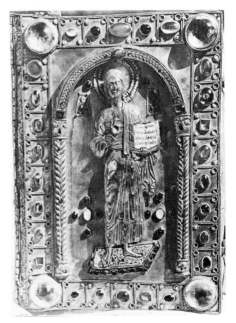

181. Christ Pantocrator. Silver-gilt, enamelled bookcover. Second half of the tenth century. *Mount Athos, Great Lavra, treasury*

studded with pearls, book and small dais brilliant with enamels, and two small enamelled panels with busts of St Gregory and St Basil. According to local tradition the Lectionary was given by the Emperor Nicephorus Phocas to St Athanasius, the founder and the first abbot of this imperial monastery, but the style of the three handsome miniatures depicting the Harrowing of Hell, the Nativity, and the Dormition points to a date later than the reign of that Emperor. St Athanasius was still alive at the beginning of the eleventh century, and it seems likely that Basil II gave the book to the Great Lavra. The selection of the illustrations to the feasts – Easter, Christmas, and the Dormition – indicates that the Lectionary was especially

commissioned for Mount Athos, since on these days in the time of St Athanasius it was the custom for all the monks on the Holy Mountain to go to Karyes, the capital of the monastic communities, to hold a common service. Crowns were not infrequently issued as gifts and claims to suzerainty. Only two have survived. The so-called Crown of Constantine IX Monomachos [182] now in Budapest may be dated by the triple portraits of the Augusti Zoe and Theodora, nieces of Basil II, and Zoe's third husband Constantine IX between the years 1042 and 1050. The diadem, which is incomplete, seems almost certainly to be a female crown and was presumably a gift to the wife of a Hungarian king, possibly at the time of the marriages of Andrew I of Hungary (1046-61) to Anastasia of Russia and of her brother – they were grandchildren of a Byzantine princess – to a daughter of Constantine IX. On the other hand, the iconography of the other panels which make up the diadem, the personifications of Sincerity

and Humility and two dancing girls placed between scrolls inhabited by birds, conform more to an article of private apparel than to an instrument of state. A change of style may also be observed. All the figures are visualized in terms of pattern rather than form; the sense of space and depth so typical of the tenth-century enamels has been jettisoned for intricate detail and superficial charm. The Holy Crown of Hungary [183] is a different matter. On one side Christ enthroned between cypresses is accompanied by the Archangels Gabriel and Michael and the patron Apostles of the Christian missions; on the other side the Emperor Michael VII Dukas (1071-8) is set parallel to Christ Pantocrator, and below him parallel to the Archangels are placed busts of his son Constantine (1074-8) and King Géza I of Hungary (1074-7). There seems to be in this case no doubt about the political significance of the crown. The iconography implies that Géza I was regarded as a satellite king by the imperial

182. Diadem of an Augusta, known as the Crown of Constantine IX Monomachos.
Silver-gilt and enamels. Between 1042 and 1050. *Budapest, National Museum*

183. Michael VII Dukas, his son Constantine, and Géza I, King of Hungary. Detail from the Holy Crown of Hungary. Silver-gilt and enamels. Between 1074 and 1077. *Budapest (formerly)*

administration. The same stylistic principles as on the diadem of Constantine Monomachos are evident: the forms treated as a flat pattern, the drapery as an arbitrary network of lines, and a tendency towards prettiness for all the solemnity of the symbol.[5]

184. Lions (with detail). Silk compound twill. Between 976 and 1025. *Cologne, cathedral treasury*

185. Elephants (with detail). Silk compound twill. Late tenth century. *Aachen, cathedral treasury*

A small group of woven silks has survived from the reign of Basil II. Several fragments of silk woven in compound twill with a pattern of large stylized lions now at Berlin, Düsseldorf, Krefeld, and Cologne [184] bear inscriptions referring to the Emperors Basil and Constantine, the sovereigns who love Christ. Since neither of the usurping Emperors Nicephorus Phocas or John Tzimisces is named, it may be presumed that the silk was woven after 976, but earlier versions existed. A Lion silk formerly at Auxerre bore an inscription referring to Leo VI, and another at Siegburg, destroyed in the Second World War, was dated to the joint reign of Romanus I Lacapenus and his son Christopher (921–3). These heavy silks were intended as hangings with a heraldic design of golden tan lions, their blue eyes staring through red pupils, against a red ground. Similarly an even heavier twilled silk with a design of elephants [185], introduced into the tomb of Charlemagne by the Emperor Otto III after the recognition of the year 1000, must also date from the early part of the reign of Basil and Constantine. In this case, however, the inscription merely states that the silk was woven in the imperial workshops in the Zeuxippos. On a brick-red ground four large medallions (two on the right are not complete) contain caparisoned elephants set amid the foliage of a standardized tree in colours of white, yellow-tan, dark green, and blue. Between these large medallions, which are well over two feet in diameter, are set small roundels composed of geometric designs and stylized foliage. The pattern shows marked Islamic influence. Two splendid Eagle silks may also be presumed to have been woven in the imperial workshops. They are much lighter in weight than the Lion or Elephant silks and could be made up into vestments. The chasuble of St Albuin (975–1006), now in the Cathedral Treasury at Bressanone (Brixen), is patterned with large dark green eagles, the details picked out in yellow, on rose-purple, with large dark green rosettes in the intervening spaces. The shroud of St Germain in Saint-Eusèbe at Auxerre [186] is woven with an identical pattern but in colours of dark blue, dark blue-green, and yellow.[6]

186. Eagles (with detail). Silk compound twill. Late tenth or early eleventh century. *Auxerre, Saint-Eusèbe*

There is frequent reference in the documents to cloth of gold, either as curtains, hangings, or costume, but not surprisingly none has survived. A few examples of silks brocaded with gold thread are known, such as the shroud of St Siviard at Sens decorated with griffins in roundels, white, purple, and gold on a white ground. The borders are similar to those in the roundels of the Elephant silk at Aachen, but this is no argument for date. Byzantine textile patterns tend to be conservative. Recognitions of the shrine of St Siviard were made at Sens in the eleventh and twelfth centuries, but the earlier date seems likely for the inclusion of the silk. With a people so sensitive to tactile values experiment in silk texture was inevitable, and numerous variants of the basic twill weave are known. An important series, called for convenience 'incised twills' because the pattern in a silk of one colour appears to be engraved and is best seen in movement against different lights, was made over a considerable period of time. Kufic inscriptions which some of them bear suggest that this type of silk was made by Islamic craftsmen, but whether within or without the Empire is now difficult to determine. Islamic servants of the Byzantine state were permitted freedom of worship, and there was at least one mosque in the city. The patterns are apt to be small in scale with continuous foliate scrolls and floral devices – silks of this type were sometimes used as ground for gold embroidery – but other sequences are patterned with birds and animals. Many of these silks were exported to the West and were made up into vestments for prominent ecclesiastics living in the late tenth and early eleventh centuries. A particularly fine 'incised twill' with a portrait of a Byzantine Emperor without an inscription was found in the tomb of St Ulrich of Augsburg (d. 973), but many complete chasubles still exist in German treasuries. Experiments were made in contrasting the texture of the pattern with the texture of the ground. Examples have been found in the tomb of Pope Clement II (d. 1047) at Bamberg and in that of King Edward the Confessor (d. 1066) at Westminster. The

patterns of lions and griffins, birds of different kinds, plant-forms and foliage exercised considerable influence on Western decoration. Weavers in Spain quickly copied Byzantine models, and these, too, were included in Western shrines. The large griffin silk found in the reliquary of St Théophrède (St Chaffre) in the church at Le Monastier (Haute-Loire) is a particularly fine example of Catalan plagiarization.[7]

The silk tapestry found in the tomb of Bishop Gunther in the cathedral of Bamberg was presumably acquired by him during his visit to Constantinople in 1064-5. The bishop died in Hungary on the return journey and, unfortunately, the tapestry was used as a shroud. A mounted Emperor in full regalia holding a *labarum* is receiving a diadem and a *toufa*, a crown crested with peacock's feathers [187], from personifications of cities. The figures are displayed against a violet-purple ground sewn with small flowers in shades of pink and blue; at the top and bottom is a border of floral devices in interlaced roundels in yellow, pink, green, and blue, on the same violet-purple ground. There are no inscriptions. As the tapestry is incomplete there may have been a *titulus* in a lower border, but today the Emperor, whose face has disappeared, is difficult to identify. Constantine I and Justinian I are possible candidates but in view of the date of acquisition Basil II seems more than likely. After his victory over the Bulgars in 1017 Basil celebrated a double triumph in Athens and at Constantinople, and when entering the metropolis by the Golden Gate he was offered a diadem crested with peacock's feathers. In view of the subject it seems probable that the tapestry was an imperial gift to Bishop Gunther, possibly intended for the Holy Roman Emperor Henry IV, a *lauraton* to show who was the real Emperor. The donor was presumably Constantine X Dukas, a civilian lawyer totally uninterested in military matters, and therefore the portrait is unlikely to be his, but the motive behind the gift was surely political.[8]

A few painted icons on Mount Sinai have been attributed to the tenth century. They in-

187. An Imperial Triumph. Silk tapestry.
Found in the tomb of Bishop Gunther (d. 1065) in Bamberg Cathedral. *Bamberg, cathedral treasury*

clude a rather indifferent representation of Christ washing the feet of His disciples and a composition of the Twelve Feasts, assigned to Constantinople, which looks more to the succeeding century. A fragmentary painting of higher quality which portrays Christ between two archangels and SS. Cosmas, Pantaleimon, and Damian has been assigned to the imperial workshops in the tenth century. But perhaps the most important of this small, far from homogeneous group is an icon which shows King Abgar holding the Mandylion juxtaposed

188. King Abgar holding the Mandylion; St Thaddeus, St Paul the Theban, St Anthony, St Basil, and St Ephraim. Icon. Probably *c.* 945. *Mount Sinai, monastery of St Catherine*

to representations of St Thaddeus, St Paul the Theban, St Anthony, St Basil, and St Ephraim [188]. The Mandylion was transferred from Edessa to Constantinople in 944. Shortly afterwards, perhaps on the first anniversary, 16 August 945, a homily for the feast was written probably by a court official under the supervision of Constantine VII. It has been suggested that the icon now on Mount Sinai was produced in a Constantinopolitan workshop about this time and, although it is difficult to believe that the painting was produced in an imperial workshop, that the portrait of King Abgar is, in fact, that of Constantine VII. The representation of the Mandylion on the icon appears to be the earliest pictorial evidence of this holy relic to have survived. The commemoration of feasts was to become one of the main types of icon during the eleventh century. Many panels on Mount Sinai are painted with representations of the Twelve Feasts distributed in diptych form or with complete sets of saints for a particular month in a set of twelve. These calendar icons which reflect contemporary menologia may also be painted on the reverse side with scenes from the life of Christ; they are partly liturgical and partly narrative. Sometimes the top row of an icon is occupied by five images of . the Virgin, of which four copy famous miraculous icons at Constantinople, the Panagia Nikopoia, the Blachernitissa, the Hodegetria, the Hagiasoritissa, and the fifth is the less well-known Cheimeutissa. Sometimes an icon may be painted with a single scene like the Last Judgement or may include several scenes from the life of the Virgin which are not included in the Twelve Feasts; sometimes there is a pictorial rendering of a liturgical ceremony such as the Elevation of the True Cross with the Patriarch, surrounded by clergy, standing in the ambo of Hagia Sophia and raising the cross in his hands. Many of these scenes, of course, are to be found in Gospel Lectionaries of the period which combine narrative and liturgical scenes with a complete calendar. Mutual interpenetration of the various media, icon painting and miniature painting, was clearly consider-

able. Liturgical programmes were apparently planned by learned clergy without regard for a special medium of the representational arts. They were – the comparison has been tentatively and justly made – like some of Bach's music composed without a specific instrument in mind. From the stylistic point of view there is a tendency to veer away from the monumental classicism of the tenth century. The physical reality of the individual figure is apt to be diminished in an attempt to create an effect of greater spirituality. The vivid colours, frequently outlined and heightened with gold – the beautiful Gospels in Paris (gr. 74) immediately come to mind – seem almost an imitation of cloisonné technique, and the sharp juxtapositions of colour recall contemporary enamels. As in the enamels, prettiness and charm are in the air, and as in the textiles, there is a sense of crystallization.[9]

Curiously enough there appears to be no record of any major building operation or mosaic decoration undertaken during the reign of Constantine VII and his immediate successors. Perhaps after the activities of Basil I and Leo VI there was no need. The Myrelaion, a small funerary church, was built by Romanus I in the monastery of that name, but only the structure and a few traces of mosaic on the vaults have survived. It seems from the poem by Constantine of Rhodes which was addressed to Constantine VII and written between 931 and 944 that the decoration of the church of the Holy Apostles was of some age – like Constantine himself, who had been imperial secretary and a faithful servant of Leo VI. Basil I is known to have restored and consolidated the church, but he appears to have stripped the imperial mausoleum at the east end of its mosaics and used the material for the decoration of the Nea. According to the continuator of Theophanes the work undertaken by Basil in 868–81 was limited to minor repairs. The account of Constantine of Rhodes is incomplete, but the mosaic decoration which covered the cupolas, pendentives, and the vaults of the church is described in some detail and consisted probably of twelve

scenes from the life of Christ ranging from the Annunciation to the Ascension. Christ Pantocrator reigned as usual in the central dome, and around Him were disposed the Virgin and the Apostles. This type of decoration was by no means unique in Constantinople. From a sermon of Leo VI we know that the church of Stylianus Zaoutzes also contained scenes depicting the principal events in the life of Christ, and this interest in the Twelve Feasts of the Church was to become dominant in the succeeding centuries. Moreover, in spite of the lack of documentary sources the structure of the church of the Holy Apostles seems to have been thoroughly altered between 944 and 985. From representations of the church in the Menologion of Basil II (Vatican, gr. 1613) executed about 985 it appears that Justinian's cupolas, of which four had been pendentive domes and only the central fifth had windows, were considerably modified. In the Menologion all the domes are raised on drums pierced by windows, and the central dome is taller than the others. If the identification is correct, this form is confirmed by a miniature in two early-twelfth-century copies of the homilies of James of Kokkinobaphos (Vatican, gr. 1162, fol. 2; Paris, gr. 1208, fol. 3 verso [207]) showing a five-domed church with tall drums and windows and with the representation in one of the vaults of the Mission of the Apostles. Now this scene is described by Nicolaos Mesarites shortly after 1200 as being in the central dome of Holy Apostles, and from his description, which is again incomplete, we learn that this decoration, though by and large conforming to the general pattern of the Twelve Feasts, was a great deal more complex than that described by Constantine of Rhodes. There were, for example, representations of St Matthew among the Syrians, St Luke preaching at Antioch, St Simon among the Persians and the Saracens, St Bartholomew preaching to the Armenians, and St Mark at Alexandria. Some of the scenes after the Resurrection are given in greater detail, such as the attempts of the priests to bribe the soldiers on guard at the Sepulchre and to suborn Pilate.

Whether this programme was worked out in the middle of the tenth century is difficult to confirm, but the church of the Holy Apostles was second only to Hagia Sophia in importance and more than once served as a model for other churches (in particular all three versions of S. Marco at Venice), and it continued to be the pantheon of the Byzantine Emperors until well into the eleventh century. The last Emperor to be buried there was Constantine VIII (d. 1028). The decoration of this church must always have been of prime importance. When the central dome collapsed after an earthquake in 1296, Andronicus II lost no time in rebuilding it.[10]

In the provinces there is sporadic evidence of sculpture and painting. The Armenian church of the Holy Cross was built between 915 and 921 by King Gagik, whose portrait still survives on the façade, on the small island of Aght'amar about two miles from the southern shore of Lake Van. From the beginning King Gagik intended the island to be a refuge. He built a wide wall with high towers to protect the palace, the church, and the new town which sprang up in little more than five years, adorned with terraced gardens, fountains, and orchards. The church, built of local pink tufa, is remarkable for the external sculptured decoration, which ranges from scenes taken from the Old and New Testaments to portraits of King Gagik and two Artzruni princes, Sahak and Hamazasp, wearing oriental court costume. The sculpture, which is scattered in tiers round the building, gives the effect of being flattened between two planes. Although the relief is high, there is hardly any surface modelling. Features and draperies are mapped out in deep grooves or shallow incisions. The forms are highly stylized, and there is little movement even where action is indicated. The broad treatment, the intense expression of the faces with their deeply marked almond eyes, the strange birds and beasts, the almost Coptic approach to vine-scrolls and foliage, conjure up an odd sense of vitality. Many of the images hark back to Early Christian models, others, like the King of Nineveh interviewing Jonah or King Saul, evoke Abba-

sid influences, and Goliath is dressed like a Byzantine warrior. In an upper frieze an inhabited vine-scroll coursing round the building brings to mind Coptic textiles. Armenian inscriptions predicate Armenian sculptors, and Armenian scholarship stresses the high quality of the work, but a comparison with the admittedly more restricted decoration in the monastery of Constantine Lips at Constantinople dedicated in 907 surely establishes different levels of excellence. There the carving of birds, peacocks, quails, and eagles, of foliage, of garlanded crosses is executed with a crispness and mastery over the material quite in a different class from the Armenian church. The paintings which cover the interior walls of the church date from the same time as the sculpture and, with their broad, sketchy treatment, the schematized drapery, and the intense gaze of the figures, share many of its characteristics. The remains of a Genesis cycle in the drum of the dome shows a type of church decoration hitherto unknown in early medieval art. A Gospel cycle starting in the upper zone of the south exedra continues in the north exedra, and it has been remarked that a representation of the second Coming of Christ in the conch above the south door has marked affinities with the miniatures in the ninth-century copy of the Christian Topography of Cosmas Indicopleustes (Vatican, gr. 699) [151–3] and the *Sacra Parallela* of John of Damascus (Paris, gr. 923). This last scene establishes that there was already current a monumental composition of the Second Coming which preceded the fully developed type of the Last Judgement known in Byzantine art from the eleventh century onwards. Both sculpture and paintings throw considerable light on aspects of East Christian art; they present a curious mixture of Early Christian survivals, contemporary fashions at Constantinople and Baghdad, and marked oriental decorative elements, with a strong emphasis on the palatine character of the church.[11]

There was a considerable production of Gospel Books in Armenia in the tenth and eleventh centuries. The Etchmiadzin Gospels

(Matenadaran 2374) executed in the monastery of Noravank', Siunik', in 989, with their beautiful canon tables and full-page miniatures, reflect vividly some Early Christian model. The miniature of the Sacrifice of Isaac [189] has little of

189. The Sacrifice of Isaac. From the Etchmiadzin Gospels, MS. Matenadaran 2374. Noravank', Siunik', 989. *Yerevan*

the reanimated classical spirit of the works done for Constantine VII, but it restates some humbler, provincial version with fidelity and force. Many of the copies, like the Gospels written in 966 by the priest Sargis for his fellow-priest T'oros now at Baltimore (Walters Art Gallery MS. 537) or the Gospel of 1038 (Matenadaran 6201), have little to do with Byzantine art; they represent strange folk traditions. Others, like the handsome Gospel of Mugni produced in north-western Armenia about the middle of the eleventh century (Matenadaran 7736), appear to have been strongly influenced by the art of the metropolis, but this influence is by no means constant, and local accents, so to speak, frequently break through.[12]

In Cappadocia numerous rock churches contain wall-paintings whose style and condition present various difficulties, but a number may be dated by inscriptions. Broadly speaking the paintings of the Göreme region and the Peristrema valley may be divided into two main groups, the first belonging to a period when the area was a buffer between the Byzantine Empire and the Arabs, the second to the time when the Arabs had been expelled, after the campaigns of Nicephorus Phocas in the second half of the tenth century. The early group is archaizing in style and draws extensively from Early Christian sources. The scenes from the life of Christ occur in chronological order, and there is no suggestion of a Twelve Feast arrangement. Considerable space is given to apocryphal scenes. The second group, which dates from the tenth century onwards, depends clearly on the art of the metropolis. In Ayvali kilisse an inscription refers to Constantine VII and the fragment of a date suggests some time in the early part of his reign (913-20). The frescoes are in the 'archaic' style and in very poor condition, but in the south chapel scenes from the childhood and the later life of Christ may be deciphered, and in the north chapel a Deesis, an apocalyptic vision of Christ in Majesty, a Last Judgement, and the Dormition. Tavchanli kilisse, a chapel near Sinassos, may also date from the early part of the reign of Constantine VII. The chapels of Tchaouch In and Toqale kilisse contain portraits and inscriptions referring to Nicephorus Phocas (963-9) and Theophano; the former has a portrait of Bardas Phocas, father of Nicephorus, created Caesar when his son came to power, and Leo Phocas curopalates, created at the same time. The Phocas family were extensive landowners in this area, and Leo Phocas had previously been strategos of the Cappadocian theme. All the figures are haloed and all the faces have been carefully erased; the paintings are in lamentable condition. The chapel of St Barbara at Sighanle is decorated with paintings of provincial quality – among them an Annunciation, a Visitation, and a Harrowing of Hell – and they are dated by an inscription to the reign of Basil II and Constantine VIII either in 1006 or 1021. The same reign is recorded in a dedicatory inscription in the Dirikli kilisse in the Peristrema valley. Generally speaking the quality of all these wall-paintings makes one sigh for the art of the metropolis; their interest is archaeological and iconographical, bolstered by the fact that they exist at all in that remote area.[13]

Between 986 and 994 Hagia Sophia at Constantinople was closed for repairs. Possibly at this time the tympanum in the south-west vestibule was decorated with a representation of the Virgin and Child enthroned [190] between the Emperors Constantine I and Justinian I. The beautiful inscriptions naming the Emperors appear to date from the second half of the tenth or the beginning of the eleventh century. It has been suggested that the decoration was set up to commemorate the victory of the usurping Emperor John I Tzimisces (969-76) over Svjatoslav, Prince of Kiev, in 971 which was attributed to the parading of the Theotokos Hodegetria before the Byzantine army, or, alternatively, to celebrate the victories of Basil II which culminated in his triumph over the Bulgars in 1017. On the other hand, these victories are in a sense irrelevant. The founder of Constantinople is offering the city and the builder of the greatest church in Christendom is offering Hagia Sophia to the Virgin, and at any time it would be only right and fitting for these Emperors to be so signally commemorated in a place of honour. They are dressed in medieval Byzantine imperial regalia, the emphasis being on the stemma, the stiff jewelled loros, and the scarlet buskins studded with pearls, but, unlike the portrait of Constantine in the patriarchal offices upstairs, the faces are clean-shaven. The modelling of the faces, the evocation of bone structure, the lines framing the mouth and creasing the forehead, the treatment of form and drapery are very different from the portrait of Basil II triumphant over the Bulgars in his Psalter (Venice, Marciana, gr. 17, fol. 1), executed possibly after 1017. It seems likely that the artists had before them models closer in date to the lives of the Emperors commemorated. The representation of the Virgin and

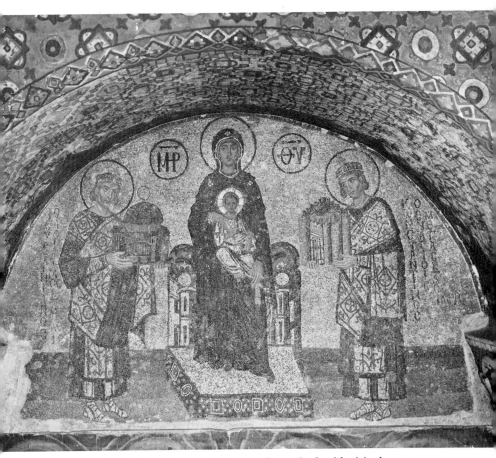

190. The Virgin and Child enthroned between the Emperors Constantine I and Justinian I.
Mosaic tympanum over the door leading from the south vestibule into the narthex.
Late tenth or early eleventh century. *Istanbul, Hagia Sophia*

Child with its narrowing and elongation of
form, its more compact folds of drapery, and a
kind of density of physiognomy is not only a
lofty alternative to the great vision of the Virgin
in the apse of Hagia Sophia [154], where the ex-
pansive form flows in streams of drapery and the
face is cast in nervous mobility, but seems closer
in style to the enthroned Virgin and Child [191]
in the apse of the catholicon of Hosios Loukas
about 1020, though here the drapery is con-
siderably more mannered and schematized.

The artists responsible for the mosaic in the
south-west vestibule were still working within
the classicizing tendencies operative in the
middle of the tenth century. The full, heavy
modelling and the naturalistic fall of drapery
are directly in line with the palatine traditions
mirrored, indeed, in the numerous illustrations
of the Menologion of Basil II (Vatican, gr.
1613), executed about 985, and one of the mile-
stones in the history of Byzantine art. This
splendid manuscript, decorated by eight artists,

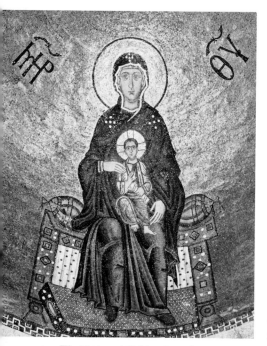

191. The Virgin and Child enthroned.
Mosaic in the apse. *c.* 1020. *Hosios Loukas, catholicon*

of whom two, Michael and Simeon, are described as 'of the Blachernae', not only bears witness to the maintenance of the palatine standards towards the end of the tenth century but shows a development in the direction of a new interest in narrative [192], a more solid treatment of form, and, for all the monotony of martyrdoms, a zest for scene and place which amounts to innovation. Even in a humbler manuscript like the pocket Psalter – usually known as the Bristol Psalter (British Museum, Add. MS. 40713) – decorated with marginal illustrations in the tradition of the patriarchal scriptorium probably early in the eleventh century, palatine influences may be detected. Quite a number of the scenes – David proclaimed king, the repentance of David, David and Goliath, the prayers of Hannah, Isaiah, and Ezechiel – are reduced versions of the full-page miniatures in the Paris Psalter (gr. 139) [171].

Perhaps the great palatine Psalter was sent over to the patriarchal offices for study. No doubt there were constant comings and goings between the various workshops. Certainly for the decoration of the tympanum in the south-west vestibule of Hagia Sophia the best craftsmen available would have been called upon wherever they were working at the time.[14]

About the same time, towards the end of the tenth and into the eleventh century, there appears to have been a change of style in the ivory carvings. A relief carved with the Entry into Jerusalem, now in Berlin [193], and another carved with the Dormition of the Virgin in the Staatsbibliothek, Munich [194], provide the starting points for the sequence. The relief of the Dormition is set in a book-cover of the so-called Evangeliary of Otto III (983-1002), which was in fact a gift from the Emperor Henry II (1002-27) to the cathedral of Bamberg. Both manuscript, which was written and illuminated at Reichenau in the late tenth century, and cover are of the same date. It is possible that the reliefs were brought from Constantinople by the Princess Theophano who married the Emperor Otto II in 972, although the style of these reliefs is not like the Court style, typified about this time by the ivory reliquary of the True Cross made for the Emperor Nicephorus Phocas (963-9) [177]. The ingredients of the new style consist of high relief, deep undercutting, angular, crisp drapery, the hair treated in tight curls, rather jagged profiles, and a tendency to treat some of the figures as puppets. Many of the triptychs or parts of triptychs are carved with selections from the Twelve Feasts: in the Louvre, for example, a triptych reveals the Nativity on the central panel, the Entry into Jerusalem and the Harrowing of Hell on the left-hand panel, and the Ascension on the right.

193 (*right*). The Entry into Jerusalem. Ivory panel.
Late tenth century.
Berlin, Ehemals Staatliche Museen

194 (*far right*). The Dormition.
Ivory panel on a book-cover, MS. Clm. 4453.
Late tenth century. *Munich, Staatsbibliothek*

192. Jonah. From a Menologion, MS. gr. 1613, fol. 59, executed for Basil II in the Palace of the Blachernae. *c.* 985. *Vatican, Biblioteca Apostolica*

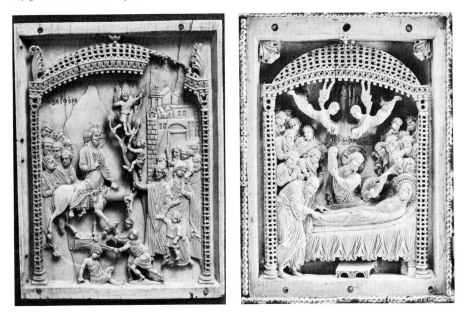

Isolated panels may be carved with the Crucifixion (New York, Metropolitan Museum) or the Deesis, the Presentation of the Virgin, or the Washing of the Feet of the Apostles (all three in Berlin). Although the suggestion has been made that the triptych carved with the exposure of the Forty Martyrs of Sebaste and warrior saints in the Hermitage and a single

relief carved with the Forty Martyrs in Berlin may date from the fourteenth century, it seems more likely that these reliefs should join the earlier group. Pseudo-Kufic inscriptions on the shields of St Demetrius and St Procopius, and on the scabbard of St Theodore Stratelates, in the Hermitage triptych tend to confirm the earlier dating. The style of these reliefs has also

195. The Veroli Casket. Ivory. Late tenth or early eleventh century. *London, Victoria and Albert Museum*

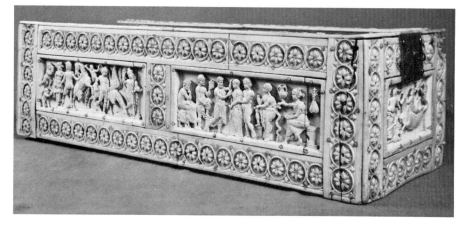

196. Mythological figures. Enamelled glass bowl. Eleventh century. *Venice, S. Marco, treasury*

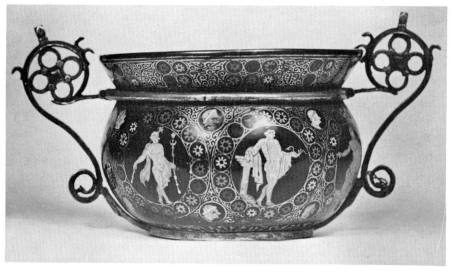

been compared with illustrations in an eleventh-century Menologion in Moscow (Historical Museum, cod. gr. 183). Indeed, the well-known Veroli Casket in the Victoria and Albert Museum [195] carved with scenes from classical drama and mythology, also part of the same group, has been compared with miniatures in a copy of the Pseudo-Oppian's *Cynegetica* (Venice, Marciana, gr. 479) which is usually dated to the eleventh century and an enamelled glass bowl with mythological figures and pseudo-Kufic inscriptions [196] in the treasury of S. Marco at Venice. Within the same stylistic context may be placed two reliefs in steatite – a small panel carved with a boar-hunt in the Victoria and Albert Museum and a fine representation of the Dormition [197] at Vienna.[15]

St Luke the younger had prophesied in 942 that Romanus II would capture Crete, and in 961 through the generalship of Nicephorus Phocas the prophecy was made fact. Romanus decided to build a large church on the site of Luke's hermitage and tomb – the saint had died

197. The Dormition. Steatite.
Late tenth or early eleventh century.
Vienna, Kunsthistorisches Museum

in 953. But the project as it stands today seems not to have been realized until the time of Basil II, when, after 1017, he went to Athens to give thanks for his victory over the Bulgars to the Virgin of Athens in the Parthenon. According to the monastery's own tradition the foundation of the catholicon is due to Romanus II, who is said to have prepared his and his wife's tomb near that of the saint. Two formerly handsome sarcophagi in the crypt of the main church seem to confirm this tradition, but the sarcophagi have been stripped of their metal covering in 1823, and long before that, probably during the Frankish occupation, the contents had been rifled. The presence of other tombs in the western part of the crypt suggests that the abbots of the monastery were buried there. So there are elements of doubt about the date of the foundation. The publication of the frescoes in the north-east chapel indicates that the founder was the *begoumenos* Philotheos and the catholicon was constructed in 1011, a date however which has since been disputed. In the extensive mosaic decoration of the catholicon there are no imperial portraits, such as might be expected in an imperial foundation, and presence on the walls of St Nikon Metanoites, who died in 998, advances the probable date well into the reign of Basil II. The carved frieze of palmettes combined with Kufic letters on the outside walls has been compared to similar decoration in the church of Nicodemus at Athens erected about 1049. On the other hand, the absence of St Meletios, who was a prominent ascetic in Greece during the second half of the eleventh century, in the mosaic decoration suggests that it was set up before the middle of the century. The catholicon of Hosios Loukas is, therefore, the earliest Middle Byzantine church in which the decoration has survived almost complete. In fact, the dome of the church with its mosaic of the Pantocrator collapsed after an earthquake in 1593, and a number of scenes including the Annunciation, which has been replaced by a fresco, and some saints are missing. Generally speaking, however, the decoration conforms to the post-

198–200. The Crucifixion (*above*),
the Harrowing of Hell (*opposite, above*),
and the Washing of the Feet of the Apostles (*opposite*).
Mosaics. *c.* 1020. *Hosios Loukas, catholicon*

Iconoclast liturgical system. The Virgin and Child are enthroned in the apse, Pentecost is represented in the dome of the sanctuary, Christ Pantocrator surrounded by four archangels was placed in the main dome, and on the pendentives the Annunciation, the Nativity, the Presentation, and the Baptism of Christ. In the narthex unfolds the cycle of the Passion and the Resurrection. Elsewhere, all over the church the invasion of the saints has taken place, rather more than one hundred and forty all told. The marble panelling goes up to a considerable height, leaving the domes, semi-domes, niches, and arches to be covered by mosaic which is unified by the gold ground and yet divided by its own architectural frame. Detail is confined to a minimum. In the scene of the Crucifixion [198], for example, the representation is reduced to three figures: Christ on the cross set with wedges on a small mound, the Virgin and St John, small symbols of the sun and moon, and inscriptions which identify the Saviour and the scene and remind the spectator of Christ's commending His mother and His disciple to one another. The livid body of the dead Christ hangs limply on the Tree of Life; a little blood spurts from the hands, feet, and the lance-given wound. The Virgin and the Disciple stand, or rather float, against the gold ground, as witnesses of the sublime sacrifice, she draped in a dark blue robe and veil, he in a pale green tunic and a pale pink cloak. There is no suggestion of historical narrative; the scene is a reminder of a liturgical feast. Similarly, the Harrowing of Hell [199] is depicted with monumental simplicity: Christ triumphant over the gates and shackles of Hell, gripping the cross like a stan-

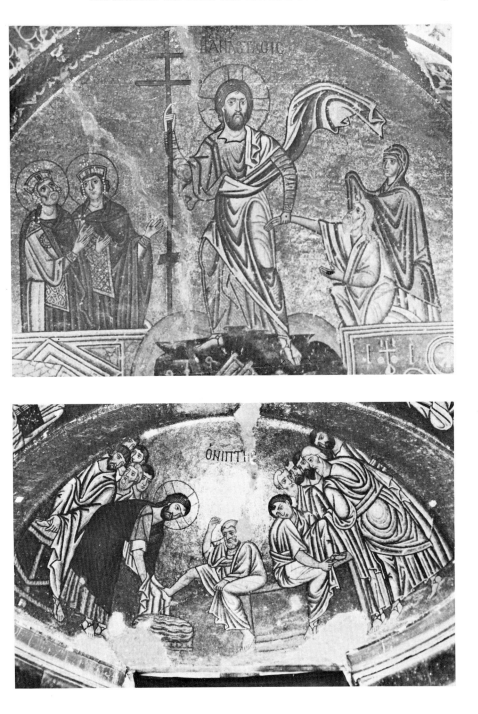

dard of victory and leading Adam and Eve from a tomb, while on the other side David and Solomon rise from their sarcophagus to greet the apparition with wonder and respect. The laconic brevity of this cataclysmic event is more telling than a thousand words and more moving than a host of images. Even in a scene which calls for a number of persons, as in the Washing of the Feet [200], the division of the Apostles into two groups on either side of Christ drying the feet of St Peter and St John(?) unloosening his sandal amounts to a composition of great severity and restraint. The liturgical note sings through the sacred act of divine humility. There are variations in quality of design and technique. It has been argued that the artists responsible for the decoration of the narthex were better than those working in the naos. Indeed, in the representation of individual saints the images vary from the sublime to the stereotype. But in general the church of Hosios Loukas is a worthy reminder of the lost churches of Constantinople, and it is difficult not to believe that the artists had learnt their craft in the metropolis.[16]

In the south gallery of Hagia Sophia at Constantinople the portraits of the Empress Zoe (1028–50), daughter of Constantine VIII, and her first husband Romanus III Argyrus (1028–34) were placed on either side of Christ enthroned. It is probable that the panel was set up during the repairs to the great church initiated by Romanus III. Unfortunately Romanus III blundered in everything he did, and even his building of the large church of the Theotokos Peribleptos in Psamatia, where he was later buried, did not escape the scorn of his contemporaries. His murder by a handsome Paphlagonian, who had already become the Empress's lover, was unmourned. Michael IV (1034–41) was not incompetent, but his epilepsy soon unfitted him for the ceremonies of the court, and the fiscal extortions of his brother John the Orphanotrophus, who was the real power behind the throne, made this new family hated by the people. All the same Michael Psellus speaks well of the Emperor and seems to have ap-

proved of his building a large church in honour of St Cosmas and St Damian, the Hagioi Anargyroi – 'a glorious monument' – in a suburb of the city on the east side where Michael IV was finally laid to rest beside the holy altar. Before his death Michael persuaded Zoe to adopt his nephew Michael Kalaphates as her son and co-Emperor. This worthless young man, as Michael V (1041–2), committed the final folly of banishing Zoe to the island of Prinkipo. It was probably at this time that the portraits in the south gallery of Hagia Sophia were defaced. The people were not prepared to see their beloved Mama, a daughter of the glorious dynasty of Basil I, niece of Basil II, treated thus by the son of a Paphlagonian docker. Zoe was brought back from exile. Her sister Theodora was conveyed in state from her convent of the Petrion by the Phanar to the Sacred Palace. The two ladies were reinstated in the purple. Michael V and his uncle Constantine the Nobilissimus had taken refuge in St John of Studius, and Zoe was inclined to be merciful to them. But Theodora was adamant. The Paphlagonians were induced to leave the altar to which they were clinging and they were blinded in the street. For a few months the sisters ruled as co-Empresses, but neither of them had a head for affairs of state and Zoe in her sixties allowed herself to be persuaded to marry again. Shortly after the marriage the portraits in the south gallery of Hagia Sophia were restored [201], and today the faces of Constantine IX Monomachos (1042–55) and the Empress Zoe gaze down from the golden walls. In comparison with the mosaic in the tympanum over the door in the southwest vestibule there are several marked changes. The face and head of Christ, which for some reason unknown also had to be restored, are less dense in structure than those of the Virgin; the planes of the face are built up in a rather sketchy, impressionistic technique. The drapery, though still classicizing and modelling the form, tends to be more mannered, with complicated folds and creases running across the body. The Augusti are encased in richly ornamented court dress, more elaborate than that worn by Con-

201. Christ enthroned between the Emperor Constantine IX Monomachos and the Empress Zoe. Mosaic panel in the south gallery. Probably executed between 1028 and 1034, defaced in 1041, and restored shortly after 1042. *Istanbul, Hagia Sophia*

stantine and Justinian, above which the heads of Zoe and her husband emerge as recognizable portraits. Even in her sixties Zoe's face showed little sign of age, and she retained her beauty almost up to her death. Constantine IX was a handsome man, of great charm and warmth of disposition; some of the distinction of his features is reflected in the mosaic in spite of the accentuation of the cheekbones by circular devices. This type of court portrait with the face, which seems to have been taken from life, emerging through and above the screen of intricate regalia was to continue until the end and

was to be adopted in most territories subject to Byzantine influence.[17]

Between 1048 and 1054 Constantine IX built the church and convent of St George of the Mangana, where he was eventually buried, though he changed his mind at least three times over the general plan, and at times it looked as though it would never be finished. 'The whole conception was on a magnificent and lofty scale. The edifice itself was decorated with gold stars throughout, like the vault of heaven, but whereas the real heaven is adorned with its golden stars only at intervals, the surface of this one

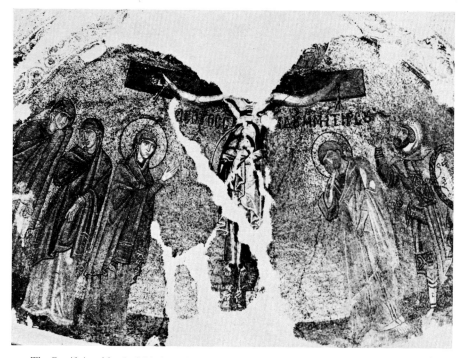

202. The Crucifixion. Mosaic. Mid eleventh century. *Nea Moni, Chios*

was entirely in gold, issuing forth from its centre as if in a never-ending stream.' Michael Psellus goes on to praise the cloisters, the lawns full of flowers, the fountains, the hanging gardens, the dewy grass sprinkled with moisture, the shade under the trees, the gracefulness of the piscina. 'To attempt to place its various merits in any order of preference was useless, for when all the parts were so lovely, even the least attractive could not fail to give pleasure inimitable.' Today, little more than the site is known. On Chios, however, the Nea Moni founded by Constantine IX still stands. Some years back three hermits had found in the middle of a burnt forest on Mount Privation a myrtle bush unharmed, and hanging from its branches an icon of the Virgin. They sought out Constantine Monomachos, who was then in exile on Mytilene, and obtained a promise that

if ever he became Emperor he would build a church in the mountains of Chios. After his enthronement the hermits reminded him of his promise. Building went on throughout the reign and was not completed until the autocracy of Theodora (1054–6). The three hermits were buried in the church. A team of mosaicists was sent from Constantinople, and some fragments of their work still survive. The scheme of decoration follows the same liturgical pattern as that of Hosios Loukas but, since the building was of a different type, there were differences of application. Eight Feasts of the Church were placed in the niches below the dome and six others in the vaults of the exonarthex; in the dome itself Christ Pantocrator (now lost) was surrounded by twelve orders of angels; in the apse the Virgin was orant; in the prothesis and diaconicon were the Archangels Michael and

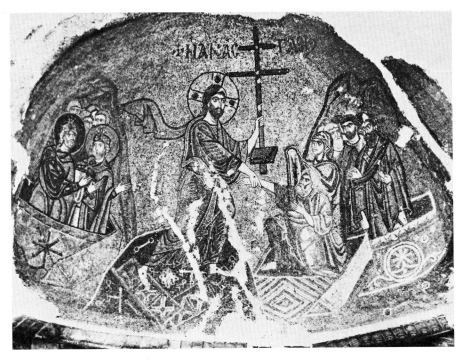

203. The Harrowing of Hell. Mosaic. Mid eleventh century. *Nea Moni, Chios*

Gabriel. There was the usual invasion of saints, many represented as busts in roundels reminiscent of pre-Iconoclast decoration. The scenes and the manner of their depiction are more elaborate than those in Hosios Loukas. In the Crucifixion [202] the Virgin is accompanied by the two other Maries and the centurion stands behind St John. In the Harrowing of Hell [203] the position of Christ is changed, and a number of figures are massed behind Adam and Eve on the one hand and behind David and Solomon on the other; behind each group the landscape of Limbo is evoked. The Washing of the Feet is a completely different composition with the Apostles sitting in various postures on a long bench and Christ on the extreme left washing the feet of St Peter. In all the scenes the outline of the figures and the detail of their forms is deeply stressed. The faces tend to have heavy brows, deep shadows under the eyes, and the dark hair of the men, their beards and brows, conjure up an atmosphere of strong Levantine virility set in a framework of vivid colours against the brilliant gold ground. The overall sternness of expression, the intent, deep-set gaze, the concentration on solemnity wherever the spectator turns, make a forceful and sombre impact. It is somehow a relief to leave the church and to calm oneself by contemplating the magnificent natural view to be seen from a balcony near by. The mosaics of the Nea Moni must in their day have been magnificent and alarming. Unlike the atmosphere of the court during the reign of Zoe and Constantine and the objects made for their personal use, there is never a hint of the need for charm.[18]

This grim atmosphere was certainly not confined to the Nea Moni; it appears about the

same time at Kiev. Vladimir Svyatoslavovich, Grand Prince of Kiev (978–1015), although reputed to have already three wives and eight hundred concubines at his disposal, demanded as a price for help in war and for his conversion to Christianity the hand of a purple-born princess. To the imperial administration, fully aware of the advantages they had gained by the conversions of the Slavs and the Bulgars in the ninth century, the opportunity for widening their sphere of influence was not to be missed. There was also a grave necessity. In 987 the metropolis was closely besieged by rebels, the young Basil II had been defeated in the field, and it was essential to secure military reinforcements from Kiev. There was nothing to be done but swallow imperial pride and hand over the unhappy princess. Anna complained bitterly that she was being sent into slavery and would rather die than leave the city, but she did her duty. Through her and the clergy she brought with her South Russia became Christian, and closely linked with the Byzantine administration. Vladimir also summoned Greek craftsmen to Kiev and proceeded to build between 989 and 996 the church of the Virgin, which was elaborately decorated with marble, porphyry, slate, mosaics, and frescoes. The church collapsed in 1240, but it is known that the decoration followed the standard Byzantine pattern. Vladimir's son Yaroslav (1019–54) was responsible for a number of religious buildings in the principality. The Pechersky Monastery was founded about the middle of the eleventh century; its statutes were received from St John of Studius at Constantinople, and close relations were maintained between Slav countries and Mount Athos. The church of the Dormition within its precincts was decorated by artists from Constantinople between 1083 and 1089 on a pattern similar to that of Hagia Sophia at Kiev, but nothing has survived. In 1037 Yaroslav founded the great cathedral of Hagia Sophia as the seat of the Metropolitan, and the Greek Theopempt was sent from Constantinople to take up his duties. The mosaic decoration was undertaken between 1043 and 1046 in the central apse and the area under the central dome, but the fresco decoration in the remainder of the church was not completed before 1061 or 1067. The Christ Pantocrator in the dome and the Virgin Orans in the apse are overwhelmingly monumental in conception. Christ was surrounded by four archangels, of which only one remains. Lower down, between the windows of the drum, the Apostles were arrayed, and of these only the half-figure of St Paul survives. The Evangelists were portrayed in the pendentives, and here only the portrait of St Mark is intact. Above the triumphal arch three medallions contain the busts of Christ, the Virgin, and St John the Baptist; on the pillars on either side of the arch the figures of the Virgin and the Archangel Gabriel refer to the Annunciation. On the eastern and western arches, between the Evangelists, medallions contain busts of the Virgin and Christ, the latter portrayed as priest, an iconographic rarity. In the middle register of the apse was set the Communion of the Apostles on either side of a ciborium and altar flanked by archangels bearing large *flabella*. The role of Christ as priest was further stressed by the presence in the same register of the High Priests Aaron and Melchisedek, but these no longer exist. Lost also are the mosaics of the bema which represented Old Testament prophets and kings. The lower part of the apse is decorated with a row of eight saints and two archdeacons gazing majestically into the centre of the church. Finally, on the arches supporting the dome, medallions contain the busts of the Forty Martyrs of Sebaste. From this brief iconographic survey it may be seen that the decoration of Hagia Sophia at Kiev complements in several important instances the evidence supplied by Hosios Loukas and the Nea Moni on Chios. In all cases the inscriptions accompanying the Kievan mosaics are in Greek. There seems no reason to doubt that Byzantine artists executed the work, possibly with the help of some local trainees, and that the whole plan is based on models at Constantinople. The great Christ Pantocrator in the dome falls nobly into line with similar representations in Hosios Loukas,

Daphni, and the churches of Palermo. The impressive Virgin Orans in the apse, the superb Eucharistic Liturgy, the solemn portraits of the saints must have had an overwhelming effect on the Vikings of Kiev. When Vladimir's ambassadors had visited Constantinople in 987, they had attended a great service in Hagia Sophia; they were overcome with emotion and believed themselves to be in Heaven with the angels descending and hovering over their heads. It was the effect of candlelight, incense, and mosaic, but the Byzantine clergy encouraged their belief. Now Vladimir's son had summoned the angels to Kiev.[19]

The frescoes tend to veer away from the Byzantine canon. There is a freer approach to the Gospel cycle which shows several deviations from the system of Feasts. As in the apse, great stress is placed on the importance of the Eucharist. This may have been considered particularly necessary since in his pagan days Vladimir had permitted animal and human sacrifices to his gods, and such traditions are apt to die hard. On the other hand, Byzantine imperial court traditions were closely followed. In the gallery where the family of the Grand Prince attended Mass there was on the western wall a representation of Christ enthroned attended by Yaroslav, carrying a model of the cathedral, and his eldest son, with the Grand Princess Irene and her eldest daughter; on the south wall were four younger daughters, on the north wall four younger sons. Although Yaroslav and Irene wear Byzantine crowns, three of the daughters, who were shortly to become Queens of Norway, France, and Hungary, are uncrowned. It has been presumed therefore that the fresco was executed in 1045. Elsewhere in the church were depicted scenes from the lives of St Peter, St Paul, and St George – who was the patron of Yaroslav – and a host of single figures were scattered without any logical pattern on arches and pillars. Unlike Byzantine churches, the walls of Hagia Sophia at Kiev are covered in fresco down to the floor, the decoration is frequently haphazard and unsymmetrical, and the ornamental details reflect local folk art. It has been argued cogently that this decoration must have been the work of a Byzantino-Kievan workshop with the local craftsmen gradually predominating.[20]

The earliest series of frescoes in the cathedral of Hagia Sophia at Ochrid in Macedonia (now Yugoslavia) have been compared to those in the narthex of Hagia Sophia at Salonika and the mosaics of Hagia Sophia at Kiev. Some believe that the church at Ochrid was built towards the end of the tenth century, during the reign of Tsar Samuel, on the occasion of the elevation of the archbishopric into a patriarchate. In 1019, however, Basil II reduced the see to an archbishopric, and from that date it depended directly on the imperial administration at Constantinople. A manuscript in Paris (gr. 880, ff. 407–8) states that Leo, cartophylax of Hagia Sophia at Constantinople and later Archbishop of Ochrid (1037–59), built 'the lower church in the name of Divine Wisdom', but there are those who consider that Leo only 'renewed' the church. Certainly the frescoes in the choir and some in the nave and the *rez-de-chaussée* of the narthex appear to date from the middle of the eleventh century and must reflect the art of the metropolis. A surprising number of portraits of Patriarchs of Constantinople and Popes of Rome suggest that, like the Church of Cyprus, the archbishopric of Ochrid had direct relations not only with the imperial court but also with Rome. Presumably these portraits date from before the letter of 1052 sent by Michael Cerularius, Patriarch of Constantinople, and Archbishop Leo of Ochrid to John, Bishop of Trani, which precipitated the schism between the Eastern and Western Churches in 1054. As a rule the Papacy was not honoured in Byzantine and Slav churches in this manner, although isolated Popes might be commemorated – Pope Clement in Hagia Sophia at Kiev, for example. In the apse, the Virgin and Child were enthroned as usual, but beneath, instead of the Communion of the Apostles, Christ is making the Offertory, the prayer of the *proskomedia* said immediately after the Grand Entry, before an altar flanked by archangels holding *flabella* and

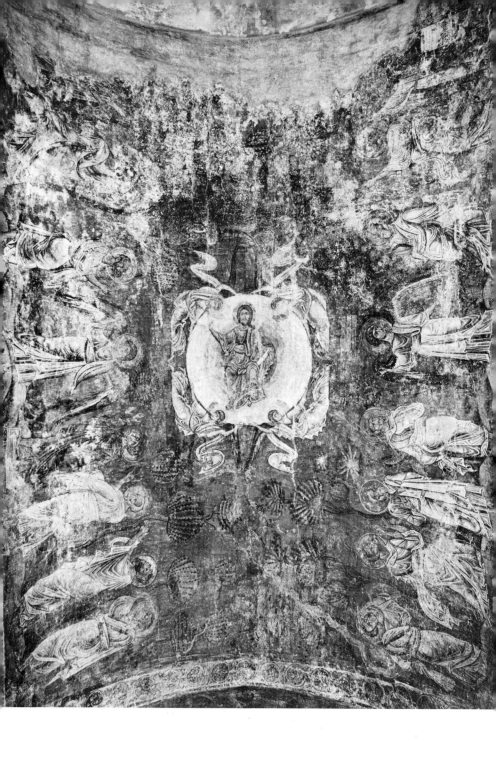

attended by the Apostles. The Divine Liturgy is invoked whereby Christ, sacrificing and sacrificed, offers Mass perpetually amid angelic splendour in the impenetrable depths of Heaven. The Patriarchs below are the earthly witnesses of this holy liturgy. The vault of the church is occupied by the Ascension [204], and beneath this scene, on the sides of the barrel-vault, two rows of angels – a remarkable sight – fly towards the apse. Below, again on the south side of the church, are scenes from the life of Abraham, and on the north side Jacob's Ladder, the Hebrews in the Fiery Furnace, and two scenes from the life of St Basil in which the saint has a vision of Christ making the Offertory, and celebrates his first Mass. In fact the scenes all stress two main themes of Byzantine church decoration: the Incarnation and the Eucharist. They also suggest that the decoration of Byzantine churches was not necessarily confined to a rigid scheme. Within the conventions of the period innumerable variants might be evolved. It is equally clear from the surviving monuments of the eleventh century that there was no hard conformity of style. Sometimes these developments might occur under local influence, as at Kiev; sometimes, as in Cappadocia, the provincial decoration receives an injection from the art of the metropolis. In Qarabach kilisse, for example, an inscription refers to the *protospatharios* Michael Skepedis, a nun Catherine, a monk Niphon, and the date 1060/1 under the Emperor Constantine Dukas. The frescoes are for the most part in poor condition, but it has been suggested that the influence of Constantinople is responsible for new types of iconography in scenes of the Nativity, the Crucifixion, the Communion of the Apostles, and the Harrowing of Hell. The frescoes in Qaranleq kilisse are also dependent on the great Byzantine models of the eleventh century.[21]

During the reign of Constantine X Dukas (1059-67), after the earthquake of 1065, the patrician Nicephorus restored the mosaics in the narthex of the church of the Dormition (now totally destroyed) at Nicaea. This decoration consisted of a double cross against a ground of stars within a roundel at the centre of the vault, reminiscent perhaps of the decoration in the church of St George in the Mangana described by Michael Psellus. Medallions containing busts of Christ Pantocrator, St John the Baptist, St Joachim, and St Anne, also in the vault, suggest that the Incarnation was again intended as the main theme. In the four corners of the vault were distributed the four Evangelists, and in the lunette over the door there was a bust of the Virgin Orans. Like the mosaics at Kiev the forms were broad and heavy, but unlike the principal monuments of this century the bodies tend to disintegrate under the pattern of folds. One of the main features of Middle Byzantine style is the tendency for the drapery to create its own pattern across the form, but there were elements in the decoration at Nicaea which looked forward to Late Comnene art.[22]

204. The Ascension. Wall-painting.
Mid eleventh century.
Ochrid, Hagia Sophia

METROPOLITAN AUTHORITY

In the eyes of modern historians the course of the Byzantine Empire in the eleventh century was set on swift decline. But no Byzantine bureaucrat, however wise and responsible, could have foreseen the calamities to come, and no Byzantine general would have pointed to the Battle of Manzikert in 1071, when the once glorious Byzantine army was routed without a full-scale engagement, as the beginning of the end. If a Nicephorus Phocas or a Basil II had been ruling at the time, the rout would have mattered little, but there was no one with vision or character to pull the state together, and eventually a large part of Asia Minor, the source of manpower and solid wealth, was lost to the Empire for ever. To the superficial observer the Empire seemed prosperous and mighty, no serious enemy menaced the frontiers, and Byzantine diplomacy manoeuvred in their eyes successfully in areas far beyond the limits of the Empire. But after the death of Basil II the throne was occupied by a rapid succession of mediocre, not to say frivolous, Emperors and Empresses, and the struggle for power hardened into a suicidal contest between the civil administration and the military aristocracy. Inevitably the civil administration with its headquarters entrenched at Constantinople was better placed than the aristocracy with their great estates in the Balkans and Asia Minor. The citizens of Constantinople, secure behind the impregnable walls, enriched by trade with Asia, the Middle East, and southern Europe, protected by God and the Virgin, were blind to the needs of the Empire, which could only survive with a strong army and navy. Time and again the people supported civilian autocrats who, either deliberately or through negligence, destroyed the military organization of the Empire. Furthermore, the aristocracy, by engulfing the small landowners who provided the manpower of the

army, undermined the entire structure, social, economic, and political, so that when great dangers appeared on the horizon, the administration had to rely on private armies and mercenaries with increased liability to treachery and double dealing.

None of these dangers was at all comparable to the serious menaces which the Empire had withstood in the seventh and eighth centuries, but in the eleventh century there was no Heraclius, no Leo III, no Constantine V after the death of the Bulgaroctonos. Imperial secretaries like Michael Psellus were well aware of the canker in the rose, that behind the imperial liturgy matters were far from satisfactory, that revenue hard gained was squandered frequently to little purpose, but no Byzantine statesman of the time could overcome his mistrust of a military usurper. The city had never forgiven Nicephorus Phocas for its occupation by Armenian troops, and the astute Basil II had always exercised his armies in distant campaigns. When finally a military aristocratic family was settled on the throne, it was almost too late. Although the Empire rallied under the Comnene dynasty – between them Alexius I, John II, and Manuel reigned for just under a hundred years, from 1081 to 1180 – the situation of the known world had so changed that the manifold abilities of these Emperors were not enough to preserve the delicate balance of power in Middle Eastern politics once the Western states were committed to the massed aggression of the Crusades. Valuable commercial rights were ceded to the Venetians, the Genoese, and the Pisans, who in the end throttled Byzantine trade and infuriated the Greeks by their avarice. Byzantine diplomacy was regarded in the West as a devious essay in perfidy. The Western armies marching through Byzantine territory were regarded with reason by the bureaucracy as an

undisciplined rabble to be policed at all costs, if not by their own troops, by friendly Slav and Islamic princes.

By the end of the Third Crusade in 1192 many people from the West had some knowledge of the prestigious metropolis. Her palpable wealth, her treasures, her relics, her innumerable palaces and churches, her mosques (these gave particular offence to the Crusaders; Latins resident in Constantinople tried to burn down a mosque when the Fourth Crusade was outside the walls and a whole quarter of the city was devastated by fire before the final catastrophe), the strange ceremonies of the court, the very cult of the Byzantine Emperors made Constantinople unique, awe-inspiring, and the object of envy and cupidity. The pity of it was that by the end of the twelfth century the God-guarded city was little more than a glittering façade.[1]

During this apparently imperceptible period of decline the influence of Byzantine art reached its highest point and its widest range. Previously a few Greek craftsmen at the court of Charlemagne might have given a short, sharp injection of something new and strange into Western achievement, or servants in attendance on the Empress Theophano might have influenced artists working for the Ottonian Emperors, but there was no staying power to the boost. The art of Kievan Rus', of the Slavs and the Bulgars always remained firmly within the Byzantine compass, even when the Greek masters died or returned to the city. Matters were different in the West, which had its own models and traditions. In the late eleventh and twelfth centuries, however, there was a new receptiveness to Byzantine art. In Italy it was to be expected; the south had long been partly under Byzantine rule, the Papacy was always in touch with the metropolis, and Venice in a sense was a daughter of Byzantium, but the Normans in Sicily called in a succession of Greek teams to decorate their churches. As a matter of course the upstart kings had themselves portrayed in Byzantine court costume. Cities in the Holy Roman Empire forged their own links with the metropolis: Salzburg, Regensburg, and particularly Cologne, whose merchants commissioned manuscripts from Constantinople for churches at home. Roger of Helmarshausen had never visited Constantinople, but in his treatise *De Diversibus Artibus*, which he wrote under the name of Theophilus, his interest in Byzantine art from the craftsman's point of view is more than once made plain. He admired the Byzantine technique of gilding glass, of making mosaic, and curiously enough of producing glazed earthenware, since the quality of Byzantine pottery tends to be rather mediocre. Perhaps Roger was thinking of glazed tiles, of which a few fragments of good quality have survived and are now in the Louvre. He admired Byzantine decoration and 'Greek foliage' in particular, although it is far from clear what he meant by the latter. Suger, Abbot of Saint-Denis, liked to ask travellers returning from Constantinople about the beauties of the city, partly because he hoped to hear that his own abbey compared favourably with the splendours of Hagia Sophia. We may be sure that in the middle of the twelfth century Henry of Blois, Bishop of Winchester, directed artists working for him in England to study Byzantine illuminated manuscripts, and before him Master Hugo, working at Bury St Edmunds between 1130 and 1140, was clearly familiar with Early Comnene style. In addition at Venice there was a revival of interest in the works of the Early Christian period, but this, too, reflects a fashion which was then current at Constantinople. Before 1204 Venice was little more than a Byzantine apprentice, and after the sack she lost no time in clothing herself in the robes of the conquered city.[2]

The authority and traditions of the Byzantine workshops were unaffected by the palace intrigues and the tortuous policies of the bureaucracy. A copy of the Homilies of St John Chrysostom produced for Michael VII Dukas about 1078 contains four altered miniatures of which one portrays the usurping Emperor Nicephorus III Botaneiates (1078–81) standing between St John Chrysostom and St Michael

205. The Emperor Nicephorus III Botaneiates between St John Chrysostom and the Archangel Michael.
From a copy of the Homilies of St John Chrysostom, MS. Coislin 79, fol. 2 verso. *c.* 1078.
Paris, Bibliothèque Nationale

[205], and another the same Emperor with the Empress Maria of Alania, the former wife of Michael VII, crowned by Christ. The portraits are executed with supreme elegance of effect, the grave, handsome faces haloed against a golden ground, the jewelled *loros* and the richly embroidered or brocaded robes creating a carapace of majesty, the calculated disproportion of the elongated figures with their tiny hands and feet stressing the remote rarefaction of the imperial image. Nor were works of quality necessarily confined to the court workshops. A Psalter and New Testament, formerly on Mount Athos (Pantocrator, no. 49) and now at Dumbarton Oaks (MS no. 3), with Paschal Tables for the years 1084-1101, contain miniatures painted against a gold ground with delicate, elegant figures which on the one hand look back to the court school of the tenth century, and on the other look forward to the mosaics in Christ in Chora executed in the early fourteenth century. The manuscript was surely produced at Constantinople and has been compared with a Gospel Book copied by Peter Grammaticus of the school of the Chalkoprateia in 1070 (Paris, suppl. gr. 1096) and a Psalter written in 1088 by Michael Attaliates (Vatican, gr. 342). All three manuscripts are smaller in scale than the Homilies of St John Chrysostom produced for Michael VII and Nicephorus III, but the Psalters belong to the so-called 'aristocratic recension'. The light colours with a predominance of pale blues, familiar in manuscripts of the early eleventh century, are heightened by vivid touches of red; even the veil of the Personification of Night (fol. 77) in the Vision of Isaiah is red instead of blue. The small figures are attenuated, with a corresponding loss in bodily weight, and are set against buildings and landscape which serve more as a backdrop than as an evocation of space as in the headpiece to the Magnificat (fol. 80 verso) [206], which shows the Annunciation and the Virgin seated near a small house. The style is quite different from the Studite group dating from the middle of the eleventh century – for example, British Museum, Add. MS. 19352, executed at St John of Studius in 1066, and Paris, gr. 74 – where the figures are even slighter and the colours just as vivid, but with much use of gold articulation and hatching. This so-called 'style mignon' or 'style cloisonné' continued well into the twelfth century and could be combined with the 'court' style, as in the superb Four Gospels at Parma (Bibl. Palat. 5), dating from the second half of the eleventh century. There was also a marked fashion for setting scenes in elaborate frames, either in copies of the New Testament like

206. The Annunciation. From a copy of a Psalter and a New Testament, MS. 3, fol. 80 verso (formerly Mount Athos, Pantocrator, MS. 49). Late eleventh century.
Washington, D.C., The Dumbarton Oaks Collection

207 (*opposite*). The Ascension.
From a copy of the Homilies of the Virgin
by James of Kokkinobaphos,
MS. gr. 1208, fol. 3 verso.
First half of the twelfth century.
Paris, Bibliothèque Nationale

208. The Virgin Orans. Serpentine.
Between 1078 and 1081.
London, Victoria and Albert Museum

Bodleian MS. Auct. T. infra 1. 10 (Misc. 136) or the Acts of the Apostles (Paris, suppl. gr. 1262), dated to 1101, or in the Homilies of the Virgin by the monk James of Kokkinobaphos [207], wherein the brilliance and ingenuity of the architectural framework almost swamp the main scene. There was undoubtedly a great variety in the metropolitan production of the twelfth century, and the work of provincial workshops is still virtually uncharted. Of the late twelfth century there are no satisfactorily dated manuscripts which can be safely assigned to the metropolis with the exception of a Psalter dated to 1177 (Vatican Barberini, gr. 320), which belongs to a retrospective current, and possibly a Gospels produced by a certain Matthew and dated 1164 (Paris, suppl. gr. 1162) which contains portraits of the Evangelists in a mannered, rather desiccated style. Colours tend to darken and the technical execution to decline in quality.[3]

The consummate elegance of the late-eleventh- and early-twelfth-century manuscripts was not necessarily extended to other media. The serpentine relief carved with a bust of Virgin Orans [208] and an inscription referring to Nicephorus Botaneiates lacks the delicate modelling of the miniatures. The face is conceived in broad contours and emerges heavily from the light folds of the veil and above the tightly creased draperies. This broad, heavy style is repeated in two marble reliefs from the church of the Theotokos Peribleptos in Psama-tia, now in Berlin, carved with full-length images of the Virgin Orans and the Archangel Michael. Nicephorus Botaneiates had repaired the church, which had been built in 1031 by Romanus III Argyrus, and both Emperors were to be buried there. The reliefs date presumably from the later reign. The forms rise in high relief; in the case of the Virgin the tight creases of the veil contrast with the vertical folds of the robe, which fall almost without interruption from the waist to the ground, although the occasional horizontal crease suggests the catching of the drapery against the form; in the case of the Archangel the form is masked by court costume, but the elongation of the figure, the small hands and feet, and the attributes of power echo at some remove the imperial portraits in the copy of the Homilies of St John Chrysostom. The heavy features of the face and similar patterns of drapery occur in a marble fragment carved with a representation of the Virgin and Child and found near the mosque of Sokollu Mehmet Pasha not far from St Sergius and St Bacchus, now in the Archaeological

Museum at Istanbul [209]. All these reliefs are in marked contrast with a superb ruin of marble carving, also in relief, of the Virgin Orans discovered in the débris of St George of the Mangana built by Constantine IX between 1048 and 1054, also now in the Archaeological Museum at Istanbul. The almost mannered treatment of the drapery with its crisply crushed folds, the lightness of the elongated form, and the slight dryness of effect [210] suggest a date after rather than before the sculpture produced for Nicephorus Botaneiates. It seems likely that the Mangana relief was added to the decoration of the church of St George long after the death of Constantine IX and probably in the twelfth century. With this relief should be considered the beautiful pierced ivory panel carved with the busts of St John the Baptist, St Philip, St Stephen, St Andrew, and St Thomas [211] in the Victoria and Albert Museum, an ivory casket decorated with busts of Christ, the Virgin, and various saints in the Museo Nazionale at

209. The Virgin and Child. Marble relief found near the mosque of Sokollu Mehmet Pasha. Second half of the eleventh century. *Istanbul, Archaeological Museum*

210 (*right*). The Virgin Orans. Marble panel from St George of the Mangana. Eleventh or twelfth century. *Istanbul, Archaeological Museum*

Florence, and the unique ivory statuette of the Theotokos Hodegetria [212] also in the Victoria and Albert Museum. The style of the statuette seems to fall somewhere between the Psamatia reliefs and the Virgin Orans from St George of the Mangana. In his apprehension of a more mannered elongation of the form and in his cursive treatment of the drapery the artist, for all his backward glance at ivory carvings of the tenth century, proposes aspects of the new Comnene style.[4]

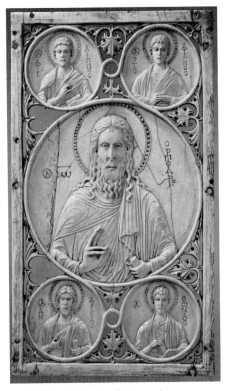

211. St John the Baptist with busts of St Philip, St Stephen, St Andrew, and St Thomas. Ivory relief. Twelfth century. *London, Victoria and Albert Museum*

212 (*right*). The Virgin and Child. Ivory statuette. Twelfth century. *London, Victoria and Albert Museum*

Also Early Comnene are parts of the Pala d'Oro in S. Marco at Venice, but its history is almost as entangled and protracted as that of the church which houses it. The first Pala d'Oro was ordered from Constantinople in 976 by Doge Pietro I Orseolo (976–8); this appears to have been a series of gold plaques nailed on a wooden ground like the Pala of Torcello and that of Caorle. A completely new Pala was ordered for S. Marco shortly before 1105 by Doge Ordelaffo Falier (1102–18). It consisted of a gold and enamelled antependium and included possibly portraits of the Emperor Alexius I, the Empress Irene, the co-Emperor John II, and the Doge Ordelaffo Falier. Only the portraits of the Empress and the Doge have survived, and the latter has been altered by a change of head and the addition of a halo. But already the complications begin. If the imperial portraits belonged to the new Pala as ordered by the Doge, this would suggest an imperial gift, for which there is no evidence. It is equally possible that the portrait of the Empress Irene and other panels were added when the Pala was altered in 1209 to include booty from Constantinople. The upper part of the Pala is considered to be constructed from a series of panels illustrating the Twelve Feasts which came from an iconostasis either in Hagia Sophia or in the church of the Pantocrator (the traditions are conflicting). The four Evangelists, an extended series of panels recounting the life of St Mark, a number of isolated panels representing Prophets and Apostles, and a series devoted to the life of Christ appear to be the work of Venetian craftsmen. The Pala was reconstituted in 1342–5 under the Doge Andrea Dandolo, and it is probable that groups of Byzantine enamels from various sources and ranging in date from the tenth to the twelfth century were included in the gold, pearl, and precious stone setting, to which enamels in the Gothic style were added. The Pala was cleaned in 1647 and again in the nineteenth century. The Byzantine enamels as typified by the portrait of Solomon [213] have the brilliance and luminosity of the contemporary manuscripts, with the same elongation of the form and the same tendency

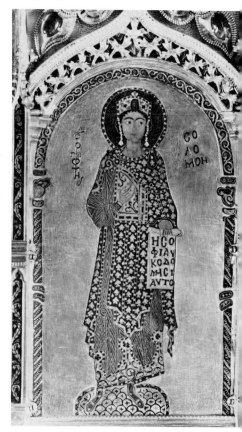

213. Solomon. Enamelled, silver-gilt plaque on the Pala d'Oro. Shortly before 1105. *Venice, S. Marco*

to weightlessness. The twelfth-century enamels are more intricate than the earlier groups, with a maze of gold cloisons and a wider colour range. If the tradition about the panels showing the Twelve Feasts is correct, there was a tendency towards even greater intricacy and a decline in quality. Nevertheless, the Entry into Jerusalem [214] is a noble composition, and in its exploitation of the medium remarkable. Generally speaking the Venetian enamels are more restricted in colour range, coarser in facture, and uninspired in design. With the panels reputedly from the Constantinopolitan icono-

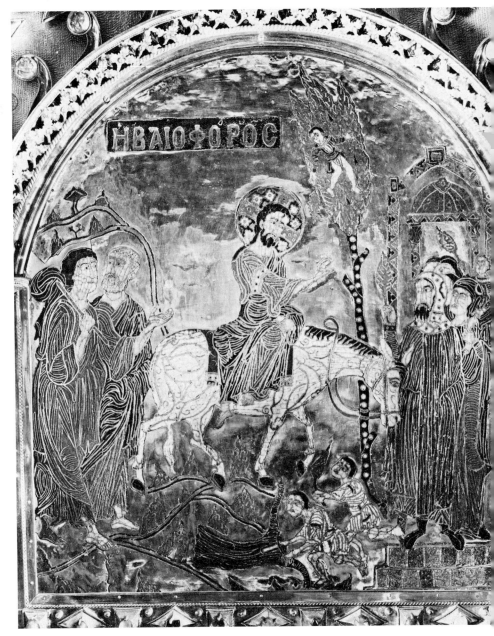

214. The Entry into Jerusalem. Enamelled, silver-gilt plaque
formerly part of an iconostasis in Hagia Sophia or the church of the Pantocrator in Constantinople,
now on the Pala d'Oro. Twelfth century. *Venice, S. Marco*

stasis should be considered a reliquary of the True Cross at Esztergom which deploys the same mannerisms, a panel with the Crucifixion in the Wittelsbacher Ausgleichsfonds at Munich, a panel with the Harrowing of Hell in the Kremlin, and a panel with the Crucifixion in a composite icon in the Hermitage Museum.[5]

Unfortunately the evidence for Comnene style in mosaic and fresco is not provided by the metropolis, but the grounds for inference that the metropolis was the source are very solid. In spite of the fact that the Empire was sinking to its doom, philanthropy was still lavish and not always confined to the imperial house. The grand and the rich felt it their duty to build churches, if only to serve as their last resting place. Romanus Argyrus and Nicephorus Botaneiates were not alone in their patronage of the church of the Theotokos Peribleptos. Thus, the church of Christ Philanthropus was founded by Irene, the daughter of Nicephorus Khoumnos; the church of the Theotokos Pammakaristos was possibly founded by the *curopalates* and Grand Domestic John Comnenus and his wife Anna Dalassena – their son was to be the Emperor Alexius I Comnenus (1081–1118) – although arguments have been advanced for a later John Comnenus and his wife Anna Dukaena and a late-twelfth-century date, in spite of the fact that both Alexius I and his daughter Anna Comnena were buried in the church; and the church of Christ Pantocrator was founded by the Empress Irene, wife of the Emperor John II Comnenus (1118–43) and daughter of St Ladislas, King of Hungary. The church of Christ in Chora was built between 1077 and 1081 by Maria Dukaena, then *protovestiaria* (Mistress of the Robes) at the imperial court and exercising considerable influence in the struggle for power between the Dukas and the Comnene families, but it was extensively altered about 1120 by Isaac Comnenus, third son of Alexius I and Irene Dukaena and grandson of Maria. Isaac also built the church of Cosmosotira at the mouth of the Maritza. The Emperor Manuel (1143–80) added a church to the Pantocrator Monastery. A new monastery dedicated to St Michael was built at Kataskepe

on the Black Sea. Throughout the century Hagia Sophia and the church of the Holy Apostles were kept in splendid repair. Nor was the decoration confined to the churches: Manuel added to the mosaics of the Sacred Palace, and he rebuilt and decorated the Palace of the Blachernae with scenes from the 'wars of antiquity' and his own exploits in hunting and war. The Spanish Jew Benjamin of Tudela was impressed by these histories and noted the skill with which they were set off by the polychrome columns around them. He admired the imperial throne glowing with gold and jewels so that even darkness was made light. He praised the paved courts which separated the imperial pavilions and the beauty of the gardens with their rare trees, flowers, and long stretches of sparkling water. To the Jew it was not just great wealth and countless treasures amassed at the metropolis; he was stunned by the artistry with which they were employed and the skill which seemed to make all things possible. Alexius, son of John Axoukh, Grand Domestic under John II and Manuel, also had his palace decorated with mosaics. They celebrated the deeds of the Sultan of Iconium – by 1078 the Seljuk Turks had reached Nicaea, and by the twelfth century the Sultanate of Rūm in Asia Minor was taken for granted. Andronicus I (1182–5) adorned his palace near the monastery of the Forty Martyrs with more mosaics of hunting and circus scenes and incidents in his own life. In 1185 Isaac Angelus celebrated his accession to the throne with commemorative mosaics. All these marvels are no more.[6]

But in the church of the Dormition at Daphni, not far from Athens, the evidence comes to light. Apparently the church was rebuilt towards the end of the eleventh century in a monastery which was already rich and distinguished. At one time frescoes in the narthex represented the founders or refounders of Daphni, two Emperors with names illegible but reigning presumably prior to 1204 and probably Alexius I and John II – the latter had been made co-Emperor in 1092. In 1207 Cistercian monks settled at Daphni, building a small cloister on the south side, and they retained the monastery

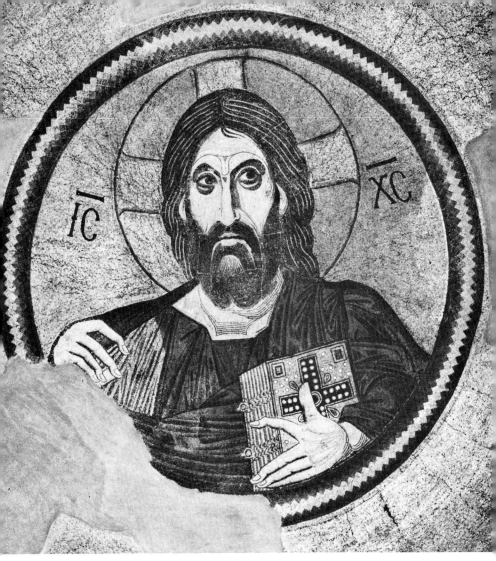

215. Christ Pantocrator. Mosaic in the dome. *c.* 1100. *Daphni, church of the Dormition*

until 1458. The vestiges of mosaic decoration in the church were drastically restored between 1889 and 1897, but no visitor leaves the building without a profound sense of wonder and awe before their beauty. The church is smaller than the main church of Hosios Loukas, and the catholicon is dominated by one of the most tremendous visions of the Christ Pantocrator ever conceived by man. Against a shimmering gold ground Christ is revealed [215] in the aspect of Jehovah, a heavy Semitic judge with thick nose and full, cruel mouth, the thick-browed eyes gazing pitilessly to one side, the lower lids underlined with shadow, the long hair offset by a full beard and moustache, the massive shoulders clothed in a brown-gold tunic and a dark blue cloak, one sinewy hand grasping a jewelled codex, the other raised in

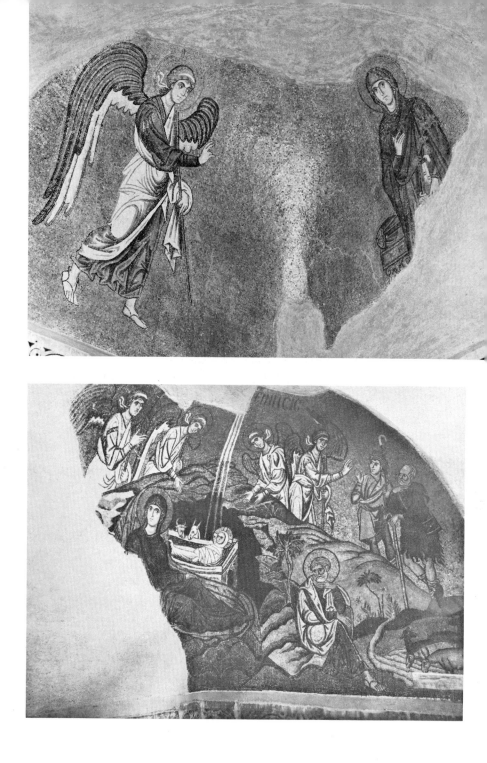

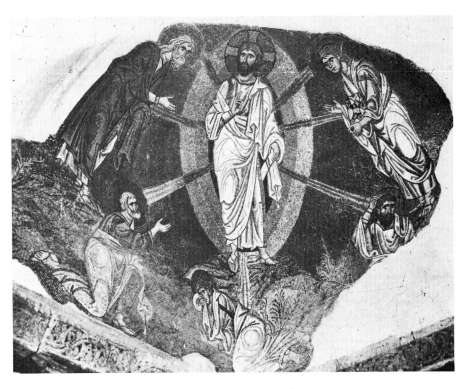

216-18. The Annunciation (*above, left*),
the Nativity (*left*), and the Transfiguration (*above*).
Mosaics in squinches. *c.* 1100.
Daphni, church of the Dormition

blessing but conveying also menace and con-
demnation. The impact of the mosaics in the
Nea Moni on Chios comes at once to mind, but
elsewhere in the church at Daphni this sombre
atmosphere is dispersed. This is partly due to
the spacing of the figures and the large expanses
of gold mosaic which must have covered the
walls. The programme is much the same as that
of Hosios Loukas and in the Nea Moni, but
there is a new lightness of touch in the scenes
from the life of Christ. The Annunciation [216],
for example, is set in a squinch, the Angel and
the Virgin as it were at right angles to one an-
other. The Angel is in classical dress and walks

with a gesture of salutation towards the Virgin,
who is seated on a cushioned stool. There is
nothing between them but a gold void which
frames and projects them before the spectator.
In the Nativity [217], also in a squinch, the gold
background recedes to reveal a rocky landscape
with trees, a stream, and pasture land in the
centre of which a dark cave is lightened by the
Child in a manger picked out by three streams
of light from heaven. The Virgin, haloed in
gold, reclines in front, St Joseph sits a little to
one side, and beyond him and slightly above
the shepherds stand in wonder. Leaning over
the rim of this world angels bow with gestures
of acclamation; one of them turns towards the
shepherds. Throughout there is an atmosphere
of light, peace, and joy. The vividness of the
colours, the attention to detail in a firmament of
gold, the sharp sense of form and gestures re-
mind one of the miniatures in the copies of the

Homilies on the Virgin by the monk James of Kokkinobaphos (Paris, Bibl. Nat. gr. 1208; Vatican, gr. 1162), where details of landscape and stretches of shrub are evoked against a golden ground, where angels bend over the edge of the world to intervene in the affairs of men, and where these affairs are presented with a new sprightliness. These same characteristics are visible in spite of the restoration in the Transfiguration [218], also in a squinch, and here too a fresh wind of classicism seems to be blowing over the landscape and filling but not disturbing the folds of drapery which define the splendid forms. In the Crucifixion [219] the scene is confined to Christ on the Cross between the Virgin and St John, but for all the severity of the drama there is a tenderness in the looks and

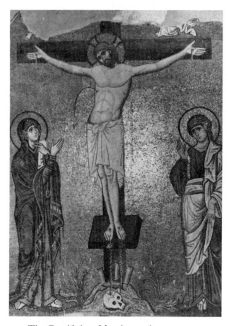

219. The Crucifixion. Mosaic panel. *c.* 1100.
Daphni, church of the Dormition

gestures of the onlookers which is a far cry from the *terribilità* of the Nea Moni and Kiev. Even at the foot of the cross flowers and herbs undulate around the skull of Golgotha. In the

Harrowing of Hell [220] – a well-developed scene with a full complement of protagonists – it is clear that the master has been studying anew classical models, or has been to a school where such traditions were still a living force. In the narthex a number of lunettes are given to scenes from the life of the Virgin presented with considerable dramatic effect, a foretaste of what the fourteenth-century craftsmen were to do in the narthex of Christ in Chora at Constantinople. Daphni seems to be the turning point when the sombre records of theophany, the old hieratic Feasts of the Church, the grim presence of countless saints are infused with a joyous light and movement as though the Byzantine heart had ceased to brood over the sorrows of God and Man and had lifted to the call of angels.[7]

These new trends are emphasized by comparison with work done in the church of the Archangel Michael at Kiev, which was founded by the Grand Prince Svjatopolk (Michael) in 1108; the mosaics probably date from between 1111 and 1112. All that remains of the decorations of this church is the Divine Liturgy in the apse and seven Apostles and Saints on the walls and pillars. Both in style and technique the work is coarser; there can be no doubt that Kievan assistants have been called in, but the spirit of Daphni is nowhere to be found. The answer is simple. In 1080 Greek mosaicists were sent from the monastery of the Blachernae in Constantinople to decorate the church of the Dormition in the Pechersky Monastery at Kiev. This decoration no longer survives. The artists remained at Kiev; they became monks in the Pechersky Monastery, where they were known as the 'twelve brethren', and they died there. They trained Kievan pupils, of whom one, Alimpios, is known by name. It has been argued plausibly that the mosaics in the church of the Archangel Michael were executed by the survivors of the Greek artists and their Kievan assistants. The representation of the Eucharist in the apse and the figures of Christ and the angels are the most Greek, and there are even mistakes in the Slavonic inscriptions; some of

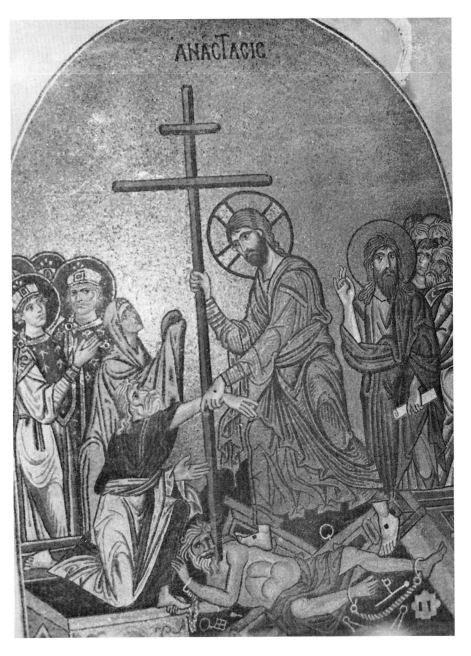

220. The Harrowing of Hell. Mosaic panel. *c.* 1100. *Daphni, church of the Dormition*

the heads of the Apostles appear to be the work of these same craftsmen, but the bodies and the drapery presumably were entrusted to the apprentices. The style looks backward to Nicaea, Chios, and Hosios Loukas rather than forward to Daphni, which suggests that the new wave of classicism so prevalent in the latter church gathered impetus after the mosaicists from Blachernae had moved to Kiev.[8]

The links between Kiev and Constantinople were fairly firm. The mosaics in the church of the Archangel Michael were the last to be produced in Russia because the expense proved prohibitive. But fresco-painting continued closely under Byzantine influence. The paintings in the south-west tower of Hagia Sophia at Kiev were probably done in the reign of Vladimir Monomakh (1113–25), who was greatly attached to all things Byzantine. His mother

was a daughter of Constantine X Dukas, and one of his daughters married Leo, the son of Romanus IV Diogenes. On the walls of the tower are represented games in the Hippodrome at Constantinople, including an interesting view of the *kathisma* with the Emperor and his court in attendance. The Kievan Grand Princes understood well enough the meaning of the contests in the Hippodrome, which were an important part of the imperial liturgy and subscribed to the power of the Emperor. This 'triumphal' aspect was continued with various hunting scenes – boars, wild horses, foxes, wolves – and in the north-west tower hawking and trapping various kinds of birds. Scenes from Byzantine court life were also depicted in the north-west tower. Unfortunately this important cycle of frescoes is fragmentary and badly preserved.[9]

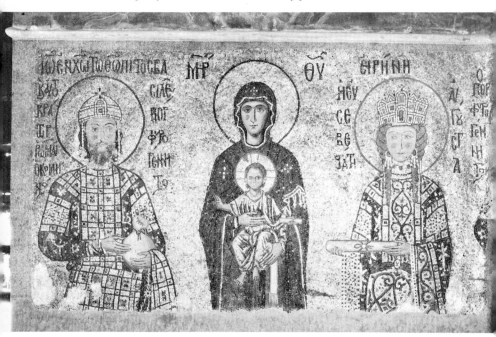

221. (A) The Virgin and Child between the Emperor John II Comnenus and the Empress Irene. *c.* 1118. (B, *opposite*) The co-Emperor Alexius. *c.* 1122. Mosaic panels in the south gallery. *Istanbul, Hagia Sophia*

The mosaic panel in the south gallery of Hagia Sophia at Constantinople represents the Virgin and Child standing between the Emperor John II Comnenus holding a bag of gold and the Empress Irene with a diploma in her hands [221] and was set up no doubt to commemorate their accession in 1118. The portrait of the prince Alexius was probably added in 1122, when he was proclaimed co-Emperor at the age of seventeen. In comparison with the portraits of Zoe and Constantine IX [201] the forms are more elongated, elegant, and refined. It has been suggested that the faces are less animated both formally and psychologically and that a dry linearism has taken over, including the four pink curves which indicate the cheeks of Irene. Certainly the sketchiness and roughness visible in the Zoe panel has disappeared, but as court portraits the images have remark-

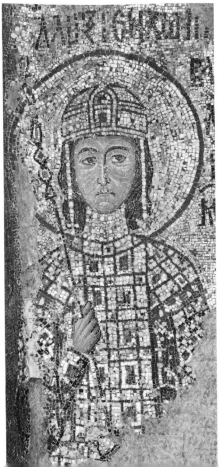

able force and validity. Were the Augusti suddenly to materialize, recognition would be instantaneous: the swarthy Emperor with his long nose and steadfast expression, the high moral principles of his public and private life made fact by his very presence, the devout Irene with her fair hair and clear complexion, and the sickly Caesar, ill-tempered and rather petulant. The figures of the Virgin and Child with their sensitive modelling, grave, gentle, and alert expressions, and the naturalistic treatment of the drapery postulate the true reality between the bedizened images of earthly power.[10]

The church at the Gelati Monastery in Georgia was partly decorated in mosaic between 1125 and 1130. In the apse the Virgin and Child are represented between the Archangels Michael and Gabriel, but the quality of the style and facture is again a far cry from Daphni or the imperial portraits in Hagia Sophia at Constantinople. Although the craftsmen appear to be familiar with the general characteristics of Early Comnene style, there is a lack of vitality, a stiffness of posture and gesture, a mechanical treatment of the drapery, a heaviness of physiognomy which betray the indifferent and provincial artist. In the attempt to suggest facial modelling the craftsmen have resorted to a kind of schematic linearism which results in an empty, flattened mask. The mosaic is not without interest, since it forecasts the fate of the Byzantine images once deprived of metropolitan impulses. After the last breath of the spirit the patterns froze.[11]

In 1130 Roger II d'Hauteville, having united southern Italy and Sicily, assumed the title of king. St Bernard of Clairvaux wrote percipiently to the Western Emperor Lothair that 'he who makes himself king of Sicily is attacking the Emperor', but the remark applied equally well to the Basileus at Constantinople. Roger had himself portrayed as a Byzantine Emperor on his seals and on his coins; his portrait in mosaic in the Martorana at Palermo not only reveals him receiving his crown from Christ but suggests that visually he was like Christ [222] – imperial *christomimesis* carried farther than

would have been considered proper at the Byzantine court. His status as Apostolic Legate placed him in a position of ecclesiastical as well as secular suzerainty similar to that of the Byzantine Emperor. He allowed himself to be addressed as 'Basileus' and demanded, during

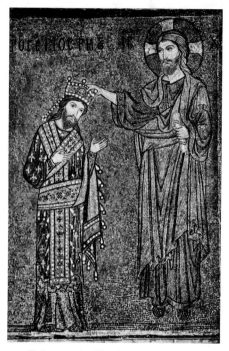

222. Christ crowning King Roger II of Sicily. Mosaic panel. *c.* 1148. *Palermo, Martorana*

negotiations for a Greek princess as wife for his son, that he should be recognized as the equal of the Emperor, a demand that the Emperor Manuel could hardly accept and which he must have considered brashly impertinent. The negotiations fell through. After the Second Crusade of 1147, in the autumn of which year Roger attacked Corfu and Greece, he made serious plans to advance on the metropolis, sack the Comnenes, and set himself up in a Latin kingdom on the Bosphorus. Meanwhile, no effort nor expense was spared to cut the right figure at Palermo. His palace-chapel was built

as a synthesis of Greek and Latin forms, with a Siculo-Arabic painted and honeycombed ceiling. The Normans realized that the island could not be held without toleration of all three cultures, and the chapel was intended to symbolize this understanding. Greek artists were summoned to complete the decoration in mosaic, and a Greek inscription round the base of the cupola implies that this was done in 1143. In fact the work continued until Roger's death in 1154 and was only completed by his son, William I. Some of this work was undertaken by a second team which had been called in to decorate the apse of the near-by church of Cefalù, which had been created a cathedral by the Antipope Anacletus II in 1131 and which was intended to serve as Roger's mausoleum. In 1145 he gave to the new cathedral two porphyry sarcophagi which were to be placed in the choir, although these were later removed by his daughter-in-law Queen Margaret and placed in the cathedral at Palermo. A mosaic inscription in the apse of Cefalù states in Latin that the decoration was completed by 1148, but again this date does not apply to the whole church. Royal interest lapsed after Roger's death, to revive briefly under William I and again under William II, when work started up again in the seventies, probably by Sicilian craftsmen. Only the mosaics of the apse can with confidence be assigned to the Byzantine team.[12]

Greek masters might be called in and Byzantine iconography adhered to in principle, but the decoration of Roger's churches was given a firm Latin twist. Cefalù was built as a South Italian basilica without a dome and this necessitated placing the bust of Christ Pantocrator in the vault of the apse, while the Virgin was set between four Archangels in the tier below, and below again in two tiers the twelve Apostles. Confrontation with this majestic vision of the court of Christ cannot fail to overawe the spectator. The portrait of Christ [223] must rank as one of the most sublime attempts to represent the Logos Incarnate. No longer the terrifying judge of Daphni [215], Christ is portrayed as a youthful, aristocratic ascetic, gazing gravely,

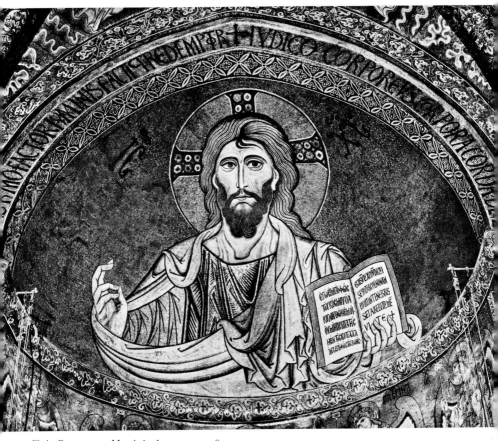

223. Christ Pantocrator. Mosaic in the apse. *c.* 1148.
Cefalù, church

sadly, but with infinite pity on the assembled
faithful. The Latin and Greek inscriptions in
the book He holds proclaim Him the Light of
the World. The hand raised in blessing reaches
out in an act of love. The atmosphere of lofty
serenity infuses all the figures of the apse. The
Virgin, the Archangels, the Apostles – each
subtly distinguished one from another, each one
a masterpiece in its own right, each one a type
made glorious – combine with harmony and
dignity into one of the noblest of Christian
pantheons. In a sense the style is less 'classical'
than that at Daphni. At Cefalù the bodies tend

to disappear behind the copious folds of drapery.
The firm lines which define the forms and the
drapery contribute a statement ghostly though
not pale, unreal and yet positive, distant and yet
most powerfully present. These divine and
apostolic beings are seen not as assertions of
humanity but as visitors from another world,
saviours indeed and timeless guardians of the
Word.[13]

The decoration of the Cappella Palatina prob-
ably never rose to the quality of the work at
Cefalù, and today so drastic have been succes-
sive stages of restoration that it is difficult to

come to any satisfactory assessment of the original interior. The chapel is an architectural hybrid, combining the nave of a Western basilica with a domed sanctuary. The mosaics in the dome and drum followed the Byzantine canon with a representation of Christ Pantocrator surrounded by his court of archangels, angels, Prophets, and Evangelists [224]. The prophets

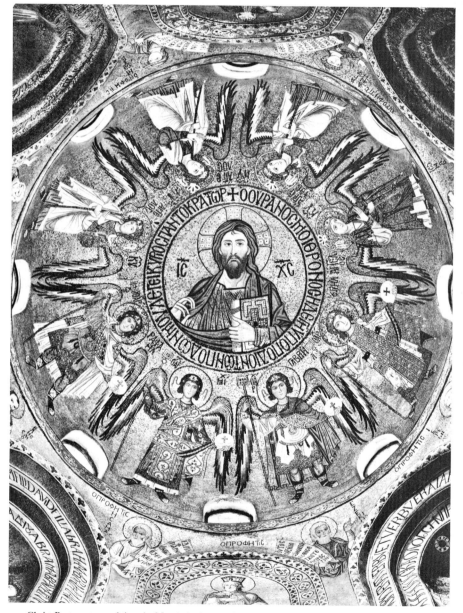

224. Christ Pantocrator and Angels. Mosaic in the cupola. c. 1143. *Palermo, Cappella Palatina*

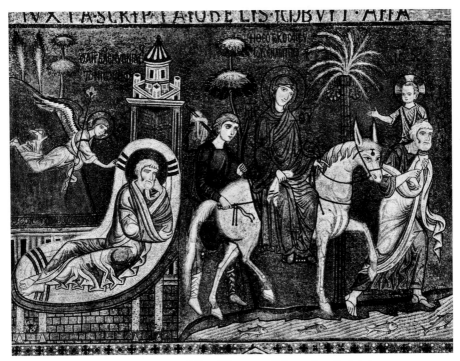

225. The Flight into Egypt. Mosaic panel. Mid twelfth century. *Palermo, Cappella Palatina*

David, Solomon, Zacharias, and St John the Baptist stand in four niches separated by seated figures of the Evangelists in the squinches. Eight additional prophets are portrayed as busts in the spandrels between the niches and the squinches. This work was done by the first team of Greeks in a Comnene style less developed than that at Cefalù. The forms are more solid, the drapery moulding the limbs, and much less ethereal. The mosaics in the three apses have been grossly restored, and, although the Christ Pantocrator in the main apse follows the Sicilian convention, it belongs to a later phase than the main sequence in the sanctuary; in view of the portraits of St Paul and St Andrew in the side apses, it has been suggested that originally St Peter, since the chapel is dedicated to him, may have been placed in the main apse. The seated Virgin below the Christ Pantocrator is not part of the original decoration. The saints to the left and right of the central window – St Peter, St Mary Magdalen, St James, and St John the Baptist – again do not conform to the Byzantine canon, and the opposition of St James to St Peter may reflect the Norman policy of playing off the Primate of Jerusalem against the Primate of Rome. Roger at one time even toyed with the idea of recognizing the primacy of Constantinople, which would have placed him at once in the hands of the Byzantine Emperor, but he thought better of it. In the side apses two large busts of St Paul and St Andrew accompanied by figures of saints whose relics were buried there also do not conform to the Byzantine tradition, which demanded in the prothesis and the diaconicon a close connexion between the decoration and the liturgy of the Mass. The presence, however, of the Virgin and Child and St John the Baptist in the northern apse may refer to the preparation of the Euchar-

ist in the Greek Church. For in this rite the priest extracts from the host the central particle which bears the seal of Christ called the Lamb (*Amnos*), and Byzantine liturgists compared the position of the *Amnos* in the centre of the bread to the Son of Man in the womb of the Virgin. The rite is accompanied by the words of St John the Baptist referring to the Lamb of God. It can hardly be mere coincidence to find in an apse in the Cappella Palatina equating with the prothesis of a Greek church the figures of the Virgin and Child with St John the Baptist holding a scroll bearing his prophecy about the Lamb. In the sanctuary scenes from the life of Christ and an abbreviated hierarchy of saints follow the Byzantine convention, but the order of the scenes has been altered to emphasize on the south wall the Flight into Egypt [225], the Presentation in the Temple, and the Entry into Jerusalem – a scene typical of Middle Comnene style – which were considered to be analogies to the royal *profectio*, *adventus*, and *occursus* and which could be seen from the royal loggia in the north wall. The mosaics in the nave consist mainly of a biblical cycle beginning with the Creation and ending with the story of Jacob. Extensive illustration of the Old Testament is a feature of Early Christian and Western medieval church decoration but was not current, as far as we know, in Middle Byzantine schemes. So it may be seen that in a number of ways the decoration of Roger's chapel deviated from the Byzantine canon. In style the decoration of the cupola and the drum is more akin to Daphni, but with the arrival of the new team a newer style takes over. The image of the Christ Pantocrator in the main apse is derived from that of Cefalù, and many of the Christological scenes are clearly the work of the new artists. It has been argued that the 'dynastic axis' based on the royal box was an introduction of William I after 1154 involving wholesale redecoration of the sanctuary and the transepts, of which some was done by Sicilian assistants trained by the Greeks, but others prefer to retain the plan and the execution of the plan within the reign of Roger II. The nave was only decorated from about 1160 onwards and the aisles probably as

late as 1170. William II (1171-89) appears to have had second thoughts about the 'dynastic axis'. He placed the throne at the west end and ordered the large mosaic of Christ enthroned between St Peter and St Paul on the west wall. In spite of the vicissitudes of the programme the decoration of the Cappella Palatina was held to be of great importance and governed to a certain extent the style and iconography of images in other Sicilian churches. Even today in its botched and restored condition the interior of the chapel provides an extraordinary and unforgettable experience.[14]

The small church of S. Maria dell'Ammiraglio, usually known as La Martorana, was built by George of Antioch and more or less completed by 1143, although the mosaic decoration was not finished before 1148. George was the son of Syro-Greek parents, Michael and Theodula of Antioch, and with his father had served under the Emir of al-Mahdia in Tunisia. In 1112 he attached himself to Roger of Sicily, served with distinction under Admiral Christodoulos in Roger's African wars, was himself created Admiral in 1126, and in 1132 became a kind of Grand Vizir to the king with the titles Emir of Emirs, Archon of Archons, and Ammiratus ammiratorum. The titles in three languages are typical of the Norman administration. George was a devout Christian with a particular devotion to the Mother of God. He dedicated his church to her, Greek and Arabic inscriptions sang her praises both inside and outside the walls of the church, and the dedicatory panel in mosaic [226] reveals him prostrate before the Virgin holding a scroll and turned towards a bust of Christ appearing in a segment of sky in the upper right corner – a version of the icon of the Panagia Chalkoprateia at Constantinople; the inscription on the scroll asks Christ to protect and forgive George, who erected this house for her. George died in 1151, and his epitaph repeated the assertion of his love for the Virgin. In plan the church was a typical Middle Byzantine square building with a dome supported by four columns in the centre and surrounded by an ambulatory, the cross-arms barrel-vaulted, and with three apses at the

226. George of Antioch prostrate before the Virgin. Mosaic panel. Before 1148. *Palermo, Martorana*

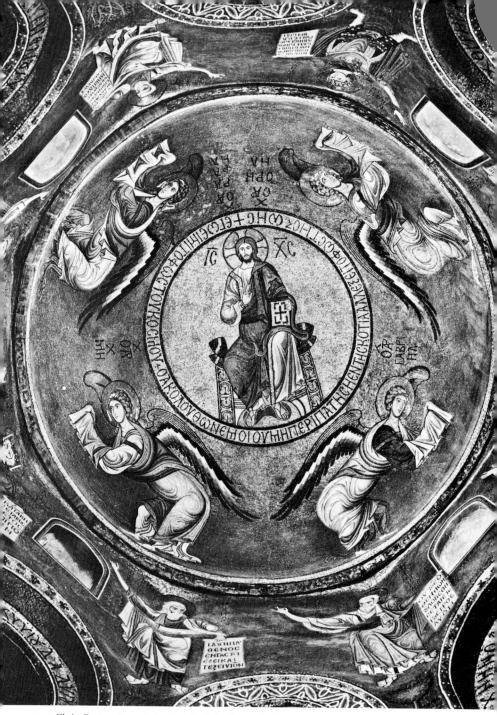

227. Christ Pantocrator and Angels. Mosaic in the cupola. Before 1148. *Palermo, Martorana*

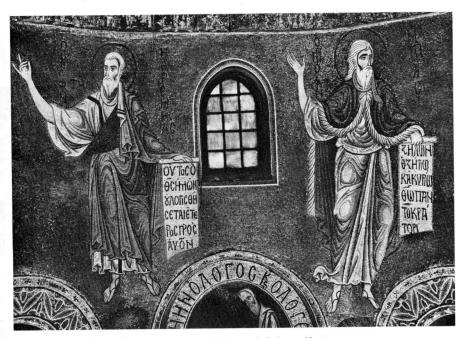

228. The Prophets Jeremiah and Elijah. Mosaic. Before 1148. *Palermo, Martorana*

east end. In construction, however, various Sicilian features were introduced, including pointed arches, squinches with receding steps in the drum, and columns set in the angles of the apse. At the west end there was a narthex and an open portico. The bell tower, also a Western feature, stood isolated opposite the façade. Unfortunately posterity was unable to leave this beautiful little church alone; it was greatly altered in 1433, possibly again in 1451, and drastic changes were made from 1588 onwards. An attempt was made to enlarge the church by incorporating the narthex and the portico, thus destroying the original west wall, the walls of the narthex, and their decoration. In the seventeenth century a chapel was added on the north-east side of the church, thus destroying the mosaics on the north wall, and in 1683 the main apse was completely destroyed with all its mosaics to make room for a Baroque chapel which has since been removed. Further

drastic changes were made in the eighteenth century, so that the present church, albeit tactfully restored in the second half of the nineteenth century, is a mere ghost of its former self. Since that time several parts of the mosaic decoration have been again restored, leaving a rather chilly impression. However, Christ Pantocrator is enthroned in the dome adored by four Archangels making a standing proskynesis and involving a distortion of form which is unique in Byzantine art [227]. Instead of the usual court costume, the Archangels are dressed in toga and himation, their hands veiled, their wings sweeping across their backs, and they appear to be dancing round the Saviour, who is framed by their wings – the effect is extraordinary. The Greek inscription around the figure of Christ is taken from John viii:12 and, as at Cefalù and in the Cappella Palatina, hails Him as the Light of the World. On the rim of the cupola an Arabic inscription gives the text

of a Byzantine hymn. On the drum are placed eight full-length Prophets holding scrolls with Greek inscriptions: Jeremiah, Isaiah, David, Moses, Zachariah, Daniel, Elisha, and Elijah [228]. In the squinches between the windows are the four Evangelists, and the Greek inscriptions round the niches give the beginnings of the Gospels, as in the Cappella Palatina. There seems no reason to doubt that the programme of decoration conformed to the Byzantine canon but because of the smallness of the church was abridged somewhat; the scenes which have survived echo similar scenes in the Cappella Palatina but are reduced in content; there are the usual groups of Church Fathers, martyrs, deacons, and warriors. The north and south barrel-vaults contain eight standing figures of the Apostles; the vault to the east of the central square holds the Archangels Michael and Gabriel in court costume, and we may be certain, in view of the donor's devotion, that the

Virgin and Child were placed in the main apse. The images of Joachim and St Anne have survived in the prothesis and diaconicon respectively. Of the Twelve Feasts it seems likely that there were never more than four, and these concerned the Virgin as much as Christ: the Annunciation on the wall facing west, as in the Cappella Palatina, with the Virgin seated instead of standing; on the wall opposite the Presentation, again abbreviated in comparison with the Cappella Palatina; on the vault to the west of the central square the Nativity, with the journey and the Adoration of the Magi excluded, and the Dormition [229, 230]. In view of the date, it seems certain that the team working in the palatine chapel and at Cefalù also worked in the Martorana: there is a general homogeneity of style throughout, though in the latter church there is an added sense of simplicity and intimacy. In its heyday the Martorana must have been a glorious jewel; even now

229. The Nativity. Mosaic. Before 1148.
Palermo, Martorana

230. The Dormition. Mosaic. Before 1148.
Palermo, Martorana

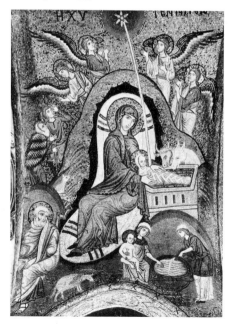

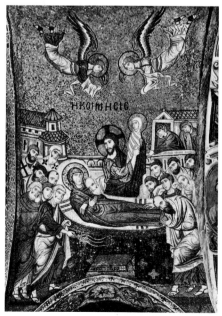

the colours have a richness and vivacity which not even the most ruthless restorer has succeeded in ironing out. In the scenes of the Annunciation and the Presentation there is a remarkable sense of movement and lightness, reminiscent of Daphni; in the Nativity and the Dormition the drama is evoked with a tenderness and dignity which were to develop even more in the second half of the century. The dedicatory portraits have survived on what may be the remnants of the original west wall of the narthex. In view of the inscription held by the Virgin, these must have been in place before the death of George of Antioch in 1151. Muhammad ibn Djobair saw and admired the 'church of the Antiochene' in 1185, and while he was marvelling at the beauty of the marble walls, the golden mosaics, and the façade with its bell-tower 'adorned with many columns' he was told by his Sicilian guide that the founder, Vizir to the grandfather of the present king (William II), had spent several hundredweight of gold on the building.[15]

The great abbey church of Monreale high on the hills outside Palermo was planned by William II (1166–89) partly as the symbol of his ecclesiastical policy and partly as his mausoleum. In less than ten years the Cluniac abbot was created an Archbishop with special relation to the King and the Papacy and outside the jurisdiction of the Archbishop of Palermo. The speed with which the church was built and decorated suggests that William II intended to present a *fait accompli* to the enemies of such a plan, particularly Walter of the Mill, Archbishop of Palermo, many of the Sicilian bishops and barons, and those whose property was transferred to the jurisdiction of the new see. After the death of William II, although the rights of the see were confirmed by his successors, the position of the archbishop was always precarious, and its prestige and power died in fact with the King. The church was built on the site of Hagia Kyriaka, which had been the see of the Greek Metropolitan of Palermo in the days of Muslim rule, and it is clear that the King intended to revive that metropolitan tradition.

Founded in 1174 and colonized by Benedictine monks from La Cava in 1176, the monastery and church were substantially completed by 1183, although the left tower of the west front was never finished; the pavement of the nave and aisles and the marble incrustation of the walls of the aisles were not added until the nineteenth century. Like the Cappella Palatina, the church is a combination of a Latin basilica and a Greek catholicon, but because of its great size only the apses and the presbytery were vaulted and a lantern was substituted for a dome. The dominating features are the great apse with its magnificent Christ Pantocrator, the Virgin Panachrantos enthroned [231] – the icon of the Virgin Immaculate was kept at Hagia Sophia in Constantinople and many churches were dedicated to this type – their court of Seraphim, Archangels, Apostles, and Saints, and the vast areas of mosaic on the walls. The Byzantine church was a perfect harmony of marble panelling which covered the walls and rich mosaics which covered the vaults. At Monreale the marble panelling only rises to the level of the lowest windows. In a Byzantine church the decoration stressed the liturgical function and the main feasts of the Church; it was never, as far as we know, didactic nor concerned with historical narrative. At Monreale the mosaics, in addition to the court of Christ at the east end, represent a history of the Christian religion: Old Testament scenes from the Creation of the World [232] to Jacob's struggle with the Angel in the nave, scenes from the life of Christ in the central square and the transepts, Christ's miracles in the aisle [233], stories of St Peter and St Paul in the side apses, and in the entrance porch scenes from the life of the Virgin and the Infancy of Christ (these have now disappeared). On the west wall of the nave were added stories of local saints: St Castrensius, St Cassius, and St Castus. Throughout the church prophets, saints, and martyrs proliferate wherever space could be found for them. In addition the Annunciation is repeated on the arch before the sanctuary in accordance with Byzantine tradition, archangels support the Holy Mandylion

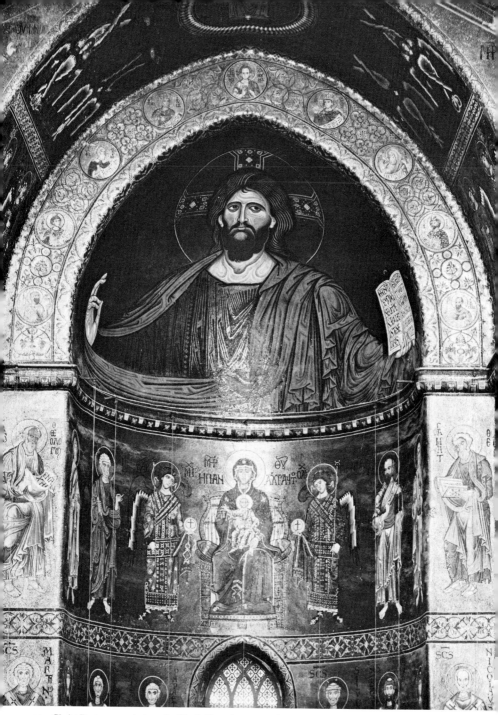

231. Christ Pantocrator; below, the Virgin Panachrantos enthroned. Mosaic in the apse. Before 1183. *Monreale, abbey church*

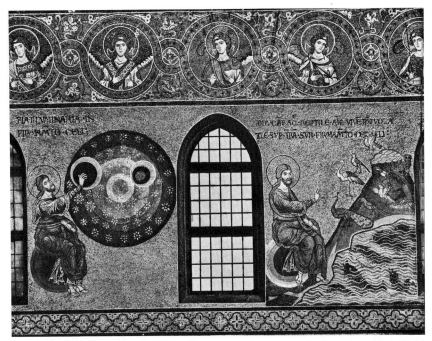

232. The Creation of the World. Mosaic. Before 1183. *Monreale, abbey church*

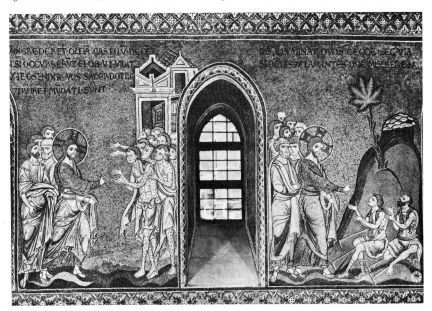

233. Christ Healing the Ten Lepers and the Two Blind Men. Mosaic. Before 1183. *Monreale, abbey church*

234. King William II offering Monreale to the Virgin. Mosaic panel. Before 1183. *Monreale, abbey church*

on the arch separating the fore-choir from the crossing, and on the two piers of this same arch are two dedicatory panels portraying William II crowned by Christ – no brash attempt at *christomimesis* here, but the royal throne was placed immediately below – and William offering the church to the Virgin [234]. The King is wearing Byzantine court dress and is crowned with a Byzantine *stemma* – what the Comnenes must have thought of this has not been revealed, and by this time Andronicus I (1182(1183)–5) was facing far greater troubles than matters of court protocol. This vast programme is carried out with logic, order, and nearly absolute symmetry; at no time, as in some of the later Serbian churches, does iconography run amok. The style is homogeneous throughout, and there can be no doubt that it was the amazing work of a fresh team of Byzantine craftsmen imported from the metropolis towards the end of the seventies. There can also be no doubt that the structure of the church and its decoration were planned from the beginning; the mosaics are neither an afterthought nor a well-fitting accessory. The members of the team were not left to their own devices: they were referred to the decoration of the Cappella Palatina; they were instructed about local interests in iconography and the stories of local saints; inscriptions were to be largely in Latin. In spite of the immensity of the task it was almost certainly completed before the death of the King, possibly some years before, but it must be remembered that Byzantine mosaic craftsmen worked astonishingly fast. A detailed plan from the outset, a well-trained team, and swiftness of execution do much to explain the astonishing unity and sweep of the design. But it must have been a challenge even for them. Most Middle Byzantine churches that have survived are of moderate size and the areas for the mosaics are defined by the architectural component parts. At Monreale the team was presented probably for the first time with huge, flat expanses of wall which they decorated with a sequence of large pictures completely integrated into the general plan. The effect is overwhelming.[16]

The style is also new. Monreale is today one of the key monuments of Late Comnene artistic development. The stages of this development may be traced in different parts of the Byzantine world. At Nerezi in Macedonia a small church dedicated to St Pantaleimon was built by Alexis, son of Constantine Angelus and his wife, Theodora, a younger daughter of the Emperor Alexius I Comnenus, and the date 1164 is given on the lintel over the main door. Several artists were sent to paint the interior, and the master who executed the great Feasts of the Church, the Feasts of the Virgin, and the portraits of most of the saints in the first zone of the *naos* was certainly trained in the school responsible for the imperial foundations. Not only do the artists treat the wall space as a compositional unit – triple windows at the ends of the north and south arms were blocked to give more surface – not only is the formal excellence and quality of the work remarkable in so remote an area, but there is clear evidence of a new emotional approach, with violently agitated drapery, flickering highlights, and strange elongation of forms. In the tense curves of the Deposition and above all in the Lamentation over the Dead Christ [235, 236] the agony of grief is made manifest in this new phase of Byzantine art. The Virgin, her face distorted with sorrow, sways to the left in a squatting position and embraces the dead Christ, whose pale form is partially framed by the dark blue robes of the Virgin; the Apostles are bent in paroxysms of grief; and from the sky emerge half-figures of wailing angels. Similar characteristics may be observed at Djurdjevi Stupovi about 1168, although these frescoes, now removed to Belgrade, are in ruinous condition, in the Hagioi Anargyroi at Kastoria, where movement is even more exaggerated and curious ripples of drapery outline in places the contours of the body, in Hagios Nikolaos tou Kasnitze in the same town, and in St George at Kurbinovo on Lake Prespa in Macedonia dated 1191, where the Angel of the Annunciation, slender, elongated, with capricious drapery fluttering, rippling, salutes the Virgin on the other side of the chan-

235 and 236. The Deposition and the Lamentation. Wall-paintings. *c.* 1164. *Nerezi, St Pantaleimon*

237. The Angel of the Annunciation. Wall-painting. 1191. *Kurbinovo, St George*

238. The Annunciation. Icon. Constantinople, *c.* 1170–80. *Mount Sinai, monastery of St Catherine*

cel arch [237]. The same characteristics appear in an icon of the Annunciation on Mount Sinai, dating from about 1170–80, one of four which may have formed part of an iconostasis previous to that constructed by Cretan artists in the early seventeenth century; with its vivid colours and quality of execution, it must surely be Constantinopolitan work [238]. In St Nicholas at Markova Varoš, near Prilep in Macedonia, the frescoes of the apse and the Annunciation on the triumphal arch all conform to the same conventions. At Bačkovo, south of Philippopolis in Bulgaria, a monastery for Georgian monks had been founded in 1083 by Grigorios Pakourian, Grand Domestic and head of the Byzantine armies, but the paintings in the church date probably from the second half of the twelfth century – an inscription refers to the *hieromonachos* Neophitos, who was fifth in order from 1083. The paintings are more restrained than the Macedonian group (the Deesis in the apse is

a case in point), but even so there is a tendency towards elaborate draperies and contrasts in highlights and shadows. In Russia the church of St George of Old Ladoga was painted by masters of the Novgorod School about 1180, and that of Spas-Nereditsa about 1199 (destroyed in the Second World War) had decoration which also combined reflections from the Novgorod School with Caucasian and Western influences – for example the portrait of St Ripsimè, an Armenian saint, in the diaconicon, presumably owes its presence to the Caucasian Princess Maria, sister of the wife of the Grand Duke Vsevolod, and wife of Prince Jaroslav Vladimirovich who built the church. The frescoes in Spas-Nereditsa included a great variety of subjects and covered the walls from top to bottom; from the Deesis in the Last Judgement it may be seen that Late Comnene style was undoubtedly animating the Novgorod School: the complicated drapery, the exaggerated high-

lights and shadows, the new dramatic exposition.

In South Russia at Vladimir there is evidence of direct Greek participation. Prince Vsevolod (1154–1212) had spent the years 1162–9 in exile at Constantinople with his mother, a Byzantine princess, and there acquired a deep admiration for Byzantine civilization. His son Constantine spoke excellent Greek, and his brother Michael was to found at Vladimir a school run by Greek and Russian monks. When Vsevolod returned to Vladimir he rebuilt the cathedral of the Dormition between 1185 and 1189 and founded the church of St Demetrius in 1194. Of the frescoes executed in the latter church about 1197 only the Last Judgement has survived, but it seems certain that a Greek artist was responsible for the twelve Apostles and the angels on the south side of the large vault, while Russian artists painted the angels on the north side and the frescoes representing Paradise covering the entire surface of the small vault. The treatment of the drapery fits naturally into the pattern of Late Comnene style without the exaggerated mannerisms of some of the Macedonian painters; the faces are modelled in brush strokes of the most complex nature, giving depth, solidity, and a sharp sense of life; as usual, the use of highlights and shadow is extremely subtle. More remote and more provincial, a group of rock churches - Qaranleq kilisse, Elmale kilisse, and Tchareqle kilisse - in Cappadocia were decorated towards the end of the twelfth century, and the style depends on the latest developments in the metropolis: the same agitated drapery, the same bold chiaroscuro, the same treatment of form.[17]

A number of churches on Cyprus provide additional evidence for the development of Comnene style in the twelfth century. The little church of the Panagia Phorbiotissa at Asinou was founded by the *magistros* Nicephorus Euphorbinos Katakalon, son of Constantine Euphorbinos, Duke and Governor of Cyprus between 1103 and 1107, and the favourite general of the Emperor Alexius I Comnenus. The first stage of the painted decoration was finished

in 1106, and the dedicatory portraits imply that Nicephorus's first wife Zephyra, who had died in 1099, had not yet been superseded by his second wife, the purple-born Princess Maria, daughter of Alexius I, at which time he was honoured with the title *panhypersebastos*. In view of the founder's position and his close connexions with the imperial court even before his grand marriage it is not surprising that the little church contains work of considerable quality. The fresco of the Dormition on the west wall of the nave bears all the ingredients of Early Comnene style: elegant forms, delicate features, fine-lined drapery modelling the forms, a certain lightness of effect. On the other hand, the equally small church of the Holy Apostles at Perachorio, not far from Nicosia, is less well documented, but on structural and stylistic grounds the building and its decoration have been assigned to the latter part of the reign of the Emperor Manuel, between 1160 and 1180. The style of the frescoes is more advanced than Asinou and approaches that of the earlier Macedonian churches, without adopting the exaggerated mannerisms of the paintings at Kurbinovo. The procession of angels in the dome has none of the dramatic intensity of the 'dancing' archangels in the dome of the Martorana at Palermo, but the style in general reflects the later stages in the decoration of the Cappella Palatina before Monreale got under way. It is paralleled to a certain extent by the first cycle of paintings by Theodore Apseudes in the cave-hermitage known as the Enkleistra of St Neophytus, near Paphos, dated to the year 1183, where a fresco of the Crucifixion is in Middle Comnene 'court' style, whereas the second cycle, after 1197, is more exaggerated than the decoration of Perachorio. The latter cycle and the frescoes in the church of Panagia tou Arakou at Lagoudera, dated 1192, conform to the general characteristics of Late Comnene style. At Lagoudera a fine Christ Pantocrator has survived in the dome, a tender, almost tearful image with delicate hands clasping a jewelled codex against the sweeping folds of the cloak – none of the Daphni menace here – and among

the Feasts of the Church the Nativity [239] is notable for its flurry of angels, the *empressement* of the Magi and the shepherds, and little incidental details busy round the large central figure of the Virgin. The drapery of the angel on the right side of the hill vies with that of Kurbinovo for eccentricity.[18]

originated in the Comnene foundations at Constantinople. Curiously enough there appears to have been a loss of spiritual intensity. For all the violence of emotion sometimes displayed – the Lamentation at Nerezi [236] comes at once to mind – the effect is apt to be facile and rather dry. The agitated figures, the burst of feeling,

239. The Nativity. Wall-painting. 1192. *Lagoudera, Cyprus, Panagia tou Arakou*

All these monuments were comparatively minor undertakings, and many have been overpraised, but their importance lies in signposting the source of style to the metropolis. It would seem that the concept of the wall as a compositional unit, the dynamic integration of figures and scenes, the new approach to form and drapery – great swirls of drapery over animated frames – the new emotional content must have

the spinning dynamism are subordinate to a theatrical display which, when tapped, rings hollow. The great Christ Pantocrators at Cefalù and Monreale are both splendid [223, 231]; both dominate the scene and the emotions. The size of the Monreale Christ was intended to stun the beholder, the handsome, sentimental face, the vast sweep of the enfolding arms were intended to comfort the faithful, perhaps, but

240. Our Lady of Vladimir. Icon.
Constantinople, first half of the twelfth century.
Moscow, Tretyakov Gallery

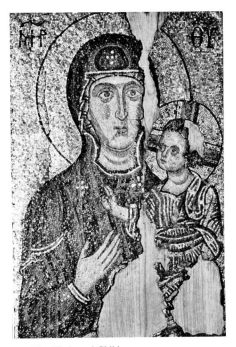

241. The Virgin and Child.
Mosaic icon. Late twelfth century.
Mount Athos, Chilandari

there is something vacuous about the image. The Christ of Cefalù, with aristocratic and ascetic reserve compels the spectator towards Him and holds the attention by sheer spiritual intensity. One is a sublime devotional image, the other a splendid mime. It may be suspected that this dichotomy existed at Constantinople. The painted icon of the Virgin and Child of Vladimir [240], of which only the faces are original, dating from the first half of the twelfth century, in its refined tenderness, pensive, remote and yet so utterly close, seems to breathe the very spirit of Incarnation. On the other hand, the mosaic portable icons of the Virgin and Child at Chilandari on Mount Athos and on Mount Sinai [241], surely also from Constantinople, for all their splendour and richness of effect share some of the vacuity of the Pantocrator at Monreale. Clearly there were different levels of excellence at the metropolis and differences of intention; objects for export must have varied in quality, but the contemporary world knew well enough that the best in whatever shape or form came from Constantinople.[19]

Few of the palaces built by the Norman kings of Sicily have survived. In the ruins of the Favara and the Menani, both built by Roger II, and in what remains of the Cuba built in 1180 by William II no traces of mosaic decoration have been found. In the Ziza, however, begun by William I and finished by his son, the Sala Terrena has a mosaic panel of interlaced roundels containing pairs of peacocks on either side of a date-palm and a pair of archers aiming at birds in a stylized tree; this kind of decoration must have been fairly common in the grander kind of palace. Flower motifs and palmettes turn up in some of the incidental decoration in the churches, and it has been suggested that one of the craftsmen working at the Ziza went on to Monreale. The Norman Stanza in the royal palace at Palermo, on the other hand, has been described as offering the most sumptuous secular decoration of the Norman epoch which has come down to the present time. Most of the marble panelling and the pavement was renewed in the nineteenth century, and the mosaics in the vaults and the upper parts of the walls have been extensively restored at various times. Nevertheless they give an interesting picture of the type of decoration which might be used in a small room: hunting scenes, peacocks, swans, lions, leopards, antelopes, and various heraldic devices set amid stylized trees or in roundels amid foliated scrolls. The dominant colours are green and gold, but pink and various shades of blue were also used. The work appears to have been put in hand between 1160 and 1170 and was probably assigned to Sicilian craftsmen.[20]

In northern Italy the chief landmarks of Byzantine influence are the cathedral at Torcello and the church of S. Marco at Venice, but in both cases the plan of operation lagged in comparison with the expedition of Monreale, and both have been subjected to extensive restoration. At Torcello the mosaics in the apse of the diaconicon and the row of Apostles in the main apse are usually assigned to the first half of the twelfth century, while the haunting vision of the Virgin and Child [242] isolated in the golden expanse of the conch of the main apse is assigned with reason to the late twelfth century. Certainly the treatment of face, form, and folds is in the idiom of the Greek masters working at Monreale, and it seems probable that a Greek was active at Torcello. The cast of face, the sche-

242. The Virgin and Child. Mosaic in the apse. Late twelfth century. *Torcello Cathedral*

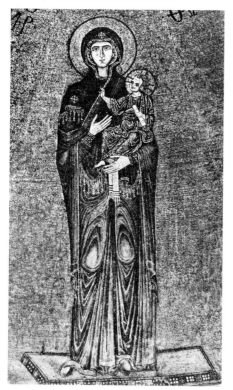

matic folds with islands of space about the knees, the fringed maphorion, the antiphon of light and dark pleats, the gold highlighting of the drapery are all to be found at Monreale. It is probable that Byzantine artists also planned the Last Judgement on the west wall of the cathedral, but their execution has been obliterated by restoration, and it seems that the lower parts of the mosaic were the work of Venetian craftsmen, some of them traceable at S. Marco. Their idiom is a local dialect.[21]

The decoration of S. Marco is a prolonged and tangled affair marred not infrequently by later restorations. The third church copied like the others the church of the Holy Apostles at Constantinople, and like the Apostoleion was intended to be a *martyrium*, a dynastic church and, to a certain extent, the pantheon of the Doges. Begun about 1063, consecrated in 1085, the brick fabric rose rapidly, and by 1100 the church was lined with marble. A serious fire in 1106 undid much of the work, and the church had to be reconsecrated in 1111. The mosaics in the apse representing St Peter, St Mark, St Hermagoras, and St Nicola – of whom relics were brought to Venice about 1100 – appear to date to between 1100 and 1112 and may have survived the fire [243]. The mosaics of Apostles in the main doorway also date to about the same time, since they may be related to vestiges of mosaic formerly in the Basilica Ursiana at Ravenna, now in the Museo Nazionale, which may be dated about 1112. A new campaign seems to have begun about the middle of the twelfth century, at which time the domes of the Pentecost and of Emmanuel were completed. These were followed towards the end of the century by the dome of the Ascension and the surrounding arches with scenes of the Passion and the Harrowing of Hell. The Genesis mosaic, the earliest work in the narthex, seems to have been completed about 1218, since similar ornament was produced by Venetian craftsmen in S. Paolo fuori le Mura in Rome in that year and is documented. But the narthex decoration as a whole was not completed until 1280. The mosaics in the west arm date to about 1220. New mosaics were added from time to time until the

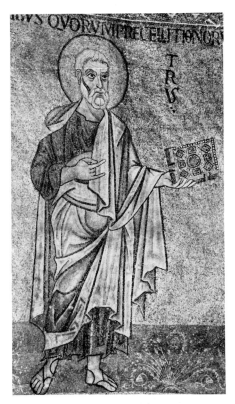

middle of the fifteenth century, by which time the restorer had started work. The basis of most of these designs was Late Comnene, but from the beginning, in contrast to Monreale, the style was never pure Byzantine. The divergence from Byzantine style is the more surprising since it has been shown that the architectural details of the third church of S. Marco derive directly from Constantinopolitan models, not only the sixth-century Church of the Holy Apostles but also late-eleventh- and twelfth-century churches like Christ in Chora, the Pammakaristos, and the Pantocrator. The revival of Early Christian style current in Venice during the twelfth and thirteenth centuries was a direct imitation of a fashion at Constantinople. On the other hand, in monumental sculpture, as in mosaic, the Venetian artists quickly followed paths of their own. The fine Deesis [244] in the south aisle of S. Marco dating from the eleventh or twelfth century was either commissioned or looted from the metropolis, as were the Ascent of Alexander

243. St Peter. Mosaic in the apse.
Between 1100 and 1112. *Venice, S. Marco*

244 (*below*). The Deesis. Marble relief in the south aisle. Constantinople, eleventh or twelfth century. *Venice, S. Marco*

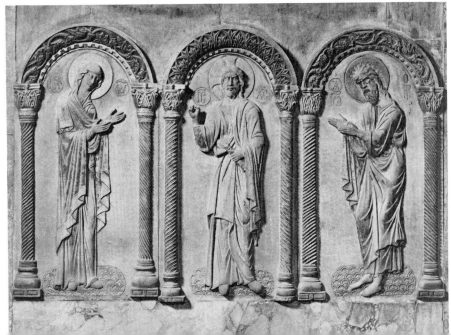

245. The Ascent of Alexander. Marble relief on the north side. Constantinople, eleventh or twelfth century. *Venice, S. Marco*

246. Herakles. Marble relief on the west façade. Constantinople, eleventh or twelfth century. *Venice, S. Marco*

247. St Demetrius. Marble relief on the west façade. Constantinople, eleventh or twelfth century. *Venice, S. Marco*

[245] on the north façade, the controversial Herakles with a boar and the St Demetrius [246, 247] on the west façade. The Gothic fantasy of Herakles with the Keryneian stag on the same façade, dating probably from about 1230, shows the parting of the ways. The relief, now in the Cappella Zeno, of the Theotokos Aniketos (Invincible) [248] bears an inscription stating that

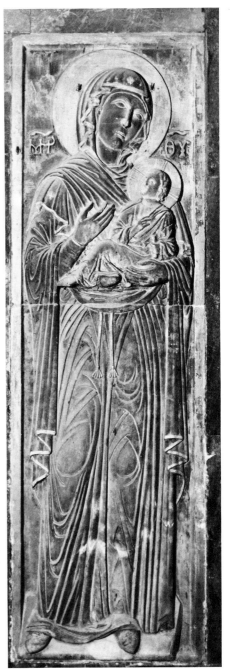

248. The Theotokos Aniketos.
Marble relief. Second half of the thirteenth century.
Venice, S. Marco, Cappella Zeno

249 (*right*). The Madonna dello Schioppo.
Marble relief in the north transept.
Thirteenth century. *Venice, S. Marco*

'the water which Moses once produced from a rock by his prayer flows now by the efforts of Michael, whom Christ protect together with his consort Irene'. Popular belief held that the marble was part of the rock from which Moses drew water in the desert, but the panel must have served as a dedicatory icon for a fountain or an aqueduct. The only Byzantine Emperor

who fits the general conditions is Michael IX (1295–1320), whose wife Ricta, Xene, or Maria was also called Irene, but, since the relief influenced Venetian sculpture of the early fourteenth century, this date appears to be too late – quite apart from the unlikelihood of sculpture being taken from Constantinople after the return of the Greek Emperors to the city. It is possible that the inscription refers to the Despot Michael of Epirus (1237–71) and that the relief was taken from one of his towns. Generally speaking, direct Venetian copies of Byzantine reliefs are weak and mannered, and only when the Romanesque and Gothic styles of northern Italy and the Holy Roman Empire are fused with the Byzantine pastiche comes the promise of a rich development. The sculpture on the west façade, on the central porch, and indeed on most of the doors – Porta S. Alippio, Porta dei Fiori, Porta di San Giovanni – the Madonna dello Schioppo in the north transept [249], and the Baptism of Christ in the baptistery are important stages in this fusion. The extraordinary effect which the first sight of S. Marco makes on the visitor – quite apart from the light at any time of day or night and the sparkle of marble, mosaic, and gilding – is the strange marriage of Byzantine domes with a Romanesque and Gothic façade. Born of a Lombard and Venetian wind, S. Marco rises like a Byzantine Aphrodite amid fountains of Gothic foam.[22]

METROPOLITAN DIFFUSION AND DECLINE

If the Third Crusade (1189–92) had done little to further Latin ambition apart from the capture of Cyprus, it had served to convince several leaders that the occupation of Constantinople was an essential preliminary to war against the infidel. So wrote Frederick Barbarossa to the Pope when asking for his blessing on such an enterprise. The marriage of Barbarossa's son Henry to Constance, the heiress of Sicily, united two kingdoms hostile to the Greeks, and on becoming Holy Roman Emperor in 1190 his main policy was to establish Western imperial overlordship over the entire eastern Mediterranean. In 1195 the Byzantine Emperor Isaac II Angelus was deposed and blinded by his brother, who assumed the purple as Alexius III, but the change was not for the better. Not only the Germans but the Serbs and the Bulgars were quick to take advantage of the apparent weakness of the Empire, and Alexius, in a desperate attempt to gain time, agreed to pay the German Emperor a heavy tribute. The collection of this tax, known as the *alamanikon*, nearly provoked a revolution. Alexius found it so difficult to raise the required sum that he was driven to the extraordinary expedient of opening the imperial tombs in the church of the Holy Apostles and removing and melting down the gold and silver treasure found in them. The tax and the plundering of the tombs in 1197 must have made a profound impression on the Byzantine people, who by now loathed the Latins for their arrogance and their greed. The German Emperor Henry VI died in September 1197, having already received recognition from the rulers of Cyprus and Lesser Armenia. Serbia was virtually an independent state. Byzantine campaigns against Bulgaria, and Byzantine intrigue involving the murder of the Princes Asen and Peter, only revealed the impotence of the central administration; the young Bulgar

Prince Kalojan acknowledged papal supremacy and was crowned Tsar in 1197. The Venetians under the guidance of the old Doge Enrico Dandolo saw that the time was propitious for an attack on the metropolis, the Fourth Crusade with a Byzantine pretender in their midst and two of its leaders allied by marriage to the imperial family played straight into Venetian hands, and on 13 April 1204 the Latins were masters of Constantinople. After the inevitable three days' sack one of the most beautiful cities of the world was left a smoking ruin. Loot amassed in three churches was valued at 400,000 silver marks – more than four times the sum demanded by the Venetians for the transport of the Crusade. Never, said Villehardouin, since the world was created had so much booty been seen in any city. The bitterness of victory was revealed later. Once a Latin Emperor had been elected and the Empire had been divided up like a fief in Brittany, it was evident that the Crusaders had no idea of what to do with a world economy, a world policy, or a world state. Hatred, envy, and greed had led Christian leaders on to an act of incredible political folly. The Greeks neither forgot nor forgave. Only Pope Innocent III was conscious of the serious crime against Christian civilization. He described it as a 'work of darkness' and confessed himself weakened by disappointment, shame, and anxiety.[1]

While the Crusaders were carving out fiefs in Asia Minor and the Morea, the Greeks at once began to retrieve the situation. Alexius and David Comnenus, grandsons of the Emperor Andronicus I, with the help of their aunt Queen Tamar of Georgia, occupied Trebizond and established a dominion along the Black Sea shores of Asia Minor. Michael Dukas Angelus Comnenus, a cousin of Isaac II and Alexius III and a bastard of the *sebastocrator* John Dukas –

the combination of illustrious names typifies the network of kinship – took command of the district round Arta and made himself Despot of Epirus. Leo Sgouros married a daughter of Alexius III and held out stubbornly in Corinth and the Argolid. More important than these, Theodore Lascaris also married a daughter of Alexius III, set up a dominion at Nicaea, and attracted to his person the uprooted elements of the Byzantine Church and State. In Holy Week 1208 the new Patriarch Michael Autorianus crowned Theodore Lascaris as Emperor, and Nicaea in the eyes of the Greeks became the capital of the legitimate Empire. But it was no longer the *Roman* Empire. Theodore's position was confirmed by a resounding defeat of Seljuq and Latin troops near Antioch on the Meander in 1211. During the battle the Sultan of Rūm was killed by Theodore. Alexius III, who had called on the Sultan's assistance, was found among the prisoners and was confined in a monastery at Nicaea. Not only had Theodore killed his most dangerous enemy, but the last surviving Greek claimant to the Byzantine throne was in his hands. Meanwhile the Latin Emperors had provoked a Bulgar war, and the Serbs were the dominant power in the Balkans.[2]

During the reign of Stephen Nemanja (1169–96), in spite of setbacks from expeditions by the Emperor Manuel in 1172 and the Emperor Isaac II Angelus in 1190, the Serbs finally gained complete independence. Nevertheless, their religion had been received from the Byzantine Church and their culture was essentially Byzantine. Their princes wore Byzantine court costume, founded churches and monasteries in the tradition of the Augusti, and frequently retired to them before death. Thus Stephen Nemanja entered the monastery of Studenica after his abdication in 1196 and before retiring to Mount Athos. Serbian literature and law owed much to the metropolis. Eventually in 1345 Stephen Dušan was to adopt the imperial title and to establish the Serbian Patriarchate. There can be no doubt that after the sack of Constantinople Greek artists fled to Serbia. The evidence begins at Studenica in the church of

the Virgin with work dated to the year 1209 by the painter of Prince Vuka, the elder son of Stephen Nemanja. The style of these paintings is quite different from that at Nerezi or at Kurbinovo. In some ways the artist has returned to the severe, withdrawn, traditional images of the eleventh century. The exaggeration of emotion, the strange proportions of the figures, and the idiosyncratic treatment of drapery found at Kurbinovo appear to have been bypassed. The impressive representation of the Crucifixion [250] on the west wall of the catholicon of the church of the Virgin at Studenica is a grave, monumental statement of a type of event. The tenderness of the Early Comnene style is present without the drama of the later years. The forms are solidly delineated, the drapery falls in heavy folds, occasionally caught at the knee, and the protagonists stand or hang like a demonstration of belief. This epic quality was to continue in all the Serbian paintings of the thirteenth century.[3]

In western Serbia, in the former state of Raška, King Vladislav I (1233–42) founded at Mileševa a monastery and a church of the Ascension. The church (1234–6) was intended to be the mausoleum of the king and ranked high in the land, becoming an important artistic, ecclesiastic, and political centre. The king's uncle St Sava on his death in 1235 was buried at Mileševa. Several times burnt and partially rebuilt, the church in its present form dates from the 1860s, but the architecture is recognized by Serbian scholars as the first clearly worked-out blending of Byzantine and Romanesque elements in Serbian art. Three distinct sets of frescoes have survived, of which some are signed by artists with Greek names – George, Demetrius, and Theodore – although these are claimed to be Serb; 'court' painters were at work in the nave, 'monastic' painters were employed in the narthex, and there is a third set in the exonarthex, but all three campaigns date from the reign of King Vladislav. It seems plausible to substitute the word Greek for 'court' and Serbian for 'monastic'. Against a gold background scenes from the life of Christ and the usual

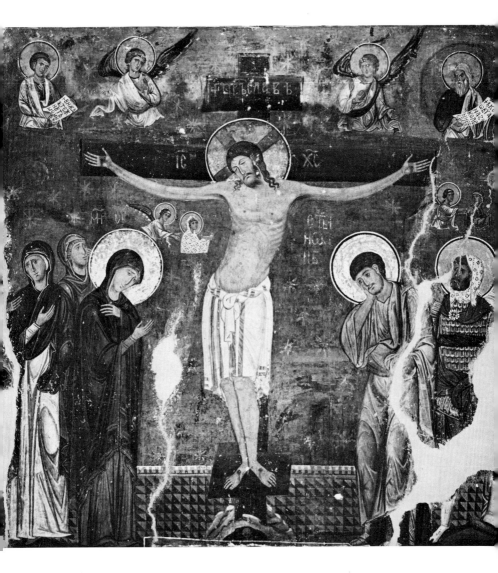

250. The Crucifixion. Wall-painting on the west wall. 1209. *Studenica, church of the Virgin, catholicon*

assembly of saints are represented with great dignity and force. The faces are sensitively modelled, the head of the Virgin Annunciate for example [251], and the drapery has none of the mannerisms of Late Comnene style. The always something new. The portrait of King Vladislav [253] presented by the Virgin to Christ enthroned appears to have been taken from life and is revealed with astonishing psychological penetration. This same reading

251. The Virgin Annunciate.
Wall-painting. Between 1234 and 1236.
Mileševa, church of the Ascension

252. The Angel at the Sepulchre.
Wall-painting. Between 1234 and 1236.
Mileševa, church of the Ascension

complex and touching Descent from the Cross is painted with a remarkable feeling for form, the limp body of Christ held by the upright Virgin, His hand kissed by another Mary, His feet not yet freed from the cross. There is an atmosphere of profound but not hysterical grief. In the scene where the Holy Women are confronted by the Angel at the Sepulchre [252], the gleaming white robes of the messenger and his noble face dominate the composition – huddled, sleeping soldiers below, the great stone on which the Angel is seated, and the flinching women on his left. Whoever these painters were, Greek or Serb, the strong classical tradition which emerges once more could only have come from a metropolitan school. There is

occurs in the narthex where the Nemanić kings are portrayed: St Sava, King Stephen the First crowned – only the pictograph of Stephen Nemanja as the monk Simeon appears stereotyped and lacks the feeling of first-hand knowledge. In the exonarthex vestiges of a Last Judgement suggest that the artist had not benefited from contact with a living metropolitan tradition; the distinction of quality from that in the nave is marked.[4]

253. King Vladislav presented by the Virgin
to Christ enthroned. Wall-painting.
Between 1234 and 1236.
Mileševa, church of the Ascension

An artist of considerable ability was at work in the church at Morača in 1252. He carried on the principles of clear, articulated composition to be found at Mileševa, but unfortunately only the cycle of Elias in the diaconicon has survived; the remainder of his work has been drastically repainted in the sixteenth and seventeenth centuries. Undoubtedly the great glory of Serbian or Greek art in the thirteenth century is to be found at Sopoćani. The monastery was founded by King Stephen Uroš I (1242–76) about 1256, and the church dedicated to the Trinity was intended as a mausoleum and a cathedral. His mother Queen Anna Dandolo was buried in the narthex, and her death (in 1256 or 1258) is represented in fresco on the north wall of the narthex. Uroš transferred the body of his father King Stephen Prvovenčani (1195–1227) from Žiča (he had previously lain at Studenica) to Sopoćani; his cousin Prince George was buried there, and finally Uroš himself, against the south wall of the church under the portrait of the founder. In the sanctuary a portrait of the third Serbian Archbishop Sava II, youngest brother of Uroš, elected in 1263, and in the narthex the portraits of the King, Queen Helena of Anjou, and their sons Dragutin and Milutin suggest that the paintings were completed between 1263 and 1268, the year of Dragutin's marriage. The tower and the exonarthex were probably added towards the end of the thirteenth or the beginning of the fourteenth century, and the frescoes in the latter date from the reign of King Stephen Dušan (1331–48; Tsar until 1355). In the earlier cycles Serbian scholars make a distinction between the 'court' style visible at Djurdjevi Stupovi, King Radoslav's narthex in the church of the Virgin at Studenica, the lesser church of St Nicholas in the same monastery, at Mileševa, Morača, and Gradac, and the 'monastic' style evident in the nave of the main church at Studenica, in the hermitage of Peter of Koriśa at Žiča, the church of the Holy Apostles at Peć, and elsewhere. At Sopoćani, as at Mileševa, both styles are to be found – the latter in the narthex and the side chapels. In the nave there are two sets of paintings: in the upper zone of the central square a master worked in an archaic style reminiscent of Kurbinovo and the Hagioi Anargyrioi at Kastoria, using strongly marked outlines, emphasized folds of drapery, and a rather crude colour scheme. The frescoes on the lower spaces were executed under the direction of a great artist trained according to some at Salonika or Nicaea, although there is little to judge at either centre today. Different hands were governed by this master, who set about his task with a grasp of composition monumental in scale, of rhythmic masses, of firmly modelled form. Fresh recollections of pastoral scenes merge into the majestic visions of the great Feasts set against a golden ground. The full force of the artist's talent is revealed in his version of the Dormition [254] on the west wall of the nave, where between architectural fantasies and crowds of Apostles, angels, and devout women the Virgin lies on a richly draped couch and behind her Christ stands holding her soul. Tenderness and gravity, reserved emotion, liturgical restraint infuse the solemn scene. After Sopoćani, with the possible exception of the monastery at Banjska, mausoleum of King Milutin I, now a total ruin, there appears to have been a lull in artistic activity. The next stage with new developments was to occur at the end of the century at Ochrid, and it should be stressed that at the time Ochrid was not part of Serbia.[5]

There is far less evidence of cultural activity in Bulgaria at this time, but at Bojana near Sofia a small tomb-chapel is decorated with paintings of some quality. An inscription refers to Kalojan *sebastocrator*, cousin of the Tsar, grandson of St Stephen, King of Serbia . . . in the time of the true-believing, God-fearing, Christ-loving Tsar Constantine Asen, and gives the date 1259. Life-size portraits of Prince Kalojan and his wife Dessislava, of the Tsar Constantine Asen and the Tsarina Irene, dressed in Byzantine court costume, are painted with that breath of realism already sensed at Mileševa. The Tsarina was a daughter of the Emperor Theodore II Lascaris of Nicaea, and when she died in 1270 the Tsar married a niece of the Emperor Michael

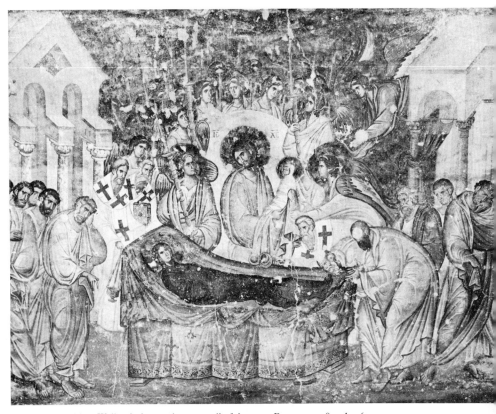

254. The Dormition. Wall-painting on the west wall of the nave. Between 1258 and 1264.
Sopoćani, church of the Trinity

VIII Palaeologus. The connexions with Byzantine civilization were, therefore, particularly close. In the chapel the image of Christ is designated *Chalkitis*, which refers to the icon over the brazen gate of the Sacred Palace at Constantinople, and it seems reasonable to suppose that the artist, probably a Bulgar, had received training either in the metropolis or in a centre where the old traditions had been cherished. The usual cycle of Twelve Feasts decorates the chapel, with the addition of some Bulgarian saints.[6]

Illuminated manuscripts of the luxury class do not appear to have been produced in Serbian or Bulgarian scriptoria, but in the eastern parts of the Byzantine Empire, in Georgia and Armenia, there had always been a demand for handsome books. The sacred texts were to the Armenians the equivalent of the icons to the Greeks and were not infrequently paraded before battle. Many of the illustrations to the texts fall outside the scope of Byzantine art or its influence; there were strong local traditions and a flavour of the Orient. Occasionally, however, in the eleventh century manuscripts had been produced within the sphere of Byzantium. The Gospels (Jerusalem, Armenian Patriarchate Library no. 2556) written for Gagik, King of

Kars, probably between 1029 and 1064 are lavishly illustrated with miniatures and rich ornamental bands. The portrait of Gagik and his Queen and daughter is wholly oriental – they are seated cross-legged on a low couch covered with a rug, the women dressed in the Persian manner, and the silks worn by all three are probably Abbasid. On the other hand, the Gospel scenes are clearly copied from Byzantine models, and the ornament is a blend of Byzantine and Armenian decoration. Presumably the artist was an Armenian with some train-ing in a Greek scriptorium. The equally hand-some Gospels brought from Trebizond to Venice (Mekhitarist Library at S. Lazzaro, no. 1400) – in the twelfth century it had belonged to a Cilician nobleman – date from about the same time as Gagik's Gospels and were prob-ably produced in the same area, although it is conceivable that some of the full-page minia-tures with Greek inscriptions may have been painted by a Greek. The Presentation, the Bap-tism [255], and the portrait of St John appear to be well within the Byzantine tradition; on the

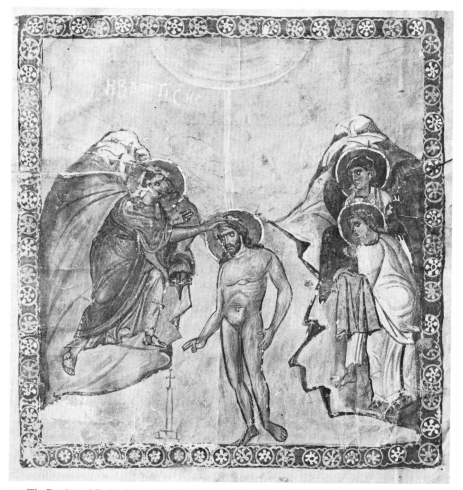

255. The Baptism of Christ. From a Gospels, MS. 1400. Kars (Armenia), mid eleventh century. *Venice, Mekhitarist Library*

other hand, some of the miniatures, such as the portrait of St Mark and that of Christ enthroned, are clearly the work of an Armenian who had not been to a Byzantine school. Work of a provincial kind continued in Greater Armenia even after the Seljuq Turks had occupied a large part of Asia Minor, but in Cilicia, where the Armenians formed a new kingdom which enjoyed considerable prosperity in the twelfth and thirteenth centuries, important scriptoria were established at the monastery of Skevra near the royal fortress of Lambron, at Mlidj near the fortress of Paperon, at Grner, Akner, Drazark, and Sis, and above all in the second half of the thirteenth century at Hromkla, the seat of the Catholicos. Indeed, the Catholicos Constantine I (1221-67) was a great patron of the arts, and his painter T'oros Roslin rivalled the best that Constantinople had produced. T'oros Roslin was not alone at this time; a certain Kyrakos was working in the same scriptorium and others, Constantine and Barsegh, had been employed by Bishop John, the brother of King Het'um I, himself an accomplished scribe. One of the finest Gospels produced for Prince Vasak (Washington, Freer Gallery, no. 32.18), a second Gospels produced for the same prince, and the Gospels of Queen Keran (Jerusalem, Armenian Patriarchate Library, nos. 2563 and 2568) cannot be assigned to any known artist. The signed works by T'oros Roslin range in date from 1256 to 1268, and it has been argued plausibly that the Freer Gospels may have been executed under the direction of the master towards the end of that period. T'oros Roslin not only knew Byzantine models; he was equally familiar with Western manuscripts, with the productions of the Crusader Kingdom of Jerusalem, and even with Chinese works of art. The Crusades had brought the Armenians of Cilicia in close contact with the Latin world. The sisters and daughters of Het'um I all married Frankish noblemen; the customs of Western chivalry were partially adopted at the Armenian court – two sons of Het'um I were knighted at ceremonies which copied Western custom; French and Latin were used in some of the official documents of the Armenian chancellery. More extraordinary, perhaps, is the Chinese and Mongol influence, but it must be remembered that already in 1222 the Mongols had made their first appearance in Europe and that Kiev had been destroyed by them in 1240. On T'oros's pages are to be found lions with manes rising in flame-like haloes and spirals covering their bodies and faces; birds with sweeping tails and wings like Chinese flying cranes; trees with gnarled and twisted trunks; the mount of a rider lunging neck and head like a water buffalo. Nor was the artist just being eclectic with his models; his compositions show careful observation of contemporary life and the people around him. In the Gospels dated 1262 (Jerusalem, Armenian Patriarchate Library, no. 2660) executed for Prince Leo (later Leo II, 1270-89), the portraits of the Evangelists in brilliant colours against a gold ground follow Byzantine models, although the incidental ornament in the margins of the text and the profusely decorated head-pieces (*khorans*) and canon tables contains a good deal of Cilician invention. The double portrait of Prince Leo and Princess Keran (fol. 288) [256] presents them in court dress, crowned and haloed, but not in Byzantine court apparel, nor are the crowns Byzantine in form. The silks worn by Princess Keran appear to be based on Seljuq models, while those worn by Prince Leo were fashionable in various parts of the Near East from Constantinople outwards. In the Gospel dated to 1268 (Jerusalem, Armenian Patriarchate Library, no. 3627) the Crucifixion is clearly derived from a Western model (fol. 328), particularly in the type of Christ and the personifications of Ecclesia and Synagogue – both wearing Western crowns, whereas in the Byzantine model only the maphorion would have been worn. Contemporary dress turns up quite frequently in the Freer Gospels – in particular Christ in the House of Levi [257] (p. 373) and the Marriage at Cana [258] (p. 548). Chinese influence is to be found in a title page with a portrait of Christ Emmanuel [259] in a Lectionary of 1288 executed for King Het'um II attributed to T'oros

256 (*left*). Prince Leo and Princess Keran.
From a Gospels, MS. 2660, fol. 288,
executed by T'oros Roslin at Hromkla. 1262.
Jerusalem, Armenian Patriarchate Library

257 (*right*). Christ in the House of Levi.
From a Gospels, MS. 32.18, p. 373,
executed under the influence of T'oros Roslin
probably at Hromkla. Shortly before 1268.
Washington, D.C., Freer Gallery of Art

258 (*below*). The Marriage at Cana.
From the Freer Gospels, p. 548

259. Christ Emmanuel.
From a Gospel Lectionary, MS. 979,
executed probably by T'oros Roslin. 1288.
Yerevan

Roslin (Yerevan, Matenadaran, no. 979).
Throughout this extraordinary sequence of
manuscripts the style is remarkable for its
vigour and liveliness, plastic modelling, rich-
ness of detail and colour, and astonishing in-

260. The Panagia Chalkoprateia. Painted icon
in its original silver-gilt and enamelled frame.
Before 1235 but repainted
towards the end of the fourteenth century.
Freising, cathedral of St Mary and St Korbinian

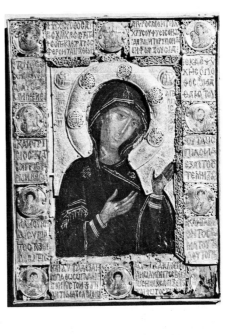

vention. In the fourteenth century the Cilician painters were to abandon this rich elegance and return to simpler and more severe forms. This new manner was to culminate in the work of Sargis Pidzak, who exercised even greater influence than T'oros Roslin – possibly because it was less eclectic and closer to the national tradition – and in that of T'oros of Taron, who worked in the province of Siunik' in Greater Armenia during the first half of the fourteenth century. With the deaths of these artists the great period of Armenian illumination comes to an end.[7]

For all the upheaval and diaspora of artists from Constantinople after 1204 there seems to be no doubt that some stayed in the ruined city and worked on both Greek and Latin commissions. The icon of the Virgin Chalkoprateia [260] now in the cathedral of St Mary and St Korbinian at Freising (Oberbayern) in its initial stage seems to have been painted before 1235. The contemporary silver-gilt frame with enamels bears an inscription referring to Manuel Dishypatos, imperial *kanstrisios* and levite in Constantinople, who became in 1235 Metropolitan of Salonika (he died in 1261). The icon was painted over by a Byzantine artist working in Italy probably towards the end of the late fourteenth century, and additions were made to the metal frame about the same time. A Latin inscription states that the icon was an imperial gift to Duke Gian Galeazzo of Milan which passed through various hands to the Bishop of Freising, Nicodemus della Scala, on 23 September 1440. Various icons dating from the thirteenth century on Mount Sinai may also have come from the metropolis, including a ruined *Panagia he Paraklesis*, a Christ Pantocrator, an icon of St Nicholas combined with a Deesis, Apostles, and Saints, a fragmentary Deesis, and the Virgin and Child between St John the Baptist and St George, all essentially

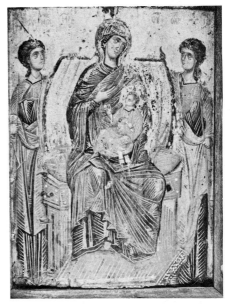

261. The Virgin and Child enthroned between Angels. Icon. Constantinople, thirteenth century.
Mount Sinai, monastery of St Catherine

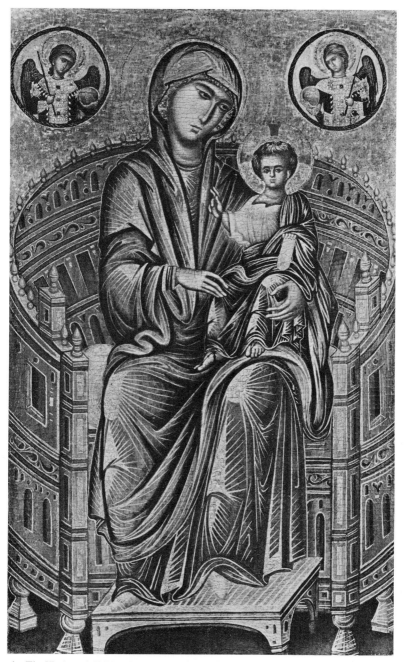

262. The Virgin and Child enthroned. Icon. By a Byzantine artist working in the West towards the end of the thirteenth century. *Washington, D.C., National Gallery of Art*

Comnene in style. An enthroned Virgin and Child between Angels, however, is much more forward-looking [261]. The figures still retain the Comnene elongation, but the drapery is mapped out in a hatchwork of gold highlights, the forms beneath the drapery have a new solidity, and the three-quarter slant of the faces hints at a Paleologue mannerism. This icon has been used plausibly in the chain of arguments which has led scholars to attribute to a Byzantine master two handsome icons of the enthroned Virgin and Child now in Washington [262]. Both the Kahn and the Mellon icons came from La Calahorra in Spain, and in spite of the characteristic of 'exploding gold lines' common to these and the Mount Sinai icon, show strong Western influences. It has been suggested, therefore, that the Greek master had seen Duccio's Rucellai Madonna, which may be dated to 1285. It so happens that two members of the imperial house came to the West in the second half of the thirteenth century. The Empress Anna-Constance, daughter of Frederick II Hohenstaufen, widow of the Emperor John III Dukas Vatatzes, had been sent back to the West after Michael VIII Palaeologus had failed to get a divorce in his attempt to marry her. In 1269 Anna-Constance went to Valencia and lived with her niece Constance, who was married to Don Pedro III, later King of Aragon, and died as a nun in 1313. She might well have brought a Greek artist in her train. Alternatively, though less likely, such an artist might have accompanied the Emperor John IV Lascaris, blinded as a child of eleven in 1261 by Michael VIII, but later known to have escaped to the West and to have been welcomed by Charles of Anjou in Sicily about 1273. Although there has been considerable difference of opinion over the date of the Kahn and Mellon icons, the last decade of the thirteenth century seems most acceptable.[8]

Manuscripts were produced or adjusted for Latin customers in the metropolis. A Gospels (Athens, Nat. Lib. cod. 118) now in poor condition was copied by the monk Sergius in the first half of the thirteenth century; the portraits of St Matthew, St Luke, and St John show them holding scrolls bearing Latin texts. In style the portraits are close to those in another Gospels (Paris, gr. 54) written about the middle of the thirteenth century in Greek with a Latin translation. The illustrations are only half complete, but they include portraits of the Evangelists on a gold ground as well as various Gospel scenes, of which some have a slightly Italianate flavour. However, the codex appears to be a direct copy of a Gospels on Mount Athos (Iviron, cod. 5), although it has been pointed out that it falls short of the latter in elegance and finesse of execution. A glance at the portrait of St John [263] shows that already the chief

263. St John the Evangelist. From a Gospels, MS. gr. 54, fol. 278 verso. Constantinople, thirteenth century. *Paris, Bibliothèque Nationale*

characteristics of the early Palaeologue style are in operation: the long backward gaze at tenth-century models, the broadening and stunting of form as opposed to the Comnene elongation, the interest in incidental details, a tendency towards greater naturalism of feature. The Gos-

pels on Mount Athos with its portraits of the four Evangelists, about thirty scenes from the life of Christ, and some Latin inscriptions appears to have been produced at Constantinople before 1260, and by 1285 the new style was well set in its ways. A Gospel written by the monk Theophilus at Constantinople (British Museum, cod. Burney 20) contains illustrations [264] which develop still further the new

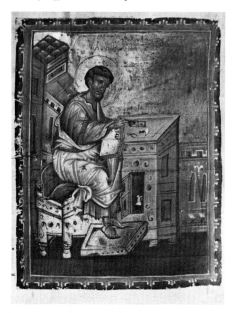

264. St Luke. From a Gospel Book, MS. cod. Burney 20, fol. 142 verso, written by the monk Theophilus. Constantinople, 1285. *London, British Museum*

solid forms set before sturdy architectural constructions in a new sense of space. Even when there are no paraphernalia in a given scene, the portrayal of the standing figures of saints against a gold ground, as in Vatican, gr. 1208, an Acts and Epistles based on Vatican, cod. Chris. gr. VIII, 54, is of such high quality and authority [265] that one is inclined to think that a new imperial scriptorium employing the best

triumphant Greeks. Two of the Canon Tables in a Gospel Book, Vatican gr. 1158, display Palaeologue monograms; it reached the Vatican as a present to Pope Innocent VIII from the last queen of Cyprus, whose mother was a Palaeologue. Gr. 1208 came from the same source. (Another female member of the family, possibly Theodora Raoulaina, a niece of the Emperor Michael VIII, was highly educated and had a fine library which she bequeathed to her favourite monastery on her death in 1300.) The thirteenth-century Psalter in Jerusalem (Greek Patriarchate Library, Hagiou Taphou 51) contains an illustration of David listening to Nathan and David doing penance [266] with such retrospective tendencies and so close to the productions inspired by Constantine VII Porphyrogenitus that the artist might almost have been instructed by the imperial ghost. Certainly at Nicaea in the third quarter of the century such quality could not be attained. A group of rather shoddy and diluted versions of greater models – it must, of course, be remembered that a good deal of routine stuff was produced at Constantinople, Paris, gr. 1335 for example –

265. St Luke and St James. From a copy of the Acts and Epistles, MS. gr. 1208, fol. 1 verso. Constantinople, second half of the thirteenth century. *Vatican, Biblioteca Apostolica*

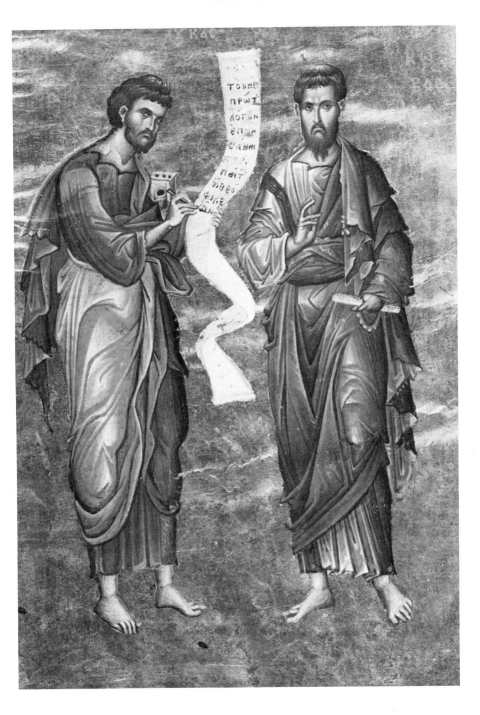

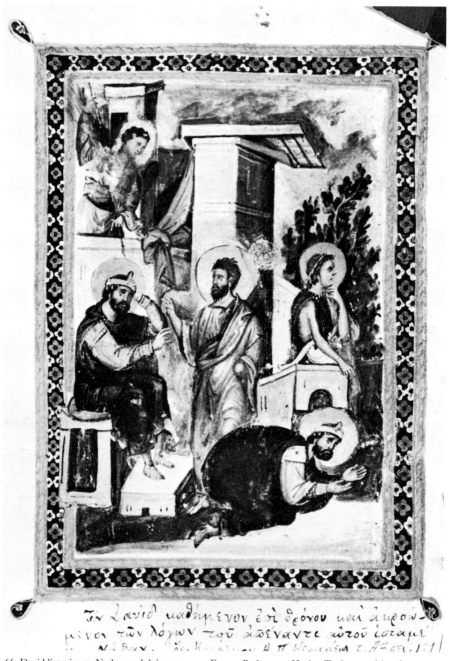

266. David listening to Nathan and doing penance. From a Psalter, MS. Hagiou Taphou 51, fol. 108.
Constantinople, thirteenth century. *Jerusalem, Greek Patriarchate Library*

are thought to have been produced at Nicaea: the Chicago New Testament (Rockefeller McCormick 2400), the Four Gospels of Karahissar (Leningrad, State Library, gr. 105), the Holkham Lectionary (MS. 3), Mount Athos Lavra B 26, and a New Testament given to King Louis IX of France by the Emperor Michael VIII Palaeologus in 1269 (Paris, Coislin 200) are all permeated with Late Comnene mannerisms, preserved, as it were, in cold storage but without the new breath of life detectable in Vatican, gr. 1208.[9]

Little is known of the religious foundations of the Lascarids. John Vatatzes built a monastery at Sosandra. Theodore II Lascaris built a church to St Tryphon, the patron of Nicaea, and in its precincts he established schools of grammar and rhetoric. Both John Vatatzes and his son Theodore II founded libraries, and Nicephorus Blemmydes was sent to buy religious and scientific manuscripts in Thrace, Macedonia, Thessaly, and on Mount Athos. Blemmydes was not the only scholar at the court; both Nicetas Acominates and George Acropolites were welcomed there and became tutors of Theodore II. Today Nicaea is reduced to a miserable village. Such evidence as has survived suggests a cold and timid conservatism in the new capital. It also seems clear that the new stirrings of artistic life were not nurtured at Trebizond. The fragmentary paintings in the church of Hagia Sophia dating from the middle of the thirteenth century are apparently the work of artists introduced from Constantinople. Those in the Theokepastos Monastery dating probably from the early fourteenth century show signs of the new movement, but even so the style is harsh and the colours are crude. The church of St Anne, the oldest in the town, with an inscription referring to a restoration by Basil I in the year 884-5, contains a few traces of frescoes which have been variously dated between the fourteenth and the sixteenth centuries. Even in Epirus, where at Arta the Despot Michael had established a court in rivalry to that of Nicaea with scholars like John Apocaucus, George Bardanes, and Demetrius Chomatianus,

the monuments which have survived are apt to be disappointing. The strangely built church – acrobatic on columns – of the Panagia Parigoritissa (the Virgin of Consolation), refounded by the Despot Nicephorus and his wife Anna Palaeologina between 1282 and 1289, contains a damaged mosaic of Christ Pantocrator surrounded by orders of angels and prophets [267] dating from about 1290. Although this is one of the earliest of the Palaeologue monuments, there is little to show from the vestiges that remain that the new movement had beginnings here. The head of Christ harks back to a more distinguished predecessor at Daphni and is a dry, vacuous version of the old noble theme.[10]

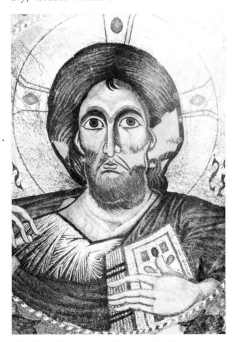

267. Christ Pantocrator. Mosaic in the dome. *c.* 1290. *Arta, Panagia Parigoritissa*

Michael Palaeologus, Regent of Nicaea, found himself master of the metropolis almost by accident. At first he refused to believe his sister Eulogia, who awoke him with the news

from Constantinople. But the arrival of a second courier carrying the regalia of Baldwin II which had been abandoned in the Palace of the Blachernae confirmed the message from the occupying general Alexius Strategopoulos, and Michael joyfully made preparations for his state entry. The Emperor John IV Lascaris, eleven years old, was left behind at Nicaea. Within a year the child was blinded by the most humane of the six methods known, as Michael announced, and was confined to a castle on the Black Sea. Meanwhile, on 15 August 1261, Michael Palaeologus entered the city by the Golden Gate and, preceded by the icon of the Theotokos Hodegetria, walked the length of the city to the church of Hagia Sophia. There he was crowned by the Patriarch Arsenius, and he eventually retired to the Sacred Palace, since the Palace of the Blachernae had been left uninhabitable by Baldwin II. Michael VIII had come to a desolate city, but at once he began to restore the walls, to dredge the harbour of the Kontoscalion, and to initiate repairs in some of the churches, notably Hagia Sophia and the Panagia Peribleptos. In a short time the imperial city began to show signs of new life. Between 1284 and 1300 more churches were built; St Andrew in Krisei (Kodja Mustafa Pasha Djami), the south church of the monastery of Constantine Lips (Fenari Isa Djami), and the north church of the monastery of the Theotokos Pammakaristos, all three perhaps by the same architect. But some quarters of the city were never redeveloped. The west and the middle were gradually abandoned, and the majority of the people lived along the shores of the Golden Horn and the Sea of Marmara.[11]

Probably during the repairs to Hagia Sophia the mosaic panel with a representation of the Deesis [268] in the south gallery was restored. Such is the beauty and quality of this mosaic that scholars have been led to assign the panel to the late eleventh or early twelfth century, and certainly there are stylistic parallels in the second half of the twelfth century – Nerezi in particular – which might support a pre-conquest hypothesis. On the other hand, others have recognized close stylistic affinities with the mosaics in the church of Christ in Chora (Kariye Djami) executed in the second decade of the fourteenth century. A detailed technical scrutiny may resolve this dilemma, and there seems reason to believe that a panel of earlier date had existed. The tender wistfulness of the Virgin's expression, the grave concentration of St John the Baptist, and the serene watchfulness of Christ are, no doubt, Comnene in origin, but the new naturalism – treatment of hair, physiognomy, drapery, and hands – of the Palaeologue style seems also to be present. Similarly the frescoes in the little church of St Euphemia near the Hippodrome including fourteen scenes of the *Passio Euphemiae* and representations of St George and St Demetrius, dated in the past to the eighth and ninth centuries, should be seen as works dating from the late thirteenth or early fourteenth century. During repairs in the church of the Theotokos Pammakaristos instigated by the Grand Constable Michael Glabas about 1293-4 frescoes were added to the south façade which are now fragmentary, but they included a Dormition cycle and a typological scene referring to the Virgin. The fragments show the Virgin praying in her house at Jerusalem – an incident taken from the apocryphal text of the Pseudo-John – and Christ appearing in the top right-hand corner to announce her departure from this world, St Peter before a small square tower no doubt being addressed by Christ after He had promised the Virgin that anyone invoking her name should find mercy, and lower down the 'Closed Door', one of the traditional symbols of the Virgin based on Ezechiel xliv:2. It has been suggested that this curious scene was followed on the south façade by other typological scenes: the Burning Bush, Jacob's Ladder, Gideon's Fleece, and so on. The elaboration of the Dormition theme and of the whole narrative cycle of the Virgin seems to be a marked characteristic of Palaeologue art. It occurs again in the church of the Peribleptos (otherwise known as St Clement) at Ochrid, where the paintings dated to 1295 are signed by two or possibly three Greek

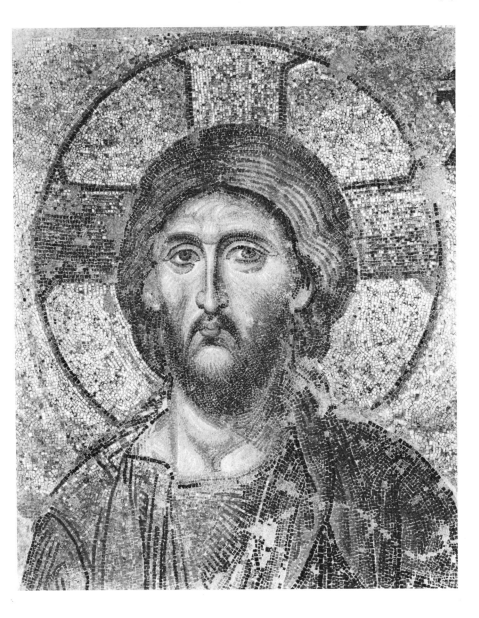

268. Christ. Detail from the mosaic panel of the Deesis in the south gallery. Late thirteenth century.
Istanbul, Hagia Sophia

masters, Astrapas, Michael (believed by some to be the son or disciple of Astrapas, by others to be one and the same artist Michael Astrapas or *tou Astrapou* – 'like lightning'), and Eutychios. The Dormition cycle at Ochrid is composed, in fact, of episodes different from those in the Pammakaristos, and appears to be inspired by a pastoral letter of John of Salonika. In view of Serbian claims, it is important to note that Ochrid was not part of Serbia at this time, that the church was founded during the reign of Andronicus II Palaeologus and his wife

and fairly complete frescoes in their restored state seem rather crude and garish, the style is unquestionably of the new metropolitan vintage, and they are the earliest full statement of this stage. If the central theme of the Dormition [269] is compared with that at Sopoćani [254], it will be seen that there is an even greater elaboration of the composition, an even fuller sense of plasticity, a more intense and vivid expression, and sharper contrasts between light and shadow. The scene of the Betrayal [270] is a violent expression of drama in which the still

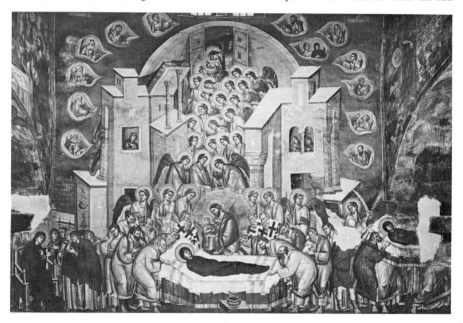

269. The Dormition. Wall-painting. *c.* 1295. *Ochrid, church of the Peribleptos (St Clement)*

Irene by the Grand Heteriarch Pragon Sgouros, who married a daughter of Andronicus II, and that the Greek painters may have been brought from Constantinople or Salonika. All the paintings date from the same time except those in the north-east chapel, dated 1365, and the funerary portrait of the Serbian nobleman related to Kral Marko, Ostoja Rajaković, who died in 1379 or 1380. Although the colours of the remarkable

figure of Christ is the target for a flurry of figures led by the massive Judas threatening almost to overwhelm physically his victim.

The frescoes in the church and narthex in the monastery of Chilandari on Mount Athos are considered by Serbian scholars to be the work of Michael and Eutychios in the early fourteenth century. Very similar work was being undertaken in the Protaton at Kariye and in the

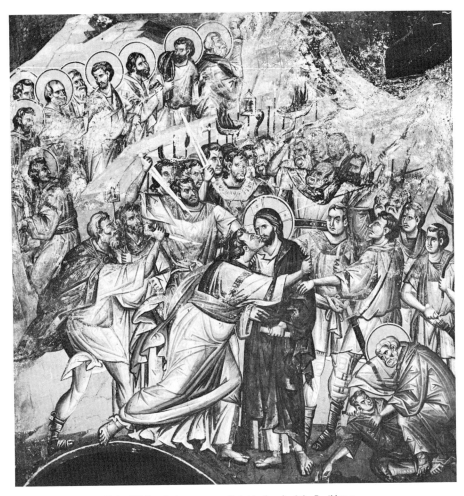

270. The Betrayal of Christ. Wall-painting. *c.* 1295. *Ochrid, church of the Peribleptos*

church at Vatopedi on the Holy Mountain around 1300, and even though 'Astrapas' means 'like lightning', it seems difficult to believe that those particular Greeks worked so fast as to cover all the churches in the area with fresco in the new style. It seems more likely that a team of painters coming from Constantinople or Salonika were working in Macedonia and Chalkidiki. Nevertheless, the names Astrapas

or Michael Astrapas turn up at Arilje in 1296, at Prizren between 1307 and 1309, and about 1310 at Žiča, and there seems every reason to assume that they founded the important Serbian school of King Milutin.[12]

The parecclesion of the Pammakaristos was built against the south wall of the church, probably about 1310, by the widow of Michael Glabas, Maria Dukaena Comnena Palaeologina,

who at the time called herself Martha the nun. The wording of the epigram by Manuel Philes, which still exists on the exterior cornice, suggests that Glabas left military service only to die. His last campaign was in 1306, when he was in his sixties and a martyr to gout, which prevented him from taking an active part in the operations. The epigram of Philes is complemented by another inscription in mosaic round the face of the apse which also refers to Martha the nun who 'set up this thank-offering to God in memory of Michael Glabas her husband, who was a renowned warrior and worthy *proto-strator*'. The perambulatory which enveloped the building on the south, west, and north sides was probably added about the middle of the

fourteenth century and may have had some connexion with the mosaic portraits of the Emperor Andronicus III (1328–41) and his Empress Anna of Savoy, which, extant in the sixteenth century, were placed to the right of one of the outside doors. This perambulatory was added partly for the accommodation of more tombs, and it was done at a time when little importance was attached to the preservation of Philes' epigram – presumably some time after the death of Martha the nun. The beautiful mosaics in full Palaeologue style which decorate the interior of the parecclesion date from her time and tend to follow the Byzantine canon – Christ Pantocrator in the dome surrounded by twelve Prophets – but in the apse Christ Hyperagathos is flanked

in the chancel by the Virgin and St John the Baptist, an unusual form of the Deesis, with four archangels in the vault. In the prothesis another unusual variant from the norm occurs with St James the Brother of the Lord in the apse symbolizing the founding of the Patriarchate of Jerusalem, St Clement representing the see of Rome, and St Metrophanes of Constantinople, the first authenticated bishop of the city during the time of Constantine the Great and representing therefore the Patriarchate of Constantinople. In the diaconicon appear the three great Church Fathers, St Gregory the Theologian in the apse, St Cyril, and St Athanasius. Apart from a number of saints and bishops only one Feast of the Church has survived, the Baptism of Christ to the east of the dome, but it is reasonable to assume that the Dormition occupied the west wall over the door; probably only nine of the usual twelve Feasts were actually represented. A sculptured frieze and cornice – a vine pattern with birds and lions single or in pairs – separates the marble incrustation (which has now disappeared) from the mosaics. A small capital carved with three busts of Apostles, found in the cistern and now in Ayasofya Museum, has been compared to the sculptured archivolt in the south church of the monastery of Constantine Lips, dating from about 1300, and may have come from an iconostasis or a wall-tomb. Although the capital has been claimed as a masterpiece of Late Byzantine sculpture, its quality is not particularly high. A fragment of a marble entablature carved with a bust of a beardless Apostle was found in the inner narthex of the main church and is now in Ayasofya Museum. It may have come from an iconostasis either Comnene or Palaeologue.[13]

Almost contemporary with the decoration of the parecclesion of the Pammakaristos the little church of the Holy Apostles at Salonika was founded, according to the incised monograms, by the Patriarch Niphon (1312-15), and the fragments of mosaics and wall-paintings suggest that the team almost certainly came from Constantinople. In the south barrel-vault the mosaics represent the Nativity [271] and the Baptism of Christ, on the west wall the Transfiguration and the Entry into Jerusalem, on the north barrel-vault the Crucifixion and the Harrowing of Hell [272]. From what remains of the scenes it appears that they are represented with all the dynamism and complexity of the frescoes in the Peribleptos at Ochrid and with all the luminosity and exquisite sense of colour to be found in the Pammakaristos and the church of Christ in Chora. The multiplication of detail and of genre scenes, the intensity of expression, the new sense of form all emerge in delectable miniature and recall the small portable mosaics which had become such a devotional fashion of the period. Fortunately these small panels have survived in some number: at Vatopedi and the Grand Lavra on Mount Athos, on Mount Sinai,

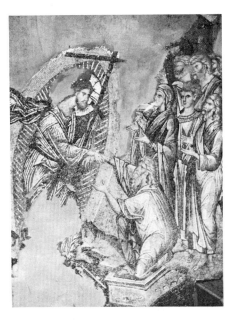

271 and 272. The Nativity (*left*) and the Harrowing of Hell (*right*). Fragments of mosaics. Between 1312 and 1315. *Salonika, church of the Holy Apostles*

on Patmos, in church treasuries in Italy and Belgium, in museums in Russia, Europe, and America. Originally these small mosaics, which are worked in gold, silver, lapis lazuli, and other semi-precious stones, were framed in silver or silver-gilt with enamels and precious stones, but, as the Empire became more impoverished, the icons were eventually stripped of their rich frames. Among the finest of these are the Trans-figuration in the Louvre [273], which in its dovetailing of Comnene and Palaeologue charac-teristics has sometimes led scholars to assign it to an earlier date, the two panels of the Twelve Feasts in the Museo dell'Opera del Duomo in Florence [274], which was given to the church of S. Giovanni in that city in 1394 by a Venetian lady Nicoletta da Grioni, widow of a chamber-lain of the Emperor John VI Cantacuzene (1341–55), an icon of St Demetrius at Sasso-ferrato, and an icon of St John Chrysostom [275] in the Dumbarton Oaks Collection.[14]

The church of the monastery of the Chora stands downhill from the Adrianople Gate at Constantinople and not far from the Theodo-sian walls, which today extend in majestic ruin from the Sea of Marmara to the Golden Horn [59]. Its origins are rooted in the early history of the city. The term Chora suggests that the mon-astery was first founded on a suburban estate, possibly outside the city before the Theodosian walls were built, but it also has a mystical sense particularly current in the fourteenth century to denote an attribute of Christ and the Virgin. Christ is the Chora, the dwelling-place of the living; the Virgin is the Chora, the dwelling-place of the Uncontainable God. This latter meaning is made evident in the church by sev-eral inscriptions dating from the fourteenth century and accompanying mosaic images. The present building incorporates three phases of Byzantine construction: the eleventh, twelfth, and fourteenth centuries. The eleventh-century church was extensively altered about 1120 by Isaac Comnenus, third son of the Emperor Alexius I Comnenus and Irene Dukaena, and grandson of the foundress Maria Dukaena. His

273. The Transfiguration. Miniature mosaic.
Constantinople, late thirteenth or early fourteenth century.
Paris, Musée du Louvre

274 A and B. The Twelve Feasts. Miniature mosaic. Constantinople, early fourteenth century.
Florence, Museo dell'Opera del Duomo

275. St John Chrysostom. Miniature mosaic. Constantinople, early fourteenth century. *Washington, D.C., The Dumbarton Oaks Collection*

portrait survives in mosaic as a commemoration of patrons adoring Christ [276] and the Virgin in the inner narthex of the church with that of Melane, who before she became a nun was known as the Lady of the Mongols, Maria Palaeologina, half-sister of Andronicus II, a

276. Christ and the Virgin adored by Isaac Comnenus and Melane the nun.
Fragments of a mosaic in the inner narthex. *Istanbul, church of Christ in Chora*

natural daughter of Michael VIII. She had also been a patroness of the convent of the Theotokos Panaghiotissa, whose church was known as that of the Theotokos Mongoulion but is better known today as St Mary of the Mongols. Maria Palaeologina was twice betrothed and once married to Mongol Khans, but after her husband's death she returned to Constantinople. In 1307 she was prepared to marry the Khan Harbadan in an attempt to impress the Sultan Osman, who was menacing the city, but the marriage did not take place and she entered a convent. By the beginning of the fourteenth century the church of the Chora had fallen into such disrepair as to render its use a serious danger. In 1275 the monastery had been occupied by the Patriarch John XI Bekkos, probably because of its proximity to the Palace of the Blachernae, and later the Patriarch Athanasius I (1289–93; 1303–9) found it useful to dwell there. The Chora was also near the palace of Theodore Metochites, Logothete of the privy purse, of the general treasury, and finally Grand Logothete to the Emperor Andronicus II. Theodore, the leading statesman of the day, a scholar of many accomplishments, a scientist and a poet, undertook the restoration of the Chora which began about 1315 and was completed by the end of 1320 or early in 1321. His claims as patron of the church are recorded in his poems and in those of his pupil and friend Nicephorus Gregoras, who was to become the opponent and critical historian of the Hesychast Controversy, but in any case the mosaic over the tympanum leading from the inner narthex into the church depicts him wearing the strange costume of his office – he was then Logothete of the general treasury – and kneeling before Christ 'the dwelling-place of the living' [277].

The mosaics and frescoes in the church of the Chora are among the key works of Late Byzantine art. No longer concentrating on the theophanic mysteries, the liturgical feasts, or the invasion of the saints, no longer attempting to subdue the spectator by tremendous majesty and mesmeric glowering, no longer necessarily sublime, the mosaics offer instead with considerable freedom of expression the intimacy of a living faith transfigured by gold and brilliant colour, luminous, exquisite, and serene. On the vaults and lunettes of the exonarthex the mosaics portray a full genealogy of Christ, cycles of His infancy and His ministry, and in the narthex scenes from the life of the Virgin taken from the canonical and the apocryphal Gospels. On the faces and soffits of the arches are figures of saints. In addition, there is a bust of Christ over the entrance door, opposite this lunette another with the Virgin and Child between two angels, the large figures of Christ and the Virgin with vestiges of Isaac Comnenus and Melane the nun, and over the door leading into the naos Theodore Metochites presenting his church to the enthroned Christ. In the catholicon none of the Feasts of the Church has survived with the exception of the Dormition – a beautifully restrained composition without the elaboration of the Peribleptos at Ochrid – in its customary place over the west door. On either side of the chancel there is to the left a large mosaic panel with a standing figure of Christ 'the dwelling-place of the living', and to the right the Theotokos Hodegetria 'the dwelling-place of the Uncontainable'; these flanked the templon or iconostasis, which would also have borne portable icons and had been a common feature of Byzantine churches since Comnene times. Over the Virgin and Child a sculptured tympanum was added later in the century; within the tympanum a bust of Christ Pantocrator is executed in fresco. It seems likely that the stone carving should date from about the same time as the sculpture framing the arcosolia in the parecclesion which, since it cuts into the frescoes, must be of about the middle or the second half of the fourteenth century.

Even in a conventional scene like the Nativity [278] the Palaeologue artists have scaled down the great theme into a graceful idyll in which

277. Theodore Metochites,
Logothete of the Imperial Treasury.
Detail from the mosaic tympanum.
Second decade of the fourteenth century.
Istanbul, church of Christ in Chora

278. The Nativity. Mosaic panel in the narthex. *Istanbul, church of Christ in Chora*

angels, shepherds, and midwives, the denizens of heaven and the denizens of earth, are in colloquy around the central figures. The gold background gives an air of unreality to what is essentially a pastoral scene. This dichotomy between the real and the unreal, the natural and the supernatural, runs through the cycles but is never forced. The platforms, stages, theatrical properties on which or against which the figures are set are in a sense integrated by the universal gold background. Many of the scenes, such as the Enrolment of the Virgin and St Joseph for Taxation, appear to be new to Byzantine art, and of these 'new' scenes one of the most enchanting is the First Seven Steps of the Virgin [279]. Before a simple architectural background topped by two cypresses the Virgin, watched anxiously by a maidservant whose veil makes a great red arch above the Virgin's head, walks

towards St Anne, who is seated. This most human scene is depicted with the utmost tenderness and grace and with those different layers of meaning and memory which were so much appreciated by the Byzantines. The figure of the maid alone with her billowing veil recalls the classical heritage, the Psalters of Constantine VII Porphyrogenitus, the traditions of the Patriarchal Library. At the same time the line, flow, and colour of the veil in contrast with the gold-edged, pale blue robe and the pink and brown wall are sheer visual delight. This is only one small instance of the infinite variety of invention within a firm tradition and the sensuous beauty of the mosaics of the Chora.

279. The First Seven Steps of the Virgin. Mosaic in the narthex. *Istanbul, church of Christ in Chora*

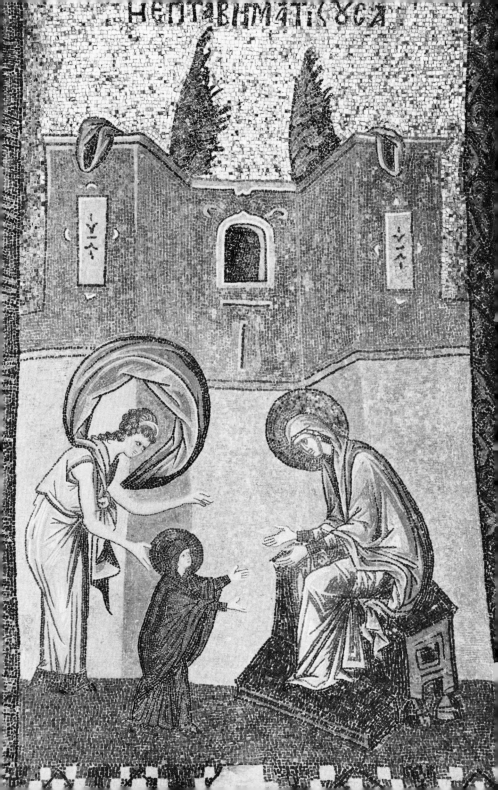

The parecclesion was designed as a mortuary chapel; four flat niches once contained sarcophagi and above them, in the back and on the soffits of the arch, were portraits of the deceased.

On the adjoining domical vault of the eastern bay and its two lunettes unfold the numerous scenes and elements attendant on the Last Judgement [281], again one of the masterpieces

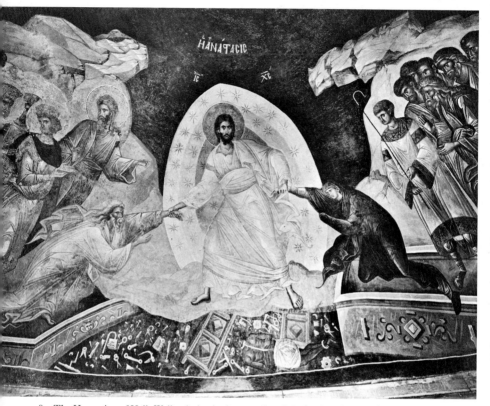

280. The Harrowing of Hell. Wall-painting in the apse. *Istanbul, church of Christ in Chora, parecclesion*

The frescoes are devoted to themes of Resurrection and Judgement, of mortality and salvation, of the importance of the Virgin in the divine plan for man's redemption assisted by the prophets and the saints. The east end of the chapel is dominated by a magnificent Harrowing of Hell [280] in the apse, which must rank as one of the great paintings of all time. On either side of the bema are depicted two resurrection miracles of Christ, the Raising of the Widow's Son and the Raising of the Daughter of Jairus.

of Byzantine painting. The dome above the western bay is assigned to the Virgin – busts of the Virgin and Child are surrounded by angels and in the pendentives four hymnographers, St John of Damascus, St Cosmas the Poet, St Joseph the Poet, and St Theophanes, compose hymns which refer to the Virgin and the funerary nature of the chapel. A large proportion of the western bay is decorated with Old Testament events which are seen as being typological of the Virgin: Jacob's Ladder, the Burning

281. The Last Judgement. Wall-painting in the vault. *Istanbul, church of Christ in Chora, parecclesion*

Bush, the sacred vessels deposited in the Holy of Holies in Solomon's temple, the closed gates of Jerusalem, and the altar of Moses. As it happens the hymns of two of the hymnographers in the pendentives also refer to Jacob's Ladder and to Mary who is the ladder between earth and heaven or the bridge leading all who praise her from death to life. Finally, at the west end of the upper zone, above the main entrance to the chapel, are depicted the Souls of the Righteous in the Hand of God. Among the individual figures on the walls of the chapel there is a series of six Church Fathers and twenty saints and martyrs. Few of the tomb niches can be identified; one in the south wall of the west bay belonged to a member of the Tornikes family. In the outer narthex were buried Irene Raoulina Palaeologina, widow of Constantine Palaeologus (brother of Andronicus II) and mother-in-law of Irene, the daughter of Theodore Metochites, and a certain Demetrius who appears to have been of royal lineage.[15]

Contemporary developments in Serbia followed closely the art of the metropolis. During the reign of King Stephen Uroš II Milutin (1282-1321) Serbian power expanded even farther, the whole of northern Macedonia was occupied, and the discovery of rich silver-mines worked by Germans had considerably increased Serbian resources. Understandably the Byzantine administration accepted with ill grace the occupation of northern Macedonia, and on five occasions Theodore Metochites was sent to the Serbian court in order to reach some agreement on the matter. It was indicative of the basic weakness of the Byzantine Empire that the *fait accompli* had to be accepted. When agreement was reached in 1299 the Emperor Andronicus II gave Milutin his five-year-old daughter Simonis in marriage and recognized the occupied towns, which included Skoplje, as dowry. From this time Milutin's relations with Con-

stantinople began to be cordial, and Byzantine cultural influence became even stronger than before. The architecture of Serbian churches in the early fourteenth century becomes more complicated: high walls with many arches and openings precluded the monumental decoration of the past. The subjects were divided into cycles along horizontal bands, but, as in the past, the liturgical functions of certain parts of the church dictated the choice of subject. Broken spaces, smaller areas, reduced size could be adapted without difficulty to the new intimacy of the Palaeologue style. Between 1306 and 1309 King Milutin rebuilt the church of the Bogorodica Ljeviška at Prizren with five domes, a narthex, and an exonarthex over which was set a bell-tower. The paintings in the narthex are signed by the masters Nikola and Astrapas. The portrait of the founder within the church reveals him in full Byzantine regalia complete with

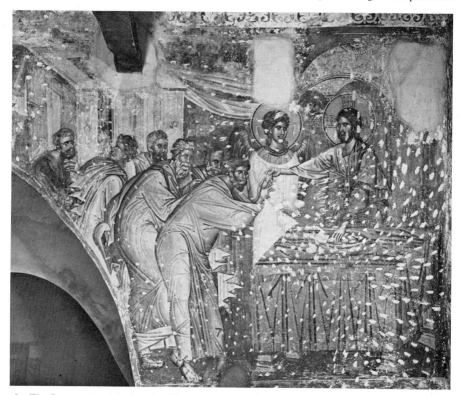

282. The Communion of the Apostles. Wall-painting. Between 1306 and 1309.
Prizren, church of the Bogorodica Ljeviška

283. King Milutin. Wall-painting. 1313–14.
Studenica, King's Church

imperial crown, sceptre, and *akakia*; the downward trend of the brows, eyes, and mouth suggests something of the compressed and reckless energy of the man. The Communion of the Apostles [282] is set before a complex architectural background, and the solid mass of the bowed Apostles contrasts somewhat with the slender forms of Christ and the Angels; drapery is a network of hatched lines; the faces of the Apostles are painted with an approach to realism which is perhaps superficial.

At Studenica the King's Church was founded by Milutin in 1313–14 and dedicated to St Joachim and St Anne. His portrait in the church [283] presents the same figure augustly crowned and vested as at Prizren, but this time he carries a model of the church at Studenica. The frescoes, though not signed, are completely within the tradition of the school and indeed of Palaeologue style. The Nativity of the Virgin, in a

284. The Nativity of the Virgin. Wall-painting.
1313–14. *Studenica, King's Church*

scene more developed than that in the church of the Chora, is represented before an architectural fantasy typical of the Serbian school, and there is considerable incidental detail [284]:

numerous servants attend St Anne, the Virgin is shown on the right in a cot being fanned by a girl while St Joachim stands by apparently deep in conversation with her, and on the left the Virgin is about to have a bath, with the midwife testing the temperature of the water. The frescoes in the little church of St Nicetas at Skoplje were signed by Michael and Eutychios about 1310, and it is believed that the artists moved on from there to Studenica. After that they passed on to the church of St George, Staro Nagoričino, which had been rebuilt 'from the foundations' in 1313, the year of a victory over the Turks. This was painted in 1317. The frescoes comprise scenes from the Passion of Christ and the life of the Virgin in the north chapel, the legends of St George and St Nicholas in the south chapel, and in the narthex the entire calendar of the Church is illustrated. The last church to be signed by Michael and Eutychios is Gračanica in 1321, where Michael painted some of his finest frescoes. The representation of Elijah in the desert is noteworthy not only for his handling of face and form but for the strange stylized landscape in the midst of which Elijah awaits the arrival of the raven. This stylization shows the way to developments at Mistra.[16]

After the death of King Milutin dynastic troubles disturbed the affairs of the realm. Milutin's son Stephen Uroš III (1321–31) finally gained ascendancy and proceeded to support the Byzantine Emperor Andronicus II against his grandson Andronicus III. The latter, on achieving supreme power, immediately formed an alliance with the Bulgars, but at the battle of Velbužd in 1330 the Serbs were victorious and the Bulgar Tsar Michael was slain in flight. In spite of Stephen Uroš III's victory, the Serbian nobles had lost confidence in him. He was deposed and strangled in 1331. His son Stephen Dušan, who was eventually to assume an imperial title, was crowned in his stead. The troubled times did not interfere with royal building schemes. Uroš III founded a church intended to be his mausoleum at Dečani in 1328, but it was not completed until 1335. The Franciscan Vita of Kotor built the church

under the direction of Archbishop Danilo II, and 'pictores graeci' from Kotor undertook the decoration. The painters were inferior to the masters of King Milutin and, although some of the individual scenes have a certain charm – for example, St Philip and Queen Kandakia's eunuch [285] – it must be said that iconography gets the better of art: not only the Genesis, Passion, and Judgement cycles are split into numerous scenes, but the entire calendar of the Church, as at Staro Nagoričino, was relentlessly illustrated. The church of St Nicholas at Psača was built in the time of the Tsar Stephen Dušan shortly before 1358, but the frescoes date from after 1366, when Vukašin was king. The portraits in the church represent the Tsar Stephen Dušan, King Vukašin, the sebastocrator Vlatko and his wife Vladislava, Prince Pasko, Princess Ozra, and Vlatko's son Uglješeva. Vlatko and Pasko hold the model of the church in their hands. These portraits, which have some quality, are an important aspect of medieval Serbian art. At Ravanica the paintings dating from 1376-7 are signed by Constantine. Towards the end of the fourteenth century the school of the Metropolitan John near Prilep returned to a more monumental style based partly on the models of the previous century. There was a return also to brighter and fresher colours and a renewed attempt at psychological penetration in the human portrait. The finest work of the school appears to be in the monastery of St Andrew on the Treska river; the paintings are signed by the Metropolitan John and by Gregory and dated 1389, the year of the decisive battle of Kossovo which finally broke medieval Serbian power. The Metropolitan John also signed and dated to the year 1394 an icon of Christ Saviour and Zoodotes in the monastery of Zrze. At Kalenić a monastery was founded between 1407 and 1413 by the protodoviar Bogdan under the despot Stephen; the founder's portrait appears on the north wall of the narthex. Western influence may be detected in the portrayal of the saints in the narthex, but in the Miracle at Cana [286] in the apse the masters seem still to be working in the Palaeologue idiom: a complex architectural background, an

285. St Philip and Queen Kandakia's eunuch. Wall-painting. Shortly before 1335. *Dečani, church*

286. The Miracle at Cana. Wall-painting. Shortly before 1413. *Kalenić, church*

increase of detail, and marked conversational implications. About the same time, 1407-18, the Despot Stephen Lazarević built the church of Manasija, also called Resava, and here Constantine the philosopher, grammarian, historian, and translator founded a school of literature and orthography which continued in spite of the Turks until the end of the seventeenth century. The Despot Stephen was also a connoisseur and patron of letters. Serbian paintings at this time are considered to be by the school of Morava, which for all its debt to the Byzantine patrimony also showed Western influence from Venice and the Adriatic coast. The system of dividing the frescoes recalls decoration at Ravanica (1377), Sisojevac, and Kalenić. The harmony between architecture and painting is reminiscent of the great schemes of the thirteenth century. Miracles and parables of Christ dominate the choice of subjects, and the lower zone of the choir is occupied almost entirely by warrior saints. The paintings are similar in style to the miniatures of Radoslav, the most important painter of the Morava school, who may have had a hand in the frescoes at Manasija. The representation of the Archangel Michael shows the grave, monumental, well-modelled figure typical of the style. In 1439 Manasija, the last great medieval Serbian monument, was captured by the Turks.[17]

In Bulgaria at Ivanovo, a village in the northern part of the country not far from the Danube, a small church was built in a grotto and decorated with frescoes at the command of the Tsar Ivan Alexander (1331-71), whose portrait figures among them. Because of the size of the church the frescoes are on a miniature scale, but they include thirty Gospel scenes mostly concerned with the Passion of Christ and a number of curious hellenistic elements: caryatids supporting architraves with lions at the base of the columns, half-naked figures emerging from fluttering draperies. The artists came from Tirnovo, but the style is wholly within the Palaeologue tradition. Manuscripts were also produced for the Bulgar Tsar, who was a cultured man with an interest in the arts. A Gospels (British Museum, Curzon MS. 153) contains the portraits of Ivan Alexander (fol. 2 verso), his wife Theodora, their sons Ivan Asen and Ivan Šišman, their daughter (fol. 3), and a son-in-law Constantine; the manuscript was commissioned in 1356. About the same time a Psalter (Moscow, Historical Museum) was executed for the Tsar, and, some years before, the twelfth-century chronicle of Constantine Manasses was translated into Bulgarian (Vatican, cod. slav II) and illustrated. A picture of the death of a son of Ivan Alexander suggests a date about 1345. The illustrations do not spare the feelings of the Bulgars; they even include Basil II's terrible vengeance after 1014, when the Bulgar army was blinded to a man, leaving one in a hundred with a single eye to lead the rest home. St Peter and St Paul at Tirnovo was decorated with frescoes in the fourteenth century, but these have been repainted at a later date. Bulgarian scholars are inclined to date these overpaintings to the succeeding century, but others are more hesitant. With the Turkish conquest of Serbia and Bulgaria many craftsmen fled to Russia, and under Prince Dimitri Donskoy (1359-89) of Moscow that city became the centre of Slav resistance to the Ottoman armies. Following the great battle of Kulikovo in 1380, when the Russian armies inflicted a crushing defeat on the Tartars, the Princes of Moscow began to see themselves as the Christian inheritors of the moribund Byzantine Empire. It is, therefore, not surprising that one of the chief artists working at Moscow in the 1390s should be the Greek Theophanes, who twenty years before had left Constantinople for Novgorod. There he produced the superb though now fragmentary frescoes in the church of the Transfiguration (1378) which astonish us today by their dynamic expression and their extraordinary portraiture. In a sense Theophanes was too personal to be a Byzantine artist. Between 1395 and 1405 he decorated three churches in Moscow: the church of the Nativity of the Virgin, the cathedral of the Archangels, and the cathedral of the Annunciation. None of this decoration has survived. It is known that he worked in conjunction with the Russian master Andrei Rublev (c. 1370-c. 1430), who

must have learned much from the distinguished Greek, although he was never a direct pupil. The last brilliant burst of Byzantine genius was in fact to merge into the local traditions of the Moscow school.[18]

The production of painted icons continued at Constantinople throughout the thirteenth, fourteenth, and fifteenth centuries. Many have survived and may be seen in various monasteries on Mount Athos, Mount Sinai, Patmos, in the monastery of the Transfiguration at Meteora, in the monastery of Vlattadon at Salonika, in the church of St Therapon on Mytilene, in the Byzantine Museum at Athens, in the Macedonian State Collections at Skoplje (many here came from the church of the Peribleptos at Ochrid), in the Hermitage, and isolated icons are scattered in collections in different parts of the world. The quality is far from consistent, nor is it possible to distinguish between poor metropolitan quality and provincial work, but

the rule is: the earlier the better. Thus the magnificent icon of the Annunciation from the church of the Peribleptos at Ochrid seems to be unquestionably metropolitan and to date from the early fourteenth century. In the treatment of form and drapery, in the superb sweeping movement of the Angel towards the Virgin, in its marvellous colour, the icon might well have been painted by one of the masters at work in the church of the Chora. The icons of the Twelve Apostles, of the prophet Elijah, of the Annunciation, of the Dormition, and an exquisite portrayal of the Virgin and Child surrounded by busts of saints, all dating from the first half of the fourteenth century and all in the Hermitage, also seem to be metropolitan work. A singularly beautiful icon of the Crucifixion surrounded by small panels depicting the Twelve Feasts on Mount Sinai bears all the marks of the most refined Palaeologue style. The delicate poignancy of the central theme is gently stressed by the

287. Christ and the Virgin and Child surrounded by busts of saints. Diptych reliquary. Painted wood, metal, enamel, pearls, and precious stones. Constantinople, between 1367 and 1384. *Cuenca, cathedral*

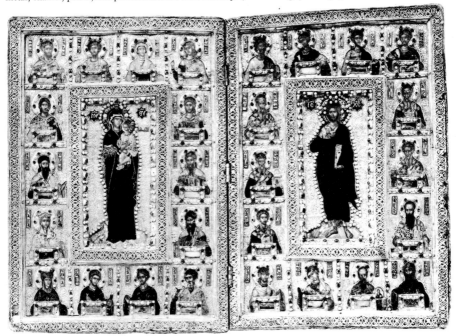

touching reminders of the life of Christ which surround it. In the British Museum an icon painted with four episodes from the Twelve Feasts – the Annunciation, the Nativity, the Baptism, and the Transfiguration – was acquired from a monastery dedicated to the Virgin in the Wadi Natrun in Egypt, and may be compared to similar icons on Mount Sinai and in the Hermitage. No work of high quality was made at St Catherine's Monastery; all the best icons were imported. It is reasonable to suppose, therefore, that these too are metropolitan work dating from the early fourteenth century. A few icons have survived with their metal frames. An icon of the Virgin and Child in the Tretyakov Gallery in Moscow has a silver frame with the portraits in the bottom corners of Constantine Acropolites (d. about 1324), son of the historian George Acropolites (1217–82) – both held office as Grand Logothete – and his wife Maria Comnena Tornikina Acropolitissa, daughter of the Duke of the Thrakesian Theme; their second daughter Eudocia married Michael, the son of the Emperor John II Comnene of Trebizond. The handsome diptych reliquary in Cuenca Cathedral [287] was made for Thomas Preljubović, Despot of Yannina (1367–84), whose portrait is shown at the foot of Christ; the face has been scratched, presumably after his assassination in 1384. The two panels are covered with silver-gilt, incised and embossed, and garnished with innumerable pearls and precious stones. The icon itself is a copy of a diptych (only one leaf has survived) in the monastery of the Transfiguration at Meteora painted for Maria Palaeologina, daughter of Simeon Uroš Palaeologus, who was married in 1359 at Trikkala to Thomas Preljubović. She presented the diptych to the monastery at Meteora because her brother John-Joasaph was the second founder. An icon of the Incredulity of St Thomas in the same monastery also bears the portraits of Thomas Preljubović and Maria Palaeologina. The icon of Christ Pantocrator [288] in the Hermitage dated 1363 carries small portraits of the donors, the Grand Stratopedarch Alexius (only vestiges of the head and headdress have survived), and the Grand Primi-

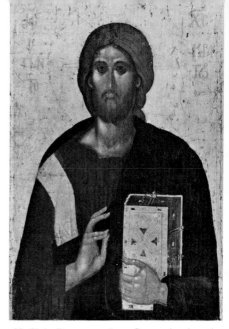

288. Christ Pantocrator. Icon. Constantinople, 1363. *Leningrad, Hermitage*

cerion John, who were the founders of the church of Christ Pantocrator at Constantinople. The mildly benign, slightly vacuous expression of Christ and the modelling of the face by means of fine white lines are characteristic of the art of the period, which was beginning to be affected by the Hesychast Controversy. The diptych painted with busts of the mourning Virgin and the dead Christ – 'the image of pity' – in the monastery of the Transfiguration at Meteora [289], dating from the late fourteenth century, has been related both technically and stylistically to the large portable icon of the Crucifixion in the church of Christ Elkomenos at Monemvasia, produced possibly by an artist who had worked on the decoration of the church of the Peribleptos at Mistra. The Monemvasia icon is believed to have been inspired by the Byzantine Passion play *Christ Suffering*, but in any case 'the image of pity' had become a popular subject at Constantinople from the beginning of the century. A miniature mosaic of the same subject now in S. Croce in Gerusalemme in Rome is certainly metropolitan work. The double-sided icon of Poganovo [290], now in the

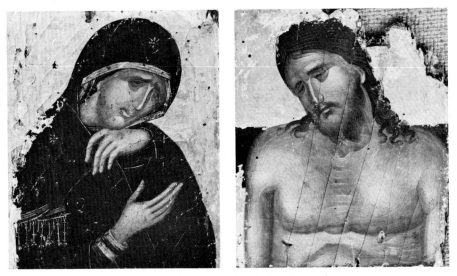

289. The Mourning Virgin and the Dead Christ. Icon-diptych. Late fourteenth century.
Meteora, monastery of the Transfiguration

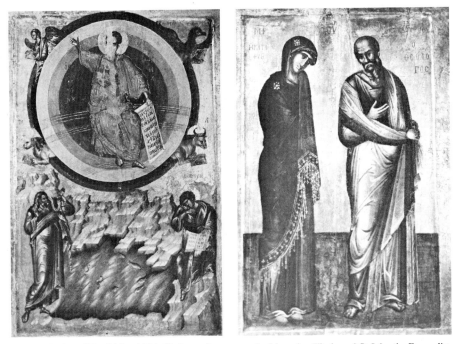

290. The Vision of Ezechiel and Habakkuk; on the reverse, the Mourning Virgin and St John the Evangelist.
Double-sided icon of Poganovo. Probably Salonika, *c.* 1395. *Sofia, Archaeological Museum*

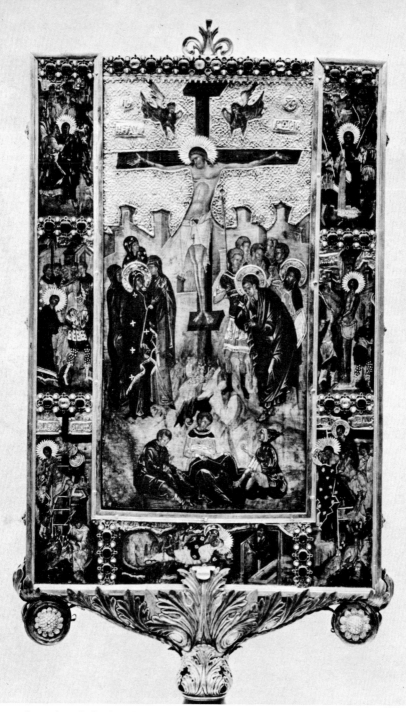

291. Scenes from the Passion of Christ. The Bessarion reliquary.
Painted wood, metal, enamel, and precious stones. Constantinople, late fourteenth or early fifteenth century.
Venice, Galleria dell'Accademia

Archaeological Museum at Sofia, is painted on one side with the Vision of God to the prophets Ezechiel and Habakkuk, and on the other are representations of the mourning Virgin and St John the Evangelist. Greek inscriptions refer to the miracle at Latomos – that is the monastery and church of Hosios David at Salonika – and to the Empress Helena, the wife of the Emperor Manuel II (1391-1425). She was a daughter of a Bulgar or Serbian nobleman from the region of Poganovo and married Manuel in 1391. The icon was probably given to the monastery shortly after October 1395, when her father Constantine Dejanović was killed at Rovina. The Virgin and St John the Evangelist were both patrons of Poganovo. It would appear that the type of the Virgin Kataphuge (the Refuge) is based on a painting in 'the Refuge' beneath the church of the Virgin Acheiropoetis at Salonika; indeed, the icon gave its name to a quarter in the city. Furthermore, the Vision of God on the icon and a similar representation in fresco at Bačkovo (dating from about 1100) depend on the sixth-century mosaic in Hosios David at Salonika, but it has also been suggested that both images may reflect a miniature in an illustrated *Diegesis* of Ignatius, Abbot of the Acapniou Monastery at Salonika, who wrote about the miraculous appearance of the mosaic at Hosios David. All in all, the icon would seem to have been produced at Salonika about 1395. Finally, the handsome Bessarion reliquary [291] contains a silver-gilt cross with Christ on its upper face and the figures of Constantine and Helena in niello on either side with above two angels in repoussé. Among the Greek inscriptions one refers to Irene, the niece of Michael IX Palaeologus (1295-1320), and another to Gregory the Confessor, who is believed to be the Patriarch Gregory III (1443-59). At some time this reliquary was placed in the present wooden case with a sliding cover. The cover and its border are decorated on the outside with painted scenes, the former with the Crucifixion, the latter with seven scenes from the Passion of Christ. The style of these paintings appears to be related to an icon of the

Crucifixion on Patmos and that produced for Maria Palaeologina, wife of Thomas Preljubović, at Meteora, which suggests a date in the second half of the fourteenth century. The reliquary was given by the great scholar Cardinal Bessarion (1403-72) to the Scuola della Carità in Venice in 1463 and is now after various vicissitudes in the Galleria dell'Accademia. A work of delicate beauty, the reliquary is a touching witness to the high standards at Constantinople almost up to the final catastrophe.[19]

Manuscript production also continued, often on a grand scale. The chrysobul addressed in 1301 to the Metropolitan of Monemvasia by the Emperor Andronicus II (1282-1328) bestowing privileges is unusual in that it has at the beginning an impressive portrait of the Emperor [292] holding the document which he has just presented to Christ and standing on a red cushion decorated with double-headed eagles.

292. The Emperor Andronicus II presenting a chrysobul to Christ. Chrysobul, MS. 1 (Index X.A.E. 3750), addressed in 1301 to the Metropolitan of Monemvasia. *Athens, Byzantine Museum*

Another example of the Palaeologue court portrait is to be found in a copy of the works of Hippocrates (Paris, gr. 2144) executed for the Grand Duke Alexis Apocaucos (d. 1345). Curtains are drawn back to reveal the Grand Duke reading the Apophthegms of Hippocrates with an attendant behind him. The hint of life, already noticed in Serbian and Bulgarian frescoes, is given once more, and although to our eyes there seems to be an uncertainty about perspective, the persons of the Grand Duke and his attendant are convincing historical statements. Attractive liturgical manuscripts were also produced in the provinces. A Menologion at Oxford (Bodleian, gr. th. f. 1) containing a calendar for the liturgical year, the Twelve Feasts, and seven scenes from the life of St Demetrius appears from the dedication to have been produced at Salonika between 1322 and 1340 for the Despot Demetrius I Palaeologus. Two artists were responsible for the miniatures and, while they were working in the Palaeologue idiom, it is clear that their standards were not those of the court. The court style continues with the illustrations in the theological works of the Emperor John VI Cantacuzene (1341–55) written after his abdication between 1370 and 1375, during his long life as a monk. In these illustrations there is an interesting dichotomy of style. In the portrait of John as Emperor and as the monk Joasaph [293] a strong naturalistic trend is revealed; the expansive form and the expressive line are more marked than in the portrait of the Grand Duke Alexis, and yet the three angels above, referring to their visit to Abraham and a passage in the Emperor's first Apologia against the Muhammadans which he holds in his left hand, are represented in the characteristic Palaeologue mode. Moreover, the illumination of the Transfiguration in the same manuscript [294] is merely a tenth-century model brought up to date. This multiple aspect of style was never absent in Byzantine art. John VI Cantacuzene was in part responsible for a change of attitude in artistic matters. His support of the Hesychast monks raised into a political issue a matter which had been better left

293. The Emperor John VI Cantacuzene. From a copy of the theological works of the Emperor, MS. gr. 1242, fol. 123 verso. Constantinople, between 1370 and 1375. *Paris, Bibliothèque Nationale*

in decent obscurity on Mount Athos. Hesychasm was a form of quietism involving auto-suggestive practices in an attempt to achieve the vision of the uncreated light of God. From a theological point of view the Hesychasts made the distinction between the divine essence, which no man could see, and the divine energy, which some men through elaborate asceticism could see. From the political point of view Hesychasm represented a reaction of national Greek theology against Western scholasticism; to a man the Hesychasts were anti-Latin. Gregory Palamas (d. about 1360), Bishop of Salonika from 1349, was one of the strongest advocates for Hesychasm and was opposed by Barlaam of Calabria, who came to Constantinople in 1339,

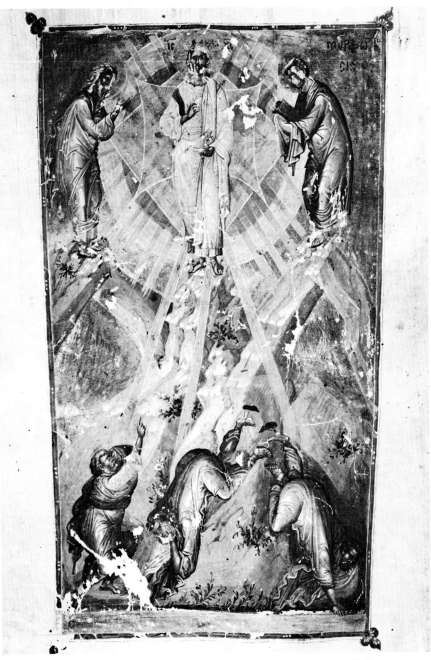

294. The Transfiguration. From a copy of the theological works of the Emperor John VI Cantacuzene, MS. gr. 1242, fol. 92 verso. Constantinople, between 1370 and 1375. *Paris, Bibliothèque Nationale*

during the reign of Andronicus III (1328-41). Barlaam was particularly scathing about the monks' pseudo-mystical practices, which he labelled 'omphalopsychia'. Nicephorus Gregoras (d. after 1339), the friend of Theodore Metochites, was also a keen opponent. Generally speaking, the court party of the Palaeologues, who were deeply concerned over the union with Rome, were as a rule anti-Hesychast, an attitude entangled by dynastic rivalry, since the usurping Cantacuzene led the opposite party. Although John VI was deposed, his support and his presence on Mount Athos meant that in fact the reactionary element in the Greek Church won the day. By the end of the fourteenth century Hesychasm had become a dogma of Orthodoxy. As a result all 'humanist' elements in religious art were frowned upon, and one rich vein of the Palaeologue style was permanently sealed. Although the portrait of the Emperor Manuel II Palaeologus (1391-1425) in the copy of his funeral oration for his brother Theodore, Despot of the Morea (d. 1407), carries on to some extent the 'naturalistic' idiom, there is a strong backward trend in the court portraits in a copy of the works of St Denys the Areopagite produced between 1401 and 1408. The forms have returned to a flat pattern, and even the busts of the Virgin and Child above seem etiolated and mere transcripts of Divinity. Once the return to this convention had been made, the artists could still evolve a beautiful image. The Lincoln College Typicon, a monastic rule of the Convent of Our Lady of Good Hope at Constantinople, preceded by a preface of the foundress Euphrosyne Comnena Dukaena Palaeologina, grand-niece of the Emperor Michael VIII, contains nine double portraits of the foundress, her parents, and other members of her family, a representation of the Virgin, and one of the monastic community [295]. The portraits date from the period around the middle of the fourteenth century, and against a golden ground one brilliant apparition follows another. Stiffly they stand and gesture, encased in the heavy brocades and diadems of their rank, their faces gravely demanding to be recognized. The court portrait of the eleventh century might have been set down the day before.[20]

295. The nuns of the Convent of Our Lady of Good Hope at Constantinople. From a Typicon of the Convent. Mid fourteenth century. *Oxford, Lincoln College*

296. The Calling of the Chosen. Front of the so-called Dalmatic of Charlemagne, in fact a patriarchal *sakkos* of the mid fourteenth century. Gold, silver, and silk embroidery on a silk ground. *Rome, St Peter's, treasury*

A few vestments and embroidered cloths have survived from the last phase of the Empire. The patriarchal *sakkos* in the Vatican, commonly known as the Dalmatic of Charlemagne, is a magnificent example of ecclesiastical embroidery dating from the middle of the fourteenth century. The theme of the vestment is Salvation. On the front [296], the Calling of the Chosen is represented with Christ Emmanuel enthroned between the Virgin and St John the Baptist and a crowd of angels; below, the Chosen offer their liturgy of praise. Christ is designated the Resurrection and the Life, and in His hands the open Gospel reads 'Come ye blessed of my Father, inherit the kingdom prepared for you' (Matthew xxv:34). In the lower

297. The Transfiguration. Back of the *sakkos* of illustration 296

corners Abraham and the Good Shepherd are placed outside the main scene. On the back [297] the Transfiguration follows twelfth-century commentaries on the Gospel texts which analysed the separate reactions of the Apostles; included in this scene are small vignettes of Christ leading the Apostles up and down the mountain. On the shoulders of the vestment the Communion of the Apostles is represented, alluding to the Eucharist, which provides the way to Salvation. The *sakkos* is embroidered in gold and silver with a little colour on a dark blue silk ground. The closed and open compositions are worked out with great elegance and grace, and the figure style is one of the finest aspects of Palaeologue art.

298. The Crucifixion and the Harrowing of Hell. Front of the 'little' *sakkos*
of the Metropolitan Photius of Moscow (1408-32). Gold, silver, and silk embroidery on silk.
Constantinople, early fifteenth century. *Moscow, Kremlin Armoury*

Two other splendid vestments are connected
with the Metropolitan Photius of Moscow
(1408-32). The 'little' *sakkos* is traditionally
believed to have been sent from Constantinople
to Moscow for the ceremonies in connexion
with the canonization of Peter, the first Metro-
politan of Moscow, in 1339, whose portrait is
included among the Hierarchs in the vertical

borders. The centre of the front [298] is em-
broidered in gold, silver, and coloured silk with
the Crucifixion and the Harrowing of Hell en-
closed within crosses; the centre of the back
bears the Transfiguration and the Ascension
also enclosed within crosses. The crosses are
flanked by full-length figures of the prophets,
at the sides are saints, and in the intervening

spaces is the Nicene Creed. On the shoulders appear the Entry into Jerusalem and Pentecost, and the Raising of Lazarus and the young Christ between Constantine and Helena. These sides have been repaired with embroidered bands containing framed Arabic inscriptions quoting texts from the Koran; the sleeves and the ornamentation with pearls are of later date. It has been argued that the 'little' *sakkos* is in fact contemporary with the 'large' *sakkos* of Photius which has embroidered portraits of Vasily Dimitrievich, Grand Prince of Moscow, and his wife Sophia Vitovtovna, with accompanying inscriptions in Russian, and the future Emperor John VIII Palaeologus and his wife Anna Vasilyevna with inscriptions in Greek. Beside John is the portrait of Photius with a Greek inscription 'Metropolitan of Kiev and all Russia, Photius'. The *sakkos* must have been sent to Moscow as a present between the time of John's marriage in 1416 and Anna Vasil-yevna's death in 1418. Once again the Feasts of the Church are embroidered in gold, silver, and coloured silks with both figures and scenes outlined with pearls, the Nicene Creed, a few scenes from the Old Testament – the Sacrifice and Hospitality of Abraham, Jacob's Ladder – and in deference to the Lithuanian Princess Sophia Vitovtovna, among the saints three Lithuanian martyrs. Borders of circles and crosses in seed pearls have been added at a later date.

Among other types of liturgical vestments surviving from the last phase of the Empire the most important are the *epitaphioi*. Indeed, in view of the imminent demise of the Empire it is meet and just that those equivalents to a pall or shroud should still exist. During the Orthodox liturgy for Holy Week the *epitaphios* was used on Good Friday and Easter Eve to cover the ceremonial bier of Christ. The dead Christ is embroidered or painted on it, and the image was venerated by the faithful. During the four-teenth century the *epitaphios* was carried on the heads of the clergy during the Grand Entry, and the scene is illustrated in the representation of the Eucharist in the apse of some of the churches of the period. The two earliest known are one which belonged to the church of the

Peribleptos at Ochrid and bore the name of Andronicus Palaeologus, presumably Androni-cus II (1282-1328) – since 1918 its whereabouts has been unknown; the other was the gift of King Milutin (1282-1321) to an unknown church and is now in the Museum of the Ser-bian Orthodox Church at Belgrade. The Slav-onic inscription reads 'Remember, Lord, the soul of Thy servant Milutin Uroš', which suggests that Milutin was already dead. The embroidered figure of Christ [299] in gold thread on a dark red ground is intended to be

299. The Dead Christ. *Epitaphios* of King Milutin.
Gold embroidery on a silk ground.
Early fourteenth century.
Belgrade, Museum of the Serbian Orthodox Church

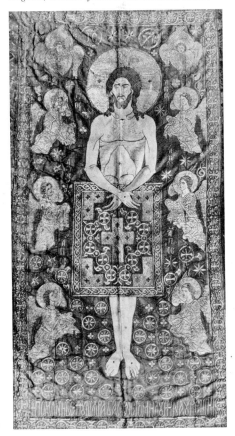

seen vertically instead of horizontally, is ritually covered with an *aër* or chalice veil, and is surrounded by two cherubim and six angels interspersed with the thrice repeated 'Hagios'.

The *epitaphios* of Milutin is the most severely liturgical of all the existing shrouds. The finest of all, however, is the *epitaphios* discovered in the modern church of the Panagia of Panagouda at Salonika and now in the Byzantine Museum at Athens. There are no inscriptions and no indications whether Salonika or Constantinople was the place of workmanship, but there is general agreement that the shroud dates from the fourteenth century. The Body of Christ with attendant heavenly powers and the Evangelists

form a central section [300] flanked on either side by panels depicting the Communion of the Apostles in each kind. Thus, the element of mourning is connected with the sacrament of the Eucharist. Embroidered almost entirely in gold and silver thread with a little blue silk, the *epitaphios* is one of the masterpieces of Byzantine art. Technically superb, visually astonishing, the design is executed in the finest traditions of the Palaeologue style by which the themes of praise, deep emotion at the sufferings of the Saviour, and the full intentions of the Divine Liturgy are most gloriously realized. Other *epitaphioi* have survived in Wallachia, Moldavia, and Roumania. One in the Victoria

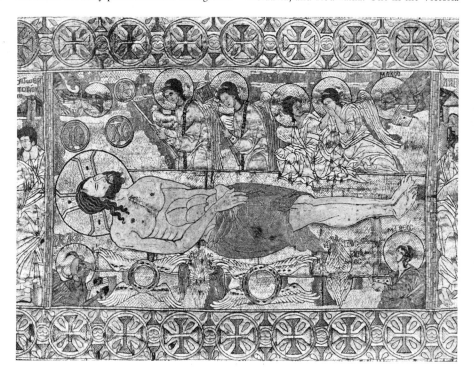

300. The Dead Christ.
Detail from the Salonika *epitaphios*.
Gold, silver, and silk embroidery on silk.
Fourteenth century. *Athens, Byzantine Museum*

and Albert Museum, dated to the year 1407, refers to Nicholas Eudaimonioannes and his family, who as archons of Monemvasia held a prominent place in the history of the Morea until the final capitulation to the Turks. But

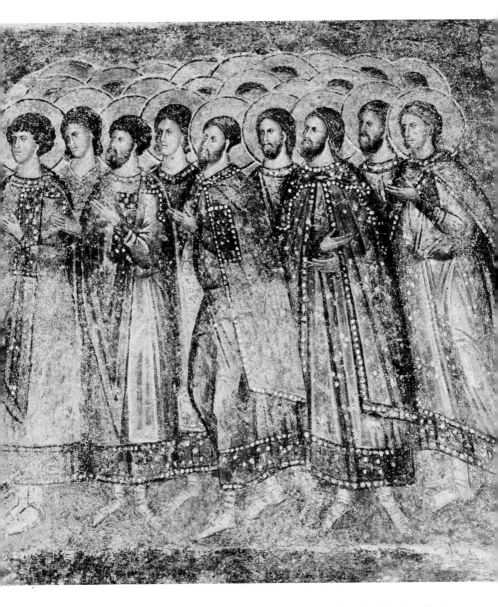

301. Procession of Martyrs.
Wall-painting. Mid fourteenth century.
Mistra, Brontocheion (Afendiko)

none can compare in quality of style and technique with the *epitaphios* from Salonika.[21]

The last stage is at hand. Mistra with its high citadel and its little churches and monasteries became the centre of the final flowering of the

Byzantine genius and for a few years was to survive even the fall of Constantinople. Mistra had been built by Guillaume de Villehardouin, Prince of Achaea, who had married *en troisième noces* in 1258 Anna Comnena Dukaena, daughter of the Despot Michael II Angelus of Epirus. The marriage involved him in the conflict between Epirus and Nicaea, and in 1259 he was captured in battle on the plains of Pelagonia. After more than two years' captivity he gained his freedom by surrendering the three great fortresses of the Morea – Mistra, Maina, and Monemvasia – to Michael VIII Palaeologus, who was then master of Constantinople. The acquisition of these fortresses had considerable consequences. In 1348 a Greek Despot was established at Mistra in the person of Manuel Cantacuzene (d. 1380), son of the Emperor John VI, and from this time the town tended to be the normal place of residence for the future successor to the throne of the Augusti and, conversely, a place of retirement for unsuccessful politicians. Even before the final collapse there was a resurgence of intellectual life. George Gemistus Pletho dreamed of a Utopia at Mistra, drafted a new constitution for it based on Plato's *Republic*, and spoke of a regenerated Sparta. He was an impressive figure at the Council of Florence in 1439, and Italian humanists were overwhelmed by his scholarship. Mistra is now a beautiful crumbling ruin looking over the vale of Sparta, but many of the little churches still stand: the convent of the Holy Theodores founded by the protosynkellos Pachomius before 1296, the Brontocheion (Afendiko) founded by the same man before 1310, the Metropolis built in the same year by the Metropolitan Nicephorus Moschopoulos and transformed by the Metropolitan Matthew at an unknown date, Hagia Sophia built by the Despot Manuel Cantacuzene about 1350, the church of the Peribleptos built in the second half of the fourteenth century, and the Pantanassa built by John Frangopoulos protostrator possibly in 1428 and certainly before 1445. Many of these churches have vestiges of wall-paintings. The Procession of Martyrs in the Brontocheion [301], dating

from about the middle of the fourteenth century, is painted with a kind of aristocratic finesse, elegant, lofty, and rich in colour. Scenes tend to telescope into each other in a galaxy of animated figures. In the representation of the Nativity in the Peribleptos painted about 1400 a new stage was reached. In a strange, jagged landscape [302] the slight dark blue form of the Virgin sleeps beside her Child, oblivious of the joyous salutations of angels, shepherds, and Magi, the ministrations of midwives, the seated Joseph. The light of romantic pathos had been kindled – so soon to be snuffed out. Indeed, one of the most beautiful of the paintings in the Pantanassa executed before the fall of the imperial city is the Raising of Lazarus [303], evoked in a quintessence of Palaeologue style full of light and fervour.[22]

Strangest of all, almost on the eve of the Turkish Conquest a new aspect of Byzantine art comes to light in the city itself. In one of the arcosolia in the exonarthex of the church in Chora the remains of a tomb painting reveals the deceased, probably a woman, standing alone before the Virgin and Child. The Virgin is shown in three-quarter view [304] and is on the same scale as the woman with whom she appears to be conversing. This extraordinary scene is unique in Byzantine art. Never before had a human being, however exalted in rank or sanctity, been represented in colloquy with Divinity in this manner. Also for the first time fixed rules of perspective appear to be applied. The woman stands on a marble floor, of which the front edge becomes part of the frame of the picture. Her dress, made of an Italian silk tissue or velvet, falls in thick, natural folds. The Virgin sits on a chair, her feet on a footstool, of which the angels seem to be visually 'correct'. The treatment of form beneath the drapery and the stiff folds of the drapery itself are a new departure. There can be little doubt that the artist had studied the art of the Italian Renaissance and had profited by it. In spite of Hesychasm, in spite of the Greek contempt for the Latins, in spite of the fact that the death rattle of the metropolis had already begun, the Byzantine

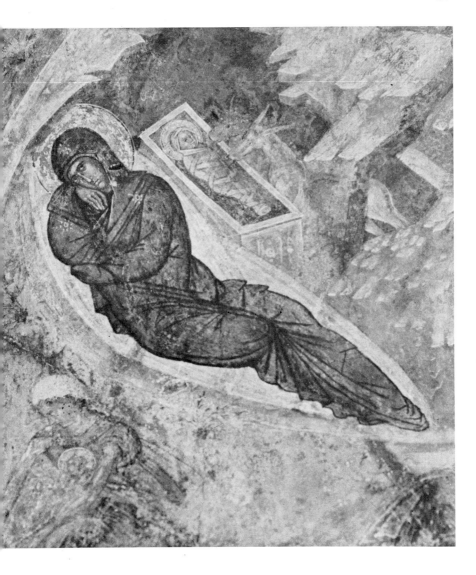

302. The Nativity. Wall-painting. *c.* 1400. *Mistra, church of the Peribleptos*

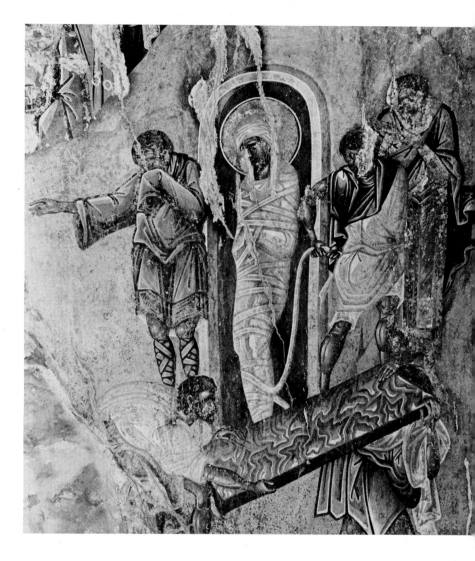

303. The Raising of Lazarus. Wall-painting. Second quarter of the fifteenth century.
Mistra, Pantanassa

304. The Virgin and Child and a Woman.
Fragment of a wall-painting.
Mid fifteenth century.
Istanbul, church of Christ in Chora, parecclesion

artist with the sound of Turkish cannon outside the walls was prepared to start a wholly new phase in the artistic history of the Empire. But it was too late. Many times before the Byzantine Empire had been reduced to the walls of the city, and always there had been hope in God's purpose, in the wonder-working icons of the Virgin, in the imperial mystique. This time, on the last night when the Emperor Constantine XI received Holy Communion and begged for-

giveness of his court and his citizens, it must have seemed to many that Extreme Unction was being administered to the city. In a matter of hours the brave man was to die at the Gate of St Romanus. Within those same hours the Empire of the Ottoman Turks, which already stretched from Mesopotamia to the shores of the Adriatic Sea, gained at last its capital, bell-haunted, gong-sounding, prayer-murmuring Istanbul.[23]

EPILOGUE

In the early part of this century it was still possible for a great Byzantine art-historian and archaeologist to write of his subject that in its fidelity to sacrosanct tradition Byzantine art is not without analogy to that of ancient Egypt. It had infinite decorative charm, but it grew languid for want of living ideas; it too readily abandoned initiative to live content in 'the narrow proficiency of perpetual iteration'. The general trend of this century's studies has been to demonstrate that such strictures are unwarranted. The rediscovery of mosaics and frescoes in various parts of Istanbul, excavations and the uncovering of treasure in Russia, Asia Minor, Syria, and Greece, the reappraisal of frescoes and mosaics in Macedonia, the Peloponnese, Serbia, Bulgaria, and South Russia, the renewed study of manuscript illuminations, icons, carvings in ivory, vessels of silver, gold, and enamel, and last but not least the study of texts have produced a new 'mosaic' of Byzantine art-history. These discoveries and reappraisals are by no means concluded; hardly a year goes by without some new fact, some new architectural or artistic detail, some new interpretation being aired or brought to light. Byzantine art was monumental, kaleidoscopic, constantly open to fashion, energizing and far-reaching. Already in the thirties such intimations had broken through the Celtic twilight of Yeats's poetry.

> Astraddle on the dolphin's mire and blood,
> Spirit after spirit! The smithies break the flood,
> The golden smithies of the Emperor!
> Marbles of the dancing floor
> Break bitter furies of complexity,
> Those images that yet
> Fresh images beget,
> That dolphin-torn, that gong-tormented sea.[1]

There was, of course, a recurrent taste for classical allusion, a recurrent awareness of the Greco-Roman inheritance. Princess Anna Comnena was not alone in this awareness, and her reactions to beauty and intellect are typical of the Byzantine administrative class. In many ways the reactions were quite mathematical, with a constant stress on exact symmetry, harmony, *eurhythmos*, and balanced movements. The Byzantines had an absorbed interest in optics – another subject of interest to Princess Anna – which led not only to experiments in perspective but to a concentration on light, conceived as itself incorporeal, though finding expression in contrasting colours. They believed in the existence of an invisible world of which the material is the shadow – so that an image presupposes the Image just as a shadow presupposes the human body that casts it, and is closely linked with it. Above all, Byzantine art was an expression of the divine and the imperial liturgy conceived as a sacred drama. The drama was enacted before the altar of God, the throne of the Emperor, before the *kathisma* in the Hippodrome, sometimes in the streets, to which all contributed, from the chants of the factions and the gestures of the Augusti to the glinting icons of Christ and the saints. Liturgy must have a worthy background and worthy properties; certain things had to be seen from a great distance, bathed in light, light-reflecting; others had to be seen near at hand, in movement, confounding in mechanism, rich to the sight and touch. Therefore, harmony, proportions, and colour conceived as light materialized were essential. There was a zest for tactile things: for rare marbles and precious stones, for gold and enamel, for ivory and silk. Like a Greek peasant today, the Byzantines cared to stroke works of art. Magic was also present. If an ancient statue happened to resemble an unpopular minister,

the people were apt to take vengeance on the statue; or in the case of the Emperor Alexander, a work of art might be restored in the hope of regaining health and potency. Byzantine descriptions and panegyrics of buildings emphasize repeatedly that the eyes should not rest on the decoration but should wander. The Byzantines could never have been satisfied with any system of perspective which presupposes that the human eye is a flat object gazing immobile at a vertical plane. When the Patriarch Photius describes the ninth-century church of the Nea, details of craftsmanship are highly praised and there is a recurrent emphasis on the eyes. For him there were three elements of aesthetic appreciation: joy, wonder, and an inner turmoil. The thirty gold crowns with their pendant jewels hung round the altar of Hagia Sophia must always have been in gentle motion. The patterns on some of the finest Byzantine silks could only be seen when the wearer moved.[2]

The Byzantines were interested in hidden meaning: the scriptural scene which contained two or more meanings for the initiated; a classical quotation whether in art or in literature bringing with it a cluster of associated images, memories, sometimes quite tangential. There was always a sharp contrast in the Byzantine world between the status of the scholar and that of the artist. There was no cult for the personality of the artist as in modern times. The artist was a craftsman who worked by contract on materials provided for him by his employer; if he broke the contract he could be 'brought to reason by flogging, mutilation and deportation', according to the Book of the Eparch dating probably from the reign of the Emperor Leo VI (886–912). The scholar was the élite. The remarkable civil service was a career open throughout Byzantine history to all the talents according to the degree of knowledge of good letters possessed by the candidates for office. The history of Byzantine art is, it has been suggested, unintelligible if the tastes of the civil service are ignored. But these tastes are far from easy to diagnose. Throughout nearly a thousand years of Byzantine history little is known about secular

decoration. It has been pointed out that as late as the fourteenth and fifteenth centuries Byzantine schoolboys learnt their grammar, their rhetoric, and their logic from textbooks of the fourth century, that Byzantine literature, both highbrow and lowbrow, merely continued the forms which had been elaborated by the sixth century, that Church homiletics never departed from the exemplars that had been set by the Fathers in the fourth century, except in the direction of greater obscurity, that even when the Byzantine intellectual went a-whoring after pagan philosophy, it was not Plato but the Neo-Platonists and especially Proclus that fascinated him most. Thus speaks an *advocatus diaboli*. Plotinus, one of the greatest of the Neo-Platonists, is seldom quoted by the Byzantines, but it seems difficult to believe that they did not know his works; perhaps he was too direct, writing in too simple a style for them to appreciate or to admire. They liked a showy, rather complicated style which succeeding scholars have found intolerable. And yet some of the histories and memoirs are written in a remarkably clear, lucid, 'up-to-date' manner – Constantine VII's minute to his son Romanus on the governing of the Empire, Michael Psellus's crisp and witty memoirs; even Princess Anna, who liked a fine turn of phrase, could be sharp and direct. Byzantine philosophy was always synthetic, and much of its originality was hidden in commentary; Byzantine aesthetic criticism, such as it was, was always opaque. Many of the poems and epigrams referring to works of art may be dismissed as clichés by which the scholar displayed his learning. And yet for all the frozen 'good taste' of the literature, for all the strange preoccupation with the magic of numbers and their proportion in a multiple diversity of harmony, the arts soared time and again to produce an ineffable expression of religious belief. Even when the artists worked outside the Empire, away from the supervision of the civil and ecclesiastical administration, they were capable of adjusting their forms to meet the needs and tastes of their patrons, whether at Kiev, Palermo, or Sopoćani.[3]

Unfortunately Byzantine art may never be seen as it was meant to be seen – a totality of aesthetic experience. The Augusti, the court, the imperial and patriarchal processions, the hymns and chants, the great diadems and robes, the high cosmetics and the heavy scents, the multiplicity of races, the great dromons breathing Greek fire, the imperial barge glittering with gold and purple, the eunuchs, secretaries, generals, admirals in the different costume of their rank are no more than a dream on a summer's day. We are left with a few odds and ends, here a great church in a state of decay, there fragments of mosaic and wall-painting, a few manuscripts, icons, carvings in ivory, an occasional jewel. But from these *disiecta membra* something may be perceived: a serene, austere expression of religious dogma and imperial power, a concept of the Godhead which was never cheap, sentimental, nor tawdry, an unabashed love for magnificence, for splendour, and for high estate, and shafts of Beauty conceived and apprehended through the senses by Mind.[4]

LIST OF THE PRINCIPAL ABBREVIATIONS

Arch.	*Archaeological, Archäologische,* etc.
Bull.	*Bulletin*
Byz.	*Byzantine, Byzantinische,* etc.
C. Arch.	*Cahiers archéologiques*
Corso (1956) etc.	Bologna University, *Corsi di cultura sull'arte ravennate e bizantina,* 1–, 1956–
D.O.P.	*Dumbarton Oaks Papers*
J.	*Jahrbuch, Journal,* etc.
Z.	*Zeitschrift*

NOTES

Bold numbers indicate page references

CHAPTER 1

13. 1. Gregory Dix, *The Shape of the Liturgy* (London, 1943), 16 ff.; F. E. Warren, *The Liturgy and Ritual of the Ante-Nicene Church* (London, 1912), 191 ff.; J. G. Davies, *The Early Christian Church* (London, 1965); J. Danielou and H. Morrou, *The Christian Centuries*, I, *The First Six Hundred Years* (London, 1964); J. Gutmann, 'The Origin of the Synagogue. The Current State of Research', *Arch. Anzeiger*, LXXXVII (1972), 36 ff.; G. T. Armstrong, 'Constantine's Churches', *Gesta*, VI (1967), 1 ff.; J. M. C. Toynbee, *Death and Burial in the Roman World* (London, 1971); G. H. Halsberghe, *The Cult of Sol Invictus* (Leyden-Brill, 1972).

2. H. J. Lawlor and J. E. Oulton, Eusebius, *The Ecclesiastical History* (London, 1932), and cf. G. A. Williamson's new translation published in Penguin Classics, 1965; Edmund Bishop, *Liturgica Historica* (Oxford, 1918), 39 ff.; Warren, *op. cit.*, 94 ff.

14. 3. The quotation from Minucius Felix: *Octavius*, Cap. XXV, *Patrologia Latina*, tom. iii, col. 339.

Dix, *op. cit.*, 36 ff.; Warren, *op. cit.*, 68 ff.; Bishop, *op. cit.*, 20 ff.; J. Toynbee and J. B. Ward-Perkins, *The Shrine of St Peter* (London, 1956), 208.

4. The quotation from St Cyprian: Ep. 70, *ad Januarium*, *Opera*, ed. Baluz (Paris, 1726), 125.

C. Hopkins, 'The Christian Church', *Excavations at Dura Europos, 5th Season, 1931–1932* (Yale University Press, 1943), 249 ff., and cf. *The Final Report*, VIII, pt II (ed. C. Bradford Welles) (New Haven, 1967), 102 ff.; J. L. Maier, *Le Baptistère de Naples et ses mosaïques: étude historique et iconographique* (Fribourg, 1964), 11, note 5; Warren, *op. cit.*, 117 ff.; A. Grabar, 'Les Sujets bibliques au service de l'iconographie', *Spoleto, Centro italiano di studi sull'arte medio evo, Settimane*, X, 387 ff.

15. 5. Warren, *op. cit.*, 189 ff.; Dix, *op. cit.*, 29 ff.

16. 6. A. H. M. Jones, 'The Social Background of the Struggle between Paganism and Christianity', in A. Momigliano (ed.), *The Conflict between Paganism and Christianity in the Fourth Century* (Oxford, 1963), 17, 37; H. von Campenhausen, *The Fathers of the Greek Church* (London, 1963); H. I. Marrou, 'Synesius of Cyrene and Alexandrian Neoplatonism', *Conflict between Paganism and Christianity*, 143–4; F. J. E.

Raby, *Secular Latin Poetry*, I, 2nd ed. (Oxford, 1957), 48.

7. G. Bovini, 'Catacombs', *Encyclopaedia of World Art*, III, 143 ff.; P. A. Février, 'Études sur les catacombes romains', *C. Arch.*, XI (1960), 9–10; H. Stern, 'Orphée dans l'art paléochrétien', *C. Arch.*, XXIII (1974), 1 ff.

17. 8. Eusebius, *Ecclesiastical History, passim*; P. Courcelle, 'Anti-Christian Arguments and Christian Platonism: from Arnobius to St Ambrose', in *Conflict between Paganism and Christianity*, 151; *idem, Histoire littéraire des grandes invasions germaniques* (Paris, 1948), 9; E. R. Dodds, *Pagan and Christian in an Age of Anxiety* (Cambridge University Press, 1965), especially chapter 4.

9. The quotations from Eusebius: *Vita Constantini*, iv. 15; *ibid.*, iii. 10.3.

K. M. Setton, *Christian Attitude towards the Emperor in the Fourth Century* (Columbia University Press, 1941), *passim*: H. von Campenhausen, *The Fathers of the Latin Church* (London, 1964), 87 ff.

10. K. M. Setton, *op. cit.*, 29; P. Courcelle, in *Conflict Between Paganism and Christianity*, 165; I. A. Richmond, *Archaeology, and the After-Life in Pagan and Christian Imagery* (Oxford University Press, 1950), 53.

18. 11. K. J. von Hefele and H. Leclercq, *Histoires des Conciles* (Paris, 1907–); von Campenhausen, *Fathers of the Greek Church* (*op. cit.*); Pierre Courcelle, *Les Lettres grecques en Occident de Macrobe à Cassiodore* (Écoles françaises d'Athènes et de Rome, Paris, 1943).

CHAPTER 2

19. 1. J. M. C. Toynbee, 'The Shrine of St Peter and its Setting', *J. of Roman Studies*, XLII–XLIII (1952–3), 1 ff.; J. B. Ward-Perkins, 'The Shrine of St Peter and its Twelve Spiral Columns', *ibid.*, 21 ff.; J. Toynbee and J. Ward-Perkins, *The Shrine of St Peter and the Vatican Excavations* (London, 1956), 72 ff., 116 ff.; O. Perler, *Die Mosaiken der Juliergruft im Vatikan (Freiburger Universitätsreden*, N. F. XVI) (1953); E. Kirschbaum, S.J., *The Tombs of St Peter and St Paul* (London, 1959).

24. 2. The *commendatio animae* is to be found in *Rit. Rom.*, tit. 5, cap. 7.

G. B. de Rossi, *La Roma sotterranea cristiana* (Rome, 1964); J. Wilpert, *Roma sotterranea, die Malereien der Katakomben Roms* (Freiburg-im-Breisgau, 1903); idem, *Die römischen Mosaiken und Malereien der kirchlichen Bauten vom IV. bis XIII. Jahrhundert*, 4 vols, 2nd ed. (Freiburg-im-Breisgau, 1917); P. Styger, *Die römischen Katakomben* (Berlin, 1933); O. Marucchi, *Le Catacombe romane* (Rome, 1933); F. Wirth, *Römische Wandmalerei vom Untergang Pompejis bis zum Ende des dritten Jahrhunderts* (Berlin, 1934); J. de Wit, *Spätrömische Bildnismalerei* (Berlin, 1938); G. Bovini, 'Monumenti tipici del linguaggio figurativo della pittura cimiteriale d'età paleocristiana', *Corso* (1957), I, 9 ff.; P. A. Février, 'Études sur les catacombes romaines', *C. Arch.*, X (1959), I ff., XI (1960), I ff.; A. Ferrua, S.J., *Le Pitture della nuova catacomba di Via Latina (Monumenti di antichità cristiana*, 2nd series, VIII) (Pontificio di Archeologia cristiana, Città del Vaticano, 1960); and cf. important reviews of this last book: E. R. Goodenough, in *J. of Biblical Literature*, LXXXI (1962), 113 ff.; J. M. C. Toynbee, in *J. of Roman Studies*, LII (1962), 256 ff.; Th. Klauser, in *J. für Antike und Christentum*, V (1962), 177 ff.

Cf. also Th. Klauser, 'Studien zur Entstehungsgeschichte der christlichen Kunst', *J. für Antike und Christentum*, I (1958), 20 ff., II (1959), 115 ff., III (1960), 112 ff., IV (1961), 128 ff., V (1962), 113 ff., VI (1963), 71 ff.; L. Eizenhöfer, 'Die Siegelbildvorschläge des Clemens von Alexandrien und die älteste christliche Literatur', *ibid.*, III (1960), 51 ff.; E. Stommel, 'Zum Probleme der frühchristlichen Jonas darstellungen', *ibid.*, I (1958), 112 ff.

26. 3. F. Fremersdorf, 'Ein bisher verkanntes . . . in der römischen Abteilung des Wallraf-Richartz-Museum, Köln', *Wallraf-Richartz J.*, N.F. I (1930), 282 ff.; C. R. Morey and G. Ferrari, *The Gold Glass Collection of the Vatican Library* (Città del Vaticano, 1959), with bibliography; J. E. Crome, 'Due Medaglioni di vetro dorato dell'anno 400', *Felix Ravenna*, LXXXI, fasc. 30 (1960), 115 ff.; E. Freistedt, *Altchristliche Totengedächtnisstage und ihre Beziehung zum Jenseitsglauben und Totenkult der Antike* (Münster, 1928).

4. Toynbee and Ward-Perkins, *The Shrine of St Peter*, 105, and cf. bibliography under Note 1; A. H. M. Jones, *The Later Roman Empire 284-602*, II (Oxford, 1964), 1014-15.

27. 5. On the mosaic in the apse of St John Lateran, cf. G. J. Hoogewerff, 'Il Mosaico absidale di S. Giovanni in Laterano ed altri mosaici romani', *Atti della Pontificia Accademia Romana di Arch.*, *Rendiconti*, XXVII (1955), 297-326, who puts forward the plausible idea that the full-length figure of Christ held the centre of the original fifth-century mosaic and was, as far as apse decoration in Rome was concerned, the ancestor of all similar figures, including that of SS. Cosma

e Damiano. And cf. C. Cecchelli, 'A proposito del mosaico dell'abside lateranense', *Miscellanea Bibliothecae Hertzianae* (Munich, 1961), 13 ff. The present mosaic dates from the time of Pope Nicholas IV (1290) and was executed by Jacopo Torrito and Jacopo da Camerino, who signed it. Cecchelli argues that the iconographical scheme follows that of the Constantian original, restored probably at various times, under Leo I (440-61) and Stephen VI (896-9) or possibly Sergius III (904-11). The bust of Christ, in particular, was regarded as 'un vera reliquia'. On Constantine's building, cf. J. Ward-Perkins, 'Constantine and the Origins of the Christian Basilica', *Papers of the British School at Rome*, XXII, N.S. IX (1954), 69 ff.

Gregory Dix, *The Shape of the Liturgy* (London, 1943), 310, and reference to *Liber Pontificalis*, ed. Duchesne, 170-87; Toynbee and Ward-Perkins, *The Shrine of St Peter, passim*.

. 6. Toynbee and Ward-Perkins, *op. cit.*, 211-12.

28. 7. K. Lehmann, 'Santa Costanza', *Art Bull.*, XXXVII (1955), 193 ff. 'Santa Costanza, an Addendum', *ibid.*, 291, maintains that the building was originally a temple of Bacchus, or at least a pagan mausoleum, but this view is contradicted by H. Stern, 'Les Mosaïques de l'église de Sainte Constance à Rome', *D.O.P.*, XII (1958), 159 ff.; W. N. Schumacher, 'Dominus legem dat', *Römische Quartalschrift*, LIV (1959), I ff., and *ibid.*, 'Ein römische Apsis-Komposition', 137 ff.; G. Matthiae, *Mosaici medioevali delle chiese di Roma*, I (1967), 3 ff.

30. 8. On porphyry sculpture in general, cf. R. Delbrueck, *Antike Porphyrwerke (Deutsches Archäologischen Instituts, Studien zur spätantiken Kunstgeschichte)* (Berlin and Leipzig, 1932); on imperial tombs, cf. A. K. Vasiliev, 'Imperial Porphyry Sarcophagi at Constantinople', *D.O.P.*, IV (1948), I ff., and P. Grierson, 'Tombs and Obits of the Byzantine Emperors', *ibid.*, XVI (1962), 3 ff. Cf. also G. Bovini, 'Le Tombe degli imperatori d'Oriente dei secoli IV, V, e VI', *Corso* (1962), 155 ff.

31. 9. Cf. H. Schlunk, in *Neue deutsche Ausgrabungen im Mittelmeergebiet und in vorderem Orient* (Berlin, 1959), 344 ff.; Theodor Hauschild and Helmut Schlunk, 'Vorbereicht über die Arbeiten in Centcelles', *Madrider Mitteilungen*, II (1961), 119 ff.; Pedro de Padol, 'El Mausoleo constantiniano de Centcelles, Tarragona', *Corso* (1961), 235 ff.; A. Grabar, 'Programmes iconographiques à l'usage des propriétaires des latifundia romains', *C. Arch.*, XII (1962), 394-5.

32. 10. A. Calderini, G. Chierici, and C. Cecchelli, *La Basilica di San Lorenzo Maggiore* (Milan, 1952); for the possible influence of Constantinople, cf. P. Verzone, 'Rapporti fra l'architettura e quella italiche del V e VI secolo', *Corso* (1958), II, 130 ff.

Cf. also G. Bovini, 'Gli Edifici di culto milanesi d'età pre-ambrosiana', *Corso* (1961), 47 ff.; 'La "Basilica maior" di Milano ed il suo battistero', *ibid.*, 73 ff.; 'La "Basilica Apostolorum" e la "Basilica martyrum" di Milano', *ibid.*, 97 ff.; 'Il Complesso monumentale di S. Lorenzo Maggiore a Milano', *ibid.*, 119 ff.

For the Basilica Ambrosiana, cf. F. Reggiore in *La Basilica Ambrosiana, Ricerchi e restauri, 1929-1940* (Milan, 1941), 113-269; E. Battisti, 'Per la datazione di alcuni mosaici di Ravenna e di Milano', *Scritti ... in onore di M. Salmi* (Rome, 1961), 119 ff. Battisti suggests that the body of the mosaic portrait of St Ambrose in S. Vittore in Ciel d'Oro dates from *c.* 386-7, but that the head was reset after 397; the portrait of St Madernus, however, dates entirely from about 386-7. The bodies of SS. Gervase and Protase were rediscovered in 386; St Victor died *c.* 377-8. The style of the mosaics in S. Vittore in Ciel d'Oro is rather different from that of the mosaics in S. Aquilino.

33. 11. E. Weigand, 'Der Kalenderfries von Hagios Giorgios in Thessaloniki', *Byz. Z.*, XXXIX (1939), 116 ff.; H. Torp, 'Quelques remarques sur les mosaïques de Saint-Georges à Thessalonique', *IXth International Congress of Byzantine Studies*, I (Athens, 1955), 164 ff.; E. Dyggve, 'Le Palais impérial de Thessaloniki', *ibid.*, 179 ff.; cf. also *idem*, 'Kurzer vorläufiger Bericht über die Ausgrabungen im Palastviertel von Thessaloniki, Frühjar 1939', *Dissertationes Pannonicae*, series 2, no. 11 (1941), 63 ff. Torp states that the mosaics form a perfect unity and were executed by one workshop. The iron staples to fix the bed of chalk and plaster for the mosaics were inserted before the hardening of the mortar in the wall. The construction of the 'calotte' is contemporary with the additions to the choir and ambulatory; these date from the time of Theodosius I. Torp compares the mosaics with sculpture of the Theodosian period. Cf. also H. Torp, *Mosaikkene i St Georg-rotunden* (Oslo, 1963); R. F. Hoddinott, *Early Byzantine Churches in Macedonia and Southern Serbia* (London, 1963), 112 ff.; A. Grabar, 'À propos les mosaïques de la coupole de Saint-Georges à Salonique', *C. Arch.*, XVII (1967), 59 ff.; Maria G. Sotiriou, 'Sur quelques problèmes de l'iconographie de la coupole de Saint-Georges de Thessalonique', *In Memoriam Panayotis A. Michelis* (Athens, 1971), 218 ff. In the centre of the dome Christ standing, bearing a cross in a roundel supported by four angels; between the angels a cross with rays, a phoenix on a palm-tree, and two palms. In the middle register were more angels, probably twenty-four, sometimes single, sometimes in groups. Before the architectural screens the chorus of martyrs consists of seven soldiers, seven bishops, and six priests representing the months of the year. 'Ainsi, l'iconographie de la coupole de Saint-Georges devient une composi-

tion panégyrique d'un symbolisme ecclésiastique-liturgique; Adoration et hymne des anges et de tous les Saints, au Christ Ressucité, en la Très-Sainte Église Céleste' (p. 230).

W. Eugene Kleinbauer, 'The Original Name and Function of Hagios Georgios at Thessaloniki', *C. Arch.*, XXII (1972), 55 ff.; *idem*, 'The Iconography and Dating of the Mosaic Decoration in the Rotunda of Hagios Georgios, Thessaloniki', *Viator*, III (1972), attempts to prove that the rotunda was converted to a Christian sanctuary and its mosaics set up *c.* 450 or in the third quarter of the fifth century at the latest. M. Vickers, 'The Date of the Mosaics of the Rotunda at Thessaloniki', *Papers of the British School at Rome*, XXXVIII (1970), 183 ff., considers the evidence at hand speaks more persuasively in favour of the pagan building having been transformed into a monumental martyrium, sheltering relics, perhaps consecrated to Christ *Dynamis Theou*, and possibly conceived *ad similitudinem S. Jerosolimitane ecclesie*, i.e. the Rotunda of the Anastasis on Golgotha.

35. 12. St Jerome: cf. *Comm. in Ezech.*, cap. 1.

W. Koehler, 'Das Apsismosaik von St Pudenziana in Rom als Stildokument', *J. Ficker zum 70. Geburtstag. Forschungen zur Kunstgeschichte und zur christlichen Kunst* (Leipzig, 1931), 167 ff.; A. Petrignani, *La Basilica di S. Pudenziana in Roma secondi gli scavi recemmente eseguiti* (Pontificio Istituto di Archeologia Cristiana, Città del Vaticano, 1934); R. W. Montini, *Santa Pudenziana* (Rome, 1959); G. Matthiae, *Mosaici medioevali*, 55 ff.; B. Vanmaele, *L'Église Pudentienne de Rome (Santa Pudenziana)*. *Contributions à l'histoire de ce monument insigne de la Rome chrétienne ancienne du II*^e *au XX*^e *siècle* (Averbode, 1965) (= *Bibliotheca Analectorum Praemonstratensium*, VI, 154/9); E. Dassmann, 'Das Apsismosaik von S. Pudentiana in Rom', *Römische Quartalschrift*, LXV (1970), 1-2, 67 ff.

On the symbols of the Evangelists, cf. J. A. Herbert, 'The Emblems of the Evangelists', *Burlington Magazine*, XIII (1908), 162. Perhaps the earliest occurrence of these symbols in a Latin MS. occurs in a psalter at Verona, which has been dated between the fifth and seventh and seventh and eighth centuries. The psalter is illustrated in a symbolic manner. Cf. also G. M. Benson, 'New Light on the Utrecht Psalter', *Art Bull.*, XIII (1931), 43; C. R. Morey, *Lost Mosaics and Frescoes of Rome* (Princeton, 1915), 45-7.

13. G. Bovini, 'I Mosaici del battistero di S. Giovanni in Fonte a Napoli', *Corso* I (1959), 5 ff.; Jean Louis Maier, *Le Baptistère de Naples et ses mosaïques: étude historique et iconographique* (Fribourg, 1964); *Excavations at Dura-Europos, Final Report*, VIII, pt II (New Haven, 1967), 222 ff.; P. Pariset, 'I Mosaici del battistero di S. Giovanni in Fonte nello sviluppo

della pittura paleocristiana a Napoli', *C. Arch.*, XX (1970), 1 ff.

37. 14. G. Bovini, *Il Cosidetto Mausoleo di Galla Placidia in Ravenna* (Pontificio Istituto di Archeologia Cristiana, Città del Vaticano, 1950); M. Marzotti, 'Ferettiana', *Felix Ravenna*, XVIII (1955), 36 ff.; G. de Francovich, 'I Primi Sarcophagi cristiani di Ravenna', *Corso*, II (1957), 17 ff.; F. Gerke, *Das Christusmosaik in der Laurentius-kapelle der Galla Placidia in Ravenna* (Stuttgart, 1965); idem, 'La Composizione musiva dell'oratorio di S. Lorenzo Formoso e della basilica palatina di S. Croce a Ravenna', *Corso* (1966), 141 ff.

On the mosaic depicting St Lawrence, cf. W. Seston, 'Le Jugement dernier au mausolée de Galla Placidia à Ravenne', *C. Arch.*, I (1945), 37 ff.; P. Courcelle, 'Le Gril de Saint-Laurent au mausolée de Galla Placidia', *ibid.*, III (1948), 28 ff.

Cf. also G. Bovini, 'Principale Bibliografia su Ravenna antica e suoi più importanti monumenti', *Corso*, I (1956), 13 ff., VII (1960), 1 ff., VIII (1961), 13 ff., IX (1962), 7 ff.; J. Gagé, 'Le Livre Sacré et l'épreuve du Feu', *Mullus, Festschrift Theodore Klauser, J. für Antike und Christentum, Ergänzungsband*, I (Münster, 1964), 130 ff.

39. 15. A. Schuchert, *S. Maria Maggiore zu Rom* (Pontificio Istituto di Archeologia Cristiana, Rome, 1939); C. Cecchelli, *I Mosaici della basilica di S. Maria Maggiore* (Turin, 1956); J. Wilpert, 'La Proclamazione efesina e i mosaici della basilica di S. Maria Maggiore', *Analecta Sacra Tarraconensia*, VI (1931), 27 ff.; E. Weigand's review of R. Kömstedt, *Vormittelalterliche Malerei* (Augsburg, 1929), in *Byz. Z.*, XXXI (1931), 110–13, wherein he considers the mosaics of S. Maria Maggiore to reflect the influence of the Greek East and the lost church art of Constantinople in the first half of the fifth century; A. Grabar, *L'Empereur dans l'art byzantin* (Paris, 1936), 211 ff.; idem, *Martyrium*, II (Paris, 1946), 168; L. de Bruyne, 'Intorno ai mosaici della navata di S. Maria Maggiore', *Rivista arch. cristiana*, XV (1938), 281 ff., and E. Weigand's *compte-rendu* in *Byz. Z.*, XV (1939), 294–6; B. Biagetti, 'Osservazione sui mosaici della navata centrale nella basilica di S. Maria Maggiore in Roma', *Atti della Pontificia Accademia Romana di Arch.*, ser III, *Rendiconti*, XIII (1937), 101 ff. A. W. Byvanck, 'Il Problema dei mosaici di S. Maria Maggiore di Roma', *Corso*, I (1958), 41 ff., argues that the mosaics were executed under the direction of a master of the first class, probably trained at Constantinople. A. Weis, 'Die Geburtsgeschichte Christi am Triumphbogen vom S. Maria Maggiore in Rom', *Das Münster*, XIII (1960), 73 ff.; Marie-Louise Thérel, 'Une Image de la Sibylle sur l'arc triomphal de Sainte-Marie-Majeure à Rome', *C. Arch.*, XII (1962), 153 ff.; G.

Bovini, 'I Mosaici romani dell'epoca di Sisto III (432–440)', *Corso* (1963), 81 ff.; G. Matthiae, *Mosaici medioevali*, 87 ff. For Jewish influence on Christian biblical illustration, cf. H. L. Hempel, 'Zum Problem der Anfänge der A. T.-illustration,' *Z. für alttestamentl. Wissenschaft*, LXIX (1957), 103 ff.; A. Grabar, 'Recherches sur les sources juives de l'art paléochrétien', *C. Arch.*, XI (1960), 41 ff., XII (1962), 115 ff.; H. Stern, 'Quelques problèmes d'iconographie paléochrétienne et juive', *C. Arch.*, XII (1962), 99 ff.; A. Grabar, 'Les Sujets bibliques au service de l'iconographie', *Spoleto, Settimane*, X (1963), 387 ff.; E. D. Goldschmidt, H. L. C. Jaffé, B. Narkis, introduction by Meyer Schapiro, *The Bird's Head Haggadah of the Bezalel Museum in Jerusalem* (Jerusalem, 1965); K. Weitzmann, 'Zur Frage des Einflusser jüdischer Bilderquellen auf die Illustrationen des Alten Testaments', *Mullus, Festschrift Theodore Klauser*, 401 ff.; U. Schubert, 'Der politische Primatanspruch der Päpste, Dargestellt am Triumphbogen von Santa Maria Maggiore in Rom', *Kairos*, Heft 3-4 (1971), 194 ff.; E. Kitzinger, 'The Role of Miniature Painting in Mural Decoration', *The Place of Book Illumination in Byzantine Art* (Princeton, 1975), 99 ff., 122 ff.

41. 16. C.-O. Nordström, *Ravennastudien* (Uppsala, 1953), 42 ff.; S. Bettini, 'Il Battistero della cattedrale', *Felix Ravenna*, LII (1950), 45 ff.; M. Mazzotti, 'Il Battistero della cattedrale di Ravenna', *Corso* (1961), 255 ff.; A. Ghezzo, 'Battistero degli Ortodossi di Ravenna - Problemi ed aspetti architettonico-strumentali e decorativi', *Felix Ravenna*, LXXXVI (1962), 5 ff.; S. K. Kostof, *The Orthodox Baptistery of Ravenna* (Yale University Press, 1965).

42. 17. K. Weitzmann, *Illustrations in Roll and Codex* (Princeton, 1947); idem, *Ancient Book Illumination* (Cambridge, Mass., 1959); C. Nordenfalk, 'The Beginning of Book Decoration', *Beiträge für G. Swarzenski* (Berlin-Chicago, 1951), 9 ff.; R. B. Bandinelli, *Hellenistic-Byzantine Miniatures of the Iliad (Ilias Ambrosiana)* (Olten, 1955); and several studies by various authors in *Studi Miscellanei*, I (Seminario di archeologia e storia dell'arte greca e romana dell'Università di Roma) (Rome, 1961), 29 ff., 55 ff., 63 ff., 69 ff. J. de Wit, *Die Miniaturen des Vergilius Vaticanus (cod. Vat. lat. 3225)* (Amsterdam, 1959), and cf. Hugo Buchthal's review in *Art Bull.*, XLV (1963), 372 ff.; idem, 'A Note on the Miniatures of the Vatican Virgil Manuscript', *Mélanges Eugène Tisserant*, VI (*Studie e testi*, 236) (Biblioteca Vaticana, 1964), 167 ff. I should like to thank Professor Buchthal for permitting me to read his so far unpublished lecture 'The Story of Troy in Medieval Art, II' which contains a number of pertinent observations on the Vatican Virgil. C. Nordenfalk, *Der Kalendar vom Jahre 354 und die lateinische Buchmalerei des IV. Jahrhunderts*

(*Göteborgs Kungl. Vetenskaps- och Vitterhets-Sam-hälles Handlinger*, föl. v, ser. A, t. v, 2, 1936); A. W. Byvanck, 'Antike Buchmalerei III, Der Kalendar vom Jahre 354 und die Notitia dignitatum', *Mnemo-syne*, ser. 3, t. VIII (1940), 177 ff.; H. Stern, *Le Calen-drier de 354. Étude sur son texte et ses illustrations* (*Institut français d'archéologie de Beirut*, LV) (Paris, 1953).

K. Weitzmann, 'Book Illustration of the Fourth Century: Tradition and Innovation', *Akten des VII. Internationalen Kongresses für christliche Archäologie, Trier, 1965, Studi di Antichità cristiana, Int. Ist. di Arch. crist.*, XXVII (Rome and Berlin, 1969), 257 f.; *idem*, 'The Study of Byzantine Book Illumination, Past, Present and Future', *The Place of Book Illumina-tion in Byzantine Art* (Princeton, 1975), 1 ff.
43. 18. C. Nordenfalk, *Die spätantiken Canontafeln* (Göteborg, 1938); *idem*, 'The Apostolic Canon Tables', *Gazette des Beaux Arts*, LXII (1963), 17 ff.; A. M. Friend, Jnr, 'The Portraits of the Evangelists in Greek and Latin Manuscripts', *Arts Studies*, V (1927), 115 ff., VII (1929), 4 ff. For the possible existence of an early illustrated Gospel harmony, Tatian's *Diates-seron* composed in the second half of the second cen-tury, cf. C. Nordenfalk, 'An Illustrated Diatesseron', *Art Bull.*, L (1968), 119 ff.

H. Degering and A. Boeckler, *Die Quedlinburger Italafragmente* (Berlin, 1932).

W. R. Lethaby, 'The Painted Book of Genesis in the British Museum', *Arch. J.*, LXIX (1912), 88 ff., LXX (1913), 162 ff.; C. R. Morey, 'Notes on East Christian Miniatures', *Art Bull.*, XI (1929), 5 ff.

For literature on St Ambrose's *De Fide Catholica*, cf. *Karl der Grosse, 10th Council of Europe Exhibition Catalogue* (Aachen, 1965), no. 389.
46. 19. G. Wilpert, *I Sarcophagi cristiani antichi* (Rome, 1929); H. von Campenhausen, *Die Passions-sarkophage* (Marburg, 1929); M. Lawrence, 'City-gate Sarcophagi', *Art Bull.*, X (1927-8), 1 ff.; *idem*, 'Columnar Sarcophagi in the Latin West', *Art Bull.*, XIV (1932), 103 ff.; A. C. Soper, 'The Latin Style on Christian Sarcophagi of the Fourth Century', *Art Bull.*, XIX (1937), 148 ff.; F. Gerke, *Die christlichen Sarcophage der vorkonstantinischen Zeit* (Berlin, 1940); G. Bovini, *Sarcophagi paleocristiani: determinazione nella loro cronologia mediante l'analisi dei ritratti* (Città del Vaticano, 1949); G. M. Gabrielli, *I Sarcophagi paleocristiani e altomedievali delle Marche* (Ravenna, 1961); T. Klauser, *Frühchristliche Sarkophage in Bild und Wort* (Basel, Vereinigung der fremde antiker Kunst, 1966). Cf. also G. M. A. Hanfmann, *The Sea-son Sarcophagus in Dumbarton Oaks* (Cambridge, Mass., 1951).

For sarcophagi in Gaul, cf. E. Le Blant, *Les Sar-cophages chrétiens de la Gaule* (Paris, 1886); *idem*,

Étude sur les sarcophages chrétiens antiques de la ville d'Arles (Paris, 1878).

For sarcophagi in Spain, G. Bovini, *I Sarcophagi paleocristiani della Spagna* (Pontificio Istituto di Archeologia Cristiana, Rome, 1954); H. Schlunk, *El Sarcofago de Castiliscar y los sarcofagos paleocristianos españoles de la primera mitad del siglo IV* (Pamplona, 1947); *idem*, 'Der Sarkophag von Puebla Nueva (prov. Toledo),' *Madrider Mitteilung, Deutsch. Arch. Inst.*, VII (Heidelberg, 1966), 210 ff.

Cf. also F. Gerke, 'La scultura paleocristiana in Occidente', *Corso* (1959), 11, 49 ff.

On the so-called sarcophagus of Stilicho, cf. H. von Schönebeck, *Der Mailänder Sarkophag und seine Nachfolge* (*Studi di antichità cristiana*, X) (Città del Vaticano, 1935); A. Katzenellenbogen, 'The Sar-cophagus in Sant'Ambrogio and St Ambrose', *Art Bull.*, XXIX (1947), 249.
48. 20. K. Goldmann, *Die ravennatischen Sarkophage* (Strassburg, 1906); H. Dütschke, *Ravennatische Studien: Beiträge zur Geschichte der späten Antike* (Leipzig, 1909); G. Gerola, *Sarcophagi ravennati in-editi (Studi Romani)* (Rome, 1914); M. Lawrence, *The Sarcophagi of Ravenna* (College Art Association Study No. 2, 1945); G. De Francovich, 'Studi sulla scultura ravennate', *Felix Ravenna*, LXXVII-LXXVIII (1958), 5 ff., LXXIX (1959), 5 ff.; *idem*, 'I Primi Sar-cophagi cristiani di Ravenna', *Corso* (1957), 17 ff.; G. Bovini, 'Qualche osservazione sul sarcofago "a colonne" della navata sinistra della chiesa di S. Fran-cesco di Ravenna', *Felix Ravenna*, LXXXVI (1962), 95 ff.; G. M. Gabrielli, 'I Sarcophagi di tipo raven-nate nelle Marche', *ibid.*, LXXXII (1960), 97 ff.; F. Gerke, 'La Scultura ravennate', *Corso* (1959), 11, 109 ff.
50. 21. J. Wiegand, *Das altchristliche Hauptportal an der Kirche der Hl. Sabina* (Trier, 1900); A. C. Soper, 'Italo-Gallic Christian Art', *Art Bull.*, XX (1938), 168; E. H. Kantorowicz, 'The "King's Advent" and the Enigmatic Panels in the Doors of Santa Sabina', *Art Bull.*, XXVI (1944), 207 ff.; R. Delbrueck, 'Notes on the Wooden Doors of Santa Sabina', *Art Bull.*, XXXIV (1952), 139 ff.; Sahoko Tsuji, 'Les Portes de Sainte-Sabine. Particularité de l'iconographie de l'Ascension', *C. Arch.*, XIII (1962), 13 ff.

A. Goldschmidt, *Die Kirchentur des hl. Ambrosius in Mailand* (Strassburg, 1902).
53. 22. For the considerable literature up to 1952 on early Christian ivory carvings cf. W. F. Volbach, *Elfenbeinarbeiten der Spätantike und des frühen Mittel-alters* (Mainz, 1952); but cf. 3rd revised ed., 1976. Since the date of this publication the following studies have appeared: J. Beckwith, 'The Werden Casket Reconsidered', *Art Bull.*, XL (1958), 1 ff.; *idem*, *The Andrews Diptych* (London, 1958); G. Bovini and L. Ottolenghi, *Avori dell'alto medioevo, Mostra nei*

Chiostri Francescani di Ravenna (1956); T. Buddensieg, 'Le Coffret de Pola, Saint-Pierre et le Latran', *C. Arch.*, x (1959), 157 ff.; E. Rosenbaum, 'The Andrews Diptych and Some Related Ivories', *Art Bull.*, XXXVI (1954), 253 ff.; K. Wessel, 'Studien zur oströmischen Elfenbeinskulptur', *Wissenschaftliche Z. der Universität Greifswald*, III (1953-4), 1 ff.; idem, 'Das Diptychon Andrews', *Byz. Z.*, L (1957), 99 ff.; P. Metz, *Elfenbein der Spätantike* (Munich, 1962).

55. 23. H. H. Arnason, 'Early Christian Silver of North Italy and Gaul', *Art Bull.*, XX (1938), 193 ff.; A. O. Curle, *The Treasure of Traprain* (Glasgow, 1923); M. T. Tozzi, 'Il Tesoro di Projecta', *Rivista di arch. cristiana*, IX (1932), 279 ff.; H. B. Walters, *Catalogue of the Silver Plate, Greek, Etruscan and Roman in the British Museum* (London, 1921); R. Jaeger, 'Ein Beitrag zur Geschichte der altchristliche Silberarbeiten', *Arch. Anzeiger, J. des deutschen arch. Instituts*, XLIII (1928), 555 ff. E. Barbier, 'La Signification du cortège représenté sur le couvercle du coffret de "Projecta"', *C. Arch.*, XII (1962), 7 ff., suggests that the scene represents a lady of means going to the bath.

CHAPTER 3

56. 1. M. Avi-Yonah, D. H. K. Amiran, J. J. Rothschild, H. M. Z. Meyer, and B. Mazar, *Jerusalem, The Saga of the Holy City* (Jerusalem, 1954), 29 ff.; A. Grabar, *Martyrium* (Paris, 1946), I, 234 ff.; A. Parrot, *Golgotha and the Church of the Holy Sepulchre* (London, 1957); R. Krautheimer, *Early Christian and Byzantine Architecture (Pelican History of Art)*, 3rd ed. (Harmondsworth, 1979), 62 ff.; A. Ovadiah, *Corpus of the Byzantine Churches in the Holy Land* (Bonn, 1970).

57. 2. Avi-Yonah, etc., *op. cit.*, 32 ff.
3. Avi-Yonah, etc., *op. cit.*, 34 ff.
60. 4. A. Grabar, *Les Ampoules de Terre Sainte* (Paris, 1958); A. Grabar, 'Un Médaillon en or provenant de Mersine en Cilicie', *D.O.P.*, VI (1951), 27 ff.; idem, 'Un Reliquaire provenant d'Isaurie', *C. Arch.*, XIII (1962), 49 ff.; M. Gough, 'A Fifth-Century Silver Reliquary from Isauria', *Byzantinoslavica*, XIX (1958), 244 ff.; Philippe Verdier, 'La Colonne de Colonia Aelia Capitolina et l'Imago Clipeata du Christ Hélios', *C. Arch.*, XXIII (1974), 17 ff.
62. 5. C. Cecchelli, J. Furlani, and M. Salmi, *The Rabbula Gospels* (Olten and Lausanne, 1959); C. R. Morey, 'The Painted Panel from the Sancta Sanctorum', *Festschrift Paul Clemen* (Düsseldorf, 1926), 151 ff.; J. Leroy, *Les Manuscrits syriaques à peintures conservés dans les bibliothèques d'Europe et d'Orient* (Paris, 1964), 139 ff.; K. Weitzmann, 'Eine vorikonoklastische Ikone des Sinai mit der Darstellung des

Chairete', *Tortulae, Festschrift für Johannes Kollwitz* (Rome, 1966), 317 ff.; idem, 'An Encaustic Icon with the Prophet Elijah at Mount Sinai', *Mélanges offerts à K. Michalowski* (Warsaw, 1966), 713 ff. The icons here attributed to a Jerusalem workshop in the seventh or early eighth century are very crude.
64. 6. Krautheimer, *op. cit.*, 79 ff.; H. Delahaye, S.J., *Les Origines du culte des martyrs* (Brussels, 1912), 65; G. Downey, 'The Shrines of St Babylas at Antioch and Daphne', *Antioch-on-the-Orontes*, II, *Excavations 1933-1936* (Princeton University Press, 1938), 45 ff.; D. Levi, *Antioch Mosaic Pavements* (Princeton University Press, 1947), I, 283 ff.; H. C. Butler, *Early Churches in Syria* (Princeton, 1929).

7. W. A. Campbell, 'The Martyrion at Seleucia Pieria', *Antioch-on-the-Orontes*, III, *Excavations 1937-1939* (Princeton University Press, 1941), 35 ff.; K. Weitzmann, 'Iconography of the Reliefs from the Martyrion', ibid., 135 ff.
65. 8. James J. Rorimer, 'The Authenticity of the Chalice of Antioch', in Dorothy Miner (ed.), *Studies in Art and Literature for Belle da Costa Greene* (Princeton University Press, 1954), 161 ff.; *Early Christian and Byzantine Art* (Walters Art Gallery, Baltimore, 1947), 86-7; J. Leroy, *Les Manuscrits syriaques*, 48 ff.
67. 9. L. Budde, 'Die frühchristlichen Mosaiken von Misis-Mopsuhestia', *Pantheon*, XVIII (1960), 116 ff.; I. Lavin, 'The Hunting Mosaics of Antioch and their Sources', *D.O.P.*, XVII (1963), 273, note 424; L. Budde, *Antike Mosaiken in Kilikien*, I, II (Recklinghausen, 1969, 1972); E. Kitzinger, 'Observations on the Samson Floor at Mopsuestia', *D.O.P.*, XXVII (1973), 135 ff., considers the possibility that the building was a synagogue and that the Samson mosaic was based on a picture roll.

10. C. H. Kraeling (ed.), *Gerasa, City of the Decapolis* (New Haven, American Schools of Oriental Research, 1938), especially F. M. Biebel's chapter on the mosaics; J. W. Crowfoot, *Early Churches in Palestine* (London, 1941); H. C. Butler, *Early Churches in Syria* (Princeton, 1929); E. Kitzinger, 'Studies on Late Antique and Early Byzantine Floor Mosaics', *D.O.P.*, VI (1951), 83 ff.; idem, 'Mosaic Pavements in the Greek East and the Question of a "Renaissance" under Justinian', *Actes du VIe Congrès International d'Études Byz.* (Paris, 1951), 209 ff.; A. M. Schneider, *Die Brotvermehrungskirche von et-tâbga am Genesarethsee und ihre Mosaiken* (Paderborn, 1934); P. Palmer and Dr. Guthe, *Die Mosaikkarte von Madaba* (Leipzig, 1906); S. J. Salles and B. Bagatti, *The Town of Nebo* (Jerusalem, 1949); B. Bagatti, 'Il Significato dei musaici della scuola di Madaba (Transgiordano)', *Rivista di arch. cristiana*, XXXIII (1957), 139 ff.; M. Bonfioli, 'Mosaici siro-palestinesi in rapporto alle decorazione delle moschee di Gerusalemme e Damasco', ibid., 161 ff.

68. 11. I. Lavin, in *D.O.P.*, XVII (1963), 181 ff.; E. Kitzinger, in *Actes du VIe Congrès . . . d'Études Byz.*, 209 ff.; *idem*, 'Stylistic Developments in Pavement Mosaics in the Greek East from the Age of Constantine to the Age of Justinian', *La Mosaïque gréco-romaine, Collogues Internationaux du Centre National de la Recherche Scientifique, Paris, 29 août-3 septembre 1963* (Paris, 1965), 341 ff.; A. Grabar, in *C. Arch.*, 11 (1947), 41 ff., especially 54-9; G. M. Fitzgerald, *A Sixth-Century Monastery at Beth-Shan* (Philadelphia, 1939). Cf. also A. Grabar, 'Quelques observations sur le décor de l'église de Qartamin', *C. Arch.*, VIII (1956), 83 ff.

70. 12. J. Beckwith, *Coptic Sculpture* (London, 1963), where I give the most useful literature and summarize the position about Alexandria. Since the publication of my book there has appeared K. Wessel, *Koptische Kunst. Die Spätantike in Ägypten* (Recklinghausen, 1963), in which numerous sculptures of doubtful authenticity are given credence, and G. de Francovich, 'L'Egitto, la Siria e Constantinopoli: Problemi de metodo', *Rivista dell'Istituto Nazionale d'Arch. e di Storia dell'Arte*, N.S. XI-XII (1963), 83 ff., who also seems to be unaware of the strangers in his sequence of sculptures. This vitiates his strictures on the methods of other scholars; no student of textiles will take seriously his views or his chronology.

Cf. also K. Wessel (ed.), *Christentum am Nil* (Internationale Arbeitstagung zur Ausstellung 'Koptische Kunst', Essen, Villa Hügel, 23-5 Juli 1963, Recklinghausen, 1964), and the various catalogues issued in connexion with that exhibition at Essen, Zürich, and Paris, 1963-4.

72. 13. C. R. Morey, *Early Christian Art*, 2nd ed. (Princeton University Press, 1953), 85 ff.; A. Fakhry, *The Necropolis of El-Bagawat in the Kharga Oasis* (Cairo, Service des Antiquités de l'Égypte, III, 1951); H. Stern, 'Les Peintures du mausolée de l'Exode à El-Bagaouat', *C. Arch.*, XI (1960), 93 ff.; J. Schwarz, 'Nouvelles Études sur des fresques d'El-Bagawat', *ibid.*, XIII (1962), 1 ff., who suggests a date before 450 for the frescoes in the chapels 'of the Exodus' and 'of Peace'. For the literature on Bawit and Saqqara, cf. my *Coptic Sculpture*, 38, 39, notes 73 and 74. K. Weitzmann, 'Some Remarks on the Sources of the Fresco Paintings of the Cathedral of Faras', *Kunst und Geschichte Nubiens in christlicher Zeit* (Recklinghausen, 1970), 325 ff.; *idem*, 'Prolegomena to a Study of the Cyprus Plates', *Metropolitan Museum J.*, III (1970, 1971), 97 ff.; *idem*, '*Loca Sancta* and the Representational Arts of Palestine', *D.O.P.*, XXVIII (1974), 33 ff.; A. Grabar, 'Deux portraits sculptés paléochrétiens d'Égypte et d'Asie Mineure, et les portraits romains', *C. Arch.*, XX (1970), 15 ff., especially for the door of al-Moallaqa.

74. 14. W. R. Lethaby, 'The Painted Book of Genesis in the British Museum', *Arch. J.*, LXIX (1912), 88 ff.; C. R. Morey, 'Notes on East Christian Miniatures', *Art Bull.*, XI (1929), 5 ff.; K. Weitzmann, *Illustrations in Roll and Codex* (Princeton, 1947), 140 ff., 176 ff.; *idem*, 'Observations on the Cotton Genesis Fragments', *Late Classical and Mediaeval Studies in Honor of Albert Mathias Friend, Jnr* (Princeton, 1955), 112 ff.; S. Tsuji, 'Nouvelles observations sur les miniatures fragmentaires de la Genèse de Cotton: cycles de Lot, d'Abraham et de Jacob', *C. Arch.*, XX (1970), 29 ff.; O. Kurz, 'The Date of the Alexandrian World Chronicle', *Kunsthistorische Forschungen Otto Pächt zu ehren* (Salzburg, 1972), 17 ff. The most likely date for the Alexandrian World Chronicle would be the last quarter of the seventh century or the years around 700.

15. P. Gauckler, *Inventaire des mosaïques de la Gaule et de l'Afrique*, II and III (Paris, 1913-25); M. Fendri, *Basiliques chrétiennes de la Skhira* (Paris, 1961); Th. Précheur-Canonge, *La Vie rurale en Afrique romaine d'après les mosaïques* (Tunis, 1962); I. Lavin, in *D.O.P.*, XVII (1963), 204 ff.; J. B. Ward-Perkins, 'A New Group of Sixth-Century Mosaics from Cyrenaica', *Rivista di arch. cristiana*, XXXIV (1958), 183 ff.; L. Foucher, 'Les Mosaïques nilotiques africaines', *La Mosaïque gréco-romaine, op. cit.* (Note 11), 137 ff.; P. Romanelli, 'Reflets de la vie locale dans les mosaïques de l'Afrique du Nord', *ibid.*, 275 ff.; P. A. Février, 'Mosaïques funéraires chrétiennes datées d'Afrique du Nord', *Atti del VI Congresso Internazionale di archeologia cristiana* (Rome, 1965), 433 ff.

16. A. H. M. Jones, *The Later Roman Empire* (Oxford, 1964), 11, chapter XXV.

75. 17. *ibid.*, I, 83-4, 11, chapter XVIII.

76. 18. P. Sherrard, *Constantinople, Iconography of a Sacred City* (London, 1965), 8 ff.

19. A. Vasiliev, 'Imperial Porphyry Sarcophagi in Constantinople', *D.O.P.*, IV (1948), 1 ff.; P. Grierson, 'Tombs and Obits of Byzantine Emperors', *ibid.*, XVI (1962), 3 ff.; G. Bovini, 'Le Tombe degli imperatori d'Oriente dei secoli IV, V e VI', *Corso* (1962), 155 ff.

77. 20. J. Beckwith, *The Art of Constantinople* (London, 1961), 15 ff.; G. Mathew, *Byzantine Aesthetics* (London, 1963), 56 ff.; A. Grabar, *Sculptures byzantines de Constantinople (IVe-X siècle)* (Paris, 1963).

CHAPTER 4

80. 1. L. Matzulewitsch, *Byzantinische Antike* (Berlin and Leipzig, 1929); R. Delbrueck, *Die Consular-Diptychen und verwandte Denkmäler* (Berlin, 1929); W. F. Volbach, *Elfenbeinarbeiten der Spätantike und des frühen Mittelalters* (Mainz, 1952); A. Grabar,

L'Iconoclasme byzantin (Paris, 1957); J. Beckwith, *The Art of Constantinople* (London, 1961).

84. 2. Delbrueck, *op. cit.*; Volbach, *op. cit.*; Grabar, *op. cit.*, chapter 1.

86. 3. Delbrueck, *op. cit.*; Volbach, *op. cit.*

4. The quotation from Eusebius is from the *Historia ecclesiastica*, VII, 18.

R. M. Walker, 'Illustrations to the Priscillian Prologues in the Gospel MSS. of the Carolingian Ada School', *Art Bull.*, XXX (1948), 1 ff.; E. Kitzinger, 'The Cult of Images in the Age Before Iconoclasm', *D.O.P.*, VIII (1954), 85 ff.; *idem*, 'On some Icons of the Seventh Century', *Late Classical and Mediaeval Studies in Honor of Albert Mathias Friend Jr* (Princeton, 1954), 132 ff.; W. Braunfels, *The Lorsch Gospels, Facsimile edition* (New York, 1967).

88. 5. A. Grabar, *La Sainte Face de Laon, Le Mandylion dans l'art orthodoxe* (Prague, 1931); K. Weitzmann, 'The Mandylion and Constantine Porphyrogennetos', *C. Arch.*, XI (1960), 163 ff.; S. Runciman, 'Some Remarks on the Image of Edessa', *Cambridge Historical Journal*, III (1938), 238 ff.; C. Bertelli, 'Storia e vicende dell'Immagine Edessina', *Paragone*, N.S. XXXVII (1968), 3 ff.

90. 6. G. A. Wellen, *Theotokos. Eine ikonographische Abhandlung über das Gottesmutterbild in frühchristlicher Zeit* (Utrecht, 1960); Sirarpie Der Nersessian, 'Two Images of the Virgin in the Dumbarton Oaks Collection', *D.O.P.*, XIV (1960), 69 ff.; R. L. Wolff, 'Footnote to an Incident of the Latin Occupation of Constantinople. The Church and the Icon of the Hodegetria', *Traditio*, VI (1948), 322-3; C. Bertelli, 'La Madonna del Pantheon', *Bollettino d'Arte, del Ministero della Pubblica Istruzione*, I-II (1961), 24 ff.; for the mosaic at Kiti, cf. A. and J. A. Stylianou, *The Painted Churches of Cyprus* (London, 1964), 27 ff. (A. H. S. Megaw, 'Byzantine Art and Decoration in Cyprus: Metropolitan or Provincial?', *D.O.P.*, XXVIII (1974), 74-6, prefers a late-sixth-century date); E. Kitzinger, 'On Some Icons of the Seventh Century', *Late Classical and Mediaeval Studies in Honor of Albert Mathias Friend, Jr* (Princeton, 1954), 132 ff.; D. H. Wright, 'The Earliest Icons in Rome', *Arts Magazine*, XXXVIII (October 1963), 24 ff.

91. 7. H. Delahaye, S.J., *Les Origines du culte des martyrs* (Brussels, 1912), 61 ff.; A. Grabar, *Martyrium* (Paris, 1946), *passim*; *idem*, *L'Iconoclasme byzantin* (Paris, 1957), 81 ff.; Sirarpie Der Nersessian, in *D.O.P.*, XIV (1960), 77 ff.; C. Bertelli, 'L'Imagine del monasterium Tempuli', *Annales Fratrum Predicatorum* (1961), 82 ff.; R. L. Wolff, in *Traditio*, VI (1948), 326, note 41.

92. 8. C. Mango, *The Brazen House* (Copenhagen, 1959), 108 ff.

For the ivory carving now at Trier which was bought in St Petersburg in 1844, cf. W. F. Volbach, *Elfenbeinarbeiten (op. cit.)*, no. 143, who gives the previous literature. Strzygowski, Wiegand, and Grabar interpreted the scene as the translation of the relics of the Forty Martyrs to Hagia Irene in Constantinople in 544. The Emperor is, therefore, Justinian and the ecclesiastics in the chariot are the Patriarchs Menas of Constantinople and Apollinarius of Alexandria; but Van Millingen, in *Byzantine Constantinople* (London, 1899), 216-17, had previously maintained that this translation was connected with the church of Hagia Irene at Syceae (Galatia) which had been rebuilt by Justinian. Molinier and Wulff preferred to identify the Augusti as Constantine and Helena, which at least would explain the Empress holding the Cross. Delbrueck on stylistic grounds dated the carving in the seventh century with a bias towards Justinian II (685-95); Volbach declined to identify the scene but assigned the carving to Constantinople in the sixth century. S. Pelikanides, 'Date et interprétation de la plaque en ivoire de Trèves', *Ann. Inst. de Phil. et d'Histoire Orientales et Slaves*, XII (1952), *Mélanges H. Grégoire*, IV, 361 ff., basing himself on the *Chronikon Paschale, c.* 415, suggests that the scene is the translation of the relics of St Joseph and St Zacharias to the old Hagia Sophia and that the Augusti are Theodosius II and his sister Pulcheria; V. Grumel, 'À propos de la plaque d'ivoire du trésor de Trèves', *Revue des études byz.*, XII (1954), 187 ff., prefers Leo I and Verina, the reliquary containing the girdle of the Virgin, and the seated figures in the chariot being the Patriarchs Gennadius of Constantinople and Martyrios of Antioch, who was in the metropolis in 464. Neither of these suggestions seems plausible. H. Schnitzler, *Rheinische Schatzkammer*, I (Düsseldorf, 1957), no. 1, refused to identify the scene and settled for Constantinople or Egypt in the sixth century. Egypt was brought in because previously Strzygowski and Wessel, the latter in *Wissenschaftliche Z. der Universität Greifswald*, III (1953-4), 12 ff., had argued for an Egyptian provenance. A. Hermann, 'Mit der Hand Singen. Ein Beitrag zur Erklärung der Trierer Elfenbeintafel', *J. für Antike und Christentum*, I (1958), 105, notes that a row of onlookers from the palace windows are swinging censers and holding their left hands to their ears, and compares the latter gesture with the action of musicians in Dynastic reliefs and with Coptic liturgical practice. The scene remains an enigma, the style is baffling, but Volbach is probably correct in settling for Constantinople in the sixth century.

94. 9. G. and M. Soteriou, *Εἰκόνες τῆς Μονῆς Σῖνα* (Athens, 1956 and 1958), give only a selection of the icons. The publication by Professor Kurt Weitzmann of all the material on Mount Sinai under the auspices

of the Institute of Advanced Studies at Princeton is eagerly awaited; see K. Weitzmann, *The Monastery of Saint Catherine on Mount Sinai, The Icons*, I, *From the Sixth to the Tenth Century* (Princeton, 1976). E. Kitzinger, 'On Some Icons of the Seventh Century', *Late Classical and Mediaeval Studies in Honor of Albert Mathias Friend Jr* (Princeton, 1955), 132 ff.; M. Chatzidakis, 'An Encaustic Icon of Christ at Sinai', *Art Bull.*, XLIX (1967), 197 ff.

96. 10. P. J. Nordhagen, 'The Earliest Decorations in Santa Maria Antiqua and Their Date', *Inst. Rom. Norv.*, I (1962), 53 ff.; P. Romanelli and P. J. Nordhagen, *Santa Maria Antiqua* (Rome, 1965), give the previous literature, among which should still be singled out the excellent paper of G. M. Rushworth in *Papers of the British School at Rome*, I (1902), I ff.
C. Bertelli, *La Madonna di Santa Maria in Trastevere* (Rome, 1961).

101. 11. L. Matzulewitsch, *Byzantinische Antike* (Berlin and Leipzig, 1929); E. Cruikshank Dodd, *Byzantine Silver Stamps* (*Dumbarton Oaks Studies*, VII) (1961); E. Coche de la Ferté, *L'Antiquité chrétienne au musée du Louvre* (Paris, 1958), no. 49, for the Homs vase. For the Cross of Justin II, cf. *Frühchristliche Kunst aus Rom*, Catalogue of the Exhibition held at the Villa Hügel (Essen, 1962), no. 463, where the previous literature is given. The cross has been restored at various times. For paleographical reasons the inscription on the back which states that the cross was a gift of Justin II appears to date from the tenth or eleventh century. Nevertheless, the style of the front of the cross with the imperial portraits, which may be compared with consular medallions of the late sixth century, would accord well with the tradition of the gift; cf. also C. Belting-Ihm, 'Das Justinus-kreuz in der Schatzkammer der Peterskirche zu Rom', *J. der römisch-germanischen Zentralmuseums Mainz*, XII (1965), 142 ff. For a selection of the church treasure found at Feníki near Antalya, now divided between the Archaeological Museum, Istanbul, and the Dumbarton Oaks Collection, cf. *Handbook of the Byzantine Collection, Dumbarton Oaks* (Washington, D.C., 1976), nos 63-70. Control stamps on many of the objects, as well as inscriptions referring to a bishop Eutychianus and invoking 'holy Sion', indicate that the silver was made for a specific church between 565 and 578. Also now E. Cruikshank Dodd, *Byzantine Silver Treasures* (*Monographien der Abegg, Stiftung Bern*, IX, 1973), especially the summary on p. 53; E. Kitzinger, 'A Pair of Silver Book Covers in the Sion Treasure', *Gatherings in Honor of Dorothy E. Miner* (Baltimore, Walters Art Gallery, 1974), 3 ff. The entire treasure clearly consists of the furnishings and ornaments of a single church which (so the inscriptions on some of the objects suggest) bore the name of

Holy Sion. Given the find place and the date, it is most likely that the church in question is that of the Monastery of Holy Sion near Myra, founded earlier in the sixth century (p. 7); S. H. Wander, 'The Cyprus Plates: the Story of David and Goliath', *Metropolitan Museum J.*, VIII (1973), 89 ff.

CHAPTER 5

102. 1. Quotation from Procopius in the first paragraph: *History of the Wars*, I, xxiv, 7-10; in the second paragraph *ibid.*, I, xxiv, 57-8.
C. Diehl, *Justinien et la civilisation byzantine au VIe siècle* (Paris, 1901); P. N. Ure, *Justinian and his Age* (Penguin Books, 1951); A. H. M. Jones, *The Later Roman Empire 284-602* (Oxford, 1964).

104. 2. R. Krautheimer, *Early Christian and Byzantine Architecture* (*Pelican History of Art*), 3rd ed. (Harmondsworth, 1979), 215 ff.; C. Mango and T. Ševčenko, 'Remains of the Church of St Polyeuktos at Constantinople', *D.O.P.*, XV (1961), 243 ff.; R. Martin Harrison and Nezih Firatlı, 'Excavations at Saraçhare in Istanbul, First Preliminary Report', *ibid.*, XIX (1965), 231 ff.; 'Second and Third Preliminary Reports', *ibid.*, XX (1966), 223 ff.; 'Fourth Preliminary Report', *ibid.*, XXI (1967), 273 ff. The first church was built by the Empress Eudocia, wife of Theodosius II (408-50). This was enlarged and rebuilt by Princess Anicia Juliana in the quarter of Olibrius where her family lay – about 524-7. C. Mango, 'The Church of Saints Sergius and Bacchus at Constantinople', *Otto Demus Festschrift*, *J. d. österreich-Byzantinistik*, XXI (1972), 189 ff., argues that the church was a martyrium specially built for a large Monophysite monastery into which the palaces of Hormisdas had been converted some time after 527, the year of Justinian's accession; the church was not a palatine chapel. The date of construction falls between 527 and 536, and it may be that SS. Sergius and Bacchus is not a precursor but a contemporary of Hagia Sophia. Mango points out that among the twenty or so churches and chapels within the Great Palace only two occupied a special place in the religious life of the imperial court: St Stephen of Daphne, where emperors and empresses were crowned and married, and St Mary of the Pharos, the repository of the major relics pertaining to Christ's Passion.
R. M. Harrison, 'A Constantinopolitan Capital in Barcelona', *D.O.P.*, XXVII (1973), 297 ff., lists the *disiecta membra* of the church of St Polyeuktos which have so far been identified. The church appears to have fallen into disuse about the year 1000 and collapsed (or was destroyed) about 1200. Architectural items from the church were carried off to Venice after

358

the Fourth Crusade, and presumably the Barcelona capital was also removed in the thirteenth century.

3. Krautheimer, *op. cit.*, 251 ff.; N. Mesarites, *Description of the Church of the Holy Apostles at Constantinople (Milan, Bibl. Ambros. gr. 350 and 352)*, ed. and trans. G. Downey in *Philadelphia, American Philosophical Society Transactions*, N.S. XLVII, pt 6 (1957).

106. 4. Procopius on Mount Sinai: *Buildings*, Chapter v, viii.

G. Agnello, 'Il Problema della provenienza delle sculture bizantine della Sicilia', *Actes du XIIe Congrès International d'Études Byz.* (Belgrade, 1964), III, 1 ff.; G. Gerster, *Sinai, Land der Offenbarung* (Berlin, Frankfurt am Main, Vienna, 1961); G. Forsyth and K. Weitzmann, in *The National Geographic Magazine* (January 1964), 84 ff.; *idem*, 'The Mosaics in St Catherine's Monastery on Mount Sinai', *Proceedings of the American Philosophical Society*, CX, no. 6 (1966), 392 ff.; J. Beckwith, *Art of Constantinople* (London, 1961), 29-30.

109. 5. Krautheimer, *op. cit.*, 196-8; A. Baumstark, 'I Mosaici di S. Apollinare Nuovo e l'antico anno liturgico ravennate', *Rassegna Gregoriana*, IX, 1-2 (Rome, 1910), cols. 33-47; C. O. Nordström, *Ravennastudien* (Uppsala, 1953), 63 ff.; A. Grabar, in *C. Arch.*, VIII (1956), 249 ff.; L. B. Ottolenghi, 'Stile e derivazione iconografiche nei riquadri cristologici di Sant' Apollinare Nuovo a Ravenna', *Felix Ravenna*, LXVII (1955), 5 ff., and LXVIII (1955), 5 ff.; G. Bovini, in *Studi Romagnoli*, III (1952), 19 ff.; *idem, Sant'Apollinare Nuovo di Ravenna* (Milan, 1961); *idem*, 'Note sui mosaici con scene cristologiche di S. Apollinare Nuovo di Ravenna', *Corso*, II (1958), 23 ff.; *idem, Mosaici di S. Apollinare Nuovo di Ravenna* (Florence, 1958); F. W. Deichmann, 'Mosaici di S. Apollinare Nuovo', *Corso* (1962), 233 ff.; H. Stern, 'Sur les influences byzantines dans les mosaïques ravennates du début du VIe siècle', *Spoleto Settimane*, IX (1962), 521 ff.; G. Bovini, 'Antichi Rifacimenti nei mosaici di S. Apollinare Nuovo di Ravenna', and 'Principale Restauri compiuti nel secolo scorso da Felice Kibel . . .', in *Corso* (1966), 51 ff., 83 ff.; G. de Francovich, *Il palatium de Teodorico a Ravenna e la cosidetta 'architettura di potenza'. Problemi d'interpretazione di raffigurazioni architettoniche nell'arte tardoantica e altomedievale* (Rome, 1970).

For Ravennate bibliography in general, see G. Bovini, 'Principale Bibliografia su Ravenna antica e suoi più importanti monumenti', *Corso* (1956), 13 ff., and also in *ibid.* (1960), 1 ff., (1961), 13 ff., (1962), 7 ff., etc.

111. 6. G. Bovini, 'Note sulla successione delle antiche fasi di lavoro nella decorazione musiva del Battistero degli Ariani', *Felix Ravenna*, LXXV, fasc. 24 (1957),

5 ff.; M. G. Breschi, *La Cattedrale ed il battistero degli Ariani a Ravenna* (Istituto di Antichità Ravennati e Bizantine, 1965).

116. 7. Krautheimer, *op. cit.*, 244-8; W. J. A. Visser, 'Over de beteekenis der Architectur op den achtergrond von het mosaiek met der voortelling van Keizerin Teodora in de Kerk van San Vitale te Ravenna', *Gildboech*, V (1936), 138 ff.; G. Rodenwaldt, 'Bemerkung zu den Kaisermosaiken in San Vitale', *J. des deutschen arch. Instituts*, LIX-LX (1944-5) (Berlin, 1949), 88 ff.; F. W. Deichmann, 'Contributi all'iconografia e al significato storico dei mosaici imperiali in San Vitale', *Felix Ravenna*, LX, fasc. 9 (1952), 5 ff.; G. Stričević, 'Iconografia dei mosaici imperiali a San Vitale', *Felix Ravenna*, LXXX, fasc. 29 (1959), 5 ff., to which A. Grabar replied in 'Quel est le sens de l'offrande de Justinian et de Théodora sur les mosaïques de Saint-Vital?', *Felix Ravenna*, LXXXI, fasc. 30 (1960), 63 ff., to which Stričević replied in 'Sur le problème de l'iconographie des mosaïques impériales de Saint-Vital', *Felix Ravenna*, LXXXV, fasc. 34 (1962), 80 ff.; F. Gerke, 'Nuovi Aspetti sull'ordinamento compositivo dei mosaici del presbiterio di San Vitale di Ravenna', *Corso* (1960), II, 85 ff.; E. Battisti, 'Per la datazione di alcuni mosaici di Ravenna e di Milano', *Scritti . . . in onore di M. Salmi* (Rome, 1961), 101 ff.; G. Bovini, 'Significato dei mosaici biblici del presbiterio di S. Vitale di Ravenna', *Corso* (1962), 193 ff.

118. 8. W. F. Volbach, *Elfenbeinarbeiten der Spätantike und des frühen Mittelalters* (Mainz, 1952), no. 140.

L. Ottolenghi, 'La Cappella arcivescovile in Ravenna', *Felix Ravenna*, LXXIII, fasc. 22 (1957), 5 ff. But cf. P. Verzone, 'Il Palazzo arcivescovile e l'oratorio di S. Andrea di Ravenna', *Corso* (1966), 145 ff., who suggests a date in the time of Bishop Peter III (570-8).

M. Mazzotti, 'L' Attività edilizia di Massimiano di Pola', *Felix Ravenna*, LXXI, fasc. 20 (1956), 5 ff., also in *Corso* (1956), 75 ff.; G. Bovini, 'Massimiano di Pola arcivescovo di Ravenna', *Felix Ravenna*, LXXIV, fasc. 23 (1957), 5 ff.

120. 9. K. Wessel, 'I Mosaici di San Michele in Affricisco', *Corso* (1961), 369 ff.

M. Mazzotti, *La Basilica di Sant'Apollinare in Classe* (Città del Vaticano, 1954); E. Dinkler, *Das Apsismosaik von S. Apollinare in Classe (Arbeitsgemeinschaft für Forschung des Landes Nordrhein-Westfalen, Wissenschaftliche Abhandlung*, XXIX) (1964).

122. 10. A. Šonje, 'Il Battistero della basilica eufrasiana di Parenzo: problema di datazione', *Actes du XIIe Congrès International d'Études Byz.* (Belgrade, 1964), III, 371 ff.; J. Maksimović, 'Iconography and the Programme of Mosaics at Poreč (Parenzo)', *Mélanges G. Ostrogorsky*, II (Belgrade, 1964), 247 ff.;

B. Molajoli, *La Basilica eufrasiana di Parenzo* (Parenzo, 1940).

M. Sacropoulo, *La Théotokos à la Mandorle de Lythrankomi* (Paris, 1975); A. H. S. Megaw, 'Byzantine Architecture and Decoration in Cyprus: Metropolitan or Provincial?', *D.O.P.*, XXVIII (1974), 73 (cf. Chapter 4, Note 6).

125. 11. M. Lawrence. *The Sarcophagi of Ravenna (College Art Association, Study No. 2)* (1945).

127. 12. C. R. Morey, *Lost Mosaics and Frescoes of Rome* (Princeton, 1915), 35 ff.; R. Krautheimer, *Corpus Basilicarum Christianarum Romae*, I (1937), 137 ff.; G. Matthiae, *SS. Cosma e Damiano* (Rome, 1961); *idem*, *Mosaici medioevali delle chiese di Roma*, I (Rome, 1967), 135 ff.

13. E. Diez, 'Die Miniaturen des Wiener Dioscurides', *Byz. Denkmäler*, III (1903), I ff.; A. von Premerstein, 'Anicia Juliana im Wiener Dioscurides Kodex', *J. der kunsthist. Samml. des allerhöch. Kaiserh.*, XXIV (1903), 103 ff.; A. von Premerstein, K. Wessely, and J. Mantuani, *Dioscurides, Codex Aniciae Julianae . . . phototypice editus* (Leyden, 1906); H. Gerstinger, *Die griechische Buchmalerei* (Vienna, 1926), I, 19 ff.; P. Buberl, 'Die antiken Grundlagen der Miniaturen des Wiener Dioscurideskodex', *J. des deutschen arch. Instituts*, LI (1936), 114 ff. Cf. also C. Mango and I. Ševčenko, in *D.O.P.*, XIV (1961), 244; I. Spatharakis, *The Portrait in Byzantine Illuminated Manuscripts* (Leiden, 1976), 145 ff.

130. 14. H. Gerstinger, *Die Wiener Genesis* (Vienna, 1931); P. Biberl, 'Das Problem der Wiener Genesis', *J. der kunsthist. Samml. in Wien*, N.F. X (1936), 9 ff.; K. Weitzmann, *Illustrations in Roll and Codex* (Princeton, 1947); O. Pächt, 'Ephraimillustration, Haggadah und Wiener Genesis', *Festschrift K. M. Swoboda* (Vienna, 1959), 213 ff.; H. Fillitz, 'Die Wiener Genesis. Résumé der Diskussion', *VII. Internationaler Kongress für Frühmittelalterforschung* (Graz-Cologne, 1962), 44 ff.; K. Weitzmann, 'Zur Frage des Einflusses jüdischer Bilderquellen auf die Illustrationen des Alten Testaments', *Mullus, Festschrift Theodore Klauser* (Münster, 1964), 401 ff.; G. Mathew, *Byzantine Aesthetics* (London, 1963), 82 ff.; Michael D. Levin, 'Some Jewish Sources for the Vienna Genesis', *Art Bull.*, LIV (1972), 241 ff.; J. Gutmann, 'Joseph Legends in the Vienna Genesis', *The Fifth World Congress of Jewish Studies*, IV (Jerusalem, 1973), 181 ff.

133. 15. A. Muñoz, *Il Codice purpureo di Rossano ed il frammento sinopense* (Rome, 1907), and cf. A. Haseloff's review in *L'Arte*, X (1907), 466 ff.; W. C. Loerke, 'The Miniatures of the Trial in the Rossano Gospels', *Art Bull.*, XLIII (1961), 171 ff.

136. 16. A. Grabar, *Les Peintures de l'évangeliaire de Sinope* (Paris, 1948).

137. 17. C. Cecchelli, J. Furlani, and M. Salmi, *The Rabbula Gospels* (Olten and Lausanne, 1959); J. Leroy, *Les Manuscrits syriaques à peintures conservés dans les bibliothèques d'Europe et d'Orient* (Paris, 1964), 139 ff. D. H. Wright, 'The Date and Arrangement of the Illustrations of the Rabbula Gospels', *D.O.P.*, XXVII (1973), 199 ff., agrees that the miniatures should be dated with the text to the year 586 and that they are in their original order.

138. 18. Leroy, *op. cit.*, 208 ff.

142. 19. L. A. Dournovo, *Armenian Miniatures* (London, 1961), 32 ff.; S. Der Nersessian, 'La Peinture arménienne au VIIe siècle et les miniatures de l'évangile d'Etchmiadzin', *Actes du XIIe Congrès International d'Études Byz.* (Belgrade, 1964), III, 49 ff.

143. 20. F. Wormald, *The Miniatures in the Gospels of St Augustine (Corpus Christi College MS. 286)* (Cambridge University Press, 1954).

For the Milan diptych, cf. Volbach, *Elfenbeinarbeiten* (*op. cit.*), no. 119; J. Beckwith, 'The Werden Casket Reconsidered', *Art Bull.*, XL (1958), I ff.

145. 21. O. v. Gebhardt, *The Miniatures of the Ashburnham Pentateuch* (London, 1883); E. A. Lowe, *Codices Latini Antiquiores*, V (Oxford, 1940), no. 693a; J. Gutmann, 'The Jewish Origin of the Ashburnham Pentateuch Miniatures', *The Jewish Quarterly Review*, XLIV (1953), 55 ff.; Paris, Bibliothèque Nationale, *Manuscrits à peintures du VIIe au XIIe siècle, Catalogue* (1954), no. 22; A. Grabar, 'Fresques romanes copiés sur les miniatures du Pentateuque de Tours', *C. Arch.*, IX (1957), 329 ff.; H. L. Hempel, 'Jüdische Traditionen in frühmittelalterlichen Miniaturen', *VII. Internationalen Kongress für Frühmittelalterforschung* (Graz-Cologne, 1962), 53 ff.; *idem*, 'Zum Problem der Anfänge der alttestamentlichen Illustration', *Z. für die alttestamentliche Wissenschaft*, LXIX (1957), 103 ff.; D. Wright, in *Art Bull.*, XLIII (1961), 250-1; J. Gutmann, 'The Illustrated Jewish Manuscripts in Antiquity: The Present State of the Question', *Gesta*, V (1966), 39-44; B. Narkiss, 'Towards a Further Study of the Ashburnham Pentateuch', *C. Arch.*, XIX (1969), 45 ff.; *idem*, 'Reconstruction of Some of the Original Quires of the Ashburnham Pentateuch (Paris, Bibl. Nat. nouv. acq. lat. 2334)', *C. Arch.*, XXII (1972), 19 ff.

CHAPTER 6

147. 1. *Cambridge Medieval History*, II (1913), *passim*; P. Goubert, S.J., *Byzance avant l'Islam*, II, *Byzance et l'Occident sous les successeurs de Justinian*, I, *Byzance et les Francs* (Paris, 1956), II, *Rome, Byzance et Carthage* (Paris, 1965).

148. 2. R. Krautheimer, etc., *Corpus Basilicarum Christianarum Romae*, II (1959), I ff.; G. Matthiae,

Mosaici medioevali delle chiese di Roma, I (1967), 149 ff. Fresco painting as well as mosaic was done in S. Lorenzo. On the east wall of chapel H.9 are two layers of frescoes; an upper layer representing the Virgin and a standing angel and SS. Lawrence, Andrew, John the Evangelist, and Catherine appear to date from about the time of Pope Gregory III (731–41); below this layer a fine crowned head surmounting a jewelled dress was probably painted about 700. Cf. also Krautheimer, *Early Christian and Byzantine Architecture (Pelican History of Art)*, 3rd ed. (Harmondsworth, 1979), 282–4.

Wilpert, *Römische Mosaiken und Malereien*, IV, I, plates 140, 141.

149. 3. Krautheimer, etc., *Corpus Basilicarum*, I, 36; idem, *Early Christian and Byzantine Architecture*, 282–4; Matthiae, *Mosaici medioevali*, I, 169 ff.

150. 4. C. R. Morey, *Early Christian Art*, 2nd ed. (Princeton, 1953), 180; Matthiae, *Mosaici medioevali*, I, 191 ff.

151. 5. E. Mâle, 'La Mosaïque de l'église de S. Stefano Rotondo', *Scritti in honore di Bartolomeo Nogara* (Città del Vaticano, 1937), 257 ff.; Morey, *Early Christian Art*, 180 ff.; C. Bertelli, *La Madonna di S. Maria in Trastevere* (Rome, 1961); P. J. Nordhagen, 'The Mosaics of John VII (A.D. 705-707)', *Acta Inst. Rom. Norv.*, II (1965), 121 ff.; Matthiae, *Mosaici medioevali*, I, 181 ff., 215 ff.

155. 6. P. Romanelli and P. J. Nordhagen, *Santa Maria Antiqua* (Rome, 1965); Beat Brenk, 'Early Byzantine Mural Paintings in Rome', *Palette*, XXVI (1967), 13 ff.; P. J. Nordhagen, 'John VII's *Adoration of the Cross* in S. Maria Antiqua', *J. of the Warburg and Courtauld Institutes*, XXX (1967), 388 ff.

157. 7. R. Kautzsch, 'Die langobardische Schmuckkunst in Oberitalien', *Römische J. für Kunstgeschichte*, V (1941), 1 ff.; G. de Francovich, 'Il Problema delle origini della scultura cosidetta "langobarda"', *Atti del Io Congresso internazionale di studi langobardi* (Spoleto, 1952), 255 ff.; idem, 'Osservazioni sull'altare di Ratchis a Cividale e suoi rapporti tra occidente ed oriente nei secoli VII e VIII D.C.', *Scritti . . . in onore di M. Salmi* (Rome, 1961), 173 ff.; M. Brozzi and A. Tagliaferri, *Arte longobarda. La Scultura figurativa su marmo* (Cividale, 1960); *La Scultura figurativa su metallo* (Cividale, 1961); J. Werner, *Die langobardischen Fibeln aus Italien* (Berlin, 1950); S. Fuchs, *Die langobardischen Goldblattkreuze aus der Zone südwärts der Alpen* (Berlin, 1938).

G. P. Bognetti, G. Chierici, and A. de Capitani d'Arzago, *Santa Maria di Castelseprio* (Milan, 1948); K. Weitzmann, *The Fresco Cycle of S. Maria di Castelseprio* (Princeton, 1951); G. P. Bognetti, 'Un Nuovo Elemento di datazione degli affreschi di Castelseprio',

C. Arch., VII (1954), 139 ff., and A. Grabar, 'À propos du nimbe crucifère à Castelseprio', *ibid.*, 157 ff.; G. de Francovich, 'I Problemi della pittura e della scultura preromanica', *Spoleto Settimane*, II (1955), 455 ff. P. Lemerle, 'L'Archéologie paléochrétienne en Italie - Milan et Castelseprio, Orient ou Rome', *Byzantion*, XXII (1952), 198, made the point that two Belgian paleographers, Marichel and Perret, assert that the inscriptions could date from the sixth or seventh century, with more difficulty to the eighth century, but could not be later. V. N. Lazareff, 'Gli Affreschi di Castelseprio', *Sibrium*, III (1956-7), 87 ff.; P. Verzone, 'Rapporti fra l'architettura bizantina e quella italiana del V e VI secolo', *Corso* (1958), II, 132–3. G. P. Bognetti, 'Aggiornamenti su Castelseprio, III, 1959', *Sibrium*, IV (1958-9), insisted on the seventh-century date originally proposed. Cf. also C. R. Morey, 'Castelseprio and the Byzantine "Renaissance"', *Art Bull.*, XXXIV (1952), 173 ff., who in *Early Christian Art*, 194 ff., stoutly maintained a date *c.* 700. M. Schapiro, 'Notes on Castelseprio', *Art Bull.*, XXXIX (1957), 292 ff., inclined to an eighth-century date.

G. Panazza and A. Peroni, 'La Chiesa di San Salvatore in Brescia', *Atti dell'VIII Congresso Internazionale di Studi sull'Arte dell'alto Medioevo*, II (Milan, 1962).

H. Torp, 'Note sugli affreschi più antichi dell'oratorio di S. Maria in Valle in Cividale', *Atti del II Congresso Internazionale di Studi sull'arte dell'alto Medioevo* (Spoleto, 1953), 75 ff.; H. Belting, 'Probleme der Kunstgeschichte Italiens in Frühmittelalter', *Frühmittelalterliche Studien* (J. des Inst. für Frühmittelforschung der Universität Münster), I (1967), 94 ff.

For Müstair, cf. J. Beckwith, *Early Medieval Art* (London, 1964), 24 and note 24 for bibliography.

159. 8. For St Gregory's Sermons on the Gospels (Vercelli, Biblioteca Capitolare, MS. CXLVIII), cf. *Karl der Grosse, Exhibition Catalogue* (Aachen, 1965), no. 462.

For the copy of Isidore of Seville's *Etymologiae* (Vercelli, Biblioteca Capitolare, MS. CCII), cf. *ibid.*, no. 463.

For St John Chrysostom's Sermons on St Matthew (Vienna, Österreichische Nationalbibliothek, Cod. 1007), *ibid.*, no. 453.

J. Beckwith, 'Byzantine Influence on Art at the Court of Charlemagne', *Karl der Grosse*, III, *Karolingische Kunst* (Düsseldorf, 1965), 288 ff.

CHAPTER 7

161. 1. *Cambridge Medieval History*, II and IV; G. Ostrogorsky, 'The Byzantine Empire in the World of

the Seventh Century', *D.O.P.*, XIII (1959), I ff.; P. Charanis, 'Ethnic Changes in the Byzantine Empire in the Seventh Century', *ibid.*, 23 ff.

162. 2. Ch. Diehl, M. Le Tourneau, and H. Saladin, *Les Monuments chrétiens de Salonique, Monuments de l'art byzantin*, IV (Paris, 1918); S. Pelekanides, *Palaeochristian Monuments of Thessaloniki* (Thessaloniki, 1949) (in Greek); N. D. Papahadjis, *Monuments of Thessaloniki* (Thessaloniki, 1960); R. Krautheimer, *Early Christian and Byzantine Architecture (Pelican History of Art)*, 3rd ed. (Harmondsworth, 1979), 105 ff., 253 ff.

For Hosios David, cf. A. Xyngopoulos, 'The "Catholikos" of the Latomos Monastery and the Mosaics', *Arch. Deltion* (1929), 142 ff. (in Greek); V. Grumel, 'La Mosaïque du Dieu Sauveur du monastère du Latome à Salonique', *Échos d'Orient*, XXXII (1930), 157 ff.; Ch. Diehl, 'À propos de la mosaïque d'Hosios David à Salonique', *Byzantion*, VII (1932), 333 ff.; C. R. Morey, 'A Note on the Mosaics of Hosios David', *ibid.*, 339 ff.; E. Kitzinger, 'Byzantine Art in the Period between Justinian and Iconoclasm', *Elfter Internationaler Byzantinisten-Kongress* (Munich, 1958), 23–4 (offprint); R. F. Hoddinott, *Early Byzantine Churches in Macedonia and Southern Serbia* (London, 1963), 173 ff.

165. 3. P. Papageorgiou, 'Monuments of the Cult of St Demetrios of Thessaloniki', *Byz. Z.*, XVII (1908), 321 ff. (in Greek); Th. Uspenskij, 'The Mosaics Discovered in 1907 at St Demetrios of Thessaloniki', *Bull. of the Russian Archaeological Institute of Constantinople*, XIV (1909), I ff. (in Russian); Diehl, Le Tourneau, Saladin, *Monuments chrétiens de Salonique*, 61 ff.; G. and M. Soteriou, *The Basilica of St Demetrios at Thessaloniki* (Athens, 1952) (in Greek); A. Xyngopoulos, *The Basilica of St Demetrios* (Salonika, 1946) (in Greek); D. Talbot Rice, 'The Lost Mosaics of St Demetrios, Salonika', *IX International Congress of Byz. Studies*, I (Athens, 1955), 474; Kitzinger, *op. cit.*, 23 ff.; Krautheimer, *Early Christian and Byzantine Architecture*, 132 ff.; R. Cormack, 'The Mosaic Decoration of S. Demetrios, Thessaloniki, a Reexamination in the Light of the Drawings of W. S. George', *Annual of the British School at Athens*, LXIV (1969), 17 ff.; W. Eugene Kleinbauer, 'Some Observations on the Dating of S. Demetrios in Thessaloniki', *Byzantion*, XL (1971), 36 ff. Cf. also A. Grabar, *Martyrium* (Paris, 1946), II, 121 ff.; F. Barišić, 'Miracles de St Démétrius comme source historique', *Académie serbe des Sciences, Monographies CCIX, Institut d'études byz. No. 2* (Belgrade, 1953); Hoddinott, *Early Byzantine Churches*, 125 ff.

167. 4. J. Beckwith, *Art of Constantinople* (London, 1961), 29–30 and notes 41 and 42 for previous litera-

ture, to which should be added P. J. Nordhagen, 'The Mosaics of the Byzantine Emperors', *Byz. Z.*, LVI (1963), 53 ff., who advocates a date in the first reign of Justinian II (685–95), identifying the 'Apsed Hall' as the Justinianos to which a courtyard, the Heliakon, seems to have been attached. Near by he also built another triclinium, the Lausikos. The complex, for which numerous sources exist, seems to have been in use quite late in Byzantine times. E. Cruikshank Dodd, *Byzantine Silver Stamps* (Dumbarton Oaks Studies, VII) (1961); M. C. Ross, *Catalogue of the Byzantine and Early Medieval Antiquities in the Dumbarton Oaks Collection*, I (1962), II (1965); C. L. Striker and Y. Doğan Kuban, 'Fourth Preliminary Report', *D.O.P.*, XXV (1971), 255–6.

168. 5. K. A. C. Creswell, *Early Muslim Architecture*, I (Oxford University Press, 1932); H. A. R. Gibb, 'Arab-Byzantine Relations under the Umayyad Caliphate', *D.O.P.*, XII (1958), 219 ff.; Marguerite Gautier van Berchem, *The Mosaics of the Dome of the Rock and of the Great Mosque in Damascus* (Oxford, 1970); Henri Stern, 'Notes sur les mosaïques du Dôme du Rocher et de la Mosquée de Damas à propos d'un livre de M^me Marguerite Gautier van Berchem', *C. Arch.*, XXII (1972), 201 ff.

6. W. Harvey, W. R. Lethaby, and O. M. Dalton, *The Church of the Nativity at Bethlehem* (London, 1910); L. H. Vincent and F. M. Abel, *Bethléem, Le Sanctuaire de la Nativité* (Paris, 1914); H. Stern, 'Les Représentations des conciles dans l'église de la Nativité à Bethléem', *Byzantion*, XI (1936), 151 ff., XIII (1938), 415 ff.; *idem*, 'Encore les mosaïques de l'église de la Nativité à Bethléem', *C. Arch.*, IX (1957), 141 ff.; R. W. Hamilton, *The Church of the Nativity, Bethlehem*, 2nd ed. (Jerusalem, 1947), 59 ff.; A. Grabar, *L'Iconoclasme byzantin* (Paris, 1957), 50 ff.

Christopher Walker, *L'Iconographie des Conciles dans la tradition byzantine* (Archives de l'Orient Chrétien, no. 13, Institut français d'études byzantines) (Paris, 1970), 79 ff.

Stephen Gero, *Byzantine Iconoclasm during the Reign of Leo III, with Particular Attention to the Oriental Sources* (Louvain, 1973): 'In the final analysis, Byzantine iconoclasm, in its first phase, was not Jewish, Muslim, or Anatolian but was indeed an imperial heresy' (p. 131).

For some wall-paintings executed during the Iconoclastic period in Cappadocia, cf. N. Thierry, 'Les Peintures murales des six églises du Haut Moyen Âge en Cappadoce', *Paris, Académie des Inscriptions et Belles-Lettres, Comptes Rendus, 1970* (juillet–octobre 1971), 444 ff. In the church of St Basil of Sinopos an inscription near a cross on the south wall states 'Le Christ ainsi figuré ne subit pas de dommage car on ne

saurait le représenter par l'image.' The decoration consists of crosses, foliate and geometric ornament, guilloche patterns, etc. Cf. also N. Thierry, 'Art byzantin du Haut Moyen Âge en Cappadoce: L'Église No. 3 de Mavrucan', *J. des Savants* (oct.-déc. 1972), 233 ff., for a seventh-century church with decoration. 'Mentalité et formulation iconoclastes en Anatolie', *ibid.* (avril-juin 1976), 81 ff.

170. 7. J. Beckwith, *Art of Constantinople*, chapter 3 and notes; Grabar, *L'Iconoclasme byzantin, passim.*

171. 8. G. Brett, 'The Automata in the Byzantine "Throne of Solomon"', *Speculum*, XXIX (1954), 477 ff. The description of the T'ang embassy is given in C. P. Fitzgerald, *China, A Cultural History* (London, 1935), 323-4; J. Perrot, *L'Orgue de ses origines hellénistiques à la fin du XIII^e siècle* (Paris, 1965), especially chapter 12.

9. Edinburgh-London, *Masterpieces of Byzantine Art*, Catalogue (1958), nos. 49, 56, 61, 64; D. Talbot Rice, *The Art of Byzantium* (London, 1959), nos. iv, v, 78, 79; Sigrid Müller-Christensen, 'Der Alexandermantel von Ottobeuren', *Ottobeuren 764-1964, Beiträge zur Geschichte der Abtei* (Augsburg, 1964), 39 ff. Cf. also O. von Falke, *Kunstgeschichte der Seidenweberei* (Berlin, 1913), although this is now considerably out of date, and W. F. Volbach, *Catalogo del Museo Sacro della Biblioteca Apostolica Vaticana*, III, 1, *I Tessuti* (Città del Vaticano, 1942).

177. 10. Grabar, *L'Iconoclasme byzantin*, 183 ff.; G. Ostrogorsky, 'The Byzantine Background of the Moravian Mission', and papers by G. C. Soulis, D. Obolensky, and A. Dostal on the work of St Cyri and St Methodius in *D.O.P.*, XIX (1965), 1 ff.; *Iconoclasm* (Papers given at the Ninth Spring Symposium of Byzantine Studies, University of Birmingham, March 1975. Ed. A. Bryer and S. Herrin) (Centre of Byzantine Studies, University of Birmingham, 1977). The papers include two by R. Cormack on the arts during the ages of Iconoclasm and painting after Iconoclasm; a study of Monophysite church decoration by M. Muridet; a discussion of the decoration of four 'Iconoclast' churches in Cappadocia by A. Epstein, who concludes that the date is, in fact, post-Iconoclast; and a speculation on the Byzantine Psalter before and after Iconoclasm by A. Cutler.

CHAPTER 8

180. 1. L. Mariès, 'Le Psautier à illustration marginale. Signification théologique des images', *Actes du VIe Congrès International d'Études Byz.* (Paris, 1951), II, 261 ff.; A. Grabar, *L'Iconoclasme byzantin* (Paris, 1957), 196 ff.; I. Ševčenko, 'The Anti-Iconoclastic Poem in the *Pantocrator* Psalter', *C. Arch.*, XV (1965),

39 ff., and articles by Grabar and S. Dufrenne, 61 ff. and 83 ff.; for a complete bibliography, cf. the catalogue of the IXth Council of Europe Exhibition, *Byzantine Art and European Art* (Athens, 1964), 296 ff. and 540; S. Dufrenne, *L'Illustration des psautiers grecs du moyen-âge*, I (Paris, 1966); Christine Paschou, 'Les Peintures dans un tétraévangile de la Bibliothèque Nationale de Paris: le grec 115 (X^e siècle)', *C. Arch.*, XXII (1972), 61 ff.

2. S. Der Nersessian, 'Le Décor des églises du IXe siècle', *Actes du VIe Congrès International d'Études Byz.* (Paris, 1951), II, 315 ff.; Grabar, *L'Iconoclasme byzantin*, 208 ff.

182. 3. K. Weitzmann, *Die byzantinische Buchmalerei des 9. und 10. Jahrhunderts* (Berlin, 1935), 3 ff. and figures 11-15, 17; a summarized bibliography appears in Paris, Bibliothèque Nationale, *Byzance et la France Médiévale* (1958), no. 9; S. Der Nersessian, 'The Illustrations of the Homilies of Gregory of Nazianzus Paris gr. 510. A Study of the Connections between Text and Images', *D.O.P.*, XVI (1962), 197 ff.; I. Spatharakis, 'The Portraits and the Date of the Codex Paris gr. 510', *C. Arch.*, XXIII (1974), 97 ff.: 'If our identification of the portrait of the drawing of Constantine is correct, then we have a precise date for the execution of the Codex Paris gr. 510, the year 879. This year of execution would help to explain why Leo on folio B verso, who was crowned co-Emperor on January 6, 870 is qualified as *despotes*, while Alexander only as *adelphos*; Alexander was only crowned co-Emperor shortly after Constantine's death. . . . We suspect that the Codex was made for the return of the Emperor and his son from the successful campaign in Germanicia' - i.e. after January 879 (pp. 98-9). J. Leroy, 'Notes codicologiques sur le Vat. gr. 699', *C. Arch.*, XXIII (1974), 72 ff., argues cogently on technical grounds that this MS. was written and put together in southern Italy and that the miniatures were by an artist from Constantinople who happened to be there. A. Grabar in a note on pp. 78-9 agrees.

I. Spatharakis, *The Portrait in Byzantine Illuminated Manuscripts* (London, 1976), 96 ff. (for Paris gr. 510), 7 ff. (for Vat. Reg. gr. 1).

185. 4. C. Stornajolo, *Le Miniature della Topografia Cristiana di Cosma Indicopleuste; codice Vaticano greco 699* (Milan, 1908); Weitzmann, *Byzantinische Buchmalerei*, 4, 38; M. V. Anastos, 'The Alexandrian Origin of the Christian Topography of Cosmas Indicopleustes', *D.O.P.*, III (1946), 75 ff.; C. R. Morey, *Early Christian Art*, 2nd ed. (Princeton University Press, 1953), 79 ff.; Weitzmann, 'Die Illustration der Septuagint', *Münchner J. der bildenden Kunst*, III F., III-IV (1952-3), 104 ff.; *idem*, in *C. Arch.*, XI (1960), 175; W. Wolska, *La Topographie chrétienne de Cosmas Indicopleustes* (*Théologie et science*

au VIe siècle, Bibliothèque byzantine, Études, III)
(Paris, 1962).

A similar monumental approach to form may be
seen in the Armenian Gospels of Queen Mlkhē, ex-
ecuted early in the second half of the ninth century.
Apart from the superb canon tables, the miniature of
the Ascension and the portraits of the Evangelists are
designed on a grand scale with a vivid appreciation of
modelling, movement of drapery, and gesture. Al-
though early Christian prototypes have been evoked,
it is difficult to believe that the artist had not studied
more up-to-date metropolitan work. Cf. Mesrop
Janashian, *Armenian Miniature Paintings of the Mon-
astic Library at San Lazzaro* (Venice, Mekhitarist
Congregation of San Lazzaro, 1967), I, 16 ff., plates
I–XI.

188. 5. Grabar, *L'Iconoclasme byzantin*, 189 ff.; C.
Mango, *The Mosaics of St Sophia at Istanbul* (*Dum-
barton Oaks Studies*, VIII) (1962), 80 ff.; C. Mango
and E. J. Hawkins, 'The Apse Mosaics of St Sophia
at Istanbul. Report on Work Carried Out in 1964',
D.O.P., XIX (1965), 115 ff.

190. 6. Mango, *Mosaics of St Sophia*, 48 ff.; S. der
Nersessian, 'Les Portraits de Grégoire l'Illuminateur
dans l'art byzantin', *Byzantion*, XXXVI (1967), 386 ff.;
C. Mango and E. J. W. Hawkins, 'The Mosaics of St
Sophia at Istanbul. The Church Fathers in the North
Tympanum', *D.O.P.*, XXVI (1972), 3 ff. ('the figures
of the Fathers should in all probability be dated to the
last two decades of the ninth century', p. 41).

191. 7. Grabar, *L'Iconoclasme byzantin*, 234 ff.;
Mango, *Mosaics of St Sophia*, 27 ff. N. Oikonomides,
'Leo VI and the Narthex Mosaic of Saint Sophia',
D.O.P., XXX (1976), 151 ff., argues for a date about
920 when the Council of that year 'put an end to a
schism that had troubled the Byzantine Church for
thirteen years' caused by Leo VI's fourth marriage.

193. 8. P. Underwood, 'Notes on the Work of the
Byzantine Institute in Istanbul: 1957–1959', *D.O.P.*,
XIV (1960), 213 ff. and figure 14; P. Underwood and
E. J. Hawkins, 'The Mosaics of Hagia Sophia at Istan-
bul. A Report on Work Done in 1959 and 1960. The
Portrait of the Emperor Alexander', *D.O.P.*, XV
(1961), 189 ff.

195. 9. P. Underwood, 'A Preliminary Report on
some Unpublished Mosaics in Hagia Sophia: Season
of 1950 of the Byzantine Institute', *American J. of
Arch.*, LV (1959), 367 ff.; Mango, *Mosaics of St Sophia*,
44 ff.; Grabar, *L'Iconoclasme byzantin*, 234 ff., 193 ff.,
250 ff.

197. 10. Diehl, Le Tourneau, and Saladin, *op. cit.*
(Chapter 7, Note 2), 117 ff.; Grabar, *L'Iconoclasme
byzantin*, 194 ff., 250 ff.; M. Kalligas, *Die Hagia Sophia
von Thessaloniki* (Würzburg, 1935). S. Pelikanides,
'Bemerkungen zu den Altarmosaiken der Hagia Sophia

zu Thessaloniki und die Frage der Datierung der
Platytera', *Byzantina*, V (1973), 31 ff., argues for a date
in the 1180s for the Virgin and Child in the apse.

200. 11. A. Goldschmidt and K. Weitzmann, *Die
byzantinischen Elfenbeinskulpturen des X. bis XIII.
Jahrhunderts* (Berlin, 1934), II, no. 88; Edinburgh–
London, *Masterpieces of Byzantine Art*, no. 59. K.
Weitzmann, 'Ivory Sculpture of the Macedonian
Renaissance', *Kolloquium über spätantike und früh-
mittelalterliche Skulptur*, II (Mainz am Rhein, 1970),
I ff., suggests Leo V for his coronation in 813 and
points out that the new iconoclastic decrees were not
enforced until after the synod of 815.

For the jasper of Leo VI cf. J. Beckwith, *Art of Con-
stantinople* (London, 1961), 81 and note 14. I should
like to thank Mr Marvin Ross for informing me that
the jasper seems to have been in the Vatican in the
eighteenth century, cf. *Veteris gemmae ad Christianum
usum exsculptae et servabatur olim in Museo Victorio.
Brevis explanatio. Editio tertia auctior* (Rome, 1760),
which gives an illustration of the cross on the back of
the jasper. There is a copy of the pamphlet in the
Gennadion Library, Athens, and a photostat at Dum-
barton Oaks. For a cameo similar in style, although
apparently of later date, in the Hermitage, cf. A. V.
Banck, 'Byzantine Cameos in the Hermitage Collec-
tion', *Vizantiiskii Vremennik*, XVI (1960), 206 ff. and
figure 2 (in Russian); *eadem, Byzantine Art in the
Collections of the USSR* (Leningrad and Moscow,
1966), figures 159, 163, and 170.

For the jasper with a representation of Christ on the
Cross between the Virgin and St John, cf. Athens,
Byzantine Art and European Art, no. 109.

12. J. Beckwith, *Art of Constantinople*, 86 ff.; Athens,
Byzantine Art and European Art, no. 463; J. Beck-
with, 'Byzantine Art in Athens', *Burlington Magazine*,
CVI (1964), 399 ff.; K. Wessel, *Die byzantinische
Emailkunst vom 5. bis 19. Jahrhundert* (Reckling-
hausen, 1967), 59 ff.

CHAPTER 9

201. 1. S. Runciman, *The Emperor Romanus Lecapenus
and his Reign. A Study of Tenth-Century Byzantium*
(Cambridge, 1929); *Cambridge Medieval History*, IV,
The Byzantine Empire, pt I, *Byzantium and its Neigh-
bours* (1966), chapter IV; Romilly Jenkins, *Byzantium:
the Imperial Centuries, A.D. 610 to 1071* (London,
1966), 227 ff.

202. 2. Jenkins, *op. cit.*, chapter XIX; Paul Lemerle,
Le Premier Humanisme byzantin (Paris, 1971), especi-
ally chapters VII, IX and X; Romilly J. H. Jenkins,
'The Classical Background of the Scriptores post
Theophanem', *D.O.P.*, VIII (1954), 13 ff.; P. G.

364

Alexander, 'Secular Biography at Byzantium', *Speculum*, XV (1940), 194–209.

207. 3. K. Weitzmann, *The Joshua Roll, A Work of the Macedonian Renaissance* (Princeton, 1948); *idem, Die byzantinische Buchmalerei des 9. und 10. Jahrhunderts* (Berlin, 1935), 18 ff., figures 169–72; *idem, Aus den Bibliotheken des Athos* (Hamburg, 1963), 45–6; H. Buchthal, *The Paris Psalter* (London, 1938); Paris, Bibliothèque Nationale, *Byzance et la France Médiévale* (1958), no. 10; K. Weitzmann, 'The Ode Pictures of the Aristocratic Psalter Recension', *D.O.P.*, XXX (1976), 65 ff. (in connexion with Paris gr. 139); *Miniature della Bibbia cod. Vat. Regina Gr. I e del Salterio cod. Vat. Palat. Gr. 381, Collez. Paleogr. Vat. Facs.*, I (Milan, 1905); C. Mango, 'The Date of Cod. Vat. Reg. gr. I and the Macedonian Renaissance', *Acta ad archeologiam et artium pertinentia* (Institutum Romanum Norvegiae), IV (1969), 122 ff., dates the Bible of Leo about 940; Hugo Buchthal, 'The Exaltation of David', *J. of the Warburg and Courtauld Institutes*, XXXVII (1974), 330 ff.; K. Weitzmann, 'A 10th Century Lectionary. A Lost Masterpiece of the Macedonian Renaissance', *Revue des Études sud-est européennes*, IX (1971), 617 ff.; *Byzantine Art, IXth Exhibition of the Council of Europe* (Athens, 1964), 291 ff. and 300, no. 283, Jerusalem, Greek Patriarchate Library, Hagiou Taphou 51, a Psalter which contains a fine full-page miniature (fol. 108 verso), executed in the thirteenth century, of David enthroned listening to Nathan and David doing penance.

210. 4. Goldschmidt and Weitzmann, *op. cit.* (Chapter 8, Note 11), nos. 35, 31, 32, 33, 43–5, 34, 77.

215. 5. J. Rauch, Schenk zu Schweinsberg, and J. Wilm, 'Die Limburger Staurothek', *Das Münster*, VIII, 7–8 (1955), 201 ff.; Marvin Ross, 'Basil the Proedros, Patron of the Arts', *Archaeology*, XI, 4 (1958), 271–5; H. Schnitzler, *Rheinische Schatzkammer* (Düsseldorf, 1958), 24, no. 12, plates 38–47; A. Pasini, *Il Tesoro di San Marco*, VIII (Venice, 1886), plate XLI, no. 83 and p. 58, plate L, no. 113 and p. 57; H. R. Hahnloser (ed.), *Il Tesoro di San Marco*, II, *Il Tesoro e il Museo* (Florence, 1971) (crown of Leo VI, cat. no. 92; book-cover, cat. no. 35; chalice, cat. no. 42; enamelled icon, Archangel Michael, cat. no. 17; enamelled glass bowl, cat. no. 83); S. G. Mercati, 'La Stauroteca di Maestricht', *Atti della Pontificia Accademia Romana di Arch.*, *Memorie*, I, pt II (Rome, 1924), 45 ff.; M. A. F. C. Thewissen, *Twee Byzantijnische H. Kruisrelicken uit de Schats der voort-Kapitelkerk te Maestricht* (Maestricht, 1939); A. Frolow, *Les Reliquaires de la Vraie Croix* (*Archives de l'Orient chrétien*, VIII) (Institut Français d'Études Byzantines, Paris, 1965); Pasini, *op. cit.*, 33 and plate XXII; K. Weitzmann, 'The Narrative and Liturgical Gospel Illustrations', in M. M. Parvis and A. P. Wikgren (eds.), *New Testament Manuscript Studies* (Chicago, 1950), 153 ff.; M. Bárány-Oberschall, *The Crown of the Emperor Constantine Monomachos* (*Arch. Hungarica*, XXII) (Budapest, 1937); P. J. Kelleher, *The Holy Crown of Hungary* (American Academy in Rome, 1951), 68 ff.; A. Grabar, 'Les Succès des arts orientaux à la cour byzantine sous les Macédoniens', *Münchner J.*, III F., II (1951), 42 ff.; *idem*, 'L'Archéologie des insignes médiévaux du pouvoir', *J. des Savants, Academie des Inscriptions et Belles Lettres* (January–March, 1957), 29 ff.; P. E. Schramm, *Herrschaftszeichen und Staatssymbolik*, III (Stuttgart, 1956), A. Boeckler's article on the Holy Crown of Hungary, pp. 730 ff.; J. Déer, *Die heilige Krone Ungarns, Österreich. Akad. d. wissenschaft. Denkschriften, Phil.-Hist. Klasse*, XCI (Vienna, 1966); Wessel, *op. cit.* (Chapter 8, Note 12), nos. 19, 20, 22, 28, 32, and 37.

For Georgian goldsmith work and enamels, cf. G. N. Chubinashvili, *Georgian Gold Repoussé Work of the Eighth to the Eighteenth Centuries* (Tiflis, 1957) (in Russian): S. Y. Amiranashvili, *Les Émaux de Géorgie* (Paris, 1962). A number appear to date from the ninth or tenth century: at Martvili a triptych and a pectoral cross; a second pectoral cross also dating from the tenth century bears Greek inscriptions, but Amiranashvili maintains that the work is Georgian; a *panagia* with a representation of the Anastasis, also tenth century, bears a Greek inscription and from the reproduction appears to be metropolitan; at Chémochmédi a plaque of the Crucifixion bears Georgian and Greek inscriptions including a reference to the Emperor of the Abkhazes – Amiranashvili suggests that this is George, who died in 957; at Katskhi an icon of the Redeemer may date from the ninth century; at Khobi an icon of the Virgin includes medallions with Georgian inscriptions, one referring to the Georgian ruler Leo III (*c.* 957–*c.* 987), another to the Empress Mariamme and her son Constantine, who preceded Leo III and reigned about 893–922, another to the Emperor David (1242–93) – the whole icon is greatly restored; in the National Museum, Tiflis, but formerly at Chémochmédi, an icon of the Annunciation and the Anastasis with busts of Christ and Saints is also assigned to the tenth century. Also in the National Museum at Tiflis, but formerly at Khobi, a pectoral cross of the Empress Tamar (1184–1213) bears Georgian inscriptions on the back. At Gelati an icon of Christ Pantocrator with medallions bearing Georgian inscriptions may date from the twelfth century, and a plaque of St Peter taken from an icon of the Virgin dates from the second half of the thirteenth century. At Djamati four medallions from an icon carry both Georgian and Greek inscriptions, and there are various icons of St George with bilingual legends. The Khakhuli triptych is a very complex matter: one of

the plaques represents Michael VII Dukas and his wife Mary of Alania crowned by Christ, and certain other plaques appear to be unquestionably metropolitan.

For Georgian manuscripts cf. R. O. Shmerling, *The Artistic Development of Georgian MSS. from the Ninth to the Eleventh Century*, Tiflis Akademiya Nauk Gruzinskoi S.S.R. (Institut Istorii Gruzinskoyo Isskusstva) (Tbilisi, 1967) (in Russian); R. P. Blake and S. Der Nersessian, 'The Gospels of Bert'ay, an Old-Georgian MS. of the Tenth Century', *Byzantion*, XVI (1944), 226 ff., plates I–VIII.

217. 6. J. Beckwith, *Art of Constantinople* (London, 1961), 98 ff.

218. 7. E. Chartraire, 'Les Tissus anciens du trésor de la cathédrale de Sens', *Revue de l'art chrétien*, XI (1911), 372, no. 18; Beckwith, *op. cit.*, 101; S. Müller-Christensen, *Sakrale Gewänder des Mittelalters*, Catalogue (Munich, 1955); *idem*, 'Liturgische Gewänder mit dem Namen des hl. Ulrich', *Augusta 955–1955*, plate 12, figure 2, pp. 53 ff.; *idem* and Alexander von Reitzenstein, *Das Grab des Papstes Clemens II im Dom zu Bamberg* (Munich, 1960); Paris, Musée des Arts Décoratifs, *Les Trésors des églises de France* (1965), 426.

8. A. Grabar, 'La Soie byzantine de l'évêque Gunther à la cathédrale de Bamberg', Technischer Exkurs von Sigrid Müller-Christensen, *Münchner J.*, III. F, VII (1956), 7 ff.; Sigrid Müller-Christensen, *Das Bamberger Günthertuch* (Bamberg, 1966); *idem*, 'Beobachtungen zum Bamberger Günthertuch', *Münchner J. der bildenden Kunst*, III. F, XVII (1966), 9 ff.

221. 9. G. and M. Soteriou, *Icones du Mont Sinaï* (Athens, 1956), I, 47 ff., II, plates 33–41; K. Weitzmann, 'The Mandylion and Constantine Porphyrogennetos', *C. Arch.*, XI (1960), 163 ff.; S. Der Nersessian, 'La Légende d'Abgar d'après un rouleau illustré de la bibliothèque Pierpont Morgan à New York', *Actes du IVe Congrès internationale des Études byz.* in *Bull. de l'Institut Arch. Bulgare*, X (1936), 105 ff.; K. Weitzmann, 'Byzantine Miniature and Icon Painting in the Eleventh Century', *XIIIth International Congress of Byz. Studies* (Oxford, 1966), *Main Paper* VII; Paris, Bibliothèque Nationale, *Byzance et la France médiévale*, no. 21. S. Der Nersessian, 'Recherches sur les miniatures du Parisinus graecus 74', *Otto Demus Festschrift. J. d. österreich. Byzantinistik*, XXI (1972), 109 ff., remarks on the importance given to the representations of St John the Baptist, who was the patron of the monastery of Studius.

222. 10. A. Heisenberg, *Die Apostelkirche in Konstantinopel* (Leipzig, 1908); Constantine of Rhodes (with commentaries by E. Legrand and Th. Reinach), *Description des œuvres d'art et de l'église des Saints-Apôtres de Constantinople* (Paris, 1896); Nikolaos

Mesarites (ed. Glanville Downey), *Description of the Church of the Holy Apostles, Transactions of the American Philosophical Society*, XLVII, pt 6 (Philadelphia, 1957); R. Krautheimer, *Early Christian and Byzantine Architecture (Pelican History of Art)*, 3rd ed. (Harmondsworth, 1979), 432, note 78.

223. 11. S. Der Nersessian, *Aght'amar, Church of the Holy Cross* (Harvard University Press, 1965); Theodore Macridy, with contributions by A. H. S. Megaw, C. Mango, and E. J. W. Hawkins, 'The Monastery of Lips (Fenari Isa Camii)', *D.O.P.*, XVIII (1964), 251 ff.; D. Winfield, 'Some Early Medieval Figure Sculpture from North-East Turkey', *J. of the Warburg and Courtauld Institutes*, XXXI (1968), 33 ff.

12. L. A. Dournovo, *Armenian Miniatures* (London, 1961); S. Der Nersessian, *Manuscrits arméniens illustrés...* (Paris, 1936); *idem*, *Armenia and the Byzantine Empire* (Cambridge, Mass., 1945); Baltimore, The Walters Art Gallery, *Early Christian and Byzantine Art*, Catalogue (1947), no. 746.

224. 13. G. de Jerphanion, *Les Églises rupestres de Cappadoce* (Paris, 1925–36); Ch. Diehl, 'Les Peintures chrétiennes de la Cappadoce', *J. des Savants*, N.S. XXVI (1927), 97 ff.; N. and M. Thierry, *Nouvelles Églises rupestres de Cappadoce. Région de Hasan Daği* (Paris, 1963); Michael Gough, 'The Monastery Church of Eski Gümüş', *Archaeology*, XVIII (1965), 254 ff.; *idem*, 'The Monastery Church of Eski Gümüş. A Preliminary Report', *Anatolian Studies*, XIV (1964), 147 ff., 'The Monastery Church of Eski Gümüş. Second Preliminary Report', *Anatolian Studies*, XV (1965), 157 ff.; N. and M. Thierry, 'Ayvali kilisse ou pigeonnier de Gülli Dere: église inédite de Cappadoce', *C. Arch.*, XV (1965), 97 ff.; M. Restlé, *Byzantine Wall-Painting in Asia Minor* (Recklinghausen, 1967), *passim*; R. Cormack, 'Byzantine Cappadocia: the Archaic Group of Wall-Paintings', *J. of the British Arch. Association*, N.S. XXX (1967), 19 ff., who insists that the models for the Archaic Group cannot be derived from any one single source, such as local pre-iconoclastic art – their genesis is complex; N. Thierry, 'Quelques monuments inédits ou mal connus de Cappadoce. Centres de Maçan, Çaverşin et Mavrucan', *L'Information d'Histoire de l'Art*, IV, no. 1 (janvier-février, 1964), 7 ff.; *idem*, 'Études cappadociennes, Région du Hasan Dagi, Compléments pour 1974', *C. Arch.*, XXIV (1975), 183 ff.; 'L'Art monumental byzantin en Asie Mineure du XIe siècle au XIVe', *D.O.P.*, XXIX (1975), 75 ff.

226. 14. Beckwith, *Art of Constantinople*, 94 ff. and notes 23–5; S. Dufrenne, *L'Illustration des psautiers grecs du moyen âge* (Paris, 1966), I, 49 ff. I. Ševčenko, 'On Pantoleon the Painter', *Otto Demus Festschrift* (*op. cit.*, Note 9), 241 ff., insists that the Menologion Vat. gr. 1613 was executed by a team of miniaturists

and that any two miniatures 'signed' by different names, for instance by that of Pantoleon and Symeon of Blachernae, are surely products of two different hands, which provides a fixed starting point for stylistic and aesthetic judgements about that manuscript's artists. Pantoleon was active between 1001 and 1016, working on an imperial commission. This suggests that Vat. gr. 1613 was created in the latter part of Basil II's reign, and is thus close in date to the Venice Psalter (Marcian. gr. 17).

229. 15. Goldschmidt and Weitzmann, *Byzantinische Elfenbeinskulpturen*, 11, nos. 1–7, 9, 10, 11, 13; J. Beckwith, *The Veroli Casket* (London, 1962).

232. 16. E. Diez and O. Demus, *Byzantine Mosaics in Greece, Hosios Lucas and Daphni* (Harvard University Press, 1931); V. N. Lazarev, *History of Byzantine Painting* (Moscow, 1948) (in Russian), 1, 91 ff., 11, figures 106–11; G. C. Miles, 'Byzantium and Arabs: Relations in Crete and the Aegean Area', *D.O.P.*, XIII (1964), 3 ff.; O. Demus, *Byzantine Mosaic Decoration* (London, 1948), 36 ff.; A. Frolow, 'La Mosaïque murale byzantine', *Byzantinoslavica*, XII (1951), 179 ff.; Tsima-Papachadzidaki, *Osios Loukas*, 3 vols (Athens, n.d.), photographic review without text; E. Stikas, *L'Église byzantine de Christianou en Triphylie et les autres édifices du même type* (Paris, 1951); M. Chatzidakis, *Byzantine Monuments of Attica and Boeotia* (Athens, 1956), 12–17, 26–7; M. Chatzidakis, 'À propos de la date et du fondateur de Saint-Luc', *C. Arch.*, XX (1969), 127 ff.; *idem*, 'Précisions sur le fondateur de Saint-Luc', *C. Arch.*, XXII (1972), 87–8; E. Stikas, Τὸ οἰκοδομικον χρονικὸν της Μονῆς Ὁςιου Λουκᾶ (Athens, 1970); A. Grabar, 'La Décoration architecturale de l'église de la Vierge à Saint-Luc en Phocide et les débuts des influences islamiques sur l'art byzantin en Grèce', *Comptes Rendus de l'Académie des Inscriptions et Belles-Lettres* (1971); M. Chatzidakis, 'Particularités iconographiques du décor peint des chapelles occidentales de Saint-Luc en Phocide', *C. Arch.*, XXII (1972), 89 ff.; E. Stikas, 'Nouvelles Observations sur la date de construction du Catholikon et de l'Église de la Vierge du monastère de Saint-Luc en Phocide', *Corso* (1972), 311–30.

233. 17. Beckwith, *Art of Constantinople*, 104 ff. and note 39; Michael Psellus, trans. E. R. A. Sewter, *Chronographia* (London, 1953), 85 ff.

235. 18. O. Wulff, 'Die Mosaiken der Nea Moni von Chios', *Byz. Z.*, XXV (1925), 115 ff.; A. Orlandos, *Les Monuments byzantins de Chios (album)* (Athens, 1930); Lazarev, *History of Byzantine Painting*, 1, 91 ff., 11, figures 102–5.

237. 19. Beckwith, *Art of Constantinople*, 106 and note 42; V. N. Lazarev, *Old Russian Murals and Mosaics* (London, 1966), 31 ff., 225 ff.; G. N. Logvin, *Kiev's*

Hagia Sophia: state architectural-historical monument (Kiev, 1971).

20. Lazarev, *op. cit.* (Note 19), 47 ff.

239. 21. F. Forlati, C. Brandi, and Y. Froidevaux, *Saint Sophia of Ochrida. Preservation and Restoration of the Building and its Frescoes* (*Unesco Museums and Monuments*, IV) (Paris, 1953); R. Ljubinkovič, *La Peinture médiévale à Ohrid. Recueil de travaux. Édition spéciale* (Ochrid, 1961); *idem*, 'La Peinture murale en Serbie et Macédoine aux XIe et XIIe siècles', *Corso* (1962), 405 ff.; A. Grabar, 'Les Peintures murales de Sainte-Sophie d'Ochrid', *C. Arch.*, XV (1965), 257 ff.; de Jerphanion, *Les Églises rupestres*, 1, 377 ff. Restlé, *op. cit.* (Note 13), 1, 64, dates Qaranleq kilisse between 1200 and 1210.

22. Beckwith, *Art of Constantinople*, 106–7 and note 43. For a brief résumé of the problems presented by Byzantine art in the eleventh century cf. A. Grabar, 'L'Art byzantin au XIe siècle', *C. Arch.*, XVII (1967), 257 ff.

CHAPTER 10

241. 1. *Cambridge Medieval History*, IV, pt 1, chapter v; Romilly Jenkins, *Byzantium: The Imperial Centuries, A.D. 610 to 1071* (London, 1966), 333 ff.

2. *Byzantine Art And European Art, Lectures* (Athens, 1966), especially Steven Runciman, 'Byzantine Art and Western Mediaeval Taste', 1 ff.; H. Buchthal, 'Byzantium and Reichenau', 21 ff.; W. F. Volbach, 'Byzanz und sein Einfluss auf Deutschland und Italien', 89 ff.; E. Kitzinger, 'Norman Sicily as a Source of Byzantine Influence on Western Art in the Twelfth Century', 121 ff.; *idem*, 'The Byzantine Contribution to Western Art of the Twelfth and Thirteenth Centuries', *D.O.P.*, XX (1966), 25 ff.

On Byzantine pottery, cf. D. Talbot Rice, *Byzantine Glazed Pottery* (Oxford, 1930); *idem*, 'Byzantine Polychrome Pottery', *C. Arch.*, VII (1954), 69 ff.; *idem*, 'The Pottery of Byzantium and the Islamic World', *Studies in Islamic Art and Architecture in honour of Professor K. A. C. Creswell* (The American University in Cairo Press, 1965), 194 ff.; *idem*, 'Late Byzantine Pottery at Dumbarton Oaks', *D.O.P.*, XX (1966), 207 ff.; E. S. Ettinghausen, 'Byzantine Tiles from the Basilica in the Topkapu Sarayi and St John of Studios', *C. Arch.*, VII (1954), 79 ff.; E. Coche de la Fierté, 'Décors en céramique byzantine au musée du Louvre', *C. Arch.*, IX (1957), 187 ff.

On Byzantine glass, cf. G. R. Davidson, 'A Medieval Glass Factory at Corinth', *American J. of Arch.*, XLIV (1940), 297 ff.; A. H. S. Megaw, 'A Twelfth-Century Scent Bottle from Cyprus', The Corning Museum of Glass, N.Y., *J. of Glass Studies*, I (1959), 59 ff.; *idem*,

'Notes on Recent Work of the Byzantine Institute in Istanbul', *D.O.P.*, XVII (1963), 333, for painted window glass found at Pantocrator and Christ in Chora; J. Philippe, 'La Verrerie des pays byzantins', *Corso* (1966), 391 ff.

245. 3. J. Beckwith, *Art of Constantinople* (London, 1961), 114 ff. with notes; S. Der Nersessian, 'A Psalter and New Testament Manuscript at Dumbarton Oaks', *D.O.P.*, XIX (1965), 155 ff.; K. Weitzmann, 'The Constantinopolitan Lectionary, Morgan 639', *Studies in Art and Literature for Belle da Costa Greene* (Princeton, 1959), 358 ff.; *Byzantine Art*, Catalogue (Athens, 1964), no. 310; and cf. H. Buchthal, 'An Illuminated Byzantine Gospel Book of about 1100 A.D.', *Special Bull. of the National Gallery of Victoria* (1961), 1 ff.; C. Meredith, 'The Illustration of Codex Ebnerianus', *J. of the Warburg and Courtauld Institutes*, XXIX (1966), 419 ff.; I. Spatharakis, *The Portrait in Byzantine Illuminated Manuscripts* (Leiden, 1976), 107 ff., for Paris Coislin 79.

247. 4. Beckwith, *op. cit.*, 117 ff.; *idem*, ' "Mother of God showing the way", A Byzantine Ivory Statuette of the Theotokos Hodegetria', *The Connoisseur*, CL (1962), 2 ff.

250. 5. O. Demus, *The Church of San Marco in Venice* (*Dumbarton Oaks Studies*, VI) (1960), 23 ff.; R. Hahnloser (ed.), *Il Tesoro di San Marco*, I, *La Pala d'Oro* (Florence, 1965); *idem*, '*Magistra latinitas* und *peritia greca*', *Festschrift von Einem* (Berlin, 1965), 77 ff., and cf. O. Demus's review, 'Zur Pala d'Oro', *J. der Österreich. byz. Gesellschaft*, XVI (1967), 263 ff.; J. de Luigi-Pomorišac, *Les Émaux byzantins de la Pala d'Oro de l'église de Saint-Marc à Venise* (Zürich, 1966), which should be read with some reserve; J. Deér, 'Die byzantinisierenden Zellenschmelze der Linköping-Mitra und ihr Denkmalkreis', *Tortulae, Studien zu altchristlichen und byz. Monumenten* (*Römische Quartalschrift für christliche Altertumskunde und Kirchengeschichte*, 30 Supplementheft) (Rome-Freising-Vienna, 1966), 49 ff.; *Byzantine Art, IXth Exhibition of the Council of Europe*, Catalogue (Athens, 1965), no. 474, for the Wittelsbach plaque; A. Banck, *Byzantine Art in the Collections of the USSR* (Leningrad, Moscow, 1966), nos. 185, 186; A. Frolow, 'Un Bijou bizantine inédit', *Mélanges offerts à René Crozet* (Poitiers, 1966), 625 ff.; S. Arpad, *Das Esztergomer (Graner) Reliquarium* (Budapest, 1959) (in Hungarian and German); Wessel, *op. cit.* (Chapter 8, Note 12), nos, 46, 49.

6. Beckwith, *Art of Constantinople*, 120 ff.; O. Demus, *The Mosaics of Norman Sicily* (London, 1949), 433; Runciman, 'Byzantine Art and Western Taste', 11–12; C. Mango and E. J. W. Hawkins, 'Report on Field Work in Istanbul and Cyprus 1962–1963', *D.O.P.*, XVIII (1964), 328 ff. For the Kalenderhane Camii cf. Cecil L. Striker and Y. Doğan Kuban, 'First

Preliminary Report', *D.O.P.*, XXI (1967), 267 ff.; 'Second Preliminary Report', *D.O.P.*, XXII (1968), 185 ff.; 'Third and Fourth Preliminary Reports', *D.O.P.*, XXV (1971), 251 ff.

254. 7. E. Diez and O. Demus, *Byzantine Mosaics* (*op. cit.*, Chapter 9, Note 16), 92 ff.; M. Chatzidakis, *Byzantine Monuments in Attica and Boeotia* (Athens, 1956), 17 ff. A. Frolow, 'La Date des mosaïques de Daphni', *Corso* (1962), 295 ff., argues for a date before Hosios Loukas and the Nea Moni, but this is surely not acceptable.

256. 8. G. Galassi, 'I Musaici di Kiev e San Michele arte russa', *Felix Ravenna*, LXX, fasc. 19 (1956), 5 ff.; V. N. Lazarev, *Old Russian Murals and Mosaics* (London, 1966), 67 ff.; *idem*, *Mosaics from St Michael's Church* (Moscow, 1966) (in Russian with French résumé).

9. Lazarev, *op. cit.*, 53 ff.

257. 10. Beckwith, *Art of Constantinople*, 121 ff.; Demus, *Mosaics of Norman Sicily*, 389–90.

11. S. Y. Amiranashvili, *A History of Georgian Art*, I (Moscow, 1950), 188 ff., plates 74-6 (in Russian); *idem*, *A History of Georgian Mural Painting*, I (Tiflis, 1957), 115 ff., plates 97-116 (in Russian); G. Alibegashvili, *Miniatures des manuscrits géorgiens des XI^e-XIII^e siècles* (summary in French) (Tiflis, Akademiya Nauk Gruzinskii S.S.R., 1973); N. and M. Thierry, 'Peintures du X^e siècle en Géorgie méridional et leurs rapports avec la peinture byzantine d'Asie Mineur', *C. Arch.*, XXIV (1975), 73 ff.; N. Thierry, 'La Peinture médiéval géorgienne', *Corso* (1973), 409 ff.; *idem*, 'La Peinture médiévale arménienne', *ibid.*, 397 ff.

258. 12. E. Kitzinger, 'On the Portrait of Roger II in the Martorana in Palermo', *Proporzioni*, III (1950), 30 ff.; Demus, *Mosaics of Norman Sicily*, 3 ff., 25 ff.

259. 13. Demus, *op. cit.*, 3 ff., 375 ff.

262. 14. Demus, *op. cit.*, 25 ff., 245 ff., 396 ff.; E. Kitzinger, 'The Mosaics of the Cappella Palatina in Palermo', *Art Bull.*, XXXI (1949), 269 ff.; I. Beck, 'The First Mosaics of the Cappella Palatina in Palermo', *Byzantion*, XL (1970), 119 ff.

267. 15. Demus, *op. cit.*, 73 ff., 265 ff., 396 ff.

271. 16. Demus, *op. cit.*, 91 ff., 271 ff., 418 ff.; E. Kitzinger, *The Mosaics of Monreale* (Palermo, 1960).

274. 17. G. Millet, *La Peinture du moyen âge en Yougoslavie* (Paris, 1954), plate 15, figures 3, 4; M. Rajković, *La Peinture de Neresi, Sbornik Radova S.A.N. XLIV* (Viz. Inst. III, Belgrade, 1955), 195 ff., résumé in French, 206 ff.; G. Gsodam, 'Die Fresken von Nerezi', *Festschrift W. Sus-Zalozieckzy zum 60. Geburtstag* (Graz, 1956), 60 ff., who argues for an early-thirteenth-century date for the frescoes. Neither Kitzinger (*Mosaics of Monreale*, 75 ff., 104, 131, note 142) nor Demus ('Studien zur byzantinischen Buchmalerei des 13. Jahrhunderts', *J. der österreichischen byz. Gesell-*

schaft, IX (1960), 84, note 26) agrees with Miss Gsodam; R. Ljubinković, 'La Peinture murale en Serbie et en Macédoine aux XIe et XIIe siècles', *Corso* (1962), 435 ff.; S. Pelikanides, *Kastoria*, I (Salonika, 1953), plates 1-42, 43-62; A. Orlandos, *Archeion ton byzantinon mnemeion tes Hellados*, IV (1938), 59 ff.; M. Rajković, 'Les Fresques de Kurbinovo et leur auteur', *Académie Serbe des Sciences: Recueil des Travaux*, XLIV (*Institut d'Études byz.*, III) (1955), 207 ff.; A. Nikolovski, *The Frescoes of Kurbinovo* (Belgrade, 1961); L. Hademann-Misguich, *Kurbinovo: les fresques de Saint-Georges et la peinture byzantine du XIIe siècle* (Brussels, 1975).

K. Weitzmann, 'Eine spätkomnenische Verkündigungsikone des Sinai und die zweite byzantinische Welle des 12. Jahrhunderts', *Festschrift von Einem* (Berlin, 1965), 299 ff.

A. Grabar, *La Peinture religieuse en Bulgarie* (Paris, 1928); *idem*, 'Une Décoration murale byzantine au monastère de Batchkovo en Bulgarie', *Bull. de l'Institut arch. Bulgare*, II (1923-4), I ff., plates 1-12.

V. N. Lazarev, *The Art of Novgorod* (Moscow, 1947) (in Russian); *idem*, *Frescoes of Old Ladoga* (Moscow, 1960) (in Russian); *idem*, *Old Russian Murals and Mosaics* (London, 1966), 80 ff., 107 ff.; G. H. Hamilton, *Art and Architecture of Russia (Pelican History of Art)*, 2nd ed. (Harmondsworth, 1975), 56 ff.

G. de Jerphanion, *Les Églises rupestres de Cappadoce* (Paris, 1925), I, 377 ff.

275. 18. M. Sacopoulo, *Asinou en 1106 et sa contribution à l'iconographie* (Brussels, 1966); A. and J. A. Stylianou, *The Painted Churches of Cyprus* (The Research Centre, Greek Communal Chamber, Cyprus, 1964); A. H. S. Megaw and E. J. W. Hawkins, 'The Church of the Holy Apostles at Perachorio, Cyprus, and its Frescoes', *D.O.P.*, XVI (1962), 279 ff.; G. A. Soteriou and A. Leukoma, *The Byzantine Monuments of Cyprus* (Athens, 1935) (in Greek); A. Stylianou, 'The Frescoes of the Church of the Panagia tou Arakou, Lagoudera, Cyprus', *Acts of IXth International Congress of Byz. Studies* (Salonika, 1953), I, 459 ff. (in Greek); A. H. S. Megaw, 'Twelfth-Century Frescoes in Cyprus', *Actes du XIIe Congrès International d'Études Byz., Ochrid (10-16 septembre 1961)* (Belgrade, 1964), III, 257 ff.; C. Mango and E. J. W. Hawkins, 'The Hermitage of St Neophytos and its Wall Paintings', *D.O.P.*, XX (1966), 119 ff.; Wessel, *op. cit.* (Chapter 8, Note 12), no. 65; David C. Winfield, 'The Church of the Panagia tou Arakos, Lagoudera' (first preliminary report, 1968, with an appendix by Cyril Mango), *D.O.P.*, XXIII and XXIV (1969 and 1970), 377 ff. The first inscription of 1192 is under a painting of the imprint of Christ's face upon the Holy Tile. This painting and the lettering are in the same style as all the other paintings of the naos and the

sanctuary. The paintings of the apses, however, are by a different master whose work is characterized by bold and more simplified lines. It is too soon to say whether or not there may be a difference of date. Some of the paintings in the narthex and in the ground register of the naos appear to date from 1333 (cf. Asinou). See also David C. Winfield, 'Reports on Work at Monagri, Lagoudera, and Hagios Neophytos, Cyprus, 1969/1970', *D.C.P.*, XXV (1971), 259 ff.

A. and J. Stylianou, *Panagia Phorbiotissa Asinou* (Nicosia-Cyprus, 1973), 58, identify from the inscriptions Nicephorus Magistros - the title denotes that he was a judge - and Yephyra, presumably his wife, who died on 15 December 1099. A second inscription gives the date of the painting of the church to 1105/6, and adds 'the Strong' to the name of the founder. Apparently Nicephorus retired to his estates soon after the erection of the church, turned it into a monastic establishment, became its first abbot under the name of Nicholaos, and died there in 1115. Of the original decoration of the church of 1105/6 about two thirds survive today: that in the western bay of the nave, most of that in the bema, and some more. Cf. pp. 65-6 for paintings in the south apse and an inscription giving the date 1332/3. In a shallow niche above the inscription is a representation of the Panagia Blachernitissa bearing the unusual appellation Phorbiotissa; on the left of the Virgin is depicted the donor priest-monk Barnabas. The appellation Phorbiotissa derives either from the plant ephorbium or from the word phorbe, which means pasture. See also A. H. S. Megaw, 'Byzantine Architecture and Decoration in Cyprus: Metropolitan or Provincial?', *D.O.P.*, XXVIII (1974), 59 ff.

277. 19. The icon of Our Lady of Vladimir was brought from Constantinople and was first at Vyshgorod (near Kiev). In 1155 the icon went to Vladimir and in 1395 to Moscow, where it was placed in the Cathedral of the Assumption in the Kremlin. Cf. A. Banck, *Byzantine Art in the Collections of the USSR*, figures 223-4 and notes in Russian and English. For the icon of the Virgin and Child at Chilandari on Mount Athos, cf. N. P. Kondakov, *Monuments of Christian Art at Athos* (St Petersburg, 1902), plate XV (text in Russian); cf. also V. Djurić, 'Icone en mosaïque de la Vierge Hodigitria du monastère de Chilandari', *Zographe*, I (1966), 16 ff. (in Serbian and French). Chilandari was founded in 1198 by St Sava and St Simeon Nemanja, and they probably presented the icon. In 1201, when St Simeon was dying, the icon was brought to his bedside. For the icon on Mount Sinai, cf. G. and M. Soteriou, *Icons of Mount Sinai* (Athens, 1956), 85 ff. and plate 71 (in Greek). Cf. also K. Weitzmann, 'Thirteenth Century Crusader Icons on Mount Sinai', *Art Bull.*, XLV (1963), 196 and

figure 23.

For a mosaic fragment of the Archangel Michael in the church of St Mary Kyriotissa (Kalenderhane Camii) in Istanbul which may date from about 1180 cf. Cecil L. Striker and Y. Doğan Kuban, 'Work at Kalenderhane Camii in Istanbul: Second Preliminary Report', *D.O.P.*, XXI (1968), 185 ff.; H. Belting, 'Eine Gruppe Konstantinopler Reliefs aus dem 11. Jahrhundert', *Pantheon*, XXX (1972), 263 ff., for capitals in the eleventh-century church of Kariye Djami and the Victoria and Albert Museum serpentine relief, Sokullu Mehmet Pasha relief, San Marco Ascent of Alexander, and S. Dimitrios; R. Lange, *Die byzantinische Reliefikone* (Recklinghausen, 1964), and reviews by A. Grabar in *C. Arch.*, XV (1965), 276 ff., O. Demus in *Byz. Z.*, LIX (1966), 386 ff., and H. Belting in *Byzantina*, I (1970), 238 ff.

20. Demus, *Mosaics of Norman Sicily*, pp. 178 ff.

While Maio of Bari was Grand Vizir to William I between 1154 and 1160, a scriptorium at Palermo was producing illuminated manuscripts deriving their main inspiration from the scriptorium of the Holy Sepulchre at Jerusalem, but Byzantine models were also at hand. Cf. H. Buchthal, 'The Beginnings of Manuscript Illumination in Norman Sicily', *Studies in Italian Medieval History presented to Miss E. M. Jamison* (*Papers of the British School at Rome*, XXIV, N.S. XI) (1956), 78 ff. Subsequently under Richard Palmer, Bishop of Syracuse, and in 1182 Archbishop of Messina, a scriptorium at Messina produced illuminated manuscripts in an eclectic style which owed much to the art of the Crusading Kingdom, with a strong Byzantine element. Cf. H. Buchthal, 'A School of Miniature Painting in Norman Sicily', *Late Classical and Mediaeval Studies in Honor of Albert Mathias Friend, Jr* (Princeton University Press, 1955), 312 ff.; cf. also H. Buchthal, 'Some Sicilian Miniatures of the Thirteenth Century', *Miscellanea pro Arte; Hermann Schnitzler zur Vollendung der 60. Lebensjahres* (Düsseldorf, 1965), 185 ff.; *idem*, 'Notes on a Sicilian Manuscript of the Early Fourteenth Century', *Essays in the History of Art presented to Rudolf Wittkower* (London, 1967), 36 ff.

For a fourteenth-century Sicilian copy of the Chronicle of John Skylitzes, cf. S. C. Estopañan, *Skylitzes Madrilensis*, I (Barcelona–Madrid, 1965); A. D. Lattanzi, *Lineamenti di storia della miniatura in Sicilia* (Florence, 1965).

For the art of the Crusading Kingdom, cf. T. S. R. Boase, 'The Arts in the Latin Kingdom of Jerusalem', *J. of the Warburg Institute*, 11 (1938–9), 14 ff.; *idem*, *Castles and Churches of the Crusading Kingdom* (Oxford University Press, 1967); H. Buchthal, *Miniature Painting in the Latin Kingdom of Jerusalem* (Oxford, 1957); K. Weitzmann, 'Thirteenth-Century Crusader

Icons on Mount Sinai', *Art Bull.*, XLV (1963), 179 ff.; *idem*, 'Icon Painting in the Crusader Kingdom', *D.O.P.*, XX (1966), 49 ff.

Mosaics in the church of the Nativity at Bethlehem were restored under the patronage of the Emperor Manuel and King Amalric of Jerusalem in 1169 'by the hand of Ephrem the monk, painter and mosaic worker', as the Greek inscription states in the apse. Unfortunately the mosaics today are in a ruinous state, but the choice of subjects appears to have followed the Byzantine canon. On the north wall of the nave the seven ecumenical councils were restored with Latin inscriptions and a procession of angels; one of the angel panels is inscribed with the name Basilius Pictor, and the Council of Constantinople is also signed with the initials B.S. The same or another Basilius was working in the scriptorium of the Holy Sepulchre at Jerusalem. The latter is believed to be a Western artist who had been sent to school at Constantinople and returned to execute the Byzantine pastiches in the Psalter of Queen Melisende produced in the years 1131–43. There were Armenians working in the scriptorium. The scribe of the Paris Missal (Bibl. Nat. lat. 12056) was an Armenian who could write Latin. Queen Melisende was after all the daughter of an Armenian princess.

For Sicilian enamel and goldsmith work, cf. A. Lipinsky, 'Sizilienische Goldschmiedekunst in Zeitalter der Normannen und Staufer', *Das Münster*, X (1957), 73 ff., 158 ff., but see also J. Deér's article on the Linköping Mitre listed under Note 5.

For Sicilian craft in ivory, cf. E. Kühnel, 'Sizilien und die islamische Elfenbeinmalerei', *Z. für bildende Kunst*, XXV (1914), 162 ff.; P. B. Cott, *Siculo-Arabic Ivories* (Princeton, 1939).

Sicilian textiles are with one or two signal exceptions highly controversial, and much that has been written about them does not stand the test of time or an objective scrutiny. However, cf. G. Migeon, *Manuel d'art musulman* (Paris, 1927), II, 309 ff.; A. F. Kendrick, 'Sicilian Woven Fabrics of the Twelfth, Thirteenth and Fourteenth Centuries', *Magazine of the Fine Arts*, I (1905), 36 ff., 124 ff.; U. Monneret de Villard, 'La Tessitura palermitana sotto i Normanni e i suoi rapporti con l'arte bizantina', *Miscellanea Giovanni Mercati*, III (Città del Vaticano, 1946), 8 ff.; R. B. Serjeant, 'Material for a History of Islamic Textiles up to the Mongol Conquest', *Ars Islamica*, XV–XVI (1951), 55 ff.; R. Grönwoldt, *Webereien und Stickereien des Mittelalters* (Kestner-Museum, Hannover, 1964), no. 31.

278. 21. M. Brunetti, S. Bettini, F. Forlati, and G. Fiocco, *Torcello* (Venice, 1940); O. Demus, 'Studies among the Torcello Mosaics', *Burlington Magazine*, LXXXII–LXXXIII (1943), 136 ff., LXXXIV–LXXXV

(1944), 41 ff., 195 ff.; I. Andreescu, 'Torcello. I Le Christ inconnu. II Anastasis et Jugement Dernier: Têtes vraies, têtes fausses', *D.O.P.*, XXVI (1972), 185 ff.; 'Torcello, III La chronologie relative des mosaïques parietales', *D.O.P.*, XXX (1976), 245 ff.; K. Wessel, 'Die byzantinische Emailtafel in der Reichen Kapelle der Münchener Residenz', *Byzantinische Forschungen*, III, *Festschrift Franz Dölger* (Amsterdam, 1968), 235 ff.

282. 22. O. Demus, *The Church of San Marco in Venice (Dumbarton Oaks Studies*, VI) (1960); *idem, Die Mosaiken von S. Marco in Venedig* (Baden bei Wien, 1935); S. Bettini, *Mosaici Antichi di San Marco a Venezia* (Bergamo, 1946); P. Toesca and F. Forlati, *The Mosaics in the Church of St Mark in Venice* (London, 1958); H. Buchwald, 'The Carved Stone Ornament of the High Middle Ages in San Marco Venice', *J. der österreichischen byz. Gesellschaft*, XI-XII (1962-3), 169 ff., XIII (1964), 137 ff.

CHAPTER 11

283. 1. S. Runciman, *A History of the Crusades*, III (Cambridge University Press, 1954); *Cambridge Medieval History*, IV, chapter VI.

284. 2. *Cambridge Medieval History*, IV, chapter VII.

3. *Cambridge Medieval History*, IV, chapter XII; S. Radojčić, *Les Maîtres de l'ancienne peinture serbe* (Belgrade, Académie Serbe des Sciences, 1955), 10-11, figures 3, 4, p. 114; G. Millet, *La Peinture du moyen âge en Yougoslavie (Serbie, Macédoine et Monténégro)*, fasc. III, *Album presenté par A. Frolow* (Paris, 1962); R. Hamann-Mac Lean and Horst Hallensleben, *Die Monumentalmalerei in Serbien und Makedonien vom 11. bis zum frühen 14. Jahrhundert (Marburger Abhandlungen zur Geschichte und Kultur Osteuropas*, Band 3-5) (Giessen, 1963), 19-20; cf. also S. Radojčić, 'Die serbische Ikonenmalerei vom 12. Jahrhundert bis zum Jahre 1459', *J. der österreichischen byz. Gesellschaft*, V (Graz-Cologne, 1956), 64-6.

286. 4. N. Okunev, 'Mileševo', *Byzantinoslavica*, VII (Prague, 1937), 33 ff.; S. Radojčić, *Mileševa* (Belgrade, 1963).

288. 5. N. Okunev, 'Les Peintures murales de Sopoćani', *Byzantinoslavica*, I (Prague, 1929), 119 ff.; V. Djurić, *Sopoćani* (Belgrade, 1963).

289. 6. A. Grabar, *La Peinture religieuse en Bulgarie* (Paris, 1928); P. Schweinfurth, *Die Fresken von Bojana* (Mainz and Berlin, 1965).

295. 7. S. Der Nersessian, *The Chester Beatty Library, A Catalogue of the Armenian Manuscripts* (Dublin, 1958); *idem, Armenian Manuscripts in the Freer Gallery of Art* (Washington, 1963); L. A. Dournovo, *Armenian Miniatures* (London, 1961); *Catalogue of Twenty-three Important Armenian Illuminated Manuscripts* (Sotheby's Sale, 14 March 1967; the sale did not take place). Cf. also S. Der Nersessian, *Armenia and the Byzantine Empire* (Harvard University Press, 1945), chapter V; for Cilician metalwork, *idem, 'Le Reliquaire de Skevra et l'orfèvrerie cilicienne aux XIIe et XIVe siècles', *Revue des études arméniennes*, N.S. I (1964), 121 ff. The Skevra triptych was made at Skevra in 1243 by the order of Bishop Constantine. Apart from a representation of Christ on the Cross, the wings are decorated with the Annunciation and busts of saints, and there is a portrait of King Het'um II and a long inscription. The author also refers to the Gospel Book and cover at Antélias (Lebanon) – the manuscript was executed at Hromkla in 1248 for Bishop Step'anos, who in 1254 added the silver covers; a Gospel book and cover at Yerevan (Matenadaran, no. 7690) – the manuscript was executed at Hromkla in 1249 for the Catholicos Constantine I, who added the silver-gilt covers in 1255; a silver cross on a Gospel cover in the Armenian Patriarchate at Istanbul; and a silver-gilt Gospel cover dated 1334 added to a Gospels illustrated by Sargis Pidzak in 1332 (Jerusalem, Armenian Patriarchate no. 2469).

297. 8. Christian Walters, 'Beobachtungen am Freisinger Lukasbild', *Kunstchronik*, XVII (1964), 85 ff.; G. and M. Soteriou, *Icones du Mont Sinaï* (Athens, 1956), II, plates 173 ff.; J. Stubblebine, 'Two Byzantine Madonnas from Calahorra, Spain', *Art Bull.*, XLVIII (1966), 379 ff.; *idem, 'Byzantine Influence on Thirteenth-Century Italian Painting', *D.O.P.*, XX (1967), 85 ff.; *Byzantine Art, IXth Council of Europe Exhibition*, Catalogue (Athens, 1964), 227 ff.; *L'Art Byzantin du XIIIᵉ siècle:* Symposium de Sopocani, 1965 (Belgrade University, 1967), especially M. Chatzidakis, 'Aspects de la peinture murale du XIIIᵉ siècle en Grèce', 59 ff.; A. Xyngopoulos, 'Icones du XIIIᵉ siècle en Grèce', 75 ff.; V. S. Djurić, 'La Peinture murale serbe au XIIIᵉ siècle', 145 ff.

Art et société à Byzance sous les Paléologues: Actes du colloque organisé par l'Association Internationale des Études Byzantines à Venise en septembre 1968. Bibliothèque de l'Institut Hellénique d'Études Byzantines et Post-Byzantines de Venise (Venice, 1971), especially A. Xyngopoulos, 'Les Fresques de l'église des Saints Apôtres à Thessalonique', 83 ff.; T. Velmans, 'Le Portrait dans l'art des Paléologues', 91 ff.; H. Belting, 'Die Auftraggeber der spätbyzantinischen Bildhandschrift', 149 ff.; V. S. Djurić, 'L'Art des Paléologues et l'état serbe. Rôle de la cour et de l'église serbes dans la première moitié du XIVᵉ siècle', 177 ff.

H. Belting, *Das illuminierte Buch in der spätbyzantinischen Gesellschaft (Abhandlung der Heidelberger Akademie der Wissenschaften, Phil. Hist. Klasse)* (Heidelberg, 1970); 'Zur Skulptur aus der Zeit 1300

in Konstantinopel', *Münchner J. der bildenden Kunst*, 3rd series, XXIII (1972), 63 ff.

S. Pelikanides, *Kalliergis* (Athens, 1973), for the frescoes in the Church of the Resurrection executed by Kalliergis and his brothers at Veroia. The church was dedicated by the Patriarch, possibly Nephon I, between September and April 1315 during the reign of Andronicus II Palaeologus.

301. 9. K. Weitzmann, 'Constantinopolitan Book Illumination in the Period of the Latin Conquest', *Gazette des Beaux Arts*, XXV (1944), 196 ff.; O. Demus, 'Studien zur byzantinischen Buchmalerei des 13. Jahrhunderts', *J. der österreichischen byz. Gesellschaft*, IX (1960), 77 ff.; H. R. Willoughby, 'Codex 2400 and its Miniatures', *Art Bull.*, XV (1933), 3 ff.; E. C. Colwell and H. R. Willoughby, *The Four Gospels of Karahissar* (Chicago, 1936); O. Demus, *The Mosaics of Norman Sicily* (London, 1949), 435, 441, note 112; R. Hamann-Maclean, 'Der Berliner codex graecus quarto 66 und seine nächsten Verwandten als Beispiele der Stilwandel im frühen 13. Jahrhundert', *Festschrift Usener* (Marburg a. d. Lahn, 1967), 225 ff.; H. Buchthal, 'Notes on Some Early Palaeologan Miniatures', *Kunsthistorische Forschungen Otto Pächt zu ehren* (Salzburg, 1972), 36 ff.; idem, 'Illuminations from an Early Palaeologan Scriptorium', *Otto Demus Festschrift, J. d. österreich. Byzantinistik*, XXI (1972), 47 ff.; H. Belting, 'Zum Palatina-Psalter des 13. Jahrhunderts', *ibid.*, 17 ff.; H. Buchthal, 'Toward a History of Palaeologan Illumination', *The Place of Book Illumination in Byzantine Art* (Princeton, 1975), 143 ff.

10. G. Millet and D. Talbot Rice, *Byzantine Paintings at Trebizond* (London, 1936); S. Ballance, 'The Byzantine Churches of Trebizond', *Anatolian Studies*, X (1960), 141 ff.; D. Talbot Rice (ed.), *The Church of Saint Sophia at Trebizond* (Edinburgh University Press, 1968), establishes that the church was built by the Emperor Manuel I Comnenus of Trebizond (1238-63) soon after 1250 and was decorated about 1260.

A. K. Orlandos, *Hē Paragoritssa tēs Artēs* (Athens, 1921).

302. 11. *Cambridge Medieval History*, IV, chapters VII and VIII.

305. 12. J. Beckwith, *Art of Constantinople* (London, 1961), 134 and note 2; H. Belting and R. Naumann, *Die Euphemia-Kirche in Istanbul* (*Istanbuler Forschungen*, XXV) (Berlin, 1965); C. Mango and E. J. W. Hawkins, 'Report on Field Work in Istanbul and Cyprus. 1962-1963', *D.O.P.*, XVIII (1964), 319 ff.; G. Millet, *La Peinture du moyen âge en Yougoslavie*, fasc. I (Paris, 1962), XV; R. Ljubinković, *La Peinture médiévale à Ohrid, Recueil de travaux. Édition spéciale* (Okhrids Narodniot Muzej, 1961) (in Serbian and French); Horst Hallensleben, *Die Malerschule des*

Königs Milutin (*Marburger Abhandlungen zur Geschichte und Kultur*, Band 5) (Giessen, 1963), and cf. Cyril Mango's review in *Art Bull.*, XLVIII (1966), 439-40; D. Čornakov, *The Frescoes of the Church of St Clement* (Belgrade, 1961); G. Millet, *Monuments de l'Athos*, I, *Les Peintures* (Paris, 1927). M. Chatzidakis, *Byzantine Monuments in Attica and Boeotia* (Athens, 1956), 24, refers to work of the Macedonian school in the Protaton. S. Radojčić, 'Monuments artistiques à Chilandari', *Académie Serbe des Sciences, Institut d'Études Byz., Recueil des Travaux*, XLIV (Belgrade, 1955), 163 ff. (résumé in French, 190 ff.); P. Miljković-Pepek, *L'Œuvre des peintres Michel et Eutych* (Skoplje, 1967) (in Serbian and French); S. Kissas, 'La Famille des artistes thessaloniciens Astrapa', *Zograph*, V (1974), 35-7 (in Serbian with French résumé): 'en parlant d'une pièce provenant de Démétrios Triclinios, écrivain thessalonicien bien connu, sur Joannis Astrapa, copiste thessalonicien du XIVe siècle inconnu jusque récemment, l'auteur prouve l'origine thessalonicienne des peintres byzantins du même nom, Mihail Astrapa et Astrapa, le principal artiste de la Vierge Ljeviška, et conclut que les peintres appartiennent à la même famille thessalonicienne.'

307. 13. Paul Underwood, in *D.O.P.*, IX and X (1955-6), 298 ff.; XIV (1960), 215 ff.; C. Mango and E. J. W. Hawkins, in *D.O.P.*, XVIII (1964), 319 ff.; P. Schreiner, 'Eine unbekannter Beschreibung der Pammaristikoskirche (Fetiye Camii) und weitere Texte zur Topographie Konstantinopels', *D.O.P.*, XXV (1971), 217 ff.

309. 14. A. Xyngopoulos, 'The Mosaics of the Church of the Holy Apostles at Thessaloniki', *Arch. Ephemeris, 1932* (1934), 133 ff. (in Greek); idem, *La Décoration en mosaïque des Saints Apôtres de Thessalonique* (Thessaloniki, 1953); T. Velmans, 'Les Fresques de Saint-Nicolas Orphanos à Salonique et les rapports entre la peinture d'icones et la décoration monumentale au XIVe siècle', *C. Arch.*, XVI (1966), 145 ff.; M. Chatzidakis, 'Une Icone en mosaïque de Lavra', *Otto Demus Festschrift* (*op. cit.*, Note 9), 73 ff.

Byzantine Art, IXth Council of Europe Exhibition, Catalogue (Athens, 1964), 233 ff., for a selection of portable mosaics and the literature; A. V. Banck, *Byzantine Art in the Collections of the USSR* (Leningrad-Moscow, 1966), nos. 234, 249-51; idem, 'A Mosaic Icon in the Collection of N. P. Likhachev', *V. N. Lazarev Festschrift* (Moscow, Akademiya S.S.R. Institut Istorii Iskusstvo, 1960), 184 ff.; G. and M. Soteriou, *Icones du Mont Sinaï*, II, figures 70, 204; A. A. Vasiliev, 'The Historical Significance of the Mosaic of St Demetrius at Sassoferrato', *D.O.P.*, V (1950), 31 ff.; O. Demus, 'Two Palaeologan Mosaic Icons in the Dumbarton Oaks Collection', *D.O.P.*, XIV (1960), 89 ff.; C. Bertelli, 'The *Image of Pity* in

Santa Croce in Gerusalemme', *Essays in the History of Art presented to Rudolf Wittkower* (London, 1967), 40 ff.

319. 15. P. A. Underwood, *The Kariye Djami* (London, 1967), 3 vols: 1. *Historical Introduction and Description of the Mosaics and Frescoes*; 2. *The Mosaics* (plates); 3. *The Frescoes* (plates). 4. *Studies in the Art of the Kariye Djami and its Intellectual Background*, ed. Paul A. Underwood (London, 1975).

322. 16. H. Hallensleben, *Die Malerschule des Königs Milutin* (Giessen, 1965); P. J. Popović and V. R. Petković, *Monumenta serbica artus mediaevalis, Staro Nagoričino, Prača, Kalenić* (Belgrade, Srpska Akademija Nauka, 1933) (in Serbian and French); S. Radojčić, *Les Maîtres de l'ancienne peinture serbe* (Belgrade, Srpska Akademija Nauka, Arkeoliki Institut, III, 1955); 'Die Meister der altserbischen Malerei vom Endes des XII. bis zur Mitte des XV. Jahrhunderts', *Acts of IX International Congress of Byz. Studies, Salonika, 1953*, I (Athens, 1955), 433 ff.; L. Misković, 'Die Ikonen der griechischen Maler in Jugoslavien und in den serbischen Kirchen ausserhalb Jugoslaviens', *ibid.*, 301 ff.

324. 17. V. R. Petković and G. Bošković, *Monumenta serbica artis mediaevalis*, II, *Dečani* (Belgrade, Srpska Akademija Nauka, 1941) (summaries in French and German); S. Tomić and R. Nikolić, *Manasija: Istorija živopis* (Belgrade, Republički Zavod za Zaštitu Spomenika Kulture, VI, 1964) (1965); V. Djurić, 'Origine thessalonicienne des fresques du monastère de Resava', *Recueil des travaux de l'Institut d'Études Byz., No. 6* (Belgrade, 1960), 111 ff.; *idem*, 'Les Fresques de la chapelle du despote Jovan Uglješa à Vatopedi et leur valeur pour l'étude de l'origine thessalonicienne de la peinture de Resava', *Recueil des travaux de l'Instutut d'Études Byz., No. 7* (Belgrade, 1961), 125 ff.; *idem*, *Moravsko slikarstvo. La Peinture murale de l'école de la Morava* (in celebration of the 550th anniversary of the monastery of Resava) (Belgrade, 1968); D. Talbot Rice and S. Radojčić, *Yugoslavia, Mediaeval Frescoes* (New York Graphic Society, 1955); V. Djurić *et al.*, *L'École de la Morava et son temps. Symposium de Resava 1968* (Belgrade, 1972).

325. 18. A. Grabar, *La Peinture religieuse en Bulgarie* (Paris, 1928); T. Velmans, 'Les Fresques d'Ivanovo et la peinture byzantine à la fin du moyen âge', *J. des Savants* (janvier-mars 1965), 385 ff.; D. Panayotova, *Bulgarian Mural Paintings of the Fourteenth Century* (Sofia, 1966); B. D. Filov, *Les Miniatures de l'évangile du roi Jean Alexandre à Londres* (*Mon. Artis Bulg.*, III) (Sofia, 1934); L. Dujčev, *Les Miniatures de la chronique de Manassès* (Sofia, 1963); M. V. Ščepkina, *La Miniature bulgare au XIVe siècle, étude du Psautier Tomić* (Moscow, 1963) (in Russian).

A. Grabar and K. Mijatev, *Bulgaria, Mediaeval Wall-*

paintings (New York Graphic Society, 1961); V. N. Lazarev, *Pheophan Grek* (Moscow, 1961); G. M. Proxorov, 'A Codicological Analysis of the Illuminated *Akathistos* to the Virgin (Moscow, State Historical Museum, *Synodal Gr.* 429)', *D.O.P.*, XXVI (1972), 237 ff.; V. D. Lixačeva, 'The Illumination of the Greek Manuscript of the *Akathistos* Hymn (Moscow, State Historical Museum, *Synodal Gr.* 429)', *ibid.*, 253 ff. (commissioned by the Patriarch Philotheos Kokkinos, executed between 1355 and 1364 probably by Theophanes the Greek, and presented to the former Emperor John VI Cantacuzene, who was then a monk on Mount Athos); Elka Bakalova, 'Sur la peinture bulgare de la seconde moitié du XIVe siècle (1331-1393)', 61 ff.

329. 19. *Byzantine Art, IXth Council of Europe Exhibition*, Catalogue (Athens, 1964), 233 ff.; W. Felicetti-Liebenfels, *Geschichte der byzantinischen Ikonenmalerei von ihren Anfängen bis zum Ausklange unter Berücksichtigung der Maniera Greca und der italo-byzantinischen Schule* (Olten, 1956); G. and M. Soteriou, *Icones du Mont Sinaï* (Athens, 1956); S. Radojčić, *Icones de Serbie et de Macédoine* (Éditions Jugoslavija, n.d.); A. Xyngopoulos, 'Une Icone byzantine à Thessalonique', *C. Arch.*, III (1948), 114 ff.; T. Gerasimov, 'L'Icone bilatérale de Poganovo au musée archéologique de Sofia', *ibid.*, X (1959), 279 ff.; A. Xyngopoulos, 'Sur l'icone bilatérale de Poganovo', *ibid.*, XII (1962), 341 ff.; A. Grabar, 'Sur les sources des peintres byzantins des XIIIe et XIVe siècles. 3. Nouvelles recherches sur l'icone bilatérale de Poganovo', *ibid.*, XII (1962), 363 ff.

A. V. Banck, *Byzantine Art in the Collections of the USSR* (Leningrad-Moscow, 1966); V. N. Lazarev, 'Nouveaux Monuments de peinture byzantine du XIVe siècle', *Vizantiski Vremennik*, IV (1951), 122 ff. (in Russian); D. M. Nicol, 'Constantine Akropolites, A Prosopographical Note', *D.O.P.*, XIX (1965), 249 ff. S. Radojčić, 'Die serbische Ikonenmalerei vom 12. Jahrhundert bis zum Jahre 1459', *J. der österreichischen byz. Gesellschaft*, V (1956), 61 ff.; V. J. Djurić, 'Über den "Čin" von Chilandar', *Byz. Z.*, LIII (1960), 333 ff.

332. 20. *Byzantine Art, IXth Council of Europe Exhibition*, Catalogue (Athens, 1964), 325 ff.; J. Beckwith, *Art of Constantinople* (London, 1961), 147 ff. and notes; John Meyendorff, *Byzantine Hesychasm: historical, theological and social patterns* (London, 1974); I. Spatharakis, *The Portrait in Byzantine Illuminated Manuscripts* (Leiden, 1976), 184 ff. for the chrysobul of Andronicus II, 190 ff. for the Lincoln Typicon ('the compilation of the Typicon of Theodora and the foundation of the Convent of Certain Hope took place some time between 1328 and 1344 and so the manuscript (Lincoln Coll. gr. 55) was executed at a later

date, but still within the same period', p. 203). Euphrosyne took over from her mother and added a supplement to the Typicon.

339. 21. P. Johnstone, *Byzantine Tradition in Church Embroidery* (London, 1967); A. V. Banck, *Byzantine Art in . . . USSR (op. cit.)*, nos. 282, 285.

340. 22. G. Millet, *Monuments byzantins de Mistra* (Paris, 1910); G. N. Georgiades, *Ho Mustras, Album photographique de Mistra et ses monuments byzantins* (Athens, 1929); P. Kanellopoulos, *Mistra, das byzantinische Pompeii* (Munich, 1962); C. Delvoye, 'Mistra', *Corso* (1964), 115 ff.

343. 23. P. A. Underwood in *Studies in the History of Art dedicated to William E. Suida on his 80th Birthday* (London, 1959), 1 ff.; *idem*, 'Notes on the Work of the Byzantine Institute in Istanbul: 1957', *D.O.P.*, XIII

(1959), 225 ff.; S. Runciman, *The Fall of Constantinople 1453* (Cambridge University Press, 1965).

CHAPTER 12

344. 1. O. M. Dalton, *Byzantine Art and Archaeology* (Oxford, 1911), 34.

345. 2. G. Mathew, *Byzantine Aesthetics* (London, 1963), 1 ff.

3. C. Mango, 'Byzantinism and Romantic Hellenism', *J. of the Warburg and Courtauld Institutes*, XXVIII (1965), 29 ff.; I. Ševčenko, 'The Decline of Byzantium seen through the Eyes of its Intellectuals', *D.O.P.*, XV (1961), 169 ff.

346. 4. Mathew, *op. cit.*, 161.

GLOSSARY

Adventus. Arrival (of an Emperor).

Akakia. A silk purse filled with dust. Part of the imperial regalia.

Ambo. Pulpit.

Ampulla. Small flask.

Anastasis. Resurrection. Usually represented in Byzantine art by the Harrowing of Hell. .

Archon. Governor.

Arcosolium. A niche for a tomb.

Atrium. A colonnaded forecourt to a church.

Augustus, Augusta. Title given to the Emperor and Empress and sometimes to other members of the imperial family.

Basileus. King or Emperor.

Basket capital. A capital of hemispherical or nearly hemispherical shape decorated with a wicker design imitating a basket.

Bema. The chancel part of a Greek church.

Cartophylax. Keeper of manuscripts.

Catatheistae. The pendant ornaments on an imperial crown.

Catholicon. The nave of a Greek church.

Catholicos. An archbishop in the Orthodox Church with primate authority; the Patriarch of Armenia.

Chlamys. A short cloak fastened by a fibula or brooch on the right shoulder.

Chrysobul. An imperial letter or diploma granting privileges.

Ciborium. A free-standing canopy above an altar.

Codex. Book.

Colobium. A long, sleeveless tunic.

Conch. Top of a semicircular niche shaped like a shell.

Curoplates. A court official of high rank.

Deesis. Christ represented between the Virgin and St John the Baptist.

Diaconicon. In Byzantine churches a chamber to the south of the sanctuary serving as sacristy and vestry.

Diptych, consular, imperial, sacred. Two panels of ivory joined together, carved on one side with a representation of the Emperor, the Empress, or a Consul, and on the other side hollowed out to receive wax. The diptychs were issued as a rule by Consuls on taking office in the New Year. Sacred diptychs inscribed with the commemoration of the living and the dead were placed on the altar during the celebration of the Mass.

Dromon. A large Byzantine ship.

Epitaphion. A Byzantine liturgical cloth used in the Good Friday ceremonies.

Etimasia, Hetimasia. The preparation of the Throne of God (for the Last Judgement).

Exarchate. A district presided over by a governor owing allegiance to the Byzantine Emperor.

Exedra. Open recess.

Exonarthex. Byzantine churches sometimes have two narthices. The exonarthex is the outer chamber entered first by the visitor.

Ex voto. An offering made in pursuance of a vow.

Fibula. Brooch.

Flabellum. Liturgical fan.

Hieromonachos. A senior monk.

Himation. Tunic.

Hodegetria. Showing the Way. An attribute of the Virgin.

Hyperagathos. Most good, noble.

Iconoclast. Destroyer or breaker of images, opposed to images.

Iconodule. Servant of images, in favour of images.

Iconostasis. A screen separating the chancel from the main area of a Byzantine church, usually decorated with a number of icons.

Kanstrisios. A Byzantine official.

Kathisma. The imperial box at the Hippodrome.

Labarum. The Christian standard. A Roman military standard decorated with the monogram of Christ (☧) – Chi-Rho – probably introduced by Constantine the Great after his vision before the Battle of the Milvian Bridge (A.D. 312).

Lauraton. The imperial portrait set up in a hall of state or justice when the Emperor was not present.

Logothete. Counsellor to the Emperor, sometimes in command of the Treasury and the Privy Purse.

Loros. A jewelled stole worn only by those of imperial rank.

Maphorion. Veil.

Martyrium. Church built over the tomb of a martyr.

Menologium. Lives of Saints arranged according to the Church's calendar.

Monophysite. A heretic who believed that in the person of Christ there is only a single, and divine, nature as distinct from the Orthodox view of the double nature of Christ – human and divine.

Monothelite. A heretic who believed that Christ had only a single, and divine, will as distinct from the

Orthodox view of the double will of Christ – human and divine.

Naos. Church, temple, nave.

Narthex. Antechamber to the main body of a church.

Occursus. A meeting (with the Emperor).

Orans. A figure in an attitude of prayer.

Palladium. Originally the image or statue of Pallas which in the reign of Ilus fell from heaven at Troy and during the Trojan war was carried off by Ulysses and Diomed, because the fate of the city depended on the possession of this image. By analogy any sacred image of which the possession involved the fate of a city.

Pallium. Originally a covering or a cloak. In Christian times the election of a bishop entailed the reception of a pallium from the hands of the Pope. This was usually done at Rome, but at times the pallium was sent to a distant see.

Panachrantos. Immaculate.

Panagia. Most holy.

Pantocrator. Creator of All.

Parakoimomenos. A special kind of chamberlain who slept within call of the Emperor or the Empress.

Parecclesion. Side-chapel.

Pentapyrgion. Cupboard with five turrets, possibly five compartments.

Perpendulia. The pendant ornaments on an imperial crown.

Primicerion. A Byzantine official of high rank.

Profectio. A setting out or going away (on the part of the Emperor and usually in connexion with a campaign).

Proskomedia. The Offertory in the Greek Mass.

Proskynesis. An act of homage before the Emperor or his image, and later before the image of Christ, which entailed falling on to the knees and touching the ground with the forehead, the hands held out in supplication.

Prothesis. In Byzantine churches a room to the north of the sanctuary where the sacred elements of the Eucharist were prepared and stored.

Protodoviar. A Byzantine official.

Protospatharios. A Byzantine military rank.

Protostrator. A Byzantine General.

Protosynkellos. A chamberlain, a proctor.

Sacramentary. A book containing those passages in the Mass which are said by the officiating priest. For example, the Sacramentary contains the Canon of the Mass but not the readings from the Epistles or the Gospels which were read by the deacon and subdeacon and were set out in separate books arranged according to the Church calendar and known as lectionaries, evangeliaries, epistolaries, books of pericopes, etc.

Sakkos. A Greek liturgical vestment rather like a dalmatic.

Sebastocrator. A Byzantine Commander-in-chief.

Secreton. An office for secretarial work.

Skaramangion. A tunic. Part of the imperial regalia.

Soros. Reliquary.

Stemma. An imperial crown.

Strategos. A Byzantine General.

Stratopedarch. A Byzantine official of military rank who could also be a provincial governor.

Synkellos. A Prior, someone who looked after the economy of a monastery.

Synthronon. In a Byzantine church bench or benches reserved for the clergy arranged in a semicircular or rectangular position in the apse.

Tablion. A badge of office in the form of a square of silk or gold thread applied to the chlamys.

Tabula ansata. Lit. a panel with handles. On consular diptychs the panel bears the name and style of the consul.

Templon. In Middle Byzantine churches, a trabeated colonnade closing off the bema.

Tetrapylon. Having four gateways. A ceremonial arch with openings on all four sides.

Theme. A Byzantine administrative district.

Theometor. Mother of God. Greek: Θεομήτωρ.

Theophany. A revelation of God to Man.

Theotokos. Mother of God.

Titulus. A dedicatory inscription on an icon.

Toufa. An imperial diadem with a crest of peacock's feathers.

Uncial. Loosely, a capital letter. Having the large rounded forms (not joined together) characteristic of early Greek and Latin manuscripts.

Zoodotes. Giver of Life.

SELECTED BIBLIOGRAPHY

The bibliography referring to specific periods or problems, or to individual works of art, is given in the Notes, chapter by chapter, the former usually in the first note, the latter as required. The list below contains on the whole books not referred to in the Notes and is intended to provide a wider background. Many contain extensive bibliographies.

I. POLITICAL, CULTURAL, AND ECCLESIASTICAL HISTORY

A. GENERAL STUDIES

Cambridge Medieval History, vol. 1, chapters 1, 2, 4–6, 14, and 17; vol. 2, chapters 1, 2, and 9; all of vol. 4, part 1 and 2, of which the revised edition appeared in 1966 and 1967. New York and Cambridge, 1936 ff.

B. EARLY CHRISTIAN

ALFÖLDI, A. *The Conversion of Constantine and Pagan Rome*. Oxford, 1948.
ALFÖLDI, A. *A Conflict of Ideas in the Late Roman Empire*. Oxford, 1952.
BAYNES, N. H. *Constantine the Great and the Christian Church* (*Proceedings of the British Academy*, XV). London, 1929.
GRABAR, A. *Christian Iconography*. London, 1969.
MATTINGLY, H. *Christianity in the Roman Empire*. University of Otago, 1955.
SETTON, K. M. *Christian Attitude towards the Emperor in the Fourth Century*. New York, 1941

C. BYZANTIUM

BAYNES, N. H., and MOSS, H. ST L. B. *Byzantium*. Oxford, 1938; Oxford paperback, 1961.
GEANOKOPLOS, D. J. *Byzantine East and Latin West: Two Worlds of Christendom in Middle Ages and Renaissance. Studies in Ecclesiastical and Cultural History*. Oxford, 1966.
JENKINS, R. *Byzantium: The Imperial Centuries, A.D. 610 to 1071*. London, 1960.
JONES, A. H. M. *The Later Roman Empire 284–602*. 3 vols. Oxford, 1964.
MACLAGAN, M. *The City of Constantinople*. London, 1968.

OSTROGORSKY, G. *Geschichte des byzantinischen Staates*. Munich, 1940; transl. as *History of the Byzantine State*, Oxford, 1956.
RUNCIMAN, S. *Byzantine Civilization*. London, 1933; New York, Meridian paperback, 1962.
STEIN, E. *Geschichte des spätrömischen Reiches*. Vienna, 1928; *Histoire du Bas-Empire*, ed. J. R. Palanque, 2 vols, Paris, 1949–59.
URE, P. N. *Justinian and his Age*. Harmondsworth, 1951.
VASILIEV, A. A. *Histoire de l'empire byzantine*. 2 vols. Paris, 1932; transl. in *University of Wisconsin Studies in the Social Sciences and History*, nos. 13 and 14, 1928–9.

D. THE CHURCH

ALEXANDER, P. J. *The Patriarch Nicephorus of Constantinople*. Oxford, 1958.
DANIELOU, J., and MARROU, H. *The Christian Centuries*, I, *The First Six Hundred Years*. London, 1964.
DAVIES, J. G. *The Early Christian Church*. London, 1965.
DVORNIK, F. *The Photian Schism*. Cambridge, 1948.
DVORNIK, F. *The Idea of Apostolicity in Byzantium and the Legend of St Andrew* (*Dumbarton Oaks Studies*, IV). Harvard University Press, Cambridge, Mass., 1948.
FLICHE, A., and MARTIN, V. (ed.). *Histoire de l'église depuis les origines jusqu'à nos jours*, I–VI. Paris, 1938 ff.
HEFELE, C. J. *History of the Councils of the Church*. London, 1871–96.
RUNCIMAN, S. *The Eastern Schism*. Oxford, 1955.

E. PRIMARY SOURCES

EUSEBIUS (eds. H. J. Lawlor and J. E. L. Oulton). *The Ecclesiastical History*. London, 1932 (cf. G. A. Williamson's new translation in *Penguin Classics*, 1965).
PROCOPIUS (ed. H. B. Dewing). In *Loeb Classical Library*, 7 vols.

II. LITURGY

BISHOP, E. *Liturgica Historica*. Oxford, 1918.
DIX, G. *The Shape of the Liturgy*. London, 1943.
WARREN, F. E. *The Liturgy and Ritual of the Ante-Nicene Church*. London, 1912.

III. EARLY CHRISTIAN AND BYZANTINE ART

A. GENERAL STUDIES

GLÜCK, H. *Die christliche Kunst des Ostens*. Berlin, 1923.

GRABAR, A. *Byzantium*. London, 1966.

KHATCHATRIAN, A. *Les Baptistères paléochrétiens*. Paris, 1962.

LASSUS, J. *The Early Christian and Byzantine World*. London, 1968.

TALBOT RICE, D. *Byzantine Art*. Revised ed. Pelican Books, 1954.

TALBOT RICE, D. *The Beginnings of Christian Art*. London, 1957.

TALBOT RICE, D. (ed.). *The Dark Ages*. London, 1965.

WULFF, O. *Altchristliche und byzantinische Kunst* (*Handbuch der Kunstwissenschaft*). Berlin, 1914–24.

B. EARLY CHRISTIAN

BEAT BRENK *et al. Spätantike und frühes Christentum* (*Propyläen Kunstgeschichte*, Supplementen Bände I). Berlin, 1977.

GRABAR, A. *The Beginnings of Christian Art, 200–395*. London, 1967.

GRABAR, A. *Byzantium from the Death of Theodosius to the Rise of Islam*. London, 1966.

HUTTER, I. *Frühchristliche Kunst. Byzantinische Kunst* (*Belser Stilgeschichte*, IV). Stuttgart, 1968.

KRAUTHEIMER, R., and others. *Corpus Basilicarum Christianarum Romae*. Vatican City, 1939 ff.

KRAUTHEIMER, R. *Early Christian and Byzantine Architecture* (*Pelican History of Art*). Harmondsworth, 1965.

OAKESHOTT, W. *The Mosaics of Rome*. London, 1967.

VAN DER MEER, F. *Early Christian Art*. London, 1967.

VERZONE, P. *From Theodoric to Charlemagne*. London, 1968.

VOLBACH, W. F. (trans. C. Ligota). *Early Christian Art*. New York, 1962.

C. BYZANTINE

BOVINI, G. *Ravenna Mosaics*. New York Graphic Society, 1956.

BOVINI, G. *Mosaici paleocristiani di Roma (secoli III–VI)*. Bologna, 1971.

DELVOYE, C. *L'Art byzantin*. Paris, 1967.

DEMUS, O. *Byzantine Mosaic Decoration*. London, 1948.

EBERSOLT, J. *Les Arts somptuaires de Byzance*. Paris, 1923.

GERO, S. *Byzantine Iconoclasm during the Reign of Leo III, with particular attention to the oriental sources*. Louvain, 1973.

GRABAR, A. *Sculptures byzantines de Constantinople (IVe–Xe siècle)*. Paris, 1963.

GRABAR, A. *Byzantine Painting*. London and Geneva, 1953.

GRABAR, A. *L'Art du Moyen Âge en Europe Orientale*. Paris, 1968.

HUNGER, H. *Das byzantinische Herrscherbild*. Darmstadt, 1975.

LEMERLE, P. *Le Premier Humanisme byzantin*. Paris, 1971.

PÄCHT, O. *Byzantine Illumination*. Oxford, 1952.

PELEKANIDES, S. M. *The Treasure of Mount Athos – Illuminated MSS. I, The Protaton and the Monasteries of Dionysiou, Koutloumousiou, Xeropotamou and Gregoriou*. Athens, 1974.

TALBOT RICE, D. *Byzantine Painting: the Last Phase*. London, 1968.

VOLBACH, W. F., LAFONTAINE-DOSOGNE, J., *et al. Byzanz und der christliche Osten* (*Propyläen Kunstgeschichte*, III). Berlin, 1968.

WEITZMANN, K. *Greek Mythology in Byzantine Art*. Princeton, 1951.

WEITZMANN, K. *Studies in Classical and Byzantine Manuscript Illumination*. Chicago and London, 1971.

WEITZMANN, K., CHATZIDAKIS, M., MIATEV, C., and RADOJĆIC, S. *Icons from South Eastern Europe and Sinai*. London, 1968.

D. PRIMARY SOURCES

CONSTANTINE PORPHYROGENITUS (ed. A. Vogt). *Le Livre des Cérémonies*. Paris, 1933 ff.

DIONYSIUS OF FOURNA (ed. A. Papadopoulos-Kerameus). *Painter's Handbook*, St Petersburg, 1900; French transl. by A. N. Didron, *Manuel d'iconographie chrétienne*, Paris, 1845; English translation of Didron by M. Stokes, *Christian Iconography*, 2 vols, London, 1886–91, with a summary of the *Painter's Handbook*; The '*Painter's Manual*' of *Dionysius of Fourna*, translated into English by Paul Hetherington, London, 1974.

DUCHESNE, L. *Le Liber Pontificalis*. 3 vols. Paris, 1881–92, 1957.

RICHTER, J. P. *Quellen der byzantinischen Kunstgeschichte* (*Quellenschriften für Kunstgeschichte und Kunsttechnik des Mittelalters und der Renaissance*, N.S. VIII). Vienna, 1897.

SCHLOSSER, J. *Quellenbuch zur Kunstgeschichte des abendländischen Mittelalters*. Vienna, 1896.

LIST OF ILLUSTRATIONS

Where no other indication is given, copyright in photographs belongs to the institution given as their location

Constantinople, *c.* 335. *Paris, Musée du Louvre* (Giraudon)

63. The Empress Ariadne. Ivory panel of an imperial diptych. Constantinople, early sixth century. *Florence, Museo Nazionale*

64. Consular diptych of Justin. Ivory. Constantinople, 540. *Berlin, Ehemals Staatliche Museen*

65. Justinian (?). Ivory leaf of an imperial diptych. Constantinople, 527. *Paris, Musée du Louvre* (Giraudon)

66. The Raising of Lazarus, and St Jerome, St Augustine, and St Gregory. Paintings executed on the interior of the consular diptych of Boethius (487) in the seventh century. *Brescia, Museo Cristiano* (Giraudon)

67. The Virgin and Child enthroned between Angels; Christ enthroned between St Peter and St Paul. Ivory diptych. Constantinople, mid sixth century. *Berlin, Ehemals Staatliche Museen* (Foto Steinkopf)

68. The Archangel Michael. Leaf of an ivory diptych. Constantinople, between 519 and 527. *London, British Museum*

69. A Procession of Icons showing the Ancestors of Christ and including portraits of Abraham, David, and Jechonias. From the Priscillian Prologue to St Matthew in the Lorsch Gospels, Batthyaneum, p. 27, executed at the Court School of Charlemagne. Early ninth century. *Alba Julia* (Robert Braunmüller)

70. The Virgin and Child (Theotokos Hodegetria). Painted icon. Rome, *c.* 609. *Rome, Pantheon* (Gabinetto Fotografico)

71. The Virgin and Child between Archangels. Mosaic in the apse. Second half of the seventh century. *Kiti, Panagia Angeloktistos* (C. Mango)

72. The Virgin and Child (Theotokos Hodegetria). Painted icon. Rome, *c.* 640. *Rome, S. Maria Nova (S. Francesca Romana)* (Gabinetto Fotografico)

73. The Virgin (Panagia Hagiasoritissa or Chalkoprateia). Painted icon. Rome, late eighth century. *Rome, S. Maria del Rosario* (Gabinetto Fotografico)

74. A Translation of Relics at Constantinople. Ivory. Byzantine, probably sixth century. *Trier, cathedral treasury*

75. The Virgin and Child enthroned between St Theodore and St George. Painted icon. Constantinople, sixth or seventh century. *Mount Sinai, monastery of St Catherine* (Alexandria-Michigan-Princeton Archaeological Expedition to Mount Sinai)

76. St Peter. Painted icon. Constantinople, sixth or seventh century. *Mount Sinai, monastery of St Catherine* (Alexandria-Michigan-Princeton Archaeological Expedition to Mount Sinai)

77. The Virgin crowned as Queen (Maria Regina). Painted icon. Rome, between 705 and 707. *Rome, S. Maria in Trastevere* (Gabinetto Fotografico)

78. A Goatherd. Silver dish with control stamps of Justinian (527–65). *Leningrad, Hermitage*

79. Dish of Paternus, Bishop of Tomi (517–20). Silver and silver-gilt. Constantinople, *c.* 518 but with later additions probably made at Tomi. *Leningrad, Hermitage*

80. Vase decorated with busts of Christ, the Virgin, Archangels, and Saints. Silver. Found at Homs in Syria. Sixth century. *Paris, Musée du Louvre*

81. Angels on either side of a cross. Silver dish. Constantinople, sixth century. *Leningrad, Hermitage*

82. The Stuma Paten, decorated with the Communion of the Apostles. Silver and silver-gilt. Constantinople, between 565 and 578. *Istanbul, Archaeological Museum* (Giraudon)

83. The Cross of Justin II. Silver-gilt. Constantinople, between 565 and 578, with later additions and restorations made in Rome. *Vatican, Treasury of St Peter's* (Gall. Mus. Vaticani)

84. The Anointing of David. Silver dish. Found in Cyprus. Constantinople, between 610 and 629. *New York, Metropolitan Museum*

85. The Transfiguration. Mosaic in the apse. Between 548 and 565. *Mount Sinai, monastery of St Catherine, church* (Alexandria-Michigan-Princeton Archaeological Expedition to Mount Sinai)

86. The Last Supper. Mosaic in the nave. Early sixth century. *Ravenna, S. Apollinare Nuovo* (German Archaeological Institute, Rome)

87. The Garden of Gethsemane. Mosaic in the nave. Early sixth century. *Ravenna, S. Apollinare Nuovo* (German Archaeological Institute, Rome)

88. Procession of Virgins. Mosaic in the nave. Between 556 and 569. *Ravenna, S. Apollinare Nuovo* (German Archaeological Institute, Rome)

89. The Baptism of Christ; below, the Apostles. Mosaic in the dome. Early sixth century. *Ravenna, Arian Baptistery* (Fotofast-Bologna)

90. Christ enthroned between St Vitalis and Bishop Ecclesius. Mosaic in the apse. Second quarter of the sixth century. *Ravenna, S. Vitale* (Hirmer Fotoarchiv)

91. The Sacrifice of Isaac. Mosaic on the left tympanum. Second quarter of the sixth century. *Ravenna, S. Vitale* (German Archaeological Institute, Rome)

92. Justinian and his suite, including Archbishop Maximian. Mosaic panel in the chancel. Probably *c.* 547. *Ravenna, S. Vitale* (Fotofast-Bologna)

93. Theodora and her suite. Mosaic panel in the chancel. Probably *c.* 547. *Ravenna, S. Vitale* (Fotofast-Bologna)

94. Maximian's Chair. Ivory. Constantinople, *c.* 547. *Ravenna, Archiepiscopal Museum* (Hirmer Fotoarchiv)

Rome, S. Lorenzo fuori le Mura (Alinari; Mansell Collection)

123. St Augustine. Wall-painting. Late sixth century. *Rome, Lateran Palace, Old Library* (Gall. Mus. Vaticani)

124. St Agnes. Mosaic in the apse. *c.* 630 (?). *Rome, S. Agnese* (Gabinetto Fotografico)

125. The Virgin in prayer amid Apostles and Saints. Mosaic in the apse. Between 640 and 642. *Rome, S. Giovanni in Laterano, Baptistery, Oratory of S. Venanzio* (Anderson; Mansell Collection)

126. A jewelled cross surmounted by a bust of Christ flanked by St Primus and St Felicianus. Mosaic in the apse. Between 642 and 649. *Rome, S. Stefano Rotondo* (Gabinetto Fotografico)

127. St Sebastian. Mosaic panel. *c.* 680. *Rome, S. Pietro in Vincoli* (Alinari; Mansell Collection)

128. The Virgin and Child enthroned. Fragment of an Adoration of the Magi. Part of the decoration in the Chapel of the Virgin in Old St Peter's. Between 705 and 707. *Rome, S. Maria in Cosmedin* (Gabinetto Fotografico)

129. St Anne. Wall-painting. 649. *Rome, S. Maria Antiqua* (Gabinetto Fotografico)

130. The Maccabees. Wall-painting. 649. *Rome, S. Maria Antiqua* (Gabinetto Fotografico)

131. The Angel of the Annunciation. Wall-painting. 649. *Rome, S. Maria Antiqua* (Gabinetto Fotografico)

132. St Luke. Wall-painting. Between 668 and 685. *Rome, catacomb of Commodilla* (Pont. Comm. di Arch. Sacra)

133. The Crucifixion. Wall-painting. Between 741 and 752. *Rome, S. Maria Antiqua, prothesis or chapel of Theodotus* (Hirmer Fotoarchiv)

134. The Flight into Egypt. Wall-painting. *c.* 700. *Castelseprio, church* (Perotti)

135. Christ Pantocrator. Wall-painting. *c.* 700. *Castelseprio, church* (Perotti)

136. St Peter presenting the deacon David Peter. From a copy of St Gregory's Sermons on the Gospels, MS. CXLVIII, fol. 7 verso. Nonantola, *c.* 800. *Vercelli, Biblioteca Capitolare* (Ann Münchow)

137. St John Chrysostom. From a Latin copy of St John Chrysostom's Sermons on St Matthew, MS. cod. 1007, fol. 1. Salzburg, early ninth century. *Vienna, Österreichische Nationalbibliothek*

138. St Matthew. From the Coronation Gospels of the Holy Roman Empire, fol. 15. Aachen, before 800. *Vienna, Weltliche und Geistliche Schatzkammer*

139. The Vision of Ezechiel. Mosaic in the apse. Probably sixth century. *Salonika, Latomos Monastery, Hosios David* (Photo Lykides)

140. St Demetrius, a donor, and a child. Mosaic panel

in the south aisle. Probably late sixth or early seventh century. *Salonika, Hagios Demetrios* (Photo Tombazi)

141. St Demetrius between donors. Mosaic panel. After 647. *Salonika, Hagios Demetrios* (Photo Lykides)

142. Pastoral scenes. Mosaic floor. Second half of the sixth century (?). *Istanbul, Great Palace*

143. St Sergius or St Bacchus. Silver dish. Between 641 and 651. *London, British Museum*

144. Emperors hunting. Silk compound twill. Constantinople, mid eighth century. *Lyon, Musée Historique des Tissus*

145. A Charioteer. Silk compound twill. Constantinople, late eighth century. *Paris, Musée de Cluny*

146. Emperors hunting. Silk compound twill. Constantinople (?), late eighth or ninth century. *Berlin, Ehemals Staatliche Museen* (Giraudon)

147. The Annunciation. Silk compound twill. Constantinople (?), late eighth or ninth century. *Vatican, Museo Sacro Cristiano* (Gall. Mus. Vaticani)

148. The Nativity. Silk compound twill. Constantinople (?), late eighth or ninth century. *Vatican, Museo Sacro Cristiano* (Gall. Mus. Vaticani)

149. The Patriarch Nicephorus triumphant over John the Grammarian. From the Chludov Psalter, MS. 129 D, fol. 51 verso. Second half of the ninth century. *Moscow, Historical Museum*

150. The Vision of Ezechiel in the Valley of Dry Bones. From a copy of the Homilies of St Gregory Nazianzen, MS. gr. 510, fol. 438 verso. Between 880 and 882. *Paris, Bibliothèque Nationale* (Hirmer Fotoarchiv)

151. The Sacrifice of Isaac. From a copy of the Christian Topography of Cosmas Indicopleustes, MS. gr. 699, fol. 59 recto. Second half of the ninth century. *Vatican, Biblioteca Apostolica*

152. The Resurrection of the Dead. From a copy of the Christian Topography of Cosmas Indicopleustes, MS. gr. 699, fol. 89 recto. Second half of the ninth century. *Vatican, Biblioteca Apostolica*

153. Above, Anna and Simeon; below, the Virgin, Christ, St John the Baptist, Zacharias and Elizabeth. From a copy of the Christian Topography of Cosmas Indicopleustes, MS. gr. 699, fol. 76 recto. Second half of the ninth century. *Vatican, Biblioteca Apostolica*

154. The Virgin and Child enthroned. Detail from the mosaic in the apse. Before 867. *Istanbul, Hagia Sophia* (The Byzantine Institute, Inc.)

155. The Archangel Gabriel. Fragments of a mosaic on the south side of the apse. Before 867. *Istanbul, Hagia Sophia* (The Byzantine Institute, Inc.)

156. St Ignatius the Younger. Mosaic panel on the north tympanum. Late ninth century. *Istanbul, Hagia Sophia* (The Byzantine Institute, Inc.)

vestibule into the narthex. Late tenth or early eleventh century. *Istanbul, Hagia Sophia* (Byzantine Institute, Inc.)

191. The Virgin and Child enthroned. Mosaic in the apse. *c.* 1020. *Hosios Loukas, catholicon* (Josephine Powell)

192. Jonah. From a Menologion, MS. gr. 1613, fol. 59, executed for Basil II in the Palace of the Blachernae. *c.* 985. *Vatican, Biblioteca Apostolica*

193. The Entry into Jerusalem. Ivory panel. Late tenth century. *Berlin, Ehemals Staatliche Museen*

194. The Dormition. Ivory panel on a book-cover, MS. Clm. 4453. Late tenth century. *Munich, Staatsbibliothek*

195. The Veroli Casket. Ivory. Late tenth or early eleventh century. *London, Victoria and Albert Museum*

196. Mythological figures. Enamelled glass bowl. Eleventh century. *Venice, S. Marco, treasury* (Osvaldo Böhm)

197. The Dormition. Steatite. Late tenth or early eleventh century. *Vienna, Kunsthistorisches Museum*

198. The Crucifixion. Mosaic. *c.* 1020. *Hosios Loukas, catholicon* (P. Papachatzidakis)

199. The Harrowing of Hell. Mosaic. *c.* 1020. *Hosios Loukas, catholicon* (P. Papachatzidakis)

200. The Washing of the Feet of the Apostles. Mosaic. *c.* 1020. *Hosios Loukas, catholicon* (P. Papachatzidakis)

201. Christ enthroned between the Emperor Constantine IX Monomachos and the Empress Zoe. Mosaic panel in the south gallery. Probably executed between 1028 and 1034, defaced in 1041, and restored shortly after 1042. *Istanbul, Hagia Sophia* (The Byzantine Institute, Inc.)

202. The Crucifixion. Mosaic. Mid eleventh century. *Nea Moni, Chios* (P. Papachatzidakis)

203. The Harrowing of Hell. Mosaic. Mid eleventh century. *Nea Moni, Chios* (P. Papachatzidakis)

204. The Ascension. Wall-painting. Mid eleventh century. *Ochrid, Hagia Sophia* (Josephine Powell)

205. The Emperor Nicephorus III Botaneiates between St John Chrysostom and the Archangel Michael. From a copy of the Homilies of St John Chrysostom, MS. Coislin 79, fol. 2 verso. *c.* 1078. *Paris, Bibliothèque Nationale*

206. The Annunciation. Faom a copy of a Psalter and a New Testament, MS. 3, fol. 80 verso (formerly Mount Athos, Pantocrator, MS. 49). Late eleventh century. *Washington, D.C., The Dumbarton Oaks Collection*

207. The Ascension. From a copy of the Homilies of the Virgin by James of Kokkinobaphos, MS. gr. 1208, fol. 3 verso. First half of the twelfth century. *Paris, Bibliothèque Nationale*

208. The Virgin Orans. Serpentine. Between 1078 and 1081. *London, Victoria and Albert Museum*

209. The Virgin and Child. Marble relief found near the mosque of Sokollu Mehmet Pasha. Second half of the eleventh century. *Istanbul, Archaeological Museum*

210. The Virgin Orans. Marble panel from St George of the Mangana. Eleventh or twelfth century. *Istanbul, Archaeological Museum*

211. St John the Baptist with busts of St Philip, St Stephen, St Andrew, and St Thomas. Ivory relief. Twelfth century. *London, Victoria and Albert Museum*

212. The Virgin and Child (Theotokos Hodegetria). Ivory statuette. Twelfth century. *London, Victoria and Albert Museum*

213. Solomon. Enamelled, silver-gilt plaque on the Pala d'Oro. Shortly before 1105. *Venice, S. Marco* (Osvaldo Böhm)

214. The Entry into Jerusalem. Enamelled, silver-gilt plaque formerly part of an iconostasis in Hagia Sophia or the church of the Pantocrator in Constantinople, now on the Pala d'Oro. Twelfth century. *Venice, S. Marco* (Osvaldo Böhm)

215. Christ Pantocrator. Mosaic in the dome. *c.* 1100. *Daphni, church of the Dormition* (Josephine Powell)

216. The Annunciation. Mosaic in a squinch. *c.* 1100. *Daphni, church of the Dormition* (Josephine Powell)

217. The Nativity. Mosaic in a squinch. *c.* 1100. *Daphni, church of the Dormition* (P. Papachatzidakis)

218. The Transfiguration. Mosaic in a squinch. *c.* 1100. *Daphni, church of the Dormition* (P. Papachatzidakis)

219. The Crucifixion. Mosaic panel. *c.* 1100. *Daphni, church of the Dormition* (P. Papachatzidakis)

220. The Harrowing of Hell. Mosaic panel. *c.* 1100. *Daphni, church of the Dormition* (P. Papachatzidakis)

221. (A) The Virgin and Child between the Emperor John II Comnenus and the Empress Irene. *c.* 1118. (B) The co-Emperor Alexius. *c.* 1122. Mosaic panels in the south gallery. *Istanbul, Hagia Sophia* (The Byzantine Institute, Inc.)

222. Christ crowning King Roger II of Sicily. Mosaic panel. *c.* 1148. *Palermo, Martorana* (Anderson; Mansell Collection)

223. Christ Pantocrator. Mosaic in the apse. *c.* 1148. *Cefalù, church* (Anderson; Mansell Collection)

224. Christ Pantocrator and Angels. Mosaic in the cupola. *c.* 1143. *Palermo, Cappella Palatina* (Anderson; Mansell Collection)

225. The Flight into Egypt. Mosaic panel. Mid twelfth century. *Palermo, Cappella Palatina* (Anderson; Mansell Collection)

226. George of Antioch prostrate before the Virgin. Mosaic panel. Before 1148. *Palermo, Martorana* (Alinari; Mansell Collection)

265. St Luke and St James. From a copy of the Acts and Epistles, MS. gr. 1208, fol. 1 verso. Constantinople, second half of the thirteenth century. *Vatican, Biblioteca Apostolica*

266. David listening to Nathan and doing penance. From a Psalter, MS. Hagiou Taphou 51, fol. 108. Constantinople, thirteenth century. *Jerusalem, Greek Patriarchate Library* (Exposition: Athens 1964)

267. Christ Pantocrator. Mosaic in the dome. *c.* 1290. *Arta, Panagia Parigoritissa* (A. K. Orlandos)

268. Christ. Detail from the mosaic panel of the Deesis in the south gallery. Late thirteenth century. *Istanbul, Hagia Sophia* (The Byzantine Institute, Inc.)

269. The Dormition. Wall-painting. *c.* 1295. *Ochrid, church of the Peribleptos (St Clement)* (Josephine Powell)

270. The Betrayal of Christ. Wall-painting. *c.* 1295. *Ochrid, church of the Peribleptos* (Josephine Powell)

271. The Nativity. Fragments of a mosaic. Between 1312 and 1315. *Salonika, church of the Holy Apostles* (Photo Lykides)

272. The Harrowing of Hell. Fragments of a mosaic. Between 1312 and 1315. *Salonika, church of the Holy Apostles* (Photo Lykides)

273. The Transfiguration. Miniature mosaic. Constantinople, late thirteenth or early fourteenth century. *Paris, Musée du Louvre* (Giraudon)

274. The Twelve Feasts. Miniature mosaic. Constantinople, early fourteenth century. *Florence, Museo dell'Opera del Duomo* (Alinari)

275. St John Chrysostom. Miniature mosaic. Constantinople, early fourteenth century. *Washington, D.C., The Dumbarton Oaks Collection*

276. Christ and the Virgin adored by Isaac Comnenus and Melane the nun. Fragments of a mosaic in the inner narthex. *Istanbul, church of Christ in Chora* (The Byzantine Institute, Inc.)

277. Theodore Metochites, Logothete of the Imperial Treasury. Detail from the mosaic tympanum. Second decade of the fourteenth century. *Istanbul, church of Christ in Chora* (The Byzantine Institute, Inc.)

278. The Nativity. Mosaic panel in the narthex. *Istanbul, church of Christ in Chora* (The Byzantine Institute, Inc.)

279. The First Seven Steps of the Virgin. Mosaic in the narthex. *Istanbul, church of Christ in Chora* (Josephine Powell)

280. The Harrowing of Hell. Wall-painting in the apse. *Istanbul, church of Christ in Chora, parecclesion* (The Byzantine Institute, Inc.)

281. The Last Judgement. Wall-painting in the vault. *Istanbul, church of Christ in Chora, parecclesion* (The Byzantine Institute, Inc.)

282. The Communion of the Apostles. Wall-painting. Between 1306 and 1309. *Prizren, church of the Bogoro-dica Ljeviška* (K. Denitch, Republic Institute for the Preservation of Cultural Monuments)

283. King Milutin. Wall-painting. 1313-14. *Studenica, King's Church* (Josephine Powell)

284. The Nativity of the Virgin. Wall-painting. 1313-14. *Studenica, King's Church* (K. Denitch, Republic Institute for the Preservation of Cultural Monuments)

285. St Philip and Queen Kandakia's eunuch. Wall-painting. Shortly before 1335. *Dečani, church* (Republic Institute for the Preservation of Cultural Monuments)

286. The Miracle at Cana. Wall-painting. Shortly before 1413. *Kalenić, church* (Josephine Powell)

287. Christ and the Virgin and Child surrounded by busts of saints. Diptych reliquary. Painted wood, metal, enamel, pearls, and precious stones. Constantinople, between 1367 and 1384. *Cuenca, cathedral treasury* (Exposition: Athens 1964)

288. Christ Pantocrator. Icon. Constantinople, 1363. *Leningrad, Hermitage*

289. The Mourning Virgin and the Dead Christ. Icon-diptych. Late fourteenth century. *Meteora, monastery of the Transfiguration* (Exposition: Athens 1964)

290. The Vision of Ezechiel and Habakkuk; on the reverse, the Mourning Virgin and St John the Evangelist. Double-sided icon of Poganovo. Probably Salonika, *c.* 1395. *Sofia, Archaeological Museum*

291. Scenes from the Passion of Christ. The Bessarion reliquary. Painted wood, metal, enamel, and precious stones. Constantinople, late fourteenth or early fifteenth century. *Venice, Galleria dell'Accademia* (Exposition: Athens 1964)

292. The Emperor Andronicus II presenting a chrysobul to Christ. Chrysobul, MS. 1 (Index X.A.E. 3750), addressed in 1301 to the Metropolitan of Monemvasia. *Athens, Byzantine Museum* (Exposition: Athens 1964)

293. The Emperor John VI Cantacuzene. From a copy of the theological works of the Emperor, MS. gr. 1242, fol. 123 verso. Constantinople, between 1370 and 1375. *Paris, Bibliothèque Nationale*

294. The Transfiguration. From a copy of the theological works of the Emperor John VI Cantacuzene, MS. gr. 1242, fol. 92 verso. Constantinople, between 1370 and 1375. *Paris, Bibliothèque Nationale*

295. The nuns of the Convent of Our Lady of Good Hope at Constantinople. From a Typicon of the Convent. Mid fourteenth century. *Oxford, Lincoln College*

296. The Calling of the Chosen. Front of the so-called Dalmatic of Charlemagne, in fact a patriarchal *sakkos* of the mid fourteenth century. Gold, silver, and silk embroidery on a silk ground. *Rome, St Peter's, treasury* (Alinari)

The courtesy of the following is acknowledged for permission to reproduce illustrations: The Trustees of the British Museum (illustrations 26, 39, 68, 112, 143, 264); Staatliche Museen, Berlin, Preussischer Kulturbesitz, Antikenabteilung (illustration 43), Frühchristlich-byzantinische Sammlung (illustrations 64, 67, 163, 193); The Master and Fellows of Corpus Christi College, Cambridge (illustration 119); The Freer Gallery of Art, Smithsonian Institution, Washington, D.C. (illustrations 257, 258).

INDEX

THE PELICAN HISTORY OF ART

COMPLETE LIST OF TITLES

*Published only in original large hardback format.
†Latest edition in integrated format (hardback and paperback).
‡Latest edition in integrated format (paperback only).
§Published only in integrated format (hardback and paperback).
‖Not yet published.

ART AND ARCHITECTURE IN BELGIUM: 1600–1800* *H. Gerson and E. H. ter Kuile, 1st ed., 1960*

FLEMISH BAROQUE ART AND ARCHITECTURE‖ *Hans Vlieghe*

DUTCH ART AND ARCHITECTURE: 1600–1800‡ *Jakob Rosenberg, Seymour Slive and E. H. ter Kuile, 3rd ed., 1977*

ART AND ARCHITECTURE IN FRANCE: 1500–1700‡ *Anthony Blunt, 4th ed., 1980, reprinted with revisions 1982*

ART AND ARCHITECTURE OF THE EIGHTEENTH CENTURY IN FRANCE* *Wend Graf Kalnein and Michael Levey, 1st ed., 1972*

ART AND ARCHITECTURE IN SPAIN AND PORTUGAL AND THEIR AMERICAN DOMINIONS: 1500–1800* *George Kubler and Martin Soria, 1st ed., 1959*

ARCHITECTURE IN BRITAIN: 1530–1830‡ *John Summerson, 7th ed., 1983*

SCULPTURE IN BRITAIN: 1530–1830† *Margaret Whinney, 2nd ed., revised by John Physick, 1988*

PAINTING IN BRITAIN: 1530–1790† *Ellis Waterhouse, 4th ed., 1978*

PAINTING IN BRITAIN: 1790–1890‖ *Michael Kitson*

ARCHITECTURE: NINETEENTH AND TWENTIETH CENTURIES‡ *Henry-Russell Hitchcock, 4th ed., 1977, reprinted with corrections 1987*

PAINTING AND SCULPTURE IN EUROPE: 1780–1880‡ *Fritz Novotny, 2nd ed., 1970, reprinted with revisions 1978*

PAINTING AND SCULPTURE IN EUROPE: 1880–1940‡ *George Heard Hamilton, 3rd ed., 1981, reprinted with revisions 1987*

AMERICAN ART* *John Wilmerding, 1st ed., 1976*

THE ART AND ARCHITECTURE OF ANCIENT AMERICA‡ *George Kubler, 3rd ed., 1984*

THE ART AND ARCHITECTURE OF RUSSIA‡ *George Heard Hamilton, 3rd ed., 1983*

THE ART AND ARCHITECTURE OF ANCIENT EGYPT† *W. Stevenson Smith, 3rd ed., revised by W. Kelly Simpson, 1981*

THE ART AND ARCHITECTURE OF INDIA: HINDU, BUDDHIST, JAIN‡ *Benjamin Rowland, 4th ed., 1977*

THE ART AND ARCHITECTURE OF THE INDIAN SUBCONTINENT§ *J. C. Harle, 1st ed., 1986*

THE ART AND ARCHITECTURE OF ISLAM: 650–1250§ *Richard Ettinghausen and Oleg Grabar, 1st ed., 1987*

THE ART AND ARCHITECTURE OF ISLAM: 1250–1800‖ *Sheila Blair and Jonathan Bloom*

THE ART AND ARCHITECTURE OF THE ANCIENT ORIENT‡ *Henri Frankfort, 4th revised impression, 1970*

THE ART AND ARCHITECTURE OF JAPAN‡ *Robert Treat Paine and Alexander Soper, 3rd ed., 1981*

THE ART AND ARCHITECTURE OF CHINA‡ *Laurence Sickman and Alexander Soper, 3rd ed., 1971*

CHINESE ART AND ARCHITECTURE‖ *William Watson, 2 vols.*

THE ARTS OF AFRICA‖ *B. J. Mack*

THE ARTS OF OCEANIA‖ *Stephen Hooper*

*Published only in original large hardback format.
†Latest edition in integrated format (hardback and paperback).
‡Latest edition in integrated format (paperback only).
§Published only in integrated format (hardback and paperback).
‖Not yet published.